The White Blackbird

Also by Honor Moore

❧

Memoir
(poems)

Mourning Pictures
(play)

The New Women's Theater:
Ten Plays by Contemporary American Women
(editor)

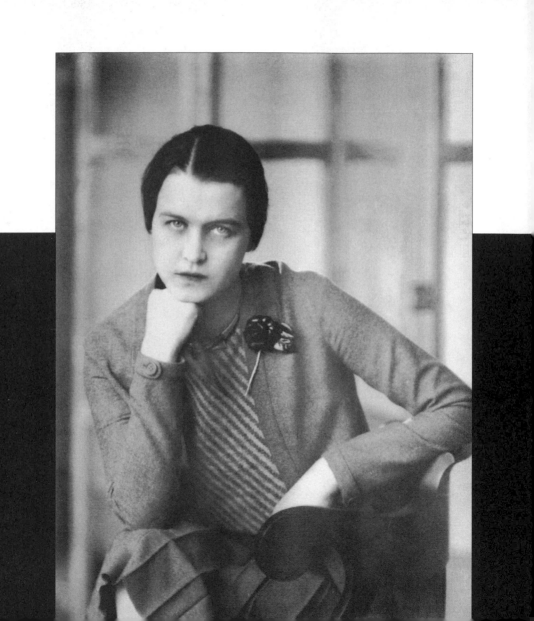

THE WHITE
BLACKBIRD

A life of the painter

Margarett Sargent

by her

granddaughter

VIKING

VIKING
Published by the Penguin Group
Penguin Books USA Inc., 375 Hudson Street,
New York, New York 10014, U.S.A.
Penguin Books Ltd, 27 Wrights Lane, London W8 5TZ, England
Penguin Books Australia Ltd, Ringwood, Victoria, Australia
Penguin Books Canada Ltd, 10 Alcorn Avenue,
Toronto, Ontario, Canada M4V 3B2
Penguin Books (N.Z.) Ltd, 182–190 Wairau Road,
Auckland 10, New Zealand

Penguin Books, Ltd, Registered Offices:
Harmondsworth, Middlesex, England

First published in 1996 by Viking Penguin,
a division of Penguin Books USA Inc.

3 5 7 9 10 8 6 4 2

Copyright © Honor Moore, 1996
All rights reserved

Page 372 constitutes an extension of the copyright page.

Frontispiece: Margarett Sargent in Paris, 1928.
(Photograph by Berenice Abbott.)

LIBRARY OF CONGRESS CATALOGING IN PUBLICATION DATA
Moore, Honor, 1945–
The white blackbird:
A life of the painter Margarett Sargent by her granddaughter
Margarett Sargent / Honor Moore
p. cm
Includes bibliographical references and index.
ISBN 0-670-80563-7 (hardcover : alk. paper)
1. Sargent, Margarett. 2. Painters—United States—Biography.
I. Title.
ND237.S313M66 1996
759.13—dc20
[B] 95–23912

This book is printed on acid-free paper.

Printed in the United States of America
Set in Adobe Garamond
Designed by Francesca Belanger

For Margarett Vernon

Contents

*Sections of photographs follow
pages 148 and 308.*

If you bring forth what is within you, what you bring forth will save you. If you do not bring forth what is within you, what you do not bring forth will destroy you.

—The Gnostic Gospel of Thomas

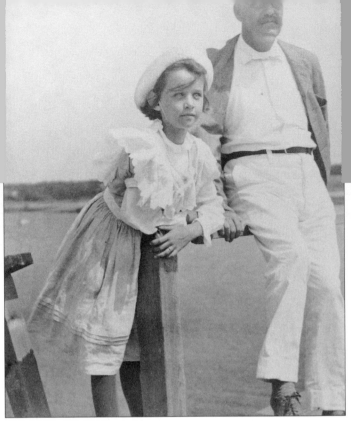

i

Sundays of course were different—
I wore plumes . . .

(1892–1908)

Margarett and her father
at Wareham, c. 1903

"YOU WILL HAVE A BOSOM like your grandmother's," my mother says. I am eleven, standing with her near the brass-fixtured highboy on the second-floor landing of our house in Indianapolis. My mother is black-haired, olive-skinned, and lean. My brother teases me for being too pale, too round—"white and gooshy, white and gooshy"—and I reassure myself: I am like my grandmother Margarett. She had black hair and very white skin. Like mine. She was not called pale. She was an artist, and she was called wonderfully fair.

"I was flat-chested until I had children," my mother says, pulling my first bra from the underwear drawer. "I envy you your bosom." At thirteen, alone in the mirrored dressing room, I cup new breasts with small, wide hands: a "bosom" like my grandmother's. The bosom grows. And the buttocks. "What's that behind you?" my mother jokes as we walk together down the street. Fat. Fat as Margarett's face in that photograph she sent from Brittany in 1953. It was the only picture of her in our house. A fat face. Too fat for the Breton headdress. Too sad to look at for long. I finger the red felt jacket from Saint-Malo. It lasts. Grandma sent it from France! She taught me to draw. To want to write letters in strange-colored inks on unusual paper.

It could have been any day in the years before the truce my mother and I reached when I left home. It happened a lot in the years my figure was becoming like my grandmother's. Standing in the twenties-vintage maroon bathroom so the other children won't hear, my mother and I scream at each other for "reasons" having to do with hair— "Sweetie, keep it away from your face!" And she pushes it from my

face. And I yank her hand away. Silence, then, "There, that's lovely," the side of my face revealed when the hair goes behind the ear. "Bitch," under my breath. My room is messy. A slap across my face—punctuation to the fights with my mother. One long fight. She is cool. I am not. Margarett was not.

Margarett is dead now, and so is my mother. I am left with the reports of war correspondents. "All the time," my brother says. "She screamed at you. Screamed." And my sister: "Once I asked Mom, Why are you so mean to Honor?" "What did she say?" "Nothing." And my father: "My psychiatrist told me to stay out of it: mothers and daughters . . ." Twenty years later, my brother: "She was fighting something back in you. Definitely. Tamping it down. It was her mother in you. She saw Margarett growing in you."

My mother at the telephone when telephones were black: "Grandma's in the hospital again." "What's wrong with her?" "Mentally ill." My mother stands there touching her head. "It means her mind is sick." Her brain? The feeling inside my own head. Nothing in my mother's voice tells me her fear. Fifteen years later, I hold a white telephone as my mother tells me she herself is going into a sanitarium: depression. Margarett's sad face. Oh, yes, her brain. Her mind. Oh, yes, I understand—that kernel of pain in my own head. A feeling starts to hurt and you have no words for it.

I help my mother set the table for a dinner party. From the high cupboard we lift white china cupids holding luscious fake grapes, gifts from Margarett, to decorate the long dining table, Margarett's wedding present. "You know the story of this table," my mother says as we place the silver and the red goblets. "She promised it as a wedding present, then she had more shock treatments, and when we went to claim it, she wouldn't give it to us! The shock treatments made her forget even our wedding!" My mother talks in a perfectly normal voice. "Finally we got it, but the whole thing was *just* awful."

"I don't want you to have to cope with her," my mother said when I told her I wanted to go to Radcliffe. Cambridge was less than an

hour from where Margarett lived. Of course I wanted to go nowhere but Radcliffe. When the time came, Margarett was in a sanitarium. At Radcliffe, I was a midwestern immigrant even though all the men in my mother's family had gone to Harvard for generations, even though Radcliffe had been founded by my mother's paternal great-great-grandmother. I cry from fear the night before my first exam. I am too ashamed to speak the secret wish: I want to write. I skate a surface, the dark water of possible creativity well below, frozen from me. Unspoken, even unthought, is the fear: If it thaws and I plunge through, if I write, will I go mad? "You look so much like Margarett," all the Boston relatives say.

Crazy Margarett, the woman always described as having been startlingly beautiful, to my child's eye bestially fat, stuffed into high heels, still attempting chic. Crazy. Scent of her perfume cut with heavy nausea smell. Image of my mother on the phone, news again of Margarett drunk, manic, sent for a few weeks to this or that sanitarium. I do not want to be crazy, and yet I want something this grandmother has. Everything she does, she does with taste so original its sensuality is palpable: letters written in brown ink on butcher's paper; a green satin purse with cream satin lining, a Christmas present for the granddaughter she barely knows; her sensitive responses when I send her an example of my own art: "Your poster is safely on my wall. When I watch it, it really moves. I admire very much the distribution of lettering you were obliged to do—I would be helpless with the problem. As I wired you, I love it. . . ."

"That week at Grandma's wrecked my life," I say. My father laughs. "We were all so worried, but you had a great time." Wrecked my life? What mystery, what example, what illusion would have formed the yearning of my imagination had I not, at the age of five, visited that grandmother in that house?

Her house. An old saltbox my grandfather bought while he was still at Harvard, built in 1630, lived in first by the king's tax collector for the Massachusetts Bay Colony, then during the Revolution by

General Burgoyne. Margarett and Shaw restored it and, after their marriage, added onto the house so that, to a small girl's eye, it seemed a castle. Its entrance hall, first built as Margarett's sculpture studio, became, with later additions, a mammoth living room. Off one corner, an octagonal tower walled with mirrors Margarett left outdoors one winter to weather to an appropriate cloudiness. A pool walled with trimmed arborvitae, its entrance hidden so the hedge seems a maze. Apple trees like candelabra, espaliered against the dark clapboard.

In her Spanish bedroom, Margarett directs as a photographer positions me. I ride a tiny antique rocking horse. Flash. On the wall above the mantel hangs a De Chirico: two stallions, creamy manes lifted by desert wind, creamy tails streaming to the sand. I sit pasting paper, intent; nearby, Margarett, pen in hand, sketch pad on her knee. Or Margarett sits near my bed, sketching as I fall asleep. When I wake, she's gone. I remember Jack, her green macaw, screaming "Margarett!!!" over and over. And the darkened bedroom. "Shhh. Quiet," the cook says. "Your grandmother was up late." I remember shafts of sun coming through skylights breaking the gloom of the living room. The quiet emptiness. But I don't remember what she sketched. I don't think I ever saw the drawing.

Margarett stopped painting in her early forties, and one day I had the nerve to ask her why. "It got too intense," she said, at eighty-two having survived five strokes, divorce, years in and out of sanitariums. "For twenty years, I worked," she answered, gravelly rasp rendered nearly incomprehensible by partial paralysis. "And then I turned to horticulture." This was the first and only time in my relationship with Margarett, a friendship that began and grew in the last seven years of her life, long after she had become bedridden, that we spoke of her art, the closest we came to speaking of her manic-depression, the "madness" I interpret as the inevitable result of conflict between art and female obligation in upper-class, old-family Boston.

I do not see a painting of hers until I have my first apartment: "I want one you painted." My letter to her says something about lots of

blank white walls. I am tentative because I have seen only one drawing of hers, never a painting; tentative because I know she stopped painting and don't know how many of her paintings there are, if any. *The Blue Girl*, its arrival announced weeks before by a note scrawled in pink on hot-turquoise stationery, comes crated. I unwind gleaming screws, one by one, lift the lid, whiff of fresh wood, peel back the cardboard.

"It has a wonderful Spanish frame," she'd written. Yes, and dazed black eyes staring as if interrupted. A stranger. A huge black hat's shadows smudge her white forehead; lips set, red, disturbed. Color: Light blue collars a pale neck, behind writhe thick green vines, exploding ultramarine blooms. Brown hair to the shoulder, she sits, volcanic, holds the graceful white arm of an orange chair with both hands, as if to hold herself to the canvas. I am twenty-one. This is my first adult intimacy with a woman who has given up.

"Who is she?" I ask Margarett later. Her voice is already muffled by the first paralytic stroke. "A model." Of despair. Hands roughly articulated. After the first stroke, Margarett's hands shake too much to draw. The Blue Girl's hands, painted in 1929, splay like fans, prophetic. "Who did that frightening painting?" a visitor asks. "My crazy grandmother." I laugh, knowing that at night when I sit down at my blue typewriter I won't be able to dismiss her piercing disturbance as I type, fingers splaying across the keyboard, drumming to tame that countenance, the steady acidic gaze that follows me everywhere in the room, watching, communicating some warning I cannot yet hear.

I am sitting with Margarett's oldest daughter, my aunt Margie, near her pool, minutes from the house I visited at the age of five. Margarett has been dead two years. My mother's spell has worked. Margarett won't fit into the poem I keep trying to write, and every time I contemplate her, I am frightened. While she was still alive, I'd sit by her bed, chest tight, unable to ask what I wanted to know. "Tell me about your life, Grandma. Tell me how you became an artist." Unasked were other questions: "What must I do not to 'go mad' as you have? What must I do to live fully both as an artist and a woman?" In Margarett's

absence, I ask questions of the daughter who was close to her, of whom she made so many drawings and paintings.

"She was not a very cozy mother," Margie says. "We'd visit her studio. We wouldn't stay long. She'd be intent on her work." And so it was true, Margarett was a working artist. "She never stopped drawing. She stopped exhibiting. I think she hated herself for not continuing." Margie, it seems, will tell me anything I want to know. She gives me names of people to talk to, assures me Margarett's brother Dan will be happy to see me. "But you better hurry up," she says. "He's nearly ninety, and so many of those left are dying." When I leave, she gives me a big portfolio, full of photographs and drawings. "The story starts in Wellesley," she says. "Hurry up."

IN THE PORTFOLIO, I find a photograph taken in Wellesley in 1952: Grown-ups lean against Corinthian columns or sit on chairs set on the front steps of an immense white house. Children sit and sprawl on the grass—babies, not-yet-teenage girls with braids and quizzical faces, little boys wearing ties, bigger boys wearing striped tee shirts, adults in fine pale linens. You can't miss Margarett. Near the center she sits, sixty years old, wearing the only dark dress in the photograph. On her head is an elegant black hat.

This was how Margarett chose to appear among her mother's family. Though she was a Sargent by name, she grew up in the domain of her maternal grandfather, Horatio Hollis Hunnewell, the son of a country doctor, who made a fortune in railroads, built the big house in the photograph, and transformed its surroundings, a "pitch pine forest with a barren soil," to an earthly paradise. As a child, Margarett visited him in the conservatory, where he sat in a wicker wheelchair among his orchids and palms. His mouth in old age had a vague expression, which, if a grandchild wound his mechanical nightingale enough to make it sing, wreathed to a smile.

When Margarett turned to horticulture, she was returning to Wellesley, where, in her childhood, the fruits of Hollis's cultivation

were at their prime. He hybridized scores of rhododendron, cultivated fruits and tropical plants in a dozen greenhouses, and proudly collected conifers for a pinetum that would include specimens from every continent. His tour de force was his Italian Garden, the first topiary display in North America. "No Vanderbilt, with all his great wealth, can possess one of these for the next fifty years," he wrote in his diary in 1899, "for it could not be grown in less time."

Judgment of topiary took into account not only the harmonious effects of the shapes of trees—a green cone by the side of a darker green pyramid, a tall pine clipped to look like an Olympian game of horseshoes—but also the effect of clipping on the texture of foliage. It was no small feat to adapt European pruning to trees that would survive in New England, and Hollis achieved it. After fifty years, two hundred sculpted trees occupied three sloping acres at the shore of Lake Waban in Wellesley. Seventy granite steps, edged by century aloes in granite urns, descended from a columned pavilion, past stone goddesses, to the water.

Margarett's brother Dan took my curiosity about his sister seriously and invited me to Wellesley for the annual Independence Day softball game the Hunnewells hold every year on the lawn of the big white house. He and Margarett were not yet born in 1889, when their aunt Isabella instituted the festivities as a way for Hollis, widowed by then, to gather his children and grandchildren. This was to be the first time I visited the Hunnewell estate. Wellesley, as the white house is called, had been designed by Arthur Gilman, architect of the Arlington Street Church in Boston. Nearby, each on a landscaped property, loom the Victorian "cottages" Hollis built, one each for his children, an extra for guests. The big house was named in honor of his wife Isabella's family, who had originally owned the land; later, grateful for his gifts of a library, a town hall, and a park, the town of West Needham changed its name to Wellesley.

At the lawn's edge, young Hunnewells stir strawberry-and-ginger-ale punch in a massive blue-and-white Chinese porcelain footbath. A breeze moves the tops of a huge tentlike stand of weeping beech, a giant catalpa,

old maples, an ancient white oak—prized lawn trees whose circumference Hollis recorded in his diary every time his son John visited from France to measure them. In 1889, the year of the first softball game, he wrote that the white oak, the one tree he had not planted, had grown half an inch a year, which made it "fully 200 years old at this time. . . . I hope that in due time it will reach the good old age of one thousand years, and that some of our descendants will be on hand to admire it."

The game is set to begin at ten-thirty. The umpire takes her seat, clipboard in hand, in the old fringe-topped buggy Hollis drove in his old age. Nonplayers (octogenarians or pregnant cousins) watch from under the trees, perched on outdoor furniture. A loud toot announces the large red jeep hurtling across the lawn, crammed with children, miniature American flags flying. This generation's Hollis leaps from the front seat and strides onto the lawn with a megaphone. "Okay," he shouts. "Everyone whose name I call, get out on the field!" He begins the list. "Hollis! Walter! Frank! Jenny! Isabella!" As he calls, players of all ages run to take their positions, as they had in response to the same names on ninety prior occasions.

Afterward, at the punch bowl, I am introduced as Cousin Margarett's granddaughter, a writer. Immediately a clamor of voices begin a story: Margarett at the softball game at age sixty-eight. If you're over sixty, you can have a younger surrogate run your bases, but Margarett hit a long ball that sent children scurrying to Washington Street, abruptly lifted her long black skirt to reveal a red taffeta petticoat, whose flounces rustled as she ran one, two, three bases—a home run.

"Why are you writing about her?" a cousin asked.

"I'm interested in her career."

"Her career?"

"She was a painter."

Lifting black to expose red among white-clad cousins, Margarett was painting, painting a banner that signaled not only her own otherness but that of her long silenced grandmother. Like Margarett the painter, Isabella Hunnewell goes virtually unmentioned on the great scroll of Hunnewells, and yet her family's money and land were the

foundation of her husband's extraordinary triumph. It was Isabella's uncle Samuel Welles who gave impoverished Horatio Hollis, his twelve-year-old cousin by marriage, the great opportunity of his life, a job at the Welles banking house in Paris; and it was Isabella's parents who took her and her young husband in after the great crash of 1837 drove them back from Europe, penniless, with two small children. After writing home that she felt old as Methuselah after giving birth to her two eldest children, Isabella had seven more, affording Hollis's dynasty the dimension of which he was so proud.

Though she was timid, with a fidelity to home and family that amounted to passion, Isabella traveled at sixteen with her sister to stay for a year in Paris with her uncle Samuel and his elegant wife. As she sat one day in her uncle's banking office, copying out his correspondence, she noticed Hollis. The two were soon betrothed, but Hollis had no intention of leaving Paris. When Isabella, in protest, resisted setting a wedding date, a favorite aunt was dispatched from Massachusetts to reassure her, and the young couple were promptly married.

Twenty-nine years later, Hollis, by now made extremely wealthy by real estate and railroad investments, took his wife and his three youngest children, including Margarett's mother, Jenny, on a grand tour of the Continent. For the winter, the children were left in school in Paris. In her diary, Isabella recorded roadside piracy, a blizzard that overturned their coach in the Alps, and the pomp of the Pope's Sunday appearance. In Venice, after a few lines about alighting from a gondola, the pages go blank. "It was in Europe," her youngest son, Henry, wrote, "that my poor mother had a nervous breakdown from which she never fully recovered." Jenny remembered that after Europe, her mother's eyes no longer met hers. At thirteen, she was effectively motherless.

For Isabella, after the trip to Europe, the tonic effect of a week in Charleston or a trip to take the waters at Saratoga was never more than fleeting. If she was not away in a sanitarium, she sat in a wheelchair in her spacious, sunny room at Wellesley, dressed in black and weeping, obsessed by a certainty her husband would run out of money. Except

at her death, in 1888, when he noted "the beloved wife has found rest at last," Hollis never hinted in his diary of his wife's illness, hardly mentioned her at all.

Jenny grew up suppressing terror at any sort of separation, avoiding adventure, and fearing for her sanity as the Hunnewell enclave moved between the summer palace on Lake Waban and a winter one Hollis built in 1862 on a Beacon Street lot he bought at auction as an alphabet of streets (Arlington, Berkeley, Clarendon) displaced the brackish Back Bay to accommodate Boston's new industrial rich. The household ran so smoothly, Jenny had no opportunity to express her lack of ease, and so she was considered shy and retiring, in contrast to her older sister, Isabella, who had her father's unconflicted assertion and strength.

When Jenny was eighteen, she made her debut at a ball her father gave in the ballroom of his Beacon Street mansion. She had grown into tall, black-haired good looks and was given to forgetting her nervousness in laughter. When she was twenty-four, her older sister was married at Wellesley, and a year later Jenny gave a "german"—a hundred and sixty friends danced the waltz and turned the intricate figures of the cotillion. The winter she was twenty-nine, she gave two dancing parties for her friends—most of whom were married—and for her sister and older brothers—all of whom were married. She had resigned herself to living the spinster life her mother's sisters had. It was 1880, fifteen years after the truce at Appomattox, and there were seventy-five thousand marriageable women in Boston. Late that winter, Frank Sargent headed east from Wyoming.

"The Hunnewells aren't as aristocratic as the Sargents," Margarett declared one day when she was fifteen and out on a walk with Dan and a Hunnewell uncle. She assigned aristocracy to the qualities of her father's family, distancing herself from the Hunnewells. As an adult, she prided herself on her weeping Sargentia, the hemlock shrub first discovered by her cousin Henry Winthrop Sargent, and when she

became an artist, she proudly declared her individual ambition by announcing that she was a "dissident" and hated the painting of her fourth cousin John Singer Sargent. As a child, she hung on her father's stories of Sargents—mesmerists, tubercular poets, famous generals, and clipper ship captains—far more interesting than the Hunnewells she saw every day, whose courtesy restrained her as an arborist would a conifer in her grandfather's Italian Garden.

Margarett's first American Sargent ancestor, William, came to Massachusetts from Bristol, England, and in 1678 was granted two acres on Eastern Point in Gloucester. Margarett's generation was the seventh of his descendants born in America. His son Epes fathered fifteen children by two wives, and it is for him that the Sargent genealogy, published in 1923, was named. Of his five surviving sons, two fought for the crown during the Revolution and three for the colonies; during the siege of Boston, one Sargent brother retreated with the British on a ship for Nova Scotia, while another led a victorious regiment into the city.

It is from two of Epes's sons that Margarett and the painter John Singer Sargent descend. Singer Sargent's great-great-grandfather Winthrop was a patriot merchant instrumental in founding the Universalist Church in America. His brother, Margarett's great-great-grandfather Daniel, made a fortune in the "triangle trade," fishing cod, shipping it to Gloucester for salting, then to the Caribbean as cheap food for the plantation slaves who loaded cargoes of sugar bound for Boston's distilleries.

Daniel Sargent had six sons. Two were merchants like their father, one was a Temperance writer, and the youngest, Henry, was a history painter, a friend of Gilbert Stuart and creator of the monumental *Landing of the Pilgrims* that hangs in the museum at Plymouth. The two remaining sons are described by their descendants either as n'er-do-wells or as poets, and one of them was Margarett's great-grandfather, John Turner Sargent. I found no poems, just his brother's assurance he had "the finest head and chest I'd ever beheld for a man" and the tale of his courtship of the beautiful Christiana Keadie Swan, the spirited

heiress to a Salem shipping fortune, who defied her mother to marry him, and was disinherited as a consequence. When John Sargent died young and her mother refused her any assistance, Kitty Swan rolled up her sleeves, took in laundry, and put three sons through Harvard.

After excelling at the study of law, her middle son, Margarett's grandfather Henry Jackson Sargent, was invited to become secretary to the great senator Daniel Webster. He turned Webster down and, when he inherited a fortune from his grandmother, abruptly abandoned law for the writing of poetry: "Lawyers must lie; I am a gentleman and can't." The Sargent genealogy offers the excuse of "poor health" for Harry's choices, but years later, a nephew, bemoaning his own compulsion to drink, blamed his uncle's genes.

Harry Sargent had a handsome head of black hair, pale skin, and bright eyes, and affected a Byronic appearance. He sang a sweet tenor in the evening when his family gathered at the fire, but when he drank, he turned cruel. He commandeered his sons to carry his guns when he hunted plover on the Boston Common, and his wife was forced to plead that he allow their three daughters to marry—he considered them an insurance policy to be redeemed for their dowries at his whim. At a dinner his brother gave for the abolitionist Theodore Parker and the runaway slaves he'd brought to Boston to promote his cause, Harry angrily refused to escort a black woman to the table, struck his brother, and left the party. The two never spoke again.

When her father died, in 1920, Margarett, then twenty-eight and living in New York, returned to Boston. In his will, Frank Sargent had distributed cherished family objects among his five children. Because Margarett was an artist, he left her Washington Allston's portrait of Kitty Swan Sargent. Because Dan was a poet, he inherited the desk at which drunken Harry Sargent wrote his poems. The desk had been in the library as long as Dan could remember, and there was no key. One afternoon while Jenny Sargent was out, Margarett hired a locksmith, opened its drawers, and began to read what she found. When Dan arrived for supper, his mother was in an uncharacteristic rage: "Margarett has done the most dishonorable thing!"

Jenny burned the contents of the desk, and Margarett never told
Dan what she found there, but Dan, at ninety-one, remained con-
vinced the unlocked drawer contained letters written to the ladies his
womanizing grandfather addressed in the poems he published in
Feathers from a Moulting Muse, his only book of verse:

> Thou art lost to me for ever!
> We must part, whate'er the pain.
> A blight hath touched my passion-flower:
> It may not bloom again. . . .

By the time Margarett's father, Frank Sargent, was ten years old, Harry
had squandered his inheritance, and his oldest son had gone to sea to
support the family. In 1862, that son, also called Harry, took com-
mand of a ship called the *Phantom* and became the youngest clipper
captain in history. In 1863, he died, lost in the China Sea, and Harry
pulled fifteen-year-old Frank out of Boston Latin School and sent him
to work. He got a job as a lamplighter and never spoke a word against
his father. He'd never cared about books, he said, and by working he
could help his mother.

But Frank soon realized he'd never make enough money quickly
enough in Boston. His sisters married well, but when he courted Grace
Revere, grandniece of Paul, she rejected him for someone richer. The
clipper trade was dead and had killed his brother, and now that Frank
was old enough to enlist, the war was over. Friends of his had moved
west to make fortunes now that livestock was shipped by railroad from
the great range to Chicago. The burly physique that suited him to am-
ateur boxing would serve him well on the frontier, and so, in 1870,
Frank Sargent packed up and headed for Wyoming.

He and a Boston friend bought a ranch in Laramie and raised
sheep, then steer, on the open range. In a photograph Margarett always
kept on the piano, Frank wore a ten-gallon hat and black-and-white
ponyskin chaps. He won road races and met Buffalo Bill and, though
he wouldn't admit he liked her, took General Custer's daughter, Belle,

for buggy rides. One summer evening, Belle broke their musing silence: "It would be so wonderful if we could just drive on and on and on." Frank told the story as a marital cautionary tale: "I stopped the horses and turned around the wagon." His friend Harry Balch could never go home, because he had married a Wyoming woman, but Frank still had Boston ambitions. He would remain out west as long as it took him to return to Beacon Street rich enough to marry well and recover the family honor. He stayed ten years.

Frank Sargent did not make a fortune in Wyoming, but the brawn he acquired wrestling steer set him clearly apart from the men with whom Jenny Hunnewell was familiar, men who wrestled with figures in the banks on Devonshire Street. At thirty-two, Frank was thickset and looked shorter than his five feet ten inches. He had a bull neck, auburn hair that fell in damp weather into waves, and twinkling vivid blue eyes. Perhaps Jenny was encouraged by mutual Sargent relations to invite their cowboy cousin to her parties the winter of 1880; perhaps the two noticed each other on Beacon Street on the blocks between his mother's house at number 73 and her father's at 130; or perhaps they danced together at someone else's cotillion. Whatever the case, there were grounds for intimacy when Jenny crossed the Common and pushed through the bustle of Tremont Street one spring morning in 1881.

Jenny, blushing, told the story not as a narrative but in exclamations and bursts of delighted laughter. As a footman opened the door of H. H. Tuttle's, Boston's most fashionable cobbler, whom should she see, trying on a pair of shoes, but Frank Sargent! There survives no description of shoes purchased, but Frank Sargent and Jenny Hunnewell emerged from Tuttle's secretly betrothed. On May 26, Hollis noted in his diary "great news from Jenny," and on June 3, that "the gentleman from Wyoming arrived yesterday."

Frank Sargent's days of penury were behind him, but he was determined not to live the kind of wasteful life his father had. He drank only milk, and every cent Jenny or her father gave him, he left in trust to his children. "I am a practical man," he'd repeat, as if reminding

himself, under his breath. Soon after the marriage, he took a position at S. M. Weld Company, a cotton brokerage, and was soon as rich as his wife, prosperous enough to feel secure in the brick town house Jenny's brother Henry, an architect, built for them at the corner of Hereford Street on the modest, shady side of Commonwealth Avenue.

At first, the memory of her mother's illness dissolved in the pleasure of her extraordinary domestic happiness. Jenny had never expected to marry, and she adored Frank Sargent. But by 1886, she was thirty-five, with three children under four, and the complexity of her household had begun to fray her composure. The Sargents moved four times a year—a hundred trunks, seven servants, two nursemaids, carriages, dogs, horses—and the details of each migration were Jenny's exhausting responsibility: Wellesley to Boston at Thanksgiving, Boston to Wellesley after Easter, Wellesley to the seashore in Wareham on July 4, Wareham to Wellesley at the beginning of September. "Our family lived very simply," Dan said, "but in three houses."

When Jenny became pregnant for the sixth time, late in 1891, she hoped for a second daughter and an easy birth. Alice, born six years before, had died at two of scarlet fever, and Jenny kept her photograph always, chubby baby face in a silver frame, on her desk. None of the children's births had been physically difficult, but the vulnerability that gave her a capacity for frequent laughter also made Jenny frightened of pain. After Dan's birth, during the summer of 1890, her depression had been debilitating and extreme, had unhinged her.

On Wednesday afternoon, August 31, at South Station in Boston, Frank Sargent boarded, as he had every weekday all summer, the 2:30 for Tempest Knob, the station on Buzzards Bay near Wareham where the "Three on Three" club train let off its passengers. Dr. Swift, who had delivered Margarett's brother Dan almost exactly two years before, accompanied Frank on the special train, called the "dude train" not after its well-heeled passengers but because its conductor was a dandy.

Perhaps Frank and the doctor chatted as the train sped toward the Cape, or perhaps they read the *Transcript*, that day dominated by news of pretrial hearings in Fall River in the case of Lizzie Borden, a young

woman accused of taking an ax to her father and stepmother one heat-wave afternoon just three weeks before. Professor Wood, a chemist from Harvard, had testified that laboratory examination of the mur-dered Bordens' stomachs evidenced no trace of poison and that the hair and blood on the ax were not human. Perhaps Frank, who loved a good story, read first about the Bordens, or perhaps he noticed first, at the bottom of the front page, an advertisement that presumed to fore-tell a Boston daughter's life:

> When Baby was sick, we gave her Castoria
> When she was a child, she cried for Castoria
> When she became a miss, she clung to Castoria
> When she had children, she gave them Castoria.

Hammond, the Sargents' coachman, drove the buggy to meet the train, which arrived on time at 3:13. Jenny Sargent was in labor, and Mary Carey, who had also attended Dan's birth, sat by her bedside. Mary Montgomery, the cook, and her two kitchen maids worked more quietly than usual in the large kitchen, heat from the huge black coal stove sucking up the afternoon breeze. Ocean-reflected light played on the dark-green paneling in the parlor, on the crisscross exposed beams in the dining room, and on the buffalo head, a Wyoming tro-phy of Frank's, that hung in the front hall. Jane, the Sargents' oldest child, and the children's nurse were playing with Harry and Dan, three and two, on the beach below, and young Frank, eight years old, was fiddling with the dinghy.

Dr. Swift delivered Frank and Jenny's sixth child during the early evening. The infant girl was immediately named Margarett Williams Sargent for her paternal grandmother, who was eighty-three and ail-ing. The next morning, from his office in Boston, Frank dispatched a message to his father-in-law in Wellesley, who wrote in his diary, "Jenny Sargent confined of a fine girl, nine and half pounds."

No break in the flow of Horatio Hollis Hunnewell's handwriting indicates he considered this birth less ordinary than the progress of a rhododendron from one spring to the next. Margarett was his twenty-

ninth grandchild and the second to be called by that name, though the other Margarett was not distinguished by two *t*'s. The two *t*'s, which seemed, as Margarett grew up, to encourage her emphatic and exuberant individuality, were the legacy of English ancestors who felt no need to conform to what was ordinary but who certainly did not intend that a name's spelling confer any untoward uniqueness.

ONE JUNE AFTERNOON when Margarett was four, Mary Sutherland, called "Nanna," dressed her in a light cotton dress, brown everyday stockings, and tie-up shoes. She parted Margarett's black hair down the middle, splitting her widow's peak, and tied the top back with white ribbon, leaving the rest soft around her ears. When Frank (called Papa, pronounced "Puppa") got back to Wellesley from his office in Boston, the family gathered on the veranda and arranged themselves for a photographer. The portrait gives the impression, not of a young family exhibiting a concerted rush of solidarity, but of a constellation of individuals, each caught in a moment of settled, if not entirely comfortable, contemplation.

Jenny (Mama, pronounced "Mumma") sits in a chair to the left, a bemused smile on her broad face. She wears a dark print dress with a black lace collar; her large hands rest on her lap. She is six months pregnant, but her figure looks merely matronly. There were no maternity clothes, and pregnancies were never mentioned.

In the center chair is Jane, the oldest, now fourteen. She's dressed in a light print guimpe with full leghorn sleeves. Her delicate, dark-blond prettiness contrasts with her mother's dark hair and olive skin. Her right elbow rests on the right arm of her chair, and her right hand cradles her small, inward-looking face. Her features are her father's.

Harry, named for his father's clipper ship brother, straddles a high stool between his mother and older sister, his right arm lolling across Jenny's knee. He still wears a sailor suit, the cowlick at his hairline gives his forelock a life of its own. He gazes at us full on with a half-smile and wide-open eyes. Dan, a year younger, fixes us with steady

six-year-old seriousness, standing as straight as the soldier uncle for whom he was named. His blond curls, still long, feather out below his ears, and his evenly trimmed bangs are undisturbed by cowlicks. No one else looks at the camera.

Frank, the eldest son, is twelve, old enough to wear a jacket and tie. He stands behind his mother and sister, arms at his sides, dark hair slicked back. He has his mother's eyes and nose and smiles his mother's smile. He looks down, perhaps at Jane; or perhaps at Margarett, with an older brother's proprietary sweetness.

Papa and Margarett form the right flank of the photograph. Frank's bald forehead seems inordinately vast because he looks down at the child who sits at his feet. Like her father, Margarett has an expansive brow. Like him she folds her hands in her lap, like him sits with legs firmly apart, her lace-yoked frock as slightly askew as the rumpled vest buttoned over his portly belly. It seems that his tender, concentrated gaze is all that keeps the unhappy, precociously disdainful, full-cheeked face of his "dear little Chump" from breaking into tears.

No more concrete diagnosis of Margarett's early physical contrariness survives than that she was "sickly." With her black hair and demanding temperament, she was not the daughter Jenny had hoped for. Alice's replacement, a little girl named Ruth, arrived in 1896, and four-year-old Margarett protested vehemently with mind, body, and spirit. In Dan's memory, she was "always crying, all the time."

Even if her relations with her mother had been easier, Margarett would not have run to her. The Sargent children, in the care of their nanny, saw their parents only fleetingly. As time went by, Margarett's protests became increasingly physical. She was sick so often that the Sargents eventually heeded Nanna's complaints and hired a trained nurse to care for their difficult daughter. With Miss Whiteside, Margarett formed a kind of satellite realm, isolated from the hurly-burly of her brothers and from her baby sister. When her eyes, which were as startlingly blue as her father's, weren't shot red with tears, she was vomiting, and Miss Whiteside was cleaning up after her. As she lay pallid and green, swaddled in a steamer chair in the Wareham sun,

Ruth toddled about, blond curls flowing to her shoulders. Jenny was enthralled. Ruth was the "pet of us all," "never cried," had "the most smiling face," "always seemed to be happy."

John Eldridge, the boatman at Wareham, took a look at Margarett one day and announced to Miss Whiteside that he could already see the flies gathering on her. Frank consulted specialists, but in spite of treatment after treatment, Margarett "did nothing but wail, day and night." When she was six or seven, she was finally diagnosed as anemic and prescribed beef juice. If Miss Whiteside wasn't looking, Margarett tossed it out or gave it to her cousin Gertrude Hunnewell, who always eagerly drank it. By the time a Viennese child specialist named Dr. Farr arrived in Boston to treat an Armour meat heiress, Frank was desperate enough to hire a foreign physician. "Dat is de stomach," Margarett mimicked as Dr. Farr poked at her. "Doze are de looongs."

Whatever her organic symptoms, Margarett's ailment had the feel of rage and grief. Jenny was comforted by Jane and delighted by Ruth, but Margarett was a different kind of daughter. With her, Jenny was apt to feel uncomprehending, as powerless to comfort as she had been with her depressed and agitated mother. In a photograph taken at Wareham, her two younger daughters stand with their backs to the ocean. Margarett, taller and almost gawky, has her hand on Ruth's shoulder. Ruth smiles right at the camera; Margarett looks down.

By the time she was eight, Margarett had recovered, and Miss Whiteside had left the household. His sister had become, in Dan's words, "a cheerful little girl who happily raised tumbler pigeons in the barn at Wellesley." Now that she was healthy, protest against her mother took a new form. Jane was demure and Ruth was adorable, so Margarett became a wild tomboy. Whenever she could, she played with her brothers and rose to their challenges. When they insisted she always be "it" in hide-and-seek, she did so. When her older brother Frank dared her to dive from the nursery sofa like the white angels on its red chintz, she did it and, landing on her head, didn't cry at all.

Her brothers marveled as she became a family contender. At the Sargent dinner table, the currency was wit—and Margarett became the

wittiest in a family of quick and charming tongues. When the boys teased her about her asymmetrical ears, she'd think up a retort that turned asymmetry to her advantage. When Harry, who tormented her about her looks, reported his fighting weight at the breakfast table, Margarett replied, "Was that before or after I manicured you?"

At Wellesley, Margarett enlisted her cousins Gertrude and Mary. She urged them up the circular stair of the tent Hollis built each June to shelter his blossoming rhododendrons; the three giggled down on his stuffy horticultural guests and zinged spitballs at Dan and their cousin Arnold Hunnewell, who played tag below. She coaxed them to take off their clothes, dive with her into the oat bin in the barn, and pretend to wash themselves with the dusty grain. Gertrude and Mary were content to watch their family sows cavort, but Margarett jumped into the pen, played with the piglets, and emerged proud and muddy. Her cousins considered the worst possible punishment a day without Margarett Sargent.

The three—Hunnewells dressed identically, Margarett a disheveled third with a strand of black hair in her mouth—were looked after by Nanna and the Hunnewells' nurse, Marmie. They were given lessons by a succession of governesses, who came out on the train to supplement what they were taught during the winter at Miss Fiske's kindergarten in Boston. One of the governesses, who happened to have a cold sore on her lip, so annoyed Margarett that she threw a ruler at her. When Gertrude asked if she regretted it, Margarett replied, to her astonishment, "Only that I missed."

At the turn of the century, Wellesley was at its peak. French parterre gardens adorned the front lawn, and palm trees that wintered in the conservatory were planted outdoors for the summer. Greenhouses produced orchids and bananas, bushels of peaches, nectarines, and grapes, and the pinetum seemed a forest primeval when the three little girls gazed up at its murmuring hemlocks. From the shore, they would wave at their playboy cousin Hollis who'd shout salutations from the gondola he'd brought back from Venice, as the gondolier Rossetti, also imported from Venice, navigated.

On Sunday, the Sargents went to the Unitarian church down the road in South Natick, where Mr. Daniels, the fiery minister, preached emulation of the world's three greatest men: the abolitionist senator Charles Sumner, the abolitionist agitator Wendell Phillips, and Jesus Christ. In a drawing she later made of herself as a child, Margarett, all dressed up, stands outdoors watching Tiger, her Boston terrier, relieve himself against a brilliant green bush hot with pink blooms. She has her back to us and wears a big feathered hat. "Sundays of course were different," she scrawled in red across the bottom. "I wore plumes."

In the spring of 1901, Frank Sargent went to Europe for the first time. He considered the Continent a world of undifferentiated wickedness and danger but declared he was now rich enough to afford to be cheated. Jenny, who hadn't returned to Europe since her mother's breakdown, refused to accompany him, so he took Jane, who had recently made her debut. Young Frank was at Groton, preparing for Harvard. Jane had passed the entrance exam for Radcliffe but had decided not to go; college would have been an unusual choice even for a serious young woman who voraciously read Channing's sermons, Emerson's essays, and William James. When they returned from Europe, Jane embarked upon the rituals of post-debutante life—gentlemen callers, house parties, and a club for young ladies called the Sewing Circle.

The four youngest—Harry was now thirteen, Dan eleven, Margarett nine, and Ruth five—still gathered, like Longfellow's offspring, "Between the dark and the daylight, / When the light is beginning to lower" for that "pause in the day's occupations, / That is known as the Children's Hour." Since they ate early and Nanna saw to all their needs, the hour when the servants had supper was the only scheduled time the younger children saw their parents. At five o'clock, Frank finished reading the *Transcript*, and Jenny put aside her needlework.

The summer parlor was a modest-size room hung with hunting prints, overstuffed and comfortable rather than stylish, dark rather than airy. Frank and Jenny had tea, and after the children chattered out news of the day, Ruth might sit on the floor, building cities with colored blocks, and Harry play a boisterous game of checkers with

Mama. Dan watched Ruth, and Margarett climbed onto Papa's lap. When the checkers were finished and the blocks built, all four clustered around Frank: Would he please tell them a story about Wyoming?

His stories always had a point. If he told how his brother Harry escaped Chinese pirates in two rowboats and saved the *Phantom*'s gold, it was to remind them of their uncle's courage. If he related how his brother Uncle Dan won swimming races in a river in Virginia with everyone in his company, then took up the challenge of the commander of the Confederate regiment camped on the opposite bank, it was to say something about the ironies of the Civil War. But Margarett always wanted a story about the West. They all wanted a story of the West.

"How many Indians did you kill?"

"Not a one."

"How many cowboys did you shoot it out with?"

"Not a one, but I did hang one."

"Tell us, oh tell us!"

And Frank would tell of being recruited for a posse, of a cattle thief who'd worked for him whom all the ranchers knew, and how such thieves were the ruin of ranchers. "We rode and rode and caught up with him," Frank said, "then tried and convicted him and hung him from a tree." But, he added, "I felt just a little seasick watching his face as the noose tightened around his neck!"

Some days Frank didn't give in to their lust for true-to-life adventure. Instead, he simply burst into song—he had studied voice before going to Wyoming—"Daisy, Daisy, give me your answer true," or, a favorite of his father's, "I dreamt I dwelt in marble halls." Once in a while, instead of singing or telling a story, he offered the specialty he reserved for Margarett, a recitation from memory, with stunning dramatic flair, of Longfellow's "The Wreck of the Hesperus."

A ship's captain takes his daughter to sea on a stormy night, bundling her "warm in his seaman's coat / Against the stinging blast." A fog bell sounds in the distance. The daughter is frightened. She thinks she hears "the sound of guns," but he pulls her closer, as Frank does Margarett, on his lap. Finally the ship hurtles like a matchbook from wave

to wave, and the father lashes his daughter to the mast to keep her safe. Margarett puts her arms around Papa's neck as the sea captain succumbs to "whistling sleet and snow," leaving his daughter alone to pray to "Christ, who stilled the wave / On the Lake of Galilee."

When morning comes, a fisherman walking the beach at Norman's Woe, a short distance from where Margarett would spend her adult life, stops

> . . . aghast,
> To see the form of a maiden fair,
> Lashed close to a drifting mast.
>
> The salt-sea was frozen on her breast,
> The salt tears in her eyes;
> And he saw her hair, like the brown sea weed,
> On the billows fall and rise.

In a photograph of Margarett and her father at Wareham taken the summer she was nine, she stands close to him on a dock. Both look past the camera into the distance. Frank sits on a railing, white trousers, shirt and tie, straw hat, eyes squinted against the sun. Margarett's white eyelet collar billows from her shoulders, her small straw hat is held on by elastic under her chin. Her blue eyes are eerily pale, her face pretty and concentrated. She and Frank look like conspirators. This Margarett is safe in her father's protection. The Weld boys down the road would have been surprised to hear she needed any protection at all. They named their rabbits Thunder, Chained Lightning, and Margarett Sargent.

In Wareham, the Sargents imagined themselves the Swiss Family Robinson. Their elephant of a house was subordinate to no white mansion, and no Commonwealth Avenue calling cards urged return visits. Margarett fished to her heart's content and worshiped her brother Frank, who wore his necktie as a belt. Papa sang at dinner, "Do you re-

member Alice, Ben Bolt?" Unlike Wellesley or Boston, where the children ate separately, here everyone ate together at the large rectangular table, watched over by the mounted head of a Wyoming elk, all talking and arguing in good-humored loud voices.

Young Frank could not rest: Would he win a pennant at the yacht club next week? Would Papa consent, in a few years' time, to his marrying the quiet young woman in the pink dress? The girl's father had bad manners, Papa said. "And yet," Frank declaimed, "it is written in the stars that we are to marry." Harry and Dan, so inseparable a cousin called them "Harridan," hung on their brother's every miraculous word. He proclaimed his dreams, pacing the bluff, waving his arms. When Margarett learned her first words of French, her handsome older brother became her beloved François.

Papa was known to get so angry at Frank he would send him from the table, but his anger always passed like a summer storm, and it was his imperturbable temperament that kept the family on an even keel. Jenny rarely lost her temper, but she worried, and her worry hung on like a heat inversion, intensifying when her emotions were stormy, receding when they were calm.

Once, young Frank was late for dinner. He was seventeen, old enough to cross the bay by himself. Jenny fretted, wrung her hands. He could have drowned rowing back from the yacht club. He could have tripped and fallen walking back through the woods from Widow's Cove. Unspoken was her real anxiety, his burgeoning sexuality. She insisted that everyone put on a wrap and set out in a search party. Papa carried a lantern, lighting the way down the long, narrow dirt road that led away from the house through a scrub pine forest. He didn't say a word, nor did the children, but Jenny wailed, "O God, bring him back. Dear God, please bring back my son!"

After they had walked half a mile, Jenny turned abruptly back. Papa and the children followed. The house glimmered through the trees, blazed against the black salt grass, the royal-blue evening sky. There in the living room sat Frank, calmly reading the *Boston Herald* by the light of a kerosene lamp. "Where have you been?" he asked,

standing up. "I arrived late for supper, having got stuck in the flats with my boat. I expected to find you all here." Papa made sure Jenny never learned the truth, which Frank admitted some time later: he had spent the afternoon in Onset with a prostitute.

The summer Margarett was nine ended with the shooting of President McKinley, on September 6, 1901, in Buffalo. By September 11, the Sargents were back in Wellesley and the President was dead. "The assassination," Hollis wrote in his diary, "by a vile anarchist, of our President McKinley, is causing profound grief and consternation throughout the whole country, and eighty seven millions of our people are mourning their great loss."

One afternoon at the children's hour, soon after the Sargents returned to Wellesley, Mama and Harry were playing checkers, Papa was telling Margarett and Dan a story, and Ruth was sitting in an easy chair, diddling with a small American flag. All at once she lay back, closed her eyes, and held the flag to her chest. Soon she had everyone's mystified attention. "What are you doing?" they asked. No answer. They repeated the question, but she held her position, the serious expression on her face. "What on earth are you doing, Ruth?" Her mother's emphasis provoked a reply. "I'm the little dead President," she said with a smile. "Oh, Ruth," Jenny gasped, her horror bringing everyone's amusement up short. "You must never make fun of the dead!"

On New Year's Day, 1902, Margarett began a diary: "January 1. 9 degrees. Pleasant. Skating with Harry and Dan." She recorded a visit to Aunt Isabella's "parrit," an expedition to Miss Knight's to get a new dress trimmed with a blue bow: "It is very pretty." On Monday, January 6, she noted that she'd taken her broken skate to school to be fixed and that Ruth had "skarlet fever." Tuesday it snowed all day, and on Wednesday, with Hope Thacher and Lily Sears, she built houses of snow. The following Monday, she stayed home: "they have got to have the school fumigated cause so many people in our school have got the skarlet fever."

By February, Margarett was back at school, and Ruth had recovered enough to go outside. Late Friday morning, February 7, Nanna

took Ruth up to Boylston Street to see the new streetcars. A coal wagon was backed up to a cellar hatch, its loading ramp obstructing the sidewalk. As Nanna took Ruth by the hand out into the street, the horse hitched to the coal cart shook its head. The rattle of his harness frightened Ruth, who let go of Nanna's hand and ran across the tracks past an outward-bound streetcar onto the inward-bound track. A streetcar was coming down a grade, and the motorman's vision was blocked by the car passing in the other direction. When he saw Ruth, he struggled to brake but succeeded only in preventing the car's wheels from passing over her body, which the fender had already struck twice, killing her.

According to the *Boston Herald* report, "the nurse's shrieks had attracted the attention of people for a block each way, and a crowd gathered in a twinkling. A multitude of brawny shoulders carefully raised the forward end of the car sufficiently to release the body, and it was conveyed to station 16, nearby." Frank arrived at the station and "had no word of blame for the nurse." He scarcely spoke to anyone.

Margarett had gone from school to the skating rink. Frank, home from Groton, had a game with Ruth planned for the afternoon but was out when Dan and Harry got home. Delia, the second parlormaid, met them at the door with the news, and because Jenny was at her father's bedside in Wellesley, Hammond took them up to the New Riding School on Hemenway Street for the afternoon. "Was that your sister who was killed?" the riding master asked Dan.

The funeral was in the living room at 40 Hereford Street, pictures and mirrors draped in black. As Mr. Foote began the prayers, Gertrude Hunnewell saw Frank's hand disappear into the fur muff Jenny wore on a chain around her neck. They stood that way, discreetly consoling each other for this break in their family, their five surviving children clustered around them, until the service was over. That night, Margarett wrote in her diary, "Ruth is dead. Imagen how I feel. She was run over by a car. It is ofly lonsome without her. If she was only liveing, how good I would be to her."

After she confided Ruth's death to her diary, Margarett did not

write for a whole month. She told no one until she was in her eighties
that when she misbehaved, Nanna scolded her by saying, "To think
dear little Ruth was killed and you were left alive!" To have reported
this would have required her to approach a mother caught up in a fever
of grief. Eighty years after Ruth's death, the walls at Wareham were
thick with enlarged photographs of the little girl with blond curls, mere
remnants of stacks stored in the attic after Jenny Sargent died.

No one spoke of Ruth after the funeral, and no one questioned
Margarett about her feelings, all too clear in her diary entry: "If she
was only liveing . . ." Well, Ruth was not alive, and so it was too late to
be good to her. Margarett was now almost ten, and she began to put
her considerable energy to the business of gaining her mother's atten-
tion. In response, Jenny often enlisted Harry and Dan to keep their
sister occupied, a task to which they did not take kindly. They were
particularly irritated when Mama insisted one day that Margarett ac-
company them to Mr. Foster's Saturday morning dancing class. She
was still too young to join. Her looks would do them no credit—she
was pale and always chewed that wisp of black hair—and aside from
the fact that it was embarrassing on principle to have your younger sis-
ter and her nurse in tow, you never knew what Margarett would do.

The Tuileries stood on the shady side of Commonwealth Avenue
and had, Dan wrote later, "a granite facade that befitted a building
named after the royal palace in Paris." The ballroom was to the left,
and, in 1902, its chandeliers threw glistening blurs on a flawless par-
quet floor. Dan and Harry barely introduced Margarett to their
friends, wary of seeming too responsible for her but not wishing to
seem unchivalrous. Dancing was the pretext for Mr. Foster's class, its
actual purpose the passing on of etiquette.

Margarett waited as Nanna gave her wrap to the attendant, and
then she entered the ballroom. When she saw the older girls curtsy to
the two hostesses, she imitated them and then carefully took a seat on
one of the painted gold chairs that stood in a row in front of a ba-
roquely paneled, voluptuously rendered scene from the siege of the
Tuileries in Paris on August 10, 1792.

Mr. Foster, a tall, lean man with a pointed red beard and white kid gloves, rose and called the march that always began the class. Margarett was behaving, and Dan was relieved enough to be able to notice how garishly the slaughter of the Swiss Guards was composed, when Mr. Foster, in the French accent he affected to camouflage his Cape Cod lineage, called the cotillion. Since Mademoiselle Sargent was the guest, she would lead off.

Margarett felt the thrust of Mr. Foster's begloved wooden hand as he escorted her to the gold chair at the center of the room. She eagerly took the mirror and the lace handkerchief he handed to her, and listened to his instructions. In some cotillions, gentlemen were required to jump hurdles to greet ladies who offered lit tapers or biscuits. In this one, a gentleman came up behind until the lady saw his face in her mirror. If she did not wish to dance with him, she dismissed his attentions by brushing her lace handkerchief across the mirror's surface.

Dressed in white, Margarett crossed her spindly legs, smoothed by Sunday-best stockings. She sat gazing into the mirror. The music began, and the boy whose name Mr. Foster called came up from behind. Margarett brushed his face from the mirror, and Mr. Foster called another name. Whom would she choose to escort her in the two-step? She dismissed the second boy, and a third. It was not proper to pass over more than two, but the music swelled, and Margarett dismissed one boy after another.

Dan and Harry looked at each other. There was just one boy left to be called. Mr. Foster maintained his composure: If acceptable manners were a paddock, Mademoiselle Marguerite had not yet jumped the fence. Would she choose Carl Searle? Dan and Harry could barely look. Margarett turned, smiled at her young man, and rose from the chair. As the pair two-stepped awkwardly around the hall, Dan gazed again at the slaughter of the Swiss Guards, wondering why on earth his sister had chosen a partner whose family was new to Boston and newly rich. When she heard the story, Aunt Mamy Hunnewell, Gertrude and Mary's mother, told her daughters their cousin would surely come to a bad end.

If the Sargents were concerned about Margarett, they did nothing about it; they had a more pressing problem. Harry had become a bully who slugged his playmates; once, he hit Wanda, the Polish nurse who taught the boys German, and broke her finger. At fourteen, he could not tell right from left and had difficulty reading, so he was also considered "slow." His anger wasn't helped by the fact that Dan was a natural student, who, though a year younger, skipped a grade and surpassed Harry in his own class. Frank and Jenny determined to send the two boys to different boarding schools, but Dan wept until they broke their resolve. "A terrible mistake," Aunt Mamy whispered to her daughters. The two were not separated until Dan was kept back at Groton so Harry could enter Harvard first.

It was Dan whom Margarett missed most when he left home. The spring before he went off to Groton, they'd had measles together. "We have a maid named Kelleher / I would not say that she has curly hair," was only one of the rhymes they composed as they lay sick. They also lampooned their brother Frank's girl chasing and made a poem of Hammond at Wareham whistling to summon the crow with one white feather from the forest to his shoulder. During the days in the darkened room, they forged an alliance, which grew stronger as they grew up and she became an artist and he a poet. They were the family vaudeville team, contriving skits for family gatherings in which they ruthlessly mimicked this or that aunt, uncle, or cousin; rendered Hunnewell life from the point of view of the Wellesley gatekeeper, who taxidermized songbirds and enshrined them in glass globes; or, years later, acted out the sinking of the *Titanic.*

The theater fed their imaginations. Frank Sargent was a man apt to slip alone from his office to see Houdini, and he loved to take his children to Buffalo Bill's Wild West Show or to Keith's, the most reputable vaudeville house in Boston. "They say Buster Brown is a dwarf but I can't believe it," Margarett wrote when she was fourteen. "There were 491 children that went on the stage to get Buster Brown's photo. We did not go but as the curtain went down, Buster Brown threw us half a dozen." The act that drew her attention was Primrose's Min-

strels, led by Lew Dockstader, a big, lumbering man who performed in outsize clothes and huge shoes, combining clowning with blackface. "I laughed my insides out," Margarett wrote. "Awfully good take-offs on 'Deary' and 'Waltz Me Around Again Willie.' Bully show."

On the stage at Keith's, the Irish, Italians, Jews, and blacks, mute or careful when Margarett encountered them as servants or saw them at a distance, became, with the actors' magic, outspoken, brash, and funny. In the dark of the theater, audiences roared with laughter at behavior that in the light of day would have prompted them to purse their lips with disapproval. In her 1907 diary, Margarett wrote that she and Lily Sears had "fooled with a nigger." The word her grandfather employed in his diary was "coon," and one of Lew Dockstader's hit songs was called "Coon Coon." The minstrel show imported to the quiet boulevards of the Back Bay a diluted form of the racist terror then building in the South. Ironically, vaudeville, which imprisoned its performers in slapstick distortion, was Margarett's first introduction to people different from herself. The performers she saw onstage seemed free and spirited, their behavior and difference an escape from the life against which she was forming a habit of rebellion.

To render the appearance of that life—animal, flower, beautiful household object—was considered a female skill like embroidery, and, like her cousins and friends, Margarett was sent to drawing class. At first, she drew things as she was taught, but soon she began to see how drawing could alter the world she found so dull: "Drew lion which I made look like a dachshund!" At Keith's, she had learned that things were not always what they seemed, and now, in her drawing, she performed similar feats of transformation. Directed to sketch the gargoyles on the Gothic facade of a house across the street on Commonwealth Avenue, she told the instructor she would prefer to draw a glass of water, half empty. When he refused, Margarett left the class for good. Drawing had become part of her, but drawing on her own terms. Now she added quick caricatures and portraits to her entertainments at Hunnewell parties.

Margarett went to these drawing classes with E. and O. Ames,

who appear often among the names that swarm her diaries. These were the daughters and sons of those her cousin Gertrude called "all the best people," the covey of companions to whose lives Margarett's life would be compared for the next seventy-five years. E. and O. and their cousin Helen Hooper preceded Margarett at the dressmaker's, and Gertrude and Mary and she went to the same sewing class. Margarett took fancy dancing with Libby Silsbee and Hope Thacher—"I danced like a cook on a tightrope"—and ice-skating with Lily and Phyllis Sears—"Loads of lessons. Hang it."

Like Gertrude and Mary at Wellesley, her Boston friends were willing lieutenants in mischief. E. Ames became Margarett's best friend. They were "intimate," E. said, using the word to describe the confidentiality of friendships in which certain rules of decorum are suspended. They were inseparable, Dan said, constantly spending the night at each other's houses. "Margarett always made us do things," E. said. "She made us have a play at the Arlington Street Church." Everyone remembers that the play was called *Edith and the Burglars*; no one remembers the plot. Margarett wrote it, talked all her friends into doing it, and talked Paul Revere Frothingham into letting them perform it in his pristine sanctuary for a packed Back Bay audience.

When she was twelve, Margarett entered Miss Winsor's School, located in buildings on Newbury and Marlborough Streets, within walking distance of the Sargents' house on Hereford. Jane and the boys had commuted each day to Boston for school, but Margarett did her fall and spring work in Wellesley, supervised by tutors she shared with Gertrude and Mary. Mary Pickard Winsor was an austere and gifted teacher, who believed that a student's behavior was as important as her academic performance. Gertrude Hunnewell joked that the only girls who met Miss Winsor were those who excelled and those who misbehaved. She herself hardly knew the headmistress, but Margarett, in time, came to know her very well.

Miss Winsor's School did not capture Margarett's imagination. She performed only when she was interested, and at least one teacher complained that she had no "power of concentration." In science and

math, she arduously progressed; cooking class was "fun"; and in French
and German, she applied herself. She became a crack speller and an
"appreciative and thoughtful" reader, and when the history teacher as-
signed a county map, she drew it with enthusiasm. She was judged
"most unsteady" in preparing her daily theme, but she wrote with rel-
ish in the diary her teachers never saw: "Bully Great Danes and vile lap
dogs, peachy setters . . . Delicious drooly English bulls . . ."

"Boys go back to Groton. It'll be rotten without them," Margarett
wrote in January 1907. She was fourteen and the only child left at
home. Riding was her salvation. She rode her pony, Logo, indoors at
the New Riding Club, and Mr. Speare, the riding master, led trail
rides in the Fenway. Girls rode sidesaddle, and Mrs. Ames, concerned
her children would become "one-sided," had a saddle made with its
pommel on the right and special habits tailored so that E. and O.
could alternate, riding right one day, left the next.

Margarett rode sidesaddle only when it was impossible to do other-
wise. "Rode astride," she exulted, "but I'll get Hail Columbia. . . . We
went like greased lightning. Jumped over stone walls, hurdles and
brooks." At the club, her riding soon drew the admiration of the older
girls. "Am smashed on Alice Thorndike," Margarett wrote. And later,
"Am smashed on Eleo and A. Thorndike." To be "smashed" was to
have a crush. Eleanora Sears had greeted Margarett once at Wareham
with a patronizing "Hello, Freckletop." Now Alice had asked her to
ride Jack Rabbit, her pony, in the club horse show! Margarett jumped
her own Logo "splendidly," and then rode Jack Rabbit to first place.
Victory brought "the dearest pin" from Alice and a surge of invitations
to ride other ponies in the next show. Even the riding master was im-
pressed; "Mr. Speare wanted me to ride Miss Wheelwright's horse."
But "Ma and Pa say jumping two horses is enough. Damn it!"

"I am always looking for Margarett to make a start in her lessons,"
Miss Winsor wrote on her 1907 report card. "A change in behavior
must come first, and it is my firm belief that that is coming at once."
She was wrong. Margarett had her own priorities. She considered her
pony an "angelic angel," but called her teacher "a pig." A week after

the 1907 report card, the school boiler burst and school was dismissed. Margarett let out a whoop of pleasure, and the headmistress sternly tapped her on the shoulder. "Miss Mary P. Winsor has got a prison," Margarett snarled in her diary later that winter.

The Sargents did nothing about their daughter's discontent. Jenny thought she could scold it away, and Frank was bemused, believing that in time Margarett would naturally follow Jane into the rites of womanhood. But the two sisters were very different. Jane had never been known for fights with teachers or desires to ride too many horses. Late in 1906, at twenty-four, she became engaged to David Cheever, Harvard '97, a young surgeon and an instructor at the Harvard Medical School. They would marry in June. On February 7, 1907, Margarett wrote in her diary, "Jane has asked me to be bridesmaid. I am thrilled!"

The day of the wedding, Hammond, in borrowed high boots and a top hat, drove Jane and Papa to the Unitarian church in the Sargents' only closed carriage, and Paul Revere Frothingham led the couple through their vows. After a reception for six hundred in a tent near the Sargents' house in Wellesley, the newlyweds left for a honeymoon on Cedar Island in Vermont. "It was quite an undertaking," Jenny wrote a friend, "but I am delighted that Jane is settled for life." Margarett, almost fifteen, had a different ambition: "When 30," she scrawled on the back binding of her diary, days after the wedding, "am going to have a horse and millions of animals. Am going to be a nice cantankerous old maid."

She kept no diary in 1908. The only record of her fourth year at Miss Winsor's are her grades, which plummet at midterm. No warning preceded Miss Winsor's final "blow up," which came to Hereford Street by letter and survived in Dan's memory: "I'm afraid we can't take back your daughter Margarett. She's a born leader, but unfortunately she always leads people in the wrong direction."

ii

*If only we hadn't sent her
to Europe!*

(1908–1913)

Margarett, her debutante year

MISS PORTER'S SCHOOL in Farmington, Connecticut, still inhabits its extraordinary original buildings, porticoed Federal mansion houses which line a street that was, when Margarett arrived in 1908, a dirt road as apt to be marked with the hoofprints of a yoke of oxen as with the tracks of a carriage. Built of brick in 1830 as the Union Hotel, "Main" was the first building purchased by Sarah Porter, and it was on its steps that Elizabeth Hale Keep, Miss Porter's successor, always stood the first day of school to greet the young women asked to present themselves "during the day or the evening." In a photograph taken in 1909 of "The School," all one hundred thirty subjects wear white dresses, and all but Margarett look at the camera.

Margarett's sister, Jane, had suggested she go to Miss Porter's. Margarett's friend Frances Saltonstall had just finished, and Dorothy Draper, another Bostonian, was in her last year there. Jenny had misgivings—no other Hunnewell daughter had gone away to school, and she remembered palpably her lonely year at school in Paris—but Jane had a clear sense of her younger sister's intelligence and believed Margarett's enthusiasm might be engaged at a good school away from home.

Sarah Porter was the intellectually voracious eldest daughter of Noah Porter, who was for sixty years the pastor of the First Church of Farmington. She became the first female student at Farmington Academy and at sixteen its first female instructor, later teaching at schools for girls in Springfield, Buffalo, and Philadelphia. When she was twenty-eight, she came home to teach a few young women in an old stone

store. A dozen years later, she was teaching more than fifty girls and attracting pupils from as far away as California.

Every afternoon, whatever the weather, Miss Porter took her students on a walk in the countryside or had them driven in a carriage up Talcott Mountain for a picnic, while she led on horseback. At fifty, she learned Greek, and at sixty-five undertook Hebrew. The depth of her knowledge of philosophy brought visits from scholars, and luminaries like Mark Twain often lectured at the school. For most of her career, Miss Porter taught all the academic subjects—Latin, French, German, chemistry, natural philosophy, and rhetoric. She had a physical constitution "hardly less remarkable than Gladstone's," *Century Magazine* reported, and "astonishing reports grew up as to the little sleep she required."

When Margarett came to Farmington, Sarah Porter had been dead eight years, but her portrait still hung in Main. The girls made secret fun of the gaunt New England likeness, which revealed little of the founder's expansive character and nothing of her belief that the essence of teaching lay not in "the fixed organization of matters educational" but in "the contact of mental and spiritual life in the teacher with the answering love and spiritual life in the pupil."

In a photograph in Margarett's scrapbook, Elizabeth Keep rises majestically from a sea of pompadoured girls in white dresses, a figure-head. Her contribution to the school was organizational; Mrs. Keep didn't teach. She was as Edwardian as Sarah Porter was Puritan, as full-bodied as Miss Porter was gaunt. Her expression is one of satisfaction rather than hunger, and she wears, pinned meticulously to beautifully coiffed nearly white hair, an enormous black hat. Miss Porter inspired her students with after-dinner readings from the classics of English fiction and poetry; Mrs. Keep entertained with chapters of popular novels. When she "sailed imposingly" into a room, Clover Todd, class of 1912, was reminded "of the Winged Victory of Samothrace." To sixteen-year-old Margarett, Mrs. Keep was, as Miss Winsor had been, an authority with whom to negotiate.

Margarett's initial "Homesick if I stopped to think" was subsumed

quickly by a routine that, unlike life in Boston, burst from her diary's tiny pages. She was awake at 6:45, then downstairs for breakfast, prayers, and hymns; classes began at 8:40. At first, Margarett was insecure in her studies. She reacted to low grades or criticism with fury and to the possibility of a test with high anxiety: "If we have an algebra exam, I meet the ghost." A mark of 64 for a "hang old Spenser exam" enraged her, and when she and a classmate were caught misbehaving in French she threw a tantrum.

But Jane's prediction proved accurate. The title page of Margarett's psychology text listed vices of defect to the left, vices of excess to the right, and virtues down the center. In time, she attained, if not virtue, a modicum of equanimity. She did well enough in French to be advanced her second year—"I was petrified. There are girls who have been in Mademoiselle Pierrard's classes for ages." She found Bible "most exciting" and ethics, though "ghastly" on Aristotle, "so interesting," but it was where algebra, psychology, and Miss McDonald converged that her heart and mind awakened to intellectual curiosity.

Jessie Claire McDonald, whose fiancé, it was rumored, had died tragically, was tall, brunette, and slender, and, by the time Margarett came to Miss Porter's, the constant companion of Miss Duclos, the English instructor. Her charisma and warmth made her the object of many a student crush, and Margarett was no exception; Miss McDonald entered her diary on a least thirty occasions. "Went to call on Miss McDonald. We talked of the big trees in California. She is the most fascinating hostess." "She is so interesting on the earthquake, Italy & The Republic, etc." "Went to call on Miss McDonald. Heavenly and melancholy."

In turn, Miss McDonald took an interest in Margarett. She was the first to encourage her intellectually, keeping her after class to tell her when she'd improved and chastising her when her work fell off: "Got slightly stung by Macy Doo who told me that I could compete with the finest mathematicians in the school, but that I had left my heart in Groton or some such thing." Miss McDonald was more sym-

pathetic than Jenny, who, when Margarett wrote "a discouraged letter," replied by "telling me to stop complaining."

"Macy Doo's" concern and attention soothed Margarett's insecurity, provincial shyness in the face of girls from New York and Chicago, who seemed unassailably worldly bedecked in their sophisticated clothing, their pompadours combed higher than anyone dared in Boston. "I have absolutely the clearest memory of Margarett coming down the stair in Main," said Marjorie Davenport, a New York girl who wore a velvet hat even on her afternoon walk. "She didn't have very pretty clothes. She dressed the way Boston girls did in those days—rather unattractively—and her hair was braided and turned up and nothing very attractive about it."

Margarett soon came to be admired for her independence and sought after for her wit. She cut required evening prayer meetings when she didn't feel like going, something her classmate Fanny Perkins never had the courage to do. "She was very sarcastic, like a knife," Fanny said, "and she made quite a few enemies." She remembered Margarett carefree, entertaining the Farmington railroad car to Boston with Harry Lauder songs, singing his "Whistle, daughter, whistle" as she jigged down the aisle, her classmates overcome with laughter. Fanny did not recall that her nervy classmate had headaches that sent her to bed with hot-water bottles.

"Woke up with a rancid headache. Got excused from Church," Margarett wrote one Sunday. In February, she announced her first period—"I am no longer an Amazon!"—but noted no accompanying pain. She could get a headache after sketch class or after indulging herself with cake or candy. There were mornings she woke feeling "rottenly" and recovered quickly, but her "old family tricks," the harrowing headache and nausea of her childhood, could devastate her for two days. Margarett had violent reactions—"Dead with loneliness," she wrote when her roommate had a visitor—and headaches often accompanied them. She got a headache when she was thwarted, as when Edith Parkman couldn't be her partner at gym, or when she asserted herself, as when she told Eleanor Hubbard she didn't want to room

with her. The more she made her desires known to herself, the more brutal, it seemed, the attacks became. One morning, sufficiently sick to leave a class in Main, she climbed the stairs to Miss McDonald's room. "I had my nerve with me enough to sleep on her bed."

"Don't Crush," read a headline Margarett cut from an ad to paste on her diary's marbled endpapers. "Sorry you were not in," reads Kaa Thompson's calling card affixed to one inside cover; Marian Turner's sew-on clothes tag flutters from the other. These are relics of the all-girls social life at Miss Porter's, which matched, in excitement and intrigue, regulated, infrequent congress with the young men who visited on the train from New Haven.

Girls were allowed to attend, by invitation, the Yale Prom or the Yale-Harvard game and to have gentlemen callers on Saturday afternoons, but weekend walks on Farmington Avenue, where Yale men were said to lurk uninvited, were forbidden. That one of her classmates had callers and flirted with local Irish boys made Margarett uneasy. "I may be a New Englander," she wrote indignantly, "but I prefer the dump and Boston any time to the behavior of New York. Grace Allen kicked her legs and behaved altogether like a chorus girl on a spree." The only admiration of the opposite sex in Margarett's diary involves a Mr. Samuel Archer King of London and Bryn Mawr College, who visited Miss Porter's to teach declamatory reading and voice placement: "Great shock—he is young and good looking."

"It was all the style to have crushes," Fanny Perkins said. "New Girls" had crushes on "Old Girls," and one's crush was often one's "date" for all the school events of the weekend. A crush was exclusive, and everyone knew its status. "What a strain," Margarett wrote after an afternoon with Eleanor Hubbard. "I am so sick of being told I am in a peeve with E. Hubbard!"

During the week, one invited a girl one admired for an afternoon of sledding, riding, or tennis, depending on the season. If you walked, you did so arm in arm. "PM with 'little Daven,' " Margarett wrote of an afternoon with Marjorie Davenport. "The first date I've had with

her and lets hope not the last." In the spring, girls walked to Diamond Glen or through Hill-Stead to Hooker's Woods, in the fall to a cider mill at the edge of the Farmington River, where they drank cider they hoped would be hard. More than once a hot-water bottle filled with cider burst in the back of a closet, for a chambermaid to find. Afternoons ended at the Gundy, the school teahouse, a short walk up the hill.

Like everyone else, Margarett had a date for Saturday evenings, who accompanied her to dinner, to the weekly theatrical entertainment, to dancing in the gym afterward. "Delaware and I sported up for a waltz, our first standing date." Mrs. Keep's secretary taught popular dances in the gymnasium Monday mornings, and on several Wednesdays each term Miss Ethel Bury-Palliser of London arrived on her circuit of girls' schools to teach deportment and carriage. "Did it with E. Orr," Margarett wrote. "I got so mad trying to do the scarf dance."

The girls attended each other like suitors. Tottie Evarts, two years younger, surprised Margarett one day by polishing her shoes "like an angel," and another admirer left this poem:

> The one was tired
> And her head ached
> For she'd had an awful day
> That was the reason when the other laughed
> She shouted "Keep out of the way!"
>
> The other was tactless
> And noisy too
> And feeling by far too gay
> Therefore her conscience smote her
> When you shouted "keep out of the way!"
>
> "The other" leaves
> These violets here
> Hoping when you see them
> You won't say (as you did to me
> the other day) "Keep out of the way!!"

But Margarett wasn't interested in the girls who pursued her. Marian Turner also sat at the table Miss Duclos supervised at supper, and it was she whom Margarett began to court: "I am glad to get to know M. Turner. I think she's sweet but too clever," she wrote after visiting her room one night. Marian was an Old Girl from Saint Louis. She was small and dark-haired, and dressed modestly. Fanny Perkins described her as "not bad looking," but to Margarett she was "so attractive." It was not a comfortable friendship. They argued about Miss McDonald and about the advisability of a girl becoming engaged before she left Miss Porter's—"I think it's childish," Margarett sniffed.

A week after their argument, Margarett wrote Marian a poem (it has not survived) and delivered it with a bunch of violets, a gesture she'd previously reserved for Miss McDonald. After Easter vacation, they had a walk, but Margarett was soon insecure: "I am afraid she is not sincere, and I like her so much." Marjorie Davenport told her reassuringly "that she thought people always would want to show me their finer side and that I was the kind of girl to bring it out!" But on the heels of a rumor that Marian was engaged came the news she was leaving before the end of term. "It is worse than I expected," Margarett wrote the day Marian left. To distract herself she went shopping in Hartford with Elinor McLane: "I bought a hat like a loon and had to borrow and borrow."

"Little Clara," or "C.C. Lemons the star of French III," looks from the likeness in Margarett's diary to be rather plain, but it's "a quick sketch," she wrote, "so I don't do her justice." Opposite is the haughty profile of a stylish young woman wearing a hat trimmed with grapes. Margarett used ink to emphasize grapes, collar, and earrings—"Girls you would not have for your friends," she captioned it. "Sleep gentle sleep," she wrote one night, then dashed off with pen and ink Cupid nesting in a cloud.

Miss Porter's was famous for its art department. Its art history course had the benefit of "all the best means of illustration: electric

lantern, lantern slides, photographs and plaster casts." Because draw-
ing and painting were always taught by professionals, the art curricu-
lum was unusual, but it was not progressive. In 1856, women students
at the Philadelphia Academy had won the right to sketch from a cast of
Apollo Belvedere provided he wore a "close-fitting but inconspicuous
fig leaf." By 1868, they were allowed to draw a live female nude, but
when male nude models were permitted ten years later, Philadelphia
was scandalized. At Miss Porter's in 1909, students sketched plaster
torsos and each other, fully clothed.

Margarett's portraits were mediums for scrutiny and admiration.
At Tuesday sketch class, she filled a book with her schoolmate models
and, in her diary, catalogued her impressions: Eleanor Hubbard in a
big black hat was "stunning," Rebekah Mills was "not very interest-
ing for me as she was in costume," and Mary Plum "wonderful to
sketch—I managed to get something quite a little like her." When she
was interviewed years later, Margarett brought out the sketchbook she
kept at Miss Porter's as an example of her early work. The reporter
described the drawings as "Ingres-like," done in "a carefully delineated
style with the shadows well blacked in."

The years Margarett was at Farmington, Theodate Pope, a Miss
Porter's graduate and one of the first American women to become a
licensed architect, was putting finishing touches on Hill-Stead, the
grand country house she had designed for her parents on one hundred
fifty acres adjacent to the school. Girls from Miss Porter's wandered
through "Miss Pope's place" as if it were part of the campus. In the
house hung a small but exquisite collection of Impressionist paintings
assembled by Theodate's iron-baron father on his travels abroad, among
them two Monet haystacks, a Degas nude bather, and a Mary Cassatt
mother and child.

Cassatt was actually a friend of Theodate's, and it was at Miss
Porter's Margarett learned that a young woman from Philadelphia had
made her way in Paris as a serious painter. Cassatt visited the Popes in
Farmington on her last trip to America. The artist was in her sixties, it
was the autumn of 1908, and Margarett was in her first term at Miss

Porter's. There is no evidence of a meeting or of the artist's visiting the school, but three years later, when her father gave her a thousand dollars for her nineteenth birthday, Margarett went to New York and bought a Cassatt, the pastel that now hangs in the Philadelphia Museum of Art—a young woman dressed in yellow in a balcony at the opera, face half hidden by an open fan. Cassatt became a talisman for Margarett's own artistic aspirations; later, she would collect three of her aquatints and a bronze head of the artist by Degas.

That Margarett mentioned in her diary neither Mary Cassatt nor Rosamond Lombard Smith, who exhibited paintings as Rosamond Smith Bouvé and whom the 1908 Miss Porter's circular listed as an instructor in drawing and painting, was not a sign of her indifference to art. Her drawing had become as organic to her as the jottings in her diary, and her classmates at Farmington were the first models to lend themselves to her most expressive subject—what is revealed when a woman sits alone for a woman artist. Long after Margarett stopped painting, she would continue to draw, capturing with the quick movement of a line what she saw and the particular intensity with which she saw it.

At first when Margarett got back to Wellesley in May, she was relieved. There were "no bells," and she could present herself for formal calls now that boarding school had made her a "lady." But Miss Porter's had changed her in ways her ascent to a new plateau of female obligation did not acknowledge. She now had dreams of a life beyond Wellesley and domesticity, and she knew she dreaded the summer at Wareham. Dan was traveling in Europe, Frank and Harry were also away, and she did not look forward to Gertrude and Mary's annual visit. She wrote madly to Farmington friends, to Fanny Perkins: "Please come see me. I am so bored!"

Between furious games of tennis, books rescued her. By the end of August she had read at least twenty. She read *Up from Slavery* and made herself "disagreeable to the rest of the family" by describing Booker T. Washington's ideas about the people to whom they routinely

referred, in the slang of the time, as "coons." She read F. Marion Crawford's *Marcella* and announced she had "serious thoughts of being a socialist." She read Thackeray's *The Virginians* and George Meredith's great novel declaring the intellectual equality of women with men, *Diana of the Crossways.* Jenny had brought her set of George Eliot to Wareham, and Margarett soon finished *The Mill on the Floss.* "I have started it so many times, but this is the first time I have persisted. Mad about G. Eliot. Teary book."

Back at Miss Porter's in September, Margarett became the school's most sought after leading man. In *Nephew or Uncle*, she played a prospective bridegroom, and in *Trying It On* sat grimacing, frock coat brushing the floor, as she banged away on the piano. When a classmate left the cast of Thackeray's *The Rose and the Ring*, Margarett was drafted as Hedzoff, captain of the guard. The play was rehearsed six weeks, programs were printed, scenery was wallpapered, costumes were dug from the school's trunks of flounced gowns, powdered wigs, waistcoats, and britches. Tuesday before the opening, "getting nervous," Margarett took a walk, ate maple sugar at the Gundy, wore no rubbers, got soaked, woke feeling "rottenly," and landed in the infirmary. On Sunday, her nose ran "like thin ink," but by Tuesday she was ransacking Main for dress rehearsal—"nothing to keep moustache on with." In a photograph as a swain, her assumed virility is utterly convincing as, wig in place, she casts a lustful eye at Polly Foster, the ingenue. "She was the best actress they ever had," Fanny said. "They begged her to stay a third year."

Margarett had other ideas. Her roommate, Elinor McLane, was going to finishing school in Florence. Margarett had read George Eliot's *Romola*, set there, and had studied Italian painting in art history. A year abroad would postpone her debut, the thought of which she found "just repulsive." She begged Mama and Papa to allow her to go, and at last, Frank and Jane prevailed over Jenny's fear of sending a daughter off to Europe. When the Florentine School denied her application, Margarett borrowed money and sent a telegram—"Please reconsider our marvellous daughter"—and signed it Mr. and Mrs. Francis W. Sargent.

MARGARETT STANDS ON THE DECK of the SS *Princess Irene* next to Catharine Bond, "my attractive blond Baltimore friend," one of the flurry of new acquaintances who will be her schoolmates in Florence. It is October 1910, and she is eighteen. Louise Delano of New York holds aside her camera to pose on the ship's bridge with Captain von Letten Peterssen, whose navy-blue uniform is brass-buttoned over a generous belly. Margarett snaps Miss Sheldon, chaperone of the Florentine School, and two schoolmates lounging on deck chairs. Catharine closes what she's reading and looks at the camera. A few popular novels balance on the ledge behind them: *The Motor Maid, Arsène Lupin, All in the Same Boat.*

Later, without Miss Sheldon, three girls, including Margarett, "the new member of The Florentine School," posed on the same chairs, books nowhere in sight, "all busy being silly." Margarett looks matronly, uncannily like her mother in a dark tweed suit that seems too big, her forehead obscured by an outsize, awkward hat. She stalked everyone with her camera: the captain, who postured in several uniforms; a uniformed gentleman she called "an intruder"; the doctor, terribly severe in his uniform.

There was no sign of her traveling companion from Miss Porter's, Elinor McLane. According to Fanny Perkins, news of their "irreperable" falling-out crackled along the Farmington grapevine as soon as protestations from Tuscany could reach New England. In a deck snapshot, Frances Breese grins impishly at the camera and Margarett smiles, eyes lowered, arm tight around the waist of her new friend.

The Florentine School, run by an American, Miss Nixon, mainly for American girls, was one of three finishing schools in Florence in 1910. In Margarett's year, thirteen girls inhabited the towered ivy-clad villa Miss Nixon leased on the Via Barbacane, a narrow street that led up steeply from the square in San Gervasio, a village near San Domenico in the hills below Fiesole, about thirty minutes from the center of the city.

When Miss Nixon's students took the tram down the hill for pastries, a teacher went along. Miss Nixon feared the young men who loitered on Via Tornabuoni near Doney's—titled young Florentines without a cent, who, in search of an American wife, routinely questioned the concierges of the Excelsior and the Grand Hotel about the lineages of young American female guests: if she wasn't rich, they weren't interested. As an antidote, Miss Nixon invited American, English, and Italian young men of whom she approved for thés dansants. On at least one occasion, Margarett escaped the headmistress to rendezvous in a park, not with an Italian princeling but with Mr. Ringling, whose circus was touring Italy. "You never knew how Margarett met people," Dan remarked. At home, she entertained her brothers with the episode, boasting she had not been caught and mercilessly mimicking Miss Nixon saying "the most banal things."

Haze obscured the heights above Florence in the morning, so the girls piled into the school's touring car to sightsee in the afternoons. Margarett snapped the famous view of Florence from Piazza Michelangelo, the Duomo rising in the distance, cedars in silhouette between her camera and the city. When the girls gathered in the square at Fiesole, she snapped seven of them, "all in suits and hats." They toured Fiesole's Romanesque cathedral, saw its schools of Giotto Madonna and saints. When they walked out back to scrutinize the Teatro Romana, they found it occupied by a Franciscan monastery and therefore, as the Baedeker put it, "not accessible to ladies."

Miss Nixon's intention was that a young girl's year at the Florentine School familiarize her with the great sights of Italy. Before Christmas, she took her students to Levante on the Riviera to escape the cold, then south to Rome and Pompeii, and, in May, to Venice. At Portofino, they climbed Monte di Portofino with its views of both Rivieras, and in Genoa, Margarett, Frances Breese, and Catharine Bond linked arms for a photo, "The Three Musketeers." Margarett's love of what she saw showed in her photographs: in Rome, the looming walls of the Colosseum; in Pompeii, the Casa dei Vettii's frescoed cupids sacrificing to Fortuna.

Though her studies in Florence consisted, Margarett said later, largely of "just looking," "just looking" had, for her, a transforming intensity. The elegance and care with which she preserved her lecture notes rather than her crowded snapshots testified that she was vulnerable to Florence. Matched brass florets mark the corners of the three leather volumes that contain them, and delicate brass chains fasten their bindings. Each front cover is stamped with a gold "MWS," each spine with a subject: Florentine History, Italian Literature, Italian Art. Inside, in black ink, Margarett recorded what she learned. Nothing of the rapscallion Farmington girl jarred her scholarly seriousness. Though Miss Nixon was strict and the situation new, caution was not what kept Margarett's penmanship precise: the enchanted city was weaving its spell.

In the margin of Margarett's history notebook, alongside a note that "Visconti becomes sole lord of Milan by the murder of his uncle," a teacher inserted, "92% Corrected to Feb. 1, 1911." Margarett sustained a high standard of achievement throughout the year, but she couldn't resist making her notebook personal. Instead of copying coats of arms, she drew and painted freehand. One of her black Urbino eagles has fallen from its shield; her blue Visconti serpent—a tiny nude shrieking from its mouth—gazes, gluttonous, from a bright-yellow ground.

E. Ames remarked that her friend came home from Florence "sporting Italian." In a scrapbook photo of the room Margarett shared with Louise Delano in Venice, a sign tacked to the organdy canopy of a rumpled bed announced, "Si prequo di non sputore," a misspelled attempt at "Please don't spit." Next to it, emphatic arrows pointing left, was another sign: "Rittrato," it said, for "Ritirata," which means WC. Whatever Margarett's mistakes, her interest in Italian was earnest and enthusiastic; when assigned the transcription of an Italian poem from each literary epoch, she chose works that expressed her own temperament: "If I were fire, I'd burn the world away; / If I were wind, I'd turn my storms thereon."

Soon after her arrival in October, Margarett left school to visit

Edward Boit, whose sister had married her uncle Arthur Hunnewell and whose daughters were the subjects of his friend John Sargent's great group portrait. She had never visited the home of an artist, and Edward Darley Boit was a working painter who had studied in Rome and Paris and exhibited at the Paris Salon of 1876. His villa crowned the summit of a hill in Pegli, in the hills above the Italian Riviera. Margarett had grown up with the topiary of Wellesley's Italian Garden, flower beds that waxed and waned with the harsh New England seasons, but she was still unused to the effortless profusion of a garden in Italy, the timeless presence of barns and granaries built and rebuilt with the same ancient stone.

Florrie, the Boit daughter who at fourteen slouched against a huge vase in the Sargent painting, led her visitor through the gardens. In the rose garden, Margarett posed, not smiling at the camera but contemplating a fountain, captivated, it seems, not only by the beauty of what she looked at but by the idea of herself in such a place. "Al cor gentil ripara sempre amore," read one of the poems in her literature notebook. "Within the gentle heart," translated Rossetti from Guincelli, "Love shelters him / As birds within the green shade of the grove."

At a fancy-dress tea soon after their arrival, the girls dressed as characters from the paintings they were studying. Frances Breese was Botticelli's Primavera, Emily Von Armin, a darkly hooded Angelico monk, and M. MacLaren so precisely Piero della Francesca's *Portrait of a Lady* that she seemed sprung from the Uffizi. Margarett walked demurely across the lawn, the startling embodiment of a portrait by Ambrogio de Predis that Bernard Berenson called simply *Profile of a Lady*. Wearing a dress that revealed her slender figure, her hair coiled in Renaissance fashion, Margarett showed signs of leaving behind the "ugly duckling" to whom her Boston friend Kay Saltonstall had bid farewell and becoming the "lovely swan" whom she would welcome home.

Margarett was assigned John Addington Symonds's *Fine Arts*, Walter Pater's *Essays on the Renaissance*, and Bernard Berenson's *Florentine Painters* to read, but it is Berenson's approach that glimmers through her notes like an original through overpainting. She recorded

that Signorelli's works had "gigantic robustness" and were "replete with primeval energy," Berenson having praised his "gigantic robustness and suggestions of primeval energy." Margarett wrote of Raphael as "the greatest master of Composition in the sense of grouping and arrangement"; Berenson, "the greatest master of Composition—whether considered as arrangement or as space."

By 1911, Bernard Berenson had lived in Florence for more than ten years, and renovations of I Tatti, his villa at Settignano, were close to completion. His "four gospels," the famous essays that constitute *Italian Painters of the Renaissance*, had long since established the authority that his breathlessly awaited "lists" enhanced every few years. A new Berenson inventory of known Italian Renaissance paintings with changed or refined attributions caused wild price swings in the art markets of Paris, New York, and London, and significant activity among the students at Miss Nixon's school, which lay just two miles northwest of I Tatti.

His influence was evident when Margarett chose which Alinari postcards she would paste into her art notebook. From the Sistine Chapel's *Incidents in the Life of Moses* she scratched "della Francesca" and inserted "Baldovinetti." In 1898, Berenson had published an article in which he reattributed a della Francesca Madonna just sold to the Louvre to the rarer Baldovinetti. On her postcard of the Uffizi Annunciation, Margarett crossed out "Da Vinci" and wrote "Verrochio"—"Berenson gives it to him."

Whether her allusions to Berenson originated with Margarett herself or with the unidentified art instructor at the Florentine School, it is his insistence a great painting "rouse the tactile sense" that explains the impact of "just looking" on her untrained but sensitive eye. It was a sculptor, not a painter, who particularly attracted her: "She came home," Dan said, "crazy about Donatello." "However tastes may differ about the positive merits of his several works," Margarett wrote in her art notebook, "there is no doubt that his principles—sincerity, truth to nature and technical accuracy—were of immense value to his age." To the left, she glued a postcard of the sculptor's bronze David, which in

1910 stood where it does now, in the large, daylit upstairs gallery of the Bargello.

Imagine it! A curious seventeen-year-old from Boston who has never seen a naked man, perhaps no bare flesh other than her own, encounters Donatello's boy hero, his foot resting on the severed head of Goliath. There he is, near her age, freestanding, genitals exposed, pure sensuality of bronze and gleaming flesh, of flank and buttocks, louche hand on hip. And the details!—hair cascading down a wide back, slim nude hips, brimmed hat, its tassel suspended, the sword held languidly, the stone easy in his hand, the feather of Goliath's helmet slithering up his taut inner leg.

Margarett was, I suspect, not shocked—was, rather, drawn in by the slippery, fluid surface, the sculptor's choice to render David's triumph as a victory of youth over age, of erotic ebullience over stentorian torpor. She saw Donatello's twin pulpits at San Lorenzo, his fulsome Judith lifting an ax to Holofernes, and his haunted, aging Magdalene. "Margarett came home," Dan repeated, "crazy about Donatello, and she started to talk about becoming a sculptor." Why not? Once moved by sculpture, she had a glimmer of its purpose. With his hands, an artist half a millennium away had given shape to something she felt, to thoughts, as she wrote in her notebook, "too deep for formulation."

I remember the look on Margarett's face when I visited her after my own first trip to Florence. "Donatello!" she said, taking a long time with each syllable. Let us say that in his work, she saw for the first time, in concrete and material form, an alternative to the sensibility into which she had been born. "Donatello," she repeated at eighty, with a nostalgic and conspiratorial smile.

THE EFFECTS on Margarett's character of the year abroad registered as a shock on the unsuspecting family seismograph at home. On her way back to Boston, she traveled in Switzerland with two friends from school. It was June 1911, the end of a year of mourning for Edward VII, and Margarett arrived in London in time to stand with thousands

cheering the coronation procession of George V. Just weeks before, in Boston, Jane Sargent Cheever had given birth to a third son, and it was Jenny Sargent's hope that Margarett would return to Boston prepared to become a flourishing matron like her sister. But the Florentine School had not polished away her rough edges. It was as if she herself were a souvenir brought home to herald the passing of the Edwardian Age, news that otherwise might not have reached the Back Bay for a year or two. "I don't understand my daughter Margarett at all," Jenny exclaimed to E. Ames, throwing up her hands.

Immediately on her return, Margarett had the walls of her room at 40 Hereford Street stripped of flowered wallpaper and painted the color of cement. After her birthday, at the end of August, she went to New York City and bought the Mary Cassatt; when she got home, she removed her bedroom curtains and replaced "those dreadful hunting pictures" with her beautiful pastel. "It was very outré," her old friend E. Ames said of the new decor. Gertrude Hunnewell, who had cautioned the departing Margarett not to expect to become a successful deb, expressed concern that her cousin, now "a sophisticated beauty," might burn the hair she waved—onduléed—like the French. "What am I saving it for?" Margarett retorted. The Miss Porter's grapevine reported "spectacular" news: Margarett Sargent had returned from Italy wearing *extraordinary* clothes.

Margarett had gone to Florence to complete the self-creation Miss Porter's had begun. Her success was acknowledged by those closest to her. "It was after Florence," Gertrude said, "that Margarett began to be different from other people." E. Ames was proud the friend who'd gone to Florence a Hunnewell had returned "a person in her own right," but Margarett's difference tore at her mother's fragile temperament. Always, in subsequent years, when her daughter did something she considered un-Bostonian, Jenny Sargent expressed her agony in one resonant, hopeless sentence: "If only we hadn't sent her to Europe!"

"Look!" Ellen Curtis said to Marian Valliant as the two girls eyed guests at a wedding at the Arlington Street Church. "There's Margarett Sar-

gent!" Marian had heard talk of Margarett, and here she was, "a vision" on the usher's arm, walking down the aisle. Marian didn't remember who the bride was, but she remembered what Margarett wore: "I promised myself then and there that when I could buy my own clothes, I would have a tartan velveteen just like Margarett Sargent."

Margarett did not record her interest in art in the diary she began early in 1912. She noted an occasional Italian lesson, the writing of an Italian poem, but Florence soon receded in the gathering momentum of her debutante year. Cries of wonder at her beauty and sophistication had not healed the wounds years of plainness had inflicted; she now applied herself to a sustained performance—she would play not the swain she'd perfected at Farmington but the damsel who attracted his admiration.

For support, she turned to E. Ames, who had come out the year before and whose clothes—"perfection"—Marian Valliant also admired. Margarett visited E. at the Ames house on the North Shore, charted E.'s winter bronchitis in her diary, lunched with E., dined with E. before the theater, and "adjourned to E.'s" in Boston so often that Fran and Kay Saltonstall teased her. "The Salts are so funny about my going there all the time as if I never used to." It seemed to Dan that the friendship thrived because Margarett did all the talking and E. did none. "Rather ashamed at the way I let my tongue run away with me," Margarett wrote once, but of another conversation she exclaimed, "E. and I had such a gasbag talk and the more I see of her the more wonderful I think she is the way she sizes up people."

It was with E. that Margarett assessed the enterprise of coming out into the world of courtship and marriage. On one "delicious drive," they ended up at The Country Club in Brookline, where they'd sledded as children. "We were comparing wives to suits. Serviceable colors, etc. E. is a pretty color but might not wear well—and you couldn't wear every hat with her." Margarett found herself more complicated: "I am made of rough cloth—and dirt does stick to it so."

Margarett was aware of her difference as she looked ahead to what was called "the season." In mid-September, she was one of ten debu-

tantes invited to join and choose the membership of the 1911 Sewing
Circle. The original Sewing Circles had evolved from the Sanitary
Commissions formed in Boston during the Civil War, when young
women gathered to roll bandages. Two years before Margarett's com-
ing-out season, a group of debutantes, Margarett's riding friend Alice
Thorndike among them, transformed what had become society lunch
clubs into "a philanthropic employment bureau" for young women,
like the Junior League founded in New York in 1901.

Like their New York counterparts, Alice and her friends chafed
against the example of Lady Bountiful, "with her promiscuous giving,"
and trained themselves for the city's settlement houses, schools, and
hospitals. By 1911, they had put four hundred young women to work.
Margarett's year in Italy and discovery of art had already given her a
taste of the independence others looked for in helping others, but
membership in the Sewing Circle, her mother told her, was an honor
she could not refuse. As the year progressed, Margarett would note the
Sewing Circle in her diary with mounting annoyance, but she did not
decline when her sister debutantes elected her president, which made
her, in the opinion of one society writer, "the most preeminently pop-
ular girl of the season."

Throughout the fall of 1911, Margarett gained prominence as a
member of "the rising generation," filling cups and offering sugar or
lemon at a succession of occasions that would often, but not always,
culminate in informal dancing. In the third week of December, cards
went out for her ball, to be held on Friday, January 12. To whom were
the invitations sent? "Just everybody, I guess," Gertrude Hunnewell
said. A daughter's debut could clear one's social slate for a year.

Jane's party had been given at home, but now Frank was more
prosperous; Margarett's would be given in the ballroom of the Somer-
set Hotel, which could accommodate scores more guests. The Som-
erset was smaller than the newer Copley Plaza, older than the Ritz,
and more equipped for chauffeured cars than the Vendôme, whose ball-
room Marian Valliant said was "hopelessly dowdy." But neither the
choice of place nor the invitation list was up to Margarett. Jenny did

it all: preparations for a party of hundreds, the hiring of forty-eight butlers and maids, two doormen, two carriage men, a valet, two extra checkroom men, and a band of fifty to play until dawn. She arranged the menu for the breakfast to be served after midnight, and chose favors for the cotillion—long beaded chains and sleigh bells on red and green ribbon for gentlemen to offer ladies, boutonnieres and boxes of cigarettes for the ladies to offer in return.

On January 12, the front page of the *Herald* predicted a cloudy day with snow and featured an account of a hearing during which Andrew Carnegie, seventy-seven years old, "frequently pounded the table with his hand" and denounced the banking system of the United States as a "threat to civilization." That afternoon, a *Boston Traveler* headline, "Miss Sargeant to Make Debut at Ball Tonight," drew attention to an item that proclaimed Margarett's party "the fashionable event of the day scheduled on society's calendar," and "one of the most important affairs of the season." Next to it appeared a three-column photograph of a lady in white lace—the late Stanford White's paramour and his jailed murderer's wife, Evelyn Nesbit Thaw, "fighting to have her husband freed."

That morning, Margarett wrote in her diary, "The day of my ball at last. Taking it easy all day—trying to be beautiful." If her aim since her return from Florence had been to create herself as a beauty, the ball was her vernissage. During the afternoon, her hair was piled high on her head and crowned with a filigreed tiara by Miss Murphy, the hairdresser. In the early evening, she put on a gown of white satin and chiffon, and at about seven, her brothers escorted her to her sister Jane's house on Marlborough Street, where a dinner was given in her honor.

Soon after nine, Frank and Dan, distinguished as head ushers by the color of their boutonnieres, assembled their corps of twenty at the Somerset. The gold-and-white ballroom was festooned with flowers from Wellesley; a basket of pink roses hung from each chandelier, and masses of pink blooms framed every window and door. After greeting Margarett, who stood between her parents, one was escorted toward the ballroom.

If a guest was female and alone, the usher took her to the "dump" (slang for "sitting-out room"), where, Gertrude said, "you sat hoping someone would come along and talk to you." A "great belle" might arrive at a ball with too many partners for the dance card she found placed in the dressing room. A younger girl might find her roster filled when an older brother returned the card he'd taken from her at the entrance. "Young ladies should be very careful not to forget their dancing engagements, and should never refuse one gentleman and then dance with another," cautioned Florence Hall, Julia Ward Howe's daughter, in a book of etiquette published the year before Margarett came out.

The *Transcript*'s reporting that evening culminated in a catalogue of its female guests, distinguished by hues, stuffs, and trim of gown. A hundred fifty descriptions burst from thirteen kaleidoscopic paragraphs that took up thirty-five column inches of Sunday's paper. E. Ames's dark hair was set off by a gown of "peach colored satin under flounces of white lace." Young ladies should wear white or light colors, Mrs. Hall advised, but color might deepen as age advanced. Margarett's sister, Jane, twenty-nine years old and the mother of three sons, wore rose velvet, and Jenny Sargent wore "a beautiful gown of royal purple velvet," its bodice embroidered with "purple beads shading to rhinestones."

As Berger's orchestra from New York played, scores of young men in formal black and white led partners through whirling rainbow figures of schottische, german, and waltz. When, at the height of the evening, Margarett led the cotillion with Philip Sears, "one of the veterans in that capacity," the guests saw a young woman with fair skin, black hair, and wide light-blue eyes. Her five-foot-ten-inch height was enhanced by coiffure and slippers, and the beaded embroidery of her white gown shimmered in the glitter of electric chandeliers. One reporter, as if writing about horseflesh, described her as "a tall, slender girl with the distinction which marks her mother."

"She was a wonderful dancer," Dan said, using the word "lithe" to describe how she moved. The confidence with which she wielded her charm stunned him. He had not expected Margarett to become glamorous. "There was a whole row of boys lined up for her!" he exclaimed

at ninety. Shaw McKean, a Harvard man from Philadelphia, fell in love with her on the spot, as did Hamilton Fish, Harvard 1910, all-American football hero and captain of the Harvard team. "She was good-looking. She had a lovely figure. She was charming, intelligent, and vivacious. All the attributes and a good family background. She was," he asserted, "the most unusual woman I met up there." Years later, when her eleven-year-old daughter asked about her coming-out ball, Margarett declared, "I looked marvelous!"

"Margarett?" her cousin Beebo Bradlee said. "Why, she was as pretty as a red wagon."

MARGARETT'S FRIENDS who had come out the year she was in Florence were becoming engaged, and after her ball, her life became a press of well-chaperoned opportunities for courtship: dances, house parties, theater evenings, football weekends. "I adored the Beals dance. I certainly deserved to after the dinner seat I had between F. Motley and Junius Morgan!!!" Activities of the marriage market were everyone's business. The announcement of Lily Sears's and Bayard Warren's engagement provoked Miss Ruth Gaston to express what Margarett considered "the extraordinary point of view" that it would be risky if Lily married Bayard because of her mother. Mrs. Sears, believing her husband was unfaithful, had thrown herself from a window.

"Mein Gott, how dreary," Margarett wrote in June at the prospect of trimming a hat for Margaret Richardson's marriage to Hall Roosevelt, but a month later, when Lily Sears visited Wareham, Margarett listened, riveted, to the details of her engagement, and two weeks after that, when her brother Frank clinched her suspicion that Kay, the youngest "Salt," had become engaged to Philip Weld, the son of Papa's business partner, Margarett couldn't stop talking about it: "I suppose the engaged bug is in my bonnet." But no one—not "Beau" Gardner, Bey Meyer, or Francis Gray; not Fat Cutler, who had actually proposed—emerged as a candidate for Margarett's undivided

attention until Dan's "very best friend" sent her a "wild telegram" the summer of 1912.

Margarett first met Eddie Morgan when Dan was at Groton. He visited Wareham in 1909, the summer after her first year at Farmington and his freshman year at Harvard, and Dan encouraged a romance. Margarett found Eddie attractive and "refined looking" that summer but made no other mention of him. In an undergraduate photograph, his darkly handsome face has an air of earnest innocence. But he had "dash," his son said, and, Dan said, was "gallant." Like Margarett, he had very dark hair, and like her father, he sang beautifully. Like his own father, Eddie was tall, six feet one. When he turned up at Hereford Street late the winter of 1912, Margarett noticed his temperament: at dinner he let it be known he was "very sore at E. Ames for turning him down at the Strong's dance."

Eddie was from New York but, in spite of what society reporters wrote later, was only distantly related to J. P. Morgan. His family lived on Long Island and in Newport in two grand houses, "Wheatly" at Old Westbury and "Beacon Rock" at Newport—both designed by Charles McKim. "But the Morgans had no swank," Eddie's son said; "no butlers or anything. They were interested in the sailing."

Eddie's "rich, racy, pithy English," the tossed-off ease with which he quoted long passages from Milton and Shakespeare, the brilliance that brought him surprise top marks on Groton's Harvard entrance exam, made him popular. At Harvard, like all of Margarett's brothers and like Teddy Roosevelt, another New Yorker, he was asked to join the Porcellian, the oldest and most quintessentially Bostonian of the college's clubs, and when he was initiated into the Hasty Pudding, he deftly met the requirements: to climb a telephone pole, smoke a cigarette, and give a speech on woman suffrage. He majored in Egyptology, then a rage, not out of interest but because it was, in Cambridge parlance, a "gut"—an easy major. Eddie's real passion was rowing—he studied only enough to stay on the crew.

Margarett had a gift for flirtation, but she was not prepared for the

consequences of real sexual feeling, nor was there anyone, even a friend, in whom, if she'd had the language, she could deeply confide. What she and Eddie felt for each other had no place in the life they had been directed to lead, no destination aside from marriage. They carried on the substance of their romance clandestinely, by letter and in secret meetings, and presented a carefree front to their families.

When Eddie Morgan began to pursue her the summer after her debut, Margarett was just back from a trip to Bermuda with Frances Breese. On the Fourth of July, she found herself at the Ameses' on the North Shore, yearning for an expected letter from Eddie and beside herself that it had not arrived. Nothing helped—not a letter from John Parker on Monday or a card from Styve Chanler on Wednesday, not expressions of interest from Walter Paine, "the only boy who doesn't repulse me in a bathing suit," or watching polo at the Myopia Hunt Club: "I can't say without profanity what I thought of it." Finally, on Saturday afternoon, between the "retouching" of her hair and a dinner party, the letter arrived. Wednesday, back at Wareham, there was a "wild telegram," and Margarett wrote in her diary, "Can I call him a beau?"

She could tell her mother nothing. Jenny Sargent watched warily. Even though he was Dan's best friend, Eddie Morgan, a New Yorker, was not who she had in mind for her younger daughter, and Margarett, at nineteen, was too young to become engaged—Jane had courted decorously at twenty-four. "Jane back soothing Mama," Margarett wrote at Wareham in July. She found the example of her older sister "furiously irritating." Jenny tried to make peace. "If you two don't become friends," she once declared, "I'll walk down to Wellesley barefoot." But Margarett's experience with Eddie separated her from both her sister and her mother. She considered herself an adult, and presumptions of authority, coming as they did in the absence of real sympathy, galled her. "Jane infuriated me about looks and dress," she wrote on July 17, and four days later, "Jane and I played tennis together. Jane irritated me beyond words making me wait on her."

At the end of the summer, days before her twentieth birthday, Margarett addressed the subject more fully: "I realize really absolutely

now, in spite of any effort—which I realize I am incapable of making—that I could never in this wide world be truly intimate with Jane—or even begin to be. She doesn't interest me—and I don't care what anyone says—she is not truly, truly sympathetic."

Her brother Frank, on the other hand, was her idol and counselor. At twenty-eight, he was still unmarried. His passion, aside from women, was steeplechasing, where skill required wild daring. Riding a horse through a risky, daredevil course showed off his most compelling qualities—startling good looks, athletic ease, and charm. His unpredictability dazzled the young and unnerved those who'd lived longer. "He was a *great* beau of mine," Kay, the youngest "Salt," boasted in her eighties, "but he was very agitated." His charisma and brilliance at Parkinson and Burr prompted an elderly and scholarly client to exclaim, "Young man, don't throw away your life being a stockbroker."

As Margarett began to fall in love, she sought him out, and he gave her what advice she got on matters of the heart. As the romance proceeded, she became restless. She was late to meals, "sassed the family til they shut up." She read her love letters alone in the woods. Even in her diary she didn't express her anxiety directly. "I lack that spirit of dash and 'en bon point' that characterized my style formerly. Sighed quite a lot." She wrote Italian poetry—"not in my best vein"—and meandered through the newspaper. "Happened to see an interesting 'want ad': reads Western oil magnate wants good looking, clever stenographer. Must have lots of self confidence.' That last rather implies 'Cheek.' Cheek of course would not apply to me."

"Margarett got engaged to Eddie to escape her mother," Dan said in his eighties. "It was my first kiss," was how Margarett excused her first engagement when her daughters asked about it as children. On a Monday late in July, she set off for a visit to the Pollards in Manchester. Eddie had spent the weekend at Wareham, and they took the train with her brother Frank, Margarett "in a white heat" that Eddie didn't sit next to her. At South Station, Eddie picked up his car. Margarett said good-bye to Frank, skipped appointments with the dentist and the hairdresser, and embarked with Eddie on a secret drive, "mostly

thro' slums"—parts of the city where they would not be recognized. An angular star, code for the momentous first kiss, was the extent of her candor about the rest of the afternoon. "Conversation in the Common watching a frog pond," she wrote mysteriously. "Boy with an umbrella and the consequences."

When Eddie dropped her in Manchester after the two-hour drive north, Margarett found her hosts "distinctly at their worst." Eddie was all she could think of. The next day, a letter arrived special delivery, and she dreamed about the kiss: "Talked last night in my sleep about EDM. Crazy to get to bed so as to think." Back at Wareham, Margarett kept her secret as if it were the trump in a family game of whist. "Can't make up my mind whether to discuss a certain matter with Frank or not. I certainly have the easiest family to fool."

On Friday, Eddie came again for the weekend, and that night everyone went out dancing in the honky-tonk town of Mattapoisett, chaperoned by Frank and a crew of his friends. When they got home, thinking Papa and Jenny were asleep, Margarett and Eddie drove alone out into the bracken, "until Papa's irate voice sounds like a melodrama and we had to come in." Eddie left early the next morning, after the two took a mosquitoey walk through the woods, and later that day Margarett let her brother Frank in on her secret, that she hoped to become engaged. "He was sweet and all I knew he'd be, but encourages the idea of both seeing other people." The next Saturday night in Mattapoisett, Margarett took his advice: "I adored dancing with Gom Goodale, Mr. Wolcott, Mr. Parker & Mr. Richardson."

As the romance proceeded, Eddie's darkness revealed itself. Beneath his charm, he was moody, mercurial, and oversensitive. He was as insecure as Margarett but more vulnerable to her than she was to him. "If only you could have seen the letter I wrote you about an hour ago! You always thought of me as emotionless. Well thank heavens I waited an hour, read it and tore it up," he wrote Margarett during a lovers' quarrel. "I had a lonely, gloomy fit. I felt that I more or less lost ground with you, wore the welcome off the mat, showed my 'shallow, stupid' side once too often." He began to drink too much. After the

incident in the bracken, he stayed away a day. When he returned after
lunch on Sunday, he was pale, wan, and hung over. Out on a drive in
the afternoon, he vomited. "Disastrous turn of events in short automo-
bile trip," Margarett wrote, "managed not to have hysterics."

Margarett apparently excused him. On Monday, August 5, two
weeks to the day after the first kiss, on a bench at the Arnold Arbore-
tum, Eddie proposed, and she accepted. They had taken another secret
drive: "Don't you think we should kiss?"

Two lions guarded the entrance to The Orchard, the Breeses' estate in
Southampton, built by Stanford White in 1906 and completed just
before his murder. Doric columns soared two stories across its facade, a
spectacularly vast garden stretched out behind. Margarett photographed
the house in the distance at the end of a long paved walk bordered
with Roman heads on tall pedestals, cedars, flowering trees, abun-
dantly planted perennials. At the center of a courtyard close to the
house splashed Janet Scudder's sculpture *Frog Fountain.* It was a week
after her secret agreement with Eddie, and Margarett was visiting her
Florence schoolmate Frances Breese. The "Salts" had not let her hear
the end of her going to Long Island: "I hate to have people talk as if I
had been to the Hindoo Isles."

James Lawrence Breese made his money as a stockbroker, but he
also worked as a semiprofessional photographer, specializing in erotic
studies of young girls he sponsored, supported, and brought to his stu-
dio for late-night parties, a pleasure he'd shared with his late friend Stan-
ford White. In the late nineties, at the climax of a stag dinner he gave, a
gigantic "Jack Horner Pie" was wheeled into the dining room. A naked
girl burst through the crust, and the guest of honor reeled her in on a
ribbon leash. Breese noticed Margarett immediately and on the first day
of her visit made his move, "patting me all over." "Disgusting," she
wrote in her diary, and the next day, "Mr. Breese tired of me."

Enthusiastically squired to polo matches, luncheons, swims, and
tennis matches, Margarett did not miss Eddie. Even in solitude, con-
templating "the Club piazzas all deserted," she did not miss him. She

was quickly caught up in the Southampton social whirl. At a dance Saturday evening, Chalmers Wood and Bill Tilden, the tennis player, were her suitors. At the Breeses' thé dansant Sunday afternoon, Frances's married older brother Sydney praised her dancing; in the evening, Oliver Harriman came for supper and was smitten. Monday at Steeplechase Park, a young man familiar enough to be called "Bob" became "quite 'devoné'—and we had quite a clutch in the scenic railways."

But Eddie yearned after Margarett. A telegram reached her on the train on her way home, and he met her at Barnstable. They took a drive and missed the last train to Wareham. Margarett was terrified. There was no telephone at Wareham. Her parents would discover that Eddie met her every time she took a train, that she had kissed him in his car: "Got myself all porked up & upset." She telephoned the Herricks, who lived down the road in Wareham, and Eddie left for Newport. She took the train to Wellesley, in nervousness dropping her money on the platform. She couldn't talk, even to Uncle Frank Hunnewell or Cousin Walter. She cried and sobbed herself to sleep, poured herself into a long letter to Eddie. The next morning, she boarded the 8:26 to Barnstable and changed for Wareham. "Papa apparently hasn't slept, otherwise not half the furor I expected." The attention of the household was elsewhere. The Herricks' daughter, Katharine, had run over and killed a child in New Bedford: "Horrible."

For her twentieth birthday, on August 31, Eddie gave Margarett a puppy, named Pilgrim for the automobile in which he'd driven her to the Arnold Arboretum the afternoon he proposed. Pilgrim came with a leash, a red collar, a comb, and a supply of dog biscuits. Eddie also presented Margarett with an oar pin: he rowed seventh on the Harvard varsity crew.

When she heard about the engagement, Jenny protested violently. Aside from the fact that Margarett was too young, Eddie's temperament frightened her, and she had a Boston prejudice against his New York origins. New Yorkers drank too much, entertained too lavishly, and were ostentatious and wasteful with money. Another year or two at home, followed by marriage to a prudent Bostonian, was what she

had in mind for her younger daughter. Another year or two at home was exactly what Margarett did not want. Jenny did not prevail, but in deference to her feelings, Margarett and Eddie agreed to a year's engagement and a postponed announcement.

In spite of their betrothal's supposed secrecy, Margarett and Eddie became a "famously beautiful couple." In 1912, the rhythm of Irving Berlin's "Everybody's Doin' It Now" began a dance craze that so departed from the decorous waltzes of hotel thés dansants that a New York grand jury was moved to investigate. Margarett learned the turkey trot from her brother Frank and passed it on to Eddie. Afternoons at Wellesley, they cranked the Victrola and gyrated to ragtime. Margarett was "*so very* attractive," said Eddie's younger sister, Kassie, fourteen at the time. "She wore a very modern bathing suit."

But betrothal began to wear on Margarett. Seven decades later, Dan's voice was earnest with horror when he told me that while she was engaged to Eddie Morgan, his sister "saw other men." "It was Shaw McKean who was the culprit," Kassie Morgan said. Dan confirmed that Margarett walked around the lake at Wellesley with Shaw McKean while she was still engaged to Eddie. Uncle Frank Hunnewell accosted her with a young man after dark on the lake path: "What are you doing here?" Eddie's son reported that Bertie Goelet was the villain. "No," snapped Kassie, "Shaw McKean," and explained that it was all much worse than it might have been, since Eddie and Margarett had been engaged "a *full year*."

Margarett did not mention other suitors in her 1912 diary, but on every page from September 24 until her last entry, written on October 17, she crossed Eddie's initials resolutely out. "I guess I want the impossible," Eddie wrote that winter "to catch a fine fish with a baitless hook."

"I didn't know you two didn't get along," Dan said to Eddie when he heard the news of the breakup. He had come home from France in May to prepare for the wedding, had given up a job in Bordeaux to be his best friend's best man. He angrily confronted Margarett. She had spent time with the Morgans in Old Westbury, she told him. Newly

married Morgans lived in "The Lodge," attached to the big house. What would she do while Eddie was at the stables with the Morgans' one hundred horses? While he exercised hunters? Trained ponies for polo? And then there was Mrs. Morgan.

" 'Margarett dear,' " she mimicked, " 'this is little Katherine, who will be your new sister-in-law.' "

"I don't want a sister-in-law," she shouted at Dan, "and I can't bear little Katherine!"

What Margarett did not tell Dan was that Eddie drank too much, that he had promised over and over again that he would stop, and that he had gone back on his promise once too often.

Margarett broke it off at Newport. She and Eddie were at a big dance, perhaps at Beacon Rock, possibly at another house whose ballroom overlooked the sea. They left the heat of dancing and went outdoors, and as they stood, pressed against a balustrade, Margarett said, "Eddie, I can't marry you." It wasn't that she didn't love him, she said. "I want to marry you, but I can't."

"Why not?" Eddie said, quite stunned.

"I'm terribly sorry."

"Margarett, why not?"

She didn't answer immediately. Then, "I'm going to Italy to sculpt."

To those around her, the announced reason for Margarett's extraordinary step seemed so mysterious it hardly registered: "I'm going to Italy to sculpt." Reasons she gave that were more understandable, that Eddie drank too much, that she couldn't bear the cloying domesticity she might expect as a member of the Morgan household, that Eddie had "no small talk"—did not, even if true, warrant such radical action in the minds of her friends and family, particularly after a year of betrothal, the setting of dates, the arrival of early wedding presents.

"Eddie took to drink over his jealousy about Margarett!" Dan exclaimed. Jane felt Margarett had treated Eddie "very badly." Jenny was "mortally wounded" that her daughter had done such a thing. "You

didn't *break* it!" she exclaimed. It was as if her daughter had gotten a divorce. Frank was more merciful. "Don't be so hard on Peggy," he said. Mrs. Morgan was "shocked and furious." "She was his only girl," Kassie said, "and she dropped him." The fault, in Dan's eyes, was Margarett's, but the tragedy was equally his. The broken engagement had—"of course," he nearly shouted decades later—broken his closest friendship. "Margarett had 'immortal longings,' " he explained, intending the deepest parallel to Cleopatra: "She wanted more than you could get. Nothing banal was good enough for her."

Margarett had been, she always said, in love with Eddie, but the desire to sculpt had turned her away. "Oh clay," she said. "How I loved clay!" With portents of war rumbling in Europe, the Sargents would not hear of her sculpting in Italy. Instead, Jenny asked Frank's business partner, General Weld, to take her daughter away from sculpture and away from Eddie, out of the country to Mount Talbot, the castle he leased in Ireland in County Roscommon. A fancy-dress ball after Margarett returned to Boston in December was the former lovers' first encounter since her precipitous action. There was barely a breath, as the revelers, who included Eddie, waited. Margarett made her entrance dressed as Joan of Arc, in a full suit of armor.

When her daughters were little, but old enough to remember, Margarett took them upstairs to the cedar closet at Hereford Street. She opened a cavernous cupboard and showed them wedding presents never returned from the first-kiss engagement. They were wrapped in coal-black tissue paper that rustled when she touched it. There were china bowls and a silver tray for calling cards. "She didn't explain the calling cards," her daughter Jenny wrote. "She made a point of never telling us of such conventions."

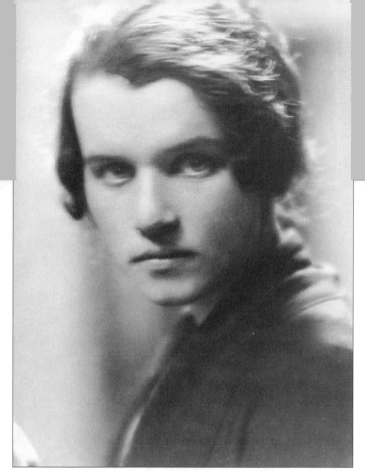

iii

*a rose the world
has dreamed . . .*

(1913–1918)

Margarett, October 1915
(photographed in New York
by Arnold Genthe)

"It will be remembered," *Town Topics* observed, "that one of the prettiest and most dashing girls of the exclusive Boston set broke an engagement just at the end of her debutante year with a Harvard man who boasts one of the most prominent names in the world of finance as well as of society. It caused a great deal of talk at the time because it was said that a classmate was the cause of the trouble and rumor points to a young man who is at work in the mines." It was not reported that Margarett's break with Eddie had required courage and that in spite of her apparent arrogance, she had suffered. Gertrude Hunnewell had a clear memory of her once triumphant cousin, "the poor thing," coming to visit. She was "covered with boils" and had brought along a suitcase of trousseau linens monogrammed in Paris, which she attempted to rescue with needle and thread, doctoring the Morgan *M* with a cramped *ck.*

The young man implicated was, of course, Quincy Adams Shaw McKean. The mines were the Calumet & Hecla copper mines, near Lake Superior, where Shaw McKean worked as a gentleman laborer from autumn 1914 through the summer of 1915, gaining, he wrote, "experience underground and in mill and smelter." The Calumet & Hecla Mining Company was a family enterprise, and Shaw was a member of the family. In 1866, his mother's uncle, Alexander Agassiz, son of Louis Agassiz, the Swiss-born naturalist famous for *Recherches sur les poissons,* the basis of modern knowledge of fish, and *Études sur les glaciers,* traveled to Michigan to inspect an undeveloped mine his brother-in-law Quincy Adams Shaw had purchased the year before.

He returned to Boston with a proposal to purchase land to the south of the mine, even richer in copper.

His ambition was to support his own zoological research and to endow his father's dream, a Harvard Museum of Comparative Zoology, without spending his life as his father had, dunning Lawrences and Thayers. His sister Pauline presented him with an unexpected opportunity when she married Quincy Adams Shaw, the son of a wealthy merchant and real estate entrepreneur whose family had made a fortune in the China trade and who, after graduation from Harvard in 1845, had explored the Oregon territory with his cousin and classmate, the historian Francis Parkman. After his trip west, Quincy lived in Paris, where he began to collect art; the schoolroom where Shaw's mother, Marian, learned to read was hung with twenty-one pastels by Jean-François Millet, meant to illustrate the sacredness of peasant labor. Throughout the house, which stood on a bluff overlooking Jamaica Pond, resided twenty-five Millet oils, paintings by French nineteenth-century artists, Dutch old masters, and works by artists of the Italian Renaissance, including Donatello.

Because he was born rich, Quincy Shaw's interest in the Michigan mines was at first more casual then Alexander Agassiz's. It was Alex who convinced "a party of Boston men," chiefly friends and family, to join in purchasing the land that became the dazzlingly profitable Hecla mine, and Alex, with his degree in mining engineering, who persuaded the investors that retooling the old shafts would increase productivity. What began for many, including Horatio Hollis Hunnewell, as a gesture of support for two young men became a bonanza. Calumet & Hecla renovated more than one tired Boston shipping fortune and made a younger generation rich.

Shaw McKean was the son of Quincy Shaw's daughter Marian and Henry P. McKean, a Philadelphia gentleman farmer. Though he wintered in Philadelphia, he went to Harvard and summered on the North Shore, which made him, to Jenny's mind, an ideal suitor for Margarett. Dan disagreed. He had roomed with Shaw for two years at Harvard, and they had not become friends. Dan was a serious student

who had contempt for the sporting life, and Shaw escaped Cambridge whenever he could to play polo. "He was too well dressed, too shiny," Dan said. "I couldn't understand his emotions." At her debut, Margarett had turned Shaw aside, but she remained struck by his dark-haired, blue-eyed looks and his shy, diffident manner. When she returned from Ireland, he was in his first year at Harvard Law School, and for some months they saw one another.

In March 1914, at the Arlington Hotel in Santa Barbara, a letter from Shaw reached Margarett, thanking her for "postals." "The Grand Canyon looks too marvelous—I have never seen such an extraordinary view in my life," he wrote. Margarett and Louise Delano, a Florence classmate, were on a tour of the West. "I'm trying to become an out-door girl," Margarett wrote her brother Harry from Pasadena. "Tomorrow I ride astride." She, Louise, and Miss White, their chaperone, sailed to Santa Catalina, cheered "cowboy races" at the country club, and surfed Sandylands Beach.

"I hear they have the only dirt polo field—which is made with dirt & oil—in the world at Pasadena," Shaw wrote. "If I didn't know I'd go to the devil doing it & if I had the money necessary, I should like to play polo all year round. California—Long Island—Narragansett etc. with three months off in the fall so as not to get stale at it." At Monterey, Margarett photographed a tree in the shape of an ostrich, and at Yosemite, Billy Wilson, their Indian guide.

From Santa Barbara, Margarett wrote to Eddie Morgan. She got no answer and wrote again. "It was my accident that prevented my answering sooner," he protested. Playing his father's polo ponies, he had taken a fall and broken his collarbone. Margarett wanted him to return the photograph of herself she'd given his mother. He replied that it might be some time before the family returned to Newport, but that when they did, his mother would either destroy the photograph or return it. She also asked about the future. "At the time I got your letter," he wrote, "I was amusing myself by drinking a good deal and half heartedly looking unsuccessfully for a girl I might fall superficially in love with, merely as a pastime." He added that since the accident, he

had cut out all "rum," with the exception of beer, for good. Margarett's final question concerned Pilgrim. "He long since fulfilled his sphere of usefulness so far as I am concerned," wrote Eddie, newly the owner of a pack of beagles. "When you marry, would it not be kinder to all four of us—you, the man, Pil and myself—to send the little fellow (Pil, I mean, not the man) in the most merciful possible way to his happy hunting ground."

Eddie doubtless assumed that "the man" was his former roommate Shaw McKean, who himself would soon learn it was through no weakness in his rival that Margarett's hand remained her own.

Before her trip, Margarett had written Shaw, "I know you love me. I hope you will like me just as much and more—for I don't think it is just for the satisfaction of your attention—or your attraction—but knowing you is a real enjoyment to me. And above all don't forget me." Shaw quoted these declarations back to her in "a page of serious stuff" he sent her to Santa Barbara:

> You have told me you liked to feel I cared for you & would hate to have to cease. . . . This all sounds pretty much as if you did not put me on entirely the same plane as your friends & that you expected something more than mere friendship would come of it. Then you turn around and berate me soundly for presuming to take you to task— You say that you don't want me to call you dearest and when you come home you don't expect to keep so much in touch with me— Well, can't you see that the two attitudes can't go together?

It was on the train east that Margarett saw the cowboy again. A hulking rancher she'd met in Wyoming had resolved to marry her, and was pursuing her. She liked him, she said later. Had talked to him, that was all. The day she reached Boston, he knocked on the door at Hereford Street and asked for Mr. Sargent. "I'd like a shot of whiskey, straight," he said, and, when he got it, knocked it back. "I'm going to marry your daughter." Frank, who had known many Wyoming ranchers, did not hesitate. "No," he said. The cowboy was shown to the door.

Margarett did not need her father's help in turning Shaw McKean away. She had declared in no uncertain terms that he had no claim on her. She intended to pursue sculpture, and no matter what sort of art collection his family had or how fascinated he seemed with her chosen career, she would not marry him.

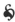

IF MARGARETT'S DECLARATION that she was "going to Italy to sculpt" had been made fifty years earlier, her parents might have sent her to Rome, where the sculptor William Wetmore Story, a Bostonian and a friend of Henry James, presided, from elegant apartments in the Palazzo Barberini, over the American expatriate colony. Story might have taken Margarett as a student, but she would also have been drawn to the group of American women sculptors, then in their twenties and thirties, who thrived in Rome at midcentury. Story nervously called them "the emancipated females," and Henry James, famously, "that strange sisterhood who at one time settled upon the seven hills in a white Marmorean flock."

Quintessential among them was Harriet Hosmer, like Margarett an energetic, unmanageable, and ambitious young woman, who prevailed over childhood sickliness to become a willful tomboy. Her school declared her incorrigible, and Harriet was sent to Miss Sedgwick's in Lenox, Massachusetts, where she met Fanny Kemble, the British actress and feminist, who encouraged her to turn a talent for modeling animals into a career in sculpture. When Harriet was twenty-two, the celebrated actress Charlotte Cushman admired her sculpture and invited her to Rome. Four years later, in 1856, Harriet sold her *Puck* to the Prince of Wales; thirty marble copies were made, and the profits were said to have amounted to thirty thousand dollars. Within ten years, she had a palatial studio, a staff of male stonecutters, and as many commissions for British gardens and American great men as she could manage.

"Hatty takes a high hand here with Rome," William Story sniffed, "and would have the Romans know that a Yankee girl can do anything

she pleases, walk alone, ride her horse alone, and laugh at their rules." She cut her hair short and wore a velvet beret, a man's cravat, and baggy Zouave trousers. She had not declined an offer of marriage to achieve her independence, but she waged an "eternal feud with the consolidating knot," aware she'd stepped from the beaten path: "I honor all those who step boldly forward," she wrote, "and, in spite of ridicule and criticism, pave a broader way for the women of the next generation."

When Hosmer's most audacious artistic descendant, Janet Scudder, decided she wanted to sculpt, American women in search of training were at the mercy of master sculptors reluctant to hire them. One man changed their destiny. When asked to take charge of all the sculpture for the 1893 World Columbian Exposition in Chicago, Lorado Taft asked if he could recruit the young sculptors working in his studio, several of whom were women. Certainly, came the answer, "white rabbits if they could help you out."

The six self-named "white rabbits," all with Taft's support, altered the course of American sculpture. At the height of her career, Scudder, offered the commission for a memorial to Longfellow, suggested a sculpture garden rather than a statue. When the committee insisted on a statue, she refused the job: "I won't add to this obsession of male egotism that is ruining every city in the United States with rows of hideous statues of men—men—men—each one uglier than the other— standing, sitting, riding horseback—every one of them pompously convinced that he is decorating the landscape!" Later, in 1907, Gertrude Vanderbilt Whitney, herself a sculptor, encouraged the National Sculpture Society to promote garden sculpture. Women like Scudder, Malvina Hoffman, Harriet Frishmuth, and Whitney herself leaped at the opportunity to sculpt "pagan" figures like Pan and Diana, in which sensuality and charm replaced funereal pomposity.

By 1913, when Margarett declared her ambition, Scudder was a successful sculptor juggling commissions, and articles about female sculptors crowded the pages of the new illustrated periodicals. "If we men do not look out, we may be pushed from our stools by women,"

an unidentified male sculptor told *Scribner's* in 1910. Edith Deacon, briefly a girlfriend of Margarett's brother Frank, was pictured in the *Boston American* when her grandmother offered her $100,000 to lure her back to the marriage market from "the study of melancholy art in the studio of a sculptor," and in 1915, when the Boston artist Marion Boyd Allen painted a portrait of Anna Vaughn Hyatt modeling the maquette for her Joan of Arc—the saint in full armor, sword raised, astride a powerful steed—the painting won the popular prize at the Newport Art Association.

The summer of 1915, Margarett returned to Southampton to visit Frances Breese and looked with new eyes at the fountain that adorned the court at The Orchard. The frolicsome marble child kicking water into the mouths of frogs was one of the most famous garden sculptures by an American woman. Margarett photographed it twice and pasted both photographs into her scrapbook. "Janet Scudder," she wrote, "Frog Fountain."

"I have found something that I think might interest you." It was ten o'clock at night, and the man's voice on my telephone was not familiar. "Just last week at auction, I picked up a sculpture by Margarett Sargent." In the 1960s, Margarett's studio had burned to the ground, and many of her sculptures were destroyed. I had seen only a few—works in the family and fragments that, for one reason or another, escaped the fire.

"Yes, I'm interested."

A week later, I met the collector at a warehouse in Boston. The work was cast in bronze and stood fifteen inches high. A young woman stands in front of a wall. She is caught, seems to pull away from the wall as if unable to escape, as if her hands are tied behind her. She wears a flared dress to her ankle and looks to be from the past, a character from a novel, perhaps. The work has no title, but at the base is inscribed "M. Sargent" and a date, 1916.

In the fall of 1914, for the first time in her life, Margarett had become "occupied," as she put it. She was sculpting, she wrote later, with

"passionate application," inspired by a sculptor her own age, a young woman named Bessie Paeff. Bessie was Jewish and had come from Russia with her family when she was less than a year old—"their crowded little flat down in the North End simply dripped melody," wrote a reporter, "and one or another of the six children of the dreamy Russian intellectual was always hurrying off to the Conservatory, clutching a violin case or a roll of piano music."

Margarett, Dan was sure, read at least one of the accounts of Bessie's triumphs published between 1913 and 1915 in the *Globe* and the *Transcript*, and in periodicals as far away as New York and Washington. Bessie drew pictures with more passion than she devoted to the violin, and her parents sent her to the Boston Normal Art School. One of her teachers showed her work to the sculptors Bela Pratt and Cyrus Dallin, who saw to it she got a scholarship to the prestigious Museum School. There she won more prizes than any student in the school's history, while earning a living making change in the Park Street subway, a lump of wet clay always at her side.

When Bessie Paeff came to lunch at Wellesley in the fall of 1915, she had just been praised in the press for "the figure of a little crouching boy, intently watching a bird that has alighted on the tips of his outstretched fingers," which was later placed at the Arlington Street entrance of the Boston Common. The war had kept her from studying in Paris with Rodin, but she would soon realize "one of the ambitions of her life"—to sculpt the great Jane Addams in Chicago. At lunch, she announced her intention to change her name to Bashka Paevi. Margarett protested. It was pretentious, she insisted, and drew allied opinions from her brothers, finally convincing "Bashka" to keep "Paeff," at least.

The two had a partnership: Bashka instructed Margarett in sculpture, and Margarett encouraged friends to give her teacher commissions. Shaw ordered a sculpture of his champion fox terrier, and Bayard Warren a portrait of his champion Sealyham. Margarett was enthralled by this woman of her own age, with black hair and flashing eyes, who dressed with bohemian glamour and moved with such assurance

among the Jewish art-collecting elite of Boston, families like the Koshlands and the Kirsteins, whom Margarett herself would not have known, even though their houses on Commonwealth Avenue were as grand as anyone else's. Under Bashka's tutelage, Margarett was soon earning her own commissions.

Late in 1915, Frank and Jenny ordered a group portrait of their Cheever grandsons. The little boys were escorted one at a time to Margarett's studio in Copley Hall by their nurse. "It was strange to be six," Sargent Cheever said, "and to tell your friends that you had to go pose for your aunt." He remembers the smell of wet clay, and Margarett, with whom he had always laughed, as having been quite serious. He remembers her discussing with Miss Paeff whether he should be clothed or bare-shouldered—in the end only the youngest, Zeke, didn't wear a shirt—and that Bashka encouraged and advised as Margarett modeled. Unlike the children captured in mischief or glee by Scudder or Paeff, Margarett's nephews lower their eyes. The forms are clear, but in the youth and shyness of the portraits, I see the youth of Margarett's talent. Cast in bronze, the sculpture's surfaces were smooth, as well-behaved as her nephews.

When Margarett got Dan to sit for her, in late 1915, he had just published his first book of poems and was about to join the American Field Service Ambulance Corps in France. His decision to volunteer was as much the consequence of rebellion against his parents as of courage—he'd fallen in love, and Jenny had forbidden marriage. Trips to France and study of its literature had opened him to real emotion about the war, and like Margarett, he was uneasy in the life to which he had been born. In poems, he expressed his discomfort: "My freedom is a torture cell," he wrote, "My peace the rack of thought." In another, he imagined himself a priest on the battlefields of his adopted country, "But tonight my fingers have a stain / The blood of men, the touch of the dead."

Margarett intended that her portrait honor Dan's new sense of self, that the bust be more than a commemorative likeness. As he sat in

her studio, no shirt on his strong young chest, she worked until his familiar face gave way to an expression that embodied her belief in his poetry and her support for his courageous choice. "She did my normal face from memory," Dan exclaimed; he had been hit in the jaw with a hockey stick, and his lip had swelled. When a Boston paper ran a photograph of the portrait, its readers saw a young man, his proud face turned fearlessly toward the dangers ahead. The reporter characterized the sculpture as "a keepsake should anything happen to him while in Europe," but there was nothing sentimental in Margarett's forthright view of her brother's heroic aspiration. It was a portrait of hers as well.

There was good reason for worry about Dan's safety; German submarines had sunk the *Lusitania* a year before, and the Kaiser would not make a commitment to spare passenger vessels. Dan sailed for France on March 16, 1916, and cabled Wellesley before embarking at Southampton to cross the Channel on "a frail swift passenger steamer" called the *Sussex*. Because the number of Channel crossings each week had been reduced, nearly five hundred passengers crowded aboard that afternoon.

At 3:05, Edwin H. Huxley of New York, on deck for a stroll, glanced at his watch. A moment later, Samuel Bemis of Harvard, also on deck, saw the wake of a torpedo moving briskly toward the steamer. Dan, in the dining room for lunch, was thrown to the deck when the ship halted "as if it had struck a rock." He rose to his feet in time to see the people at the next table disappear beneath the waves. "The Sussex had been cut in two at the bridge," Huxley told the *New York Times*, "as cleanly as though it had been done with a knife."

The rear half of the ship remained afloat, electric lights eerily ablaze, as passengers crying for help clung to bits of furniture. Men on board pulled the wounded and the mangled bodies of the dead from beneath collapsed debris. President Wilson announced he would not sever diplomatic ties with Germany until there was proof the *Sussex* had been hit by a torpedo. When the *New York Times* interviewed Frank Sargent on Saturday evening, he said he "had not received any word

regarding the safety of his son." Margarett waited for word at Wellesley with everyone else.

Dan was rescued by a French trawler at almost midnight and, when he disembarked in Boulogne at dawn Saturday, took a train for Paris. "It was broad daylight when I arrived at Paris, at the Gare du Nord. I bought a newspaper there and read that all the passengers on the *Sussex* had been drowned and that among them was an American, Daniel Sargent—a bit of news that was reported to my parents in Boston, six hours later." It was hours before the Sargents received his one-word telegram, "Safe," or heard the reports that there had been no American casualties.

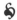

UNTIL DAN'S CLOSE CALLS, Margarett's life had not been much affected by the war, but gradually, in the months following, the American reality began to change. During the summer of 1915, General Leonard Wood opened the first Plattsburgh camp to train civilian volunteers, and in December, Wilson asked Congress for a standing army of 142,000 and a reserve of 400,000 men. In another year, he would announce the United States ready to fight for a just cause, but now, in spite of relentless German victories and virtual German control of the Eastern front, he steered a course of neutrality, and Americans went about their ordinary business.

In early October, Margarett traveled to Southampton, Long Island, for the double weddings of Frances Breese and her brother. A train was hired to transport guests from New York, and automobiles greeted them at the station and ferried them to Saint Andrew's, a "quaint little wooden structure," which stood on the dunes close to the sea. Robert Breese and his new bride processed from the church, followed by the full choir of Grace Church, New York, singing Mendelssohn's wedding music, and the guests were conveyed to The Orchard, where, in the music room, Frances married Lawrence McKeever Miller, Harvard 1911, of Tuxedo Park.

The portieres were pulled closed in the vast high-ceilinged room, and candles provided the only illumination. Margarett, the lone attendant, wore a mist of pale-blue chiffon over mauve and a shepherdess hat, and preceded Frances down the aisle carrying a basket of blue asters suspended from a shepherd's crook. *Town Topics* reported that next to the bride, "Miss Margaret [*sic*] Sargent, the Boston bridesmaid, commanded the most attention and admiration."

One of Margarett's admirers that afternoon was the famous photographer Arnold Genthe. Three days after the wedding, she had a sitting in his New York studio. It was characteristic of Genthe, when a young woman caught his eye, to ask to photograph her. A girl on a New York street reminded him of the Venus de Milo, and the *Sunday World* gave his photograph a full page, headed "Finding a Venus on Broadway." A discouraged singer arrived at his door, and her face reminded him of Rossetti's *Beata Beatrix*; days later, his portrait was published as "The Girl with the Rossetti Mouth."

Margarett could not have been unaware of Genthe's stature as a photographer. He had attracted a prestigious clientele for unique portraits in which his subjects' likenesses seem to emerge unbidden from an ethereal chiaroscuro. A month before Margarett sat for him, Genthe photographed the artist Florine Stettheimer and her sister Ettie. Two weeks afterward, he photographed Pavlova in a leap—the only record of the dancer in motion—and two weeks after that, Theda Bara. He photographed Edna St. Vincent Millay and Dorothy Parker, Sinclair Lewis and William Butler Yeats, President Taft and Alice B. Toklas. He made famous photographs of Isadora Duncan, with whom he had an affair, and misty studies of her young dancers, which were published in *Vanity Fair*.

Dorothea Lange, who worked as his assistant, called Genthe "an unconscionable old goat, in that he seduced everyone who came into the place," but admitted, too, that he was a great photographer of women, "because he really loved them." In his skylit top-floor studio at 1 West 46th Street, he cut a breathtakingly romantic figure. He was six feet two, kept fit by riding daily in Central Park, and always wore

jodhpurs to work. Margarett had never met a man like this among her Harvard beaux, even among her racy Southampton admirers. "A real roué," Lange said.

Margarett had been instructed to dress simply, but Genthe asked her to pose in one of his Japanese kimonos, and then, stomping around in his riding boots, muttering to himself in German, he posed her, adjusted the light, and peered through his lens. The young woman he saw was neither a giggling schoolgirl, a serene debutante, nor a smiling fiancée. Her hair was loosely pulled back, widow's peak distinct; her dark eyebrows perfectly shaped above large, haunted eyes. Her mouth was full, and a half-moon of light accentuated the lustrous curve of her lower lip. She faced the camera with a look that was intense, sexual, almost savage.

"Thanks for your letter, dear Margarett," Jenny wrote not long after the sitting, "it told me quite a lot of things I wanted to know." A mother would have been incautious not to worry about this daughter, and Margarett knew it. In the pose she had printed for her family, her face is half hidden in shadow, the curve of her cheek quiet and lyrical, her hair smooth, and her gaze indirect.

WHEN MARGARETT BEGAN her career as a sculptor, Boston was a city of artists. In 1903, a New York critic had excoriated the Athens of America as "merely a metropolis of a locality, a provincial capital," but a Boston critic refuted him, citing his city's "army of professional artists—six hundred painters, three hundred fifty architects, more than a hundred engravers, almost as many picture dealers." The educated rich of the Back Bay bought paintings for their walls and commissioned sculpture for their city's "Emerald Necklace" of Olmsted parks. Collectors mixed with gentlemen artists at the St. Botolph and Boston art clubs, and a group of painters known as the Boston School perfected an elegant aesthetic, which they passed on at the Museum of Fine Arts School of Painting and Drawing. Two of them, Edmund Tarbell and Frank Benson, were also members of "the Ten," a group

of artists who led an Impressionist secession from the Society of American Artists in 1889 and whose work dominated the mainstream of American art as the century turned.

In 1891, Tarbell had painted *In the Orchard*, a group of young men and women gathered outdoors on a summer afternoon. Using high color shot through with light, he emulated the Renoir of *The Boating Party*. Like other Boston artists, Tarbell had come under the influence of the Impressionists while studying in Paris, but his work changed. In 1892, Isabella Gardner purchased Vermeer's *The Concert*, in 1897 exhibited it in Boston, and in 1907 hung it in her house museum, Fenway Court. Subsequently, in the paintings of the Boston School, *plein air* and loose brush acquiesced to indoors and tight brushwork, to paintings *of* light rather than *with* light, and Vermeer and Velázquez replaced Monet and Renoir as aesthetic models.

The spring of 1914, which Margarett had spent out West, confirmed Boston's art conservatism. After triumphs in New York and Chicago, the notorious Armory Show opened at Copley Hall; because of limited space, no paintings or sculptures by American artists or pre-Modernist work by Europeans blunted its avant-garde edge. "Exhibition of Post-Impressionists at Copley Hall like Dream of Psychopathy," read the *Herald*'s headline the day after the opening; "Art Branded with the Mark of Cocaine." The turbulent shapes and surfaces of Modernism had been welcomed in New York and Chicago, but Boston wanted no revolution, and most of its artists joined the ridicule with which reviewers greeted the exhibition. Philip Leslie Hale, one of the few Boston painters in the New York show, dismissed Marcel Duchamp's *Nude Descending a Staircase* with a limerick:

> . . . a lady, quite bare,
> Descended the stair,
> Now wouldn't that rattle your slats?

By the time the Armory Show reached Boston, the verve of Impressionism had entirely left the work of what *American Art News* called "the near-Vermeer Boston School," and its signature painting

was an exquisitely painted luminous interior in which the quiet presence of a beautifully dressed woman competed for the eye with porcelain brought home by an ancestor in the China trade, a richly decorative screen, or the play of light through an open window. In Tarbell's *The Breakfast Room*, painted in 1903, a woman sits at a table, gown off one shoulder, a bowl of grapes in front of her. In the background, a maid, visible through an open door to the pantry, reaches toward a cupboard.

Margarett had an aversion to the Boston School. By breaking her engagement, she had left behind the life its painters depicted, and she knew that the women they painted as contemplative dreamers were often nothing of the kind. Tarbell's *Mrs. C.* was actually Blanche Ames, a cousin of E.'s and an illustrator, botanist, and suffragist; and Elizabeth Okie Paxton, whom her husband, William, painted dressed for a ball, was a painter in her own right. When Margarett began to make sculpture in Boston in 1914, she joined a considerable population of women artists.

The Museum School had declared its mission the transformation of "a boor of rather superior natural tastes and refinement into the well-educated and cultivated gentleman that an artist needs to be," but in fact it trained more women than men, and many of its female graduates worked in Boston as professional artists. Lillian Westcott Hale was more gifted and sought after as a portraitist than her husband, Philip; Lila Cabot Perry worked at Giverny with Monet for ten summers beginning in 1889; and Gertrude Fiske rebuked her mentors by painting women in other than domestic circumstances, women who seemed to contemplate their own individual destinies, among them Margarett herself. "John Doe," writing for *American Art News* in 1915, was sure "the march of Art Amazons" exhibiting at the St. Botolph Club that winter was "quite a shock to the 'old fogy members' who think the proper place for 'Woman' is 'The Home' (especially if it can be on Beacon Street)."

Every winter, a simple pamphlet was circulated in the art quarters of Boston, announcing the Woodbury Summer School of Drawing and

Painting, set in the ravishing landscape—seashore, pine forest, undulating farmland—of Ogunquit, Maine. E. Ames and her family spent part of each summer in Biddeford Pool, not far from Ogunquit, and during the foggy summer of 1915, Margarett and E. took a few classes with Charles Woodbury, the admired and respected Boston painter who ran the school. The next summer, Margarett returned to Ogunquit by herself, rented a studio, and enrolled for the full session of instruction in "painting & drawing from nature in oil, watercolor & pencil."

By 1916, artists had painted in Ogunquit for two decades, and the tiny fishing village perched on a bluff overlooking the ocean had become what a 1920 tourist brochure called "a highclass resort." The Ontio Hotel had a "hop" on Friday nights, and the Sparhawk, where a dance was held each Saturday, was the largest of the half-dozen hotels that rose like baroque castles along the shore. When Margarett came to Ogunquit, three summer art schools flourished, and the town was a magnet for painters and sculptors, a place where the conflict brought to a pitch by the Armory Show was reenacted each summer in earnest miniature.

Through the small fishing settlement at Perkins Cove ran a trickle called the Josiah River. On the west side, in and out of his large shingled studio, Woodbury presided over his students, most of whom were women. One mean-spirited Boston painter called them "fanatically adoring disciples," and an Ogunquit literary man dubbed them "virginal wayfarers," after the Marginal Way, the path that edged the bluff high above the Atlantic. In fact, Woodbury was genuinely supportive of women artists, perhaps because his wife, who had died in 1913, had been a painter.

In his friend John Singer Sargent's 1921 portrait, Woodbury is a handsome, delicately featured man with silver hair, a trim beard, and evidence of charm and humor about the eyes. Like Tarbell, he had studied at the Académie Julian in Paris, but he was almost exclusively a marine painter, whose fierce, raw approach to his subject belied his slight build and gentle nature. Though his painting retained the Impressionist spontaneity abandoned by the Boston School, he represented, in the binary system of Ogunquit, the traditional and academic.

In 1911, on the other side of Perkins Cove, Hamilton Easter Field, a painter and art critic from Brooklyn, had established another school of art. Field was ten years younger than Woodbury, tall and dark-haired, Byronic in appearance, bohemian by temperament, and said to be homosexual. Educated at Harvard and at the Columbia School of Architecture, he went in the late 1890s to Paris, where he stayed for several years, studying painting at the Accademia Collarossi. Paris exposed him to the beginnings of Cubism, and he returned to America ready to put his inheritance to the service of Modernism. He supported individual artists financially, and before long Perkins Cove lured them north. Field ran his school with the sculptor Robert Laurent and settled his students in converted shacks, cheek by jowl with artists who would become great American Modernists—Marsden Hartley, Gaston Lachaise, and Stuart Davis among them.

While Woodbury encouraged painting outdoors from nature, Field hired models, who posed nude in fishing shacks or, to the delight of the fishermen, on rocks at the far end of the cove. Woodbury's young women worked to render nature "as it seemed," and Field's young men, influenced by Europe, distorted the coastline to suit their avant-garde ardor. Parents like Margarett's trusted Woodbury to protect their daughters, but Field, citing Monet's peasant sabots at Giverny, exhorted his students to mix with the fishermen at Perkins Cove. Once, on a dare, a European countess, posing nude for Field's class, grabbed a kimono, ran across the footbridge, and flung herself naked on the steps of Woodbury's studio, but there is no record of a virginal wayfarer crossing the bridge in the other direction.

Realistically, though, the bridge was passable and the distance between Woodbury's studio and Field's shacks a mere hundred yards. Some of Field's students regularly attended Woodbury's classes, and the Ogunquit beach welcomed artists of both persuasions. It is altogether possible that the Boston girl who met Mr. Ringling in Florence managed to meet some of the artists who worked with Field. The summers Margarett was in Ogunquit, Walt Kuhn, George Bellows, and Robert Henri were in residence, and the summer of 1916, she took her

meals at Eva Perkins's boardinghouse, where many artists, including the young Josephine Nivison and her future husband, Edward Hopper, ate desserts piled high with whipped cream.

"Good-lookin'," was how Phyllis Ramsdell Eaton, aged eighty, described Margarett as she was in 1915. "Tall, slender. She wore very nice clothes." Phyllis was a child then, and her mother cleaned the shingled studio Margarett rented behind the Riverside Inn. Each cottage had a kerosene stove, a hot-water heater run on kerosene, an icebox that held one block of ice, and a small bed, and each day Lizzie Ramsdell tidied up, dusted, swept, and did the laundry. At the end of the summer, Margarett was so grateful she gave Mrs. Ramsdell a gold bangle.

On weekends, the rich whose grand houses lined the sea north from York gave parties, but during the week, there were cultural activities. Thursday evenings, Hamilton Field sponsored the Thurnscoe Forum, meetings held "for the open discussion of art, music, literature and kindred subjects," where questions addressed ranged from "Which is better fitted to express the emotions of our modern world, music or painting?" to "Has William Dean Howells contributed to American Literature anything which will be valued a century hence?" At the Village Studio, there were musicales and lectures by Nathan Dole or the humorist John Kendrick Bangs, owner of the newspaper in neighboring York, whom a local reporter called "the generator of more hearty, healthful, purely good-humored laughs than any other half-dozen men of our country today."

Margarett had brought Pilgrim to Ogunquit, and in no time at all, she met Libby Burgess, a giggly, chubby fellow art student who lived with a whippet named Covey in another Riverside studio. Class was held in the morning, so if Margarett and Libby weren't painting, they could play tennis at the Sparhawk, take tea at the Whistling Oyster, or shop in town for what a guidebook called "rich and expensive importation of all kinds."

If they took their dogs to walk on Pine Hill, they were apt to en-

counter Gertrude Fiske and Boy, her Boston bull terrier, whose bronze
portrait Bashka Paeff had exhibited in Boston that spring. Like Amy
Cabot and Charlotte Butler, two painters who lived together across from
the Ramsdells, Gertrude was one of the "Pine Hill Girls," former vir-
ginal wayfarers who, after many summers painting with Woodbury,
bought houses on the hill where the trolley ran above town, forming a
community around the Woodbury School. It must have heartened Mar-
garett to work among women who had committed themselves to art
over marriage, and who welcomed and supported younger women.

Margarett was one of between seventy and a hundred students at
the Woodbury School that summer. They came from New York, from
Boston as she did, and from as far away as Chicago, Saint Louis, and
the West. Woodbury always wore a starched collar and a necktie under
a gray smock, and an old battered hat. As he lectured, he chain-smoked,
the gold rims of his spectacles glinting in the sun, and his class, young
women in large hats, shading themselves with umbrellas, and a few
young men in shirtsleeves, leaned against the fish shacks, straining to
hear every word.

Woodbury's first lecture of the season concerned the impact of the
new movements in art. "The divergence of opinion is so great," he
said, "as to make it possible for a picture to be held up by one person
as an absolute masterpiece, and by another an unforgivable atrocity."
In just a few years, Margarett would be a convert to Modernism, exco-
riating as "a dreadful picture" *El Jaleo*, John Singer Sargent's auda-
cious panorama of a flamenco dancer, a jewel of Isabella Gardner's
collection. Woodbury cautioned his students against such extremism,
warning that the "futurists" would "throw away all tradition and man-
ufacture something new." He advocated a quiet middle course: "It
would not seem likely we should need to sweep away everything that
has been done before . . . we still must use it."

To make the first assignment, Woodbury placed several paintings
of the same tree on an easel to demonstrate how land, sky, and sea—
in the manner of Monet's haystacks—changed color as light moved
through the day. "I will say then that a picture is a sensation of emotion

expressed in terms of nature," he said, and directed his students to make nine sketches of a single scene under varying conditions. Each sketch was not to take more than half an hour, and when looked at together, the series should demonstrate continuous change, however slight.

On Saturday mornings, each student placed her series on racks set up by the cove, and Woodbury inspected the work, criticizing gently in order to encourage improvement. Each subsequent assignment built on the previous week. "You will always find color interesting," he told them. "Light and form may not be, but color is." Woodbury repeatedly emphasized that his words should not take the place of experience with paint. "I am not trying to teach you to paint," he said. "I am trying to teach you to think pictures, with the hope that some day you may paint them." Whatever Woodbury taught, Margarett could see in his tempestuous and rather startling oceanscapes what happened when an artist worked directly from feeling, feeling that without the discipline of art might have proved overwhelming. His was an example she would put to use when she began to paint ten years later.

At the end of the summer, Margarett sent home her boxes of canvases, brushes, and paints, and though Woodbury advised his students to keep their summer's work for reference, no specimens document what she produced in his classes. What survived from that summer were four works by Charles Woodbury: a woodcut of porpoises, an etching of two men in a boat, and two portraits of Margarett. One was called *Portrait of Miss Sargent.* The other, a lithograph—*Artist (Miss Sargent) Painting on a Bluff*—shows her at a windswept distance, a virginal wayfarer poised at an easel high above the sea, somewhere along the Marginal Way.

IN OGUNQUIT during the summer of 1916, Margarett began to leave behind the Boston of Shaw McKean. Grace Allen, whom she had known slightly at Miss Porter's, had married George Peabody of New York in 1911. Now the mother of two small sons, she was a divorcée who wrote on stationery engraved "Mrs. Grace Allen Peabody" and

the mistress of a large house on the ocean in York Harbor, just south of Ogunquit. There she entertained her contemporaries, young people drawn to Maine not only by its beauty but by the atmosphere of bohemian excitement around its art colonies.

Margarett had never liked Grace, of whom Archibald MacLeish wrote that summer, "Lily, red wool lily, / Flaunting fairy lily." It was precisely Grace's "flaunting" that had provoked Margarett's disapproval when they met at Farmington and Grace "kicked her legs, and behaved altogether like a chorus girl on a spree." Now Margarett was attracted by Grace's experience with men and by the interest in ancient Greece she held to with such passion that her friends called her "Helen of Troy." Grace looked like a goddess—dark-blond hair tumbling down her back in curls, skin that turned tawny in the sun, and a classically beautiful face.

At a party at Grace's late that August, Margarett met Frank Bangs, an English teacher at St. Paul's School in New Hampshire. He was immediately "fascinated." Margarett was curious. Unlike many of the young men she was used to, who talked about sports, cards, or dogs, Frank was literary. Not only did he read books, he talked about them. He had wit and was born to using it—his father was the humorist John Kendrick Bangs. He called Margarett "Sargent" and insisted she call him "Bangs." He saw her as an artist and understood what she meant when she told him she was resting her eyes by doing watercolor that summer rather than sculpture.

After a small party Margarett gave at her studio, it was Bangs she invited to stay behind. She shortened Shaw McKean's planned weekend visit to a few hours Sunday afternoon. Frank hardly left her side the rest of her stay in Ogunquit. When Margarett left, he was in love, and his letters, literary and self-conscious, followed her home. "Why should you distrust the bronze strength I send you?" he wrote, and she responded, "O my brazen prophet . . ."

Bangs was not the only person in love when Margarett left Maine. On her way back home from Ogunquit, she spent the night at Grace's in York, and there had a reunion with another friend from Miss Porter's. Marjorie Davenport had not seen Margarett since her dowdy Farm-

ington days and was stunned at the transformation. "She was marvelously dressed, and she had fifteen million bags. Why I thought she was the most exciting thing I had ever known!"

Margarett was also pleased. She planned to rent a house the next summer in Ogunquit, and Marjorie was a companion of whom her parents would approve. Marjorie also had domestic talents. She made her own beautiful clothes, and she could cook. Margarett extended the invitation, and Marjorie accepted. "This glorious person wanted to spend a summer with me!" When Margarett left York Harbor in her parents' chauffeured car, wearing a yellow linen dress, Marjorie yearned after her. "You don't know when your life takes a sudden direction," she said, "and mine took one which went on for many years when Margarett spent that night at Grace's."

Margarett also had plans to see Grace again, and soon after she returned to Wellesley, Grace wrote: "I can't see a Green Sea-Bus without longing to set sail on one with you. The too few hours we spent together remain very vivid—" Margarett had invited her to Boston, but Grace hoped Margarett would return to Maine "for a few days of sanddunes and hours in which to tell you how deeply I feel your friendship which I can only hope to deserve in the future." Margarett was interested in Grace's knowledge of the classics. She planned a sculpture of the goddess Diana, and she had asked Grace to do some research. Grace relished the opportunity to respond: "I send you a few lines on the Keen-Sighted, Untouched, Fair-tressed Artemis—Diana Huntress of Men and Stags," she wrote. "Curious you should turn to the Goddess so very like yourself in many ways. . . . This divine creature surpassed all in strength—beauty of courage and activity—I think she loved women because she gave them gentle and painless deaths."

Margarett accepted Grace's invitation and during her visit photographed her hostess as Diana and in the results seemed to return her hostess's erotic admiration. Her eyes took in Grace's statuesque beauty, her long limbs, studied her profile and cheekbones. Grace, contemplative, rested on a rock, and Margarett photographed her in profile, legs bare to the hip, the sea beyond. Grace stood in her garden, Greek-style

chiton flowing, and Margarett photographed her fingering the late-summer hollyhock, which towered above her considerable well-proportioned height. They talked of their mutual friend Bangs and of his friend Archie MacLeish, who had flattered Grace with the "flaunting lily" poem when he visited Bangs in July.

When Bangs visited Margarett at Wellesley in October, he was eager to have her meet his poet friend. Ever since their years together at Yale, where they shared their passion for poetry, he had delighted in startling Archie with introductions to extraordinary women. Now Bangs looked forward to his friend's reaction to "what he deemed a marvel," as he put it in his diary. Margarett played the part with gusto when she and Bangs had lunch with MacLeish and his new wife, Ada, at the Hotel Touraine in Boston. Archie was suitably impressed.

But when he and Ada met Margarett alone, MacLeish was a bit put off: "One doesn't tell a lady he admires that her personality is a brazen trumpet about Jericho—be Jericho a city walled or not." Later, they met without Ada, and afterward Margarett wrote Bangs with wild enthusiasm. She was enchanted by the beauty that came into Archie's face when he read and the expressiveness with which he moved his hands. He'd read aloud poems by others, but she was thrilled when he read her something of his own. "She is all you claim for her," Archie wrote Bangs, enclosing a poem to Margarett, which, he said, "I dare not show her for fear of annihilation."

When "The 'Chantress" later appeared in MacLeish's first book, he removed one of Margarett's two *t*'s, but when Bangs sent it along to Margarett, in November 1916, her name had two *t*'s and its subject was evident and undisguised:

> Lo, the Lady Margarett
> Spreadeth beauty for a net,
> Springeth souls thereby
> Springeth souls to light her clay.

Margarett was delighted, and when Archie sought her out to read the poem to her, she watched and listened, never letting on she had

already seen it: "Cunningly her fingers fret / Witcheries in clay," he intoned. "Her dark hair is springes set, / Her two hands a spell. / Whom she tangleth, him they bind," and so on. Margarett wrote Bangs that Archie "never would have known I knew aught of it," but she was lying. After MacLeish, with excruciating self-consciousness, read her the poem, Margarett told him she had previously read it. He was devastated. His proud reading voice shattered into stammers of embarrassment. Margarett wrote Bangs, "Did he fear our dual laughter?"

In spite of Archie's reaction that day, Margarett became, to Bangs's satisfaction, "a considerable stimulus to MacLeish's poetic faculties." In early spring, when he imagined Helen for "Our Lady of Troy," a dramatic poem inspired by Faust, it was Margarett he conjured naked on the hearth, her limbs that shone "like silver in the light."

> Lo! I am she ye seek in every maid
> Ye love and leave again. I am desire
> Of woman that no man may slake in women.
> This thing am I,—a rose the world has dreamed.

Bangs was astonished at the success of his introduction. In May, he received a sonnet after MacLeish encountered Margarett at a wedding:

> . . . she sat, self-mimicking,
> The center of her inward-looking world,
> And costumed her, and tuned her mood, and curled
> The cap-plumes of her soul, and strummed a string.
> Her words were swift as swallows in a gale—
> Darted and flashed and poised, and then in flight
> Essayed the sun, and then vanished quite
> In some perplexing eddy . . .

"Sargent, that Archibald should be casting such lines your way is beyond my comprehension," Bangs wrote jealously, while denying knowledge of any "personal relations" between his friend and his beloved. "I could shriek but instead in half an hour I shall pull an oar in the rowing tank." For MacLeish, Margarett remained safely a muse,

but Bangs lacked the shields of poetry and wedlock. He was in love and wished actually to do what his friend, he assumed, only imagined, "To wind her tresses this way 'bout the thumb, / or twist the heavy thunder of her hair. . . ."

Archie didn't trust Margarett's intentions toward Bangs, and he feared for his friend. He was not alone. Bangs took Margarett to dinner with his former Yale instructor, Lawrence Mason, and Margarett folded a dinner napkin on her head like a wimple and impersonated a nun. It was a trick that always made her family roar with laughter. Mason, who taught English literature, was reminded of all "the great Nun-passages in Milton" and wrote Bangs that Margarett's performance had been "one of the great triumphs of the American stage."

But he found her terrifying, comparing her to the audacious heroine of George Meredith's *Modern Love*. "She does indeed bear out all your preposterous praise," he wrote, "BUT is there anything sacred to her? Has she a soul? The transfiguring life-force that so wonderfully streams through her is like so much meaningless electricity unless there be a higher sanction." Bangs himself found Margarett "always extraordinarily simple and direct." He did not tell Mason that on June 25, 1917, at midnight, he had proposed marriage, and that she declined: "Maybe after the war."

The draft was passed on May 18, 1917, and in late July, MacLeish and Bangs enlisted in the Yale Mobile Hospital Unit in New Haven and sailed on the SS *Baltic* for France. One night, they leaned over the rail, peering out into the utter darkness of the submarine zone. Later, in his cabin, Archie wrote a poem with, he wrote Bangs, thoughts of Margarett and his wife:

> Like moon-dark, like brown water you escape
> O laughing mouth, O sweet uplighted lips.
> Within the peering brain old ghosts take shape
> You flame and wither as the white foam slips
> Back from the broken wave. . . .

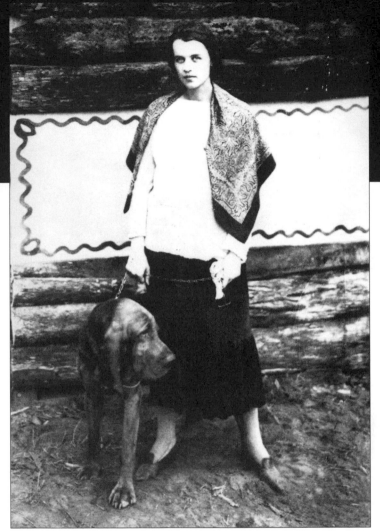

iv

The White Blackbird

(1917–1919)

Margarett at Borgland, 1918

"WAR HAS BEGUN," was the *Transcript*'s laconic lead headline on Friday evening, April 6, 1917. The young men of Margarett's circle acted quickly. Eddie Morgan, who had already passed competitive civilian exams and earned a commission of second lieutenant, sailed immediately for France. E. Ames's brothers, Oliver and Dickie, enlisted, and before she saw them off, Marian McKean sent her sons, Shaw and Harry, to John Singer Sargent's studio at the Copley Plaza to sit in uniform for charcoal portraits. Harry Sargent passed officer training at Plattsburgh and sailed for France at the end of August, and Dan, who had been fighting in North Africa for the French, returned to Paris to receive a commission of second lieutenant in the American infantry.

Only Margarett's oldest brother, Frank, remained at home. In 1914, at thirty years old, he'd finally married. Margery Lee was the dark-haired granddaughter of an equerry to the king of Italy; the daughter of George Lee, a Bostonian yachtsman, steeplechaser, and painter; and widely considered "the most beautiful girl in Boston." But marriage did not calm Frank's temperament; once, after Sunday lunch at the Cheevers', the newlyweds bolted the table and retired for an hour to a guest room upstairs.

Frank had married for love, but he timed the wedding to avoid the draft. Only as the country turned toward war and he read Dan's account of heroism at Verdun was he inspired to fight. At the end of his officer training stint at Harvard the summer of 1918, he stood expectantly as the names of those commissioned were announced and, when

his was not among them, fell to the ground in a dead faint. The training officer found him "over-intense," Dan later said; his barrage of questions, his brilliant and unbridled talk, had seemed evidence of "nervousness." The army offered a commission in the quartermaster corps, but Frank proudly refused and gamely enlisted as a private. It was good this way, he told himself; he'd be a better officer, having suffered the "hard knocks" of rising through the ranks.

But his failure was a bitter comedown. His career at Harvard and in sports, his marriage to Margery, his precocious achievement in business, all paled beside the military stature of his younger brothers. His sister Jane advised him to conceal that he'd been denied a commission, and he assured her he'd be discreet. "I've never lost *faith* in myself," he wrote her in a determinedly upbeat letter. But he must have felt he failed his father; although Papa would not have reproached him directly, he was no longer the family's golden hero. "I hate to think of them going to the front," Papa wrote to Margarett about Harry and Dan, "but if they had turned out slackers I should have been a very unhappy man."

As families disguised their anxiety in the bright trappings of patriotism, the rituals of betrothal and marriage were displaced by the ministrations of leavetaking, letters from the front, photographs of young men in uniform, newspaper casualty lists. In the face of the real danger to the boys in combat, everything at home seemed temporary. To those left behind, the dislocations of war extended a freedom that would not have been allowed in peaceful times. For Margarett, this suspension of social and domestic life was an opportunity.

Her sculpture career was already flourishing. In October 1916, a form postcard had arrived at her studio from the Art Institute of Chicago: "Dear Sir," it addressed Margarett, "I have the pleasure of informing you that the following works have been accepted for exhibition." The sculpture jury, all sculptors of national reputation, had chosen *The Cheever Boys* and *Outdoors: A Sketch* (now lost) for the institute's annual in November.

The Twenty-ninth Annual Exhibition of American Oil Painting and Sculpture of the Art Institute of Chicago was the first public display of Margarett's work. Since it opened the museum's new wing and was joined by a sculpture show organized by the National Sculpture Society, hailed as "the most comprehensive and remarkable ever shown in America," it was not a mere annual. Margarett's pieces stood among seven hundred by two hundred of the most prominent contemporary American sculptors, more than sixty of them women. "It's all there," commented the *Chicago Herald*, "busts, animals, Indians, Greeks, Egyptians, cowboys and lovers."

In the months before America entered the war, Margarett was absorbed in her work. She stayed long hours in her studio, making portraits and "statuettes" on commission to earn her own money. She advertised herself among her family and family friends. Portraits of animals and children sold easily, so she made a lot of them. She worked in the traditional way, constructing an armature, sculpting in clay, refining a plaster, then having the piece cast at a foundry. Each season, she had her pieces photographed and submitted them to annuals. In March 1917, at the age of twenty-five, she exhibited the bust of Dan and a work called *Bronze* at the 92nd Annual Exhibition of the National Academy of Design in New York.

It was the mother of her childhood friends the "Salts" who recommended Margarett's next teacher, Gutzon Borglum, later the sculptor of Mount Rushmore. Mrs. Saltonstall's friend Joseph Lindon Smith, a Boston muralist and painter, had been impressed with Borglum's instruction of his son, and arranged an introduction. Margarett had learned all she could from Bashka Paeff, and the idea of leaving Boston was exciting. Borglum was a hardworking artist with two studios, in New York and in Connecticut. Margarett would work at the country studio, where he undertook his largest pieces, commissions for public sculptures all over the country.

Gutzon Borglum was an ambitious man, to his own mind a visionary. It was hard to miss him in the newspapers. Recently it had been reported that the Daughters of the Confederacy had commissioned

him to carve a Civil War memorial into the bare face of Stone Mountain near Atlanta. The Daughters had in mind an equestrian relief of General Lee, but Borglum offered a grander proposal: Lee on horseback, leading a full regiment across the virgin granite expanse.

He did nothing uncontentiously. He joined the Association of American Painters and Sculptors because he shared their rage at the strictures of the National Academy of Design, but when their plans for the Armory Show expanded to include works from the European avant-garde and it became clear that Modernism's "personal note distinctly sounded" had prevailed, he withdrew his work, resigned as chair of the sculpture committee, and raucously took his case to the press: "we wish Mr. Borglum walked to the battlefield upon ankles not quite so thick," remarked the *New York Globe*.

It had taken the force of pure ambition for John de la Mothe Gutzon Borglum to emerge from the Mormon household where he was born on the Idaho frontier in 1867, the first son of the second of his father's sister wives. At twenty he went to San Francisco, and at twenty-two married his painting teacher, Lisa Putnam, who was forty and a working artist. A painting of a stagecoach drawn by six horses hurtling down a Sierra chasm attracted his first patron, Jessie Benton Frémont, the brilliant wife of the explorer John Charles Frémont. When Lisa, eager to civilize her young husband, planned a trip to Europe, Mrs. Frémont provided letters of introduction.

In London, Gutzon painted portraits of patrons his wife cultivated with lavish entertaining—at one party, a young Isadora Duncan, scattering rose petals, danced "out into the garden." But his frontier ambition soon chafed at the civilized British life Lisa encouraged, and he turned from painting to sculpture and exhibited at the Paris Salon. When his younger brother Solon triumphed as a sculptor of the great American West at the 1900 Paris Exposition, Gutzon walked out on Lisa and sailed alone for America. On shipboard, he met Mary Montgomery, twenty-four years old, who had just earned a doctorate in Sanskrit from the University of Berlin. Eventually she became his second wife.

Brazen with self-righteousness, Gutzon Borglum assaulted the civilized gates of the New York art world. When Augustus Saint-Gaudens threw his entry out of competition for an equestrian sculpture of General Grant, Borglum took revenge in a tirade published in Gustave Stickley's *The Craftsman*. He would liberate his work from "the top-notch of mediocrity" to which this vaunted artist, in his opinion a mere "workman," had brought American sculpture. It was Saint-Gaudens's influence, with its smooth and careful surfaces, that Bashka Paeff had passed on to Margarett. Borglum, who had met Rodin in Paris, believed expression of America's "unsatisfied hunger" required sculpture with a raw, gestural surface. Given ten million dollars, he would dynamite all the public memorials in the United States and set about erecting his own Washington monument, his own Lincoln memorial. Then he would endow a real art school: "There is no such institution in America."

It was to Borgland, Borglum's estate and studio at Turn of River, Connecticut, rather than to Ogunquit, that Margarett invited Marjorie Davenport for the summer of 1917. Six years earlier, joining "the search for country homes by city men," Borglum had purchased land to create an "estate" near his brother Solon's home in the Wire Mills district, near Stamford. Margarett was his only pupil that summer. Gutzon had taught at the Art Students League in New York, but he preferred informal arrangements, usually with young women from prominent families. In lieu of tuition, Margarett bought him a gold cigarette case which she charged at Cartier: "My name is Margarett Sargent, and I come from Turn of River," she told the clerk by way of identification.

At Borgland, Margarett found a paradise—wild orchids, a lake stocked with trout, a canoe from which her host fished with a barbless fly: "Oh no," he explained, "I do not catch them. I only play with them." Nor was one permitted to pick the wildflowers. Borgland was that "most sacred recess in the life of human beings," a haven for the hungry creative soul. Gutzon and Mary and their two children lived in

a renovated farmhouse, but his studio was a distance away, on the other side of the river, so he could ride his horse to work. Built of pink granite mined from its site by Italian stonecutters who camped there, the vaulted studio was heated with ten-foot logs cut from Borgland's forests, which burned in a looming Gothic fireplace of Gutzon's design. Outside, the Rippowam River ran so swiftly its roar penetrated the granite walls.

Margarett brought Pilgrim to Borgland, and eventually she kept birds—a parrot and a crow. Relieved of the suits and dresses required in Boston, she wore long loose skirts, pullovers, a scarf around her shoulders. She and Marjorie shared a small outbuilding near the studio. Marjorie took charge of the household, as Margarett had hoped she would. She did the mending and, when they didn't eat with the Borglums, the cooking. On summer days, they swam in a pool gouged from the river, with Mr. Borglum, as they called him, and his children.

In the studio, Margarett measured contours— "Through the neck 7 one degree—under ears, chin to eyebrow 10 one degree," she noted on a drawing. Each day she pulled muslin tarpaulins from sculptures and sprayed them with water to keep them wet and workable. She worked sections of Borglum's pieces under his direction, and she worked in the office. In exchange, he gave her suggestions and criticized her sculpture. For *The Spirit of Aviation,* a memorial to the first American flier killed in the war, Gutzon had hired a model with flat feet, so Margarett posed for the feet. "You can see it," she would say later, "if you go to the University of Virginia."

At first, Margarett was in thrall to Borglum's charisma and the "vision" to which he held with religious zeal. His masculinity had the roughness of the West, his courtliness the veneer of Europe. He had technique and discipline, and he insisted she measure up. In the beginning, Margarett thrived. It didn't occur to her that his assignments condescended to the skill she'd already achieved; he was the master. She didn't mind that he was volatile, that his criticism was pompous and his praise patronizing. When he ranted about his debts, she talked her father into buying his sculpture. When he told her to make sculp-

tures of animals, she did. Borglum, in turn, found his apprentice talented and attractive. "He was crazy about her," Marjorie said. "He thought she was glamorous." As time went on, Margarett would see Borglum in a harsher light. "Those three years were a horror," she said, "but I didn't know it at the time."

In fair weather, Margarett worked on her own pieces outside the studio, its enormous door propped open with a chunk of granite. Behind her, in Borglum's workroom, huge animal figures stood in the half-dark. In a photograph of Margarett working, a sculpture of Pilgrim sits looking down as if at his reflection, and Margarett, Pilgrim himself jumping up on her, models his head and front legs. His rear haunches are still an undefined mass of clay, and she works his right shoulder with no instrument but her long fingers, his other side with a scraping tool.

Margarett made three sculptures of Pilgrim, sculpted the Borglum children, forced Marjorie to pose for hours: "She seemed to think I was Oriental-looking," remarked Marjorie. And she sculpted her birds. Two parrots were accepted for the 1918 Pennsylvania Academy Annual. Margarett and Marjorie had expected to leave Connecticut at the end of the summer of 1917, but instead they stayed on. In the winter, they moved, as the Borglums did, to New York, where Margarett continued her apprenticeship in Gutzon's city studio. Early in the spring, she and Marjorie moved back to Borgland, where things had changed dramatically.

A granite worker had won Mary Borglum to the cause of Czechoslovak unification, and Gutzon, with typical grandiosity, donated a hundred fifty acres at Borgland as a training camp. In Europe, thousands of young Czechs and Slovaks had risked execution by deserting the Austro-Hungarian Army for the Allies; their recent heroism at the pivotal battle for Vladivostok had inspired support for their cause. In America, Czech and Slovak immigrants clamored to join up, and soon young men poured into Borgland from Pittsburgh steel mills, Detroit factories, and Omaha farms. They cleared a parade ground through the woods, converted an outbuilding to a hospital, built log barracks,

which they whitewashed and painted with bright folk patterns. Each week, a hundred volunteers passed through the camp, and by late August two regiments had sailed for France.

Gutzon was devoted to the Czechoslovak cause, but he was infuriated by the wild behavior of its young recruits. Where was their discipline? How would the cause be won if its soldiers could not fight? He wrote letters of protest to Tomáš Masaryk, who came to Borgland and exhorted his followers from a platform festooned with stars and stripes, but the camp got no calmer. Spanish flu raged, and killed four volunteers. Marjorie contracted it, and the Sargents called Margarett home for a vaccination. Futilely, Gutzon wrote begging Masaryk to finance provisions, and the Borglums fed the volunteers with their own money. Margarett and Marjorie loved the carousing and singing they heard at night, the sergeant's commands echoing through the forest during the day. Very soon Margarett had young men in uniform sitting for portraits and amorous officers competing for her attention.

Word of the camp attracted notice in New York and, at the height of the summer, brought to Turn of River an artist who would profoundly change Margarett's life. George Luks was Borglum's contemporary, an icon in American art, and a celebrity. He was the most flamboyant of "the Eight," the group of artists whose 1908 show had rebuked with "new art realism" what Luks called "the pink and white painters," the American Impressionists led by Edmund Tarbell and the New Yorker William Merritt Chase. Luks had as much fame and as much energy as Gutzon, but he also had charm and a sense of humor, qualities Borglum utterly lacked. He dressed Mary Borglum in Moravian costume to paint her, persuaded an officer to sit for a painting he titled *Czechoslovak Chieftain*, and, after listening to officers tell stories from the Russian front, painted *Czechoslovak Army Entering Vladivostok*. Margarett asked him to sit for her and began to model his head.

At fifty-one, George Luks was a robust, compactly built man of five feet six, with twinkly blue eyes and fading blond hair. Like Margarett's father, he was an amateur boxer, but with what she later called "the dangerous habit of insulting people in bars." Like Frank Sargent,

he might burst into song—he sang while he painted—and could enthrall with a story. Margarett adored him, and he was struck by her insurgent spirit. As he watched her, he set about encouraging that quality in her sculpture. Go ahead, he told her, get your *self* into the texture of that surface. She should throw away her sculptor's tools and attack the clay with "any odd kitchen implement." He arrived in time, Margarett said, "to protect me from the grandiloquence of Borglum's work." Luks was to become her close friend, her mentor, and her most important influence.

One Sunday at the end of the summer, the Borglums arranged a pageant to benefit the camp. The volunteers built thatched huts, and citizens of Stamford, dressed as Bohemian villagers, arrived to inhabit them. Guests came from New York, including Louisine Havemeyer, the collector, suffragist, and intimate friend of Mary Cassatt. Gutzon, Margarett, and Luks dressed as peasant artists and wandered the "village" peddling cartoons and drawings "that would not," a newspaper said, "be termed pro-Teuton." In a dramatic sketch she wrote, Margarett portrayed "in a thrilling manner" a Frenchwoman "robbed by the Huns of all that was dear to her." Suddenly gunfire broke out. "Occupying Germans" had just managed to handcuff the artists, when soldiers, dressed in the horizon blue of independent Czechoslovakia, galloped down the hill, shouting that peace had been declared.

The camp celebrated with folk dancing and singing, Mrs. Havemeyer presented an American flag, and the artists auctioned off drawings and posters and raised fifteen hundred dollars. One of Margarett's sales was to Mrs. Havemeyer.

WHEN MARGARETT and Marjorie moved to New York for the winter of 1917, they lived together in an apartment on Forty-ninth Street near Madison Avenue. Their housekeeper, Jane Barnato, brought her monkey along to work, or her two parrots. Marjorie earned money by sewing, and Margarett went out to work at Borglum's studio on Thirty-eighth Street, where live models might include a buffalo, a Per-

sian dancer, or an Indian brave. Margarett and Marjorie had trans-
ferred their life together to New York, but the city soon threatened
their contentment.

Though Marjorie was Margarett's verbal and intellectual match,
she did not have Margarett's ambition. Nor did she have a career.
Margarett, with a talent for seduction Marjorie did not share, had al-
ways overshadowed her with men, and Marjorie watched her exploits
with a complicated mixture of delight, awe, envy, and horror. "I tell
you," Marjorie said, "she was so popular and men were so crazy about
her that one would make an appointment to meet her at the train,
then another one drive in the taxi with her to the apartment, then
she'd be having dinner with somebody else."

Marjorie was eighty-eight when she said this, dark-gray hair to her
shoulders, dressed for tea in a long red dress.

"Do you remember their names?"

"Yes, but they married. I don't know whether their families . . ."

"It was a long time ago."

"Well, there was a Harriman," she said, but she would not tell me
his first name.

For Margarett, the city was a new arena, and any constraint an echo
of her mother's infuriating worry. The limits of convention were hers to
scorn. Kay Saltonstall and her husband, Philip Weld, were now living
in New York. Margarett took a beau to their apartment for dinner and
scandalized her old friends by visibly holding his hand. Kay may have
been a great belle when they were coming out in Boston, but Mar-
garett, in her fashion, was the belle now. Hamilton Fish, determined to
marry her, wrote daily letters: meet me on that corner, at that restau-
rant. Shaw wrote from France, accommodating his dreams of wedded
bliss to her "independent—free life." Margarett did not respond.

Marjorie viewed her friend's admirers as hopeless victims, no match
for their predator. After a while, she also had compassion for them
and, though she disapproved of Margarett's behavior, took smug plea-
sure in the fact that it was she with whom Margarett had chosen to
live. In turn, Margarett, with intermittent warmth and extravagance,

included Marjorie in her success. The "miserable man" took them to Delmonico's. Everyone ordered a full dinner, and then Margarett, pretending the man had said something wrong, berated him, stood up, and announced that she and Marjorie were leaving.

"We hadn't had a bite to eat!" Marjorie said. "They must have brought the dinner and he must have paid for it."

When Marjorie criticized what she'd done, Margarett shut her up, full force, with the sarcasm she'd honed for years on her mother.

Marjorie was also jealous. She and Margarett shared a bed, and though nothing documents what they did there, Marjorie, at the end of her life, raged against Margarett with the fury of a thwarted lover. At its best, their friendship had the pleasures of a conspiracy, the two of them poised against a world with expectations of women neither intended to fulfill. At its worst, their relationship was unequal and exploitative. Margarett was the artist, Marjorie the admirer. Marjorie did the housework, Margarett paid the bills. Margarett got angry, Marjorie cowered. Anything might trip the spring: Marjorie sewing, Marjorie not sewing; Marjorie leaping with terror in the night as mice ran across their pillows. But Marjorie considered her years with Margarett "great days," days she would remember forever. Going home for Christmas with her widowed mother was, by contrast, "retiring to a quiet life."

In Margarett's last bedroom, a painting hung so that she could see it from the bed to which she was, by then, confined. It was her portrait as a young woman, which George Luks painted from memory in early 1919. If I turn from my desk now as I work, I can see the young woman, sitting in profile. Her pale hands are folded, disappearing into the black of her lap. She wears a dark hat, its swath of auburn feather trailing down her back. Her dark dress has a creamy collar and cuffs, daubed with salmon trim. Luks invented the clothes, he said, to make her look timeless.

Because of her black hair, her very light complexion, and the contradictions in her character, Luks called Margarett "The White Blackbird," and that is what he called the painting. The young woman's decorous pose contrasts with the low, open neck of her gown. The re-

straint of her expression belies the worldly rush of her life in New York and her racy reputation. In the warm whites of cheeks and chin, the dark of eyes steadily forward, mouth gently closed, Luks caught uncertainty and sadness, a vulnerability Margarett rarely revealed. Against the old-master darkness of the rest of the surface, the pale flesh of her neck and décolletage takes on the luminous shape of a white bird in moonlit flight.

At nearly twenty-four, Margarett knew the power of her looks. Frank Bangs wrote lyrically of "unusually light-blue eyes, a countenance pale as marble, and amazingly thick dark hair." She dressed to emphasize her height, her long neck, and her voluptuous figure, but childhood plainness had taught her that beauty was currency, and just as ephemeral. "My memories," wrote Archibald MacLeish of Margarett, "are of vividness—almost a glitter it was sometimes—and movement." She held her own in conversation, with what friends called "the Sargent gift for brilliant language." Out from under the sheen of elegant manners came the wit she'd honed to disarm her brothers into a collapse of laughter. If repartee didn't shock or charm, she performed. Once, at a party, to Gertrude Hunnewell's astonishment, she "accidentally on purpose popped out of a black velvet evening dress."

"Hundreds" of passionate letters Margarett received during this period were destroyed by her children. Many of her correspondents were friends or classmates of her brothers, Harvard boys on their way to managing inherited money or family property. Others she had met at parties in Newport or Long Island—New York boys of whom her mother disapproved simply because they were not from Boston. All of them were attracted by her beauty, enthralled by her talk, and drawn in by her seductiveness. "I know, Margarett darling, that I cannot do without you, & the only thing that has enabled me to leave you is the thought & hope of your being with me before so very long," wrote Oliver Harriman, en route to Mexico, from the Metropolitan Club in Washington. "I had a long dream about you the other night which was very encouraging if true," wrote "Freddy" from the University Club in

Portland, Oregon, begging her to write "a little more often." One unsigned letter set forth an island tryst:

> . . . just as the canoe touched the beach you ran down to meet
> me leaving the turtle soup to burn or boil over to its heart's
> content, and I am ashamed to say that you didn't have any
> clothes on at all . . . a big moon came up over the water and
> threw shafts of light among the trees. We very slowly awoke
> . . . our lips moved and our mouths met in a long kiss and our
> bodies stirred and came closer together and your hand stole
> down from my shoulder and touched an old friend and wakened him. . . .

Margarett's anonymous correspondent was not impertinent; he was responding to the sexuality that infused her speech, dress, and movement. What he could not have known, because she would not have told him, was what suffering intense feeling had always brought her. The cost of breaking her engagement had taught her to seek seduction without obligation, physical passion without loss of virginity, love without the consequence of marriage. Her desire for independence set her apart not only from the lives of most of her friends but from their understanding. It was this solitude that George Luks caught in his portrait, but it was not what most people saw. Betty Parsons met Margarett in 1919: "She had such magnetism, Margarett. Such physical magnetism plus that fantastic, witty brain. The combination was just devastating. You could see them being knocked down, right and left."

In the fall of 1919, Margarett and Marjorie moved to New York for good and settled into an apartment at 10 West 58th Street, across from the Plaza Hotel. Margarett continued to work for Borglum— "mentally I feel I have not lingered and my hands are better prepared," she wrote him. She was soon getting portrait commissions, charging for them, she quipped, "no more than a man would pay for a car." She also had the income from a trust, and she furnished the flat with en-

thusiasm, worrying her father with the amount of money she spent. Always, Dan said, she complained she was hard up. "She wouldn't buy potatoes, but she'd buy a wonderful rug." Margarett took a room with north light as a studio, and their pet rabbit had the run of it—"his . . . you know," Marjorie said, "got mixed with the clay." Downstairs, in a dark, sculpture-filled duplex, lived the Ziegfeld star Fanny Brice, with her husband, just back from prison, the tall, handsome gangster, of Norwegian descent, Jules Arnstein (called Nicky for the nickel-plated wheels of his motorcycle).

Margarett may have seen Brice perform in Boston in 1911 at the height of the rage for ragtime, singing "Ephraham Played Upon the Piano" in the *Ziegfeld Follies*. Now Fanny was at the peak of her career, headlining in Ziegfeld's *Nine O'Clock Review* and *Midnight Frolic*, cabaret shows that played in nightclub luxury on the roof of the New Amsterdam Theatre on Forty-second Street. At the Roof, Margarett saw Ziegfeld's best acts up close. Backed by thirty-six chorus girls, the black comedian Bert Williams sang, and Bird ("Bird on a Wire") Millman swung on his trapeze. Affecting a Yiddish accent, Fanny vamped "I'm Bad," slouching in tight black silk across the stage in an angular spoof of Theda Bara. Later in the show, dressed as an Apache squaw who unaccountably sang Yiddish, she hooted out a new number called "I'm an Indian."

After her shows, Fanny gave parties. For the first time in Margarett's life, a party was not an occasion to greet her parents' friends and relatives or a ritual assembly of boys in tails and girls in gowns. Even Grace Peabody's Maine gatherings paled beside the heady crowd at Fanny's, where at least one of Nicky's near-underworld cronies noticed a tall sculptress from Boston with blue eyes and elegant clothes. Ziegfeld girls and Broadway impresarios pressed up against Whitneys and Astors, and just across the room, where Margarett could easily meet them, mingled the people who made her laugh so hard when she saw them on the stage—Eddie Cantor, W. C. Fields, who had just made his first silent movie, and Bert Williams. Margarett learned at Fanny's that entertaining might be an occasion for invention, and

when she married and had her own household, she planned parties that surprised, even enlightened, with their mix of guests.

Margarett and Fanny encountered each other at a time and in an atmosphere where both their differences and their resemblances brought them together. Each had fled a childhood that predicted a destiny she would work hard to reject; each might have chosen the other's life to make up the deficits in her own. Margarett envied the romance of Fanny's nomadic youth in the saloons her mother ran in Brooklyn and Newark, the freedom of a girlhood on city streets, the blaze of theatrical triumph. Fanny envied Margarett's education, the luxurious security of her Boston girlhood, her beauty and her glamour. As interested in art as Margarett was in theater, she drew and painted a little herself. She knew she was funny, but she had no sense that she was attractive; later, she would bob her nose to play down the appearance she believed kept her from serious acting roles. She had a long, lanky figure, beautiful skin, dark hair, lively green eyes, looks that lit up with extraordinary vitality and warmth. Like Margarett, she was mercurial, an extrovert who was terribly shy, a courteous woman who shocked with her candor.

Margarett was twenty-six and Fanny twenty-seven when they met, so theirs was the friendship of young women. Margarett and Marjorie went eagerly to Milgrim's, a dress shop in which Fanny had invested, and Fanny slept on their sofa when she lost her keys and came upstairs to talk the nights and days Nicky Arnstein disappeared. Margarett and Marjorie were intrigued that Nicky was an actual gambler, and they thought him devastating. He gave Margarett one of his monogrammed silk shirts to use as a smock. As far as Fanny was concerned, Nicky could do no wrong; when he was arrested for fraud in 1916, she sold her jewels to pay his lawyers. "He was elegant—very swell," Marjorie said. "How he must have hated prison."

IN MARGARETT'S STUDIO, a damp cloth drapes a head to keep the clay damp. Under the towel, her sculpture of a woman's head is erect, the

profile definite. The trace of fingers has given the eyes vitality without detail of iris, pupil, or sclera. Under another cloth, the portrait head of an old man: For wrinkles, Margarett has delicately creased the clay near his eyes, and the eyes, rough suggestions, directly fix one's gaze. She's kept the clay very wet, so the hair near his ear is not heavy or inert but lifted and light. She is no longer smoothing surfaces until texture disappears.

Margarett takes a fistful of clay and presses it to an armature made of wire and wood. The soldier sits on a chair. In the structure of the armature is the beginning of her idea of what he looks like. Perhaps, as she works, they make conversation. This is the first of a number of sittings or the only sitting. It goes on for hours or until she has something of his shape. A plain but handsome face. How will she communicate the light color of his hair? She shoves the clay to resemble his face, moves the head—as if holding a living face in her hands—to position it on the neck.

Soon it doesn't matter if he is sitting there or has gone. Something had taken hold. Margarett has looked at heads on necks, and she has looked at soldiers. She has loved her brothers and her brothers' friends, and she has watched them in uniform. As the clay softens in her hands, the experience of looking becomes knowledge of the soldier's form. Now she pulls that knowledge through the clay, which, as long as it stays soft, has the pliancy of flesh. She works outside thought, or thought enters the motion of her hands. The soldier will look the way she believes he looks, and as her fingers move, a face will emerge, a face that does not change. The work is long, but the clay returns her effort. When she has finished, she has no idea how tired she is.

Later, the soldier stands, his portrait beside him on a sculpture stand. Margarett photographs the sculpture in profile and the soldier in profile just behind it: a double image. The portrait's hair has texture; the soldier's is smooth, as if slicked down to pass an inspection. The portrait's mouth seems resigned, the soldier's mouth weak. The curve of his ear is smooth; she's modeled it rough. The roughness will catch the light when the portrait is cast in bronze, and the light will catch the eye.

On September 26, Margarett delivered a sculpture to the Roman Bronze Works, a foundry in Long Island City. The woman's head was small enough to hold in her hand; with it, she sacrificed precision for emotion, restraint for abandon. Thick locks of hair snake and entangle, seeming to take mysterious shape—a figure, almost, a bacchante in motion. The woman's head is thrown back, her neck long and bare. Her eyes are closed, her mouth is partly open, breaking the surface of a stormy face. This head is too intimate to be a portrait. Margarett called her Hagar, for Abraham's concubine.

Margarett's hand loosened under the influence of George Luks, and it showed in a portrait of him she finished in late 1918. As with Hagar, she expressed her personal sense of a moment—a surge of feeling for a man she loved as she loved her father. Life-size, Luks rises from a swirl of clay—an impression of shirt, balding head, slightly smiling face. He had been still, it seemed, for barely a moment, but his character came across with more expression than the soldier's, more clarity than Hagar's. In the spring of 1919, after the Pennsylvania Academy accepted the head for its annual, Margarett heard from her father: "I am glad you have been successful with Mr. Luks's head, and although I have never seen him I should like to see photographs of it."

Luks was pleased as well. "Get *Town and Country*," he scrawled, and jammed the note into a small envelope; "the March 10th issue has something in it that may interest you." He had helped a photograph of the portrait make its way into the magazine. "Miss Sargent still has been unusually deft-fingered in catching the flexibility of Luks's Old Master mouth and unquenchable enthusiasm," read the accompanying review, Margarett's first critical praise. To the reviewer, Luks's friend Frederick James Gregg of the *New York Herald*, the head suggested "a cross between a bookmaker and a trainer of successful prizefighters." It might have been "carried further," but it was certainly, he wrote, "a refutation of the theory that nobody ought to pay attention to the work of a woman sculptor."

Luks drew Margarett into his New York world of painters and hard drinkers. She was mesmerized. He did not condescend, and he

made her laugh with a combination of melodramatic humor and language so obscene even his most progressive friends censored it when they wrote about him. No Boston painter would have attempted to settle an aesthetic difference like Luks did when he punched Edmund Tarbell in the jaw. His excess of vitality mirrored and encouraged Margarett's own. "The eye was made to see; the hand to paint; the nose to smell good food, the earth after rain and the pushcarts of the East Side," he proclaimed.

When asked about her training, Margarett said, "I had the good fortune to become the lone and solitary pupil of George Luks." In the winter of 1917, she'd entered the women's modeling class at the Art Students League, taught by Robert Aitken, famous at the time for memorials to President McKinley. She quickly left, finding, as Luks had, that formal study tried her patience. Luks claimed he learned to paint looking at works by those he considered great—Rembrandt, Hals, Velázquez—and he taught by a combination of anecdote and exhortation: "Don't tell me. Show me!" he would shout.

Margarett asked him to teach her to draw. She wanted the accuracy and speed he'd perfected during years as an artist reporter for the *Philadelphia Press*, the depth he managed in fast portraits of a Czech volunteer or an ordinary woman, the humor distilled from drawing *The Yellow Kid*, America's first comic strip. Margarett was a voracious student. She saw that Luks drew everywhere he went. She watched him sketch her birds at Borgland, marveled as he disappeared into a vortex of speeding pencil to emerge with a double portrait, "Gutzon Borglum critiquing Miss Sargent's sculpture." She saw how he derived a watercolor from a drawing, an oil from a watercolor. His approach freed her from the careful lyricism of Bashka Paeff and Borglum's ponderous formality. She worked harder than she ever had.

During the day, Margarett carried a sketchbook, and it became a diary of drawings. At night, she hired a model, whom she drew again and again. She drew in charcoal and she drew in pencil and, in the manner of Rodin's late erotic drawings, applied a watercolor wash when she finished. A careful line of charcoal edged the figure who lay, legs

erotically akimbo, on her stomach, hands concealed beneath her pelvis. Once, as Margarett drew, the doorbell rang, and a tall, rangy man burst in and began to make love to the woman posing on the floor; he was a sculptor, the model his girlfriend. Margarett continued to draw, adding to the nude the faint image of her lover bent over her. "I know I should have been shocked," she said, "but I wasn't."

If Margarett had any remaining allegiance to the gentility of Boston, Luks decimated it. His brutal way of sizing people up satisfied the temperament beneath her manners. "To hell with your hats!" he snorted. He rewarded her hard work with late-night excursions to Chez Mouquin, a favorite haunt of artists, under the Sixth Avenue el at Twenty-eighth Street. They climbed canopied stairs from the sidewalk to eat and drink with the writers and painters who were Luks's friends. Red-upholstered banquettes lined the mirrored walls of gaslit dining rooms, where straightforward food described in ersatz French was served with plenty of booze until two A.M. Soon Margarett was at work malleting into shape a bust of Chaffard, Mouquin's famous headwaiter, and Luks was at her shoulder, insisting, she wrote later, on "spontaneity and freedom of attack."

"Art!—my slats. . . . I can paint with a shoe string dipped in pitch and lard," Luks would shout, drinking and sketching wildly on napkins, tablecloths, menus. His emotion, John Sloan observed, drove "the paint before it to the end his heart desired," but, as Margarett learned, when Luks drank, his rapturous facility abandoned him, and he could work a painting until he destroyed it. He had started to drink as a boy, and now, at intervals, he landed at the Northern Dispensary on Waverly Place, where his brother, its director, saw to it he abstained until he was ready to go back to the world. Eventually a drunken brawl landed him in jail, and Margarett introduced him to a young lawyer, Harrison Tweed, a Harvard classmate of her brother Frank, and one of her beaux. Often Margarett found herself in Harrison's company, escorting a barely coherent Luks home to his wife or downtown to his brother.

Margarett began to experiment with watercolor. She showed Luks a series of washes of women in draped garments. "Very good, in fact

the best," he wrote in bold pencil across one of them. He took her to see Maurice Prendergast, whom he considered a master of watercolor. Prendergast was tall and lean, still handsome, but going deaf. He was fifty-nine when Margarett met him, but to her he seemed a thousand years old. He was a bachelor given to quoting Kipling's "If a man would be successful in his art, art, art / He must keep the girls away from his heart, heart, heart . . ." But he also encouraged women artists. When he pulled out portfolios and sketchbooks from his early years in Boston and Paris, Margarett saw color that seemed to flow unguided into the most delicate and lifelike images. She left his Washington Square studio with three studies of single female figures done in Paris, gifts from the artist.

Luks also took Margarett to see Alfred Maurer, one of the first Americans of his generation to paint in Paris. By 1905, under the influence of Matisse, hot color and exaggerated form burst his Whistlerian boundaries, and his paintings hung among the Fauves at the Salon d'Automne. In 1909, Alfred Stieglitz summoned him to New York for a triumphant exhibition at "291." Maurer returned to Paris, but in 1914 the war wrenched him home. When Margarett met him, he was struggling to paint in a small room in the Hell's Kitchen apartment of his father, a once prosperous Currier and Ives illustrator who held his son's work in cool contempt.

Looking at Maurer's paintings, Margarett saw a style that matched the spirit of Luks's blunt brush sensuality, but she also saw the influence of Paris, which Luks had summarily rejected when the Armory Show turned American dealers toward Europe. Luks, who valued the integrity of work no matter what its school, urged Margarett to buy Maurer. She purchased a watercolor and two oils—one a regally luscious still life—and talked to everyone about the wonderful painter she'd found so despondent in his tiny studio. Weeks later, she got a letter. Maurer thanked her for "having bought more pictures and having influenced more people to buy him in a month than he sold in years." When she began to paint, Margarett would harken in her own portraits to paintings like his 1907 *Woman with Hat*, the planes of her

face daubed yellow and red. By then, Maurer would be in his last depression, which ended, after his father's death at one hundred, in suicide by hanging. He was sixty-five.

George Luks was singularly qualified to introduce Margarett to the world of progressive art. During his years in New York, he had been at the center of the great changes that culminated in the Armory Show in 1913. He regaled her with stories that instilled a belief in the importance of what was new. He told her about the Eight, the group of painters of which he and Prendergast were part, which broke the grip of the National Academy of Design and opened American art to subjects outside the world in which Margarett had grown up, the world portrayed by painters of the Boston School and by John Singer Sargent. She learned how, in the wake of the Eight's legendary exhibition and the movement of artists it inspired, the Armory Show had irrevocably altered the circumstances and sensibilities of American art.

In 1907, fresh to New York, Luks had submitted his *Man with Dyed Moustachios* to the annual of the National Academy of Design. Kenyon Cox, juror and critic, took one look and knocked it from its easel, shouting "To hell with it!" Luks's friend the painter Robert Henri took immediate action, resigning from the Academy and seeing to it that the offending painting was exhibited at the Macbeth Gallery on lower Fifth Avenue. Then he approached William Macbeth with the idea of a nonjuried exhibition of painters whose independent ways of seeing and painting had kept them out of the Academy.

Henri, Luks, and three artists who had worked with them in Philadelphia—John Sloan, Everett Shinn, and William Glackens—invited three other anti-academic painters—Arthur B. Davies, Ernest Lawson, and Prendergast—to join them. Each was stylistically distinct. "We've come together because we're so unlike," they told the press, with a snicker at the boilerplate Impressionists. In the months that followed, as John Sloan photographed works for the catalogue and Gertrude Käsebier posed each artist for a publicity shot, the New York critics chose sides. Heavy snow on February 3, 1908, did not deter three hundred people an hour from filing through two small rooms to

view the sixty-three paintings, six of them by George Luks. "Vulgarity smites one in the face at this exhibition," *Town Topics* sneered, but hostile reviews were drowned out by the cheers of critics who welcomed Luks's city people, Sloan's back streets, and Davies's symbolist landscapes.

The Eight's exhibition broke the power of the Academy and inspired the movement that culminated on February 17, 1913, when the International Exhibition of Modern Art opened at the 69th Regiment Armory on Lexington Avenue. The Armory Show included many insurgent American artists, but it was the work of the European avant-garde, brought before a large American public for the first time, that changed the course of American art. Until then, Alfred Stieglitz had been the only New York dealer to take notice of what had happened in Paris since the Impressionists. In 1908, he'd shown the late watercolors of Rodin and works by Matisse, both for the first time in America, and in 1911, he'd mounted Picasso's first American one-man exhibition. In 1912, as Margarett led the march at her debutante ball, he showed Marsden Hartley, and during the weeks her bronze of Dan was exhibited at the National Academy of Design, visitors to "291" saw works by the Italian futurist Gino Severini and Georgia O'Keeffe's first one-woman show. By 1917, when Margarett arrived in New York, Stieglitz's contribution had been subsumed in the breaking open wrought by the Armory Show, and European Modernists and their American followers were no longer hard to find.

"He was a mean old bastard," Betty Parsons said of Stieglitz. When she'd asked the price of a John Marin watercolor, he said six thousand dollars when in fact he'd priced it at under three hundred. "He thought I was some kind of socialite, and he didn't like me," she said. In 1919, Margarett made the acquaintance of this "socialite," a young woman from New York and Newport who had been in love with modern art since her governess took her to the Armory Show as a beribboned thirteen-year-old.

When Margarett encountered her, Betty was Betty Pierson, nineteen, and studying sculpture in New York. The Armory Show had in-

stilled in her a passionate and insistent ambition to be an artist, and after a standoff with her stockbroker father, she was allowed to work with Solon Borglum, Gutzon's brother, who had her sketch bones until she was "blue in the face"—not what she had imagined doing when she looked at Bourdelle and Brancusi at the 69th Regiment Armory. Betty was an exquisitely beautiful young woman, small and blond, with startling, very blue eyes. Her figure was boyish, and she was not afraid to swagger. She had a wry sense of humor and a penchant to explore what was on her mind by talking passionately.

Margarett had heard of Betty Pierson; Betty had been seeing Eddie Morgan's brother, Archer, until she broke it off for Schuyler Parsons, whom she chose because he made her laugh. And Betty had heard of Margarett Sargent. She remembered later that Margarett introduced herself at a formal party, approached her across the dance floor. Margarett was a head taller than she and wore, that night, a low-necked gown and white kid gloves nearly to her shoulders. Betty remembered Margarett's black hair and her pale, beautiful skin. "We began to talk," she said. And they didn't stop. Margarett talked about the artists she knew, about Luks, and, Betty remembered, Hartley, Marin, and Arthur Dove, all Stieglitz painters.

The next morning, Margarett sent a bouquet of violets and lily of the valley, "with quite a note." Betty was shocked that a woman would send her flowers, and fell, she admitted, a little in love. Though Betty was eight years younger, Margarett recognized in her someone who was as strong as she; that, more than anything, attracted her. They talked, gossiped, argued, agreed, disagreed. Soon Betty was at Fifty-eighth Street, sitting for Margarett and staying on for supper with Marjorie. "Always the art," Betty said, "but it was an emotional thing too. Margarett used to madden me, madden me, but I always had the utmost admiration for her." They became lifelong friends.

Despite the war, there was a great deal of art activity in New York during the fall of 1918. Margarett had been asked to show her bust of Dan in November as part of "Carry On," an exhibition at the Gorham

Galleries to benefit the war effort. Also among the thirty-five sculptors invited were Bashka Paeff, Daniel Chester French, and Solon Borglum, whose massive war sculpture, riderless horses and men with rifles raised, was to be the show's centerpiece.

In April, Margarett had got a letter from Dan in which he wrote that his French landlady "passes a visit here only in order to be sure that a speck of dirt has not fallen in the kitchen, and that the tongue of the great clock is always swinging to and fro." He wrote his sister only cheerful news, so the letter in which he described his narrow escape at Cantigny during the Americans' first independent offensive went to his brother Frank. The splinter of a shell had ripped into his haversack, pierced his canteen, and halted just short of his ribs at the metal case of his Gillette, "on which it made a memorable dent."

Now that Americans were fighting in earnest, news of casualties was in the air. Margarett passed on a rumor that MacLeish had been killed, which he corrected in a crisp letter to Bangs. Frank's Harvard roommate was killed, as was Margarett's onetime beau Oliver Ames, E. and O.'s brother. Mothers of sons who didn't fight were secretly relieved, but men kept from combat wrote letters tinged with shame. In August, Shaw McKean wrote Margarett from France. He was making the best of "a whale of a job" in the Classification Camp, supervising the suiting up and equipping of replacement troops. Margarett did not respond.

After six months at the front, Dan was assigned to Fort Sill, Oklahoma, as an instructor. Margarett pestered the War Department until they divulged his day of return from Europe, then met him at the pier and brought him, joyously, to Fifty-eighth Street, to see Marjorie and to meet Fanny. She worried about Harry, still in France, who in mid-October had been transferred from supply to combat. "You needn't worry however," Harry wrote their parents, "because you know how many have gone to the front and never got even wounded. Of course my only worry is whether I can make good."

News of Austria's surrender came on November 3, and all the next week New York headlines bannered certain armistice, as Harry's

division fought in Pershing's "sensational advance" in the Meuse-Argonne. On November 5, the *Times* ran a report that the retreating Germans had been "told to apply to Foch." On Sunday the Kaiser abdicated, and on November 11, at five A.M., Paris time, peace was signed in French Marshal Foch's private railway car. In New York, Margarett and Marjorie, roused by the tooting of horns and the wailing of sirens, watched from their window as a sailor leaped into the fountain in front of the Plaza Hotel.

"After this armistice I feel like writing everybody," Harry wrote to Margarett from France. Dan, who would soon receive a Croix de Guerre from the French, complained from Fort Sill of a victory parade of artillery regiments and "several thousand students" that filed through the streets of Lawton, Oklahoma: "If only I were in France or in some city where the feeling about the end of the war were not so local, so unpardonably down east." Margarett traveled to Boston for Thanksgiving at Wellesley, and Dan turned up in person. Frank was discharged soon after. On a morning in May, Margarett and Dan were at the pier in New York to meet Harry, finally back from France.

Now that her brothers had come home, Margarett made frequent visits to Boston. She particularly wanted to spend time with Frank, whose state of mind all through the war had worried her. Margarett was not alone. Letters exchanged among the family assessed the degree of his depression. In the summer of 1918, when Dan was home on leave, Frank had seemed happier than at any time since he failed to win his commission, but after the armistice, his swings of mood intensified. He was either overactive and too talkative or sluggish and silent—"so nearly," Margarett wrote years later, "without life." Finally he committed himself to a sanitarium, and after several months was sent home with a male companion. In June 1919, when he visited her in New York, Margarett found him near his old self.

On June 18, two days after he returned home to Dover from New York, Frank was considered well enough to ride out alone. Hours later, the horse came back without a rider, its flanks bloodied. A search party fanned the countryside. On the second evening, David Cheever and

his friend Jack Parkinson found the body. Dan always said Frank cut his own throat, Jack that he hanged himself. "I always understood he did both," said David Cheever's grandson. On seeing him, Jack, with some hope, said, "We must cut him down." But David, a surgeon, knew better: "It's a task for the coroner."

Margarett took the train to Boston, where the family, reeling with shock, did not discuss the details of the death. After relating the bare facts of the suicide decades later, Dan looked away, shuddering to keep his composure. All Margarett could think of was how well Frank had seemed in New York—he was her adored oldest brother, her valued adviser, and, when he was himself, her most delightful companion. "She worshiped him, and it haunted her," Margarett's oldest daughter, Margie, said. Margarett returned to New York after the funeral. "I remember she looked so wonderful," Marjorie Davenport said. "She wore mourning with a little widow's turban. Oh, she looked great."

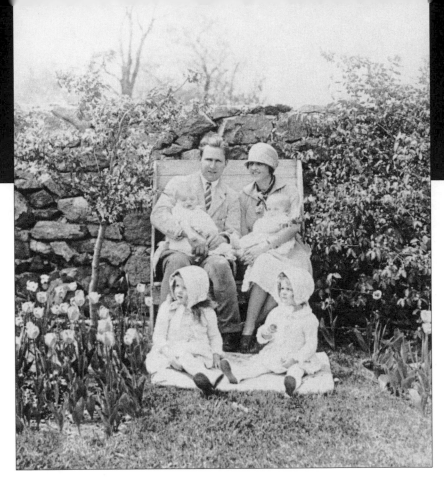

V

I guess I will
marry you

(1919–1926)

Margarett with her family, 1924

Jenny Sargent and Marjorie Davenport were alone in a room upstairs at 40 Hereford Street. Jenny was pacing, opening and closing bureau drawers. "Oh, Marjorie, in life we have lots of experiences, don't we?" she said. It was just weeks after Frank's suicide, and Marjorie and Margarett were visiting Boston. "Yes, I think so," said Marjorie. "I knew I was queer," Jenny continued, using the word to mean something irreparably flawed. She talked about Ruth's death, opened another drawer, took something out, turned to Marjorie. "Well, I never should have married."

But she did not conceive of unmarried life as a solution. Her fear for her daughter, twenty-six and single, was palpable: another child under the spell of her inherited, fatal queerness. She herself had not married until she was thirty, but she'd had no suitor until Frank Sargent. Margarett was glutted with suitors but insisted on her art—something to be tolerated in a girl, but not, Jenny believed, in a woman. Jenny chided and argued; Margarett countered with indignant rage. "Why, you serpent! How dare you!" Or seduction: a perfect scarf from New York, accompanied by a tender note, "Can I do any shopping for you, Mama?"

In July, Margarett left home again. With Marjorie, she rented a tiny cottage at the edge of a dairy farm in Dorset, Vermont. She spent the summer doing watercolors. A local resident, Carleton Howe, home from the war, delivered milk and butter and admired the two young city women, who had such unusual taste. In September, Margarett and Marjorie returned to New York.

. . .

On a Monday in October 1919, in Margarett's studio, a model stands naked. She reaches forward with her left arm, lifts her left foot like a shore bird, holds it at ankle height, balancing. Then she crouches, and Margarett draws her from behind. She sits on the floor, folds her legs beneath her, face forward, one arm high—hand cropped by the paper's edge. She is a large woman, hair knotted at the base of her neck, a narrow ribbon strung around her head like a Greek fillet. Her figure is womanly, but as Margarett draws her, the force of her sensuality is androgynous. Margarett's line is spare, no longer bound to the figure or excused by drapery.

The following day, the model sits as if on a bench or chair, but Margarett leaves out everything but the woman in seated position— elbows resting on her parted knees—quick lines digging at her edges. In another sketch, the model sits, arms folded across her belly, legs crossed like a man's. In another, hands between her knees, she begins to pull open her thighs. Finally she leans to one side, presses a palm to the floor, and with her other hand guides her left thigh, leading her torso into an upward twist. In a sketch Margarett makes the last day of the series, the model stands face forward, hands covering her sex.

At twenty-seven, Margarett was drawing with the line she would use all her life, seeing with an eye that permitted a young woman raised Bostonian to draw a naked woman and her lover writhing on the floor, sketching with a line so economical a woman's eyeless face required just five lines. Because it was 1919, six years after the Armory Show, these drawings are distinguished not only by what they include. "Look!" Betty Parsons said, seeing them for the first time. "Look what she leaves out."

In New York in 1919, Margarett and Betty saw exhibition after exhibition, talked, Betty said, "always about art." Modern art crowded the galleries: in January, Marsden Hartley's pastels of New Mexico; in March, Man Ray and Marguerite Zorach; in May, "Modernists"— Max Weber and John Marin. Margarett cultivated her eye, and Luks continued to mark up her watercolors: "You will notice what I mean

in my suggestions on the others, in that the washes are not so cottony in this one."

Margarett had left behind her family, but not her grief. "One simply did not speak of suicide," her daughter Margie said. Asked about his father decades later, Francis Sargent, five when Frank killed himself, said, "I know it will seem strange to you. I really know very little about my father. I was so young when he committed suicide, and my mother *never* spoke to me about him!" Margarett spoke only to those closest to her. "It always came up," Betty said, "sooner or later."

In the night quiet of her studio, the silent pulse of an artist's concentration, the whisper and scratch of a pencil, the grace of a carefully rendered hand, a forceful body, hands folded over sex. The woman who draws is not the clown who coiffed herself with table linen to imitate a vaudeville nun, the beauty who spurned one admirer for another. In the transforming quiet of the night, what infuses her line expresses a deeper self. She draws a face for which a line at the brow suffices for eyes, then a face with no eyes at all. She does not wish to see anything outside this room.

The model's eyes look forward, range to some middle distance, then are lowered. Or they lead the body's movement upward: fear, hesitation; desire awakened; modesty; a reach beyond grief, past what Margarett has lived and known, into imagination.

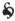

In May, Papa had been ill, unable to come to New York to welcome Harry back from the war. But he'd recovered, the bull-necked loving father who always teased, coddled, and encouraged Margarett, doted on her charm, smoothed the wakes of her Hereford Street departures. They adored each other. In a small scrapbook, she pasted a photo from a magazine—a young woman with black hair, wearing a filmy nightgown, lolls in bed, looking joyously out a morning window. "When did you have this photo taken?" Papa joked hastily across the bottom.

Frank did not entirely understand Margarett, but he trusted her, and he saw in her New York adventures a mirror of his own out west. His

attention and trust gave her jocular ease with men and what accep-
tance she had of her own forceful character. As Jane was Jenny's
daughter, Margarett was Frank's. It was he who allowed and encour-
aged the path of her ambition. He did not know art, but he listened
when she talked about what she was doing. His gifts as a storyteller
gave him an instinct for what was expressive, and he knew how to look
for it in what she did. When Jenny pressed to get Margarett home to
marry, Frank turned a bemused ear until his wife abdicated her worry
to his overarching confidence in their talented daughter.

On January 16, 1920, Margarett and Marjorie, each with a beau,
spent the eve of prohibition with George Luks and his wife. Like much
of the city, Luks was in mourning. At one restaurant that night, guests
were directed to wear black, tables were draped in black, and black
bottles overflowed a casket. At another, each diner took home a minia-
ture coffin. "Instead of passing from us in violent paroxysms," the
New York Times reported the morning of January 17, "the demon rum
lay down to a painless, peaceful, though lamented by some, death."

Early the next morning, there was a call from Hereford Street.
Margarett immediately caught a train to Boston.

Even in retirement, Frank Sargent kept to his routine, but one morn-
ing in October 1919, after going to Boston on his usual train, he'd
telephoned Jenny: "Please come pick me up." His illness progressed
quickly. He was bedridden in Wellesley until the family moved to
Boston in November. Soon he could not climb the stairs without help.
Eventually he could not leave his bed, even for an occasional meal. In
late December, Jane Cheever brought his first granddaughter, two
week old, to visit. He died on January 17, 1920, and an obituary in
the *Transcript,* the paper he read every evening, marked the event with
economy: "Francis Williams Sargent died today at his home at 40 Here-
ford Street, following a severe illness which had been prolonged through
two months. He was in his seventy-second year."

Margarett, disoriented by grief, moved back home to be with her
mother. At first, Jenny could not speak. When she began to speak again,

her boisterous laughter was gone. Her mother Isabella's legacy of depression had always threatened her happiness; now it overcame her, and the strength and stability fostered by thirty-nine years of companionship fell to pieces. More than once when she had grandsons to dinner, she excused herself midsentence and hurried out to the vestibule off the living room. There she wept and fought to compose herself before returning to the parlor with a small, pinched smile.

Margarett thought she would live at home indefinitely. Her father's death had shaken her feeling of safety and moved her to new tenderness for her mother. But Jenny's vulnerability soon gave way to clinging desperation: "To have the children happy is the only bright spot I have before me," she wrote. Over her mother's protests, Margarett returned to New York. She was not the only child who fled. When Dan began to court Louise Coolidge, one of three daughters of J. Templeton Coolidge, a Beacon Street collector and painter, Jenny immediately made it clear this young woman was not an appropriate choice for her now most promising son.

Louise had been frail since the death of her mother, when she was eleven, and her father's remarriage when she was sixteen occasioned the first of three internments in Swiss sanitariums. A marriage of Hunnewell "queerness" to the Coolidge version, manifested most notably in the mental instability of Louise's late uncle Francis Parkman, historian of the West, filled Jenny with dread. Joined by Mr. Coolidge, who agreed his daughter was not marriage material, Jenny emerged from the gauze of bereavement to forbid the union.

To Dan, Louise's delicate blond looks were irresistible. Her jaggedly frail temperament mirrored his own disorientation, her breakdowns his return in nightly dreams to the moans of the dying at Verdun. Louise had briefly nursed wounded soldiers in Paris, and her Catholicism affirmed Dan's own new faith. Priests on the battlefield, the beatific faces of French soldiers as they passed to death, had inspired him to turn from a "naturalistic view of life" and become a Catholic. To his parents, the departure of their heroic son to the hocus-pocus faith of their Irish servants had been appalling. Now, supported

by his belief and steadied by his distinction as a soldier, Dan brooked a new torrent of family disapproval. His mother had succeeded the first time she obstructed him in love; he would resist her now.

As it turned out, Jenny's anxiety was prophetic. In late winter, Louise collapsed. Dan faltered, but his indecision dissolved by April: their gentle love and Christian faith would return her to sanity. "I cannot wait any longer to send you a line of welcome into the family," Jenny wrote Louise, bowing to the inevitable on black-bordered stationery. In late spring, Louise sailed for Europe. They would marry in August in the sanitarium chapel in Lausanne. Dan booked a first-class stateroom, but when Louise pressed for an earlier date, he left his position as a Harvard tutor. "Sails Steerage for Wedding," read the Boston headline.

Margarett had made some effort to overcome an initial dislike of Louise, but Louise considered her a threat, and it soon became clear that Dan would always accommodate his wife, even if it meant pulling away from his sister. That abandonment of their intimacy and his plans for a year's honeymoon abroad turned Margarett's already ruptured family landscape utterly stark. As the unmarried daughter, she was now expected to return to Boston and take charge of her mother's household. She had no defender against this requirement, just Mama and Jane amplifying an inner, dutiful voice Papa would have freed her to ignore.

What lay before her was the darkened sitting room at 40 Hereford Street, heavy furniture, dreary pea-green upholstery ("shit green," her daughter Margie would call it), fading brocade walls. Or Wellesley: the Hunnewells, from whom her New York life had estranged her, more heavy furniture, hunting prints, her sister Jane ("the compleat Bostonian," E. Ames said) across the street. Margarett had no intention of living with her mother. "I simply couldn't bear the thought of it," she said more than once. "That is why I married."

There was an obvious candidate. Shaw McKean was Bostonian, rich. He was seeing "a girl" in Philadelphia, to whom it was rumored he intended to propose, but he had pursued Margarett for nine years.

She loved his looks, and when he stood up to her, she found him very attractive. He had always lived among paintings and he appreciated them—his final letter from France had rapturously described his officers club, appropriated from an artist, its walls "simply a mass of paintings—a great number of Early Italian. . . . I wish you could see the house & everything just as it is."

Married to him, Margarett could continue her career—he had said, always, that he wanted her to. She could marry in good faith. Shaw would be a wonderful father. They would grow to love each other as devoutly as her parents had done. And, as she put it to Betty Parsons, he was a fine stud. One day during the late winter or early spring of 1920, Margarett picked up the telephone. Shaw was courting in Philadelphia. He was unnerved by what he heard but utterly thrilled. "It's Margarett," she said. "I guess I will marry you." Seven years earlier, she had retreated from marriage to protect her career; now she would marry to defend her independence.

It's not clear when she left New York. She was still there in February when Fanny Brice telephoned: Would Margarett take her daughter, six months old, out into Central Park? Fanny did not want the child at home when the police arrived to question her. Nicky Arnstein, "known internationally as a criminal," the paper said, "having been arrested in Paris, London and Monte Carlo at various times in the last ten years," had now conspired to steal five million dollars in securities from brokerage houses and banks. Margarett walked the baby in a perambulator until she saw the police leave the building hours later. The next day's *Times* headline read: "500 Banks Watch for Arnstein Loot; Quiz Fannie Brice." A month later, Nicky's photograph on "wanted" posters hung in every U.S. post office. By the time he slipped into Fanny's limousine to turn himself in, Margarett had arrived in Boston to meet her betrothed face-to-face.

Shaw's mother awaited her. Unlike Margarett's parents, Marian Haughton had a taste for elegance. She wore beautiful clothes and cherished the paintings, French silver, and import china that had passed down to her

through generations. She financially supported the Boston Symphony, would count among her friends its most famous music director, Serge Koussevitzky, and religiously attended its Friday afternoon concerts, all her life purchasing an extra seat for her coat.

Marian's love of style was in part a reaction to her mother, Pauline Agassiz Shaw, who had rescued herself from the depression she suffered as a young wife by committing herself, with her husband's blessing and fortune, to an extraordinary life of service. In 1877, she opened her first kindergarten for poor children, and eventually she supported thirty-one of them. Her day nurseries evolved into the first Boston settlement houses, and in 1897 she became a major contributor to woman suffrage, a position that did not meet with unanimous sympathy in her Boston circles. As a girl, Marian was embarrassed by her mother's philanthropy, but later in her life, when Emma Eames and Myra Hess, refugee musicians from Europe, needed financial help, she quietly provided it.

At twenty-three, Marian married Henry Pratt McKean and moved with him to his gentleman's farm outside Philadelphia. "Harry" was a direct descendant of Thomas McKean, governor of Pennsylvania and a signer of the Declaration of Independence, but his pedigree did not keep the Episcopalians of Philadelphia from ostracizing his Unitarian wife. Marian found no solace in her marriage. Harry was alcoholic; on their wedding night, drunk, he locked the door and chased her, terrified and ignorant of sex, around the bedroom. When her sons were ten and twelve, Marian moved back to Boston and put them in boarding school; when they were safely at Harvard, she took the audacious step of divorce. The experience set her apart—"She was as hard as nails," her grandson Shaw said—and estranged her sons from their father. Eventually Marian married Malcolm Graeme Haughton, a genial, red-haired beau from her school days. She could do what she wanted; in 1913, her income was a million dollars a year.

After his discharge, in December 1918, Shaw McKean had returned to Boston. He'd seen no "action," had spent his months in France as captain of a headquarters troop. In late 1919, his friend George Putnam,

at Harvard Business School while Shaw was an undergraduate, asked him to join Richardson, Hill, a brokerage in Boston, "who were at the time," Shaw later wrote, "active in industrial financing." The thousand-dollar monthly salary, extravagant for a beginning partner, made Marian nervous. She suspected that Shaw's interest as an heir to McKean founding shares in the Insurance Company of North America and to Calumet & Hecla copper were a greater factor in his hiring than his potential as a broker. If she warned him, Shaw did not heed her. He began work in December 1919.

Weekends he spent north of Boston in the dark clapboard saltbox he'd purchased with his old friend Bayard Warren and his law school classmate, the songwriter Cole Porter. Eventually he bought them out, moved his registered fox terriers from Marian's estate, and named the place Prides Hill Kennels. When the war threatened to interrupt his polo, he took his ponies along to Fort Devens, Massachusetts. Now he was laying out a polo field next to the house. His social life enlisted those of his generation who weekended and summered, often at their parents' grand houses, in the cluster of seashore towns that by 1909, when President Taft leased a summer White House in Beverly, had become Boston's Gold Coast.

Early in the century, the new industrial rich arrived from New York, bought land, and laid out grand estates, displacing old Boston families. "Goodness!" Katharine Peabody Loring said when Henry Clay Frick offered to buy her house and land. "What on earth would I do with a million dollars?" Frick built a mansion on the ocean in Prides Crossing, behind a hundred-thousand-dollar fence. Frank Sargent had chosen Wareham because the North Shore's opulence offended him, but Marian's family had vacationed there for generations. Even when she lived in Philadelphia, she'd moved her sons to Prides Crossing each June.

When Shaw took Margarett to Prides Hill Kennels, she saw an unusually large old saltbox, fitted up for a bachelor. In the library were foxhunting trophies and silver cups his dogs had won, and throughout the house were paintings he'd inherited from his grandparents'

legendary collection—two Corots, a Delacroix, a Rembrandt, an exquisite, tiny Géricault. "The most I can say of him is that he was a good dancer," was how Dan Sargent characterized the Harvard roommate he considered in no way worthy of his sister. Margarett chose Shaw, Dan always believed, in a rage at Jenny, who was predictably relieved her untamed daughter finally became engaged.

Marian Haughton did not share Jenny Sargent's happiness at the match. Ever since Margarett passed over her son for Eddie Morgan in her debutante year, she had hoped Shaw's obsession would run its course. When his trips to Philadelphia indicated that at long last it had, she was delighted. The charms that ignited Shaw left her cold. Margarett Sargent had broken a year-long engagement, and nothing she had done since had retrieved her reputation. Marian had lived with Graeme Haughton before she married him and had sympathy for resistance to certain aspects of Boston propriety, but she objected to what she considered Margarett's brazen disregard for the feelings of other people, particularly those of her son. Finally, and discreetly, she feared Frank Sargent's suicide was evidence his sister's behavior was not bad form merely, but bad blood.

To Shaw, Margarett offered a direct and spirited approach to life. When lived through her, everything had a heady, almost dangerous edge—and she made him laugh. He defended Margarett to his mother, his argument rooted in an intuition he could not put into words. He insisted she was not wanton or mean-spirited, but he had not grasped that the behavior Marian found cruel was an expression of Margarett's genuine desire to protect the freedom she found in art. He argued that in marriage, what he believed to be her confusion would be quieted. Whatever his love and respect for his mother, he would not, in his decision to marry, bow to her wishes.

Shaw's arguments did not calm Marian's fears, but his obvious happiness subdued her protests, and when Margarett arrived at Prides Crossing for Independence Day, she offered an embrace and turned a cool, pale cheek to her future daughter-in-law's kiss. At the close of a fortnight's visit, the engagement of Miss Margarett Williams Sargent

and Quincy Adams Shaw McKean was announced on the front page of the *Transcript*. They were married at Kings Chapel two weeks later, on Saturday morning, July 31, 1920.

Kings Chapel, built in 1749, stood on Beacon Hill, blocks from the Bulfinch capitol, with its glinting, gilded dome. Its painted white interior—Corinthian columns rising, enclosed pews with red damask upholstery—was cool on the summer morning, and the sun shone bright through arched, clear-glazed windows. Because of Frank's suicide and Papa's death, the wedding was simple and quiet. That and its haste led to *Town Topics'* catty assessment, "the biggest kind of a surprise." Margarett wore a light-gray traveling suit and a demure gray hat with short lace veil. She carried wild roses. The wedding party was so small she greeted everyone before the ceremony.

Margarett might have chosen Dan to take their father's place at her side, but he was honeymooning in Italy, so her brother Harry gave her in marriage. Shaw slipped a plain gold band onto the finger where she already wore an engagement ring, three large diamonds set simply in gold. Because the Sargents were in mourning, there was no wedding lunch. Margarett and Shaw received embraces and congratulations on the steps outside, then embarked in Marian's touring car, stocked for the day's journey with a picnic and champagne.

That day in New York, Marjorie Davenport had received a telegram: "Leaving for Kings Chapel . . ." Margarett had not told her of the engagement. Marjorie herself would never marry—not because there were no offers, but because she espoused free love. When she quoted Margarett's telegram decades later, remembered feeling drove her voice. If the surprise marriage was not an end to their friendship, it was the end of a domestic arrangement, a shared bed; a farewell, too blithe for Marjorie's feelings, to three years of association that had formed the center of her daily life. Marjorie had known Margarett nearly as long as Shaw had pursued her, and she knew that at the very least, her love for him did not match the quality of his for her.

After the service, sometime past noon, the chauffeur maneuvered the car through the narrow streets of Beacon Hill north to New Hamp-

shire, deep into farming country. As the newlyweds settled into the
four-hour trip, the excitement of triumph over family disapproval re-
ceded. Suddenly Shaw turned to Margarett. "You think that you mar-
ried me for my money," he said lightly. "Well, I don't have any; I'm
going to live on yours; you'll have to live on your looks."

What Margarett did not know was that the day before the wed-
ding, Calumet & Hecla had plummeted to a six-year low. Nor did she
know that Richardson, Hill had entered shaky times and that George
Putnam expected Shaw to bail it out. Calumet & Hecla's highs had
sustained Marian's vast wealth throughout his memory. This new low
reduced her holdings, at least temporarily, but it obliterated Shaw's.
"Not all his money was lost," his daughter Margie said, "but a good
deal of it." Was the news of financial reversal enough to explain his un-
characteristic outburst? Or did his triumph, so actual now, sitting in
his mother's car, fail to calm the anxiety that had lifted for an instant
when he heard her voice on the telephone in Philadelphia?

Margarett was unnerved. Once, during their engagement, Shaw
had told a riddle as they danced. "What's the definition of dancing?"
The coarseness of his answer had scared her—"a naval engagement
without a loss of seamen"—but she had never known him to be cruel.
She sat quietly as they continued toward their destination, a shingled
cottage with a white porch at the edge of a secluded lake. Shaw broke
the silence: "Don't expect me to spend much time with you. I shall be
fishing. I hope you've brought your paints."

Toward afternoon, he rapped on the dividing window and asked
the chauffeur to stop. He carried the picnic hamper as they walked out
of sunlight into the cool, dark forest, still dressed in wedding clothes.
He placed the hamper on the ground, spread a cloth. Or the chauf-
feur, walking ahead, carried the hamper, spread the cloth, returned to
the car. Alone, the newlyweds sat on the ground, and over her protests,
Shaw made love to his wife, a virgin at her marriage. For Shaw, the
outdoor encounter was a first exercise of conjugal right, Margarett's re-
sistance anachronistic, even coy. For her, it was something else. She
hardly knew what she felt as she rose, brushed forest debris from her

wedding suit, smoothed wrinkles, composed herself in order to face the chauffeur. More than once, when she spoke of the incident, she used the word "rape."

Over a woman drawn with sketchy lines, loose hair pulled up, downward-looking face half hidden by a cloak, Margarett applied watercolor wash—a faint red to the hair and, to the drapes of the cloak, pale yellow and then pale blue. She dated the watercolor November 23, 1920. Just a year before, alone with a model in her New York studio, she had drawn a woman naked, moving through a room, self-possessed and self-assured, sensuality infused with calm power. Her direct, single line had been simple but also curious and willing. A face achieved with five lines hid nothing. What was economy there had become lassitude— lines for eyes uncommitted, a mouth in shadow. Margarett wrapped the woman in a shroud and hid her hands. This watercolor is the only surviving work from the months after she married.

After spending their first summer at Prides, Margarett and Shaw moved to the Agassiz Hotel on Commonwealth Avenue, not far from Jenny, at the corner of Hereford Street, or Marian, across from the Ritz. Margarett leased a studio at 30 St. Botolph Street in the South End, a street where Frank Benson, Philip Hale, and Edmund Tarbell had all painted at one time or another. There, recovering from the rupture of her father's death and adjusting to marriage, she resumed her work. She continued to sign herself "Margarett Sargent," though in what society pages called "private life" she was now Mrs. Quincy Adams Shaw McKean.

"They were spellbinding walking into a room," was a frequent description of the new couple. He was slightly taller than she, his dark hair pomaded to the curve of his handsome head, and he had his mother's long nose and dark-blue eyes. The tall woman on his arm was given to wearing black or white to set off the strong contrasts in her own coloring—hair nearly black against very pale skin and dark-lashed pale eyes. Their physical allure was set to music in the unusual grace of their dancing and set off by the care and elegance with which they dressed.

Margarett's sensibility, refined by her years in New York, gave her a sophistication that seemed exotic in Boston, and she had what were always described as *beautiful* manners. "Drop dead attractive, I mean it," said C.Z. Guest, born and brought up as Cizzie Cochrane in Boston in the twenties.

One of Margarett's new friends was C.Z.'s mother, Vivian Cochrane, whose husband, Alexander, older by twenty years, had plucked her, young and blond, from the cast of a Broadway musical. When they were all in their cups after dinner at Prides, Vivian might perch on the grand piano, strike a pose, and sing a song from her chorus girl past. She had something of the toughness that attracted Margarett in Fanny Brice; with this Boston outsider, Margarett had more in common than with her girlhood friends. She and Vivian laughed at the same jokes and ridiculed the same conventions. Margarett christened Vivian "VV," and Vivian returned the compliment with "Big Marge." When they met, Vivian had just had her first daughter. By April, Margarett was pregnant.

Pregnancy did not keep her from working—in the studio, or on the grounds at Prides Hill. When Margarett arrived as a bride, the house stood in a fallow field, electrical poles askew, no trees except for a large old elm out front. Her grandfather Hunnewell's gardens at Wellesley began as a cow pasture; this was no worse. Mr. Coughlin came with his horses to plow up the witchgrass, and Margarett's imagination was stirred, as much as by clay or a blank sheet of drawing paper. She went to Wellesley to look again at her grandfather's gardens, her eyes hungry for inspiration. She visited her cousin Charles Sprague Sargent at the Arnold Arboretum and took home a shrub, *Tsuga canadensis "Sargenti,"* a weeping hemlock named for their cousin Henry Winthrop Sargent, who had first collected it.

At Prides, Margarett planted the hemlock as if the act were sacred, as if digging it in assured her landscape a place in the Sargent and Hunnewell horticultural pantheon. The feel of earth relieved her like the feel of clay. She began to get up early to work outdoors, made friends of the men who helped her in the garden, always sharing with

them what she was learning about particular trees and shrubs. When Betty Parsons came for the weekend, she enlisted her to plant tulips. She got Shaw to dig holes for new trees and wait as she determined the most aesthetic placement. In the next fifty years, Margarett planted almost as many trees at Prides as Grandpa Hollis had in seventy-five at Wellesley. Her gardens would rival his in ambition, and horticulture would become for her, as it had for him, a source of exhilaration. Soon a wide and sumptuous perennial border curved out into the new lawn, clematis framed the doorway, and a riot of zinnias edged the front walk.

In the spring, the foundation was laid for an addition to the house. A studio for Margarett, its beamed ceiling broken by skylights, would soar to two stories. A loggia, eight French doors opening onto a garden, would connect the addition to the old saltbox, and upstairs there were to be two new bedrooms. The architect, Joe Leland, his Harvard sensibility burnished at the Sorbonne and by years in Paris, was inspired by the fervor of Margarett's imagination; in the next ten years, he would spin from the seventeenth-century saltbox an unlikely American version of a Florentine villa. He considered Margarett a collaborator. "She thinks like a man," he said. He considered the house at Prides the crown of his career.

By THE TIME Fanny Brice and the *Follies* arrived in Boston at the end of September 1921, Margarett and Shaw had moved to Marian's house to avoid the construction at Prides and await the baby. The new show was Fanny's triumph—"She has the fattest lines and the skinniest legs in the troupe," the *Variety* critic wrote. "It is," he continued, "by far the most conspicuous work this veteran funner has ever offered." She played a lanky George Carpentier boxing tiny Ray Dooley as Jack Dempsey, and Ethel Barrymore as La Dame aux Camellias to W. C. Fields's John Barrymore and Ray Hitchcock's Lionel. At the end of the evening, alone on a bridge across a painted Seine, she brought down the house singing, full voice and as herself, a new number adapted

from a French *diseuse* tearjerker. In the wake of months of headlines about Nicky's incarceration, "My Man" was a sensation.

On Halloween night, Marian's immense shingled house, empty for the evening, burned to the ground. On November 1, Shaw turned thirty, and on November 2, Margarett gave birth to her first child, a daughter, Margarett Sargent McKean, at the Phillips House, a smaller hospital attached to Massachusetts General. There Margarett slept on her own linens and had her meals sent in; her infant was watched over by Miss Barron, her private baby nurse. When she returned to the Agassiz Hotel with the infant Margie, a pair of tiny red shoes awaited them, a gift from Fanny, gone with the *Follies* on to Philadelphia.

Miss Barron, nicknamed "Ba," changed the diapers, and Margarett attended Margie with sketchbook and pad, pencil and watercolor: dash of pencil for an eye, looped scribble for a mouth. She had fallen in love—with the sensual pleasures of taking care of a baby, with the creative rush of forming a child's sensibility. When Ba brought Margie to the studio, Margarett wrote pages of poems on 30 St. Botolph Street stationery, which she illustrated with sketch after sketch of her namesake's round-faced prettiness:

> You're such a happy baby
> I'd like to be one too,
> It's easier to be big like me,
> Than to be good like you.

At home, she took the baby into her bed and read to her—"*Romeo and Juliet* by the time I was two," Margie said later. Margie's earliest memory was not her nanny's. ministrations but the fragrance of her mother's bedclothes and the deep sound of Margarett's voice reading Shakespeare. It became a matter of passionate principle to Margarett that her daughter not learn merely by rote, as she had at Miss Winsor's. She determined to bring her children early to the excitement of learning awakened in her at Miss Porter's.

Shaw was, as Margarett had predicted, a loving and enthusiastic father, and in the transforming aura of Margie's birth, Margarett became,

briefly, a devoted wife and a doting daughter-in-law. Unaccountably, everything fell together. She celebrated Marian in baby poems:

> Grandma's fingers are just ten
> But they seem a hundred, when
> She plays game for Baby!
> Churches, tables even chairs
> Grandma makes while baby stares . . .

In the late summer of 1922, the addition to Prides was completed and Margarett moved her clay bins and sculpture stands into the new studio. By September, she was pregnant again, and in November, George Luks telephoned. He arrived on the train, freshly divorced, just out of a sanitarium after a bout with alcohol. Neither the divorce nor the binge was a surprise to Margarett. Emma Luks had initiated the divorce; the settlement—dozens of his best paintings—sent Luks out on a ten-day drunk. When he got to Prides, he was physically broken and penniless, with no paintings to sell.

Margarett was shocked at how frail he looked, and immediately began to buoy him up. "How *could* that awful woman harass and torment you so!" Because she was pregnant and working at Prides, she insisted he take her St. Botolph Street studio. By the time she moved to Boston at Christmas, Luks had fallen in love: "I have lived in Paris and all those other places, but there is nothing like Boston!" The city, he said, preserved what New York had "wiped out with the onrush of events." He painted Commonwealth Avenue, governesses and children in the snow. He painted Kings Chapel as a looming monolith in a crush of narrow streets, a rebuke to the Boston painters who haloed landmarks in Impressionist fuzz. As the warm weather came, he painted swan boats in the Public Garden, prostitutes on Malcolm Street on a languid summer night.

Through Luks's eyes and in his headlong drawings, Margarett saw a living city sheared of Back Bay claustrophobia: Copley Square darted at with pencil, sailors lounging with girls in the Common, naked bathers at the L Street pier. She could watch Shaw's polo as Luks's

pencil caught it—players, mallets, horses at full gallop—the dense rhythm of the game rather than niceties between chukkas, the preen and gloat of competitors.

Shaw appreciated the grit of Luks's painting. He guffawed at his nonstop jokes, and continued to welcome him as his visit extended through the spring into the summer. Luks spiced Margarett's dinner parties with his irreverence—he joked with the men, flattered the women, and cut loose occasionally to a barroom. Dan found him "a bruiser" but was enthralled when he illustrated the margins of his book-length poem about Noah's ark.

Soon after his arrival, Luks was elected an honorary member of the Boston Art Club. Edmund Tarbell told a story for years of Luks turning up at a club dinner with a black eye and a torn shirt. "Sorry I'm late," Luks announced. "I couldn't find my collar button." The club men were less tolerant of his painting. In midwinter, John T. Spaulding, a Boston collector, lent Luks's vertiginous *Wrestlers* to the club for exhibition. The huge painting depicted two men, bodies straining in a visceral grip threateningly close to the viewer. "The works wreaks [*sic*] not with perspiration, as I might more politely say," sputtered the *Transcript*, "but with common sweat."

Margarett and Luks were aware that the conservatism the Eight had vanquished in New York lived on in Boston. Just that February, Tarbell's first show in four years had drawn twelve thousand viewers in two weeks. Harley Perkins, a 1909 graduate of the Museum School, combated the thrall of the Boston School with John Marin–influenced abstraction; since the Armory Show, he and other younger artists had fought an uphill battle to bring progressive art to Boston. When Margarett announced a Luks exhibition at Prides, Perkins trumpeted her effort in the *Transcript*, of which he was junior art critic. He also noted that Mrs. McKean, the sculptor Margarett Sargent, evidenced "in her artistic efforts a sympathetic understanding of the full free manner which characterizes the work of the painter."

For five afternoons, Ameses, Cochranes, Searses, and others to whom Margarett sent printed cards, clustered by the light of Joe Leland's

north-facing skylights to see George Luks's Boston: a lone vendor shouting up to a resident on Mount Vernon Street, the riotous bustle of a Saturday night market in the immigrant North End, roustabouts striking a circus before dawn. Margarett had hoped for a Boston run on George Luks, but only John Spaulding made a purchase. She vowed that when the time came, she would show her work not in the backwater of Boston but in New York.

On March 12, 1923, Margarett gave birth to a second child, my mother—a black-haired, bright-eyed daughter whom she named Jenny. When Jenny Sargent, still wearing black, came to her namesake's christening, Margarett posed the baby for a photo on her lap in a long white dress. Jenny's evident pleasure, as she tipped a parasol to protect the infant from the sun, was momentary. Mourning her husband and son had become a chronic and debilitating depression akin to what had institutionalized her mother. Since her husband's death, she had abdicated leadership of the family to Dan and to Jane's husband, David Cheever. The departures of her children into their own lives, no matter how physically close their residences, left her full of dread. She had never recovered her laugh. Now she was almost always soft-spoken, given to whispering a quick "much obliged" in response to any kindness. Even her daily visits to Jane failed to stem her melancholy. Finally her children sent her to Dr. Edgerly's in Concord, a sanitarium that offered basket weaving, quiet, and not much else.

Left with nothing to battle in her mother, Margarett ministered to Jenny with an ebullience that infuriated the Cheevers. She'd arrive at Wellesley, little girls in tow, with abundant and luxurious gifts—a piece of jewelry, a dress her sister Jane would never have chosen. After a few hours, she'd depart, leaving behind ideas for brightening the parlor, or opinions on the employment of chauffeurs, suggestions for the resentful David Cheevers to carry out.

In 1921, after a Christmas of profligate bonuses, Richardson, Hill again fell on hard times, and Shaw shored it up with half a million dol-

lars of his McKean inheritance. When the company failed completely
two years later, Shaw did not declare bankruptcy. Instead, he paid
back the investors he could from what remained of the inheritance and
borrowed the balance from the Boston bank of which he was a third-
generation client. The debt was not cleared until he inherited half of
Marian's fortune more than thirty years later.

Shaw spoke of his bad luck only to those who had to know: his
mother and his brother. He had a gentleman's inclination to spare his
wife worldly troubles and concerns, and Margarett a lady's correspond-
ing lack of interest in finance. She knew only that Shaw's contributions
to the household now came entirely from his mother. Throughout their
marriage, Marian provided an ample monthly allowance, capitalized
additions to the house, and was consulted on all family matters, even
those that did not involve money. If the monthly disbursement ran
low, Margarett, drawing on the trust her father had left, wrote Shaw a
check. Later, when she inherited money from her mother, Shaw's sec-
retary, John Spanbauer, would drive up from Boston with checks for
payment of household bills, typed and ready for her signature.

Shaw never recovered from the failure of Richardson, Hill. All his
life he resented George Putnam, whom he watched rise from the ashes
of disaster and move on as if there were no such thing as adversity.
Shaw had been brought up in untold luxury and was used to having
his own money. The fact that his finances were now controlled by his
mother, and therefore limited, irritated him. When asked what he did,
he replied that he "engaged in what might be termed private banking
. . . placing going businesses either with investment banks or with
businesses that wished to expand."

He took on several enterprises, but their exact nature was always
obscure and there were no evident profits. In spite of his social charm,
he could be tactless and insensitive in business unless a partnership had
the feel of sporting companionship. His most conspicuous reversal was
the collapse of an effort to capitalize a chain of restaurants for Howard
Johnson, a loss he always described as a swindle at his expense. He had,
his daughter Jenny wrote, "a Boston arrogance, just missing eccentric-

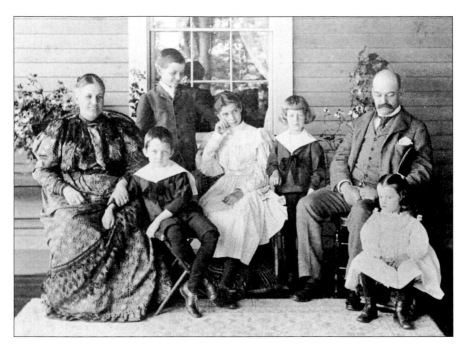

1. Margarett, aged four, with her family. *L. to r.*, Jenny (Mama) pregnant with Ruth, Harry, Young Frank, Jane, Dan, Frank (Papa), and Margarett.

2. Two hired men hoist the family's catch the summer before Margarett's sister Ruth was killed. *Front, l. to r.*, Margarett, Ruth, and Dan. *Rear*, a cousin and Papa.

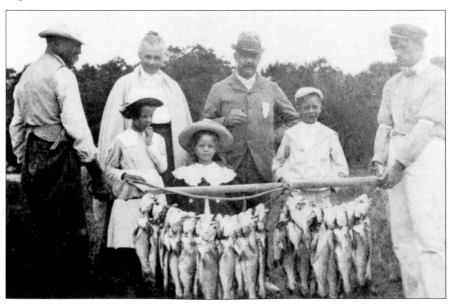

3. Margarett became the most sought-after leading man at Miss Porter's School.

4. RIGHT: Margarett as a Renaissance portrait by Abrogio de Predis, at finishing school in Italy.

6. Against the wishes of her mother, Margarett became engaged to Eddie Morgan, *c. L.*, Margarett's brother Harry; *r.*, Styve Chanler.

5. Q.A.S. "Shaw" McKean began his eight-year courtship of Margarett at her debut ball in 1912. This 1917 portrait is by John Singer Sargent.

7. RIGHT: Margarett's adored older brother, Frank, just before he killed himself in 1919.

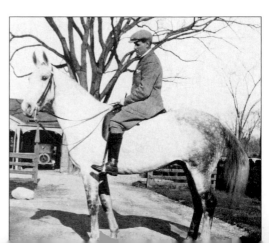

8. Margarett worked for Gutzon Borglum, the sculptor of Mount Rushmore, at his studio estate in Connecticut. Here, she sculpts her dog, Pilgrim.

9. George Luks's 1919 portrait of Margarett, *The White Blackbird.*

10. Ziegfeld's star comic Fanny Brice and her gangster husband, Jules "Nicky" Arnstein. Margarett became Fanny's confidante.

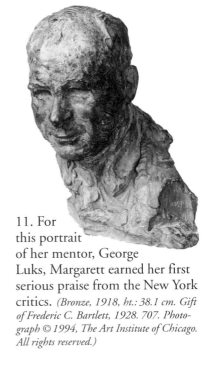

11. For this portrait of her mentor, George Luks, Margarett earned her first serious praise from the New York critics. *(Bronze, 1918, ht.: 38.1 cm. Gift of Frederic C. Bartlett, 1928. 707. Photograph © 1994, The Art Institute of Chicago. All rights reserved.)*

12. LEFT: Margarett's roommate and frequent subject, Marjorie Davenport.

13. ABOVE: Betty Parsons, artist and renowned dealer. Their meeting sparked a lifelong friendship.

14. Margarett's Boston studio became her retreat. After twin sons were born in 1924, she was the mother of four children under three. The plaster reliefs were exhibited at her first New York show in 1926.

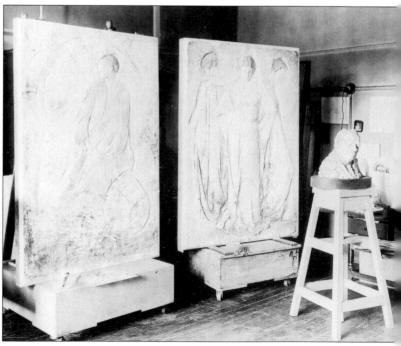

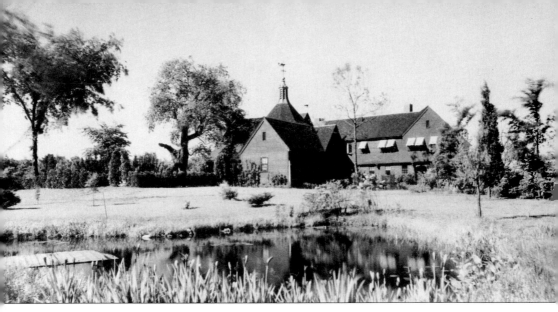

15. Prides, spun from a seventeenth-century saltbox, was designed by Joseph Leland.

16. Margarett's four children, *(l. to r.)* Shaw, Jr., Margie, Jenny, and Harry shoveling snow in front of the McKeans' Boston townhouse.

17. Margarett and Shaw at the Myopia Hunt Club, after their return from the year spent in Europe to repair their marriage. "She took to affairs," said Margarett's friend Mrs. Henry Cabot Lodge, "as easily as to brushing her teeth."

18. The catalogue of Margarett's last New York show, in 1931, illustrated with a portrait of her friend Harpo Marx. Soon after, she stopped painting.

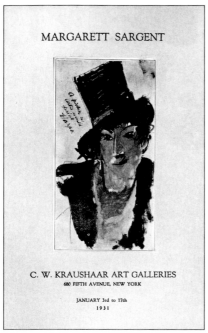

MARGARETT SARGENT

C. W. KRAUSHAAR ART GALLERIES
680 FIFTH AVENUE, NEW YORK

JANUARY 3rd to 17th
1931

EZRA STOLLER © ESTO

19. The great hall at Prides, built to be Margarett's studio, became a gallery where she displayed her treasures— by Gauguin, Calder, Degas, Lachaise, and others.

20. Margarett and *(r.)* her close friend Vivian Pickman, a New York chorus girl turned Boston socialite. They fell out in the 1940s over Margarett's drinking.

Margarett often sketched her lovers.

21. The French art dealer Roland Balay

22. The sportswoman and "notorious lesbian" Isabel Pell

23. LEFT: Shaw's cousin by marriage, Florence Shaw, with her Pekingese dogs

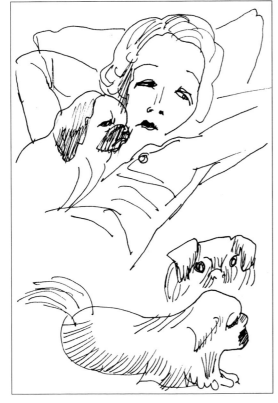

24. The writer Jane Bowles, half Margarett's age when they became involved in 1944

25. ABOVE: The family at Shaw's forty-fifth birthday party. Margarett turned the great hall into a stable, and brought a donkey and a horse through the entrance originally built to accommodate out-sized sculpture.

26. After the years of breakdown and loss, Margarett began a new life, entertaining artists, old friends, lovers, and family. At eighty, she gave a final party at Prides.

ity, which convinced him bad times were bad dreams—most of the time." His son Shaw put it more bluntly: "He was a born loser."

Spanbauer got the telephone call at Shaw's office in Boston, someone from Prides summoning Shaw home to see to Mrs. McKean. Or Margarett, weeping, called Dan, and Dan called Shaw at his office. Dan would say only that "sometimes Margarett behaved very badly." Spanbauer put it more directly: "At times she drank a little bit." Shaw would leave the office immediately, take the train to Prides "to quiet things down." If Margarett had drunk too much at lunch, he would put her to bed. If she was lying down, he sat at her bedside and talked to her.

Naked of confidence and will, she seemed again to be the isolated child with a mysterious illness, blanketed in a deck chair on the seaside porch at Wareham. Nothing Shaw said or did could comfort the old despair, which tugged like an undertow: brothers fleeing her red-faced crying, hands over their ears; headaches at Farmington; the mornings, her debutante year, she awoke "feeling deathly" and stayed in bed. Marjorie Davenport remembered sharp rebukes and black moods, but "of course, in the early days, she didn't drink." Dan became familiar with this particular distress. It started, he said, "only after her marriage to Shaw McKean."

As time went on, Margarett learned to navigate her circumstances. Though her parents' devotion was her ideal, it was not possible for her to surrender without conditions, as her mother had, to marriage and motherhood. Nor was she the sort of woman who could calmly accept the imperfection of her situation and adjudge her marriage "an arrangement." Instead, the relationship became a battleground. Margarett tried to change Shaw, and he tried to change her. His desires were simpler than hers. He loved his children, his dogs, his gardens, his sporting life. He expected Margarett's artistic nature to enhance his domestic arrangement, and it did; but he assumed what she did in her studio would remain there, and it did not. In the moment Margarett decided to become Shaw's wife, she believed she could satisfy him and that, in exchange, he would conform to her specifications. As it turned

out, neither was able or willing to change, and neither could forgive the other. Shaw was in the wrong marriage, but Margarett was in the wrong life.

Margarett was also a creature of her historical moment. On the crest of suffrage, the 1920s had promised new opportunity for women, but in fact, Margarett was as reined in as her mother had been as a young matron. Even her older sister, Jane, a woman without Margarett's talent or temperament, felt thwarted by the administration of an upper-class Boston household, the complexity of which—servants, multiple houses, and entertaining—required a great deal and returned little. One did not, after all, engage in domestic tasks that might offer actual satisfaction—the handling of food, the small attentions to the needs of one's children.

Nothing has survived in Margarett's words from these years—no diary, no letter to Luks, no testimony from Betty Parsons, who had moved to Paris to sculpt after divorcing her husband. Instead, there is a self-portrait called *Distance*. Margarett has drawn her expression as fearful. She wears a smock. She clasps two large brushes, right hand over left, to her breast. The pastoral surroundings indicate that she intended she be seen as contemplative, but how her hands hold the brush, the angle of her head turning to the right, the degree to which her eyes strain right, as if what is behind her could come into view, contradict the serenity in the drape of the smock, the ease of her line, the Vermont hillside stretching out behind her.

In early spring of 1924, Margarett supervised the planting of an arbor-vitae hedge to enclose the new swimming pool at Prides. At one end, she placed her sculpture of Pilgrim, so he could gaze into the water at his reflection. In January, she had become pregnant, and in the spring learned she was going to have twins. By early summer, she could no longer walk unassisted. A new phase of work on the house was completed—the octagonal tower, with its mirrored interior, and a new master bedroom. In August, Margarett hired horses and a flatbed wagon and moved Marian's music room, the only outbuilding to survive the

fire, to a wooded hill at Prides. Her studio had evolved into a living room; with two small daughters and the two babies on the way, it would be utterly impossible to work in the house.

In mid-September, Margarett went to the hospital and, on Sunday, September 22, with some difficulty, gave birth to two boys, Quincy Adams Shaw McKean, Jr., and Henry Pratt McKean II, named for Shaw's brother. Now thirty-two, she had four children under three years old. "May God bless the wonderful mother, the twins & the distinguished father," Luks wrote. Margarett was exhilarated. The twins proved her talent for motherhood to be as protean as her other gifts. "I don't remember what time you were born," she said to her daughter Jenny years later; "I remember only when I had two sons."

The household was already staffed by cook, kitchen maid, waitress, parlormaid, upstairs maid, lady's maid, valet, kennelman, laundress, chauffeur, gardener, and two stable hands. Now it became a circus of doubles: double nurses, double pram, double bassinet. To look after Margie and Jenny, Margarett hired a governess, an eighteen-year-old girl from Manchester named Catherine Neary, whom Margie christened "Senny." In early summer, Margarett posed the twins' baby nurses, photographing them, each with an infant on her left hip, each with a little girl at her side holding a brother's tiny foot.

That winter, Margarett returned to the studio. The chaos of her household had changed her work. Her new sculptures were of women, but not of living models like the 1919 drawings for which a woman's physical motion had provided suspense and surprise. Nor were they documents of volubility and exchange, like the head of Luks. Working in plaster and in two dimensions, Margarett began to make reliefs, studies of the female figure that were mysterious and quiet. Until now, she had used sculpture as a way into character and passion; now, with large figures that represented no one in particular, she explored silence and contemplation.

As the plaster set in a freestanding wood frame six feet high, Margarett textured its surface to hold the wet plaster she would add later

and model into relief. As that plaster thickened from the consistency of milk to the feel of heavy cream, and then to a paste almost as dense as clay, she raced its loss of malleability, feeling on her hands the heat it gave off as it hardened. Across the surface she modeled drapery—a rhythmic roil of plaster—and the rising contours of face and hand. Next, she incised the surface—long sweeping lines for drapery, short lines for eyebrow or mouth, an edged-in pattern for the roughness of hair. Finally, at the suggestion of Luks, who, she told a reporter, "claimed the Greeks had employed it," she tinged the panel with color to achieve an effect "faintly reminiscent of Pompeiian frescoes and Egyptian tomb decorations."

A seated woman takes up the entire surface of *The Wheel,* spokes opening behind her. Fifteen nudes move through a mythic forest scribed onto a second panel. When the third relief—three standing figures, Graces or Fates, classically draped, each facing a different direction—is viewed from a distance, the women become one form, a huge amaryllis-like flower, opening. "To a remarkable degree," Harley Perkins wrote after he saw the panels at the studio on St. Botolph Street, "they seem to express the quite natural and unaffected unfolding of their creator's thought." By the end of the winter, Margarett was ready to show.

THE SEASON of Margarett's first New York exhibition was marked by two events. In December 1925, Alfred Stieglitz opened his first gallery since he closed "291" in 1918. The Intimate's first exhibition was of John Marin, followed by Arthur Dove in January and, in February, Georgia O'Keeffe—large flower paintings and one cityscape. But Stieglitz's American modernists were no longer isolated in their innovation; other New York galleries that winter exhibited Chagall, Archipenko, and Fujita.

The second event was a memorial exhibition of the collection of John Quinn, the explosive red-haired lawyer of Irish decent who had represented the organizers of the Armory Show and defended James Joyce's *Ulysses* against obscenity charges in 1921. "Art World Amazed

at Contents of Quinn Memorial," read a front-page *Art News* headline on January 2, 1926. Below it reclined Henri Rousseau's *The Sleeping Gypsy*, and an alphabetical inventory—Braque, Cassatt, Cézanne, Picasso, Prendergast, et cetera—enumerated works offered in the first sale to test the market for the Post-Impressionists. After a year of sales in New York and Paris, the proceeds totaled a stunning, for the time, $700,000. The "artistic anarchists" of whom Kenyon Cox warned after the Armory Show were now worth real money.

American museums and a new generation of American collectors scurried to catch up. The 1920s were the years in which "Modern Art" would make it way into the American mainstream, displacing forever the sensibilities that had nurtured Margarett as a young artist. The gallery where she chose to exhibit, and with which she had a six-year association, embraced Luks and his contemporaries, while looking abroad to the School of Paris, the painters who would be her later influence.

Margarett had met John Kraushaar through Luks when she lived in New York, but she must have approached him herself when she wanted a show, because by 1925, Luks was exhibiting elsewhere. Kraushaar was Luks's contemporary—they had met as young men playing scrub baseball on Long Island—and nine days after the Armory Show closed, he'd opened Luks's first one-man show. The Kraushaar Galleries, founded in 1885 by John's older brother, Charles, made its reputation showing nineteenth-century paintings by French and Dutch artists, but when John joined the business, he began to acquire French modernists—Matisse, Rouault, eventually Modigliani and an occasional Picasso. By the time Margarett came to New York in 1918, he also showed Sloan, Glackens, and Prendergast, all members of the Eight. After Charles died, in 1918, John took over the gallery, by then one of the three or four most important in the city. He continued to exhibit French paintings and, from time to time, showed American modernists like Marsden Hartley and Gaston Lachaise. The year of Margarett's first show, he began his season with John Sloan and ended it with a group that included Constantin Guys, Maurice Vlaminck, and Aristide Maillol.

Margarett's first one-person exhibition opened on March 1, 1926. It was advertised in seven newspapers, and five hundred announcements, illustrated with *The Wheel,* were mailed. The catalogue listed twelve watercolors and four sculptures. *Town Topics* hadn't had so much to say about Margarett Sargent since her broken engagement: "the fascinating Mrs. Q. A. Shaw McKean, known to the artistic world at Margaret [*sic*] Sargent, is showing her things this week at the Kraushaar Galleries in New York. . . . While Margaret has her art, Shaw has his dogs which he loves almost as much as she loves her creations."

The watercolors, the three large plaster reliefs, and the bronze head of the Mouquin headwaiter, Chaffard, were installed in one of the gallery's two rooms. Among the watercolors were the self-portrait *Distance* and a portrait of George Luks, which *Art News* praised for its economy: "hardly more than a soft brown hat." The panels were priced at $1,000, the head at $500, and the watercolors between $50 and $200. Two watercolors sold, *Distance* and *Birches*—a woman in a purple jacket standing in a grove of the white trees. To Antoinette Kraushaar, in her early twenties and working as her father's stenographer, Margarett seemed terribly glamorous: "She had a *lot* of admirers." But she didn't remember talking to her: "She couldn't have been, probably, less interested in me."

The critics greeted Margarett warmly. Several remarked on the likenesses of Luks and Chaffard, whom they knew from Chez Mouquin. Henry McBride found "an innovation" in the surfaces of her plaster panels, *Art News* praised her "amazing talent for leaving out of her delicate watercolors all that is not strictly essential," and the *Herald Tribune* spoke of "the glamor of a new and ingratiating talent." Helen Appleton Read, the only woman critic to review the show, wrote a long piece in the *Brooklyn Eagle.* She saw in "the movement of the body suggested by a great sweeping curve, the head by a simple egg shape," that Margarett had "observed the beauties of abstract sculpture with profit to herself." She praised her freedom in the face of Modernism, "a tyrant," she said, "to which scarcely a talent has not paid homage."

Read was the only critic to refer to the fact that Margarett was a woman. She had struggled with the issue of femininity in a review of Georgia O'Keeffe's flower paintings in 1924 and, in writing about Margarett's watercolors, raised it again, drawing the vague conclusion that the artist's gender was evident and, as with Berthe Morisot, Marie Laurencin, and Mary Cassatt, "a full half of her distinction." But it was the quality of her line, Read concluded, that was Margarett Sargent's "most striking characteristic, her outstanding contribution as an artist."

Margarett had achieved what she envisioned for herself when she turned aside Eddie Morgan, and neither the death of her father, marriage, nor the quick arrival of four children had obstructed her way. Now, at thirty-three, her first show mounted by one of the most prominent dealers in New York and welcomed by the critics, she was not only an exhibiting sculptor but "that rare apparition," an enraptured critic wrote, "a stranger coming here wholly unheralded and yet with an astonishing number of things to say for herself."

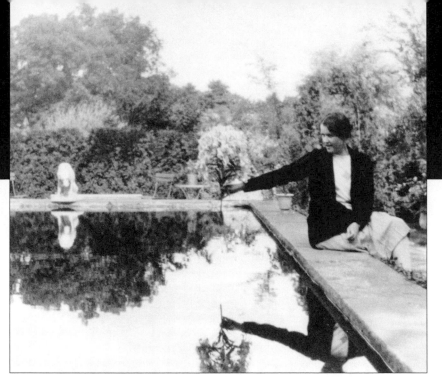

vi

It was a time of hope,
that was the thing

(1927–1930)

Margarett at Prides, c. 1928

H ER LINE RUSHES as if attracted to each object in the room: the dark wood bed frame, its tall, ornamental headboard; a small American bedside table—on it, telephone, tumbler, pocket watch; a child's chair at bedside; pictures on the wall; a woman's shoes askew on the floor; the bed itself, linens rumpled, a hat hurled on mussed pillows—all sketched with charcoal. Then, as if composing a variation, she lays in pastel: white-green striates walls, buff paper shows through where light doesn't reach; sky-blue diamonds on the seat of the chair, black telephone rendered blue, white-green to model one pillow, heavy cream etching curves of another, bright white for the creases of sheets, all leading the eye to two garments—one rose, the other robin's-egg blue—slung on a bedpost toward the lower right of the drawing. Below, on the slightly tilted floor, the shoes—black with rose insides.

If you enter the room, you see something else: an artist at work, tray of pastels set out beside her, paper on a small easel. This was the bed-room Margarett shared with Shaw, but his bed is not in the picture. In this room, its walls lined with silk, there were two Venetian beds, one unlike the other; Margarett has left out her husband's. What you see is a woman's sleeping room, sunlight falling across the voluptuous shapes of an unmade bed, sheet, pillow, beautifully made nightclothes.

"There were five, six, or seven remotely happy years," Margie said of her parents' marriage. "It was a terribly abnormal, strained, difficult, tenuous relationship," said young Shaw. And Harry, his twin: "I never knew any happiness between them, ever."

In 1927, when Margarett reencountered Eddie Morgan, Margie was six, Jenny four, and the twins three. As they got older, they became aware that their parents led separate lives, that Margarett had many affairs, and that Shaw, in spite of an abiding fascination with his wife, had, as young Shaw put it, "his share of girlfriends." Eventually they learned that Margarett was once engaged to someone named Eddie Morgan, but never that she saw him again, except to arrange for his two sons to come to Prides and play—"they could run very fast," Jenny remembered, "and had mysteriously dark eyes."

"It went on for quite a while," said Eddie Morgan's son. Years. "There were even rumors that Shaw McKean went down to Philadelphia to dig them out of some hotel." Eddie had become a partner in the Wall Street brokerage Richard Whitney and Company, which traded for big banks and big clients, notably J. P. Morgan and Company. In 1927, he was thirty-seven years old: black hair slicked back, handsome face symmetrical enough to carry off a part down the center of his widow's peak. He'd handily paid off the eighty thousand Mike Vanderbilt lent him to buy a seat on the New York Stock Exchange and had made a quick fortune in steel stocks. Now he ran what his son called "the Old Westbury rat race—social life and alcohol."

In just a few years, the sheen of luck would be off Eddie Morgan's life. His wife would die in 1934, just months after Eddie, knowing she was terminally ill, announced to her his plans to leave her for her best friend. In 1938, Richard Whitney, whose efforts to stem the fall at the stock exchange late Black Thursday had earned him its presidency five years in succession, would defraud his clients of more than a million dollars to shore up the applejack distillery in which he had a controlling interest. Eddie, innocent of knowledge or complicity, would read the news on the front page of the *New York Times*; Whitney would go to Sing Sing, his wife and daughters to work. Bankrupt and socially disgraced, Eddie would move his new wife, her two children, and his to a Maryland farm purchased for him by a group of friends, Dan Sargent among them.

But in 1927, Lybba Morgan was alive and beautiful, Richard

Whitney trading in a booming market, and Eddie eager to pursue the woman who had broken his youthful heart. "The old man told the story more than once," said Eddie Morgan, tall and dark like his father. Margarett would come to New York and check into a hotel. She would telephone, and he'd be summoned from the floor of the stock exchange. " 'Eddie, I'm here,' she'd say in that deep voice, and he'd leave the floor and go shack up with her." Young Eddie was a bit embarrassed to report the detail his father most often boasted of: Margarett would arrive in New York, check into a hotel, telephone, and Eddie would rush from the floor of the New York Stock Exchange "with an erection."

Margarett was, as Betty Parsons put it, "a highly sexed woman." "She took to affairs," her old friend Emily Lodge said, "as easily as to brushing her teeth." War and the reality of her marriage had sundered all obligation to her parents' expectations. The difficulty of the twins' birth had prompted her obstetrician to prescribe an abortion when she got pregnant in 1927 and, soon after, in spite of her desire for more children, a hysterectomy, which, she said, "made me careless with men." Fifteen years after the broken engagement, her attraction to Eddie was muddled neither by youth nor by the threat of matrimony. They resumed their relationship, young Eddie said, "in a red-hot sexy affair."

Aside from Betty, who was in Paris, Marjorie was the only person in whom Margarett confided. "I've been seeing something of Eddie Morgan," was how she phrased it, with a particular grin, relishing her friend's familiar horror and delight. In 1927, Marjorie was thirty-six, Margarett thirty-five. Differences that had seemed slight when they were in their early twenties now bore social weight. Margarett paid Marjorie's rent in Vermont until an uncle left her enough money to buy a house, enough to go to Paris. Margarett traveled whenever she pleased, and she was married. "Margarett could have had anything, you know," Betty Parsons said, "and Marjorie was Little Miss Muffet." Marjorie brought a beau to Prides, and Margarett flirted with him, even, Betty thought, took him to bed. But the friendship survived this, as it had Margarett's marriage and the offense of the last-minute telegram.

At the end of her life, Marjorie did not believe Margarett had ever loved her, and when she described Isabel Pell, the woman whose visits to Prides supplanted hers, she used the word "wicked." Margarett would never have admitted she treated Marjorie callously, would have described herself as "devoted"—"incredulous" at her friend's indignation. In 1926, leaving out the tension in their friendship, she did a watercolor called *The Quilt*—Marjorie asleep, beautiful and dreamily rendered in pale washes, both hands resting carefully on her chest, the quilt covering her a splash of vividly painted squares, an opening path.

Margarett's second New York exhibition, at Kraushaar in March 1927, included a group of large watercolors, *The Quilt* among them. "Though slight, their note is clear and fresh," the progressive critic Forbes Watson wrote in the *New York World*. "Her attack is not in the least literal," he continued, "and where a hint will do she does not, so to speak, insist upon writing a chapter." Margarett also showed three new plaster panels, to be the last she'd exhibit. Life at Prides pulled her from the studio and its solitude. What had been confined to her sketchbooks—the vitality of the household—she began to treat in large pastels.

Marjorie sits at a dressing table, hands in her lap, having her hair washed by Miss McNamara from Manchester. Margarett puts Margie behind her; in short underwear, spindly legs bare, she scrutinizes a book. Jenny looks up from a book on her lap; and a small black-and-white dog, slash of red for his collar, poses on the floor.

A woman, reclining on a green chaise longue, wears a rose peignoir, its ostrich collar languorously open. Margarett uses colors as dusky as those Lautrec painted Paris prostitutes, so the little girl is a surprise. In short dress and hair ribbon, she sits on the edge of the chaise, hand resting on the woman's. Marjorie, wearing Margarett's peignoir, hair dark around her face, could be Margarett, if Margie, who was the child, did not remember it was Marjorie's hand she held and her mother who quickly and quietly drew.

The announcement of Margarett's third Kraushaar show, in February 1928, was illustrated by the pastel of the unmade bed. For the first

time, she did not show sculpture, just pastels and watercolors. In the *Brooklyn Eagle*, Helen Appleton Read remarked on her "new-found vivacity and interest in reality," and Henry McBride, in the *Sun*, noted her search for "free expression and simplicity. . . . Occasionally in the effort for the last named quality she misses a direct contact with life, but occasionally also, she gets it precisely."

Although Margarett was showing in New York, she had become a presence in the Boston art world. Kraushaar advertised her New York shows in the *Transcript*, and in December 1927, she was included in a group exhibition of American portraits at the Boston Art Club. "It is here that a Bostonian, Margarett Sargent, makes her first local appearance in a general exhibition," Harley Perkins wrote in the *Transcript*, "saying the essential things with the fewest of means."

By showing at the Art Club, Margarett allied herself with the group of insurgent painters, Perkins among them, who were turning the venerable organization into a venue for artists who looked toward what was new in New York and Paris. Though Margarett was more interested in work that distorted the recognizable than she was in abstraction, and though her temperament was more "avant-garde" than her taste, it was in Modernism that she found her aesthetic home. Its expressiveness reassured her; it seemed natural to be more interested in color than in fidelity, to experience distortion as revelation. Her rage at "those dreadful hunting prints," transformed to a hunger to see things in her own way, would soon change her art.

Easily and naturally, she sought the like-minded. "Modernists respect the past," she snapped to a reporter in 1928, "but why copy it?" Two years later, when Florence Cowles of the tabloid *Boston Post* came to interview her, Margarett was more diplomatic. Smiling, she said she understood why her work was considered modernist: "We must be called something. If you say a girl is pretty or ugly, I know what you mean, but literally of course, we are not 'modern' as many of the painters who belong to the school were painting 60 or 70 years ago. It is that the public is just becoming aware of us."

Boston associated Margarett with modernism not only because of

her work but because of the paintings she and Shaw had begun to collect. She had always collected what she aspired to in her own work. When she was sculpting, she bought heads by Despiau and Lachaise, and when she was rendering women in pastel and watercolor, she purchased female likenesses by other women artists—Mary Cassatt, Berthe Morisot, Marie Laurencin. In the autumn of 1927 in New York, Margarett began to buy bold paintings by French Modernists—in September, *Mademoiselle X*, the head of a young woman by André Derain; in December, *The Storm*, a landscape by Maurice Vlaminck. On the last day of the year, she bought a painting the Reinhardt Gallery listed as *Head of the Artist's First Wife*, by Picasso.

It's possible the title was a nod to propriety; the subject of Margarett's Picasso was not Fernande Olivier, the woman considered his first wife (they never married), but a courtesan. In 1901 in Paris, twenty years old and under the influence of Lautrec—Blue Period and Cubism still years ahead—the artist painted a woman with a strong, hard face, a twist of red lips, a pompadour of orange hair, a huge, curling yellow hat with an enormous black plume. In Boston, where there were no Picassos on public view and few in private collections, Margarett's purchase got publicity—in the *Transcript*, a large reproduction announced acquisition "for the McKean collection of Boston" of "A Painting by Pablo Picasso, a Leader of the Modern Movement in Paris."

Margarett's Picasso was no longer avant-garde, but the artist's name, even on a work barely twentieth century, was a salvo in the battle between the Young Turks at the Boston Art Club and the old Tarbell-Benson establishment. In December 1925, the club had mounted an exhibition of thirty-nine Post-Impressionist paintings, the first significant display of modern European painting in Boston since the Armory Show. Crowning it were Seurat's *Sunday Afternoon on the Grand Jatte* and Matisse's *Woman Before an Aquarium*. In a long essay in the *Transcript*, Margarett's friend Harley Perkins cheered on the Art Club's campaign to ease acceptance in Boston of the work it had so vehemently rejected in 1913.

The paintings in the exhibition belonged to Frederic Clay Bartlett,

a Chicago artist and collector who had just purchased a house on the
sea at Beverly, not far from Prides. Like Margarett, he was a child of
the upper class who had declared himself an artist. He wrote with
sacred intensity of his youthful apprenticeship in Munich, described
touching a bowl decorated by Dürer, its surface "made gloriously
beautiful, most holy and divine by the great master." He'd traveled in
Italy, studied with Whistler in Paris, and met Puvis de Chavannes,
whose allegorical murals inspired him. Within a few years of his return
to Chicago, his commissions decorated many of its buildings.

Margarett immediately sought him out. He was, like Luks, an
older man with a great deal to teach her about art, and she was, like his
wife who had just died, a strong and artistic woman. Frederic fell a lit-
tle in love with her, and Margarett considered him a godfather. By the
time they met, Bartlett had turned away from murals and was painting
canvases in a vivid, School of Paris style; it was through him that Mar-
garett first took a good look at the painters who became her major in-
fluence. Bartlett had always been a collector as well as an artist, but it
was not until his marriage to Helen Birch, a younger poet and com-
poser, who shared with her friend Harriet Monroe, editor of *Poetry*, a
passion for modern art, that he began to buy Matisse and Seurat, Gau-
guin and Modigliani—avant-garde works, Helen wrote with excite-
ment to a friend, "which someday not far in the future will be seen."

In 1925, Helen died of cancer—they had been married just six
years—and Frederic offered their collection to the Art Institute of
Chicago. After a fractious debate among its conservative trustees, the
museum accepted the gift, and in the spring of 1926 the Birch-Bartlett
collection opened, in an explosion of publicity. "Americans who wish
to enjoy the acquaintance of European modernist artists must make
the journey to the metropolis of the Middle West," a New York edito-
rial advised, "for since the disposal of the John Quinn collection here,
there has been no representative aggregation of their work in this
neighborhood."

In fact, the Barnes Foundation, with its collection of nearly a
thousand Impressionist and Post-Impressionist paintings, had opened

in monumental limestone galleries near Philadelphia in March 1925, but admission was granted, irascibly, only to a chosen few. In New York in 1920, Marcel Duchamp and Katharine Drier had founded the Société Anonyme to introduce European abstraction—Kandinsky, Mondrian, Malevich—but the Museum of Modern Art, its inaugurating collections rich in the Post-Impressionists, would not open until 1929. Bostonians had to wait even longer. The Institute of Contemporary Art (founded as the Boston Museum of Modern Art) was not to be incorporated until 1936.

Despite the exhibition of the Birch-Bartlett collection, the climate in 1926 for Margarett and her fellow Boston modernists was, as Harley Perkins put it, "a tight lid." That February, in the Boston column he wrote for *The Arts*, he flew the idea of a Boston Independents show, open to any painter who wished to accept the invitation. He believed the Museum of Fine Arts, which had barely flirted with European modernism, would never embrace contemporary American art. "It is time for another Revolution," he wrote, "with minute men in ambush."

The revolution came in the form of Jane Houston Kilham, a tall Californian redhead trained as an artist in New York and Paris, who paid her six children a dime an hour to pose. She envisioned a Boston exhibition in the tradition of the Salon des Réfusés of 1863 and the First Impressionist Show of 1874, and rented a derelict stable on Beacon Hill. Margarett enthusiastically joined Kilham's Boston Society of Independent Artists, which proclaimed itself "reactionary toward no existing institution, but open to all." The New York independents had been organized by Robert Henri and John Sloan, great men; the Boston group was led by women—"one of the most striking points of the whole undertaking," Perkins remarked. Kilham was president, an anonymous Boston woman paid renovation expenses, and, from New York, Gertrude Vanderbilt Whitney and Juliana Force lent support by encouraging the participation of several New York artists.

Margarett and Shaw were among those who arrived at the Beacon Hill stable on the very cold afternoon of January 16, 1927, entering the exhibition space through a "tea room and eating place where the

visitors may dally" and a central court "lit from above and hung with flowering plants." Hundreds of paintings, each fully illuminated by the specially designed lighting grid, jammed every foot of available wall. Harley Perkins praised the show's "robust vitality" and assured readers of the *Transcript* that they would find "a goodly number of very able achievements pricking through the rift of mediocre and nondescript offerings."

Among the "considerable percentage" of female exhibitors were Margarett Sargent, Jane Kilham, and the Boston Impressionist Lilla Cabot Perry, seventy-nine years old and a friend of Monet. No checklist of the first show survives, but when the *Transcript* reported works sold from the Independents' second annual, the following winter, all three Margarett Sargents were on the list.

THE SKETCHBOOK is eight by ten inches. On its mottled black-and-white cover is the date, 1927. On its first page, Margarett draws a young man, half of him. Her line is thick as a wire hanger not meant to bend. She gets what's gentle about his mouth, the tentative angle of his head, then contradicts with a swagger of lapel. On the reverse page is his other half: bottom of jacket, hand, crayon-jagged legs crossed at the ankle. If an entire face does not hold her, she excerpts. Of an anguished man, she draws just a balding brow and eyes that don't balance.

There are pages of men drawn with that hanger line. They wear ties. Their hair is slicked back. They are weak and weakly drawn, don't look up from their reading or out through their glasses. Then, abruptly, Margarett is no longer bored. She draws a man in a tuxedo, places him at an angle on the page. Poker-straight lines as random as pick-up-sticks cohere as his jacket, and above the tall starched collar and the black tie, a densely drawn swarthy face. He looks up—dark hair, bristling eyebrows, sunken eyes, turned-down mouth, gutted cheeks. This in charcoal, then across the surface, like bird tracks in sand, the odd delicate line exposes the pain beneath: a quick moment, like certain silences in conversation.

The drawing is of Roland Balay, a French dealer, member of the Knoedler family and director of its galleries. Margarett met him in London, walked with Shaw into an exhibition of old-master flower paintings, asked to see the person responsible. Roland came forward— a small, quietly witty man with a spark behind his eyes, no sign of the darkness Margarett later got in the drawing. They had dinner immediately, talked in French and English, talked about, among other things, Donatello and Della Francesca. Roland was, by his own account years later, undone. "Surrealiste," he said of his new friend. "The essence— aristocracy, intellectuality, vulgarity."

Roland was married, but in the French way he continued his amorous adventures. When he got to New York, he did not hesitate to telephone Margarett. He was coming to Boston, he said, to deliver a Braque; perhaps she might like to see it. They had lunch at the Ritz, and afterward, when he rose to go up to his room to get the picture, Margarett stopped him. "I'll come with you," she said.

"No, no," Roland said, "I'll bring it down."

"I'd like to come with you—"

"But no, Margarett, I—"

She hesitated. Telling the story, Roland shrugged and, disingenuously, blushed.

It was the beginning of a long affair. "In and out," Betty Parsons said, "as the wind blows." Afternoons at exhibitions and evenings in hotel rooms in Paris and New York, the tango at El Morocco, nights in Harlem at the Cotton Club. Roland understood Margarett in a way she wasn't used to. She had *"fantasie,"* he said, purposely avoiding an English word. Soon he and his wife were visiting Prides, and Roland was hunting and fishing with Shaw. One night, hours after Roland and Mimi had gone to bed, Margarett appeared in the garden outside the guest room. Roland was not surprised, just eager she not wake Mimi. "Roland!" Margarett said in a stage whisper.

"Shhhhhhh." He gestured through the window, putting on his robe.

"I have something extraordinary to show you," she said, leading him to the pool. There, by the light of the moon and its reflection,

calmly floated a Canada goose. Again Roland was not surprised, as he had come to expect from Margarett a confusion of life with dreams. The next day, he took her aside. "That was certainly one of the most interesting things I've ever seen." "Well," she said, "I tied it there for you to see."

If Margarett was to move on entirely from sculpture, she would need a medium to accommodate and amplify what had such force in the drawing of Roland. The face with gutted cheeks burned through pages of children, nursery twins, tentative young men, and a woman beautifully drawn with a supple, fluid line. "George Luks met me and told me I should be a painter," Margarett said. Her old friend had guided her through every transition she'd made as an artist, but the urgency had always been her own. The shift to oil was swift. In February 1928, she had shown pastels and drawings. That summer, she began to prepare for a January show at Kraushaar, in which she would exhibit twenty-four oil paintings.

"Your photograph irks me that I did not seize your face in paint," she wrote me once. Seize: Margarett's most characteristic paintings took possession with the unapologetic directness of that word. Her bravado was another gift from Luks. In 1927, he visited Prides, and Margarett commissioned a portrait of Jenny, who was then four, dressed as an infanta. Little Jenny stood as with frenzied dispatch Luks laid in brocade with a housepainter's brush, muttering, "Velázquez, he was the baby," and producing a delicate and vital likeness.

Margarett took from the older painter, sixty that year, what served her—spirit, nerve, speed, an emotional approach—but not color or brush technique. His palette evoked the Spanish or the Dutch: colors rich and dark, lighter hues emerging from darkness like light in a night fog, figures modeled with an abundance of paint. Margarett painted with bright, clear colors, diluting pigment so the color became almost transparent, or modeling a faint impasto across the canvas.

She began to use oils in Vermont the summer of 1927, the family's first in Dorset, the village where Marjorie Davenport lived. In the

countryside, large working farms interrupted a landscape of mountains, meadow, marshland, and abandoned quarries. In town, the sidewalks were slabs of white Vermont marble, and in the clapboard farmhouse Margarett and Shaw bought for four hundred dollars and moved to a plateau on West Road, everything that could be was marble—bathtub, windowsills, thresholds, the terrace out back.

For a month, the McKeans lived, as the Sargents had at Wareham, a life that could be described as simple. Everyone ate at a big table at one end of the open living room, then sat around after supper on furniture Margarett picked up at farmyard auctions and draped with patchwork quilts. Margarett and Shaw shared a room that adjoined the only full bath; the girls and Senny the only other bedroom. The twins slept in a loft above the big room.

Margarett often left the house at six in the morning. She took ink, charcoal, and watercolor, made sketches, then, at home, enlarged and enhanced the images with oil paint on canvas. She painted Vermont people without sentimentality: country women, whose gaunt faces showed both their intelligence and the harshness of their lives; a tall thin man in a dark, derelict doorway; Annie, a neighbor girl who played with Margie and Jenny, wearing a white dress, bent over sewing, too large for her chair.

When Margarett returned at dusk, Shaw was often at the stove. He had learned camp cooking in his copper-mining days, and he and Senny split the job in Dorset. "I imagine you painting boys with apples, or women with arms covered with soap suds," Dan wrote Margarett. "Shaw has a white chef's cap on when he cooks. He heats up the sauce in a blue sauce-pan, stirring it with a wooden spoon. 'Taste this,' he says."

There had been artists in southern Vermont for decades, and painting was in the air. Margarett got the children to paint, and in the ease of the country even Shaw set up an easel. In the 1928 summer annual at the Equinox Hotel in Manchester, Margarett showed paintings, Jenny McKean a portrait in the children's division, and Shaw McKean a group of oils—colors faithful, edges definite, contours re-

strained: the bone china tureen on a table between two windows in the big room; little Shaw, blond, sitting neatly on a chair.

In a photograph, Margarett stands grinning on the marble-slab terrace behind the house. "She loved it there," Margie said.

By the autumn of 1928, back in Boston, Margarett was painting with assurance. If you looked for American resonance, you saw the women Alfred Maurer painted in hot Fauve colors; the stylized, chic restaurant habitués of Guy Péne du Bois, the 1920s figures of Walt Kuhn. Or you saw Paris: the abrupt, committed intensity of her own Picasso, the unnerving challenge in the gaze of that woman in the yellow hat. Margarett brought this directness to her most compelling subjects, women and men of social Boston who like herself chafed against its suppression of sensual will, its curb on the demonstration of feeling, its social requirements. How this conflict came through a face was what she painted.

At first, the portraits were ironic. Like Margarett, her subjects rebelled with charm and wit, a tossed-off light-touch arrogance, as in a 1928 portrait of a woman in a cloche hat, devil-may-care "Whoopee!" scrawled across the top of the canvas. As she became more experienced, the paintings challenged and deepened, leaving behind the pale lyricism with which she'd made watercolors of Marjorie Davenport, the buoyant entertainment of her Prides pastels. When she first used oils in Boston, Margarett hired a round-faced model named Edna, of whom she painted disengaged, placid portraits, but there was nothing, it seemed, in Edna's presence to knot the elements of composition into a tough, energetic whole. In 1928, when she began to paint her cousin Bobo's widow, Maria, all that changed.

The wall behind the woman is pale pink. Next to her, loosely painted, a table; on it, a large Chinese lamp, white porcelain and white silk shade swirled light and dark blue. Visible behind the lamp is the edge of a gilt frame, and in the foreground, a vase of pink flowers cropped at the right edge of the canvas. It is a background for a lyric Cupid or a languishing Venus, but Margarett has introduced a mod-

ern Diana. Sitting tall, the dark-haired woman holds a dog, a fox ter-
rier that sprawls across her lap. The dog looks at us; we see the woman
in profile. Her alabaster skin shimmers with faint undertones of blue,
pink, and yellow, and the effect is luminescence, paleness that shocks
in contrast to the black of her hair, short and pulled behind her right
ear. Her nose is slender, aquiline, her long neck elegant, chin delicate.
Her shirt with its flipped-back man's collar is deep cornflower blue; its
faint purple glow sets off a luscious violet jacket. All of this would re-
cede in pleasing harmony if it weren't for the bright-red hat, close to
the head—a crimson crown—not modest or restrained.

Maria deAcosta was born in New York, one of eight children of a
Cuban father of Spanish ancestry and a Castilian mother whose noble
birth, beauty, and inheritance eased the deAcostas to the center of
New York society. Their daughters became unreluctantly famous:
"Oh, she was one of the deAcostas," people would remark. The
youngest, Mercedes, was an intimate friend, possibly a lover, of Greta
Garbo, and in her 1960 autobiography published photographs of her-
self with Garbo, Cecil Beaton, Stravinsky, and Marie Laurencin. The
oldest, Rita, was a famous beauty, whose portrait by Boldini is in the
collection of the Louvre.

Maria was a dozen years older than Margarett, who met her when
she was married to Charles Sprague Sargent's only son, Robeson. After
Bobo's death, of flu in 1918, Maria lived in Harvard, Massachusetts,
with her son and a woman named Miriam Shaw. "A Boston mar-
riage," a niece explained: Maria flamboyant, effusive, and Spanish in
her picador hat; Miriam a bluestocking and, though younger, "more
like Maria's governess than anything else."

In another of Margarett's portraits, Maria wears a plum-colored
beret. Her right hand rests on her knee, her left is half hidden in a
pocket. Her sharp Spanish features are animated. One eyebrow is nearly
obscured by the angle of her beret; the other is raised, bemused and
disdainful. Her expression is mischievous, her mouth about to laugh.
The taupe suit she wore for this portrait could be called "mannish," an
effect accentuated by the tawny vest, the pale-blue ascot. "Oh, I'm sure

she was a lesbian," exclaimed another niece, telling a story—Maria greeting her from bed, wearing a black lace slip, holding a glass of whiskey, the two of them alone in the house. At lunch once at a women's club in Boston, Maria malapropped: "I wouldn't be in town at all, but I needed a new pair of bisexual glasses." Margarett called the portrait *Tailleur Classique.*

"Oh," said Betty Parsons, looking at a slide. "That was Maria deAcosta. She had a *passion* for Margarett."

What sort of passion? If the red hat were a faded letter in a torn envelope, a page from a journal, it might answer that question. If *Tailleur Classique* were a short story, one might find clues to the mysteries of a half-hidden eyebrow, a hand almost concealed in a pocket. What passed between the two women when Margarett wasn't painting, when Maria wasn't posing with a dog or, as in a third portrait, sporting a bright-red smock and holding a cigarette, its ash hot and live?

Margarett and Maria may have had an affair or they may not have, but Margarett's lovers were not all men. More than one woman testified to having been approached, to having reciprocated with confidence. "Margarett had love affairs with women, there's no doubt about that," Betty said. But, also, "Margarett was a very subtle woman. She wouldn't tell you." When Margie was in her late twenties and curious about her mother's life, she sat Margarett down and recited a list of certain women who had come to stay at Prides for weeks at a time. "They were all lesbians. Surely you had affairs . . . !" Margarett faced her daughter down. "I've only known one lesbian in my life," she declared, and mentioned a woman with whom she had no particular friendship. She knew that as long as she was discreet, she could do as she pleased. If she was a lady in her behavior, her secret life, however well known it was, would not interfere with invitations to dinner.

Margarett had admired—had even had a crush on—Eleo Sears when she was a child and Eleo and Alice Thorndike were Amazons of the pony rink at the New Riding Club. Eleonora Sears had never married. She was the first national women's squash champion, four times the national women's tennis doubles champion, and the first woman

to play polo, and was famous for the long walks she took from Providence to Boston accompanied by Harvard undergraduates, escorted by a chauffeured limousine stocked with refreshments. Eleo was both open and discreet. Protected by great wealth, her mystique enhanced by tall good looks, she lived a proper Bostonian life and, apparently, loved women. "Everyone knew it, but it was never spoken of," said Nancy Cochrane, one of Vivian Cochrane's daughters.

Miss Sears, as she was known to servants and children, was eagerly received by every North Shore and Boston hostess, and invitations to the famous dances she gave in the ballroom of her house in Prides Crossing or, in the winter, in Boston were prized. "She was such fun," said Margie. "I loved Miss Sears," said Paul Moore, who would marry Jenny. "Even a stuffy banker like my father loved her!" On a Thursday afternoon, Eleo might play bridge with a group of North Shore wives, on the weekend receive her particular friend, a young French actress who'd take the train up from New York. "Mother would take us to tea at Miss Sears'," Nancy Cochrane said, "and there she'd be, Mademoiselle. Eleo was madly in love with her, gave her a Duesenberg. Oh, they were so glamorous!"

The young actress had displaced another woman in Eleo's life. Isabel Pell, of New York, London, and, later, Paris, was tall, lean, and, Margie said, "handsome, *wonderfully* handsome." By the late 1920s, Isabel was visiting Prides three or four times a year for weeks at a time, and she and Margarett were seeing each other in New York. It was she whom Marjorie Davenport had characterized as "wicked." Among other lesbians, Isabel had a reputation as a sexual predator, and in her dominating character even those who admired her found a streak of duplicity.

Like Margarett, Isabel had broken an early engagement, and like Eleo, she lived an independent life unprotected by marriage or a married name. She was also an adventurer. Margarett pasted clippings of her exploits in her scrapbook, one of which recounts the rescue, sometime in the early thirties, of two "sporting" women off the coast of Denmark by a German freighter. Isabel had taken a seaplane voyage

with Mrs. Henry T. Fleitman, an attractive brunette and "habituée of London's Mayfair equally with Long Island's Hamptons." Mr. Fleitman had not heard from his wife since she'd sailed for France months before, and "knew nothing of the crash."

Shaw seemed to be no more aware of the nature of Margarett's relationship with Isabel than of the erotic element in her association with Roland Balay. He and Isabel talked about golf. The children loved her so much they asked to call her "Cousin" rather than "Miss" Pell. They'd never seen a woman wear anything but a nightgown to bed until Cousin Pell appeared in pajamas cut from heavy silk crepe, "exactly like a man's." She drove a succession of maroon Duesenbergs named Olga, her perfume—Tabac Blanc—was musky and sexy, and she wore her honey-colored hair smooth and short. She was reputed to own forty pairs of riding boots, and if she abandoned jodhpurs or slacks for a skirt, she wore, Margie said, a "marvelously tailored" suit.

Nothing documents what Margarett and Isabel said to each other, the defiant wit they apparently shared, or what they actually did behind closed doors, but Margarett made one ink drawing after another of a woman with bobbed hair and prominent eyebrows who always wore pants. Her first painting of Isabel was of a mannish woman in leather jacket and necktie, cigarette hanging from her mouth, background fire-engine red. In a second portrait, she enthroned Isabel in an arched chair of pale gray and painted the wall behind her almost lavender. Her jacket is the color of flesh; her white shirt, which must be silk, is open at the collar, its shadows watery gray. She has large hands, and the look on her face is surprisingly tender. Pepe, her black Scottie, sits in her lap.

Soon after Isabel appeared, Marjorie Davenport challenged Margarett about the nature of her new friendship, but Margarett would tell her nothing. Marjorie, at last standing up to her, accused her of betrayal. "You've changed," Margarett retorted, "ever since you inherited that money from your uncle. . . ." It was dark, a late afternoon at Prides, and they shouted until Marjorie threw down her glass, shattering it on the tile floor. "She and Isabel deserved one another," she said

bitterly at eighty-eight. "Finally Margarett got someone whose cruelty matched hers."

Thirty years later, not having seen her since the afternoon of the broken glass, Margarett arrived at Marjorie's house in Vermont, bringing flowers. Marjorie opened the door, and Margarett gave her the bouquet. They stood there at the door for a few minutes but said very little. It was the last time they saw each other.

When Margarett's first oils were exhibited, in 1929, two portraits of Maria deAcosta Sargent were among them. The walls at Kraushaar bristled with color, Margarett's strongest work since the sculpted heads of Luks and Chaffard, her freest since the model walked naked in her studio in 1919. A cigarette hung from the mouth of a woman in a striped sweater; a cook and a kitchen maid played cards at a table; two blond children mixed with a pattern of vivid red-and-blue pinwheels. Maria as *Tailleur Classique* bore little resemblance to the woman washed in watercolor who, dressed like a Greek supplicant, had raised a draped arm to obscure her face.

This, Margarett's fourth Kraushaar exhibition, allied her with other American Modernist and Post-Impressionist painters whose works were on display in New York that month—Marsden Hartley, Jane Peterson, and Edward Hopper. Henry McBride considered her in the context of her famous relative: "Miss Sargent seems more than careful not to let a suggestion of the relationship extend to her art. She burns her incense before the later gods." *Art News* noticed the shift in her work and found a way to patronize: "Miss Margarett Sargent has quite evidently grown a trifle weary of the sedate muse she used to follow and has mounted a more fiery Pegasus who has taken her for a somewhat breathless ride among the colorful phenomena of modern art."

But many reviews wholeheartedly affirmed Margarett's work in the new medium. "Her subjects," Forbes Watson wrote, "seem ready to step from their frames and become really alive." And *Vanity Fair*, whose editor, Frank Crowninshield, himself a collector of modern art, was a distant cousin and friend, reproduced three paintings: "Unfortu-

nately the black and white reproductions fail to convey their beauty and importance."

Les Arts à Paris was published in Paris by the dealer Paul Guillaume to promote his own artists and collectors; in particular, his most famous collector, Dr. Albert Barnes. The magazine rarely discussed American painters, but in January 1929, it reproduced Margarett's *The Striped Sweater* (*Le Sweater Rayé*), and its columnist Jacques Villeneuve wrote enthusiastically of *"la femme peintre américaine dont l'exposition cet hiver aux Galeries Kraushaar à New York a été si remarquée par les connoisseurs."* He continued:

> Her expressive art reveals some praiseworthy affinities in inspi-
> ration and also in intention with the painters who work in
> France. There will be a time when the French public, enlight-
> ened or ill informed, will take account of the efforts of the
> young school of American painting, the passionate admiration
> that has borne witness for a quarter century to the painting
> which comes from France. . . .

The revolution in painting that exploded in Paris before the war had resumed in a shifting international community of artists in Montparnasse, some of whom, like Alexander Calder, Max Jacob, Jean Lurçat, Jean Pascin, and Isamu Noguchi, Margarett knew, collected, or came to know. She was also aware of the American expatriate writers Janet Flanner reported to be "richer than most in creative ambition but rather modest in purse" and had read their work in émigré journals like *transition* and *Broom*.

In the years after the war, navy surplus and shipping yards hot with a new capacity to build had swelled the count of great ocean liners from 117 in 1918 to 328 four years later. Daily columns in the Paris editions of the *New York Herald* and the *Chicago Tribune* reported arrivals and departures of notable and moneyed Americans. The impoverished crossed in steerage for fifty dollars; the prosperous strolled first-class decks and drank champagne at captains' tables. Each

season, Paris couture emblazoned American magazines, beckoning women of fashion to its source, and American men like Shaw, who had fallen in love with France during the war, returned with their wives in pursuit of pleasure and the postwar business opportunities that waited all over Europe.

It was not unusual to read of the arrival of thirty-five hundred tourists in one day or of the railroad's scramble to schedule seven extra trains for transport from Cherbourg or Le Havre to Gare Saint-Lazare. It was less expensive to sail to Le Havre than to take the train to California, and France was cheap. In 1926, the exchange rate peaked at fifty francs to the dollar; later, it leveled off at twenty. A meal *haute cuisine* might be had for a dollar or two, a suite in a first-class hotel for six dollars a night. The *bar americain* was devised to quench the thirst of those in flight from prohibition: "10,000 Yankee Cocktails 'Go' in Nice Daily," exulted a *Herald* headline in 1924, the year Margarett and Shaw made the first of their trips abroad.

"In those days you met anybody anywhere," wrote Gertrude Stein. Margarett and Shaw were as likely to run into friends from New York or Boston at the Ritz in Paris as they were at the Ritz in New York or Boston. Dan and Louise Sargent stayed at the Hôtel de Cambon; the MacLeishes had an apartment on rue Las Cases; and Dickie Ames took two rooms at the Ritz, the second to store his paintings. In 1927, the *Herald* reported Marjorie Davenport at the American Women's Club, and on Easter Sunday, 1928, the marriage of Margarett's cousin Hollis Hunnewell to Mary Frances Oakes at the American Cathedral on avenue George. "Paris has now frankly become an American suburb," wrote the American Elizabeth Eyre in *Town and Country* in 1926. "One warm night, Paris suddenly turned American."

When Margarett first visited Paris in 1924, she found her friend Betty Parsons hungrily living the life of an artist, sharing a house on rue Boulard in Montparnasse with the painter Adge Baker, an Englishwoman, with whom she would live for six years. The exchange rate multiplied her alimony to a small fortune, and marriage had convinced her that her sexuality was inspired more by women than by men. She

was twenty-four years old and burned, as she put it, with a "love for the unfamiliar."

On her arrival in Paris, she had enrolled in Antoine Bourdelle's sculpture class at the Grande Chaumière. There she met fellow Americans Caresse Crosby and Alexander Calder and shared their teacher's most enthusiastic encouragement with a tall, quiet sculptor named Alberto Giacometti. She canoed the Seine with Caresse's husband, Harry, and went dancing with Sandy Calder, "twice a week," she said, "for exercise." She was invited to the Saturday lunches Natalie Barney gave for young people at her salon on rue Jacob, where "All the men were homosexual, all the women were lesbian, and the conversation was brilliant. Brilliant."

She had tea with Gertrude Stein and Alice Toklas, and she met Janet Flanner, who would soon begin to write her "Letter from Paris" for Harold Ross's new magazine, *The New Yorker*. Flanner, eight years older, took her in hand, guided her to theater, concerts, and exhibitions. In the galleries of Paris and the studios of Montparnasse, Betty began to develop the eye that fifteen years later made her a revolutionary dealer in the history of American art. "After years of knowing only people who did what they were supposed to do, I suddenly knew people who did nothing whatsoever that was conventional," she said.

When she and Betty met in 1919, Margarett was an unmarried daughter defying family expectation by pursuing art in a great city. Now it was Betty who lived and worked with heady excitement, meeting everyone, allowing herself to be changed by a city at the center of the world. Betty took Margarett to hear *les diseuses*, "those *fantastic* woman singers," and to Le Boeuf sur le Toit, Cocteau's jazz club, hung with Picabia's paintings and Man Ray's photographs, where the Montparnasse model Kiki sang and artists gossiped and drank.

If Margarett had been ten years younger and still unmarried, she might have gone to Paris to seek her fortune as an artist. As it was, she checked into a Right Bank hotel with a businessman husband who played squash at the Travellers Club with his friends from Morgan's Bank. As Madame Q. A. Shaw McKean, she plied the glistening shops

along the curved phalanx of Place Vendôme. She bought handker-
chiefs, *"crêpe uni couleur,"* the latest accessory, "to be caught in the ex-
act center and carried with all four points waving," had several
monogrammed "Maria" and "Vivian." She bought lingerie and gloves
at La Grande Maison de Blanc on the Place de l'Opéra, and at Goupy,
under the arcade on rue Castiglione, a dress of raw silk. For the chil-
dren, left at home with Senny, she shopped at "Fairyland."

The earliest Paris document I have, a bill of sale for a Mary Cassatt
aquatint, *Mère et Enfant,* places Margarett and Shaw in Paris in Febru-
ary 1924. The following month, Cassatt, going blind, would offer for
sale "those of her works which she had guarded with jealous care." A
receipt for an unidentified Cassatt from the venerable dealer Hode-
bert, had Margarett and Shaw back in Paris on May 5, 1925, in time
for L'Exposition des Arts Décoratifs, the first international exhibition
of Art Deco. Though there are no documents for 1926 or 1927, "They
went every year," Margie said, "and stayed three or four months." And
Betty, sentences racing as Margarett must have—from taxi to shop,
luncheon, galleries—said, "Yes. Oh, yes. They did the life of Paris in
the spring." Expensive restaurants, horse races at Longchamps, Mau-
rice Chevalier at Casino de Paris, Mistinguett at the Moulin Rouge,
and then on to Monte Carlo, London, or Berlin.

They visited the Princes at their foxhunting estate in the moun-
tains at Pau. Margarett liked Freddie Prince, who was one of Shaw's
Myopia polo friends—"he was far more aesthetic in his business," she
wrote once to Betty, "than most painters are on canvas." In Paris, they
dined with Hope Thacher, Margarett's childhood playmate, and her
husband, "Bunny" Carter, head of the Paris office of Morgan's Bank.
At Harry and Caresse Crosby's parties on rue de Lille or at their con-
verted mill outside Paris, they mixed with guests as likely to include
Bunny Carter as D. H. Lawrence, Kay Boyle, or Hart Crane.

The novelist Louis Bromfield became a great friend. Because of
two best-sellers and a Pulitzer Prize at thirty, he was celebrity enough
that when he accidentally tore up his steamer ticket on his way to the
pier, the *New York Times* reported it. Janet Flanner declared his "the

finest flower garden of any American in the Île de France territory, except Mrs. Edith Wharton, whose white garden was celebrated." He was such a gracious host, it was remarked that in another life he might have run a great hotel. At the Bromfields' converted monastery outside Paris, Margarett and Shaw met Gertrude Stein and Alice Toklas, and Edith Wharton. There is no record of Margarett's response to Gertrude and Alice, but as an old woman she yelped with scorn at the mention of Wharton, whose books she admired but whose approach to decorating she found extremely dreary.

More than once Margarett pulled Betty from class at the Grande Chaumière for the morning auction at the Hôtel Drouot. She bought one of Betty's sculptures—a red clay cat—and took her to meet Marie Laurencin. She went to Durand-Ruel for Cassatt and Morisot and, at Georges Aubry, bought *Women and Children* by Bazille, whose work was so scarce—he had died young in the Franco-Prussian War—that any acquisition was a coup. When she got to Paris in April 1928, an exposition of one hundred lithographs by Toulouse-Lautrec had just opened; she would eventually own two of his drawings and eleven lithographs—among them three of Yvette Guilbert, one of Jane Avril.

If Shaw was in Berlin or Amsterdam on business, Margarett went to auctions with Dr. Barnes, who was still buying Renoir and Modigliani, or to galleries with Frederic Bartlett, who, not yet remarried, unabashedly courted her. Out for the afternoon in Montparnasse, he sketched them having an apéritif at the Dôme. "You couldn't get an inning with Margarett. Bartlett was always there. He was mad for her. Mad for her," Betty said. "She was happiest when he was her boyfriend."

Check stubs dated 1928, checks made out to Betty Parsons, Harry Crosby . . . I am leafing through a messy stack of papers: pages torn from a 1930s sketchbook—"Île de France, 1931." A man with a funny fat face slouches in a deck chair; a figure in a green coat climbs a gangway; then a photograph, dusky with age, creased and bent. It takes a moment to recognize her. Her irises rest above the horizon of her lower eyelids; the stare fixes me. This was not the Margarett who glit-

tered in a silver Poiret gown, fragrant with Le Bleu, out for the evening with Shaw, who walked with Frederic Bartlett along rue La Boétie, or drank with Betty and Sandy Calder at le Boeuf sur le Toit. This was Margarett, by herself, at the age of thirty-six. On the back of the photograph, the inky stamp: *"Photographie de Berenice Abbott."*

Abbott left a darkroom job with Man Ray in late 1926 and in January 1928 moved to a "big old daylit studio" near the Palais Luxembourg. It was to this studio, a top-floor room with a large, north-facing skylight, that Margarett went to have her portrait made by the talented, unusual young woman, an Ohio refugee in Paris. In 1926, Abbott's first exhibition of portraits, invitation card designed by Jean Cocteau, had opened at Au Sacre du Printemps, where André Kertesz had shown photographs, Kiki of Montparnasse paintings, and Calder sculpture. A month after she photographed Margarett, in April 1928, twelve of her portraits, exhibited with work by Kertesz, Man Ray, Nadar, and Atget, would make her international reputation.

Margarett climbed the five flights at rue Servandoni. "A stranger. Out of the blue," Abbott told me at ninety-three, chic in trousers, hair still elegantly short, scarf tied like an ascot at her neck. "I didn't know her well." The photographer, eight years younger than her subject, saw Margarett first on the threshold, illuminated in a spill of north light. She invited her to make herself at home while she set up. "I didn't have many props. The studio was simple. I used odd things." Margarett was immediately curious. They talked about what they had in common. Art? Paris? The old woman couldn't summon up their conversation, but she remembered Margarett's energy. "Paris was a magnet for a woman like that, looking for freedom."

Margarett had pulled back her hair rather severely and parted it on the side. She wore a suit with a pleated skirt, which reads gray in the black-and-white photograph, and under her jacket, to which was pinned an artificial flower, a thin sweater with narrow diagonal stripes. Abbott directed her to a mahogany chair with a curved back, the same chair visible in other seated portraits she made that spring: of André Maurois, Leo Stein, James Joyce.

"I relied on the instincts of the moment," Abbott said, a gesture in which the person "would reveal something about herself." Margarett crossed her legs, leaned forward, set her right elbow on her knee, chin on her fist, and looked straight at the lens. "A portrait was a collaboration?" I asked. "An exchange," the old woman answered. What Margarett gave was a gaze that followed one everywhere in a room. Nothing remained of the girl Arnold Genthe caught in a youthful smolder of romantic challenge, or of the young mother shot by a studio photographer at Prides, smiling, baby on her hip.

Margarett looks strong but uneasy; female but stripped of effeminizing clutter; handsome but not beautiful, not genderless exactly. You could imagine this woman lived and worked in Paris, that she was one of Abbott's famous female subjects: Sylvia Beach in a shiny black raincoat, face caught in an almost violent expression; Jane Heap, hair cut like a man's, tuxedo and black tie, full lips darkly rouged; Janet Flanner, cross-legged on the floor, top hat decorated with one black, one white mask. But Margarett was not a resident of Paris who sought like-minded friends in a café at the end of a day or labored in the solitary light of a Left Bank studio. In spite of the sophisticated angularity of the photograph, the unassailed, even enraged, determination in her expression, the look in her eyes is lonely and frankly sad.

Margarett stands at an easel. A woman sits facing her, and Margarett is painting, not the woman's anger, but the longing and sadness beneath it. Abruptly she picks up a wooden chair, slams it down on the floor. "Her face must disturb like a sudden, dangerous sound," I imagine her saying to no one in particular, then see her for a moment looking at herself in a mirror. The intensity in her eyes is not sadness and fear but what remains of work pursued that day, ideas argued through the night with artists who are her friends. Margarett paints and then she erupts into her loud, deep laugh and, with abandon, sitting in her chair, rocks back and forth in a rapture of having got it right.

"It was a time of hope," Berenice Abbott said, "that was the thing."

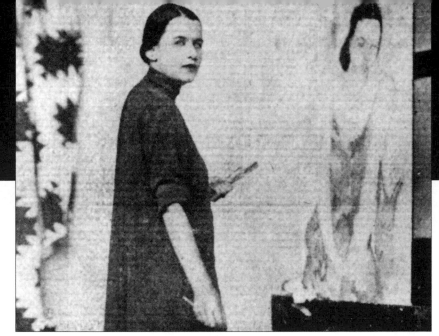

vii

*I like arms and
their movements, and
striped blouses*

(1930–1932)

Margarett in her Boston studio, 1930
(from a newspaper photograph)

PRIME THE TALL CANVAS, lay her in quick with charcoal. The mirrored walls of the bathroom reflect her, sitting on the *moderne* gray satin vanity stool, legs apart, black pumps, a short pink circus gown, low-cut, string strap falling from her shoulder. She wears a top hat. A shiver of magenta vibrates a yellow aureole of wall, dark teal scribbles a cloud of gray-blue floor. She is young and slender, beautiful, you would say, but for the—what?—disconsolate fury given off by dark eyes, scraped at by the stick end of a brush, asymmetrical. The left eye is encircled with a shadow of teal and finished with a glint of white; the right is its dimmed double. The shadow of the hat brim colors her forehead lavender. Her cheeks are flushed the fluorescent melon orange that also glimmers on her lower lip. The upper lip is red, bigger, messed at.

The North Shore *Breeze and Reminder*, which chronicled "society" north of Boston, had not caught up with soignée girls wearing top hats, foreheads turned lavender with intensity.

"The District Offers More of Beauty, Romance and History Than Any Other Spot in the Country," read a headline at the start of a late 1920s season. An article might authenticate Longfellow's "The Wreck of the Hesperus" as the true story of a shipwreck at Norman's Woe right up the road, or, reproducing a period engraving, recall the Salem witch trials. Photographs enshrined gardens of great estates, and captions described as "charming" oceanfront houses that rivaled the sea palaces at Newport in dimension. Each issue tracked the residents who moved from Boston to the Shore in summer; traveled in winter to

Boca Grande, Palm Beach, or Aiken, South Carolina; booked state-rooms on steamers for Europe.

Margarett, identified as "Mrs. Q. A. Shaw McKean (Margarett Williams Sargent)," was reported "busy with her art work all summer," in a column that followed the art colonies of Rockport and Eastern Point and activities of noted local painters like Cecilia Beaux and Charles Hopkinson. Margaret Fitzhugh Browne, breezing through as the portraitist who lured the retired golfer Bobby Jones to her studio, was the region's fierce opponent of "Modern Art." Its advocate was Mrs. Morris Pancoast, who exhibited "selected groups of paintings by the modern men" in "an unusual gallery in East Gloucester."

The *Breeze* never mentioned the stock market crash. Margie, then almost eight, overheard her father tell "some terrible story" of a man he knew throwing himself from a window after learning he'd lost all his money. Harry and Caresse Crosby's visits to Apple Trees, his parents' estate in Manchester, were always reported, but the *Breeze* was mute on his suicide in New York (surely the talk of Boston), six weeks after the crash. Crosby's death had nothing to do with money, but it marked the end of the 1920s "innocents abroad" and coincided with the turn in financial circumstance that brought the Gerald Murphys, the Archibald MacLeishes, and many other Americans home.

The crash affected Margarett and Shaw less than it did some of their friends. Bebo and Josephine Bradlee let servants go, sold a great house, moved to a smaller one, and Mrs. Bradlee opened a dress shop. The alimony Betty Parsons lived on abruptly ceased, and she was forced to leave Paris. Marjorie Davenport lost her uncle's legacy and left New York to live the year round in Vermont. For the very, very rich like Shaw's mother and Harry Crosby's parents, nothing much changed. Margarett and Shaw did not go to Europe in 1930 or 1931, but they went to Cuba in 1932 and returned to Europe in 1933. Margarett kept her studio on St. Botolph Street, but she and Shaw closed their Boston town house on Commonwealth Avenue in 1931, put it on the market, where it moldered unsold for years, and wintered at

Prides. What Margie remembered was Shaw sitting at the edge of Margarett's bed, whispering, "We're all right."

Asymmetrical eyes slant like the eyes of a jungle cat. Muscled arms bulge from a short-sleeved shirt. His green sweater vest is patterned yellow and red and black. No one knows who he is. Outsize hands loose on a knee. Where did she find him, this no-account sitting in the corner? Walls a saturated sky blue, broken by gray the color of storm clouds. She crops the top from his cap, the feet from his legs. The cuffs of his gray trousers billow. His chair is deeper yellow, more orange than butter, and it's coming apart—disrupted, perhaps, by his unsettled, piercing, contemptuous gaze. Its ladder back tilts—bands of gold sprung from proportion—so he seems pushed toward us, as if what caused the bright chair to fall apart were emptying him from its arms.

Painting the growl that came from the young man's eyes, Margarett pulled from herself what she could put nowhere else, turned that furor into something that could exist independently, seared what she felt and saw into the eye of the viewer. The girl with the lavender forehead and the boy in the yellow chair represent her at the height of her powers. From these paintings she has sheared the clutter of life as Mrs. Quincy Adams Shaw McKean. Margarett Sargent burns fiercely, with a burning that both divides her from those around her and enables her to live her double life. Her painting protects her, as magic does a sorceress, but it also endangers her. As her work homed in on the truth of her circumstances, Margarett became more vulnerable.

In the wake of the crash, Shaw closed down the investment banking firm he'd started after the failure of Richardson, Hill and "pretty much retired," John Spanbauer said, to devote himself to "sporting interests"—fishing and hunting trips to Canada, golf at Myopia, bridge in the evening. Prides Hill Kennels was a going concern. Shaw's fox terriers, with names like Bounce and Miss Barbarian, were advertised monthly in the kennel pages of *Vanity Fair*; in 1928, a dog called Style won the Best American Bred Bitch at the Eastern Dog Club Show in

Boston, where her competitors in other breeds were dogs shown by Shaw's North Shore friends. Margarett hated fox terriers. They were small and they yapped. They were Shaw's pride, and just one of their differences.

In October 1928, Paul Gauguin's great portrait of Meyer de Hahn was delivered to their rooms at the Ritz in New York. Margarett had bought it for $3,500—a huge sum—at Kraushaar. She knew what Shaw's reaction would be, even relished its inevitability, but his anger made no sense to her, at least not as much sense as the painting. She hung it like an icon at the entrance to the great hall at Prides, so that from anywhere in the room, you could see its audacious diagonal divide darkness from light; the pensive, magical, inward-looking face; its flagrant blaze of reds and yellows.

Increasingly, where Shaw was concerned, Margarett's lack of ease overcame her natural courtesy. The difference now was that their friends knew it. "They were physically drawn but mismatched," said Ted Weeks of the *Atlantic Monthly*, one of Shaw's golfing friends. "Shaw always stood to the side," said Garson Kanin, who met them in the 1930s. "She was so artistic, so creative," said Mabel Storey, with whom Margarett rode to the hunt. "Margarett needed something . . . else."

Guests were quiet when she got a laugh at his expense, when she taunted him at the table, Marie Laurencin's *Femme au Balcon*—black rail restraining her, hat abundant with pink roses—gazing down from above the fireplace.

"Fights about what?" I asked Margie.

"Nothing. The sugar."

The children joined in when Margarett suggested a game: Name the most appalling combination of food you can think of. "Oh, for God's sake, Margarett," Shaw would yelp. She invented an ongoing story she told the children, of Lizzie and James, a married couple who did nothing but argue. Shaw took Mountain Valley spring water along whenever he traveled. Margarett forged a letter from the company awarding him a certificate as its most esteemed customer and roared

with laughter as his delight turned to speechlessness when she exposed the hoax. Once, during a party, she hid behind the curtains and kicked at his ankle as he passed. Sometimes he was able to laugh. Often, suppressing rage or hurt, and with natural tenderness and a kind of hopeless faith, he continued to try to please her.

In 1931, Shaw finally launched an enterprise that pleased Margarett very much. His friend George Thomas, dog judge and breeder, had two extraordinary dogs, which had been imported from England by Zeppo, the youngest Marx brother. Afghan hounds were virtually unknown in America and had been bred in Britain only since 1921, when Begum, a pale dog with large brown eyes and perfect carriage, was glimpsed by an English horsewoman galloping the plains of Baluchistan. By acquiring Zeppo Marx's pair, Shaw became the first American breeder of Afghan hounds. "Can kill leopards," he wrote in the Prides Hill brochure, quoting a Britisher who used Afghans to hunt white leopard in North India. The centerfold photo had Shaw, two leads in each hand; a twin son to either side, a lead in each of their hands; eight dogs attentively flocked to face the camera, pale fur ruffled by the breeze.

The dogs entranced Margarett. After Sunday lunch, as guests stepped from the darkness of the house into the bright afternoon, she saw to it the kennelman opened the runs. "You couldn't believe it," a visitor said. "There they'd be, thirty Afghans, leaping across that great green lawn."

Some of her friends considered Prides Margarett's greatest achievement. John Walker, a Harvard student in the late twenties, saw it as an exquisite net in which she ensnared herself. "She would have been much better," he said, "if she had broken the net and flown away." For Margarett, Prides was not a prison but a context, and she worked to realize it as single-mindedly as she worked on a painting. When she talked to Joe Leland about the shape of an addition, with her gardener, George Day, about a plan for a topiary hedge, she spoke with creative excitement. The house continued to evolve; in the summer of 1929,

another addition was completed. The big room, the living room since Margarett moved her work to the studio on the hill, had been extended thirty feet, an entryway added.

"Room" is the wrong word to describe what Margarett had composed to resemble the great hall of a Florentine villa—two stories high, giant skylights facing north. If you came through the iron gate that separated the entry from the living room and turned to look back, you saw, to the right, the portrait of Meyer de Hahn, and to the left *The White Blackbird*, George Luks's portrait of Margarett. The way paintings were hung, how sculpture and furniture were placed across the vast expanse, suggested landscape rather than decor.

Odd decorative ends of antique wrought iron, a multitude of Italian and Spanish chairs, a pair of Venetian corner cupboards, challenged Calder's wooden giraffe and Ossip Zadkine's brass bird for attention as sculpture. Lengths of tapestry or textile—tawny, terra-cotta, dusky blue—lay across surfaces. A huge abstraction—flags and banners, all gray and black, Jean Lurçat's *Les Bateaux à Voiles*, traded from the artist for two Afghans—commanded the south wall. Over the fireplace hung a narrow horizontal Derain still life of a loaf of bread. Small Degas bronze horses gathered on an open desk, and near the fireplace, a polychrome marble head of a woman by Gaston Lachaise gazed from the top of a Shaker cabinet. During the day, shafts of light fell through skylights, breaking the shadow and brightening the creamy walls. At night, the light of candles and hanging lamps rose into the darkness so the high beamed ceiling was barely visible. The glow illuminated a profusion of cut flowers and was reflected when dark floorboard interrupted an expanse of pale Oriental carpet or a maze of American hooked rugs.

It was here, in the big room, that drinks were replenished until dinner was called, here that Margarett wandered, adjusting an imperfect flower arrangement or exchanging one painting for another so that she could see each anew. Looking out a sequence of leaded windows nearly the height of the room, she could see the arborvitae topiary, the espaliered apple trees, the pool, and beyond it the schoolroom, with its own kitchen, where the children had their lessons in the morning.

Senny's older brother, John Neary, had arrived when the twins were old enough for a teacher. He was a warm, funny, intellectually passionate, hard-drinking Boston Irishman. When he wrote Margarett a note accompanied by some of the children's writing, he commented that their poems had not sprung "full-fledged, like Minerva, from the brain of Jove." He did not think them too young—Margie was eight when he came, the boys five—to insist that they reflect before choosing a word, and he criticized the results "with a little imaginative baiting now and again." Nothing fine could be finished without reworking, he told them.

The children took to John as they had to Senny, and he was perfect for Margarett's requirements. She remembered her boredom at Miss Winsor's and was convinced the local private school, organized by one of her childhood friends, would be deadly. She didn't care that the children longed to go to school with their friends; she wanted them to be inspired. With the Nearys, she devised a curriculum that was intellectually serious and unusually advanced for children so young. John and Senny took care of literature, geography, and history, and twice a week, "Madame," Mrs. E. Power Biggs, the wife of the organist and renowned interpreter of Bach, came out from Cambridge to teach French and piano. John introduced Latin when the boys were five, and by the time she was nine, Jenny used it to write letters to Margarett.

When the girls were tiny, Senny sat at the foot of their beds at night, wrote down what they said about the day, and later typed it up. John would direct all four children to keep their own diaries. They also published a mimeographed newspaper, *The Prides Hill Gazette*, and occasional books—a collection of poems and stories when Margarett and Shaw went abroad in 1933, and, the next year, for their wedding anniversary, *The Onion River Anthology*—poems in the voice of everyone in the household, including the divorced Joe Leland: "It seems to me/ That all of life/ Is just the problem/ of a wife."

On rainy days, Senny and the girls climbed to the attic, pulled out trunks of Margarett's out-of-date clothes, dressed up, and put on plays in the schoolroom. The *Gazette* of April 1932 reviewed Jenny, aged

nine, as Macbeth ("She had a good costume and her acting was mar-
velous") and Margie, eleven, as Macduff ("did it very well especially
fighting Macbeth"). The art column covered exhibitions by Freddie
Hall, an artist friend of Margarett's ("I liked Mr. Hall's etchings better
than his paintings"), and Margarett Sargent ("She is a great artist. Her
work shows ability and strength of character—one or two of her pic-
tures I feel could be more finished—especially the young woman hold-
ing a child"). Once, when Margarett and Shaw were in Europe, the
children put on their own exhibition and invited friends of their par-
ents who they knew were interested in art. "4 under 8" was the name
of the show, and Harry sold two nudes.

ONE AFTERNOON early in 1930, the last winter the family spent in the
house on Commonwealth Avenue, a big man in a mustard-colored
suit lugged five large, battered suitcases to the door of number 205.
"Paris," read layers of labels and luggage tags. *"Calder,"* read the large
painted signature. Margarett greeted her old friend at the door, sum-
moned Walsh, the chauffeur, to help with his bags, and offered Sandy
Calder a drink. The children had been told Mr. Calder would bring a
circus, but what kind of circus could possibly fit into a suitcase?
Margie and Jenny knew he was going to make portraits of them later
in the week. They were accustomed to Margarett painting them,
shouting "Hold that pose!" as they scampered away, but Mr. Calder
was going to use wire, Margarett told them, instead of ink or paint.

Margarett had met Calder in New York, probably in 1922 or
1923, when he was studying with George Luks, painting city scenes
with a bright palette inspired by John Sloan and emulating Luks's fast,
blunt brush. He always called her Maggie. When she saw him again in
Paris with Betty Parsons, it was 1927, and Josephine Baker was his
subject. Margarett was entranced by the witty ease of his wire line. Any
household quandary was an occasion for sculpture—the broken spigot
he replaced with a wire dog that lifted a leg when the water was turned

on; the fish Betty Parsons found, wire head and tail out either end of the toilet paper, after he left one evening.

Calder began the circus by accident. He'd always made toy animals to entertain his family; now he'd sell them to make money. "A lion with a wire body and tawny head of velvet and wool led to a cage on wheels," his sister wrote. His Paris friends loved how he moved the animals with his fingers, making animal noises. Soon he was manipulating a score of creatures and trapeze artists with a web of pulleys or by hand so deftly his pudgy fingers seemed to disappear. "He was lightfingered like a thief," said one enthusiast.

After a year, he had made enough figures to fill two suitcases and had printed bright linoleum-cut announcements. Circus performances at Calder's studio became the rage of Montparnasse. Isamu Noguchi cranked the gramophone, and Mary Butts brought Jean Cocteau. Sylvia Beach and Janet Flanner came, André Kertesz and Tristan Tzara, Mondrian and Miró, Adge Baker and Betty Parsons. Wherever Margarett saw the circus first—in Paris or at a New York performance in 1929—she was utterly charmed. Who could resist? The figures, seemingly thrown together with spit and paste, had the quirk of life, the poignance of a cripple hurling aside a crutch to break into dance.

The occasion for Calder's Boston visit was an exhibition of his wire sculpture at the Harvard Society for Contemporary Art in Cambridge. The story got out that he arrived at South Station with nothing but pliers in his pocket and a bolt of wire slung over a shoulder, but actually, he wrote later, "I took the circus along." His exhibition opened in Cambridge on Tuesday, January 27, and a circus performance at Harvard the following Friday was packed with students. The performance in Margarett's huge living room would be the only one in Boston, and she invited a crowd.

Margarett did not mind Sandy pushing the furniture into rows or constructing bleachers from boards and pails. He rolled back the rug, threw sawdust on the floor, and set out the peanuts. He unrolled a bit of green carpet and laid out a ring made of red and white rounds of

painted wood. Crawling around the floor and talking to himself, he erected two steel poles about three feet high, a miniature French flag fluttering at the top of each. He suspended trapezes and a tightrope between them, looped a red-striped curtain to either side of the ring so his "performers" would have "privacy" offstage, and aimed a home-made spotlight at the center of the ring.

After dinner, Margarett summoned her guests, bespangled in evening clothes, to sit on the "bleachers," the children to sit on the floor. "Ladies and gentlemen," Sandy declaimed, and music cranked from a gramophone heralded a grand procession led by Monsieur Loyal, the spool-faced ringmaster. Applause! Loyal blew his whistle, and wooden horses with manes of string circled the ring, powered by an eggbeater, wire cowboys leaping to their backs. Enter clowns, Sandy's fingers effecting stumble and pratfall, then he barked for seals and roared for the lion, which leaped as the tamer lashed his whip.

Skinny tightrope walkers, feet weighted with fishing sinkers, traversed the high wire. Dalmatians sprinted between spokes of a buggy's spinning wheels, and a flock of doves—bits of white paper, weighted, spinning down a wire—fluttered to the creamy shoulders of the bejeweled passenger. Drum roll! Rigoulet, the strong man, strains at his dumbbell. Drum roll! The sword swallower is fed his sword. Are the children still awake? How thirsty are Margarett's patient guests, who have been eating peanuts for two, maybe three hours?

The trapeze act was the *pièce de résistance*. Sometimes the girl did not leave hold of her swing, and the act failed. Would she tonight? Would she spin through the air, hook her wire hands through her fellow's wire feet? A net reassured beneath. Sandy hesitated as if taking aim, then jerked the wire and released her into the air, wire arms outstretched. It was over in a moment, and there she was, hooked to her consort, swinging like a pendulum!

Calder and his circus had come to Boston through the efforts of three imaginative Harvard undergraduates. One fall afternoon in 1928, Lincoln Kirstein, John Walker, and Edward W. W. Warburg had marched

into the university's new Fogg Art Museum and confronted Paul Sachs, its assistant director: "Why is there no modern art at Harvard?" Sachs—a bond trader turned connoisseur, who was heir to the Goldman, Sachs investment house—had collected his first Picasso drawing in 1920. He considered Modernism "the work of actuality," but his opponents on the Harvard faculty had balked at endorsing works that had not stood the test of time, and so the Fogg included nothing newer than the Impressionists. "Why don't *you* do it?" Sachs suggested to the three students. The result, six months later, was the Harvard Society for Contemporary Art.

Through Sachs, Margarett soon met the three "executives" of the new organization. For each, as for her, art was a redemptive passion. After an "excessively affluent" childhood in Pittsburgh, John Walker contracted polio at thirteen and was taken for treatment to New York, where he discovered art while spinning through the galleries of the Metropolitan Museum in his wheelchair. By the time he got to Harvard, he wanted to be a curator, and one day, drawn by reports of Picasso reproductions on his walls, his traveled classmate Lincoln Kirstein turned up, "dark, saturnine, shaved-headed," to discuss modern art.

Earlier in his Harvard career, Kirstein launched *Hound and Horn,* which shared writers, artists, and point of view with journals published by Americans in Paris. In England, with his sister, Mina, he'd gone to Bloomsbury parties and met Virginia Woolf and Roger Fry, and in Paris he'd seen Diaghilev's company dance on sets by Picasso and Derain. On his return, Boston seemed, as it often did to Margarett, "a combination of a prison and Friday afternoons at the symphony." He enrolled at the Museum School but soon ran up against "old Philip Hale who loathed Modern Art and any young twit like me who tried to draw from casts in the manner of Wyndham Lewis or Eric Gill."

Eddie Warburg had also traveled in Europe, but until the summer of 1929, when he bought Picasso's *Blue Boy* in Berlin, his taste for simplicity and directness had drawn him to the Renaissance rather than to modern art. The gouache portrait of a humble young man was a far cry from the brocaded, luxurious taste of his collector father, Felix

Warburg, whom he immediately recruited for the board of the Harvard Society for Contemporary Art. "Eddie was our clown," said John Walker. "He raised us a lot of lovely money."

Money was easy to come by in early 1929, and Paul Sachs helped connect his protégés with patrons and lenders—dealers and collectors of modern art in New York, Boston, and Chicago. For gallery space, the three leased two rooms above the Harvard Cooperative Society in Harvard Square. They painted the ceilings silver and the walls white, furnished one room with steel café chairs and tables, the other with a large rectangular table Lincoln and John constructed by balancing a highly polished metal top on marble legs from an old soda fountain.

When they asked to close their first year with a full retrospective of Margarett's work, she enthusiastically accepted. The Society's first exhibition, "Americans," included the abstract work of Marin, O'Keeffe, and Demuth, set off by the figurative and landscape painting of George Bellows, John Sloan, Arthur B. Davies, and others. The second show, an exhibition of European artists, brought "the work of thirty-three painters and sculptors, regardless of nationality, who have been working in Paris and who have made the influence of 'Modern' art what it is today."

Not only did Kirstein, Walker, and Warburg share Margarett's frame of reference as far as painting and sculpture were concerned; they also understood her impulse, demonstrated at Prides, to mix crafts like American quilts and hooked rugs with modern paintings. For the first time in an American art context, the Society showed contemporary design, folk art, and works in media not then considered art. Their first season also acknowledged the aesthetic attributes of certain technological advances; a photography exhibition included not only works by Americans and Europeans but aerial photographs, pictures from astronomical and surgical laboratories, and photos from the daily press. Their most sensational show, revived the second year by popular demand, was of Buckminster Fuller's Dymaxion House, a " 'machine-for-living-in' that could be constructed by mass productive methods, cost approximately $500 a ton."

As the Harvard Society for Contemporary Art was getting under way, some of its lenders and patrons, including Paul Sachs, Frederic Bartlett, and Margarett, became involved in a project in New York. When the Museum of Modern Art opened, on November 8, 1929, Bartlett and Sachs were on its board of directors, and Margarett's Gauguin hung on the walls of its temporary galleries, four rented rooms at 730 Fifth Avenue. Alfred Barr, recommended by Sachs as the new museum's director, had chosen for its inaugural exhibition the four painters he considered preeminent in "the genealogy of contemporary painting"—Cézanne, Gauguin, Seurat, and Van Gogh. When he characterized their work in the catalogue essay, he might have been articulating the aesthetic of Margarett's painting. "For soft contours they substitute rigid angularities; instead of hazy atmosphere they offer color surfaces, lacquer-hard."

It was at this new museum in New York that the eclectic experiments of the Harvard Society for Contemporary Art would eventually become exhibition policy, but by the time Margarett's exhibition closed the Society's first season, its reputation had already reached beyond Boston, and the debates that had roiled Back Bay art clubs for decades had become obsolete. The conservative Boston painter Ives Gammell could sneer in his diary that Lincoln Kirstein's discussion of Margarett's paintings at a dinner at Prides was "too broad a caricature for slapstick farce," but something new had taken root in Boston, and Margarett was close to its center.

Two women—boisterous, naughty, and big. They wear swimming costumes cut high on the leg. It's a close-up that crops heads at midbrow, legs at midthigh. One woman, her back to us, wears bright yellow; black stripes encircle buttock, hipbone. The other, facing us, wears aqua, four thin black stripes low on her hips. Two women— color against blue sky, flappers rowdy at the beach to jazz in the air. They have confidence and size. Yellow looks away, black cap, face in profile, eye a line, orange cheek, lips open. She has hips. She moves. Aqua has a brown bob, red mouth, full-face, no eyes, as she leaps

to catch a yellow ball with big hands. Margarett has fixed them, hip-to-hip.

"First reaction: Immense thrill," read the dispatch from Cambridge to the *Chicago Evening Post.* "It's her colors. Her loving feeling for colors, her sensitiveness for grading colors, molding colors, contrasting colors." *Bathers* illustrated the review by a writer named H. von Erffa. "I like arms," Margarett told her. "I like arms and their movements, and striped blouses." At the galleries of the Harvard Society for Contemporary Art, twenty-eight of Margarett's paintings hung on bright white walls, their colors reflected in the silver ceiling. This was her first one-person show in the Boston area and included fifteen watercolors, two pastels, a wall of drawings, and the bronze heads of George Luks and Chaffard.

At the private view on Thursday, February 7, 1930, collector friends like Frederic Bartlett and John Spaulding circulated among Harvard and Radcliffe students and old friends like Emily and Henry Cabot Lodge and Vivian Cochrane. Maria deAcosta Sargent greeted the portrait of herself as *Tailleur Classique,* and Paul Sachs bought a drawing. Marian Haughton bought a watercolor of her grandchildren, rascals around a table. Freddie Hall gazed back at himself on canvas— about to laugh, intelligent eyes through round spectacles, cheeks flushed, a gardenia in his buttonhole. His wife, Evelyn, wore purple and carried an alarm clock in her purse, set to go off when she wished to depart. The children crowded near two paintings of Jimmy Durante—"If you can find enough oils, paint that schnozz of mine again," he'd written Margarett on a photograph he sent after the first time he sat for her.

"She is an out-and-out modernist in style as well as spirit, and her special field seems to be the interpretation of the post-war life that is our modern world," wrote the *Transcript* reviewer. Margarett was now considered a major Boston artist, and the writer met her on her own terms:

> Her style is slap-dash, but when she confines herself to a few
> bold colors, and a few bold slashes of the brush, she has an un-
> canny knack of saying everything with the most powerful
> economy. Her drawings reveal this gift in its greatest purity.

Here a line will betray a whole trend of emotion or indeed an entire personality with the lift of an eyelid, the slouch of an arm, the sag of a mouth. . . .

"SHE WAS A GOOD PAINTER at a time when that kind of expressionism was not very much in vogue. I felt then and feel now that she's not been appreciated enough," said John Walker at eighty-two, his careers as assistant to Bernard Berenson and director of the National Gallery in Washington years behind him. His dark hair had gone bright white, and the effects of polio had returned in old age.

In 1930, he was a young man whose life had been saved by art, and Margarett was an artist, a glamorous woman, fifteen years older than he. "She had a big mouth, I remember that. And a deep voice." He was physically drawn to her. She appreciated him, he said, flattered him, but always seemed to withhold something. He was fascinated. "She never seemed to do things like other human beings," he said.

Sometime during the spring of 1930, Margarett began to imagine John Walker's face in paint—vivid dark eyes, wide brow, dark hair. He met her at the studio on St. Botolph Street. It was not the first time he'd been there; he'd come before, to choose paintings for her Harvard exhibition. "She had an idea of what I looked like—which may not have been what I actually looked like, but very few portraits are of the sitter: they are rather an idea of the sitter."

Margarett painted him as a romantic young man, swooped at the canvas with her brushes, painted a ground that was almost mauve. "Her rapidity was what struck me," Walker said. She sculpted his suit with soft browns, modeled the salmon-pink tie so it seemed to stand up from his chest. He sat just once for that portrait, which she framed in white and hung over the fireplace in her Art Deco bathroom.

Margarett was painting ferociously that spring and contributing to Mrs. Pancoast's series of group shows, "Moderns at Pancoast." She went to Palm Beach in April, and when she returned, John saw her whenever he could. Often they went to galleries, to museums. The

way she thought about painting converted him to an instinctive way of looking that cracked open the formalism he'd learned at Harvard. "She was a great teacher," he said.

"What did you learn?" I asked him.

"I learned how to look at pictures."

"How?"

"You couldn't show it with words. She'd grab my arm and point. That was it."

"Did you have a crush on Margarett?"

"What?"

"When you met her—"

"Of course I did," the old man snapped, as if it should have been self-evident. "She was the love of my youthful life."

The culmination of their relationship came one evening in June 1930, just after his graduation from Harvard and before he left for Italy to work for Berenson. He was invited to Prides for the night. Shaw was away, but the children were in the house. He and Margarett had dinner alone, or perhaps there were guests who then left. She'd given him the tower room, with its silvery mirrored ceiling. "I feel quite sure I could find the room if I were in the house again," the old man said. "What I remember is a bed and a chair."

Margarett came to him, unexpectedly, in the night, wearing a filmy dressing gown and carrying a candle. He was a virgin.

"She seduced me. No, that's not right. I wanted to be seduced."

John Walker was not the only young man whom Margarett visited in her negligee. Nor were all the men she seduced as young as he was, nor is there any possibility of coming up with a complete list. The translator Louis Galantiere, wandering up and down the road in Dorset, calling her name; Artur Schnabel, a frequent guest at Marian Haughton's, in Boston to perform a concerto under Koussevitzky or an evening of violently swift, heartbreakingly delicate Beethoven sonatas. "We saw Mr. Schnabel," Jenny wrote Margarett in Europe in 1933, "and he

told us how wonderful he thinks you are." And of course there was Roland Balay, in New York or in Paris, for years.

And, like a descant, the women.

Attention still came to Margarett naturally, and to respond, she believed, transgressed nothing. She fixed you with her eyes, and if you looked back at her, the room disappeared. Then she began to talk, to smile at you, and you were riveted, fascinated, caught. She did not miss the erotic subtext to a smile or gesture.

She must have been lonely, living as she did in the midst of a crowd of people, intimate with none of them—not even with the children once they passed the age of coming unbidden to her arms, except in the quiet moments when she drew or painted them, or when she got them laughing in a game. Certainly not with Shaw, with whom, now, tenderness was rare—with whom she now had something that could be called an arrangement.

Shaw looked away when it came to Margarett's romances, or perhaps he genuinely didn't know about them—no one is sure. What bothered him was her drinking, a vague problem at the beginning of their marriage, which now alarmed him. She was late coming in to dinner, or she fell asleep at the table. She was present in a conversation, then she was not. He wished she would not drink, and after a while he began to ask her not to, to exact promises she'd take it easy, have just one drink or none at all—for the sake of the children, for the sake of health. He could handle her selfishness when it came to her art, even when it came to the Harvard boys she kept inviting to the house, whom he found boring and somehow threatening. But he could not bear the humiliation, becoming more frequent, of her behavior after a few drinks.

The roar of the twenties had reached Boston halfway through the decade and emancipated an entire generation to the cocktail, to booze procured through bootleggers. Dressed to the nines, the young of old Boston drank at dinner parties, at speakeasies in New York or Chicago, and in Paris at Scheherazade, the Blue Room, Bricktop's. Mar-

garett drank with Betty Parsons, who matched her drink for drink but she said she never saw her drunk. She drank with Roland Balay and she drank with Isabel Pell. She drank with Maria Sargent and with Vivian Cochrane, who drank in New York as a young actress, in Boston as a young widow, and who later, as Mrs. Dudley Pickman of 303 Commonwealth Avenue, made sure her house had a bar on every floor and that her butler greeted all who knocked with the offer of a martini.

Margarett and Shaw drank through the clamor of their parties and in the gleaming quiet of the dining room at Prides. They had cocktails with Harry and Bessie McKean, with Ham and Ruthie Robb, who lived up the road. "They all drank," said Ruthie Robb's daughter, "and it turned on many of them." Alcohol turned on Shaw's brother Harry and Eddie Morgan. And it turned on Margarett. By the time the stock market crashed, she'd been drinking almost ten years, and it had started to show around her eyes. Her body began to betray her. A woman's liver, which succumbs to alcohol sooner than a man's, separated her drinking from Shaw's. The genes of the poet grandfather who sang sluiced with claret presented themselves, partnered by the depression that felled Hunnewell women at the prime of life. Increasingly, Senny greeted the children at breakfast with "Your mother has a headache. Please be quiet." Margie and Jenny had a word for it before they knew what *it* was: "Mama is languid today."

Apparently, Margarett had forgotten how extreme Eddie Morgan's drinking had seemed to her as a girl. She drank as much as she wanted. Or, if it pleased her, she didn't drink for weeks or months at a time. Her appetites were hers, and her capacity to satisfy them put her at a kind of liberty. She held to that liberty despite promising Shaw she'd never drink again, in spite of her love for her children. Her beauty and her talk still attracted anyone she wished for company, and she never drank when she painted. If she could not drink when she and Shaw were out together, she would drink by herself, hiding bottles in the bathroom, among the spangled shoes in all those mirrored closets. If she could not drink at Prides, she would drink elsewhere.

Margarett liked the release alcohol gave her, but she had no idea what it might take away. She was willing to sacrifice a few evenings to early drowsiness, a few daylights to the dark room of the headache, in order to have that particular vivid intensity. It did not threaten her in the slightest to stop or to promise to stop; she could stop, she kept proving, whenever she pleased. What she did not understand was that in abdicating to Shaw the responsibility for managing her drinking lay the threat of losing everything she had, that in months or years of lies and slips from his straight and narrow, she might lose her freedom, her upper hand, her magic.

" 'Beyond Good & Evil' is the picture of me," Margarett wrote to Frederic Bartlett. She had painted the self-portrait during the summer of 1930, had been photographed in her smock painting it, by Bachrach. She placed the image of herself almost diagonally across a ground of pale, smoky blue—slender, black hair pulled to her neck in a chignon, her skin translucently pale, eyes wide and light, light blue. Her hands, one on the other, press into her lap; her arms are tensely extended. Animals crowd the canvas, as if eager to push her from it—a leopard, a goat, a dove. The dress, string straps, is patterned magenta, poison green, and aqua. This is a self-portrait not as an artist but as a woman. The woman restrains herself, keeps her breath in. She is frightened, without defense.

In September 1930, Margarett mailed an exhibition checklist to Frederic, who had arranged an exhibition for her in November at the Arts Club of Chicago. Incorporated in 1916 by a group of collectors, the Arts Club soon became an innovative forum for modern art, years before New York, let alone Boston, had any such venue. By 1921, it had shown Marin, Demuth, and Lachaise, and, among the French, Seurat, Delaunay, and Cézanne. In 1924, it presented the first one-man show of Rodin's sculpture west of New York and the first American exhibition of Picasso's drawings, with a catalogue essay by Clive Bell. In the late 1920s, Marcel Duchamp installed a major Brancusi

exhibition and Léger showed his film *Ballet Mécanique*. In its small theater, Igor Stravinsky and Serge Prokofiev performed their music, Edna St. Vincent Millay and Robert Frost read their poems, Marsden Hartley lectured on art, and Ford Madox Ford spoke on literature.

At nine o'clock in the morning on the day of the opening, Margarett met Alice Roullier, the club's secretary, and Isabel Jarvis, her assistant, at the Arts Club, then housed in the Wrigley Building on Michigan Avenue. Miss Jarvis was skeptical about the woman whom Mr. Bartlett had praised as "married, but a very good artist," but fifty years later, she remembered "an unusually beautiful woman, a very good painter, very informed about modern art." In the largest of the club's three galleries, they supervised the hanging of forty paintings, twenty-five watercolors, and fourteen drawings. Like the show at Harvard, this was both exhibition and retrospective. Two of the paintings were loans from Frederic Barlett, who, in his home, hung them on a wall with a Matisse and a Utrillo. "They have all the beauty of color of Marie Laurencin," a society columnist wrote, "and an underlying primitive power of their own."

Unlike Boston, where a gathering to celebrate modern art had the feel of a conspiracy, Chicago had boisterous pride in its innovation. The opening was celebrated with a tea, and fashionable Chicago crowded the gallery. Margarett arrived on Bartlett's arm, to be greeted by Mrs. John Alden Carpenter, the club's president, and by Mrs. Potter Palmer, daughter-in-law of the great collector who had commissioned Mary Cassatt's mural for the Woman's Building at the World's Columbian Exposition in Chicago in 1893.

In its weekly magazine of the art world, the *Chicago Post* headlined Margarett's exhibition. Bartlett, who personally handled the publicity, made sure photographs were provided, and *Blue Girl* took all of page one under a banner headline. The city's most prominent critic, C. J. Bulliet, was a conservative who usually panned the Arts Club's shows; he hated abstraction and would declare in 1936 that Modernism "began with Cézanne and ended with Picasso." In Margarett's work, how-

ever, he saw a kinship to his beloved Post-Impressionists; she was, he wrote, the leading Modernist in a city "where 'Modernism' has even a tougher row to hoe than it has here." and a rebel "regarded over in her hometown as a lost soul because of her art bolshevism." The strength of the exhibition was reflected in the clarity of Bulliet's review. As influences he cited "Matisse, principally, and Picasso and Chagall and Modigliani" but concluded that "despite the influences, there is a unity of effect running thru her work—something distinctively 'Margarett Sargent.' " He praised her gift for capturing character, in particular her ability, unusual in a woman, to paint men. "Given another three years like the last three and Margarett Sargent will have sublimated all her 'influences' and stand revealed in all the power of her own high talent."

When the exhibition closed, Margarett, long back in Boston, cabled Frederic to have her paintings packed. She had set up her easel backstage at the Metropolitan Theatre, she told him, and, with the company standing about, had painted Harpo Marx, first with a flaming corkscrew crown of orange hair, then with a parrot on his shoulder and his scribbled caption, "a portrait no artist would paint." Frederic directed the Arts Club to ship half the paintings to a New York warehouse to await Margarett's third exhibition of the year, which was to open on January 3. Harpo with his parrot illustrated the Kraushaar announcement. "Burlesque Picture a Hit," read the headline of a *New York World* report that the painting had "attracted many to the gallery."

Margarett showed fourteen paintings at Kraushaar, all of which, except for Harpo, she had shown in Chicago, and a group of drawings and watercolors, of which she sold six. The exhibition was her first in New York in two years, and the critics took note of her development. The *Post* reported a burst from prior reticence "into a full-fledged palette." Like Bulliet in Chicago, the New York reviewers were interested in what lay ahead. "If she is ever able to forget, or conceal, her somewhat noticeable admiration for Matisse she will prove an artist that has to be taken very much into account," Henry McBride wrote

in the *Sun.* "A little more concentration and what used to be known as 'slogging' would do wonders for this gifted and imaginative painter," Margaret Breunig wrote in the *Times.*

There was no need to tell Margarett to keep working. She brought her sketchbook to the breakfast table and took watercolors out to dinner. Her most significant attention to her children was the command "Hold that pose," and when they came up the hill to visit her studio, she might ask them to sit for an hour and a half, "hardly entertaining if you're seven and prefer baseball," said young Shaw. Jenny escaped to the barn and her pony, so Margarett got her, dark-eyed, in the bathtub, a pink towel turbaning her black hair. Of the children, Margie was her favorite subject: prim and solitary in a chair; in the library with Senny reading to her; face resting in her arms; a solemn portrait, her blond hair, a slate-blue ground.

Often Margarett hired a model. Betty Fittamore arrived on the train from Boston, and Margarett painted her over and over again— chestnut hair, deep-set black eyes, and smooth, lean face. Betty was the Blue Girl, with a hawk-wing swoop of black hat, forbidding gaze, hands grasping the white chair. She was the Amazon, with a crimson headdress, eyeing the miniature man she held between thumb and forefinger. And a woman stripped naked to the waist, her luxuriant, flowered yellow hat vibrating against a deep black ground.

Margarett sketched at Elizabeth Arden, on the train to New York. She carried her supplies in a neat leather case. She did watercolors "at restaurants and night clubs," reported the *Breeze,* "aboard ship, from the tailboard of a truck, from a garden chair." She took canvas and paints to Florida, ventured inland from Palm Beach cabana and beach club and returned with a painting of a young black girl, fierce and meditative, sitting at a table. She visited Frederic Bartlett at his beachfront estate in Fort Lauderdale and painted his caretaker and friend, Fred Lockheart, an older black man, with a chicken under his arm. She did not, as *Town Topics* reported, spend all her time chatting at Sea Spray beach.

Her Boston School forebears had painted in the New Hampshire landscape or the quiet of a Back Bay living room. Margarett painted in the dining room at the Ritz. She took her paintbox to a party given on Beacon Street, billed as "an imaginary voyage to interesting places in the Mediterranean." While the travelers projected "moving pictures," Margarett took pencil and wash to the back of the invitation: a man, black-tuxedoed back to us, a woman to each side. He raises a hand to his face as if to express—what? It's not evident from the diffident profiles of his female companions.

Later, in the studio, Margarett made a painting from the sketch: the three figures on a hot-yellow ground; the gentleman's black back and arm take the breadth of the canvas. The lift of his hand to his face expresses ennui, which, if one removes the humor, the trick of the turned back, cuts deep. Margarett was inside social Boston, but as an artist she stood outside, looking at its back.

"I NEVER COULD UNDERSTAND," Gertrude Hunnewell often said, "how two such dear people as Uncle Frank and Aunt Jenny could have produced such *unusual* children." Gertrude had never questioned her own destiny, but Margarett and her sister and brothers all suffered from the requirements of the life they were raised to lead. Jane Cheever, well married and the mother of four children, was by 1930 an annual guest in a sanitarium, overcome like her grandmother by panic that alternated with debilitating depression. After a few years, Dan's marriage to Louise became the torment Jenny had predicted: "When Dan became an instructor at Harvard, Louise went to bed and never got up," Margie said. He cowered at demands she delivered from her chaise, getting his attention with the rap of her cane on the floor. He supervised the care of their children as best he could, wrote his poems, his biographies of saints, and prayed fervently at daily mass.

Harry, still unmarried, lived with Jenny and her hired companion, Eva Niblock, in Wellesley, Boston, and Wareham. He had left banking to become "an explorer," first in the fjords of Norway. In 1929, he

financed a film about the lives of seal hunters, and in March 1931, went along to Newfoundland for the final shoot. On March 16, a front-page article in the *Transcript* reported that an explosion on the seal steamer *Viking* had killed twenty-five. One hundred men walked nine miles across the ice to safety, but there were no Americans among the known survivors. Though no body had been found, the *Transcript* ran Harry's obituary on March 17. When news came that he was alive, Margarett and Shaw sailed to Newfoundland.

Harry was alive, barely. He had spent two and a half days on an ice floe, his eyes burned temporarily blind, first by the explosion and then by the glare of sun on ice. He nursed a fire of ship debris, feeding cans of beans to two wounded crewmen until, three days later, a rescue ship crashed through the ice and carried him to shore with one surviving companion. In a hospital bed, he read he'd drowned.

When Margarett and Shaw brought her brother back to Boston, Margarett had a portfolio—sketches of seal men and caricatures of the Boston reporters who scavenged the *Viking* explosion, a watercolor of a cab stand in Quebec, a gouache of bellboys at the Hotel Frontenac. There was nothing, it seemed, she did not turn into art, and when that was true, the balance she managed between her life as an artist and her life as a woman was no feat at all. Florence Cowles celebrated Margarett on a full page of the *Boston Post*, under the headline "Applies Her Artistic Skill to Make Her Home Beautiful; Mrs. McKean's Hobbies Modern Paintings and Old Doors."

The article was nationally syndicated, and at least two versions were published, one illustrated with a portrait of the artist, brushes in hand; the other, by a collage—the children, a view of the big room, Margarett at the pool with her sculpture of Pilgrim. Cowles was promoting Margarett's first North Shore exhibition. Frederick Poole, an antique dealer, had suggested she hang her contemporary work throughout the twenty-six rooms of his shops, two seventeenth-century houses at Fresh Water Cove. By the summer, Poole, a friend and often Margarett's portrait subject, had died. It was he who had reproduced the Venetian corner cupboard, so that two cabinets might frame the end

of the big room, he who repaired the sticks of American furniture she bought at auction in Vermont. His daughter insisted the show proceed.

It was Margarett's fourth exhibition in nineteen months—nearly two hundred paintings, watercolors, and drawings. "Into such a setting of antiquities come hundreds of people in fashionable cars each day to see her pictures," wrote the veteran *Globe* critic A. J. Philpott, who went on condescendingly to praise her work as "out of the ordinary . . . distinctive and outré and all that sort of thing." The *Transcript* listed spectators, leading off with Justice Oliver Wendell Holmes, just retired from the Supreme Court. "Margarett Sargent Exhibition Popular, Pictures Attract Hundreds at Gloucester," read the *Globe* headline.

Margarett had had five major exhibitions in New York, one in Chicago, and one in Cambridge. Now she had shown a large selection of her work to a popular audience in an unconventional venue just miles from her home. She had painted for only three years, but she was recognized as a painter, collected, exhibited, and reviewed by those who were bringing an aesthetic she shared into the mainstream of American art. At thirty-eight and at the height of her productivity, she was well positioned to take advantage of her opportunities, but she seemed to harbor some ambivalence. Tucked into the *Transcript* coverage was the unexplained news that she had been "indisposed" since her return from Vermont for the exhibition, unable to supervise hanging the pictures or to attend the opening.

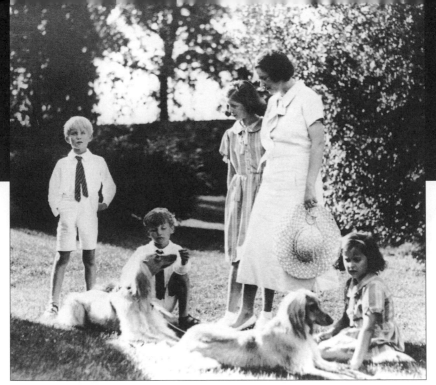

viii

Isolation is delicious,
especially in a crowd

(1932–1936)

Margarett and her children at Prides, c. 1934
(from left, Shaw, Harry, Margie,
Margarett, Jenny)

I N 1932, EMLEN ETTING, a young painter Margarett had met in Paris, visited with his camera. He set up a screen outdoors and posed her for a series of photographs. She wore pearls around her neck and on her wrist, a loose white silk shirt, a dark crepe pinafore fastened aside with a gardenia. Her hair, cut to a length above the shoulder and pulled back from her face, blurs as it recedes in the depth of field. Faint blemishes in her skin are visible in the high-contrast light, and her lips are painted dark with lipstick. The beginning of creases shadow her neck. She throws back her head and closes her eyes.

Later, she sits, legs pulled up under her, on the leaf-strewn grass, arms loosely folded on the brocade seat of a stool placed in front of her. Because of the whiteness of the screen behind her and the darkness of her hair, the extremely pale color of her eyes is strikingly evident. At forty, Margarett no longer has the slenderness of a girl, but she has come into her stature as a woman, and her age shows as fierceness and certainty.

When Margarett agreed to have her first one-person show in Boston, she chucked the gallery's usual exhibition notice, which looked like an invitation to a debutante tea, and designed her own—bright-black letters and Mondrian lines. Doll and Richards, a venerable gallery on Newbury Street, was where "everyone" sent a Barbizon landscape or a Boston School portrait to be cleaned or reframed. Exhibitions of paintings by Freddie Hall and Margarett's friend the watercolorist Marian Monks Chase occasionally interrupted displays of English sil-

ver, Persian antiques, or sculpture by Katherine Weems Lane, who, in 1932, showed a sleek bronze of Caresse Crosby's black whippet, Narcisse Noir.

Margarett showed thirty paintings and a group of watercolors and pastels. At the opening, Dan escorted Jenny Sargent, and Margarett's friend Vivian, newly married to Dudley Pickman, brought her daughters. Frederic Bartlett, John Spaulding, Robert Treat Paine, and Freddie Hall lent Margarett Sargents from their own collections. Josef Stransky of the Wildenstein Gallery in New York bought an oil called *The Blue Hat*, and Margarett's cousin Aimée Lamb, whose own paintings were strictly Boston School, purchased *The Next Table*, a gouache of a woman alone in a café, smoking—"I found it convincing," she said. The *Transcript* acknowledged Margarett as perhaps "the leading figure in our non-conservative art movement" because "the influence of her brush and pencil is traceable in the work of others," and called her "the most direct link between this city and Paris."

Until she and Shaw sailed for a holiday in Cuba on April 9, Margarett turned up frequently at the gallery, often with the children, whom she directed to count the red "sold" dots on the wall labels. In Cuba, she did watercolors, and when she came home, quickly completed a painting—a Cuban woman in a maroon dress, wearing a Spanish comb—which she placed in a group show organized at the Museum of Fine Arts by the New England Society of Contemporary Artists. Aside from the Boston painters, the exhibition included artists like Edward Hopper and Blanche Lazelle, and works by a group of African American painters lent by the Harmon Foundation of New York. Margarett's *The Watteau Hat*, of Betty Fittamore in deep browns, vivid blues and yellows, illustrated reviews in both *Art and Archeology* and the *Transcript*.

Margarett's exhibition in 1931 had been her last at Kraushaar. Antoinette Kraushaar recalled "no unpleasantness" to account for the end of the association, but in the years of the Depression, New York galleries closed down, and the number of exhibitions declined dramatically. Kraushaar did not close, but it mounted fewer shows, and Mar-

garett began to focus more of her artistic attention on Boston. In return, Boston claimed her as an artist. A gentleman wandering through the 1933 Jordan Marsh annual, in which Margarett showed a painting called *The Opera,* was heard to remark to his male companion, "I'll tell you who that's by without going up to it—that Sargent girl!" A Brookline matron complained about the same painting in a letter to the *Herald*: "Here, indeed, was field for use of the favorite brand of soap . . . to remove daubs of this and that, in which case the lady might feel she was in the company of a gentleman not an ape."

Margarett's *The Opera* resonated with a painting by George Luks. In 1906, from a sketch made at the Café Francis, in New York, Luks painted a buxom brunette with dark eyes and high color, her white gown cut low, a bouquet of pink plumes waving from her hat, and, helping her out of an ostrich wrap, a mustached, solicitous gentleman. In the far background, mellowly lit, are a man with a guitar, and, farther on, other revelers. Because it was painted the year of Stanford White's murder, Luks may have intended a comment on the kind of high-life adultery that brought the womanizing architect to his death. Twenty-five years later, with a memory of Luks's *Café Francis,* Margarett painted a brunette, slender in a ball gown, with her own tuxed gentleman.

Luks's model offered her cleavage like a Mediterranean market woman might proffer a basket of fruit. Margarett's brunette gives us her back, bare to the waist, her face turned back toward us over her shoulder. Margarett painted her escort in the tuxedo as an unshaven, leering grotesque, and those who gather in the distance on the opera stage are not revelers but an angel in white dancing with a devil, her mortal partner vanquished at their feet. Luks's heroine seemed to relish her seductive power; Margarett's has a look of wide-eyed apprehension.

In painting *The Opera* as she did, Margarett reflected on her situation as she did not in conversation. A woman turns away, but seduces with an expanse of creamy back. She looks back at us, pleading, before disappearing like Persephone into the arms of a tuxedoed hell. Margarett has pulled back from the female face to reveal not only the

woman but her female circumstances and, in doing so, finds herself more vulnerable than she ordinarily let on.

"Margarett was not an introspective person," said Dorothy DeSantillana, a book editor who met her in the late thirties. Others ascribed Margarett's discretion to manners: She was a "lady" and did not discuss certain things. Betty Parsons said Margarett talked about events in her private life only in exclamatory bursts. She was in love with someone, angry at Shaw, mad for a painter, had bought an extraordinary strain of Dutch tulip. Once, she was in love with "a Spaniard. Carlos was his name. Oh, how in love she was with him!" But Margarett did not talk through difficulty or emotion. She had seen her father take things in and move on. She had watched her brother Frank's depression bring suicide, her mother's mourning turn paralytic, her sister Jane's despair send her yearly to Silver Hill or Austen Riggs. But like them, Margarett considered the direct expression of feeling a weakness.

For those whose desires do not conflict with how they live, restraint has a kind of elegance. People admired Margarett's courtesy as if it were a rare and exquisite artifact. All her life, she had disguised her defiance with one aesthetic form or another, but increasingly now, her authentic self came through. When life at Prides meshed with her imaginative design, it was enchanting, and she moved through it with creativity and vitality. When things did not go as she planned and her efforts to correct or embellish failed, when she drank too much or could not drink enough, her body rescued her with headache or illness, and she retired to her bedroom and pulled the shades. Sometimes the headaches came even if she didn't drink. As the children grew older, Shaw more distant, the elixir of lovers less powerful, quiet hours in her room became less a comfort than the visitation of a pestilence, less a refuge than a fortress.

Only to the family, her household, and a few close friends was the woman in the dark room as truly Margarett as the joyous, powerful, infectiously attractive woman who greeted a guest or a journalist. When Louise Tarr arrived at Prides in October 1932, Margarett exuberantly received her in linen lounging pajamas—black trousers and a

bright plaid jacket. Tarr, a friend and a reporter from the tabloid *Boston Sunday Post*, had conceived an article on the racy subject of "feminine charm." She would interview Margarett, the "well-known artist and leader of Boston society," as an authority. The piece took up a full page of the color feature section and was illustrated with tinted photographs of Sonja Henie, Sarah Bernhardt, and on a ship's deck with a bevy of her models, Coco Chanel.

The interview was a performance, and Tarr must have heightened the drama in her text. "Women try to charm attractive men by doing what the men want them to do—to the point of lunacy!" she reports Margarett declaring. "But charm is infinitely more dangerous than beauty," Margarett continued, gesturing toward her aviary, where drab females chirped at brilliantly plumaged mates. "Men are scared of the sorceress type, the flagrantly beautiful ones; they are warned against Helen of Troy in school. Charm is a plainclothesman who gets us before we know what he's doing." The housekeeper, Mary McLellan, served Dubonnet, Margarett opened the aviary, and a parakeet flew to her shoulder. The conversation continued, punctuated by the French-taxicab calls of zebra finches.

At the end of the interview, Margarett seemed to become personal. "There is no reason why women should not grow more charming as they grow older, but few of them do. The loneliness that overtakes a woman, the gradual fading away of admiration, and the knowledge that she is no longer held by someone to be the most important thing in the world—all this is hard to weather. The years from 30 to 50 are the dangerous years for women with charm. If she gets up to 50 without losing it—she can be a wallop at 80."

In 1933, Margarett and Shaw went to Europe for the first time since the stock market crash. They traveled with Arthur Hobson, one of Shaw's younger business associates, and his wife, Tiny, a small, gregarious redhead. The Depression drop in prices allowed an extended stay in Paris at the Ritz, a chauffeured Rolls-Royce, the hiring of ladies' maids and valets. The day after the new German Lloyd liner, the

Bremen, docked at Cherbourg on June 7, 1933, the *Paris Tribune* announced the arrival of Mr. and Mrs. Q. A. S. McKean for the summer. Their itinerary also included weeks in London and a visit to Berlin, where Shaw and Hobson had a business venture.

In Germany, the Weimar Republic had finally fallen, and Hitler, who had been named chancellor on January 30, was consolidating his power. In February, the Reichstag burned in Berlin and Communists were attacked in the streets and rounded up. In March, the Nazis and their Nationalist allies won the Reichstag majority, Hindenburg ordered the German flag replaced by the swastika, and the first concentration camp was opened, near Dachau. In early April, the Nazis enforced a ban on Jewish businesses, and in May, bonfires of books did away with Mann, Hegel, and Marx.

The new chancellor made sure to meet Americans interested in doing business in Germany. Facilitating many of these encounters was Ernst Franz Sedgwick Hanfstaengl, a robust man of six feet four with a booming voice, known as "Putzi" or "little doll," and an old college friend of Shaw's. Half Bostonian and half Bavarian, Putzi had been famous at Harvard for piano impromptus, his huge deft hands pounding out selections from Beethoven or Wagner. After the Munich Beer Hall putsch in 1923, the Hanfstaengls hid Hitler in their castle in Bavaria, and he and Putzi became intimate friends. Hitler was beginning to think about writing *Mein Kampf,* and Putzi was composing "The German Storm," which in time would become familiar as a Nazi march.

Sometime during June 1933, Putzi engineered a dinner with the chancellor for a group of potential investors and their wives, including the McKeans and the Hobsons. When he met rich Americans, Hitler was at his most seductive and devious, as he had been just a month before when he delivered his "Peace Speech" to the Reichstag, assuring the world that Germany supported Roosevelt's call for the abolition of all offensive weapons. The dinner Putzi organized was small enough for Margarett to have a good look at the newly ascended dictator. Janet Flanner, in a 1936 *New Yorker* profile, would describe how Hitler looked during conversation: "In anything approaching serious talk, his

sapphire-blue eyes, which are his only good feature, brighten and glow heavily as if words fanned them."

Margarett had no interest in politics. If she voted, she voted Republican as her father had, and if she took a position, she came to it on instinct. When she spoke of the dinner with Hitler, she talked about the eyes Flanner described so impeccably. They drove her from the dinner table, she said, as soon as she could manage it: "I thought he was absolutely mad."

As always, Margarett had looked forward to Paris, but she found it a changed city. The movements in art that had excited the Continent in the twenties had been reined in by the Depression, which by 1933 had spread to France. In the 1920s, as F. Scott Fitzgerald put it, "even when you were broke, you didn't worry about money, because it was in such profusion around you." By 1933, many of the shops that catered to American tourists had closed down, and Charles Ritz was touring American cities to drum up business for his hotel. The Bromfields and the Carters were still in residence, but Betty Parsons had left France, as had Sandy Calder, and Caresse Crosby would shortly give her last party at Le Moulin before returning to the United States, to live in Virginia.

But there was Roland. Margarett and Shaw saw him with his wife, Mimi, and Margarett saw him alone at one of two or three restaurants they loved, where they could be, Roland said, "as we always had been." Of all the men in Margarett's life, Roland most enthusiastically entered her psyche, emboldening the part of her Shaw considered slightly mad, the part of her that, thwarted, could pull her down into darkness. Margarett confided in Roland, and he watched her carefully. He noticed when she got bored and removed herself from a conversation, and he saw what her marriage was like. Once, in New York, he and his wife had the McKeans to a dinner party. "Everyone was gay and joyous," he said. "Margarett was telling a riveting story." As the maid passed a vegetable dish, Margarett made "a grand gesture," and the peas in it spilled.

"Margarett!" Shaw shouted. "Look what you've done!"

"I'll pick them up," she said, retrieved one pea, put it back in the dish, and continued her story.

"Intellectual sensuality is the most rare and the most devastating," Margarett had said in the Louise Tarr interview. Perhaps she was referring to Roland. "An affair built up by a person exciting you verbally is much more intense than an affair which is all gin and chest." In Margarett, Roland sensed a companion for his own wildness, an echo of his dissolute youth at the edge of Cocteau's circle. "I was very deeply in love with her," he said, "and I think she reciprocated that love."

One day when they met, Roland announced that he had a surprise for her. As they drove toward the river, Margarett needled him. "Where are we going?" He kept silent, a feline grin spreading across his face. At the edge of the Seine, they left the car, and, Margarett saw birds of every description and breed chirping, singing, and whirling through the air in capacious cages. There were birds for decoration, birds that talked, fowl for eating, prize chickens for breeding. Roland remembered the goose in the moonlight and Margarett's delight when he once suggestively jiggled the handle of his umbrella—a swan carved from ivory—turning it into a discreet instrument of seduction as they sat at the Ritz in Boston for lunch with her children.

Margarett collected birds as if they were works of art—a finch of an obscure variety, a canary that was orange rather than yellow, a pair of gray-cheeked parakeets. Her aviary at Prides was a carnival of sentient color and living sound. She bought several birds and several cages that day. She planned to keep them with her for the rest of the summer, take them home on the *Bremen*. She had them delivered to the Ritz, and she and Roland celebrated in the bar.

Margarett was in the room when Shaw returned.

"My God, Margarett," he said.

"Aren't they beautiful?"

Shaw opened the windows, then the cages. Perhaps Margarett rushed to rescue her birds, or perhaps she stood there, helpless, as they flew out the window onto the Place Vendôme. Roland had never heard her so upset, so inchoate with rage, so close to tears, as when she telephoned

and told him what "that damn Shaw" had done. Shaw detested how Margarett disrupted things, but Roland thrived on what he called her refusal of rational life—birds in the bedroom, phone calls that interrupted him at Knoedler's with improbable emergencies, her deep voice telling him about a new pair of *extraordinary* chartreuse pumps.

Shaw was having an affair with Beatrice Dabney, a Bostonian, younger than Margarett, divorcing or divorced, slender and dark-haired. She spoke with a lisp—particularly amusing when she addressed a pet goose she'd named Pompous Ass. She was also a friend of Margarett's and, like Margarett, had a talent for enchanting men. Beatrice had not hired a maid for her sojourn in Paris, which coincided, not by coincidence, with Margarett and Shaw's. For weeks, at Shaw's behest, when not ironing or mending for Mrs. McKean, Margarett's personal maid attended to Mrs. Dabney, who was staying at another hotel. Of this Margarett had no knowledge, but the arrangement eventually upset the maid, who, in tears, reported the story to "Madame McKean." "And do you know," Margarett said later to Dorothy DeSantillana, "he had *my* maid taking care of Beatrice Dabney!" No matter that she herself had affairs; the humiliation stung.

In September 1933, an interviewer arrived at Prides from *House Beautiful.* Margarett entered the room, "fit as always," wearing something black with quick interruptions of silver. "With her comes the steady, deep flow of gorgeous conversation, a steady cruising speed of about 110 miles an hour," wrote the reporter. "She never stakes all on a brilliant crack; her patter flows along on the income of a tremendous wit, she never spends from her capital account." The enthralled journalist had come without paper. Margarett supplied a handful of the pink laundry checks she occasionally used for sketching.

They settled themselves in the library, the reporter taking in what hung on the walls: George Luks's painting of the original house at Prides, a dark saltbox in a luminous field of snow; Mary Cassatt's aquatint *The Coiffure*, a nude sitting in front of a mirror, her pale back to us, bare arms raised to tie up her hair.

The reporter remarked on the food—a first course of baked can-
taloupe, "warm and swimming," rack of lamb, fresh green beans,
whipped potato. After supper, the children performed their poems, and
Jenny brought out the biography she'd written of her mother: "Mar-
garett Sargent was born in Boston. She took up sculpturing at an early
age. Mr. Gutzon Borglum taught her, but she hated him and still does
hate him." The interviewer left with glossies of three paintings, and a
Berenice Abbott portrait in which Margarett, smiling at the camera,
wears a dark smock and a black-and-white-striped polo shirt. The arti-
cle in *House Beautiful* introduced an artist with "an artistic quality
of immense candle power." But it misread the woman. "She laughs off
everything," the reporter wrote. "Whatever it is, nothing is serious on
the surface."

A month after the *House Beautiful* interview, Margarett went down
to New York. She would go to the theater and to some exhibitions,
and as always, she would see George Luks. At sixty-six, he continued
to be celebrated as an artist—in 1931, he'd won the Clark Prize and
Gold Medal from the Corcoran Gallery—but he'd broken with his
dealer, who had forbidden him to come drunk to the gallery.

On an evening the previous December, it had been advertised that
at eight o'clock, at the Artists' Cooperative on East Thirty-fourth Street,
Luks would paint a demonstration portrait of Doris Humphrey, the
dancer, and speak afterward on painting technique. Instead, he mounted
the stage and escorted the model from her stand. "I'm George Luks,
and I'm a rare bird," he began, and lectured the audience of five
hundred on the appropriation of American taste by "French superior
salesmanship." Americans were victimized by "cheap little lawyers who
become diplomats," he fumed, "and financiers who let their wives buy
pictures from dealers who perfume them with bombast and saddle
them with trash."

The evening's organizer came forward to direct him to the easel
and meekly offered a smock. Luks threw it on the floor. The audience
began to shout. He shouted back: "I can paint and you know it. Now

shut up and listen to me." People surged toward the stage, and Luks took hold of a large man who had called him a braggart. "You're talking to Chicago Whitey, the best amateur boxer and barroom fighter in America."

"Luks Lecture Drives Most of 500 from Hall," read a *Herald Tribune* headline the next morning; the reporter wrote that Luks had exercised "the gusto and delight of a child tearing apart his mother's favorite tapestry." His friends knew from the account that he must have been drinking. Even his most recent wife, Mercedes, had thrown up her hands. When Luks left after supper and told her he'd stay out just long enough to observe dawn come to Seventh Avenue, she knew he was going to a bar.

Early on the evening of October 28, Luks and Mercedes argued, and he stormed from their apartment on East Twenty-eighth Street. Margarett had not yet seen Luks—on arriving in New York she'd come down with bronchitis, which had quickly become pneumonia—and she was too ill to travel back to Boston, so her maid, Anna de Schott, had come to New York to take care of her.

By two A.M. on October 29, Luks was in a bar on Sixth Avenue, drunk and drawing on a napkin. In no time he was "Chicago Whitey," picking a fight. In early morning, he was found propped up in a doorway under the Sixth Avenue el. The sun cast light and shadow as it did in his best painting, but the figure dimly visible in the center of the field of vision was Luks himself, and he was not drunk or down on his luck; he was dead. Margarett's telephone number at the Hotel Weylin was in his pocket. He had died of injuries sustained in Chicago Whitey's last brawl.

There is no document of Margarett's response to the phone call, only Dan's testimony that it was she who identified Luks to the police, she who called Harrison Tweed, the lawyer to whom she had introduced him all those years ago. Had Margarett worried about the new intensity in Luks's drinking? Or had she, like his drinking buddies, denied it, believing what the newspapers said, that "Lusty" Luks "had been in good health"? She stayed in New York another month, grief

deepening her cough. Luks's resilience had convinced her he'd always get back on his feet. His death was a promise broken, the loss of the most consistent witness to her life as an artist. When Frank killed himself and her father died, the unambiguous momentum of youth had pulled her forward, but she could imagine nowhere to go from this death. She stayed on as editorials and obituaries pronounced the "famous painter" dead of cardiac arrest, repeated stories of his Rabelaisian exploits, and fictionalized his demise: "He had died of a heart attack while studying the effect of the sunrise on the elevated structure for a picture he planned to paint."

Something happened to Margarett as letters from the children and Senny arrived day after day, full of get-well greetings, condolences, and family news: "Cara mater," Jenny wrote. "Esne melior?" Margarett wrote to Prides of having had a "good" night or a "bad" night, of news from the doctor, of a visit with Isabel Pell or Artur Schnabel. She did not write about her grief, how in the weeks after Luks's death, as the pneumonia held, sadness cut into her belief that she would always transcend the events that waylaid other, weaker beings.

It had been years since Margarett worked, Luks at her shoulder urging her on, as if with his coaching she was sure to score a knockout. But he inhabited her spirit. He was a source of courage should her ambition flag, should she be distracted by life or vanity. "To hell with your hats!" he'd shouted when she was a young woman, and she had learned to rely on the solace of blank paper, the feel of clay in her hands, the rapture of color on canvas. The times she had seen Luks work, wielding brushes like a flamethrower, had shown her paint as an expression of appetite, a means to renew with each emerging image her sense of a connected self.

At the opening of a Luks retrospective she curated in Boston in 1966, thirty-three years after his death, Margarett sat in a wheelchair, silent in pale-blue satin as friends viewed a room of his Boston paintings and drawings—among them, his portrait of Jenny and *The White Blackbird*. "The details of his death were typical of him," Margarett had written in an exhibition handout. "He was found in early morning,

dead, having been assaulted beneath the elevated on one of the sidewalks he loved so well." She did not respond to any greeting that day with more than a monosyllable. Luks's death had marked the end of her youth, of the New York years in which she worked with such passion. It had brought back the death of her father, of his love without conditions, his moral and spiritual protection. Margarett's family honored her grief, but they did not understand the depth or significance of her loss. She suffered it by herself.

A doctor made the suggestion that she recuperate from her pneumonia in Atlantic City, take the sea air even though it was November. Just before Thanksgiving, she returned to New York, where Shaw met her to take her back to Prides. After the New Year, they sailed for Europe. The children, as usual, stayed behind. By the end of January, Margarett was in the Sicily sun.

That something had shifted was evident when Margarett and Shaw returned from Europe. Margarett now drank with impunity, even before she appeared in the morning. She drank from bottles hidden in the bathroom, in the closet, or under the bed. If she invited friends for lunch, four or five women in the middle of the week, Margie or Jenny was sent out to greet them. Margarett could keep guests waiting as long as forty-five minutes, and so Margie, dying to be grown up, would make conversation and summon Mary McLellan to pass hors d'oeuvres and offer drinks. She knew that something was often wrong with her mother, something connected with her long mornings in the dark bedroom, but she and Jenny still didn't know what they were describing when they said to each other, "Mama is languid again."

"She'd look perfectly lovely, and she'd be absolutely blasted," Margie said years later, describing her mother entering the living room to greet guests. Margarett would seem different from how she usually was—scary, imprecise in her movements, slow in her speech. The guests would be terribly kind, behaving as if she were all right or suffering an unidentified malady. Eventually someone might suggest she excuse herself to lie down. Once, as she slowly retreated along the corridor

toward her bedroom, Tiny Hobson recommended that Margie, then twelve, call a doctor. Margie was too embarrassed to ask Mrs. Hobson to make the call, and it was Senny's day off. Later that afternoon, when the doctor emerged from the bedroom, he assured Margie her mother would soon be fine: "Just let her sleep."

No one in the household talked openly about Margarett's drinking. They talked about her headaches. They complained about her temper, joked about her perfectionism. And they continued to seek her approval and pleasure. The children wrote get-well notes, which were sent in on the breakfast tray, the lunch tray, the supper tray. In their mother's place, they had Senny, who, never speaking ill of Margarett, distracted and protected them the days the shades were lowered. When Senny was not around and Shaw was at his office, Margie stood in: "Senny's days off were 'doozies.' "

As Margarett's behavior came more to obstruct her life with Shaw, her drinking became more clandestine and her existence more alienated from the life of her family. For Margie, there was still no greater pleasure than to be close to her mother, but she now distinguished between two Margaretts—the one she adored and the one who frightened her. Jenny fled the sarcastic dining table, the shouts that echoed up the hallway from Margarett's bedroom, and was wary even when her mother did not drink. The arguments that erupted between her parents with increasing frequency terrorized and embarrassed her; never again would she feel close to Margarett. She escaped to the stable and her horse, Me Too, and never, she told me, invited friends home. Margarett noticed her coolness and when Jenny started to win blue ribbons, boasted about her own childhood riding exploits; without Jenny's consent, she began to enter them in mother-and-daughter events at Myopia horse shows.

No one wanted the twins, still very young, to encounter their mother's unfocused eye or slurring tongue, and so, as her habit became predictable, they were kept out of her path and away from her bedroom. One day, after a lunch in Boston, Margarett burst into the house at four in the afternoon. Shaw and Harry, playing in the living

room, watched as she opened the door, as she fell to the floor in her exquisite black suit, iridescent hat feathers wobbling in the failing light. They raced to the library. "Papa," they said, "Papa, Mama is drunk." They stood there as Shaw sat down and dialed his mother's number. "Mama," he said, as if tolling a knell, "the boys know."

Not even work calmed Margarett's despair. It shows in a portrait of Margie: ground of dry white daubed onto dimmer gray, blond head of hair an abundant sculptured shape, face a pale oval settled like a mask, golden hair springing from behind, expression benumbed and too world-weary for a thirteen-year-old.

In another painting, the subject, a woman, wears yellow. Black hair frames her face. Margarett paints her arms folded, a cigarette burning in her left hand, a garish smear of red lipstick on a mouth set mid-anguish.

And in a third painting, a woman's dark hair is pulled back into a knot at the base of her neck. Her eyes are downcast, seem, to the viewer, closed. Her arms are folded, each hand grasping its opposite elbow, so that her simple black tunic dress appears to be a straitjacket.

HARRY SNELLING WAS TALL and he was younger than Margarett. Ruby Newman's orchestra was playing at a dance Eleo Sears was giving in the same Boston ballroom where Margarett had made her debut twenty-two years before. She and Harry Snelling danced right off the floor. He had red-blond hair, and he made her laugh. She made him laugh. Perhaps his wife hadn't come to the dance; perhaps Shaw hadn't come either. Harry didn't live on the North Shore, but from time to time he came up from Weston to play golf at Myopia. That was how Eleo knew him.

At eighty-two, Margarett, reclining on a hospital bed in an apartment high above Boston, told me the story. Her hair was dyed tawny brown and carefully waved. Her bones held the shape of her face. Her eyes were still wide and blue, and her mouth was lipsticked carmine red. A practical nurse brought old red wine, a silver tray of smoked salmon, crumbled hard-boiled egg, capers and lemon. Margarett held

forth like a dowager queen, evening darkness encroaching on a room lit by lamps that illuminated the paintings, hers among them, ganged on creamy walls.

Her affair with Harry Snelling marked, as far as Boston was concerned, the same sort of change in direction as the clothes she wore after Florence or the breaking of her engagement to Eddie Morgan. By the time Margarett told me the story, her articulation had been impaired by a stroke, so I cannot be sure how accurately I heard her: We danced right off the floor, then we went to a hotel, purposely not the Ritz. Her voice was deep, somewhere between laughter and scorn.

They fell in love. They planned a trip abroad. They plotted divorce, the abandoning of young children. They were intoxicated, enthralled with one another, by what had happened on the dance floor, what followed in the privacy of the hotel room, where they spent, apparently, a few days. "And Shaw came to the hotel! Imagine!" Margarett laughed in the gloom of the winter lamplight. The hotel lobby was brightly lit, and Shaw, his face set, walked toward her, across a parquet floor. "Him or me," he said. She laughed. "Can you imagine that?"

When she met Harry at the ball, Margarett was wearing black velvet and her section of Empress Eugénie's pearls. Grandpa Hollis had purchased the full strand as a financial favor to Napoleon III and, after Isabella's death, split them between his daughters, who in turn divided them between their own. Harry wore a tuxedo, was big and blond like the man Margarett had painted sitting next to Betty Fittamore as a redhead bored to death, dancers whirling in the background.

"He was attractive to women," Dan said. He did not mean it as a compliment.

"He was a great amateur golfer," said Shaw's friend Ted Weeks.

"He was a dreadful man," said Margarett's son Harry, repeating what he heard as soon as he was old enough to play the links at Myopia. "A real rotter. He was considered to be very amusing and terrific fun, but he was a great woman chaser, a heavy drinker and gambler and all that stuff. A rough guy—certainly a complete nonconformist in Boston."

Harry Snelling had been married since 1928, and he and his wife had two small children. When Margarett met him, he was thirty-five and she was forty-two.

"Did he drink?"

"Well," said Margarett's friend Mabel Storey, putting a hand to her face, "he had a ruddy complexion. They all drank."

He had a car. He and Margarett left the ball and went straight to the hotel.

"So he was a big sexy guy."

"Yes."

Mabel repeated a story, apocryphal perhaps, that Margarett tagged the children before she ran off, each with the name of a friend to whom she wished that child sent.

"Shaw's friends all rallied during the Snelling thing," said Ted Weeks.

"They went abroad," someone said.

"They planned to go abroad," someone else said.

"Mrs. Haughton went to the hotel to put a stop to it."

"Margarett came out to Wellesley," Dan said, "and we went for a drive in Mama's car." Though he did not overtly approve of his sister's nonconformity, a part of him applauded it—he himself was a Catholic convert among Unitarians and Episcopalians, a poet among investment bankers. Because Margarett believed he understood her, he got the calls when she retreated to the dark room—if not from her, from Shaw, sometimes even from Mrs. Haughton. He'd listen patiently and make suggestions, grateful his religious practice shielded him from her kind of suffering.

"I'm going to leave Shaw," Margarett announced once they were settled in their mother's car. "Everything will change," she said. "I'm going to marry this man and begin again." The window between front and back kept the conversation from the chauffeur, and Dan was silent. "Are you with me?"

"No," he answered. "I'm not."

"At the time, I knew something was wrong," Margie said, "but I

didn't know what. Mama had Harry Snelling to the house years later. He was terrifically dull."

"I don't know how long it went on," said Ruthie Wolcott, daughter of Ham and Ruthie Robb, "but I know it must have been pretty violent, you know. Because it was hot—pretty hot." What was unusual was not that the affair occurred but that it was public enough to be a scandal, public enough that friends and friends of friends walked past a particular Boston hotel to gaze up, with amusement or distress, at a certain row of windows.

Margarett took Harry to New York.

"I'll ruin you in business," Shaw told Snelling.

Ted Weeks climbed the stairs to the second-floor dining room at the Ritz, and there he saw Harry Snelling, sitting with his wife, her eyes red-rimmed.

Harry had trained himself for business by working first in a foundry, later in machine shops in the Midwest. He'd gone to school to learn the textile trade, had then helped to finance Franklin Rayon, which later became the Textron Corporation. Unlike Shaw, he had to work, and he worked hard. In a photograph taken his senior year at Harvard, hair parted up the middle, he has a wide, placid face, a delicate mouth, and large, light eyes. By the time he posed at forty-six for his twenty-fifth-reunion photograph, his hair had thinned, his eyes had narrowed, and his cheeks had dropped, but when Margarett fell in love with him, he was still in possession of the tension between delicacy and masculine heft that made him "attractive to women."

"Margarett was terribly in love with him, and he ditched her," Mabel Storey said.

"He did?"

"Oh, yes."

One evening, Ham Robb received a phone call. He had been in Harry's class at Harvard, and Harry had confided the affair. Now Harry told Ham he had broken it off and that Margarett was extremely upset. He simply couldn't go through with it, he said. He wasn't going to leave his marriage. He wasn't going to risk the talk.

"Him or me," Margarett reported at eighty-two, red mouth swerving in a smile of triumph. "Can you imagine?"

When Ham and Ruthie reached Prides, Margarett was distraught, had opened a window to fling herself from. Ham pulled her back. For hours she wept and raged. Out of her feeling for Harry Snelling had come a resolve to leave Shaw, a belief that she could be free of the guilt of her failed marriage, her inadequate motherhood. Her brother Harry drove her out to Wareham. They walked to the end of the pier. The tide was out. The rocks glistened, but there was no water. "All I want to do is dive in." Harry pulled her back. The rest of the family heard about it from Jenny Sargent: "If only we hadn't sent her to Europe!"

When Shaw learned Harry Snelling had thrown Margarett over, he returned to Prides. He had been staying with his mother, had probably taken the children with him. In morning-after daylight, Margarett greeted him. They went to see Mrs. Haughton, who spoke sternly. The marriage must be saved, she said, for the good of the children. As soon as they could manage to sail, she would send them to Europe. The events of the spring would, in the course of things, recede, and they could return to Boston, if not in happiness, at least in an appearance of tranquillity.

Margarett didn't tell me, on that winter afternoon, what she felt when she and Shaw left her mother-in-law's house. Apparently she took her pain in stride and packed her trunks for Europe without protest.

ON MAY 29, 1935, the family, including Senny, sailed on the *Bremen*. The twins, at almost eleven, were clowns, especially Shaw, who was beginning a career as the family subversive. Jenny, at twelve, had outgrown her nickname, Dizzy, given because she seemed to dance rather than walk or run. Margie, at thirteen, was ready for the diary Margarett had given her—"To my Margie, from her publisher & mother"—and she kept a running commentary of the trip: "Read. Write. Listen to rebukes and commands." It was Shaw's job to manage logistics, and he was mercilessly teased for any blunder. Margarett threw herself into

the trip. She wanted to give her children what Europe had given her at eighteen, and she routed guidebooks for excursion ideas, with which she regaled them as the twins rolled their eyes.

Hardy, a chauffeur, met them at Southampton in a Rolls-Royce. He had been advertised as trilingual but spoke English with a thick Cockney burr, German when French was required, and, as it turned out, French for German. They settled first at Bournemouth, where Margie and Jenny had begged to go because it had a professional skating rink. They stayed for a month, and when the girls weren't skating, Margarett began her sightseeing campaign, with Hardy in the driver's seat. Jenny took snapshots of Margie and young Shaw at Stonehenge, of the ruins at Beaulieu Abbey, of swans at Abbotsbury. She caught her father, eyes downcast, in boredom or melancholy, sitting on the grass; her mother in a garden chair, sketching. Margarett looked straight into the camera, pencil in hand, sketchbook on her lap. "Isolation is delicious, especially in a crowd," she wrote in a sketchbook. She drew all the time that summer, filling book after book with watercolors.

They arrived at Brown's Hotel in London with forty trunks, and it rained for four days. A maid had joined the party. "Olga can be heard for miles shrieking about what 'Madame' has forgotten to pack," Margie wrote. "Jenny got sick, Senny was homesick." Everyone, including Margarett, played Monopoly, the latest game. "Shaw going slowly bankrupt. Harry gloating. Jenny making casual remarks, causing fistfights. Senny shushing from the bathroom next door." The girls skated at Streatham. Lady Astor, whom Shaw, because she had been married to his uncle Robert Shaw, still called "Aunt Nancy," escorted the twins through the members' entrance into the House of Commons. "Terrific amount of hailing taxis, buying paints & painting boxes, presents for people," Margie wrote.

Margarett took the girls to every possible museum. Without seeming to teach, she seduced them into looking, and they loved it. In the National Gallery, she showed them the Florentine painters, pointing out a particular color, the embrace of angels in a Botticelli nativity, an incidental vase of lilies in a painting of a Madonna and child. Almost

without words, she communicated that a painting wasn't just something pretty, that it hadn't just gotten there but had been made by a person whose name it was important to remember. Looking with them at paintings, she infused her daughters with the language most precious to her. "Victorious happiness with Margie and Jenny," she wrote on July 22. "Everything is easy now—everything is evolvable—everything is worthwhile."

For August, Lady Astor provided her house in Plymouth, the town she'd represented as the first woman in Parliament since 1919. The acerbic wit that had always delighted Shaw only hinted at the combative parliamentary style that bore out her campaign slogan: "If you can't get a fighting man, take a fighting woman." In 1936, when Chamberlain accepted Hitler's invasion of the Rhineland without protest, Astor would position herself firmly with the appeasers, but in August 1935, Plymouth was a pretty town on the sea and Aunt Nancy was, to her guests, not the object of controversy, but a generous, though absentee, hostess. William, the butler, took care of things, serving breakfast on the porch before the children's morning lessons with Senny. After lunch, the family would set off to sightsee. "The landscape has a noble haunted tinge," Margarett wrote in her sketchbook. "Hurry to motor to one town," Margie reported. "Hurry to motor to next town."

After Plymouth, they moved on to France, to Guéthary, a small seashore town on the Spanish border, only a short drive from the casinos of Biarritz. Margarett and Shaw had decided they would not return to Prides in September. They'd spend the autumn in Paris, perhaps even stay into the winter to see Shaw's niece Sis McKean compete at the Olympics in February. At the end of September, they moved into a flat in a silver-gray pension that stood on avenue Marceau just where the avenue begins to slope; from one set of windows, you could see the Arc de Triomphe. The children settled back into their lessons with Senny, and two days a week, Mademoiselle Yvonne James, who spoke no English, arrived to supplement the French they'd learned at Prides.

Soon after they got to Paris, Margarett decided Margie should be

painted by Marie Laurencin, and telephoned. "I don't do portraits," said the artist, then fifty, still in her prime and never kindly disposed to commissions. "You haven't seen my daughter," Margarett retorted. Laurencin did not say no. Margarett took the girls to shop at Elizabeth Arden, to see the fall collection at Rochas, and one day, coming down the staircase after an exhibition at the Grand Palais, she introduced them to Mrs. Edith Wharton, dressed all in black. Often the family went to the Bromfields' for Sunday lunch, and once, before the grown-ups sat down, Margie and Jenny were introduced to Gertrude Stein and Alice Toklas.

Shaw's niece Butsy McKean was living in Paris that winter, and Margarett invited her to avenue Marceau, to the theater, the circus, sightseeing, and museums. Butsy was sixteen and aware that the trip had been precipitated by a crisis. She admired Margarett, so she paid attention. Margarett seemed to her more removed than usual, quieter, but at the same time more attentive to her family. Butsy didn't remember Margarett drinking or even ill that fall, but Margie recorded a darkened room more than once. "Came back to find Mama stretched out on bed with bad headache."

One evening, they all went to the circus. Margarett wore a white evening suit with long white gloves, her pearls, the emerald ring that had belonged to Pauline Agassiz Shaw glinting from her hand. The family, including Senny, sat in a box, watched the pony act, the dog act, an acrobatic elephant. The boys held their breath as a hypnotist began his exhortations. Such concentration, such silence, and then, with no warning, the sound of Margarett falling in a stone faint from her chair. "Of course what we were told was that she had been hypnotized by mistake," Harry said. Years later, Margarett was diagnosed as having a vascular disorder that caused her, periodically, to faint, but at the time, what went unsaid was everyone's assumption she was drunk. She was carried from the tent.

In late January, with Hardy at the wheel of the Rolls-Royce, the McKeans left Paris for the Winter Olympics, the first phase in Hitler's full-dress campaign to present his new Germany to the world. They

drove east toward Bavaria, where, in September at Nuremberg, Hitler had announced laws denying Jews citizenship and forbidding marriage between Jews and "Aryans." At the border, swastika flags fluttered from passport control and police sauntered to the car to demand identification. Shaw pulled out the family passports and by mistake a hidden fifty thousand marks. The police asked questions in loud German, and Hardy broke forth with French excuses. "For God's sake," Shaw shouted with horror, "don't speak French!" After a moment, with a frown, the guard waved them on.

Half a million converged for the games at Garmisch-Partenkirchen, a small winter resort nestled in the Bavarian Alps near the Austrian border. Two million would attend the Olympics that summer in Berlin and see Jesse Owens, an American of African descent, win four gold medals, an unprecedented triumph for one athlete. Garmisch was a smaller affair, a prelude to the summer and, for the McKeans, a Boston reunion. Butsy's older sister, Sis, had been in Garmisch for weeks, practicing with the American team for the first women's Olympic ski competition. Her mother, Bessie, came from Boston, and Butsy came over from Paris.

The McKean children had their own ski teacher and when they weren't at the games were on the slopes learning to telemark, boots fastened to their skis with rawhide. Shaw and Harry saw a man with a black face and tails ski down the mountain; he was a chimney sweep, their teacher told them. Margie dispensed quickly with ski lessons to skate on the Eibsee, the huge lake that stretched out from the hotel, whose staff kept its surface free of snow.

Garmisch had been refurbished for the games, but it was short of accommodations. Nazi officials had taken all the hotel rooms, and foreign journalists were relegated to pensions. The McKeans' rooms, procured weeks in advance, and their extraordinary seats at the stadium and on the final curve of the bobsled run, across from Hitler's box, were arranged by Shaw's German business friends, in particular Putzi Hanfstaengl, who, since they'd seen him in 1933, had become notorious in America.

In the spring of 1934, Putzi had made his first visit to the United

States since Harvard. When a "storm of protest" followed his invitation to serve as a twenty-fifth-reunion marshal at the Harvard commencement, he declined the honor but agreed to attend the reunion if his duties to the Reich permitted. Jewish alumni were openly enraged, but vocal Gentiles supported the university's position that every Harvard graduate must be accorded freedom of speech, no matter what his beliefs—the *Harvard Crimson* even suggested Putzi be awarded an honorary degree. Most of Putzi's friends on the North Shore would not have gone that far, but a number of them, including Shaw and Margarett, did not allow themselves to understand what the Nazis intended until the brink of war. An attitude toward Jews as "other," a casual, unexamined anti-Semitism, was a fact of life in most of Brahmin Boston, in spite of Jewish friends, assimilated like Shaw's business partner Clement Burnhome, or unassimilated like Fanny Brice.

In the days before the Harvard commencement, Putzi came to dinner at Prides and played the grand piano in the living room, entertaining his old friends as he had when they were young at Harvard, never suspecting that at home Hitler was moving to execute Ernst Roehm and hundreds of others for suspected treason. As the details of the Night of the Long Knives made their way across the Atlantic, Putzi stood on the lawn of his Harvard roommate, Shaw's cousin Louis Agassiz Shaw, and declared to journalists his fealty to Hitler's "providential mission" and his belief that the chancellor had "proven himself never greater, never more human than in the last forty-eight hours."

Official Harvard remained silent about Hanfstaengl's politics and, on the morning of commencement, called in state troopers to restrain demonstrators at the gates of Harvard Yard. Aware of his celebrity, Putzi greeted classmates with the Nazi salute and responded, deadpan, to questions about Germany's "Jewish Problem." "It will be restored to normal soon," he said cheerfully. "By extermination?" a Boston rabbi shouted, before Hanfstaengl was hustled to safety by the police. When the press asked political questions, he dodged, saying "his visit was not official" but "for the sole purpose of attending his class reunion and renewing old friendships."

The Reich took precautions at Garmisch. Under pressure from the International Olympic Committee, the customary anti-Semitic signs were torn from trees and fence posts in town, and later, under further pressure, from highway markers along entrance roads to the city. But one could not escape the Nazi presence. Near the stadium, gangs of Hitler Youth and Nazi Labor Battalions marched and sang, shovels held to brownshirt shoulders in lieu of the guns forbidden at Versailles in 1919, torches throwing eerie light across the snow.

Forty years later, Harry recalled the unmistakable feel of war in the atmosphere, but there is no record of his mother's feeling at Garmisch-Partenkirchen, and only one photograph places Margarett there. She is standing on a snowy slope with a group of friends, her arm around a photographer's shill costumed as a white bear. Her head is thrown back, and she is laughing. She left behind no opinion of Putzi Hanfstaengl or of the Olympics, nor do sketchbooks survive. Nothing but the children's testimony: Margarett and Shaw had lots of friends whom they saw at night.

On March 7, 1936, three brigades of German troops crossed bridges on the Rhine and entered the demilitarized zone of the Rhineland in defiance of the treaty at Versailles. The action was opposed by neither the French nor the British. Immediately, Shaw booked passage home.

Back at Prides, Margarett painted a woman and two blond children around a table in a garden of red tulips. On the table sits a white rabbit, ears erect. The woman is blond and angular; the children could be Harry and Shaw, and one of them looks toward us. The garden is enclosed by a tall green hedge. Outside, a ring of soldiers in uniform point rifles over the hedge, into the circle, toward the woman and the children.

FROM THE POINT OF VIEW of the family, the trip had been a success. Whatever sadness Butsy McKean intuited in Paris, whatever the occasional crisis, marriage and family returned, on the face of it, repaired.

"She was wonderful there," Butsy reported to her parents and to Marian Haughton. The family resumed the round of North Shore life— "McKean Twins Have Eye on the Big Leagues," announced the caption beneath a newspaper photo of the not altogether happy-looking eleven-year-olds; another caption, identifying a photograph of two well-dressed women, announced the presence at a dog show of "Mrs. Quincy Adams Shaw McKean and her friend Miss Isabel Pell."

There is nothing in a photo of Margarett taken at a church fair later that weekend—slender in a black sheath to midcalf, smiling glamorously, black Parisian hat at an unexpected angle—to suggest she was anything but delighted with herself on their return from Europe. She began to ride with Shaw to the hunt at Myopia. She returned to the garden, to entertaining, resumed her trips to New York and her friendships. She redecorated the still unsold house on Commonwealth Avenue—black and white, stark chrome furniture—and the family moved back into it for the winter. But six months later, when she posed indoors with five of the Afghans at her feet, her face had no animation, she had gained weight, and a circular white collar lay on her dark tailored shoulders like the ruff of a clown suit.

By June, Jenny Sargent, now eighty-five, was bedridden with cancer; by August, in and out of coma. "I hope," she told Margarett, "that you will never be afflicted in this way." On August 31, Margarett had her forty-fourth birthday, and on Tuesday, September 2, she was called to Wellesley. Jenny died in her sleep on Wednesday, and Margarett remained at her bedside, keeping watch as her mother lay "so serene in all her lovely patience." On Friday, she wrote thanking Mabel Storey for sending a gardenia plant. "I dread tomorrow when she is moved from her bedroom. I have been here ever since Tuesday in my old time little bedroom almost adjoining hers, and they have been days to love. I wish I did not feel so lonely about tomorrow."

Margie and Jenny arrived Friday morning and were brought in to see the old woman with tissue-paper skin who lay dead on the bed where she had slept all her married life. "How incredibly beautiful she

looks," Margarett wrote, "and the voice that in any pain still asks me if everything is all right speaks no more. It's the only difference. It seems everything I ever gave her is on her or near her. She said they brighten the room." Shaw and the boys drove down from Prides for the funeral on Saturday, arriving at the Unitarian Church in the family Rolls-Royce, the twins, dressed alike, sitting next to the chauffeur, "like footmen," Sargent Cheever remembered.

As his grandmother was lowered into the ground at Mount Auburn Cemetery, Harry, not knowing what else to do, wept until he noticed his father's disapproving glare. Jenny was buried beside her husband, not far from her daughters Ruth and Alice, whose small, identical gravestones were etched, each with a single lily.

Ever since her marriage, Margarett's relationship with her mother had been evolving. When she named her second daughter Jenny, she seemed to forgive the years of conflict, and since then, in her flamboyant way, she had been a dutiful daughter. Still, in light of their stormy history, Margarett's surviving reference to her mother's death seems surprisingly tender. She would not have confided her own recent losses, but perhaps, now, she could have deeper compassion for what Jenny had suffered.

"So much gratitude to you for saying what I believe," she wrote Mabel Storey. "In love there can be no separation."

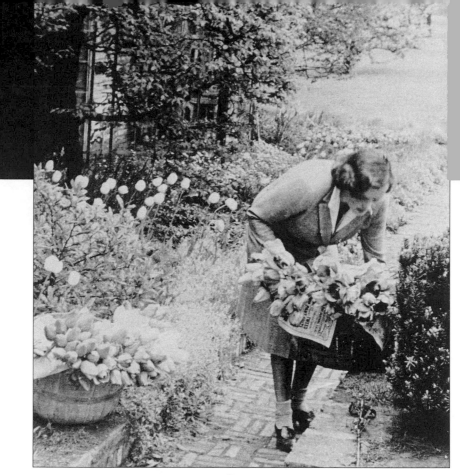

ix

I turned to horticulture

(1937–1945)

*Margarett in the garden
at Prides, c. 1944*

THE WOMAN'S LEGS ARE BARE, her shoulders are exposed. She has dark hair, wears a slip of patterned silk pulled up to reveal her thighs. She sits on a low rush-seated chair painted robin's-egg blue. Large bust, narrow waist, broad hips, slender ankles, small graceful feet. She and another woman are having a conversation. The other woman wears a kimono. She has a modest little face and red hair, and she stands, body facing the mirror, face turned toward Margarett as if to speak to her, but she doesn't seem to be speaking. Margarett herself—for the woman with dark hair dressed only in a slip is Margarett—sits, hands on her hips, face turned toward her model.

On the left side of the painting is a standing mirror with a white wood frame. In the mirror is reflected the part of the room where an artist would stand to paint the scene, but we do not see her, see instead a Sheraton sofa, the pale-brown floor, corner of a rug, tawny walls. Logically, Margarett, posing in her chair, should be reflected in the mirror, but she is not. She should see herself in the mirror, but she does not. The woman casts no reflection, and there is no evidence of the artist. Knowing we cannot be sure, let's say this is Margarett's last painting—herself with no face, casting no reflection in a mirror she clearly faces.

Fifty-five years later, two women lay slides on a light table, arrange them according to catalogue numbers. One of us is the granddaughter who rescued the paintings from a warehouse room; the other, a young art historian. We list individual works, note characteristics—use of paint, of color, approach to drawing or outlining, the swag of an eye-

lid, treatment of hands. The eye of the artist comes into us as slides flash and images startle the dark. On the basis of the few paintings Margarett dated, of illustrated reviews, ages of children, and exhibition catalogues, we date the slides. We confirm that Margarett Sargent began to sculpt in 1916, that her work evolved to paint on plaster in 1925, and that she began to paint with oil in approximately 1927. Using our dates, we arrange the slides in chronological order, and again images flash, one by one, onto the wall. We observe her increasing mastery, a swift, intense development. In our excitement, we have almost forgotten, until the wall burns white after the final slide, the bare fact that Margarett stopped painting.

When the family returned from Paris in 1936 after the year abroad, Margarett's most recent exhibition was four years behind her. If she had not intended to stop painting when they left, by their return the distance to the studio had become unbridgeable. She exhibited *The Ritz Waiter* both in a biennial at the Worcester Museum in 1935 and in the Ninth Annual of the Boston Society for Independent Artists in 1936, but there is no painting that can be dated, with certainty, later than 1936.

No event punctuated the end of Margarett's painting. Instead, there ceased to be solo exhibitions for which to prepare work; later, when invitations to exhibit in group shows arrived, she turned them down or left them unopened. Eventually there were unfinished paintings, a studio used less frequently, then not at all, palettes and tubes of color hardening. By the early forties, there were people whom Margarett met who had no idea she had been an exhibiting artist, people to whom the sketchbook she continued to pull from her bag and fill with drawings was evidence only that she was a gifted amateur.

A nurse opens the door. Wearing a fuchsia satin jacket and makeup as porcelain as Empress Josephine's, Margarett sits in a hospital bed. It is 1975, and she's eighty-two. Scrapbooks crammed with yellowed reviews overflow onto sheets the color of daffodils, a salmon satin blanket

cover. She looks up. "Why, I'd forgotten these!" she exclaims, shocked, genuine, and then, inconsolably, "Why did I ever stop?"

It will be years before I catalogue her paintings in a warehouse room. I stand there, mute, my eye drawn first to her face, then to newsprint Blue Girl and Harpo Marx, her artist face by Bachrach and Abbott unfolding from scrapbook pages.

This is the visit I keep going back to, the first and only time Margarett and I talk about her life as a painter. I haven't walked my way through it for years, not since I set off from Margie's, armed with that portfolio of Margarett's drawings and photographs, in search of answers to the questions I was never able to ask: What must I do not to "go mad" as you did? What must I do to live fully both as an artist and as a woman? Tell me about your life.

As I write now, I shelve that memory of Margarett on the hospital bed, freeze it in time like a moment from one of her paintings, walk again into the apartment on Tremont Street and look at her there, the salmon blanket cover, the mass of yellowed reviews.

"Why, I'd forgotten these!" she exclaims, waiting for my response. "Why did I ever stop?"

"Why *did* you stop?"

"It got too intense," she answers slowly, articulation blurred by the stroke.

Margarett, I want to ask, what do you mean? Too hot? Color blooming across canvas after canvas that gets hot, hotter, then too hot for any brush, and explodes, burns out, leaving just a tiny pile of ash? But my chest tightens, and, instead, I am as silent as I was the last time. I see her pull herself together before she says the next sentence.

"For twenty years I worked," she says, "and then I turned to horticulture."

She speaks as if the transition had been orderly, as if she'd made a conscious decision to stop. The expression on her face tells me she did not. Her answer says both everything and nothing, and it stops the conversation.

At the time, I believed that if I could have said something more, I would have got more information, but now I understand that Margarett made it difficult for me, that her locution, "I turned to," was itself a turning away. She turned from my question, as she had from painting all those years ago, leaving me mystified, silenced, and, I realize now, angry.

But what did I want? What did I imagine a deeper conversation might give me?

With the young art historian, I show slides of Margarett's work to a museum director, herself a young woman. Again we wheel through the bright images, again come to the cruel ending. I make aesthetic conversation, but beneath its veneer is my shame that Margarett stopped painting and, beneath that, grief and fear for my own creative life. What I wanted that day was for Margarett to rise from her bed, for paints magically to appear, for me to watch her at the easel as she painted herself back into the room with the mirror, for her to answer my questions by sitting me down and seizing my face, as she once said she wished to, in paint.

"I think she hated herself for not continuing," Margie said. "Once, in the sixties, I suggested that she have an exhibition," Al Hochberg said. He was her lawyer the last twenty years of her life. "What did she say to that?" "She didn't want to."

In fact, there had always been gardening; the difference now was that it had no rival. In the absence of canvas, Margarett's appetite to seize the entire world in paint—every face that interested her, every configuration or movement that caught her eye—went unsatisfied. To do so now seemed too revealing: the erotic appreciation with which she painted women, the weakness in his image the few times she painted her husband. That she continued to draw—to outline, to catch on the run, on the train, in a restaurant, the striking face or posture—was no substitute for hours in the studio, the full-bodied satisfaction of color on canvas. Bury it instead, in the earth when you plant a bulb, and it will come up acceptable, looking for all the world like anyone else's tulip.

She bought hundreds of bulbs—one year, seven hundred *Narcissus poeticus*—supervised their planting, planted some herself. She was up at six, worked until dusk, perhaps stopping to have people for lunch, perhaps not. The arborvitae at the end of the pool had grown full and high enough to cut back, and she directed the clipping—topiary not to rival her grandfather's Italian Garden but certainly to pay it homage. When the grounds at Prides would take no more work, she did gardens for friends like Emily and Henry Cabot Lodge, or picked up a shrub for someone as a favor and arrived with Fusco, her gardener, to put it in. Eventually she designed gardens professionally, for friends like Nat Saltonstall, a Boston architect and art patron, younger brother of the Salts, and Lily Saarinen, a writer once married to the architect. By the early 1940s, she had clients like Helena Rubinstein, whose penthouse garden she designed in New York.

In 1938, Shaw bought a nursery north of Prides, and he and Margarett began to collaborate, his Magnolia Nurseries providing stock for her landscape design. For a while, she had a flower shop in Boston on Newbury Street. A sheaf of garden plans turned up among some gouaches in a suitcase in an auctioneer's attic, along with a note: "This came near being a very good plan—it just isn't—naturally the color proportions are not right—as I do not plan ahead properly but sketch in free—therefore follow the locations—but not proportions." She'd drawn the pool, then blocked in color with cut-out patches of gouache, labeling them with names and numbers of bulbs: "Murillo Pale Blue Hyacinth 150. Murillo Pale Pink Hyacinth 125." In the spring, pink hyacinths alternating with blue bordered the pool, and behind them, banners of white narcissus quivered in the breeze.

When the force with which Margarett approached painting lost its object, those around her felt the consequences. She talked all night, spilling virtuosic, hilarious stories. She planned a party to bring this person together with that one, to celebrate a new friendship. She planned a garden. She got angry. She went to New York. "Margarett needed a project," Dorothy DeSantillana said. She discovered an artist. She bought six boxes of watercolors and used only one of them. She

ordered a new suit. She drank. One morning, Shaw accosted Mary McLellan on her way to Margarett's room with a breakfast tray; he lifted the teapot lid, smelled whiskey, sent Mary back to the kitchen. Or she didn't drink at all, which confused him: for weeks, even months, there would be no incident.

Once, he took her to New York for dinner and a play she was dying to see. When he left her upstairs in their hotel room, she looked lovely, was herself, even gave him a kiss. "You go downstairs, I'll be there in a second." But when she turned up in the dining room ten minutes later, "She was absolutely blasted." This became a talismanic story. Shaw couldn't comprehend how in just ten minutes she could have drunk enough to get "blasted," did not understand that in its progressed form addiction to alcohol needs barely a glass to ignite a full-dress binge. He thought that perhaps on her evenings out with Roland in Harlem, Margarett acquired drugs, that "dope" was responsible when her condition changed so quickly. He and Margie searched her bedroom, the closets, the bathroom, but what they found were bottles—bottles in the backs of closets, in garment bags, slipped into riding boots.

When they were fifteen and fourteen, Margie and Jenny invited their father out to the Ritz for lunch. Margie was, in her own opinion, finally grown up, short blond curls held back by a headband, eager to begin wearing lipstick. Jenny, the tomboy, still felt awkward wearing a dress, and so she wore jodhpurs most of the time. Tall and slender, with pale skin and jet-black hair, she was less outgoing than her older sister. His daughters were paying for the lunch. Shaw was amused and delighted.

As they'd become more wary of Margarett, the girls had turned to Shaw, whom they could count on. They saw him as a victim in the hostilities: Their mother lashed out, he cowered, dodged, exploded, or did not fight back, proceeded as if nothing had happened. Margarett seduced them with her affection, but tell her something in confidence, and she'd broadcast it with a sarcastic twist to get a laugh at the dinner table, no matter who was there. And they were terrified Senny would

leave. Late at night in their rooms on the top floor of the old part of the house, they conspired to talk to their father. They wanted him to know that it would be all right if he divorced her. In fact, their purpose in inviting him to lunch was to *ask* him to divorce her.

Shaw refused. He understood how they felt, he was touched they had taken him to lunch, but the divorce laws were such, he said, that their mother was likely to win custody, and he could not allow that to happen. But you're so unhappy, Papa! They imagined a family without Mama, her headaches, her chaos, and her cruelty. They imagined a mother as calm and loving as Senny, as authoritative and responsive as Grandma Haughton, a mother who would put their interests before hers. They believed Margarett's suffering was entirely of her own making. "If the house burned down," young Shaw said, "and there was a choice between a child and a Renoir, the Renoir would win, hands down."

But even Margie admitted that when Margarett was well, "she could be *great fun*." The young people, friends of the children, who came to Prides characterized Margarett as "great fun," "very warm," "interested." She would engage you in a real conversation if she found you sitting alone at a party, or she would draw out of you what you wanted to do with your life and encourage you, particularly if your ambition involved leaving Boston or becoming some sort of artist.

Ben Bradlee, one of the children of Margarett's second cousins Bebo and Josephine Bradlee, came to Prides often. After "being ditched by Margie," he "fell hard for Jenny" and turned up to court her and to absorb at Prides the first glimmer of life beyond cold roast Boston, a glimmer that later led him to become a journalist. "Margarett would be talking about painting or about music, or there would be interesting people there," he said. "The house had an enchanted quality, but with slightly ominous overtones. Some days Margarett would be in a good mood—there was more joy on those days."

Ben's older brother, Freddie, an aspiring actor and writer, worked up a mean imitation of his Prides hostess. He loved setting the pitch of

his voice to capture Margarett's. One day it was chilly, and she turned to him. "Dahling"—as he mimicked, he let his voice settle—"will you go up to the octagonal room and if that window's open, close it, and if it's closed, put your foot through it?"

Their younger sister, Connie, a friend of Jenny's, came for lunch or supper or to spend the night. Once, at lunch, Margarett complained about the gloom of her bedroom. The standing lamp simply did not give enough light to read by.

"Well, Mrs. McKean, have you seen those new lamps for night reading that clamp right to the headboard?"

"Seen them? I've been married to one for fifteen years!"

"Like that," Connie Bradlee said, "one after another, so fast you got almost unpleasantly sick laughing."

One day, an enormous box arrived at Prides addressed to Margarett, with instructions to open it immediately. Hardly visible were small holes at intervals on each side. Margarett set upon the package, tearing at its wrappings, only to find beneath it another carton, then still another. Inside the third carton was a huge cage in which sat a large green macaw, a gift from Shaw, in appeasement, perhaps, for the finches set loose in Paris.

Margarett immediately named her new bird Jack. Very soon he was shrieking Margarett's name with a broad Boston *a*, and when the phone rang, he'd summon Mary McLellan. One evening, Margarett had a young Harvard friend to supper by himself, and Jack sidled along the table, moving at a microscopic pace. Just as he was about to strike with his beak, the young man, watchful, moved his hand, and Jack tumbled to the floor.

One morning, he laid an egg. "Oh," Shaw said, "you're Jacqueline!"

"Go to hell!" Jack replied.

On one of Shaw's birthdays, Margarett had the floor of the big room strewn with hay, fodder suspended from the Venetian lanterns, tables set out for dinner. For music she hired an Italian accordion band, and at the climax of the party, a donkey led a procession of animals through the front door (built to accommodate monumental sculp-

ture) and into the living room. To entertain at another party, Margarett hired wrestlers. In a ring, constructed for the evening, a very large man, his head shaved bald, threw around his Greek opponent. Another evening, waiters carrying trays of champagne executed pratfalls without spilling, and when one guest requested an ice cube, the waiter returned struggling under the weight of a chunk of ice "practically the size of a boulder."

If Margarett could not manage to disturb the surface of a canvas, she could certainly disrupt social expectations. In time, the sheer profusion of her pranks exhausted her family. "It would be Papa's birthday, and everyone would be complimenting Mama on the brilliance of the party!" Margie said. Margarett would invite thirty to dinner: "Come to my owl party!" And a multitude of stuffed owls, peering through the candlelight, would mutely rebuke stuffed shirts. Or telephone her friend the actress Hope Williams in New York: "I'm planning the most extraordinary evening." That Saturday night, the guests cooked and served, and the Prides staff sat for dinner at the table; afterward everyone drank and danced into the night.

One Christmas Eve, Shaw's brother, Harry, and his wife, Bessie, gave a family party. Their five teenage children, the Shaw McKeans, Bessie's aged mother, and assorted cousins were guests at a dinner large enough to be catered by Creed, a figure so familiar he and his staff added to the *bonhomie* of any North Shore party. Once in a while, if it was a big dinner, as this was, the hostess hired an "extra," as Bessie had this evening.

Margarett, whom Creed always called Maggie, was expected later, and though Shaw reassured Bessie when she asked, he could never be sure these days if his wife would turn up. When the additional waitress appeared, Bessie's daughter Butsy was sorry Aunt Margarett wasn't there to sketch her. She had wild, curly red hair, and she smiled strangely to obscure a missing tooth. Over the regulation black uniform, she wore a garishly ruffled apron, and on her feet were brown-and-white saddle shoes. It seemed to Butsy, as the woman lunged toward her, that she had a slight limp.

"Would you care for an hor d'oeuvre, miss?" she asked, in a "ghastly Irish accent," passing the plate so high Butsy couldn't see what was on it, and then so high it came within an inch of her grandmother's nose. Mrs. Lee, in her eighties and an Italian aristocrat, pushed the plate away so that she could see the canapés. "We'll all just rise above it," she said to Butsy under her breath.

A cousin arrived late. "Better get at it," the redhead told her at the door, yanking off her coat. "The drinks are flowing like glue." Later, in the parlor, the maid returned to Mrs. Lee with another tray. "What's going on, mum, have ye had too much to drink?" Grandma Lee lost her temper. "If you don't behave, I'm going to tell Mrs. McKean to throw you out!"

Butsy's sister Sis was furious her mother wouldn't tell the woman to leave. Butsy kept her own feelings—more amusement than disapproval—to herself, and suddenly, as she walked across the room to join her father near the fireplace, realized who the maid was. As the redhead let loose another raucous "Excuse me," Butsy's father also caught on, and the two of them began to laugh. "Stop laughing," fumed Sis, still thinking the woman was a maid.

When the guests entered the dining room a few minutes later, they found Margarett, red wig off, blacking smudged from her tooth, feet up on the damask-draped table, cocktail in her hand, laughing with Creed, who'd been as taken in as anyone but hadn't dared complain to his client about her hired extra. Only Bessie had been in on the secret.

"Nobody could get over it," Butsy said. "It was so clever and so good." It occurred to no one that their habitual lack of attention to hired help had greatly helped Margarett to carry off her disguise.

"What's a den of iniquity?" Margie asked her father once, on returning from a visit to Wellesley.

"Why do you ask?"

"Because Uncle David Cheever says we live in one."

§

By 1934, the generation of curators Margarett had known as students at Harvard were bringing European Modernism into the mainstream of American cultural life. Their new prominence was announced that February, when A. Everett "Chick" Austin, a Harvard product and the new director of the Wadsworth Atheneum, mounted the world premiere of Gertrude Stein and Virgil Thomson's *Four Saints in Three Acts.* Margarett made a pilgrimage to Hartford for the opera, cast entirely with black gospel singers, designed by the painter Florine Stettheimer (the scenery was a bouillabaisse of cellophane and colored light, the costumes pale-blue robes and white gloves), and directed by John Houseman, a young German-born director newly arrived in American by way of London.

When Margarett went to New York, she encountered Harvard graduates on the staff of the Museum of Modern Art and in the directorships of two major galleries. In a small brownstone on Madison Avenue, Julien Levy showed the group of young European painters who called themselves the neo-Romantics (among them, Pavel Tchelitchew and Leonid and Eugene Berman) and, in 1936, mounted the first significant American exhibition of the Surrealists, including, most sensationally, Salvador Dalí's *The Persistence of Memory*—limp pocket watches in a desolate landscape. At Durlacher Brothers, on Fifty-seventh Street, Kirk Askew exercised a flawless eye for old-master drawings, an instinct for the then unfashionable Italian Baroque, and a tough but effective gift for nurturing new American artists. Later, when he inherited them from Levy, Askew showed the neo-Romantics; in 1948, when a young Yale graduate, George Dix, became his partner and brought them along, he took on the British painters Francis Bacon and Ben Nicholson.

Kirk Askew and his wife, Constance, were friends of Margarett's, and by the mid-thirties their salon was one of her New York destinations. At their brownstone on East Sixty-first Street, Kirk, slight of stature, with bright, prematurely white hair, and Constance, blond and statuesque—her "relaxed visage," Virgil Thomson wrote, "as calm as that of Garbo"—received their influential friends: curators from the

Museum of Modern Art, artists, composers, writers, theater people, and collectors. Tea and drinks were served Sunday afternoons from five o'clock on "during the R months," John Houseman wrote, "like oysters," in a large sitting room whose windows overlooked a garden. On the fringes simmered an unrepressed erotic life one habitué characterized as "extremely bisexual—nobody worried much about the gender of the other person in bed." But excess in flirtation, drink, or shoptalk was not to interfere with the purpose of the gatherings, which Kirk, "smiling and efficient," kept to an elegant blend of repartee and an exchange of ideas that might lead to collaboration.

At the Askews', Margarett reencountered Lincoln Kirstein, Archibald MacLeish, and Paris friends like the artist Jean Lurçat and the dealer Valentine Dudensing, from whom she had bought her De Chiricos. Aaron Copland, the three Stettheimer sisters, and George Balanchine turned up from time to time, and when they visited from England, Elizabeth Bowen and the Sitwells always stayed with the Askews. In the forties, Pavel Tchelitchew joined the Sunday parties, bringing his companion, the poet Charles Henri Ford, who edited the avant-garde magazine *View.* As the decade wore on, the crowd got younger—Leonard Bernstein, the librettist John LaTouche, the composer and writer Paul Bowles, and his wife, the writer Jane Bowles.

In Kirk Askew, Margarett found a sharp-tongued companion and a compassionate friend. At his parties, she was marveled at by aspiring artists and writers—mostly young men—drawn by her combination of what the writer Leo Lerman called "granite solid background," intelligence, wit, and an ability to talk about art. "When she spoke, she delivered a thought as if it were a poetic phrase, almost like an actress, with low voice," said Gloria Etting, one of the dancing Braggiotti sisters, who as a child had known Margarett in Boston. To this younger generation, just a few years older than her children, Margarett represented rebellion, all the more admirable because it came from within, all the more important to them because it was sexual as well as aesthetic. "She knew things," Bowden Broadwater said. "She had," said the playwright William Alfred, "fauve majesty."

Margarett's new admirers were the kind of people who had always attracted her—engaged in art or theater, in the intensity of aesthetic argument or creative collaboration, people for whom gossip was a medium of intelligence rather than social control. To them her talk was unusual but not alien, her taste welcome but not intimidating, her appetites familiar.

In New York, she danced on the table. In Boston, she passed out. Life there, increasingly, was tolerable only if she drank. She went to New York once, often twice, a month. Or she went foxhunting in Virginia. She went to Vermont, with and without the children. Sometimes she was happy there. "Mrs. McKean was extraordinary the whole time," Connie Bradlee wrote her brother Freddie from Dorset in 1937. "She is really blissfully happy up there as she can do exactly what she wants without anyone criticizing her."

But often now, even in Vermont, Margarett wept for hours at a time, had what Margie described as "terrible crying jags." Once in a while, when she came out of a spate of sadness, she would, in a burst of high spirits, make a false start at painting—buy sketchbooks and paints and hire a model, even rent a studio in Boston. Or she'd rip up a garden and lay out a new one, over Shaw's protests at her extravagance. But her discontent had become harder to disguise, and she exploded unpredictably now, even at friends, with whom she usually concealed her pain.

Hope Williams, the actress, had become a friend. She had a dry sense of humor and a walk so distinctive that her first Broadway entrance, in Philip Barry's *Paris Bound*, got laughs and applause before she spoke a word. Margarett met her through Betty Parsons and pursued her, "like a schoolgirl," Hope said. They had a slight affair. Hope would come up to Prides on the Sunday train after the matinee, Margarett would meet her in New York, or they would go to Dorset for the weekend.

One spring day in Vermont, after lunch and in the middle of a conversation, "Margarett walked away from me," Hope said. "I could see by her walk that she had become another person, and when she

turned back, she turned on me." Hope did not recognize the unfamiliar and frightening look in her friend's eyes, or her loud, cruel voice. She packed her bag for New York and left immediately. "After that I never loved her again," she said. Or saw her.

In Dorset for a weekend with Betty Parsons, Margarett woke from a dream. "A little golden flower in a snowbank," she said. "I dreamed I was a golden flower in a snowbank."

Most of Margarett's friends treated her torment as if it were the weather. Even those few in whom she felt free to confide, like Betty, felt powerless to help her; but in 1937, she began find some solace with the help of her old friend, Maria deAcosta. Maria, now married to Teddy Chanler, credited the Catholic Church with much of their happiness. Related by marriage to Vivian Pickman, Teddy was a composer, who had skipped Harvard to study in Paris with Nadia Boulanger, "an experiment," Virgil Thomson archly observed, "in upper class male education." He was considered one of the more talented of the generation that included Thomson, Aaron Copland, and Walter Piston, but music had failed to restrain him from a life his family considered dissolute: "Drink, drugs, sex of all kinds, as I understand it," said his friend Bill Alfred. Maria met Teddy in Paris, abandoned her Boston marriage to Miriam Shaw, and, to his family's everlasting gratitude, married him. Both had been born Catholic, and by the late 1930s, each had returned to the Church.

Maria and Teddy were not unusual; for many conflicted bohemians, the Church was a safer haven for spiritual longing than art or sex. To many in trouble with drink, it offered the kind of spiritual surrender Alcoholics Anonymous, then in its infancy, would later provide. The Chanlers, knowing Margarett's suffering, took it upon themselves to encourage her, Maria with what Bill Alfred called a "loopy" sort of faith, and Teddy with "a gift of mirth" that amounted to grace. "Nobody could resist him," Alfred said—it was Teddy who would successfully encourage Alice Toklas's deeper embrace of Catholicism in the 1950s.

That summer of 1937, Father Thomas Feeney, a Jesuit, gave a

preaching mission at Saint Margaret's Church in Beverly Farms. The first week was for women, and Margarett refused to go, but eventually Teddy persuaded her to meet Father Tom, as he was called, and Margarett invited him to Prides for lunch. "A lot of fancy people were flirting with the Church in those days," Paul Moore said, and charismatic priests like Feeney and his brother Leonard were in part responsible. Margarett recognized in Tom Feeney, a professor of French and English at Boston College, a literate sophistication akin to her brother Dan's, and they talked all afternoon. When Teddy told Father Tom after the lunch at Prides that he sensed Margarett was close to conversion, Feeney replied, "Wouldn't it be nice if she came in soon, while she is still young and beautiful?"

Margarett listened to the priest's passionate talk and to Teddy and Maria. She began to imagine there was a way to ease what she suffered in the darkened room, to bring her close again to her children, to make peace with Shaw. She imagined a return to the clarity she'd had when she was painting and showing, imagined giving herself over to a connectedness resembling what she'd felt in the studio, or early mornings in the garden. If she could be relieved of the terrible sense she had of her own imperfection and simply call herself a sinner, if she could lose herself to a force of beauty and forgiveness outside her knowledge, why not relinquish some of her prized independence?

That weekend, Margarett went to Lake Placid, where Margie and Jenny were spending the month with Senny, taking lessons and skating in the all-weather rink built for the 1932 Olympics. She was planning to convert to the Catholic Church, Margarett announced to her daughters. To the girls it was as if she had announced a trip or the purchase of a new coat. "By then I didn't gave a damn what she did," Margie said. Neither believed anymore that their mother could or would change for the better, particularly under the influence of a church they perceived as a peculiarity in the lives of Uncle Dan's odd family.

On Sunday evening, back at Prides, Margarett was no longer sure of her decision, but Teddy and Maria persuaded her to come hear

Father Tom's first sermon the second week of the mission, which was devoted to men. "We sat upstairs," Teddy wrote Dan, "so as not to distract the male congregation." They returned Monday night, and Tuesday Father Tom began to address his preaching to Margarett. At lunch at Prides, he'd admired the way Jack spread his wings when Margarett asked him to, and so, when he preached of angels, he said, "Isn't it hard on these wonderful beings to be near us and over us every minute of the day and night and never to receive a word of recognition from us—never to be asked to 'spread their wings'!" And then he invented a parable: A princess lives in a "beautiful tower surrounded by gardens." A beggar comes to her gate with an invitation "from the Queen of Heaven to attend a banquet where you will be fed the Bread of Angels." Pray for her, he exhorted the congregation of men.

The final night of the mission, at a ceremony for the renewal of baptismal vows, Margarett again sat upstairs. She watched the congregation below, and as each man lifted a lighted candle up into the darkness, and Father Tom "spoke like a sort of child-soldier to us," she turned to Maria, in tears. "I cannot stay as I am any longer."

Teddy and Maria took her to the rectory after the service to talk to Father Tom. "Have you been crying?" he asked.

She refused his offer to be baptized the next morning. "The devil's tail," Teddy wrote Dan, "was still sticking out from under the lid." He sharply informed Margarett that Jesuits were not in the habit of making such offers, and at the church the next morning after seven-thirty mass, Father Tom greeted Teddy and Maria, smiling, a note from Margarett clasped in his hand: "I desire to become a Catholic."

She was baptized that morning at ten.

The Church reached her through its aesthetics—the light of candles in a darkened church, the liturgy sung in Latin, the antique Spanish crucifix she hung beside her bed. Its promise of absolution moved her to believe that her most private, unshared agonies might be lifted. Once she joined the Church, Margarett never disavowed her faith, but she kept her belief private. Asked once why she converted, she replied,

"There was nothing else to do that year to shock Boston." Only the few religious people—her brother Dan, for one—with whom she became intimate understood the depth at which the Church reached her. Dan went to mass every morning, but Margarett would not take communion from a priest she didn't like. David Challinor, born what he called a "WASP Catholic," was one of Jenny's boyfriends and a frequent Prides houseguest the summer of 1942. He remembered Margarett, then five years a Catholic, calling him to her room to discuss the nonconformist faith of François Mauriac.

Margarett's new religion did not forestall the inevitable. Two months after her conversion, she and Shaw and Mary McLellan became the only residents at Prides. For years the children had clamored to go away to school, to lead, as Jenny put it, "normal lives." Now they were old enough, and Margarett was no longer in a position to keep them at home. Margie, at sixteen, was dying to go, as her mother had, to Florence, but the threat of war prevented travel abroad, and in the autumn of 1937, she went instead to the French School for Girls in New York. Jenny, who wanted to go to a school that would prepare her for college, went to Madeira in Virginia. The twins, because of the deficits of their Neary education—"We were stars of French, but we'd never heard of science"—were sent to the Fay School in Massachusetts to prepare for Saint Paul's in New Hampshire.

After a year, Margie finished school, and for her seventeenth birthday, the autumn of 1938, Margarett and Shaw gave her a coming-out party. Margie was pleasantly surprised. "That whole year, I never saw Mama drunk. She was absolutely marvelous." And marvelous again the winter of 1940, when, longing to see Machu Picchu and Cuzco, she took Margie to Peru. They sailed on a cruise ship. "God knows Mama was attractive," Margie said, "and so we had quantities, swarms, of unattached males lurking around."

In less than a year, Margie was engaged. Walter "Wally" Reed was from New York and had gone to Harvard. He was tall, with romantic,

dark-haired good looks. "Very smart, very funny, and a drunk," his daughter said. What Margie said later was that she married at nineteen to get out of the house.

On a spring day in 1941, Margarett sat in the Ritz dining room. Whomever she'd lunched with had long gone, and the dining room was empty except for waiters tidying up, who were trying, tactfully, to persuade her to leave. She refused, first falling asleep and then laughing at the headwaiter. She was heavier than she'd been—not overweight but certainly full-bodied—and she could feel it. She drank the last of her wine as the room darkened. She asked for another drink, and a waiter filled her glass with water. She cursed him and began to laugh. "Mrs. McKean," the headwaiter kept pleading, politely.

At Prides, the telephone rang. It was the Ritz calling, Mary McLellan reported to Shaw. Apparently, Mrs. McKean would not leave the dining room. She was shouting at the waiters.

"Mrs. McKean, we must close the dining room." Margarett just sat there. "Mrs. McKean." Shaw walked toward her across the long floor, young Shaw, then sixteen, behind him. The waiters pulled the table from the banquette, and together Shaw and young Shaw lifted Margarett's dead weight to standing, escorted her from the dining room, down the stairs, into a waiting car.

Barely six months later, on November 19, 1941, Margie married Wally Reed in a small ceremony at a church in Beverly and Margarett organized a lunch at Prides. She arranged the flowers and orchestrated the seating, saw the newlyweds off to New York and an apartment on East Tenth Street, made sure they had furniture, linens, and silver. This was another occasion on which, as Margie put it, Margarett pulled herself together. She adored Wally, whom Margie had met through a group of his Saint Paul's classmates, and who, while he was at Harvard, had come to Prides often for Sunday lunch or for the weekend. The relatives and friends who wrote effusive notes of congratulation would soon observe that Margie had chosen a husband

who shared not only her mother's wit and verbal skill but her weakness. Wally drank too much and disappeared for days, returning nonchalant and without explanation.

In the autumn of 1940, Jenny had entered Vassar. She appeared to her classmates very much a product of Madeira, but beneath a veneer of what one of them called "saying all the right things," she carried a powerful sense of the peculiarity of her background—"shame," she would call it later when she described her childhood to me. But she concealed it, in writing class transforming her mother's character in pieces of writing, once wittily imagining Margarett and Margie on the boat to Peru:

MARGARETT: Mr. Cross gave me a letter to a man who has a private zoo filled with honey bears . . . but the boat doesn't stop there.

MARGIE: Who's Mr. Cross?

MARGARETT: Margie, don't look as though you had unearthed a scandal, Papa knows him very well.

During the summer of 1941, Margarett was hostess at Prides as young men courted her younger daughter, and Jenny eased into what Paul Moore, who would become my father, called "a golden summer." The specter of war hovered as Roosevelt declared a national emergency and Hitler invaded Russia, but the blandishments of July and August on the North Shore kept the ominous news just outside awareness. Young Ruthie Robb, Bob Potter, Paul Moore, and Jenny cleaved together in no particular romantic configuration and called themselves "the younger set." They spent days at Singing Beach or playing tennis, had dinner at one or another of their parents' houses, and at night danced to Ruby Newman's orchestra at the Magnolia casino, drinking martinis, more than once spending the night in a hungover heap on someone's living room floor.

As the Germans subdued Ukraine in August, as Leningrad stood against the Nazis and winter halted Hilter outside Moscow, young men began to make decisions about war. When the Japanese bombed

Pearl Harbor, on December 7, even Shaw decided to enlist. He'd missed combat in the first war, now he'd have his chance, as a major, he imagined. When he was rejected because of high blood pressure, he helped organize a Boston center for GIs. Marian donated her house at 13 Commonwealth Avenue and moved across the street to the Ritz, and Margarett organized cabaret evenings for soldiers on leave. Jenny's friends Bob Potter and Paul Moore were called up, and in the summer of 1942, Wally Reed was drafted. He left for India in October, just after Margie gave birth to Margarett's first grandchild, Jenny.

In July 1943, a month after their graduation from Saint Paul's the twins were drafted. Harry wanted to join the air force, but his father advised against it. Asked in his entrance interview why he wanted to join the infantry, he replied, "Because I like to shoot." By November, he was stationed in England, living in a hut on the Salisbury Plain, hiding the luxurious packages Margarett sent from S. S. Pierce, claiming Lady Astor as a relative, and taking weekend leaves at Cliveden, the Astor country house in Buckinghamshire. Unlike Harry, who at first felt uncomfortable with his fellow enlisted men, Shaw took to the company of soldiers and reveled in leaving Prides behind; a hernia diagnosed the day before embarkation kept him in America throughout the war, in spite of his father's efforts to have him assigned to combat. In 1944, Harry would fight in the Battle of the Bulge, following, as his division advanced, the road on which Hardy had driven the family to Garmisch-Partenkirchen eight years before.

With the household now essentially dissolved, Margarett spent even more time in New York. She'd stop at Durlacher's, with its old-world ambience, then mount the elevator in the next building west on Fifty-seventh Street to visit Betty Parsons who by then was working at Mortimer Brandt's gallery. Betty had settled in California after Paris, and in 1935 returned to New York. In 1940, she opened a gallery at the Wakefield Bookshop on East Fifty-fifth Street where, combining audacious taste and a gift for persuasion, she built a controversial stable of artists that included Saul Steinberg, Theodoros Stamos, Hedda Sterne, and Joseph Cornell.

In 1946, Betty took over Brandt's entire suite of galleries, stripped away architectural detail, and painted the walls flat white. "A gallery isn't a place to rest," she said of her new space, and created a sensation showing the bold, vibrant assertions of the revolution in American art being made by the painters who would come to be called the Abstract Expressionists—among them, Barnett Newman, Jackson Pollock, and Mark Rothko.

At Christmas, 1946, Elsa Maxwell's effusive account of a group show there was syndicated on society pages nationwide, and soon after, Rosalind Constable published an article in *Time*. For the first time since the Eight, American art was chic. Maxwell dropped the names of artists like Newman, "Rathko," and Sterne, and finished off the column with an exhortation: "Some dissenters scream, 'Hang the abstractionists!' I echo, 'Certainly, but why not on your walls.' "

Margarett was amazed and impressed by Betty's enormous success, but she was also intimidated. The new art that was making her friend's name seemed to have no roots in the European Modernism that had inspired her. Betty had always admired Margarett's eye, had in fact shown her collection at the Wakefield in 1942, but her own taste had always been the more obviously experimental. Though it is possible that if Margarett had not stopped painting, the visceral relationship to paint central to the Abstract Expressionist aesthetic would have entered her work, she never turned to those artists as a collector. In-stead, she bought from Betty the artists who carried forward, more clearly, a European aesthetic—not Newman or Rothko, but Steinberg and Stamos.

The turn in Betty's fortunes came at a difficult time for Margarett, who now felt less able to call on the friend who had always been her confidante. When she appeared in Betty's gallery, she carried on with her usual bravado, but alone in her hotel room, she often panicked. She was afraid to go out on the street, afraid to go back to Prides, afraid to go by herself to Grand Central. She'd call and ask Margie to pick her up in a taxi and take her to the train, but Margie, terrified in any case of her mother's desperation, was alone in an apartment on

East Tenth Street with an infant. More than once Margie telephoned Betty, who left her gallery to take the friend she once called "the most talented woman I've ever met," weeping, to the train.

MARGARETT'S ISOLATION was in part a consequence of her drinking, but her loneliness was real. She no longer had the companionship of the studio, Prides was bleak without the children and their activities, and the war had closed off part of her world. Roland Balay was in Paris and would not return to America until peace was declared. Isabel Pell was also in France, living with a marquise near Grasse in the south, where she would remain until the war's end. By 1942 or so, shorn of these old allies and friends, Margarett began "to see a great deal of" Florence Shaw, the widow of Shaw's cousin and Putzi Hanfstaengl's old friend, Louis Agassiz Shaw.

Florence, "Auntie Floto," to the children, was a brassy, flirtatious sportswoman with a beautiful figure and a buoyant spirit, who reminded the boys of the "younger set" of Lauren Bacall. Louis, who had died in 1941, had done early research on decompression sickness (the "bends") and, with Cecil Drinker, had invented the Drinker Respirator, which came to be called the "iron lung." He and Florence had been frequent dinner guests at Prides, had had, by all accounts, a felicitous, even blissful marriage. After Louis died, Florence divided her time between houses on the North Shore and in Boca Grande, Florida, where Vivian and Dudley Pickman also had a house, and where Maria and Teddy Chanler wintered in a small cottage.

During the 1940s, Margarett and Shaw visited Florence in Boca Grande nearly every winter, and Margarett often stayed on. When a young Hunnewell cousin visited there, she assumed Florence's house belonged to Margarett. Florence liked to drink and laugh as Margarett did, and eventually the two became lovers. It was this relationship that made people outside the family aware that Margarett McKean was given to more than one kind of romance.

"Did you know your grandmother had love affairs with women?" a friend of my mother's asked me when I was thirty.

"I had that feeling. . . ."

"There was a woman named Florence Shaw."

"Was it a long relationship?"

"More than ten years."

Margarett's discretion was total as usual, and so her liaison with Florence was another love affair about which everyone knew and nobody spoke.

"Did you know about my grandmother and Florence Shaw?" I asked Nancy Palmer, one of Vivian Pickman's daughters.

"Oh, yes, everybody knew."

"Well, if nobody spoke of it, how did you know?"

"Mother told me."

Since she lived nearby, Florence did not come to Prides as a houseguest, like Isabel or Marjorie. As she had when her husband was alive, she came to dinner or to lunch, in turn inviting Margarett to her house in Beverly Farms. Or, guests at the same party, they would leave at the end of the evening, one at a time, often going on to Florence's or, if Shaw was not there, to Prides. As always, if Shaw noticed the affair, he made it his business to look away. No one has a story of an erotic moment witnessed, and there are no letters. Only Margarett's sketchbooks attest to what was, from time to time, a life together.

"Margaret S. McKean, Boca Grande, Florida, March, 1942." The cover is calf stamped to look like lizard: inked, rotund scribbles for Florence's black Pekingeses; a woman through the window of a green-blue car, yellow broad-brimmed hat, naked ear, eyelash, fingers obscuring her mouth; pencil drawing of a woman with a cigarette, just her face, the line as effortless as exhaling; in gouache, the captain of a pleasure boat: "No Smoking." In pencil, a long-legged woman in a well-cut jacket, a man in a uniform: "So you're living in a rented house.'"

At a restaurant in Tampa, as Margarett makes her portrait in ink, a little girl asks: "Do you just draw anywhere—anything you want?"

Or anyone she wanted. Margarett had never been a monogamist.

A small sheet of paper, ripped from a sketch pad: Hair that stands straight up. Mouth from two brush strokes, pale orange; black eyes daubed with a loose brush, circles beneath them the same color as her lips. Her hair is wild black grass, diluted to purple across her brow. She looks right at you. Diminutive body, pink puffed sleeves, dress a crisscross of black stripes. The likeness is unmistakable. It is a portrait of Jane Bowles, at the time twenty-eight years old, and Margarett had done her from memory.

The summer of 1944, Wally Reed, now separated from Margie, frequently visited Jane and Paul Bowles in their rented house in Amagansett, and that autumn in New York, he introduced Margarett to the Bowleses. Jane, who thrived on flirtatious pursuit and was given to obsessive romance, was undeterred by the fact that Margarett, at fifty-two, was nearly twice her age. She had a penchant for older women: "She was no longer beautiful," she wrote in her novel *Two Serious Ladies*, "but in her face I found fragments of beauty which were much more exciting to me than any beauty that I have known at its height."

Two Serious Ladies, peopled with odd characters in baldly original configurations, had been published a year before by Alfred Knopf. Margarett certainly talked about the book with her friends at the Askews'. Like them, she marveled at Bowles's disjunctive, deadpan style and recognized her bisexual characters, her opposition to sentimentality, and the ache she evoked in fleeting moments of human connection. *Two Serious Ladies* had a cult success, and overnight Jane became, in Ned Rorem's phrase, "a major minor writer."

When Jane was fourteen, her widowed mother had sent her to private school in Massachusetts, where she became painfully conscious of her difference as a Jew. At fifteen, she fell from a horse, broke her right leg, developed tuberculosis of the knee, and spent two years in a sanitarium in Switzerland, most of it in traction. There, in an agony of pain and loneliness, she found her vocation as a writer and developed "a fear of dogs, of sharks, or mountains, of elevators, of being burned alive," phobias that, along with her stiff right leg, gave her a perverse

sense of uniqueness. "Crippie, the kike dyke," she called herself with the bravado of self-hatred.

Jane was small, gamine or boyish, depending on your point of view, and "brilliant," Betty Parsons said, "just brilliant." By the time Margarett met her, her marriage to Paul Bowles resembled a sister's dependence on a beloved older brother, and she lived for part of the year on a farm in Vermont (not far from Dorset) with a woman companion—in an astonishing coincidence, Helvetia Orr (now Perkins), with whom Margarett had occasionally skated afternoons forty years earlier at Miss Porter's School. Helvetia had given her life over to caring for Jane, keeping her from the chaotic New York life that, Helvetia believed, made her drink too much, depressed her, and led her to slit her wrists the first summer they were together.

Margarett had no interest in taking care of Jane; she recognized her talent, and if at first she resisted her young admirer's insistent pursuit, she soon capitulated. Jane courted her in New York and followed her to Massachusetts. It was rare that Margarett had this sort of rapport with a woman. Jane delighted in Margarett's mode of expression, which she called "controlled non sequitur," a phrase she might have used to describe her own prose style. By the same token, Margarett, in the single slinky line with which she drew women, might have been describing Jane's fictional characters.

When in New York, Margarett stayed at the Gladstone Hotel, on Fifty-second Street, where the socialite Alice Astor and Gerald Murphy's sister Esther kept apartments, and where the international arts patron Mabel Dodge and Tony Luhan, her Indian husband, took a suite when they visited from Taos. On the left as you came in was a tiny crowded bar, legendary as a meeting place for women who loved women but by no means confined to them. There, in the smoky crowd, you might encounter Marlene Dietrich in a backless gown or the novelist Sybil Bedford. A friend of Margarett's, a young actor, rang her once from the desk at the Gladstone and was directed up to her suite. Margarett greeted him at the door, stockings down around her ankles, Jane trailing out of the bedroom behind her, both of them laughing and high.

Unlike most of her earlier liaisons with women, Margarett's relationship with Jane was discussed openly—at the Askews', at the Gladstone, even in certain Boston circles. Kirk Askew remarked that Jane's crippled leg and the difference in their sizes—Margarett was robust and five feet ten, Jane petite and five feet three—must have made certain aspects of the relationships "inconvenient." Maud Morgan, a Boston artist, told a story of Margarett and Jane in her Andover kitchen, pursuing each other, laughing and brandishing skillets. Betty Parsons worried about their drinking and later blamed Jane for "ruining Margarett, ruining her." But Oliver Smith disagreed. "They had conversation and engagement with one another," he said, "not just booze."

Jane talked and talked to Oliver about Margarett, first with enormous excitement about her wit, her articulateness, her voluptuous body, later with disappointment that after a while Margarett no longer shared the degree of her sexual passion. At first, he and the others with whom Jane lived, in a revolving commune on Tenth Street, thought Margarett was a character Jane had invented, but eventually "Margarett McKean" turned up in chic suits, elegant hats, and beautiful shoes for dinners Jane marshaled from a narrow galley kitchen.

Margarett took to Jane's friends immediately. She was enthralled by the double piano Bobby Fizdale played with Arthur Gold and by Oliver's connection to the theater—he was about to design and produce *On the Town*, which would launch his extraordinary career and introduce Leonard Bernstein's music to Broadway. At Tenth Street, Margarett also met John La Touche, a young lyricist and librettist, who became a new combatant in repartee. Margarett's new friends soon came to feel protective of her. They could not understand why she returned to Prides when it was so clear she belonged in New York, why she remained married to a husband they heard her only revile and ridicule. Jane was at work on a play; "My husband never loved me," one of its characters moaned, tipsy and out of control.

Once, Bobby Fizdale and Oliver Smith had lunch with Margarett and Jane and another woman, to whom Margarett took a dislike. Bobby knew it was just a matter of time before Margarett made her

opinion known. "What type are you?" she finally asked the woman, who looked back at her blankly. "Hmmm, it's coming to me," Margarett said. "I know what type you are. You're the type my husband likes; you're the restaurant type."

WHEN PAUL MOORE APPROACHED his father for permission to marry Jenny McKean, the senior Paul Moore expressed concern. It was not that he disliked Margarett McKean—in fact, she made him laugh—but he feared her daughter might inherit the instability evidenced in Margarett's drinking and her rumored sexual career, and in her brother's suicide. He wanted his son to consider his choice carefully, but Paul was madly in love and already a rebel. He planned to marry Jenny and, when the war ended, enter theological school to prepare for the Episcopal priesthood—which pleased his mother, infuriated his father, and delighted Margarett, who always made a point of engaging him in theological discussion.

The easy friendship of the "golden summer" had intensified when Paul returned to New York to recuperate from a war wound. He'd been shot straight through the chest by a Japanese soldier while commanding a platoon at Guadalcanal and had returned to New York with three medals for bravery. In a newspaper photograph taken at El Morocco, zebra upholstery behind them, he is identified as a Marine hero, Jenny as a "socialite." But Paul's experience in combat had traumatized him, and he was uncomfortable thinking of himself as courageous. To Jenny he could express his confusion about killing, could even cry, as she did when she talked about her mother's drinking or showed him Margarett's studio at Prides. Paul, with his successful father and his kind and effusive mother, represented to Jenny a hope for authentic family happiness, "a normal life."

The Moores lived in an apartment on Fifth Avenue overlooking the Central Park Zoo and on a farm, called Hollow Hill, in New Jersey. They summered at Rockmarge, the huge white Beaux Arts house Paul's grandmother maintained on the ocean at Prides Crossing, next

door to the Fricks. Paul's mother, Fanny, and Margarett were friends in North Shore dog show, gardening, and dinner party circles, but his grandmother, Mrs. William H. Moore, and Marian Haughton, intimate enough to have played golf every week for forty years, had always stopped short of calling each other by their first names.

Margarett and Shaw gave an engagement dinner at the Somerset Club in Boston on November 10, 1944, but the wedding was planned for New York. Three years before, Margarett had pulled herself together to plan Margie's wedding, but Jenny did not want to take any chances. Fanny Moore, whom she would one day call "the only mother I ever knew," made the arrangements. The ceremony at the Church of the Resurrection was preceded by an Episcopal nuptial mass. Jenny wore Jenny Sargent's 1881 bridal gown, Paul his full-dress Marine blues. That night, soldiers forgot their dead comrades, and their foxtrot partners forgot they would soon be alone again. Early the next morning, the newlyweds left for Virginia and the tiny plantation cottage where they would live while Paul taught at the Officers Training School in Quantico.

At the wedding, Margarett had looked nervous when the photographer caught her, long dark fingernails to her face hiding a lipsticked smile. Afterward, she wrote Jenny a series of letters, as if to make up for her deficiency as mother of the bride: Her brother Harry had sent a check rather than a gift; she'd send an alarm clock if they needed one; their wedding, Paul's good looks, Jenny's radiance, were the talk of the North Shore. "Last night I was tempted into calling you," she wrote, "to wish you 'Bon Voyage' on the move to the box planting & wizardry of Virginia landscape—but you & Paul were protected—you were out, and so I took mercy and cancelled the call."

When Margarett fell into abject depression days later, Shaw was prepared. He suggested she check into Four Winds, a sanitarium near Katonah, New York.

Jane Bowles was appalled when she heard, as was Oliver Smith. They had not lived with Margarett through years of utter powerlessness, as Shaw had, and so they saw her situation in simple terms. The

problem was her split life, the division between her artistic self, represented by New York, and her Bostonian self, represented by Shaw. Oliver remembered a visit to Prides. "Shaw was in the house. They didn't speak. I heard shouting, but they didn't speak to one another."

On December 29, Margarett wrote Shaw from Four Winds. He was bird shooting in Aiken, South Carolina, had spent Christmas with Jenny and Paul at their honeymoon cottage. "The watercolor of Prendergast is still being framed—I swapped a Luks drawing to get it," she wrote, and, without a transition, continued her letter as if what followed simply filled out a list of household loose ends. "I can't understand how most people can take these shock treatments. My headaches recently have been fierce, unlike any I have ever had. Dr. Lambert says, all right, cancel treatments, but that seems so senseless that I said keep on. . . ."

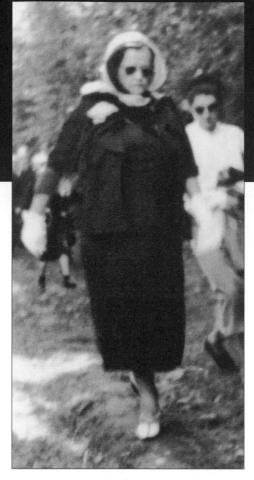

X

Nothing equalled the day I left

(1945–1978)

Margarett in Brittany, c. 1954
(from a snapshot by Joseph Gelli)

EAST OF KATONAH, New York, along a country road, a lawn slopes up to an enormous Tudor edifice situated on a three-hundred-acre estate. "The whole place is very reminiscent of Wellesley," Margarett wrote Shaw, "with polite ladylike furniture & safe taste—Cousin Gertrude might be in a corner—most harmoniously and consistently." Thirty years later, under different management, Four Winds Hospital would become a model facility for the treatment of alcoholism, drug abuse, and mental illness, particularly among young people, but in the 1940s, it was a model of a different kind—a sanitarium for the wealthy, particularly women, whose depression, mania, alcoholic excess, or untoward sexual enthusiasm rendered their presence unacceptable.

The grand house was furnished with antiques Dr. Charles Lambert and his son, "Dr. Jack," picked up at auction. The women who served breakfast at eight, lunch at twelve-thirty, and supper at six were uniformed in apple green during the summer and in black with white trim after Halloween. A Norwegian chef produced aspics, rarebits, and, on Sundays, roast beef and Yorkshire pudding; a Swiss baker did the desserts. Certain "guests" were permanent residents. An Eagle Pencil heiress built her own house on the grounds, and a Delano aunt of President Roosevelt's resided there for years, visited on Sundays by her husband, with whom she dined, a cameo at her throat, a fork in one hand, his hand in the other.

Electroshock was administered out of sight, on the third floor of the main building, and was not referred to by name in the brochure

that characterized Four Winds as "a home-like neuropsychiatric sani-
tarium" with "laboratory, studios, gymnasium, swimming pool, bowl-
ing green, trails, trout streams . . ." Patients in the midst of treatment
or too depressed to meet company took meals in their rooms, where
social life was limited to visits from Dr. Charles Lambert and, after he
died, Dr. Jack.

Electroshock treatment, or ECT, was instituted in the United
States in 1938, and its heyday was the 1940s, before the discovery and
availability of lithium, psychotropic drugs, tricyclic compounds, and
MAO inhibitors. No one then knew that those treated with ECT were
more apt to return to the hospital than those who had not been, or
that shock itself altered the course of manic-depressive illness, later
called bipolar affective disorder. Later research would confirm that
electroshock caused hemorrhages in the blood vessels of the brain, but
in 1944, the important fact was that the seizure it brought on dis-
solved certain constellations of depression. No matter that relief was
usually not permanent and that the biological consequences were irre-
versible; very few patients suffered the most extreme side effects—
permanent epilepsy, extreme memory loss, or death.

At Four Winds in 1944, Margarett's alcoholism was considered a
symptom of her manic-depressive illness. No one then theorized that
alcoholism in a patient like her was a separately occurring illness; fur-
thermore, treatment of alcoholism was in transition. Alcoholics
Anonymous had been founded in Ohio in 1935, but the first national
announcement of the group's successes, an article by Jack Anderson
in the *Saturday Evening Post*, did not appear until 1941, and only in
1972 did the American Medical Association proclaim alcoholism a
disease. In 1944, it was possible that even a physician might consider
Margarett's drinking weakness, moral failing, or self-indulgence.

Decades later, the experiences of manic-depressive alcoholics in Alco-
holics Anonymous would open new avenues of treatment for patients
like Margarett, but when she entered Four Winds, it was assumed that if
her manic-depressive illness was relieved, she would no longer medicate
herself with alcohol. Treatment that combined sobriety, medication with

lithium (not introduced until 1968), and group support would not become commonplace until more than a decade after her death.

Margarett also contended with an attitude that confused a woman's rebellion with mental illness. It was this mind-set, made institutional with asylums that changed only superficially with the times, which Charlotte Perkins Gilman protested in her classic *The Yellow Wallpaper* and that, nearly a hundred years later, the feminist therapist Phyllis Chesler challenged in her book *Women and Madness*. Chesler called for a reexamination of "the relationship between the female condition and what we call madness—that divinely menacing behavior from whose eloquence and exhausting demands society protects itself through 'reason' and force."

More recently, the psychologist Kay Redmond Jamison has questioned society's lack of subtlety when dealing with the artist and "madness." In a book called *Touched with Fire*, she compares an artist's ecstatic, engaged creative state to the euphoria a bipolar patient enjoys before being overtaken by mania. She points out that great writers have had the illness—William Blake, Mary Wollstonecraft, Virginia Woolf, F. Scott Fitzgerald, and Sylvia Plath among them—and suggests that culture has benefited. Her work raises a question that Margarett, when her mood was flattened by treatment, must often have asked herself: Is there no way to have the ecstasy of creativity without suffering its darkness?

For all their good intentions, the physicians at Four Winds in 1945 were practitioners of what Chesler called "reason and force." Margarett was confined to her room, entertained only by Dr. Lambert's visits and his tales of former guests, "such as the man who tried to take 50 drinks a night but couldn't quite make it." She had her first shock treatment immediately. She was taken to the third floor and secured to a treatment table with straps to prevent her breaking bones or injuring an attendant during the involuntary thrashing that always followed the surge of electrical current. Next, the doctor fit a metal plate to either side of her head. "He buckled them into place with a strap that dented my forehead, and gave me a wire to bite," Sylvia

Plath wrote of electroshock. "I shut my eyes. There was a brief silence like an indrawn breath. Then something bent down and shook me like the end of the world. Whee-ee-ee-ee-ee, it shrilled, through an air crackling with blue light, and with each flash a great jolt drubbed me till I thought my bones would break and the sap fly out of me like a split plant."

"They were no doubt efficient, but extremely disagreeable," was how Margarett described her treatments in a letter to Shaw. Patients led out of the third-floor laboratory at Four Winds seemed woozy to those who observed them, and Margarett suffered severe headaches after treatment, but no one denied that the results could be miraculous. Margarett's depression did begin to lift, and so, when she complained of headaches and Dr. Lambert again offered to stop the treatments, she waved him off. She wrote proudly to Shaw that "many patients could not take them at all," but that when she completed eight treatments, she'd asked for more.

When the course of treatment was over, Margarett found Four Winds "conducive to application." She ordered seeds from Burpee's and planned the vegetable garden for Prides—"radishes (good varieties), parsley, lettuce and tomatoes (yellow)." She considered writing a book and discovered that Van Wyck Brooks, author of *The Flowering of New England*, had, at Four Winds, "pulled off his masterstroke. . . . He was a chain smoker, coupled with breakdowns, I believe." She resumed the cutouts she had been doing before she came to Four Winds, now combining them with watercolor. "I am crazy over a paint box of strange dry oriental colors that make drawings look almost like aquatints—or Lautrec colored lithographs—(nothing like self-complacency)."

Friends sent books and she read them—books on art, books on herbs from E. Ames Parker—and she ventured out to occupational therapy. She liked the young woman in charge—"a merry kid about Margie's age—daughter of a Yale professor—crazy over art but obliged to teach every type of activity from weaving to playing jacks which must drive her mad." Soon Margarett and she were talking about art magazines, and Margarett was "rather unobtrusively" drawing the other guests:

"one had the most wonderful coloring—I loved her; she looked like a very valuable Carriere *the best period.*" Eventually she was seriously at work: "My pen drawings have been successful—my pencil ones stupid. There is not enough danger to them in execution. I hate being able to correct with eraser etc."

There is nothing in Margarett's letters to Shaw to suggest she suffered much that winter at Four Winds, and no other letters survive. She had wanted Margie to have a new fur coat and was delighted to hear that Marian had given her a broadtail. She regretted she had not been able to invent "some wonderful letters" for Harry, still in combat. And she was grateful to those who thought of her: "your mother has been extraordinarily wonderful about writing—and when I think I am one needle in her haystack of correspondence—" She still wrote as if her illness were a cosmetic condition to be corrected, a head of hair to be permanently waved—but of course she was reporting to Shaw, to whom she had to prove she was capable of behaving, or recovering. "Please write frivolous news of Aiken," she urged him. "Please write voluminously & indiscreetly—"

On April 12, to celebrate the death of President Roosevelt, Shaw cracked open a very good bottle of champagne. Margarett had left Four Winds and was visiting Florence Shaw in Boca Grande. She sent Betty Parsons a postcard—a tarpon on a line, leaping, the background a garish sunset: "Not because it's a Winslow Homer, but entirely for the slogan—'Hooked but gamely fighting.' " Her battle was not over, but she considered her time at Four Winds a success and gave the impression that her loss of short-term memory—any recollection of, for instance, Paul and Jenny's wedding—a small price to pay for relief. Her New York friends were not so sure. Oliver Smith, when he saw Margarett after Four Winds, thought she looked as if she'd been hit over the head.

The end of the war, in August, brought Harry and Shaw home. Either they were not told what had happened to their mother or it did not register. Each complained that neither parent treated him as the adult he had become. Young Shaw was at Prides for two days before he

moved into the house Marian had leased at 15 Louisburg Square. Living there, he could go out as he pleased or sit for hours talking to the grandmother he considered far more canny than either of his parents. Harry, unlike Shaw, had seen battle and the worst of war. The banner—"Welcome to Beverly"—that greeted him made him sick to his stomach, and he was appalled to hear his parents' friends complain about the rationing of gas and sugar, when he had seen people starve. No one wanted to hear his stories of combat or of the spectacle of death he encountered when his company liberated Mauthausen concentration camp. In Vienna, he'd given money and ration cards to Marian's musical friends. He had met people who'd escaped the Warsaw ghetto and had seen hundreds of young women from Czechoslovakia walking west in flight from the Russians. When he began to send money, all his money, to CARE and the Red Cross, Marian stopped him. In the spring of 1946, both he and Shaw entered Harvard.

Writing to Betty Parsons after Four Winds, Margarett referred to 1945 as a year to be ashamed of. She apologized for lunches and confused letters. She criticized herself for "indulgence," for allowing Helvetia Perkins, Jane Bowles, and Betty to help her onto a train to Florida—"all your nursing and first aid in Penn Station . . ." She thanked Jane for "being so patient with me." When she learned Helvetia was jealous, she wrote Betty over and over for advice. "I think if I had not been in such an alcoholic mirage, I would not have made such involved mistakes about the Vermont pair. It never occurred to me any one could consider me as a *plausible* or *passable* foe." That Jane and Margarett drank together particularly provoked Helvetia, "the jury of Mr. & Mrs. Alcohol," who still tried to keep Jane sober, in Vermont, and away from New York and other women.

Four Winds had not helped Margarett to adjust to a life without work or a household without children. By the end of the year, her friends in New York were concerned. Wally Reed hated the idea of her spending the winter "alone" at Prides and suggested she return to the hospital. Others suggested she move to New York. Oliver Smith invited her to lunch "en famille" at Tenth Street on New Year's Day,

1946. "You belong here, with us," wrote Briggs Buchanan, another Tenth Street communard. But by April, she was back in Four Winds.

Margarett sat alone in her room. "I must have been ossified to have made this decision." The first week, Dr. Lambert came to see her only once. "The only way I survive is I have countless books." She read Elizabeth Bowen's short stories, asked Betty to send *The Death of the Heart*: "Do you believe it is too out of print to obtain?" She read E. M. Forster—"He is my new friend, have you read him?" She wrote Jane and Helvetia for French books and a French dictionary. She wanted to study, to read Italian poetry, to memorize. "Please lay any practical task before me," she wrote Betty. "I am in a grim, grim fix—I must make it positive." In long letters, Jane encouraged her to draw and write. "It would be easier to walk a tight rope," Margarett replied, but Jane's caring stunned her: "I had truly no idea she was upset beyond her mercy & her imagination for my pain."

In "the terror—of losing everything," she wrote Betty nearly every day:

> If I were *well, I would go crazy*—I still have not cried but my horror of the place—has become so extreme—because I doubt it—& think all they want is the weekly money—I admit I sought them—but in pain anything can look easier—& I was not responsible for my decision—all of which I admit is my fault— But if Shaw & I were in any way compatible he would comprehend what I mean & I could explain—sign a pledge— go into a convent or the Bowery or Sing Sing—the only thing I *don't crave* is alcohol—& for the first time I can soberly think of destruction, including self—I have said nothing of this to Shaw—

It was Wally Reed who had prevailed one night at Prides when Margaret couldn't sleep. She'd allowed him to see behind her drunken state and into her distress, and when he insisted she go back to Four Winds, he stated his position so strongly she believed he was right.

I never analyzed (like a maniac) what it would mean—& allowing no telephone or telegraph drives me mad—I would be willing to have anyone in the room as I spoke—but I will burn up with this bed life—

When she complained about the isolation and the lack of treatment, Dr. Lambert told her his strategy was to deprive her of alcohol and allow nature to take its course. Her only regular visitor was the woman dressed in apple green who brought her breakfast: "Well—the day is about to clear." Or her supper: "I declare it's clouding over." Margarett wanted "counsellorship & conversation," but psychotherapy was not offered, and she resented the money spent for what she considered "just isolation—& a whistling neighbor—a mowing machine—& tea house food. . . ."

I cannot understand about last year—I can only say it must have been the shock treatments which made me oblivious & this year—they refuse probably to give them—at least they smacked of danger— It really is a race with idiocy now—not depression—the sharpest arrow in my side was when Dr. Lambert brought in 2 narcissi—I recognized them "Thalia"—he had bought the bulbs from me—the most poignant of white flowers—an old crocked tub remarked, "Is that an orchid?" The answer is no, it's rarer—& far more innocent—& topping it all it's no parasite—orchids are. Betty Dear, there are always two to a stem—Thalia—and I am cut off from it all—with my own hand—

Betty suggested confiding her dissatisfaction to Shaw, but Margarett was certain he'd say "they did so well before." In her isolation, she began to doubt her friendships. When she didn't hear from Jane for a week, she became convinced Helvetia's jealousy had destroyed her place in the Tenth Street group, that she would lose all of them—in particular Oliver, who represented to her "the standards of intellect & office in the world." Kirk Askew, who was storing a Delacroix pastel

Shaw had inherited, was going to England. Margarett realized his gallery wasn't fireproof but was ashamed to write him "from this address." She was amazed at his response, "a touchingly thoughtful letter—even sending me books." On top of her fear for herself, she worried about Harry, whose reaction to the war had rendered him so vulnerable she considered his life in danger. "No Beverly life is safe," she wrote Betty.

The only document of Jenny's graduation from Barnard, aside from her election certificate to Phi Beta Kappa, is a color snapshot. She stands, twenty-three years old, in black cap and gown, a baby on her hip. I am the baby, Jenny's oldest child and Margarett's second grandchild. There is no sign of Margarett in the photograph, but she and Shaw were at the ceremony. She had managed to "knock down the bars" of Four Winds, not only for the graduation but to have lunch with Betty: "I must see you."

I had been born eight months before, in October. In the baby book kept the first years of my life, Jenny noted that her daughter's first visitors were "Grandma and Grandpa McKean." I was one day old. Margarett and Shaw also came to my christening, in December 1945. Obviously, I remember none of this. What Jenny, my mother, told me when I was a child was that I rarely saw Grandma Kean, as we came to call her, not because she didn't love me but because she was ill. She explained carefully what this meant, even touched her head to communicate what mental illness was. She also told me about "shock treatments," which she compared to the shock you feel touching an electrical plug when a wire is loose or your hands are wet. She explained that shock treatments made Grandma feel better, but that they also caused her to forget things.

When I try to summon an early memory of Margarett, or of my mother, Jenny, in her early twenties, telling me about her mother's illness, I hear a voice coolly explaining and I'm pulled into shadows, noise in the night, and darkness. I think I must have overheard telephone conversations about Margarett getting drunk and late-night

parties at Prides. My mother seemed less sad about her mother than exasperated. Only now, approaching Margarett's age at the time of her treatments and reading her letters to Betty Parsons, do I begin to understand what she suffered. I remember her sad face. I remember that she wore dark suits and talked slowly in a deep voice.

At the graduation, Margarett was uncomfortable. There was scant warmth in her encounter with Jenny, who kept her usual self-protective distance. By contrast, Margie, in the wake of divorce from Wally, had recently surprised her with letter after letter, "holding nothing back . . . She even writes she loves me." To Margarett, Jenny's "secure existence" seemed a rebuke from which she, in her vulnerable state, had no protection. She didn't want to go back to the Moores' farm in New Jersey after the ceremony. She had planned to spend the night at the Gladstone, but she was relieved when Wally offered to drive her back to Katonah. "I wish I could 'do over' our lunch," she wrote Betty. Probably what shamed her about lunch was that she wept, unacceptable in her view, and that Betty, austere in her emotional manner, had not allowed her compassion to show. After seeing Margarett at the graduation, Shaw, "rather startled when I described how literally nothing had been done," directed Dr. Lambert to begin another course of electroshock.

An aging envelope Margarett addressed to Betty is garish with flower stickers, as if by merely drawing she could no longer communicate the required gaiety. In the envelope is a sheaf of drawings. If they had been drawn by a cartoonist, the effect would be comic, but they were not. Margarett calls one of them "Bus Stop." At first, it looks like the reflection of a cloud in rippling water, but on scrutiny you see six figures clustered on a sidewalk. A buxom woman wears a tall hat. Two men talk. Another woman—large, behatted—stands with a child who comes only to her waist. Margarett's line oscillates, as if the shock to her head had animated her hand. "How do you like my wiggle technique?" she wrote Betty.

The effect of the course of shock treatments was not as dramatic as

it had been the year before and did not reassure Margarett about the integrity of Four Winds; she continued to complain that the two hundred fifty dollars per week was exorbitant, but she came out of her depression and by mid-June had taken herself in hand:

> I like to sweep things very clean but understand what I am sweeping. . . . It was a very difficult decision coming here and I do not think a particularly astute one but a gullible one on my part—I believed because of last year but I was wrong— however I think the discipline of facing myself in this brutal light is excellent and necessary.

At the end of June, against Dr. Lambert's advice, she made plans to leave Four Winds, but she panicked at the thought of going home. "I would prefer not to be around Prides on the 4th," she wrote Betty. "Maybe I can 'call' on you." Betty was moving to Gloucester for the summer, near Rockport, where some of her own artists—Stamos and Barnett Newman—had also rented studios. To her next letter, as if aware her loneliness might overwhelm even her oldest friend, Margarett added a postscript: "Please be as stern as you want with me. I can take it. I would rather be scolded than receive silence."

Margarett made no pencil compromises in the little notebook with brown covers. Her line is single and clean. She dated the first drawing July 5, 1946. Consider the sketchbook a diary. At Singing Beach in Manchester, thirty minutes up the coast from Prides, on an afternoon during the July Fourth weekend she had dreaded, Margaret sits drawing. As usual, her sketchbook, pen, and pencils are in her bag, among an overstuffing of paints, scarves, seed packets, wallet, and notebooks. Let's say she sits with friends for lunch at the beach club, at an umbrella-shaded table overlooking the ocean, and that she takes notice of a particular little boy, newly allowed to walk by himself.

As the child stops to look at something, Margarett draws his expression as suspicion, his bangs neatly across his forehead. Then she renders his socks, his legs, and the outline of his shoes with an ink line

as conscious of his gawkiness as he is. She draws the fingers of his right hand to look like spider legs, nearly obscures them with a pouch of stomach. At his left hip, she cuts off his forearm at the wrist. Read the look on the child's face as an expression of Margarett's own doubt, his physical awkwardness as the portrait of a new discomfort in her own bodily self.

For all her assertions of a cure, the visits to Four Winds had been an assault. An electrical current had repeatedly disrupted her body, competing with her own energy for control of her nerve and her brain. She had become passive, a patient, had entered a realm where the qualities that made her uniquely herself, which gave her the capacity to draw, which had driven her to sculpt and to paint, had been assaulted by "polite ladylike furniture & safe taste."

It is true she had been desperate, had needed a cure, someone or something to do for her what she could not do for herself. She had taken a risk, had looked to doctors for caring, and what were the results? "She looked as if she had been hit over the head," Oliver Smith repeated.

No one can figure out exactly how he did it, since the doors to Dudley and Vivian Pickman's dining room were terribly heavy and, it seems, could not be easily or quietly opened, but that is the story. Margarett was in Boca Grande with Florence late the winter of 1947, and Vivian invited Shaw to dinner on the North Shore. At cocktails, he was introduced to Kay Winthrop, whom he'd met at a party once with Margarett. She was a competitive tennis player, recently the national women's doubles champion. She was thirty-four years old (twenty years younger than Margarett), vibrantly attractive, very wealthy, and, as a descendant of John Winthrop, a member of one of the oldest Boston families.

Shaw quietly left the cocktail hour, opened the dining room doors, and switched the place cards. At dinner, he discovered that Kay loved dogs, horses, and foxhunting. She had a quality of kind attentiveness and honey-colored hair. She loved to laugh, and was both delighted

and flustered at his attention. After dinner, he asked her for a ride home. His car had broken down, he told her, though it hadn't. "He said he hadn't been happily married for years," Kay told me. "And then one thing led to another."

When Margarett returned from Boca Grande, there was already talk among the staff at Prides, some of whom had seen Miss Winthrop's car in the driveway at odd hours. Shaw let Margarett know that he wanted to divorce her. She was incredulous. After the Snelling affair, since her conversion, she had never considered leaving him, and she had not believed he would ever leave her. She went immediately to Marian, who in the past had always insisted they keep the marriage together. She loved Shaw, Margarett told her mother-in-law. How could he leave her? She had been ill; her religion forbade divorce. Marian was upset with the precipitousness of Shaw's decision, but, she told Margarett, he had made up his mind. The children had grown up; she would not intervene.

The children were jubilant about the separation. "It was what I had always wanted him to do," Shaw said. "It wounded her pride more than anything else," said Margie.

Shaw hoped for an early-summer wedding, but one morning the upstairs maid presented Margarett with a gold earring she'd found while tidying his room. Margarett decided to contest the divorce. The maid would testify about the earring, and Shaw couldn't use the Snelling affair because he condoned it by taking her back. Rather than risk litigation, he planned a Nevada divorce and postponed his marriage. He would leave Margarett practically everything—Prides and the house at Dorset; furniture, paintings, and china they jointly owned; anything Margarett believed belonged to her. Margarett's lawyers advised her to agree to his terms, and eventually she did. For weeks afterward the two sniped and fought, passed each other in the house in frosty silence.

Because Wally Reed had become a close friend, Margarett was not enthusiastic when, just two years after her divorce from him, Margie

announced that she planned to marry Barclay Warburton III, a hand-
some, swashbuckling Vanderbilt relation and a Newport sportsman,
who loved sailing. Buzzie Warburton, Margarett wrote Betty, "irre-
spective of his innocuous charm & courtesy . . . is merely all I have
avoided." He was younger than Margie and still at Harvard when the
wedding took place, on March 29. Margarett and Shaw put up a united
and cordial front for the ceremony and the celebratory luncheon at
Prides. The newlyweds had barely left when young Harry's grief about
the war brought on a serious depression—"a severe and ghastly shock
to me," Margarett wrote Betty. She was reminded of her brother
Frank's visit to New York before he killed himself.

In the wake of all this, Roland Balay arrived in Boston. Margarett
had not seen him for six or seven years, not since before the war. They
met in Boston, walked in the Public Garden, dined at "odd restaurants,"
visited "French churches." They went to Mrs. Gardner's museum at
Fenway Court, to galleries and to the Museum of Fine Arts. As always,
Margarett talked openly to him.

"I found a great change in her," Roland said, "when I came back
after the war."

"As if something had broken?"

"Something—yes, something had happened."

"We had three days of strong happiness," Margarett wrote Betty.
On April 5, she took the train with Roland to New York, returning
the next morning to Prides. The following week, she left for Boca
Grande, trusting Harry's care to his father.

On June 15, Shaw packed a suitcase and moved out of Prides.
Young Shaw accompanied him to Reno to wait out the divorce and
shocked his father by romancing an older blonde who was divorcing
Milton Berle. When he left Prides, Shaw determinedly began a new
life. He never spoke against Margarett to Kay, but he had no desire
to hear news of her, and once, questioned about her at a party, he
abruptly turned on his heel and left. He and Kay married on Octo-
ber 24 and spent the winter in California. When they returned to the

North Shore, they purchased Bayard Tuckerman's estate in Hamilton, where Margarett had been celebrated as a debutante. For two years, Shaw wrote courteous letters to Margarett's lawyer, asking, futilely, for the few things from Prides to which he believed he was entitled. On August 6, 1948, John McKean was born, the first of five children he would have with Kay.

In May 1948, Margarett had sent out an invitation: "You are invited to a private viewing of the recent landscape designs of Margarett Sargent McKean." Sometime later, she hired Mark Pagano, who'd once worked for Kirk Askew, to direct a gallery—which she christened the Belvedere—on the roof of Driscoll's, the elegant Boston dress shop where she bought her clothes. She planned exhibitions of drawings, paintings, and sculpture (not her own), and renovated the space at her expense. There was a publicized opening, and an article in the *Sunday Herald*: "Mrs. McKean, Fabulous Resident of Beverly, Returns to Art Again," which gushed her associations with Borglum and Luks and showed Margarett, heavier now at nearly sixty, holding forth in the garden at Prides.

She was her old self, creative and productive. She received guests at Prides: Robert Lowell and Elizabeth Hardwick, the writer Alan Pryce-Jones, George Dix, the Askews. In New York she saw Betty and scouted artists for the gallery. She hired a young Marine veteran, Charlie Driscoll, to be her chauffeur, but he soon became a friend as well—planting trees, hanging paintings, and keeping her company at supper. Eventually, she overcame her aversion to Buzzie Warburton and invited him to lunch. Sketchbook in hand, she visited her grandchildren—Margie had had a second child.

Margarett hadn't taken a drink since Four Winds, but in time, to have a glass of wine did not seem to be courting danger. She began to drink now and then. She began to argue, to criticize, to fight with Mary McLellan, or with Driscoll, once opening the car door to jump as they sped down the Merritt Parkway. She shouted angrily. The Belvedere Gallery lost tens of thousands of dollars, and her lawyers closed it

down. She accused a friend's maid of stealing her jewelry. She struck a Washington taxicab driver with her purse. By her birthday, she was back in the darkened room, weeping as if the world had ended.

As I sifted through letters, medical bills, and legal correspondence, it became clear that the worst depression of Margarett's life had come after Shaw left. His departure finished off the idea of Prides as a household. Though there had certainly been times when she'd wanted to be rid of him, his presence had provided a structure. When, at Shaw's insistence, John Spanbauer stopped paying Margarett's bills and keeping her accounts—in effect, managing the household—that structure, in place for twenty-seven years, utterly collapsed. Margarett did not admit she was frightened, and she grieved with the self-destructive intensity of a Euripidean heroine.

In Shaw's absence, Mary McLellan telephoned Margie, and Margie turned to Buzzie, who went immediately to Prides. What greeted him as he walked the corridor to Margarett's bedroom was his new mother-in-law screaming, shouting, shrieking, throwing things. At the suggestion of a friend, Buzzie called Dr. Max Rinkel, a Viennese psychiatrist who practiced in Boston. Dr. Rinkel came up to Prides and suggested Margarett be hospitalized. He would call his friend Dr. George Schlomer, of Baldpate Hospital, in Georgetown, just forty-five minutes north. After some resistance, Buzzie gave in. "I said, get the wagon and the man and the straitjacket and do it."

The ambulance, with Margarett sedated, in a straitjacket, and lying on a stretcher, sped north from Prides and swerved up a small hill, through entrance gates, to the "Inn" at Baldpate, a towering clapboard Victorian, garish with turrets, porches, and windows, and painted barn red. When Robert Lowell arrived manic and violent six months after Margarett, he was put in a cell padded with leather to keep him from injuring himself. Baldpate Hospital advertised the same amenities as Four Winds and, in addition to shock treatment, offered "Prolonged Sleep Treatment, Psychoanalysis, Fever Therapy, and Definitive Psychotherapy." Car service was available for day trips, and

the telephone was not off limits. Families were informed they would be charged for any property damage a patient incurred. After a few days in the infirmary, Margarett settled into an outlying "bungalow" with a sitting room.

"Half dozen treatments like Katonah—have made me love life again," she wrote Betty on March 11, 1948. ". . . I am at Baldpate—& now triumphant & wanting to paint & draw all the time—This is *my first letter*—except to my young—I would not have dreamt of such a performance a fortnight ago—but I am grateful to you—& do not worry . . . it *was* unadulterated agony—however . . ."

After the initial crisis passed, Margarett took frequent outings, but by November 1948, it was clear her stay in the hospital was not temporary. The bills at Prides were piling up, and the staff went unsupervised. On behalf of the children and after consulting Dan, Buzzie wrote Dr. Schlomer, asking for a letter on the subject of Margarett's competence. The doctor quickly replied that he did not consider her able to take care of her financial affairs.

In the spring of 1949, Margie visited Baldpate and found Margarett drunk. She complained, visited again, and found her mother slurring words, as if drugged. The nurses searched Margarett's room and discovered barbiturates—she'd had a Beverly pharmacist telephone a doctor, who'd written a prescription. Dr. Schlomer wrote both the doctor and the pharmacist, asking that the prescription not be refilled. On May 5, 1949, a citation was published and filed in court appointing the Old Colony Trust conservator of Margarett's assets: "To all persons interested in the estate of Margarett Sargent McKean of Beverly in said County, a person of mental weakness. . . ."

The staff at Prides, now four or five people, was reduced to two, Charlie Driscoll for the grounds and Mary McLellan for the house. Plans were made to heat only a few rooms. Without Shaw's contribution, after the extravagance of the Belvedere and with the postwar rise in prices, Margarett could not afford both Prides as she had known it and Baldpate. Before she was hospitalized, her response to financial

pressure had been to send a painting off to New York to be sold—through Roland, through Kirk. One turned up in the cloakroom of the Gladstone Hotel: Margarett had sworn the attendant to secrecy. Once in a while a long-unpaid bill arrived in the mail, and the Old Colony officer in charge of her affairs wrote to Buzzie, "There's little we can do other than to pay it." Eventually the bank suggested Margarett's charge accounts be shut down.

Two weeks after the conservatorship was announced, Buzzie wrote Dr. Schlomer that the children, in consultation with Judge Cabot of the Essex County Court, had decided it was in Margarett's best interest that they formally commit her. The decisions as to when she might leave the hospital for the day or be discharged would now be Baldpate's, her "madness" under the legal authority of someone other than herself. On June 8, Dr. Schlomer dictated a legally binding letter: "In accordance with the rules and regulations of the department of Mental Health of the Commonwealth of Massachusetts, we are writing to notify you that Mrs. Margarett Sargent McKean was committed to Baldpate, Inc. by the Justice of the Central District Court of Northern Essex, on June 7, 1949."

Her friends came to expect to find her at Baldpate. It was the place she went to dry out, to overcome a depression, to receive a course of ECT. By the end of her long acquaintance with it, she considered the place nothing better than a prison. Like other such facilities in the forties, Baldpate attended to a patient's symptoms rather than to the life that had produced her illness. Electroshock and hospitalization kept Margarett from alcohol and pills only temporarily. She'd leave, live at Prides, and, when it became necessary, return to endure an existence that barely broke the surface when she was out in the world.

"You could tell when it was coming," her friend George Dix said, "because she would dance on the tables in the bar of the Gladstone Hotel."

After nearly a year and a half in Baldpate, Margarett returned to Prides in the fall of 1949 as if washed up on a shore, as dazed as the survivor

of a shipwreck. She was fifty-seven years old. She began to draw, and to write, in a large bound book:

> It is a delight to throw away empty bottles, even if they have only contained oil. It is startling to make plans without permission & not to have it breaking a law, merely mending a habit. I am nursing along a very different type of good fortune than encountered by most people. I am looking at Society with the other end of the telescope. I am aware of a fresh climate. I am alone, on my own, in unmedicated air.

On page after page, in charcoal, she drew rows of women's legs, crossed, their feet in high-cut pumps. Then she switched to ink and drew a sequence of women with a fine, sure line. At a desk. In a chair. Elbow on a table. There is an ease to this drawing—an arm across a lap, the open collar of a simple dress, a female body comfortably filling the dress, a compassionate face.

> The greater the complication, the clearer the drawing it necessitates. Simplification & elimination of line—is equal—no *exceeds* the opening of a window in stifling air. It includes forgetfulness of agony & absorption akin to delight. There is no explanation of the line that obeys smoothly & suavely & the line that balks the finger. The result is totally disconnected from discipline & reason,—that is its hypnosis for me—its lure. There is no cheating with a line in ink.

Margarett saw Dr. Rinkel for thirty-minute sessions twice a week in Boston. He courted, complimented, and dispensed the alcoholism remedy paraldehyde, an ether derivative, which, when Margarett took it instead of a drink, put her right to sleep. He and his wife were frequent guests at Prides, and Margarett's family and friends did not like him. They insisted he cheated her, but Margarett defended him, took his side against her brother Dan, against her children. "Dr. Rinkel was wonderful yesterday," she once told Dorothy DeSantillana. "He told me I should always wear gray stockings because my legs look

beautiful in them." When he invited her to a dinner party, he sent her the bill. When a society writer lunching with him at the Ritz asked if Margarett McKean would be home by Thanksgiving, he was heard to reply that it made no difference to him, just as long as he got his stipend. "She liked admiration," Dorothy DeSantillana said. "She'd been a beautiful girl and she was used to it."

Dr. Rinkel wrote the children in 1949 that he assumed Margarett would recover from her current illness, that she now seemed "nice and quiet and calm." Closer to the truth was what another psychiatrist wrote them in 1964: "I think it unlikely Mrs. McKean can return to a relatively normal state again." The children were now in their twenties and thirties, and their mother still scared them. Because there were months when she carried on with full command of her intelligence and perception, months in which she did not drink, she also confused them. They did not want to deprive her of what she enjoyed, even though the conservators advised that the sale of Prides would make her life financially much more secure.

The clarity Margarett felt after leaving Baldpate was short-lived. In the early spring, by herself, she took a trip up the Mississippi on the paddle steamer *Delta Queen.* She sketched in restaurants in New Orleans, visited every museum, sent postcards to Betty from Cincinnati—"Blow up 57th Street & I'll be waiting for you in Louisiana"— but by the winter of 1951, she seemed lost again. In letters, she made self-effacing distinctions between Betty and herself: Betty was the famous dealer, Margarett privileged to be her oldest friend. The isolation of the hospital, disorientation brought about by repeated shock treatments, the grip of alcohol, gain of weight and the displacement of beauty with a tenuously maintained handsomeness, had made her a supplicant.

During the autumn and winter, Margarett gave occasional dinners at Prides. She saw Florence, the DeSantillanas, the artist Gardner Cox and his wife, and her brother Harry. She telephoned her brother Dan every day just as he and Louise sat down to lunch. Charlie Driscoll

drove her to New York. She saw Betty and the Askews, John La Touche and his new lover, a tall blond taxi driver named Harry Martin. With Touche, Margarett settled back into laughs and repartee. Harry Martin, twenty-two, just out of college, and an aspiring artist, was dazzled: "She entertained so marvelously—her knowledge of painting was so exciting. . . ."

One snowy winter day, Margarett, Touche, Harry, and a couple of other people piled into Alice Astor Bouverie's Rolls-Royce and set off for a weekend at Alice's house in Rhinebeck. By the time they reached Harlem, all drinking in the car, the light snowfall had become a blizzard, and the chauffeur would drive no farther. They turned back to Manhattan and continued their carousing in the lobby of the Gladstone. Touche began a wild monologue in which he told the story of every Christian martyr, miming the fate of each. Everyone was laughing. Margarett could not keep from laughing, laughing until tears rolled down her cheeks. "Stop! Stop!" she protested as if the next blasphemous vignette would send her to hell—she was, after all, a Catholic! Finally, drunk and laughing, she got up for another drink and fell to the floor. In a flash, Touche put his foot on her large fallen torso and raised his right arm heavenward as if holding a sword aloft. "Saint George and the Dragon," he said.

"You have to remember, we all drank so much. Frankly, I don't know how any of us got away with it," Harry Martin said. Among her usual friends, Margarett's drinking was merely the extreme of what everyone did, but Jane Bowles, who was trying to control her own heavy drinking, could no longer bear to be in her presence. Margarett's wit, which Jane continued to find "keener than anyone's in New York," now seemed to her a smoke screen for "an endless plot which she herself ignores." Unlike Margarett's young male friends, who were content to laugh at her jokes or respond to her generosity, who in some sense accepted her condition, Jane turned away.

Before long Jane withdrew from Margarett altogether. "Do you think there is something wrong with me that I am able to turn so on

someone I once liked as much as I did Margarett?" she wrote to her friend Libby Holman, the singer. "In those days of course she was self-ish as hell and a fat tyrant but now is just humble and could be slavish if she had the energy or sobriety to run errands and she is fatter than ever." Margarett telephoned repeatedly that winter in New York, and repeatedly Jane refused to see her.

> She called me up today and whispered to me that she was tele-phoning from the Algonquin as if she was revealing the for-mula for the hydrogen bomb. The poor woman is just hunted and haunted all of the time. She is of course drinking like a fish, gallons of cider in public and alone in the bathroom, gin out of her purse, I'm convinced. Naturally she is disturbing because of her disembodied talent. . . . The terrible thing is that while all along I thought she liked my feeling for her but never me, I now feel that perhaps I was wrong because she seems dead set on me, though she behaves in a most dis-tinguished manner and never makes me feel either guilty or uncomfortable.

Jane was not the only friend from whom Margarett's drinking separated her. By the end of the 1940s, she had fallen out with Vivian Pickman and with Florence Shaw. She spent time in Gloucester at John Hammond's antique-filled castle, where poets and painters of a younger generation gathered, and she invited more of her New York friends to Prides. Her children associated her new friends with her drinking, and Harry, who still lived at home, resented it when she en-tertained them. When Harry Martin and Touche came to dinner one night during the summer of 1951, the evening led to Margarett and Touche's usual raucous performance. At about one A.M., Harry ap-peared on the balcony above the living room and shouted to his mother, "Get those awful people out of here!"

Margarett saw a lot of Harry and Touche that summer, both at Prides and at John Hammond's, where they were staying. She also

continued her friendship with Nat Saltonstall, an architect and collector, the closeted homosexual younger brother of the "Salts," and often visited him at a settlement of bungalows he'd built on Cape Cod. One night, with Harry, Touche, and Whitey Lutz, a sculptor friend of Betty's, Margarett drove down to Wellfleet to visit a friend who'd rented one of Nat's cottages.

They arrived drunk and carried on so loudly that Nat appeared at the door to complain. He was startled to see Margarett among the offenders, even more startled that she was preparing to bed down on the floor with people like Touche and Harry. He recovered himself and introduced the young man with him as "my protégé." "Hmph," said Margarett, when she told the story, "and there was Nat at the door with a young man who had nothing to recommend him but two cowlicks and central heating!"

Whitey Lutz was living at Prides that summer, quietly working in the old greenhouse, sculpting angels. He and Margarett talked about sculpture, and she commented on his work.

"I'd give anything to see Margarett start painting again," he wrote Betty.

Sometime in the fall, Margarett rented a studio on Bearskin Neck in Rockport, "but she never went there much," Margie said. By the spring of 1952, she was planning a trip to France and Italy.

On May 31, 1952, two weeks before Margarett left for Europe, young Shaw married Linda Borden in Rumson, New Jersey. The children were nervous: though Margarett had invited Kay to lunch once at Prides, she had not seen Shaw since the divorce. She arrived at the rehearsal dinner wearing a black dress and a satin cape that was orange on one side, magenta on the other. She stopped all the guests in their tracks with her old beauty and, Jenny said, swung her cape like a matador.

"Shaw," Margaret said, coming quietly up to him, "aren't the trees in New Jersey beautiful?"

"Yes, Margarett, they are."

At the reception, he took her for a turn around the dance floor, and she returned to the table, Charlie Driscoll reported, with tears in her eyes.

WHEN MARGARETT arrived in Paris in June, she checked into the Saint-James et d'Albany on rue de Rivoli, a small, elegant hotel surrounding a courtyard. The city was slowly coming to after the war, but its vitality had been as compromised by the intervening decades as Margarett's. The giddy jubilance of the 1920s was not the mood with which to greet devastation that was both spiritual and material, a devastation of ethics as well as economics. That spring, six heads of state had signed the agreements that would lead to the establishment of the North Atlantic Treaty Organization, but when Margarett arrived, Paris was still occupied by American GIs.

On the Left Bank, at the Café de Flore, Sartre and de Beauvoir debated existentialism; on the Right Bank, a new generation of couturiers, led by Dior and Balenciaga, flourished, and as old social barriers began to collapse, young women who modeled on the runway were for the first time invited to certain society dinners. A revolution in theater had exploded in the work of Jean-Louis Barrault and Madeleine Renaud, and in March 1953, Samuel Beckett's *Waiting for Godot*—"a curious and interesting two-act play," Janet Flanner wrote—opened at Théâtre Babylone, a tiny space hidden in a court behind an apartment house on the Left Bank. From Vallauris in the south came news first of Picasso's experiments with ceramics and later that Françoise Gilot was about to pack up and leave him.

Margarett had come abroad to reclaim the parts of herself from which she had been torn, as she said, by her own hand. In France, she sought herself as she had been in the Paris of the late 1920s and early 1930s; in Italy, the exuberance she'd brought to Florence as a young girl. She was to remain in Europe for three years, through France's first disenchantment with de Gaulle, the bracing regime of Mendès-France, the national strikes of the summer of 1953, and the deaths, in 1954,

of Colette, Derain, and Matisse, emblems of the passing age. When Margarett took a sentimental journey to Betty's former house on rue Boulard, she was starkly reminded that her friend was in New York, her attention turned to American art, and that the days "with my acrobatic finches on Place Vendôme when Frederic Bartlett was godfather to us both" were long past.

On her arrival at Le Havre, Margarett was welcomed by Joseph Gelli, in uniform and driving a black limousine. He was a short, dark-haired Florentine, a famous driver among certain American travelers. He looked like the actor Rossano Brazzi and was terribly kind. Enthusiastically, he drove Margarett anywhere she wished, through the car-poor streets of Paris, out into the countryside, down through France and northern Italy to Florence. Europe was much cheaper than America in the 1950s, and the exchange rate relieved nervousness at home about Margarett's extravagance. The conservators issued a monthly stipend that allowed her to live well in hotels but restrained openhanded visits to galleries and shops. "I have no checking account," she complained to Betty.

In Paris, she saw Roland, and in Florence that summer she saw Harold Acton and Bernard Berenson, whom she revered from her days as a girl in Florence and had met briefly in 1929. Young Shaw had a job with a law firm in Paris, and after a wedding trip in Spain and Portugal, he and Linda arrived to set up housekeeping. They were greeted by a telegram from Joseph in Florence. Day after day, he told Shaw, he found Madame weeping for "her past happy time." And she drank, he said, even if he told her it would do no good, even when he refused to buy her alcohol. She drank, Margarett told him, because she was alone and there was nothing to do. She drank, Joseph said, even the cologne.

Shaw cabled Margie, and Dr. Rinkel contacted a doctor in Paris, who administered "sedative therapy"—a pattern of medication that made it possible for Margarett to sleep through the night. What Rinkel had given her had her sleeping all day and wide awake all night. Two weeks after Dr. Pichaut first saw her, she emerged from her depression and resumed her travels.

She fell in love with Brittany, and she and Joseph returned four

times in eight months. "I am in *your* country," she wrote Betty, who
had painted there every summer she lived in Paris. "And don't you
admire the Bretons—I believe they are almost my favorite people, &
their oysters certainly are my favorite oysters!!" She took photographs
of women in Breton dress with wide faces, tall narrow lace caps clipped
to their hair. She abandoned herself to the austere Romanesque archi-
tecture, the anguish of belief in the faces of stone saints that balanced,
in wild feats of sculptural genius, on ancient crosses that aged against a
bleak and purifying sky.

Her other headquarters was Florence, and that winter she and
Berenson became friends. Margarett was such a frequent guest at I
Tatti that his companion, Nicky Mariani, apparently became jealous.
"Why?" Dan asked in a letter. "Well," Margarett replied, "the kisses he
gave me were pretty terrific." She was almost embarrassingly grateful
for Berenson's kindness. "Surfeited as you must be with admiration—
and its attendant adorations," she wrote him on January 14, "I cannot
with any possible comfort bottle mine. What an incredible magic you
deal out when you see fit." The great man was eighty-nine, just five
years from his death, and so fragile it was said his wristwatch was
heated to prevent a chill when it was put on his arm.

Before Margarett left for Naples in mid-January, her friends
Robert Fizdale and Arthur Gold, the pianists, performed in Florence.
She went backstage and the next morning telephoned to tell them Mr.
Berenson wished to see them that afternoon for tea. At I Tatti, they
waited for "the presence," who materialized, on Nicky's arm, at the far
end of a long hallway. He came into the room and, Bobby remem-
bered, "plunked himself down right next to Margarett on the sofa."
Bobby saw him cuddle up as if to get warmth from her large body.

Margarett reported her travels to Berenson by letter. From France,
she wrote of the Apocalypse tapestries at Angers—the "beautiful *un*-
emphasized bodies" reminded her of William Blake; and of seeing at
Rouen "with a semi-braille system" in "the one *un*lighted gallery" the
drawings of Géricault. In his replies, Berenson directed, recommended,

and referred. At the Von Maries murals in Naples, his name sent the librarian, "a Jane Austen character," scuttling off to find the director, who rushed to Margarett's side, coattails flying. In Otranto, Margarett was enraptured by a mosaic of Noah and his animals, and at the museum in Taranto, "which opens at the extraordinary hour of 8:30 a.m.," the "flawless unimpaired fragile figures" held her "a voluntary prisoner" day after day.

From Sicily, she wrote she had finally found the "right" hotel in Siracusa, "overlooking Arithusa's Spring." Like Goethe, she fell out of love with Neptune's temple at Paestum when she saw the pink ruins of Agrigento:

> . . . though I saw them at many different hours—& lights—
> nothing equalled the day I left when the sea looked like a mad-
> dened opal—still & wild simultaneously—everything excites
> me so superbly here—even the clouds which choose to lie on
> the land rather than remaining in the sky. . . .

She photographed four columns rising Olympian to the sky and stood beside the Temple of Concord as Joseph took her picture—"rightfully insignificant," the ruin towering behind her, battered by the sirocco but intact and sacred.

> What you prophesied of orange—lemon & almond was all
> beautifully true. Now more is happening—& the wild stretches
> of earth are "dappled—dimpled" with small sweet things—
> valerian—noscaria & small sultry poppies—all stridently in
> bloom.

Much was made back in Massachusetts of the great distance Margarett traveled to see a particular door. "Imagine that," said Dorothy DeSantillana, astonished. "She drove a hundred miles to see a door, and it wasn't the famous door of a church or something, it was just a door in some village!" As it had when she was a girl in Florence, "just looking" came to Margarett's rescue. Seeing had become a matter of

life and death. She sought out beauty not merely to please her eye but to bring the spiritual equilibrium she had once found in the studio. She was sure Betty understood:

> You have been so true to your beliefs—and that is wonderfully and incredibly rare. I could not bear for you to suffer as I do at times when I am not frenzied with visual joys, I can feel shipwrecked. The change of my routine of life came too late I can see now, and this prison of trustees drives me crazy. . . . Europe has meant more independence, therefore. I have written you nakedly. Please do the same to me.

Joseph photographed Margarett in Florence at dusk, dressed in black, tall and romantic, opening a high wrought-iron gate, a garden behind her. "My hair obstinately is not gray for some odd reason, but the color is displeasing increasingly—and my thoughts are often gray." He photographed her among the suppliants on an Assumption Day pilgrimage in Brittany. Chic among the Bretons, walking the eight kilometers up a country road, she wore sunglasses and lowered her eyes. A white length of chiffon swathed her dark hair, and her long black coat fell to narrow ankles. Put a magnifying glass on the tiny snapshot and you see a face loosened on its bones, a dark lipsticked mouth.

Margarett's stay in Europe stretched to six months, a year, then two years. She planned her itinerary a little at a time. In October 1954, she wrote Berenson she'd turn up in Florence in early December, which was no guarantee she would. When Dan arrived in Paris that spring to meet her, Margarett was not at the Saint-James et d'Albany, and Bunny and Hope Carter had not seen her. She was not at her Florence pensione, nor on the lists of tourists each hotel registered with the police. Distressed cables crossed the Atlantic. When Dan heard from her, Margarett reported she *had* been in Florence, staying not at the Albergo Berchielli but with Joseph Gelli and his family.

"The Easter dinner was horrifying!" she said.

"Oh, why?"

"I admired their two Belgian hares. Such beautiful animals, I said.

And Joseph told me their names, and then for our meal we had the most glorious stew, and when I asked after the hares, Signora Gelli pointed at the stew pot."

Margarett did not report the mornings she wept for the past when she was happy in Paris. She did not write letters about Joseph's kindness to her when, having persuaded him to let her have just one glass of wine, she could not keep her head from falling into the soup. Instead, her children got letters from those who came across her in Paris. Bunny Carter, visiting Boston, telephoned Oliver Wolcott he'd heard Margarett was in "very good shape." More frequent were complaints: "Why don't you do something about your mother!?"

On August 31, 1954, Margarett's sixty-second birthday, a hurricane hit Prides. She lost one hundred fifteen trees, forty of them matched lindens that bordered a walk. "I am rightly considered fortunate," she wrote Betty, "but mine are not like others' trees—Thank God I was not there. A spring return may be workable." But she did not return until late the summer of 1955. One day she went silent in Paris, and Joseph Gelli made a decision. He escorted her across the Atlantic and home to Prides. Within two weeks, she was back in Baldpate.

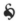

In April 1958, Margarett hired a New York lawyer. She had been out of Baldpate for more than a year and believed that with the help of a bank, she could manage her own affairs. Margie, Jenny, and Shaw were skeptical, but with Harry's support, their mother prevailed and, in July 1958, was declared competent. The conservatorship was replaced by two trusts: Margarett again had control of her own income.

To the distress of her children, she soon began to sell things. She sold three parcels of land at Prides. She wrapped the Gauguin in brown paper and took it on the train to New York, where Roland sold it for her to David Rockefeller for ninety thousand dollars. "It wasn't that we minded her selling things, it was that she rarely got a fair price," young Shaw said. She sold one of her own paintings, *The Watteau Hat*, to buy liquor. Furs disappeared, and jewelry—her engagement

ring and Pauline Agassiz Shaw's emerald, which Shaw had intended young Shaw have for Linda.

There were rumors she propositioned models at Driscoll's, that when she arrived in the store, the girls hid in the back. Once, Buzzie got a call from the police. Margarett had refused to leave a restaurant; she'd been arrested and jailed. Buzzie called a lawyer friend to keep it out of the paper. In September 1958, just after her sixty-sixth birthday, she was again admitted to Baldpate. By the time she was released three years later, in October 1961, Margie and Buzzie had divorced.

That January, Margarett moved to New York for the winter, into an apartment in the Gladstone. But the change Oliver Smith and Jane Bowles had suggested so long ago came too late. In February, she began to drink, and by the twenty-first was admitted to Regent Hospital, whose supervising physician reported her difficult to evaluate "because she was so angry." She refused to answer questions, he said, and when he asked what change she should receive from five dollars after purchasing one item for twenty-five cents and another for fifty, she replied that she was an artist and had never been very good at figures. "Mrs. McKean possesses superior intellectual endowment and abundant creative artistic talent," he wrote, "but it would appear she has always been emotionally labile, eccentric, opinionated, egocentric and not a little sadistic." He concluded that Margarett suffered from four illnesses: manic-depressive illness; alcoholism; cerebral arteriosclerosis and associated "senile changes"; and basic psychopathic personality.

In the fall of 1962, having spent a good summer at Prides, Margarett planned another trip to Europe. "I feel reasonably certain," her new Boston psychiatrist reported, "that if she will not use alcohol, the outlook for the immediate future is not too bad." What he did not understand was that his patient could not stop using alcohol. Joseph met her at the Florence airport in a new limousine, and they began to travel as they had ten years before. After a few days, Margarett had a severe fainting spell. "Her skin was like ice," Joseph told the doctor who arrived to help him massage her back to health. Gloria Etting, a younger friend from New York, joined them for an excursion to Nice. "I was

with this extraordinary person I adored, going to my favorite place." When Margarett retreated into silence and alcohol, Gloria fled, and Margarett and Joseph traveled on to Naples. Then Margarett failed again, and the doctor diagnosed a minor stroke. She soon recovered enough to take a cruise in the harbor, and Joseph snapped her on the deck, smiling—"When the sun came out in Naples," Dan captioned the photo he glued into his scrapbook.

The third week in January, Margarett and Joseph reached Madrid, where Margie's daughter Jenny was studying. When Jenny arrived at the hotel to see her grandmother, she found her lying in bed with her clothes on, not drinking but unable to move, insisting that Joseph never leave the room. Jenny called Harry, who now lived and worked in London, and he flew to Madrid. His mother was unable to understand what he said when he spoke to her. She was panicked about her health but adamant she would not go to a hospital. Eventually she agreed to go to London to stay with him. She and Joseph would drive up through France, stop in Paris to see Dr. Pichaut, who'd helped so much in the past.

When Harry got home to London, he wrote to my mother, Jenny, whom he had attacked in his campaign to have their mother declared competent: "She is very ill not just physically. I now see no hope." Days before she was expected in London, Margarett cabled Harry from Paris that her "present state of acute anxiety and depression" would prevent her coming. He flew to Paris. She had no money for food, she told him. He suggested she go home to Prides, but she said she was afraid. Margie would trick her into Baldpate, and she'd lie in the dark for days without a doctor's visit. The house would be empty—the lawyers said she had to sell her pictures. There was no one to meet her, because Driscoll was sure to be out at lunch.

Margie met the plane, and on April 7, 1963, Margarett was admitted to Westwood Lodge, a sanitarium in Dedham, Massachusetts.

While Margarett was in Europe, Jenny and Shaw had consulted a Boston lawyer, Alvin Hochberg. He was their contemporary, a kind and intelligent man. He suggested that Margie become her mother's

legal guardian. In an account of a meeting among her children, lawyers, and a doctor about her future, the only record of Margarett's voice is the testimony of her psychiatrist. He had recently suggested she might sell her house and paintings, and she had "reacted violently," showing "more spirit than he had observed before." Her response was, in his view, "really quite uncommon"; he expected that she would also protest becoming, in effect, her daughter's ward.

In fact, after some persuasion, Margarett agreed. On June 17, the register of probate for the County of Essex certified that Margie had been appointed "guardian of the person of Margarett Sargent McKean—mentally ill person," and, with the Boston Safe Deposit Trust, guardian of her assets. The guardianship confirmed what had been true for some time, that in the collision of talent and illness, of an uncommon woman with a particular historical circumstance, Margarett had lost her power. She never recovered from the anger. "The change in my life came too late, I fear," she'd written to Betty almost ten years before. It was certainly too late for a return to the freedom of the past. When Al Hochberg offered, thirty years after she'd stopped painting, to organize an exhibition of her work, she brushed him off. How could he understand that it wasn't the pictures that had sustained her, but the act of painting? When she had strength she raged, and when she didn't, she fell silent. Only the pleasures of drawing, of looking, of company, restored her to herself, to the radiant carpet of talk.

"Mrs. McKean is living at Westwood," Al Hochberg wrote Joseph Gelli in Italy, canceling the visit to Prides Margarett had planned for him the spring of 1964. She was again having shock treatments, and her friends knew they wouldn't find her at home. "Am being mesmerized by your painted stone," Margarett telegraphed Betty on February 23. Betty was painting stones she picked up on the beach. "The colors are bright and the design successful," Margarett continued. "I miss your gallery announcements. You can send them here." But when Roland called her at Westwood, she refused to come to the telephone. To him she was as she had always been; for her, talking to him would have been too bald a reminder that she was not.

*"Beyond Good
and Evil* is
the picture
of me."
Self-portrait,
c. 1930

Herself with
no face,
casting no
reflection.
*Self-portrait
with model,*
c. 1936

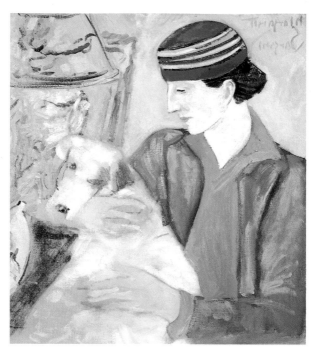

Margarett has introduced a modern Diana.
The White Dog (Maria deAcosta), 1928

Flappers rowdy at the beach to jazz in the air.
Bathers, 1930

A man in gray.
Untitled,
1930

This no-account,
sitting in a corner.
Untitled,
c. 1932

Dazed black eyes,
staring as if
interrupted.
Blue Girl,
1929

Forehead turned
lavender with
intensity.
Untitled,
c. 1932

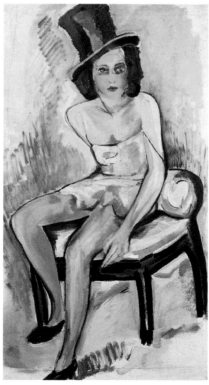

Ironically, it was Al Hochberg, the architect of the guardianship, who restored Margarett to a form of freedom. After a first hostile encounter at Westwood, they met at Margie's for lunch. "I saw it happen," Margie said. "Mama fell in love." And Al was utterly fascinated—not just by Margarett's charm but by her intelligence and her history. "She taught me all I know about art," he said much later, gesturing at the paintings on his walls. There was nothing he did not want to hear about, and for years he sat, bemused and rapt, as she told him about George Luks, about Prendergast, about her days in Paris and New York; as she taught him how to look at pictures, what was good, what was important.

On February 12, 1966, an attendant brought Margarett her supper at Westwood. She was feeling depressed but was otherwise perfectly well. She was seventy-four years old. She walked over to the supper table, sat down, and began to eat. Suddenly she lost feeling in her right leg. She returned to bed and tried to lift her leg from the floor onto the bed. She could not. In the morning, an ambulance arrived to take her to the emergency room at Massachusetts General Hospital, where, on examination, she was found to have difficulty talking and a weakness of the right side. She had had a stroke. In her confusion, she named Buzzie, now divorced from Margie for seven years, and Dan as her two nearest relatives.

On February 14, Dr. Raymond Adams, a neurologist, visited Margarett in her hospital room. Though she was in pain and the action of her tongue had slowed, he found her completely aware she was in a hospital, able to name and spell, to comprehend written and spoken language, and to make the appropriate sound when he mentioned a particular animal. On the telephone with Dan that afternoon, she exuberantly imitated herself barking, cawing, and oinking. Later, when Dr. Adams asked her to, she scrawled, slowly and with great difficulty, on a yellow pad: "Margarett" and "Hospital."

But she could no longer draw.

After a month, Margarett was well enough to begin physical therapy. She hated it. She shouted and wept when she was forced to walk, first

with a cane and finally on her own. She moved to the Phillips House, where she'd had her children, and, as she recovered, hung her room with paintings from Prides. When I visited her, she was leafing through some of her George Luks drawings, planning an exhibition of her collection of his work for a gallery in Boston. I promised to be there.

On June 15, the exhibition opened at Joan Peterson's gallery in a Back Bay brownstone. The small room was hung with more than thirty paintings and drawings—Jenny as an infanta, *The White Blackbird, Women in the Doorway of St. Botolph Street,* governesses pushing their strollers on Commonwealth Avenue, the old part of Prides in the snow, called *Cottage in Winter.* Margarett dressed in pale-blue satin and arrived in a wheelchair. It was a muggy summer day, and the gallery was jammed with friends and family, visitors from New York, Boston artists and museum people.

By the time I arrived, the room had become terribly close. When I said hello, Margarett did not speak. It was as if she couldn't hear me, and her face did not move. She sat that way, silent, all afternoon. As I stepped out of the heat onto the street, I fainted on the sidewalk. Margarett knew she would not recover from the stroke and that she would not draw again. It was as if the heat in that room were that realization, vivid and closing in. "Simplification & elimination of line—is equal—no *exceeds* the opening of a window," she'd written twenty years before.

Now, for relief, her doctors considered shock treatment, but in the end, Dr. Adams prescribed drugs—Dexedrine and antidepressants when she was low and, when she was manic, something to calm her down. At various times, he gave her lithium. "None of them seemed to work," he said, meaning that Margarett continued to have her usual cycles of hypomania and depression. She stayed at the Phillips House for nearly two years. In November 1967, she moved to the apartment on Tremont Street and, once or twice a week, went out to Prides for the day.

The apartment was high above the Boston Common, with a panoramic view of the city where she'd been a famous beauty, whose post

office had once, in her youth, delivered a letter to Hereford Street addressed, simply, "Margarett Sargent, Boston." She had visitors there, and as her cousin Aimée Lamb remarked at ninety-nine, "she had parties." In her bedroom, she hung her own painting of three children in a green field and, where she could see them, *The White Blackbird* and the watercolors of single women Prendergast had given her when she was young. The living room walls were crowded with Schiele and Luks, Lurçat and Prendergast, and furniture from Prides civilized the boxy high-rise rooms.

When she had parties, Margarett directed her nurses to set up card tables to seat two dozen—museum curators, art dealers, family, old friends. "Always such interesting people!" said Al Hochberg's young associate, Sylvia Cox, who came often with her husband. During the early seventies, guests came for cocktails and then walked in summer twilight to the Shubert Theatre or the Wibur, returning to the apartment after the play for supper, often with the cast. Once, Margarett commandeered her sister Jane's grandson to push her wheelchair. "For God's sake, Russell," she shouted as he wended her along Tremont Street through sidewalk construction. "Hurry up!" Margarett saw the Boston tour of *Godspell* so many times the cast knew to look up toward her box during performances.

Dan visited every week, often before going for supper to the Tavern Club. If he brought along their nephew Sargent Cheever, a surgeon at Mass. General, Margarett was apt to say, "Oh, Sarge, why did you bring my brother along, he's so dull!" sending Dan off into gales of laughter. Louise Sargent was long dead, and with her, the only obstacle to Dan's passionate affection for his sister. Intimacy restored, they talked at least once a day on the telephone, about their parents, their sisters and brothers, about the death of Ruth, about Wellesley, about everything, filling in each other's details like a finely tuned duet.

Margie and Al Hochberg supervised, and several times a week, Margie's third husband, Stephen Vernon, stopped in after work: "We talked about trees; she taught me how to prune." Jenny came to Tremont Street twice a year, Shaw called every Sunday, Harry visited from

time to time, and every few weeks, Margie brought her needlework and sat until Stephen arrived later in the afternoon. "Do you know, Margie," Margarett said after one of her strokes, "that you've done needlepoint every time I've been dying?"

Margarett's grandchildren—Margie's six, Jenny's nine, Shaw's three—brought boyfriends or girlfriends. Sometimes Margarett would be silent and answer our greetings only in monosyllables. More often she fought to be clear through the blur of her stroke-damaged articulation. "I have something to tell you," she said to Margie's daughter Minnie one day in 1968, at the height of protest against the Vietnam War.

"What, Grandma?"

"Something I don't want anyone else in the family to know."

"Okay," Minnie said, bracing herself for the revelation.

"I've become a Democrat."

MARGARETT STILL HAD SIEGES of depression, but by 1970, Dr. Adams was able, for the most part, to keep her on an even keel with medication. He made house calls to Tremont Street and recruited an associate who was an expert on Italian art. He himself never tired of her conversation. "I got her away from the psychiatrists," he said. Margarett was attended by a covey of nurses, whose population shifted. It took a particular kind of woman to withstand her orders, her shouts of pain, the willful perfectionism that had never changed. On day visits to Prides, she continued to plant trees and once, behind Margie's back, planned a garden on the site of her studio, which had burned in the early sixties. "Sargent's Secret," she called the projected garden—a vast checkerboard, thousands of dollars' worth of imported tulips. Her conflicts with the trustees now had the feel of comedy. When they heard about the garden, they canceled the bulb order.

On August 27, 1971, Shaw died of a stroke, and Harry called Margarett. "Thank you for telling me," was all she said. She was silent for several days, and then, Jenny observed, seemed almost happy to

have survived him. When Harry cleared out Prides, he found photographs of Shaw "under every blotter in the house." That fall, Dickie Demenocal, a Catholic convert whom Margarett had known since the 1930s, telephoned. He had been a lay brother in a monastery for years and had returned to Boston to paint. He came often to visit, sometimes bringing his paints. "We'd talk about flowers," he said. "She'd tell me about a particular tulip, and she'd start weeping. She was so profoundly moved. I'd say, describe it to me, and tears would start pouring from her eyes."

Now that Al had brought her financial affairs under control, Margarett no longer clung to her paintings. He encouraged her to look on her collection as bounty she could take pleasure in giving away, and she did so, amusing herself by alternately seducing and fending off the curators, museum directors, and dealers who circled like courteous vultures. She gave paintings—including her own—to grandchildren and to friends she cared about. She cut drawings from her sketchbooks, had them framed, and handed them out like party favors to visitors at Tremont Street. She determined which paintings in her collection should go to which museums—the Cassatt pastel, for instance, she lent to the Museum of Fine Arts but left to the museum in Philadelphia because Cassatt had lived there.

Once in a while, she sold paintings to raise cash. One designated afternoon, a dealer came to Tremont Street to see her de Chiricos. The doorbell rang, and Al, who had arrived beforehand, brought the man into her bedroom. Margarett, perfectly made up and coiffed, suddenly became convincingly drowsy, and when the dealer was introduced, asked him to repeat his name. Al pulled out the first painting.

"Well, Mrs. McKean, how much do you want? It isn't a very good painting, you know. . . ."

"Twenty-five thousand dollars," she said, closing her eyes, seeming to fall asleep.

"That painting isn't worth twenty-five thousand dollars," he said, and ran a medley of what was wrong with it.

Suddenly, as if jerked awake, Margarett said, without opening her eyes, "Twenty-seven thousand, five hundred dollars." When the dealer protested, she opened her eyes and said, calmly, "You had your chance to buy it for twenty-five thousand." She got her twenty-seven thousand five hundred dollars for the painting of the horses and her asking price for the others.

Ordinarily, when Sylvia Cox arrived with papers for her to sign, Margarett charmed her with stories from the past—how Shaw McKean had been so furious to see *The White Blackbird* in a New York gallery window ("My wife, dressed like that!") that he'd bought the painting; how she'd commissioned Sandy Calder to make her a wire head of Harpo Marx. She was fascinated that Sylvia had a career and that she'd kept her own name when she married. "Call me Sargent," she said one day, not telling Sylvia about the days of Frank Bangs and MacLeish's sonnet "Sargent on a city street . . ."

But one day when Sylvia arrived, Margarett turned on her. "I don't know who you think you are, trying to be a lawyer," she said evenly. "You're nothing but an incompetent nobody." Sylvia, dark-haired, brown-eyed, and small, waited until Margarett signed the papers, and left in silence, bursting into tears when the door closed behind her. Though Margarett never attacked her again, Sylvia withdrew, did not, for instance, reveal that it was her birthday when she arrived one day a few weeks later with another sheaf of papers. As she turned to leave, Margarett summoned the nurse, who presented Sylvia with an enormous basket of red anemones.

"As I walked down Tremont Street, the flowers were so abundant they almost hid my face," she remembered. "I saw that people were looking at me as they never had before, and I understood what it must be to be a beautiful woman."

During the late spring of 1973, Margarett gave an enormous party at Prides, a sit-down dinner for what seemed like hundreds of her friends,

relations, acquaintances, people who had worked for her. Creed, the caterer, set up tables throughout the house—in the bedroom, the loggia, the dressing rooms—as Margarett, dressed in pink satin trousers, supervised from a wheelchair in the big room, her hair finally gone gray but carefully curled, her face beautifully made up, her eyes pale and wide. The cast of *Godspell* would be out to perform after their matinee, and a friend's grandson's rock band was to provide dance music. The white weeping tree wisteria were in bloom; it was a perfect May evening.

As cars pulled up and Driscoll directed them to parking, Margarett's brother Frank's son, then Governor Sargent of Massachusetts, stood on the front lawn, talking to the composer Randall Thompson and to Dan. Mabel Storey came, and Jane Cheever's grandchildren; I flew up from New York, and one of my brothers drove out from Cambridge. Inside, guests crowded at tables set with linen and crystal, laughing and talking just like the old days. "Margie," someone joked as a multitude of waiters served veal and poured champagne, "you better enjoy this—it's the last of your inheritance."

Earlier that spring, Jenny had been diagnosed with terminal cancer. Margarett showered her with paintings and drawings—the George Luks painting of her at four as the Spanish infanta, the Mary Cassatt aquatint of a dark-haired mother lifting her blond child in a very green garden. Toward midsummer, Jenny took a turn for the worse, and Margarett fell into a depression. When Sylvia or Al or Stephen came to the apartment, she spoke of her worry about Jenny or ordered another painting sent. She knew that Margie had gone to Washington in mid-September and hadn't returned.

On October 3, Stephen called to tell her that Jenny had died early that morning. At first, Margarett didn't want to go to the funeral, but he encouraged her. He worked for an airline and was able to arrange, at the last minute, first-class seats on the shuttle. When he pushed the wheelchair down the long white marble aisle of Washington Cathedral, Margarett bent and swathed in black lace, the service had already

begun. "She upstaged Jenny," my father, Paul, said, "even at her own funeral."

In 1977, it became clear to Margie and Al that keeping a full-time nursing staff at Tremont Street would soon become impossible. Margarett had suffered a few more small strokes and now required even more care. That summer, she was moved, against her will, to Oakwood, a mansion turned nursing home, overlooking the ocean in Magnolia. She would never return to Prides. Without her knowledge, the house was emptied of furniture and pictures, and an auction was held on the front lawn. That fall, without her knowledge, Prides was sold to a developer.

HER BLUE EYES, still like lakes. Skinny, skin fallen back to her bones, hair no longer dyed, no makeup. Vulnerable as a child, she lies on her side in a hospital bed. "Hello, Grandma," I say, hating that I speak as if to a child to a woman who has lived eighty-six years. "Oh, hello, dahling," her voice very low. "Hello. Hello." She's been repeating things since she came to Oakwood.

"How are you?" "Not very well. Not very well." It is August. In the bare but spacious room, the only photographs are five of Jenny, and one of me. Beside Margarett's bed is a copy of the anthology I've edited, my first book, new plays by women, including one of mine. I'd sent a first copy to her months ago. A week later had come her call: "I read your book, read your book, read your book. I've read it twice. Twice." The nurse, worried I haven't understood, explains before hanging up: "When she finishes reading it, she begins all over again."

On Thursday, January 19, Father Duquette, a friend of Dickie Demenocal's, brought Margarett communion at Oakwood. On Friday, January 20, Stephen visited, and early Saturday morning, January 21, 1978, Margarett died alone in her room.

When I got the call in New York, it was dark and snowy. I was sitting at the breakfast table with friends and one of my sisters. It was my uncle Shaw. "Your grandmother died last night," he said. "The funeral

is on Wednesday." I told everyone, then I took out the telephone book, looked up the number of the Betty Parsons Gallery, and called to tell a woman I'd never met that her friend had died.

Sixteen years later, on an early-summer afternoon, I sat surrounded by paper—scribbled-on and crumpled typescript, photocopies of Margarett's drawings, books open to certain pages—the storm of finishing her biography, this book. When I wrote her death, that one sentence, I dropped my head to the table and cried.

I wrote the end on a Friday. Saturday night I dreamed we were in Paris together, at the Saint-James et d'Albany.

The room is hung with crimson and gold. Healthy and in possession of her beauty, Margarett reclines on a bed, in an elegant black sheath. I sit by her side, notebook on my knee, interviewing her. In the way of dreams, I am both viewer and participant. As I watch, I can see we are both laughing. I want to sleep forever if I can keep dreaming this, me asking, Margarett exclaiming, telling me all her answers.

Acknowledgments

THERE ARE a few people, in particular, without whom, literally, this book could not have been written. With great generosity, Margarett Vernon opened her memory and her house, provided leads and archives, and persevered in a decade-long conversation about her mother, which could not have been as riveting for her as it was for me; it is with gratitude and love that I have dedicated the book to her. In addition, I thank Shaw McKean, his wife, Linda, and Henry P. McKean II for the hours they spent talking to me; and for the memoir she wrote before her death, I am grateful to my mother, the late Jenny McKean Moore.

Ingrid Schaffner included Margarett Sargent in "The Feminine Gaze," an exhibition she co-curated at the Whitney Museum (Stamford, Connecticut) in 1984, and subsequently brought her intelligence, wit, perseverance, and curiosity to the project as a research collaborator. Diane Gelon, armed with camera, lights, and expertise as an art historian, accompanied me to the Metropolitan Warehouse in Cambridge for a week of photographing and cataloguing; without her slides, I would not have the visual record that formed my understanding of Margarett as an artist. Patterson Sims introduced me to the New York art world, shared his knowledge of American painting gleaned from years as the curator of the permanent collection of the Whitney Museum, and directed me to sources I would otherwise not have found.

Alvin Hochberg, Margarett Sargent's lawyer in the last twenty years of her life, generously made available files that clarified the years she spent in mental hospitals. The late Daniel Sargent, a great raconteur with an extraordinary gift of recall, painted, in hours of interviews, his favorite sister's childhood and youth, and their unusual relationship. In

the last years of her life, Betty Parsons, in many interviews, situated Margarett in the New York art world of the 1910s and 1920s, and, with an artist's insight, cast light on the convolutions of her friend's character. After Betty's death, her friend Gwyn Metz made available the revelatory letters Margarett Sargent wrote from Four Winds and Baldpate.

For *The Writer on Her Work* (Volume I), Janet Sternburg commissioned "My Grandmother Who Painted"; it was in writing that essay that I decided to write Margarett Sargent's life.

Margarett's friends, family, and associates, the friends and families of those who knew her, and those who guided me to them were extraordinarily generous with their time and memories. I would like to thank Dr. Raymond Adams, William Alfred, K. K. Auchincloss, Lyn Austin, Mr. and Mrs. Roland Balay, Mrs. Frederic Bartlett, Susan Blatchford, Benjamin Bradlee, Frederick Bradlee, William Brice, John Malcolm Brinnin, Sargent Cheever, Susan Sargent Cooper, Jonathan Coppelman, Sylvia Cox, Richard Demenocal, Millicent Dillon, George Dix, Gertrude Hunnewell Donald, Charles Driscoll, Laura Delano Eastman, Kenward Elmslie, Katharine Evarts, Evelyn Evers, Hamilton Fish III, Robert Fizdale, Michael Gladstone, Stephen Green, C.Z. Guest, Lee Hall, John Hohnsbeen, Jane Hunnewell, Mrs. and Mrs. Walter Hunnewell, Phyllis Jenkins, Buffie Johnson, Garson Kanin, Walter Kilham, Lincoln Kirstein, Alida Lessard, Mrs. John Lodge, Lily Lodge, Jane Lyman, Russell Lyman, John McGovern, John McKean, Katharine McKean, Agnes Mongan, Edwin Denison Morgan, Jr., Daisy Oakley, Gina Ogden, Morton Palmer, Eve Pell, Robert Pell-Dechame, Stephanie Pell-Dechame, David Pickman, Perry Rathbone, Rosemary Rawcliffe, William Roerick, Mr. and Mrs. Daniel Ignatius Sargent, Francis W. Sargent, Joan Sargent, Charlotte Sheedy, Dr. Pamela Sicher, Jenny Slote, John Spanbauer, Constance Tilton, Katharine W. Tweed, Stephen Vernon, John Walker, Theresa Walsh, Minnie Warburton, Sylvia Whitman, Eugene Williams, Ruth Robb Wolcott. I am also grateful for conversations with Billie Sorenson, Dr. Terry Twichell, and Polly Abel of Four Winds Hospital.

A great many of the people most central to my understanding of Margarett Sargent have died since I spoke with them. I remain grateful

to Berenice Abbott, Elizabeth McKean Bourneuf, Emily (Lodge) Clark, Fanny Perkins Cox, Marjorie Davenport, Dorothy DeSantillana, Hamilton Fish, Sr., Antoinette Kraushaar, Aimée and Rosamond Lamb, Leo Lerman, Archibald MacLeish, Harry Martin, Father Hilary Martin, Elizabeth McKean, Nancy Cochrane Palmer, E. Ames Parker, Joseph Pulitzer, Oliver Smith, Marian Valliant, Barclay Warburton, Edward Weeks, Kay Saltonstall Weld, Annie Laurie Wetzel, John White, and Hope Williams.

Certain people gave crucial direction to my research or thinking, sometimes without knowing it. I thank all of them, in particular Miranda Barry, Bowden Broadwater, Dr. Leonard Glass, Philip Grausman, Jasper Johns, Moira Kelly, William Koshland, Gail Levin, Arthur Lewis, Eleanor Munro, Toby Quitslund, John Richardson, Dr. Susan Robertson, Mira Schor, Dr. Sue Shapiro, Michael Steiner, George W. S. Trow, and Gillian Walker. I also thank my friends and colleagues who read the manuscript during its composition, providing encouragement to clarify and deepen my writing and thinking: Louise Bernikow, Helen Brann, Joyce Chopra, Michelle Cliff, Kennedy Fraser, Suzannah Lessard, Nancy Mowll Matthews, Dr. Phyllis Meshover, Arthur Miller, and Victoria Wilson.

A number of scholars and biographers have been invaluable teachers, some through their work and others with advice and direction. In particular, I would like to thank Carol Walker Aten, Deirdre Bair, Shari Benstock, Lawrence Bergreen, Flora Biddle, Liana Borghi, Milton Brown, Shareen Brysac, William Coles, Janis C. Conner, Blanche Wiesen Cook, Wanda Corn, Stanley L. Cuba, Courtney Graham Donnell, Louise DeSalvo, Trevor J. Fairbrother, Joseph E. Garland, Françoise Gilot, Cleve Gray, Kathryn Greenthal, Barbara Grossman, Nancy Grossman, Gillian Hanna (who also provided translations of Italian poems), Ann d'Harnoncourt, Anne Higonnet, Erica Hirschler, Kay Redfield Jamison, Temma Kaplan, Bernice Kramer Leader, Eunice Lipton, Celia McGee, Joan Marter, Diane Middlebrook, Nancy Milford, Alexandra Murphy, Linda Nochlin, Judith H. O'Toole, Arlene Raven, Joseph Rishel, Charlotte Streifer Rubenstein, Jean Strouse, Judith Thurman, Louise Tragard, Carol Troyen, Nicholas Fox Weber, and Judith Zilczer. I have also been privileged to participate in five years of discussion about biography and women as a member of

the Women Writing Women's Lives Seminar, first at the New York Institute for the Humanities, and later at the Graduate School and University Center of the City University of New York.

No book about an artist is complete without its visual component. I am grateful to Gloria Etting for permission to use the photograph of Margarett Sargent by her late husband, Emlen Etting, for the jacket; to Rebecca Busselle, Joan Barker, Sarah Jenkins, and Monica Stevenson for making exquisite copies of old photographs, often at a moment's notice; to Monica Stevenson, Robert Houser, and Gregory Heins for photographing works of art for use in the book; and to Rustin Levenson Art Conservation Associates for the care with which they have restored Margarett Sargent's works, and help beyond the call of duty. I am also grateful to Vincent Virga for his invaluable help with the black-and-white picture section. Most of all I thank the people at Viking Penguin who made the visual elements of the book possible.

For important research assistance, I thank Ann Butler, Martha Finamore, and the late Margaret Stevens; and for their transcriptions of interview tapes, Ellie Mikalchus, Laura Stroehlein, and especially Judith Herrick.

For their memories of Margarett and patience during the years I devoted myself more to my family of the past than to my family of the present, I thank my brothers and sisters, Paul, Adelia, Rosemary, George, Marian, Daniel, Susanna, and Patience Moore; my brothers-in-law and sisters-in-law; my nieces and nephews; my Moore and McKean cousins; and my aunt Pauline Nickerson. And for their love and support, I thank my father, Paul Moore, and his wife, Brenda.

During the years of composition, friends have sustained me practically and spiritually, and their insights have enriched what I've written. I especially thank Margie Adam, Ann Arensberg, Dorothy Austin, Judy Baca, Rebecca Busselle, Martha Clarke, Tom Cole, Jane and Tom Doyle, Karen Durbin, Gabriela de Ferrari, Lucy Flint-Gohlke, Carolyn Forché, Phyllis Foster, Gerald Freund, Nancy Fried, Francine du Plessix Gray, Venable Herndon, Christopher Hewat, Richard Howard, Howard and Susan Kaminsky, Joan Larkin, James McCourt, Kathryn Meetz, Inge Morath, Eileen Myles, Ginger Nelson, Peter Passell, Joan K. Peters, Maletta Pfeiffer,

Jane Rothschild, Victoria Rue, Christina Schlesinger, Paul Schmidt, Faith Stewart-Gordon, Susan Taylor, Vincent Virga, Kathryn Walker, Arnold Weinstein, Marguerite and Tom Whitney, Peregrine Whittlesey, and Sondra Zeidenstein.

Finally, I would like to thank Amanda Vaill, the editor who originally commissioned this book for Viking, Wendy Weil, the agent who first represented it, and Nan Graham, the book's second editor, for their enthusiasm at the beginning and along the way. I also thank my agent Andrew Wylie, whose tough criticism and vigorous encouragement came at crucial times, his associates Sarah Chalfant and Jeffrey Posternak, for their continuing contributions to my work, and Viking's publisher, Barbara Grossman, for her warmth and support. Last, but in no way least, I thank Courtney Hodell, my editor, whose passion for *The White Blackbird* and its subject has been the great gift of its publication.

This book has taken years to write, and it's altogether possible I've inadvertently failed to acknowledge someone who provided time and important assistance. If I have, I apologize; I did—and do—value your contribution.

H.M.

Kent, Connecticut
May 1995

A Note on Sources

THE SOURCES, aside from interviews, that most intimately revealed my story are the scrapbooks, sketchbooks, diaries, photographs, paintings, and drawings left by Margarett Sargent McKean and now either in my possession or spread among her children and grandchildren. Family material relevant to Margarett's life was also generously provided by Sargent Cheever, Susan Sargent Cooper, Gertrude Hunnewell Donald, Alvin Hochberg, Jane Hunnewell, Mr. and Mrs. Walter Hunnewell, the late Betty Parsons, and the late Daniel Sargent.

But whatever the wealth of personal material, it cannot take shape without the resources of institutions. At the Sargent Murray Gilman House in Gloucester, Massachusetts, which was once the residence of Judith Sargent Murray, I found a profusion of Sargent family material to supplement the encyclopedic *Epes Sargent of Gloucester and His Descendants,* arranged by Emma Worcester Sargent, with biographical notes by Charles Sprague Sargent (Houghton Mifflin, 1923). At the Essex Institute in Salem, Massachusetts, I leafed through logs kept on ships owned by Daniel and Winthrop Sargent, and later through issues of the *North Shore Breeze and Reminder.* My major source for the Hunnewell family was *The Life, Letters and Diaries of Horatio Hollis Hunnewell, with a Short History of the Hunnewell and Welles Families and an Account of the Wellesley and Natick Estates,* edited by Hollis H. Hunnewell, privately printed, 1906.

By the Winsor School in Boston, I was given copies of Margarett Sargent's report cards; and with the assistance of Gloria Gavert, I consulted the rich archives of Miss Porter's School in Farmington, Connecticut. In the Harvard University Archives, I discovered a treasury of autobiography, personal statements written by Harvard graduates on the

occasion of each important class reunion, called "Anniversary Reports." At the Arthur and Elizabeth Schlesinger Library on the History of Women in America, Radcliffe College, I consulted the papers of the Boston Junior League (including those of the Sewing Circle). In the Yale Collection of American Literature at the Beinecke Rare Book and Manuscript Library, Yale University, I consulted Francis Hyde Bangs's annotated *Letters and Verses of Archibald MacLeish, 1914–1942, together with poems sent to Francis Hyde Bangs from 1914–1942*, in the Archibald MacLeish Collection, an invaluable document originally brought to my attention by R. H. Winnick.

For information about the history of Ogunquit as an art colony, I consulted, with the guidance of Louise Tragard, the archives of the York Historical Society, York, Maine, and later read the excellent *A Century of Color: 1886–1986*, by Tragard, Patricia E. Hart, and W. L. Copithorne (Ogunquit: Barn Gallery Associates, 1987). At the Library of Congress in Washington, D.C., in the Prints and Photographs Division, I consulted the Arnold Genthe Collection; and in the Manuscript Division, the Gutzon Borglum Collection. For much of my information about George Luks, I am grateful to Arthur Lewis, who has amassed a great deal of material toward a biography of the painter. In New York, Larry Campbell answered questions about the history of the Art Students League. And in Chicago, Patricia Scheidt, then its director, gave me a tour of the Arts Club of Chicago, whose archives I consulted at the Newberry Library. For information about the Harvard Society for Contemporary Art, with the help of Phoebe Peebles and Abigail Smith, archivists, I consulted the Harvard University Art Museum Archives.

The Archives of American Art, Smithsonian Institution, and Robert Brown of its New England Regional Center, were invaluable resources for information and material about Margarett Sargent and her artist contemporaries. Carol Pesner, director of the Kraushaar Gallery in New York, kindly perused its archives for me. In addition, I consulted the libraries of the Art Institute of Chicago; the Boston Museum of Fine Arts; the Metropolitan Museum of Art; the Museum of Modern Art; the National Museum of American Art, Smithsonian Institution; the Wadsworth Atheneum, Hartford; and the Whitney Museum, New York

City. And at the Harvard University Center for Italian Renaissance Studies at Villa I Tatti, in the Berenson Archive, I found the letters written to Bernard Berenson by Margarett Sargent McKean.

For periodicals, the New York Public Library (Astor, Tilden and Lenox Foundations) and the Library of Congress were extraordinary sources. I also consulted the Elmer Bobst Library of New York University, the Lamont and Widener libraries of Harvard University, and the Fine Arts Department of the Boston Public Library. In Litchfield County, Connecticut, the John Gray Park Library of Kent School, Kent, and the Edsel Ford Library of the Hotchkiss School, Lakeville, graciously made their resources available.

To all these institutions, which seem particularly precious now, I extend my heartfelt gratitude.

Notes

Chapter i

5. *great-great-grandmother:* Margarett's husband, my grandfather QASMcK, was the grandson of Pauline Agassiz Shaw, stepdaughter of Elizabeth Cary Agassiz (1822–1907), who founded the Harvard Annex, which became Radcliffe College in 1879.

6. *De Chirico: Horses in Moonlight,* purchased in New York from F. Valentine Dudensing, February 1, 1930.

8. *"pitch pine forest":* Quoted in "A Garden for the Public: H. H. Hunnewell's Rhododendron Show," *Horticulture,* July 1978, p. 53. In 1873, at his own expense, HHH temporarily transplanted most of his rhododendrons and many of his tropical plants to the Boston Common, which he then enclosed in a giant tent. His intention was to encourage cultivation of shrubs then unknown to the American public. Forty thousand Bostonians attended the show. With his friends Margarett's cousins Charles Sprague Sargent of the Arnold Arboretum and Henry Winthrop Sargent of Woodenethe, and Frederick Law Olmsted, designer of Central Park in New York, Hunnewell believed that the cultivation of the landscape contributed to the social good.

9. *"No Vanderbilt":* HHH, vol. I, p. 118.

10. *"fully 200 years old":* HHH, vol. III, p. 190.

11. *old as Methuselah:* To her sister, Jane Welles Hunnewell, November 28, 1838; *HHH,* vol. I, p. 43.

11. *"It was in Europe":* Henry Sargent Hunnewell, *Recollections* (Boston: Privately printed, 1930), n.p.

12. *"the beloved wife":* HHH, vol. II, p. 148.

12. *Beacon Street lot:* HHH's mansion, at 130 Beacon Street, now houses Emerson College.

12. *"The Hunnewells aren't":* This and all subsequent quotes from Margarett in this chapter, unless otherwise noted, are from interviews with DS held at South Natick, Mass., between 1980 and his death in 1988; all quotes from DS are also from these interviews.

13. *the Sargent genealogy:* Emma Worcester Sargent, with biographical notes by Charles Sprague Sargent, *Epes Sargent of Gloucester and His Descendants* (Boston and New York: Houghton Mifflin, 1923). Unless otherwise noted, all Sargent genealogical material comes from this volume.

13. *the "triangle trade":* Though I was told by the librarian at the Essex Institute in Salem, where I looked through registries of cargo shipped on Daniel Sargent's ships, that he was not known as a slaver, no records were kept of slave cargo because the slave trade (distinct from slavery itself) was illegal after 1808. If he was not a slaver, certainly his participation in the triangle trade implicated him in the enterprise, which made so many New England fortunes.

13. *"the finest head":* Emma Worcester Sargent, *Epes Sargent of Gloucester*, p. 161.

14. *put three sons:* The eldest, John Turner Sargent, emerged an abolitionist preacher, who, with his wife, Mary, founded the Radical Club of Chestnut Street, where Unitarians met with Spiritualists, Calvinists, and Quakers, and women like Lucretia Mott and Julia Ward Howe spoke on equal terms about abolition, suffrage, and temperance with men like William Ellery Channing, Henry James, Sr., John Greenleaf Whittier, and Thomas Wentworth Higginson. Christiana (Kitty) Sargent's youngest son, Howard, became a physician.

14. *"I am a gentleman":* DS, *Our Sargent Family* (Boston: Privately printed, 1992), p. I-6.

15. *"Thou art lost":* Henry Jackson Sargent, *Feathers from a Moulting Muse* (Boston: Crosby Nichols, 1854), p. 123.

15. *youngest clipper captain:* His letters are collected in *The Captain of the Phantom: The Story of Henry Jackson Sargent, Jr., 1834–1862 as Revealed in Family Letters* (Mystic, Conn.: Marine Historical Association, 1967).

15. *"General Custer's daughter":* My best efforts could not prove the existence of such a daughter or of any Custer children. This story and all quotes from Sargent family members come from DS interviews unless otherwise noted.

16. *"great news . . . the gentleman":* HHH, vol. II, p. 118.

18. *"When Baby was sick":* Boston Evening Transcript, August 31, 1892, p. 1.

18. *"Jenny Sargent":* HHH, vol. I, p. 173.

22. *"Only that I missed":* GHD, author interview, Brookline, Mass., September 1978. All subsequent GHD quotes from this interview, unless otherwise noted.

23. *"Sundays of course":* pastel, n.d. Unless otherwise noted, all MS works noted are in the collection of the author.

23. *"Between the dark":* Henry Wadsworth Longfellow, "The Children's Hour," The Library of America, *American Poetry: The Nineteenth Century*, vol. I: Freneau to Whitman, p. 409.

24. *"warm in his seaman's coat":* Henry Wadsworth Longfellow, "The Wreck of the Hesperus," ibid., pp. 373–75.

27. *"The assassination":* HHH, vol. II, p. 273.

27. *"January 1. 9 degrees":* Diary kept by MS, 1902. Diary entries quoted come from this volume, until otherwise noted. All MS diaries and scrapbooks referred to are, unless otherwise noted, in the collection of the author.

28. *Boston Herald report:* Quoted in DS, *Our Sargent Family*, chap. 2, pp. 18–19.

31. *"They say Buster":* MS diary, 1906. Entries quoted are from this diary, until otherwise noted.

32. *E. and O. Ames:* Elise and Olivia were daughters of Oliver Ames, heir to a farm implements company which had evolved into a manufacturer

of railroad hardware and a lucrative railroad holding company. The Ameses were more ostentatiously rich than the Hunnewells, but not as rich as the Searses, who were "swells," Dan said, meaning not that their house was bigger or their carriages were more opulent, but that they observed certain amenities, such as having butlers rather than maids to wait at table.

33. *Lily and Phyllis Sears:* Once, at Wareham, as Frank Sargent plunged off the pier, Lily Sears said, "I should think you'd be ashamed that your father goes swimming in a topless suit." "Well," Margarett replied, "I should think you'd be ashamed that your ancestors dug clams on Cape Cod," referring to the Searses' fishing origins but not repeating the story that the Searses were rumored to have first made money by selling horses to George Washington at exorbitant prices.

33. *"power of concentration":* This remark, as well as Margarett's grades, are recorded on her report cards, still in the archives of the Winsor School, Boston.

35. *"It was quite":* Jenny Sargent to Alice Russell, July 11, 1907. All family papers referred to are in the collection of the author, unless otherwise noted.

Chapter ii

39. *"during the day":* Annual Circular of Miss Porter's School, Farmington, Connecticut, 1910–1911. Courtesy Miss Porter's School.

39. *Noah Porter:* Sarah's brother Noah was a philosopher and president of Yale; an ancestor was a founder of the town of Farmington.

40. *"hardly less . . . she required":* William M. Sloane, "Sarah Porter: Her Unique Educational Work," *Century Magazine* LX, no. 41 (penciled date "1900") p. 346. Courtesy Miss Porter's School.

40. *"the fixed organization":* Ibid.

40. *"sailed imposingly":* Clover Todd (Mrs. Allen Dulles) in a reminiscence, typescript, p. 3. Courtesy Miss Porter's School.

40. *"Homesick if I stopped":* From a diary kept by MS at Miss Porter's School, 1908–1909. All quotes, all notes from others, all drawings referred to in this chapter, are from (or preserved with) this diary, unless otherwise noted.

41. *psychology text:* This detail from Fanny Perkins Cox, author interviews cited below.

42. *"I have absolutely":* MD, author interview, Dorset, Vt., January 9, 1979. All MD quotes from this interview, unless otherwise noted.

42. *Fanny Perkins:* Her brother Maxwell would become the famous editor. One of her sons, Archibald Cox, was the solicitor general of the United States fired by President Nixon in 1974 during the famous "Friday night massacre" of the Watergate scandals. All FPC quotes are from an author interview conducted in Windsor, Vt., January 8, 1979, and a telephone interview conducted November 1983.

43. *"the dump"*: Slang for the place set aside to wait for a partner's approach at a dance; also the place where wallflowers inevitably ended up.

46. *"close-fitting but inconspicuous"*: Quoted without attribution in Charlotte Streifer Rubenstein, *American Women Artists* (New York and Boston: Avon Books and G. K. Hall, 1982), p. 92.

46. *"Ingres-like"*: "On Our Street," *House Beautiful*, December 1933, p. 248A.

46. *Theodate Pope:* The design of Hill-Stead is often wrongly attributed to McKim, Mead and White, who provided practical assistance to the young architect. Pope (1867–1946) also designed Westover, Avon Old Farms, and Hop Brook Elementary schools, all in Connecticut.

47. *Cassatt pastel: In the Loge*, pastel and metallic paint on canvas, unsigned, now in the Philadelphia Museum of Art, gift of Margarett Sargent McKean.

47. *Rosamond Smith Bouve:* A member of the Boston Guild of Artists, the Connecticut Academy of Fine Arts, the National Association of Women Painters and Sculptors of New York, winner of a Bronze Medal at the Panama Pacific Exposition in San Francisco in 1915.

48. *"most sought after leading man"*: At Miss Porter's, plays were put on by the Players Club and the French and German departments. Briefly rehearsed pantomimes like *The Peterkin Papers* were performed on weekends, and, for graduation, the Players Club, the Mandolin Club (seven girls poised with stringed instruments), and the Glee Club produced a comedy by Shakespeare.

49. *"my attractive blond"*: MS to QASMcK, n.d.

49. *"the new member"*: A caption from the scrapbook MS kept in Florence. All quotes attributed to her in Florence are from this scrapbook, unless otherwise noted.

49. *three finishing schools:* In a 1980 interview in Florence, Evelyn Evers told me that Miss Penrose's, on the Piazza Donatello, was for English girls, and Eversholm, a school run by her mother, an English widow, was international.

50. *"the most banal things"*: DS, author interview.

50. *"not accessible to ladies"*: Karl Baedeker, *Italy: Handbook for Travellers, First Part: Northern Italy*, 12th Remodelled Edition (Leipsig [*sic*], London, New York, 1903), p. 528.

51. *"just looking"*: Lawrence Dame, "Mrs. McKean, Fabulous Resident of Beverly, Turns to Art Again," MS scrapbook clipping, *Boston Sunday Herald*, c.1948. Margarett kept intermittent scrapbooks, but she was not systematic. Often the clippings she preserved were not dated. Whenever possible, I've located the clipping in its original periodical. If unable to, I've simply labeled it as above and speculated a date.

51. *"sporting Italian"*: E. Ames Parker, telephone interview, January 1979. All EAP quotes from this interview, unless otherwise noted.

51. *"If I were fire":* Cecco Angiolieri in D. G. Rossetti, trans., *The Early Italian Poets from Ciullo D'Alcama to Dante Alighieri: 1100–1200–1300: In the Original Metres Together with Dante's Vita Nuova* (London: George Routledge & Sons; New York: E. P. Dutton, n.d.), p. 337.

52. *great group portrait:* John Singer Sargent, *The Daughters of Edward D. Boit,* 1883, Museum of Fine Arts, Boston.

52. *Edward Darley Boit:* By 1910, Boit had a reputation as a watercolorist. In 1912, he and Sargent exhibited their watercolors jointly at Knoedler's in New York, and the Boston Museum of Fine Arts bought out the exhibition. The story is that Sargent would allow the purchase of all his watercolors only if the museum bought all of Boit's as well.

52. *Guincelli:* In Rossetti, *The Early Italian Poets,* p. 19.

52. *Ambrogio de Predis:* The portrait was either of Beatrice d'Este, patron of Castiglione and subject of da Vinci, or of Bianca Sforza.

52. *"ugly duckling":* Kay Saltonstall Weld, author interview, September 1978.

53. *"gigantic robustness":* Bernard Berenson, *Italian Painters of the Renaissance* (London: Phaidon Press, 1956), p. 40.

53. *"the greatest master":* Ibid., p. 131.

53. *In 1898, Berenson:* See Ernest Samuels, *The Making of a Connoisseur* (Cambridge: Harvard University Press, 1979), p. 297.

53. *"Berenson gives it":* Two years later, Berenson, in a new edition of his "gospels," again attributed the painting to Leonardo, but with the assistance of Credi.

53. *"rouse the tactile sense":* Berenson, *Italian Painters,* p. 40.

55. *"There's Margarett Sargent!"* Marian Valliant, author interview, Washington, Conn., December 1984. All MV quotes from this interview.

56. *early in 1912:* MS diary, 1912. MS quotes in the balance of the chapter are from this diary, unless otherwise noted.

57. *"philanthropic employment bureau":* Elizabeth Gray, "Talk to Debutante Sewing Circle," handwritten notes c.1912, Papers of the Boston Junior League. Schlesinger Library, Radcliffe College, Carton #1 79–M9.

57. *New York in 1901:* The history of the Junior League is told in Janet Gordon and Diana Reische, *The Volunteer Powerhouse: The Junior League* (New York: Rutledge Press, 1982).

57. *"promiscuous giving":* Gray, "Talk."

57. *"most preeminently popular":* Town Topics, c.1912. MS scrapbook clipping.

57. *"the rising generation":* Boston Sunday Herald, January 14, 1912, p. 18.

58. *"frequently pounded the table":* Boston Herald, January 12, 1912, p. 1.

58. *"Miss Sargent":* Boston Traveler, January 12, 1912, p. 11.

59. *"Young ladies should":* Florence Howe Hall, *Social Customs* (Boston, 1911; original edition, 1887), p. 182.

59. *"peach colored satin"*: *Boston Herald*, January 13, 1912, p. 5. All descriptions of gowns quoted are from this article.

59. *"one of the veterans"*: Ibid., January 14, 1912, p. 19.

59. *"a tall, slender"*: Ibid.

60. *"She was good-looking"*: Hamilton Fish, Sr., author interview, New York, February 16, 1981. All HF quotes from this interview.

60. *"a red wagon"*: FB, author interviews, New York, April 1979, April 1986. All FB quotes from these interviews. Bebo (Frederick Josiah Bradlee) was the father of FB and of Benjamin Bradlee, executive editor of the *Washington Post*, 1968–1991, and of the late Constance Bradlee Devens.

60. *"Junius Morgan"*: J. P. Morgan's grandson.

60. *Hall Roosevelt:* Eleanor Roosevelt's younger brother.

61. *only distantly related:* Three Welsh Puritan brothers had come to America in 1630: Edwin Denison Morgan descended from the eldest, James; John Pierpont Morgan from Miles, the youngest.

61. *"But the Morgans had no swank"*: Eddie's father, Edwin Denison Morgan, called "Altie" (Harvard 1877), was heir to the fortune his grandfather, Civil War governor of New York and Lincoln confidant, had made in the boom the followed the opening of the Eric Canal. He was a serious yachtsman—his *Columbia* won the America's Cup—and, as an amateur engineer, made innovations in hull design that increased the speed of his boats. The dark side of his brilliance and his famous charm was a merciless vulnerability to alcohol, which he inherited from his father, who died young of drink, and passed on to Eddie, the elder of his two sons.

61. *He majored in Egyptology:* During the winter of 1910, Eddie's freshman year, an archaeological expedition sponsored jointly by Harvard and the Boston Museum of Fine Arts unearthed, at Giza, the slate sculptures of Mycerinus and his queen, now in the museum.

63. *"It was my first kiss"*: JMcKM, unpublished memoir.

64. *"If only you could have seen"*: EDM to MS, n.d.

65. *"Don't you think"*: DS interviews.

65. *Frog Fountain:* "I want you to have another made in marble for Jim Breese's Long Island garden," was how Janet Scudder reported Stanford White's 1906 commission in her autobiography. Janet Scudder, *Modeling My Life* (New York: Harcourt Brace, 1925), pp. 196–97.

67. *"famously beautiful"*: EDM, Jr., (EDM's son), author interview, New York, April 28, 1986.

67. *"Everybody's Doin' It"*: The story of the impact of ragtime is admirably told in Lawrence Bergreen, *As Thousands Cheered: The Life of Irving Berlin* (New York: Viking, 1990), chaps. 4, 5.

67. *"so very attractive"*: Katherine Morgan Evarts (EDM's sister), author interview, April 29, 1986, Kent, Conn.

68. *One hundred horses:* At Wheatly, he kept a hundred ponies and, with Thomas J. Hitchcock, Elliot Roosevelt, and Winthrop Rutherford (who would later marry FDR's mistress, Lucy Mercer), formed the first American team to compete in the International Polo League.

68. *"I'm going to Italy to sculpt":* MW, author interview. All MW quotes from interviews held between October 1979 and June 1989 on the telephone and in Newport, R.I.

68. *"no small talk":* Theo (Mrs. Charles) Codman told EDM, Jr., that Margarett had told her she couldn't marry a man with no small talk.

68. *"Eddie took to drink":* The Sargent family stories are from DS; the Morgan ones from Katharine Morgan Evarts.

69. *"Oh clay":* Diary of Adelia Moore, after visiting her grandmother, c.1973. Courtesy AM.

69. *"She didn't explain":* JMcKM, unpublished memoir.

Chapter iii

73. *"It will be remembered":* Town Topics, c.1913. MS scrapbook clipping.

73. *"experience underground":* QASMcK, Harvard College, Class of 1913, Secretary's Third Report, June 1920, p. 206.

74. *Jean-François Millet:* Quincy Shaw met Millet through the Boston painter William Morris Hunt. When his widow, Pauline, died, in 1917, her children gave most of the collection, which includes the famous painting *The Sower*, to the Museum of Fine Arts.

74. *"a party of Boston men":* Louise Hall Tharp, *Adventurous Alliance: The Story of the Agassiz Family of Boston* (Boston: Little Brown, 1959), p. 199. Horatio Hollis Hunnewell accepted stock in the new mines as payment of a debt owed him by Quincy Shaw, and Major Henry Lee Higginson, married to Ida, Pauline Agassiz's sister, invested, putting his trust in "Quin and Alex . . . with their ability, honesty, industry, nerve and power."—Russell B. Adams, Jr., *The Boston Money Tree* (New York, 1977), p. 164. No one could have predicted that by the 1870s, the Calumet-Hecla Mining Company would produce half the copper in the United States and that by 1898, an investor who purchased 100 shares at $30 each in 1868 would own 250 shares worth $530 each, his original investment having also earned dividends of $131,250. During his lifetime, Alexander Agassiz made gifts of more than $1 million to the Harvard Museum of Comparative Zoology, and in 1908, Quincy Shaw died New England's largest individual taxpayer.

75. *"The Grand Canyon":* QASMcK to MS, March 10, 1914.

75. *"I'm trying to become an outdoor girl":* MS postcard to her brother Harry, c.1914.

75. *"It was my accident":* EDM to MS, September 8, 1914.

75. *"At the time I got your letter"*: Ibid.
76. *"I know you love me"*: QASMcK to MS, March 10, 1914.
76. *"I'd like a shot"*: Story from DS.
77. *"the emancipated females"*: William Wetmore Story to James Russell Lowell, 1852, quoted in Henry James, *William Wetmore Story and His Friends* (Boston: Houghton Mifflin, 1903; New York: Grove Press, 1957), p. 257.
77. *"that strange sisterhood"*: Ibid.
77. *"Hatty takes a high hand"*: Ibid.
78. *"eternal feud"*: Harriet Hosmer, quoted in Rubinstein, *American Women Artists,* p. 79; from Cornelia Crow Carr, *Harriet Hosmer: Letters and Memories* (New York: Moffat Yard, 1912), p. 35.
78. *"I honor all those"*: Harriet Hosmer, quoted in Rubinstein, p. 79; from Phebe Hanaford, *Daughters of America* (no publisher cited) pp. 321–22.
78. *"white rabbits"*: Janet Scudder, *Modeling My Life,* p. 58.
78. *"I won't add"*: Ibid., p. 155.
78. *"If we men"*: Quoted in Janis C. Conner, "American Women Sculptors Break the Mold," *Art and Antiques,* May–June 1980, p. 81, from William Walton, "Some Contemporary Young Women Sculptors," *Scribner's Magazine* 47 (May 1910).
79. *"the study of melancholy"*: "$100,000 if Edith Deacon Weds," *Boston American,* July 1912, Boston Museum of Fine Arts School Scrapbooks, vol. V., p. 80.
79. *"occupied . . . passionate application"*: MS to her son SMcK, 1966.
80. *"their crowded little flat"*: " 'L' Ticket Seller Is Wonderful Sculptress," *Boston Journal,* July 6, 1914; MFA School Scrapbooks, vol. VII, p. 106. Courtesy Kathryn Greenthal.
80. *"the figure of a crouching"*: Jessie E. Henderson, "A Girl Sculptor Who Models in a Subway Ticket Booth,"*American Magazine,* June 1914; MFA School Scrapbooks, vol. VI, p. 109. Courtesy Kathryn Greenthal.
80. *"one of the ambitions"*: "Relief Portrait of Jane Addams," unidentified clipping, ibid., vol. VIII, p. 19. Courtesy Kathryn Greenthal.
80. *bohemian glamour*: William Koshland tells a story of Bashka Paeff visiting his family's house in Boston; it is his description that informs mine.
81. *"It was strange"*: All Sargent Cheever quotes from author interview, Wellesley, Mass., November 16, 1981.
81. *"My freedom"*: DS, "Freedom," *Our Gleaming Days* (Boston: Richard G. Badger, 1915), p. 29.
81. *"But tonight"*: "Rain—October 1914," ibid., p. 57.
82. *"a keepsake"*: "Miss Margarett Sargent Moulds Bust of Brother," c.1915. MS scrapbook clipping.
82. *"a frail swift passenger steamer"*: DS, *Our Sargent Family,* chap. 2, p. 15.
82. *"struck a rock"*: Ibid., p. 14.

82. *"The Sussex had been cut"*: "Fifty Lives Lost in U-Boat Attack on the Sussex," *New York Times*, March 26, 1916, p. 3.

82. *"had not received any word"*: "New Yorkers on Sussex," Ibid.

83. *"It was broad daylight"*: DS, *Our Sargent Family*, chap. 2., p. 15.

83. *"quaint little"*: "Dinner and Dance Precede Weddings of Miss Breese and Miss Claflin," *New York Herald*, October 10, 1915. MS scrapbook clipping.

84. *"Miss Margaret Sargent"*: *Town Topics*, October 21, 1915, p. 5.

84. *"Finding a Venus"*: Arnold Genthe, *As I Remember* (New York: Arno Press, 1979), p. 163.

84. *"Rossetti Mouth"*: ibid. p. 169.

84. *"unconscionable old goat"*: Interview with Dorothea Lange, n.d., original transcript in the Bancroft Library, UC Berkeley. Courtesy Toby Quitslund.

85. *"Thanks for your letter"*: JS to MS, n.d.

85. *"merely a metropolis"*: Herbert D. Croly, "New York as the American Metropolis," *Architectural Record* XIII (March 1903), pp. 193–206; quoted in Trevor Fairbrother (with contributions by Theodore Stebbins, Jr., William L. Vance, Erica E. Hirshler), *The Bostonians: Painters of an Elegant Age, 1879–1930*, exhibition catalogue (Boston: Museum of Fine Arts, 1986), p. 64.

85. *"army of professionial artists"*: William Howe Downes, "Boston as an Art Centre," *New England Magazine* XXX (March–April 1904), pp. 155–66. Quoted in ibid.

86. *In the Orchard*: Oil on canvas; Daniel J. Terra Collection, Chicago.

86. *"Exhibition of Post-Impressionists"*: Headlines, *Boston Herald*, April 28, 1913, p. 1.

86. *"a lady, quite bare"*: Philip Leslie Hale, quoted in Nancy Hale, *The Life in the Studio* (New York: Avon, 1980), p. 138.

86. *"the near-Vermeer"*: *American Art News*, December 12, 1916, p. 3.

87. *The Breakfast Room*: Oil on canvas; collection The Pennsylvania Academy.

87. *Mrs. C:* The disjunction between the actual lives of Boston School models and how they were depicted is studied in Bernice Kramer Leader, *The Boston Lady as a Work of Art: Paintings by the Boston School at the Turn of the Century* (Ph.D. diss., Columbia University, 1980).

87. *"a boor"*: Ibid., p. 26.

87. *Gertrude Fiske*: Portrait of Margarett Sargent, oil on canvas, private collection.

87. *"the march of Art Amazons"*: "John Doe," *American Art News*, January 23, 1915, p. 3.

88. *"painting & drawing"*: In Charles Woodbury scrapbook, shown to me by India Woodbury, daughter-in-law of the artist, Ogunquit, Maine, August 1984.

88. *"a highclass resort":* Brochure, "An Attractive Resort on the Coast of Maine" (1920); collection York Historical Society, York, Maine.

88. *"fanatically adoring disciples":* R. H. Ives Gammell *The Boston Painters, 1900–1930* (Orleans, Mass.: Parnassus Imprints, 1986), p. 138.

88. *"virginal wayfarers":* Author interviews with Louise Tragard, Ogunquit, July 1984, July 1985.

88. *John Singer Sargent's 1921 portrait:* Collection, National Portrait Gallery, Washington, D.C.

89. *Robert Laurent:* Laurent was a boy when Field met him in Brittany and undertook his education. Laurent was one of those responsible for introducing to American sculpture the technique of direct carving, which challenged the then accepted practice of modeling and casting. Together, Field and Laurent exhibited in New York, and in Ogunquit, one taught painting and the other sculpture. They lived with Laurent's family in a big house on an island at the end of Perkins Cove.

90. *"Good-lookin'":* Phyllis Ramsdell Eaton, author interview, Ogunquit, Maine, July 1985. All PRE quotes from this interview.

90. *"for the open discussion":* Pamphlets, "Thurnscoe Forum, Ogunquit, Maine: Meetings Held Thursday Evenings for the Open Discussion of Art, Music, Literature and Kindred Subjects: Season of 1918." Original, collection George Karfiol. Courtesy Louise Tragard.

90. *"the generator":* *Interior* (Chicago), review of *Mr. Bonaparte of Corsica,* by John Kendrick Bangs, quoted in advertisement on back of Bangs, *A House-Boat on the Styx* (New York: Harper & Brothers, 1895).

90. *"rich and expensive":* Pamphlet, "Two Weeks in Ogunquit-by-the-Sea," York Historical Society, York, Maine.

91. *"Pine Hill Girls":* See Tragard et al., *A Century of Color* (Ogunquit: Barn Gallery Associates, 1987), p. 17.

91. *"divergence of opinion":* Charles Woodbury, Lectures of July 8, 1916–August 12, 1916; on microfilm, Woodbury Collection, Archives of American Art, roll 1255, frame 482. Courtesy Louise Tragard.

91. *"a dreadful picture":* To Daniel Sargent, among others.

91. *"throw away all tradition":* Woodbury Collection, roll 1255, frame 490, Courtesy Louise Tragard.

91. *"I will say then":* Ibid., frame 482.

92. *"You will always":* Ibid., frame 508.

92. *"I am trying":* Ibid., frame 657.

92. *four works by Charles Woodbury:* Inventory of the collection of Margarett Sargent McKean, 1966; Collection of author. Works themselves were probably destroyed by fire.

93. *"Lily, red wool":* Archibald MacLeish, *Tower of Ivory* (New Haven: Yale University Press, 1917), p. 57.

93. *"kicked her legs"*: MS's Farmington diary, final entry, n.d.

93. *"fascinated"*: Francis Hyde Bangs, Archibald MacLeish, *Letters and Verses of Archibald MacLeish, 1914–1924, together with poems sent to Francis Hyde Bangs from 1914 to 1924, together with ms. and typewritten notes of explanation by Mr. F. H. Bangs.* Unpaged. Archibald MacLeish Collection, The Yale Collection of American Literature, Beinecke Rare Book and Manuscript Library, Yale University. Hereafter referred to as Bangs material.

93. *"O my brazen prophet"*: Bangs material.

94. *"I can't see"*: Grace Allen Peabody to MS. All GAP quotes from this letter, unless otherwise noted.

95. *"what he deemed"*: Bangs material.

95. *"One doesn't tell"*: Ibid.

95. *"She is all"*: Ibid.

95. *"Lo, the lady"*: Archibald MacLeish, *Letters of Archibald MacLeish 1907–1982*, ed. R. H. Winnick (Boston: Houghton Mifflin, 1983), p. 36. The poem in a slightly different version appears as "The 'Chantress" in MacLeish's first collection, *Tower of Ivory*, p. 50.

96. *"never would have known"*: Bangs material.

96. *"Did he fear"*: Ibid.

96. *"a considerable stimulus"*: Ibid.

96. *"like silver . . . has dreamed"*: *Tower of Ivory*, pp. 15–16.

96. *"she sat, self-mimicking"*: "A Portrait," ibid., p. 36. Years before, when MacLeish sent it to Bangs, he titled it "The Showman: A Portrait of Margarett Sargent." Bangs material.

96. *"Sargent, that Archibald should"*: Bangs material.

97. *"To wind her tresses"*: Ibid.

97. *"the great Nun"*: Ibid.

97. *"She does indeed"*: Ibid.

97. *"Like moon-dark"*: "Soul-Sight," *Tower of Ivory*, p. 60.

Chapter iv

101. *"War has begun"*: *Boston Evening Transcript*, April 6, 1917, p. 1.

101. *"most beautiful girl"*: Sargent Cheever, author interview, Wellesley, November 16, 1981.

102. *"I've never lost faith"*: Francis Williams Sargent to Jane Sargent Cheever, c.1917. Courtesy Russell Lyman.

102. *"I hate to think"*: FWS, Sr., to MS, July 1, 1918.

102. *"The Cheever Boys"*: Bronze, in the collection of Sargent Cheever.

103. *"It's all there"*: Lloyd D. Lewis, "Sculpture Exhibit Is Remarkable," *Chicago Herald*, November 3, 1916. Art Institute of Chicago scrapbook.

104. *"personal note":* Quoted in Milton Brown, *The Story of the Armory Show* (New York: Joseph H. Hirshhorn Foundation, 1963), p. 78.

104. *"we wish Mr. Borglum":* Ibid., p. 83.

105. *The Craftsman:* Gutzon Borglum, "Individuality, Sincerity and Reverence in American Art," *The Craftsman* XV, no. 1 (October 1908), pp. 3–5.

105. *"no such institution":* " 'What I Would Do with $10,000,000' by Gutzon Borglum, Sculptor," clipping from *The World Magazine*, March 29, 1914. Borglum Collection, Manuscript Division, Library of Congress, Washington, D.C.

105. *"the search for country homes":* "A Greater Stamford," newspaper clipping, source unknown. Borglum Collection, Library of Congress.

105. *"My name is":* MD, author interview.

105. *"Oh no":* Edward F. Bigelow, "Beauty in the Life of a Portrayer of Beauty," *The Guide to Nature: Education and Recreation*, IV, no. 5 (September 1911). All remarks of Borglum quoted about Borgland/Nature are from this article. Borglum Collection, Library of Congress.

105. *"most sacred recess":* Untitled typescript, p. 1. Borglum Collection, Library of Congress.

106. *"Through the neck":* Drawing in MS papers.

106. *"You can see it":* William Coles, author interview, Boston, October 9, 1986.

107. *"Those three years":* Dame, "Mrs. McKean . . ." clipping.

108. *"new art realism":* New York American, February 4, 1908. MS scrapbook clipping.

108. *"pink and white painters":* Quoted in Bernard B. Perlman, *The Immortal Eight* (Westport, Conn.: North Light, 1979), p. 175.

108. *"the dangerous habit":* Margarett Sargent McKean, "George Luks," printed sheet for Luks retrospective, June 1966, Joan Peterson Gallery, Boston.

109. *"any odd kitchen implement":* Ibid.

109. *"to protect me":* Ibid.

109. *"robbed by the Huns":* MS scrapbook clipping.

110. *"independent—free life":* QASMcK to MS, August 14, 1916.

112. *"unusually light-blue":* Bangs material.

112. *"My memories":* A. MacLeish, letter to author, October 28, 1981.

112. *"the Sargent gift":* FB, author interview.

113. *"just as the canoe":* These letters turned up in MS's effects.

113. *"She had such magnetism":* BPP, author interviews, May 1979–August 1980, New York City and Southold, N.Y. All BPP quotes from these interviews, unless otherwise noted.

113. *"mentally I feel":* MS to Gutzon Borglum, n.d., Borglum Collection, Library of Congress.

113. *"pay for a car"*: Dame, "Mrs. McKean . . ."

114. *Margarett may have seen Brice:* Fanny Brice material from Barbara Grossman's excellent *Funny Woman: The Life and Times of Fanny Brice* (Bloomington and Indianapolis: Indiana University Press, 1991); Norman Katkov, *The Fabulous Fanny: The Story of Fanny Brice* (New York: Alfred A. Knopf, 1953), and a telephone interview with Brice's son, William Brice, February 27, 1988.

114. *near-underworld cronies:* Author interview with Francine Julian Clark, daughter of Frank Biscardi, Sr.

117. *"I am glad"*: FWS to MS, July 21, 1918.

117. *"Get* Town and Country": George Luks note to MS, n.d.

117. *"Miss Sargent"*: Frederick James Gregg, "Miss Sargent Models George B. Luks; Ingres at Best in Leblanc Portrait," *New York Herald,* June 29, 1919. MS scrapbook clipping.

118. *"The eye was made"*: Benjamin deCasseres, "The Fantastic George Luks," *New York Herald Tribune,* September 10, 1933, p. 11.

118. *"I had the good fortune"*: McKean, "George Luks."

118. *"Don't tell me"*: Alexander Z. Kruse, "Luks Still Lives in His Work, Wit and Wisdom," *Greenwich Villager,* February 1934, p. 12.

118. *"Gutzon Borglum critiquing"*: Such a drawing, included in an inventory of Margarett Sargent McKean's collection made in 1966, is now apparently lost.

119. *"I should have been shocked"*: Author interview with MW.

119. *"To hell with"*: Quoted in Dame, "Mrs. McKean . . ."

119. *"Spontaneity and freedom"*: McKean, "George Luks."

119. *"Art!—my slats"*: Quoted by MS, from Van Wyck Brooks, *John Sloan: A Painter's Life* (New York: Dutton, 1955) pp. 44–45.

119. *"the paint before it"*: John Sloan, in preface to catalogue for George Luks memorial exhibition at Newark Museum, October 30, 1933–January 6, 1934, p. 12.

120. *"If a man"*: Quoted in Perlman, *The Immortal Eight,* p. 151. Gwendolyn Owens, formerly of the Prendergast Project, and Nancy Mowll Matthews, Prendergast Curator, both at the Williams College Museum of Art, provided information about Prendergast and women artists, and the provenance of Prendergast works in Margarett Sargent's collection. According to Matthews, the artist rarely sold single female figure studies but often gave them away to visitors. See also Nancy Mowll Matthews, *Maurice Prendergast* (Williamstown and Munich: Williams College Museum of Art and Presel, 1990).

120. *"having bought more pictures"*: McKean, "George Luks."

121. *"We've come together"*: Quoted in Perlman, *The Immortal Eight,* p. 154.

122. *"Vulgarity smites"*: Quoted in *George Luks: An American Artist,* es-

says by Stanley L. Cuba, Nina Kasanof, and Judith O'Toole (Wilkes-Barre, Pa.: Sordoni Art Gallery, 1987), p. 28.

124. *"passes a visit"*: DS to MS, April 14, 1918.

124. *"a memorable dent"*: DS to FWS, Jr. May 1918. Courtesy Susan Sargent Cooper.

124. *"a whale of a job"*: QASMcK to MS, August 15, 1918.

124. *"You needn't worry"*: Henry Jackson (Harry) Sargent to FWS, Sr., October 28, 1918. Courtesy Susan Sargent Cooper.

125. *"sensational advance"*: Edwin L. James, "Pershing's Drive Goes On," *New York Times*, November 4, 1918, p. 1.

125. *"told to apply"*: *New York Times*, headline, November 6, 1918, p. 1.

125. *"After this armistice"*: Harry Sargent to MS, December 1, 1918.

125. *"several thousand . . . down east"*: DS to MS, November 13, 1918.

125. *"so nearly"*: MS to BP, April 23, 1947.

126. *"I always understood"*: Russell Lyman, author interview, Needham, Mass., November 1986. All RL quotes from this interview.

126. *"We must cut him down"*: DS, author interview.

126. *"She worshiped him"*: MV, author interviews, Hamilton, Mass., September 1978–June 1992. All MV quotations from these interviews.

Chapter v

129. *"Oh, Marjorie . . . married"*: This story from MD.

129. *"Why, you serpent!"*: This story from EDM, Jr., told him repeatedly by his father.

129. *"Can I do"*: MS to Jenny Sargent, n.d.

130. *"Modernists"*: This information from *American Art News*, January–May 1919.

130. *"You will notice"*: George Luks on drawing by MS.

131. *"I know it will seem"*: Letter to author from Governor Francis Sargent, FWS Jr.'s son, June 3, 1988.

131. *"When did you"*: MS scrapbook clipping.

132. *"Instead of passing"*: "John Barleycorn Died Peacefully at the Toll of 12," *New York Times*, January, 17, 1920, p. 1.

132. *"Please come pick me up"*: DS, author interview.

132. *"Francis Williams Sargent"*: *Boston Evening Transcript*, January 19, 1920. Clipping from Harvard College Archives.

133. *"To have the children"*: JS to Louise Coolidge, n.d. Courtesy Susan Sargent Cooper.

133. *"naturalistic view"*: DS, Harvard College, Class of 1913, 25th Anniversary Report, 1938, p. 736.

134. *"I cannot wait"*: JS to Louise Coolidge, n.d. Courtesy Susan Sargent Cooper.

134. *"Sails Steerage"*: Undated, unattributed clipping. Courtesy Susan Sargent Cooper.

134. *"a girl"*: Katharine Winthrop McKean (the second Mrs. QASMcK), author interview, Hamilton, Mass., August 1986.

135. *"simply a mass"*: QASMcK to MS, August 15, 1918.

135. *"I guess I will"*: Author interviews with DS, Katharine Winthrop McKean, MV.

135. *"known internationally"*: "Name Master Mind in Great Bond Plot," *New York Times*, February 1, 1920, p. 1.

135. *"500 Banks Watch"*: *New York Times*, February 22, 1920, p. 1.

136. *"Boston Symphony"*: Marian's aunt Ida Agassiz Higginson was married to its founding benefactor, the financier Henry Lee Higginson.

136. *"woman suffrage"*: In 1882, Mrs. Charles Dudley Homans, Mrs. Randolph Coolidge, and Mrs. R. C. Winthrop founded the Boston Committee of Remonstrants and with it the American antisuffrage movement. When Margarett's suffragist aunt Isabella, Jenny Sargent's sister, encountered Dan at Tremont Temple and asked his opinion of the evening's lecturer, Sylvia Pankhurst, he answered, to his aunt's chagrin, "I think she's pretty good looking!" Margaret, at nineteen, was amused at the combination when a 1912 dinner conversation took up "Guinea pigs and votes for women" and, when her sister had a son, rejoiced, "I am not patriotic for my race."

137. *"who were at the time"*: QASMcK, Harvard College, Class of 1913, 25th Anniversary Report, 1938, p. 567.

137. *"Goodness!"*: Katharine Peabody Loring's remark is quoted in Joseph E. Garland, *Boston's Gold Coast: The North Shore 1890–1929* (Boston: Little, Brown, 1981), p. 124.

139. *"the biggest kind of a surprise"*: *Town Topics*, August 5, 1920, p. 6.

139. *"Leaving for Kings Chapel"*: MD, author interview.

140. *"You think"*: Identical stories of Margarett's account of the wedding trip were told me by MW, Stephen Vernon (November 1989), and BW (March 1982).

140. *"What's the definition"*: BW, author interview, Newport, R.I., March 20–21, 1982.

141. *Agassiz Hotel:* An apartment house built in 1872 by Shaw's great-uncle Henry Lee Higginson, one of three such buildings in the Back Bay, which accommodated the "newly wed and the nearly dead" (a phrase quoted without attribution in Douglass Shand Tucci, *Built in Boston: City and Suburb* [Boston: New York Graphic Society, 1978], p. 101). The address was 191 Commonwealth Avenue.

141. *"They were spellbinding"*: HMcK, author interviews, Manchester,

Mass., August and November 1980. All HMcK quotes from these interviews, unless otherwise noted.

142. *"Drop dead"*: Mrs. Winston (C.Z.) Guest, author interview, Old Westbury, N.Y., November 1989. All CZG quotes from this interview.

143. *"She thinks like a man"*: Quoted in an interview with Phyllis Leland, daughter-in-law of Joseph Leland, Beverly, Mass., October 1986.

143. *"She had the fattest lines"*: *Variety*, June 24, 1921, p. 17. Quoted in Grossman, *Funny Woman*, p. 123.

145. *"How could that awful woman"*: Quoted by Walter Vanderburgh in an unpublished typescript about George Luks. Courtesy Arthur Lewis.

145. *"I have lived"*: Quoted by Harley Perkins in *Boston Evening Transcript*, August 11, 1923, p. 6.

146. *"Sorry I'm late"*: This story from DS.

146. *"The work wreaks"*: *Boston Evening Transcript*, n.d., MS scrapbook clipping. *The Wrestlers* was exhibited at the Boston Art Club in January 1923.

146. *"in her artistic efforts"*: *Boston Evening Transcript*, August 11, 1923, p. 6.

148. *"engaged in what might"*: QASMcK, Harvard College, Class of 1913, 25th Anniversary Report, p. 567.

148. *"a Boston arrogance"*: JMcKM, unpublished memoir, 1973.

149. *"a born loser"*: SMcK, author interview, Rumson, N.J., April 1987. All SMcK quotes from this interview.

149. *"At times she drank"*: John Spanbauer, author interview, Brighton, Mass., June 1991. All JS quotes from this interview.

149. *"feeling deathly"*: MS diary, January 5, 1912.

151. *"May God bless"*: George Luks to MS, n.d.

151. *"I don't remember"*: Quoted by JMcKM in conversation, c.1972.

152. *"claimed the Greeks"*: Harley Perkins, *Boston Evening Transcript*, n.d. MS scrapbook clipping.

152. *"To a remarkable degree"*: Ibid.

152. *"Art World Amazed"*: *The Art News*, January 2, 1926, p. 1.

153. *"artistic anarchists"*: Kenyon Cox, "The 'Modern' Spirit in Art: Some Reflections Inspired by the Recent International Exhibition," *Harper's Weekly*, March 15, 1913, p. 57.

154. *"the fascinating Mrs. Q. A. Shaw McKean"*: *Town Topics*, 1926, n.d. MS scrapbook clipping.

154. *"She had a lot"*: Antoinette Kraushaar, author interview, New York, June 1979. All AK quotes from this interview.

154. *"an innovation"*: Henry McBride, *New York Sun*, March 6, 1926, n.p. MS scrapbook clipping.

154. *"amazing talent"*: *The Art News*, March 6, 1926, p. 7. MS scrapbook clipping.

154. *"the glamor"*: *New York Herald Tribune*, March 7, 1926, n.p. MS scrapbook clipping.

154. *Helen Appleton Read:* "Boston Woman Shows Notable Work at Kraushaar Galleries," *Brooklyn Eagle*, March 7, 1926, n.p. MS scrapbook clipping.

155. *"that rare apparition"*: "Kraushaar's New Find," *New York American*, March 14, 1926. n.p. MS scrapbook clipping.

Chapter vi

160. *"they could run very fast"*: Jenny McKean Moore, unpublished memoir, 1973.

161. *"took to affairs"*: EL, author interview, Beverly, Mass., November 1980. All EL quotes from this interview.

161. *"made me careless"*: quoted by MV.

161. *"I've been seeing"*: MD, author interview.

162. *"Though slight"*: Forbes Watson, *New York World*, April 3, 1927. MS scrapbook clipping.

162. *three new plaster panels:* These were more engaging than those of 1926: *Nude* seemed almost a pastiche of the idea of a rhythmic study, a reclining nude with a fan of nude figures in the background, prescient of Busby Berkeley; the faces of the five subjects of *Heads*, a horizontal overmantel, "expressed character rather than mere mood," according to Helen Appleton Read, who also speculated in her review that Margarett was probably "the sole exponent of the decorative possibilities of colored bas relief in this country" and noted in the new work "a more profound sense of form which adds to the richness and variety of surface." *Brooklyn Eagle*, April 3, 1927. MS scrapbook clipping.

163. *"new-found vivacity"*: Helen Appleton Read, *Brooklyn Eagle*, February 12, 1928. MS scrapbook clipping.

163. *"free expression and simplicity"*: Henry McBride, *New York Sun*, February 11, 1928, p. 10.

163. *"It is here that a Bostonian"*: Harley Perkins, *Boston Evening Transcript*, December 10, 1927, p. 10.

163. *insurgent painters:* A painter himself, Harley Perkins was a member of the Whitney Studio Club in New York and of a group of artists called the Boston Five, who showed together and fought to open venues in Boston for progressive art. Margarett's connection to the Five was through Perkins and Marian Monks Chase, a watercolorist who showed at Montross in New York.

163. *"Modernists respect"*: Katharine K. Crosby, "Paintings by Margaret [*sic*] Sargent, Boston Artist, to Be Shown in New York Soon—Canvases Pos-

sess Modern Spirit, Design and the Influence of Sculptural Knowledge," *Boston Evening Transcript*, December 29, 1928, n.p. MS scrapbook clipping.

163. *"We must be called something":* Florence Cowles, "Mrs. Quincy A. Shaw McKean's Beverly Home Growth from 280-Year-Old House of the King's Tax Collector," *Boston Sunday Post*, August 10, 1930, n.p. MS scrapbook clipping.

164. *Head of the Artist's First Wife:* The painting, now known as *Woman Wearing a Necklace of Gems*, Paris, 1901, is in the Ayala and Sam Zacks Collection, Toronto, Zervos, VI, 85. I have never seen the Derain and have been unable to locate the Vlaminck, of which I have seen a black and white photograph.

164. *"for the McKean collection":* MS scrapbook clipping with illustration is unattributed. Another clip, from *The Art Digest* (Mid-February 1928, p. 10), reported that the *Transcript* had noted the Picasso purchase by "Mrs. Q. A. Shaw McKean, a new name among collectors. She has a flair for Modernism, and the *Transcript* says she recently purchased a fine Derain head and Vlaminck landscape."

164. *"In a long essay":* Harley Perkins, *Boston Evening Transcript*, December 9, 1925, p. 12.

164. *acceptance in Boston:* The renaissance would be short-lived; by 1930, the Boston Art Club was back in the grip of conservatives.

165. *"made gloriously beautiful":* Frederic Clay Bartlett, *Sortova Kindofa Journey of My Own* (Privately printed, 1965), p. 10.

165. *"which someday":* Quoted in Courtney Graham Donnell, "Frederic Clay and Helen Birch Bartlett: The Collectors," *Museum Studies* 12, no. 2, 1986, The Art Institute of Chicago, p. 92.

165. *"Americans who wish":* Ibid., p. 94.

166. *Bostonians had to wait:* Isabella Gardner had been given a rather restrained Matisse, which hung at Fenway Court, but John Walker, later director of the National Gallery, told me in an interview (Fishers Island, N.Y., 1990) that when he came to Harvard as a freshman in 1926, "There was nowhere in Boston to see a Picasso!" Robert Treat Paine II and John T. Spaulding bought Post-Impressionists, but their collections did not come to the Museum of Fine Arts until after 1935.

166. *"a tight lid . . . in ambush":* Harley Perkins, "Boston Notes," *The Arts* IX (April 1926), p. 211.

166. *"reactionary toward no":* Catalogue of First Annual Exhibition of the Boston Society of Independent Artists, Inc., Jan. 15–Feb. 16, 1927." Quoted in Jane Bock, "The Boston Society of Independent Artists," manuscript, April 20, 1978 (which also provided a good chronology), p. 2. Courtesy Walter Kilham.

166. *"one of the most striking":* Harley Perkins, *Boston Evening Transcript*, January 15, 1927, p. 10.

166. *"tea room and eating place"*: Ibid.

167. *"robust vitality . . . percentage"*: Ibid.

168. *"Surrealiste"*: Roland Balay, author interviews, New York, February, April, May 1981. All RB quotes from these interviews, unless otherwise noted.

169. *"George Luks met me"*: MS to Adelia Moore, May 2, 1971, recorded in her unpublished journal. Courtesy AM.

169. *"Your photograph"*: MS to the author, July 24, 1971.

169. *"Velázquez, he was"*: McKean, "George Luks."

172. *her 1960 autobiography:* Mercedes deAcosta, *Here Lies the Heart* (New York: Arno Press, 1975). See also Barry Paris, *Garbo* (New York: Alfred A. Knopf, 1995) pp. 257–259.

172. *"A Boston marriage"*: Daisy Oakley, author interview, Bedford, Mass., November 1990.

172. *"Oh, I'm sure"*: Alida Lessard, author interview, September 1994.

173. *"bisexual glasses"*: Quoted by Williams Alfred, author interview, Cambridge, Mass., March 1988. All WA quotes from this interview.

174. *"Everyone knew it"*: Nancy Cochrane Palmer, author interview, Hamilton, Mass., June 1990. All NCP quotes from this interview.

174. *"I loved Miss Sears"*: Author conversation with Right Reverend Paul Moore, 1980.

174. *"sporting . . . the crash"*: *Sunday News*, August 27, 1933, p. 10. MS scrapbook clipping.

176. *"Miss Sargent seems"*: Henry McBride, *New York Sun*, January 17, 1929, n.p. MS scrapbook clipping.

176. *"a more fiery Pegasus"*: *American Art News*, January 12, 1929, p. 7.

176. *"Her subjects"*: Forbes Watson, *New York World*, January 13, 1929, n.p. MS scrapbook clipping.

176. *"Unfortunately"*: "New Oils by Margaret [*sic*] Sargent," *Vanity Fair*, February 1929, p. 111.

177. *Les Arts à Paris:* Jacques Villeneuve, January 1929, p. 2 (translation by the author). In 1928 in Paris, Margarett took Betty Parsons to lunch at Paul Guillaume's, and he made cubist drawings of both women. Also at the table that day were his famously beautiful young wife, Dr. Albert Barnes, and Frederic Bartlett, who frequently escorted Margarett in Paris. Before the war, the poet Guillaume Apollinaire had introduced Paul Guillaume to the painters of Montparnasse. Guillaume became Modigliani's first dealer and the first dealer in Paris to organize a commercial exhibition of African art. Early in his acquisitions career, Dr. Barnes chose him as his representative, and by the end of the twenties, Guillaume was the most important advocate of Montparnasse on the Right Bank.

177. *"richer than most"*: Janet Flanner (Genêt), *Paris Was Yesterday*, ed. Irving Drutman (New York, Viking, 1972), p. 4.

178. *"10,000 Yankee":* New York Herald, Paris edition, February 12, 1924, p. 1.

178. *"In those days":* Gertrude Stein, *The Autobiography of Alice B. Toklas* (New York: Alfred A. Knopf, 1933; Vintage edition, n.d.), p. 197.

178. *"One warm night":* Elizabeth Eyre, "Letters of Elizabeth," *Town and Country,* May 15, 1926, p. 58.

180. *"crêpe uni couleur":* Sales receipt, "Mrs. Shaw McKean," Ed. Charvet & Fils, 8 Place Vendôme, Paris, 5 April 1928.

180. *"to be caught in the exact center":* Rosemary Carr Benét, "Our Paris Letter," *Town and Country,* April 1, 1928, p. 72.

180. *"those of her works":* New York Herald, Paris edition, March 4, 1924, p. 5.

180. *"he was far more":* MS to BP, December 2, 1954.

180. *tore up:* "Tore Up Ship Ticket," *New York Times,* March 26, 1935, p. 16.

181. *"the finest flower garden":* Flanner, *Paris Was Yesterday,* p. xvi.

182. *"big old daylit studio":* Berenice Abbott, author interview, Monson, Maine, June 1990. All BA quotes from this interview, unless otherwise noted.

C h a p t e r v i i

187. *"The District Offers":* North Shore *Breeze and Reminder,* June 19, 1928, p. 1.

188. *"busy with her art work":* Ibid., September 16, 1926, p. 32.

188. *"selected groups of paintings":* Ibid., May 4, 1928, p. 26.

190. *"They were physically drawn":* Edward Weeks, author interview, Boston, November 1980. All EW quotes from this interview.

190. *"Shaw always stood":* Garson Kanin, author conversation, New York, April 1989.

190. *"She was so artistic":* MTS, author interview, Hamilton, Mass., June 23, 1979. All MTS quotes from this interview.

191. *"Can kill leopards":* Promotional brochure, Prides Hill Kennels, Afghan Hounds, n.d. My source for the history of Afghan breeding was Constance O. Miller and Edward M. Gilbert, Jr., *The Complete Afghan Hound* (New York: Howell Book House, 1971).

191. *"You couldn't believe it":* William Roerick, author interview, Tyringham, Mass., July 1979.

191. *"She would have been":* JW, author interviews, Fishers Islands, N.Y., August 1989; Sussex, U.K., November 1989. All JW quotes from these interviews, unless otherwise noted.

193. *"full-fledged":* John Neary to MS, n.d.

195. *"A lion with a wire body":* Margaret Calder Hayes, *Three Alexander Calders* (New York: Universe Books, 1987), p. 209.

195. *"He was lightfingered"*: Billy Kluver and Julie Martin, *Kiki's Paris: Artists and Lovers, 1900–1930* (New York: Abrams, 1989), p. 239n.

195. *"I took the circus"*: Quoted in Jean Lipman with Nancy Foote, eds., *Calder's Circus* (New York: E. P. Dutton in association with the Whitney Museum of American Art, 1972), p. 14.

196. *"Ladies and gentlemen"*: The sources of my description of the circus are the circus itself, on exhibition at the Whitney Museum, New York; the accompanying videotape; Thomas Wolfe, *You Can't Go Home Again* (New York: Scribner, 1934), pp. 273–83; Carole Klein, *Aline: The First Biography of Aline Bernstein, Famed Stage Designer and Mistress of Thomas Wolfe* (New York: Harper & Row, 1979), pp. 248–53.

197. *"Why is there no modern art"*: JW, author interview.

197. *"the work of actuality"*: Quoted in Caroline A. Jones, *Modern Art at Harvard* (New York: Abbeville Press, 1985), p. 44.

197. *"Why don't you"*: Quoted by Agnes Mongan, author interview, Cambridge, Mass., March 1988.

197. *"excessively affluent"*: John Walker, *Self-Portrait with Donors* (Boston: Atlantic/Little, Brown, 1974), p. 4.

197. *"dark, saturnine"*: Ibid., p. 22.

197. *"a combination . . . Eric Gill"*: Lincoln Kirstein, letter quoted in *The Bostonians: Painters of an Elegant Age, 1870–1930* (Boston: Boston Museum of Fine Arts, 1986), p. 92n.

198. *"the work of thirty-three"*: Harvard University Art Museums Archives, Harvard Society for Contemporary Art files, First Annual Report, February 1929–February 1930.

198. *"not then considered art"*: Including Japanese and English pottery and weaving by people "wholly uninfluenced by the methods of modern commercial production" (ibid.); American cartoons, including examples from daily newspapers, and photography as "an individual medium of artistic expression." Harvard University Art Museum Archives, HSCA files, Second Annual Report, February 1930–February 1931. For a full account of the history of the Harvard Society for Contemporary Art and its influence on the founding of the Museum of Modern Art, see Nicholas Fox Weber, *Patron Saints: Five Rebels Who Opened America to a New Art* (New York: Alfred A. Knopf, 1992).

198. *" 'machine-for-living-in' "*: Harvard Society, First Annual Report.

199. *"the genealogy"*: Alfred Barr, *The Museum of Modern Art, First Loan Exhibition, New York, November, 1929; Cézanne, Gauguin, Seurat, Van Gogh* (New York: Museum of Modern Art, 1929), p. 11. Barr was a Harvard graduate, an alumnus of Sachs's museum course, and in the mid-twenties taught art history at Wellesley, where he mounted exhibitions of modern art and hosted multidisciplinary panels of modernist writers and composers.

199. *"For soft contours"*: Ibid., p. 13.

199. *"too broad a caricature"*: Ives Gammell, unpublished diary, January 7, 1930. Courtesy Williams Coles.

200. *"First reaction"*: H. Von Erffa, *Chicago Evening Post Magazine of the Art World*, February 25, 1930, p. 12. MS scrapbook clipping.

200. *"She is an out-and-out"*: "G.K.," *Boston Evening Transcript*, February 12, 1930. MS scrapbook clipping.

204. *"They all drank"*: RRW, author interview, Manchester, Mass., May 1991. All RRW quotes from this interview.

205. *" 'Beyond Good & Evil' "*: MS to Frederic Bartlett, The Arts Club of Chicago Archives, The Newberry Library, Chicago.

206. *"married, but"*: Isabel Jarvis, telephone interview, November 1980.

206. *"They have all the beauty"*: "Cousin Eve," *Chicago Tribune*, November 30, 1930, sec. 8, p. 1.

206. *"began with Cézanne"*: in C.J. Bulliet, *The Significant Moderns* (New York: Covici Friede, 1936), p. v.

207. *"where 'Modernism' "*: C. J. Bulliet, *Chicago Evening Post Magazine of the Art World*, December 2, 1930, p. 1.

207. *"Burlesque Picture"*: *New York World*, January 11, 1931, n.p. MS scrapbook clipping.

207. *"full-fledged palette"*: *New York Post*, January 10, 1931, n.p. MS scrapbook clipping.

207. *"If she is ever able"*: Henry McBride, *New York Sun*, January 13, 1931, n.p. MS scrapbook clipping.

208. *"A little more concentration"*: Margaret Breunig, *New York Times*, January 10, 1931, p. 60.

208. *"at restaurants"*: "Margarett Sargent's One-Man Show," *The Breeze*, n.d. MS scrapbook clipping.

210. *"Applies Her Artistic"*: Florence Cowles article (newspaper unnamed in MS scrapbook clipping) was syndicated, often with cuts, in newspapers as far away as Colorado Springs. With slight changes, it ran under headline "Mrs. Quincy A. Shaw McKean's Beverly Home Growth from 280-Year-Old House of the King's Tax Collector," in *Boston Sunday Post*, August 10, 1930, which MS also preserved in her scrapbook.

211. *"Into such a setting"*: A.J. Philpott, "Margarett Sargent Exhibition Popular," *Boston Globe*, n.d. MS scrapbook clipping.

211. *"indisposed"*: *Boston Transcript*, n.d. MS scrapbook clipping.

Chapter viii

216. *"the leading figure"*: Alfred Franz Cochrane, "Margarett Sargent's Paintings," *Boston Evening Transcript*, March 26, 1932, p. 10.

216. *"New England Society of Contemporary Artists":* Formed by rebel members of the Boston Art Club (including Frederic Bartlett) in 1928, it showed for a while in Magnolia on the North Shore and lay moribund for two years until revived by this exhibition.

216. *The Watteau Hat:* Black-and-white reproductions of Margarett's portrait of Betty Fittamore illustrated reviews of the New England's Society's exhibition in both *Art and Archeology* XXXIII, no. 4 (July–August 1932), p. 177, and *Boston Evening Transcript,* June 25, 1932. MS scrapbook clipping.

217. *"that Sargent girl!":* Alfred Franz Cochrane, *Boston Evening Transcript.* MS scrapbook clipping.

217. *"a gentleman not an ape":* Mrs. Forest Shea, letter to the editor, *Boston Herald,* April 1, 1933. MS scrapbook clipping.

217. *a buxom brunette:* George Luks, oil on canvas, c.1906, Butler Institute of American Art.

218. *"Margarett was not an introspective person":* DDeS, author interview, Beverly Farms, Mass., June 1979. All DDeS quotes from this interview.

219. *"feminine charm":* Louise Tarr, "Why Feminine Charm Snares More Hearts Than Mere Beauty—and Is More Dangerous: Mrs. Sargent McKean, Noted Boston Society Leader, Famed as an Artist, Reveals Woman's Most Closely Guarded Secret—the Gift That Made Garbo, That Other Women Fear and That Turns Men into Slaves and Holds Them Without Dread of Rivalry," *Boston Sunday Post,* 2nd Color Feature Section, October 9, 1932, p. 3.

220. *Paris Tribune:* Also "News of Americans in Europe," *New York Herald,* Paris edition, June 8, 1933, p. 4.

221. *"his sapphire-blue eyes":* Janet Flanner, *Janet Flanner's World, Uncollected Writings, 1932–1975,* ed. Irving Drutman (New York: Harcourt Brace Jovanovich, 1979), p. 9.

221. *"I thought he was absolutely mad":* Quoted by AH, author interview, Boston, June 1987.

221. *"even when you were broke":* Quoted without attribution in Tony Allan, *The Glamor Years: Paris 1919–1940* (New York: Gallery Books, 1977), p. 163.

222. *"Intellectual sensuality":* Tarr, op. cit.

223. *"fit as always": House Beautiful,* December 1933, pp. 248A–249A.

224. *"a rare bird":* "Luks Lecture Drives Most of 500 from Hall," *New York Herald Tribune,* December 22, 1932. MS scrapbook clipping. Excerpted as "Luks Speaks Up," *The Art Digest,* January 1, 1933, p. 12.

225. *"Lusty" Luks:* "George B. Luks Found Dead in 6th Av. at Dawn," *New York Herald Tribune,* October 30, 1933, n.p. MS scrapbook clipping.

226. *"studying the effect of the sunrise":* Ibid.

226. *"Cara mater":* JMcK letter to MS, October 25, 1933.

226. *"The details of his death":* McKean, "George Luks."

229. *"the boys know"*: Story from HMcK.

230. *"And Shaw came to the hotel!"*: MS conversation with author, c.1973.

231. *"They went abroad"*: The gossip about Margarett's affair with Harry Snelling, gathered from many interviews—MTS, Ted Weeks, DS, FB, RRW, MV—are a cacophony of contradictions and rumor one-upmanship. I've tried to reproduce the effect.

232. *"I'll ruin you in business"*: Quoted by Ted Weeks.

232. *"attractive to women"*: DS.

233. *"Read. Write"*: Diary kept by Margie on 1934–1935 trip to Europe. Courtesy MV.

234. *"Isolation is delicious"*: MS sketchbook, c.1934–1940.

235. *"Victorious happiness"*: MS sketchbook, July 22, 1934.

236. *"I don't do portraits"*: Quoted by Hilary Martin, author interview, Newport, R.I., February 1980. Laurencin was indeed turning down portraits at the time.

236. *Butsy McKean:* Many Paris details and all quotes attributed to Butsy are from EB, author interview, Beverly Farms, Mass., October 1986.

237. *"don't speak French!"*: This story and many details of the stay in Germany are from HPMcK, author interviews.

238. *"storm of protest"*: "Hitler Lieutenant Refuses Bid as Harvard Commencement Aide," *New York Times*, April 5, 1934, p. 1.

238. *the* Harvard Crimson: "Urges Harvard Honor Hanfstaengl by Degree," *New York Times*, June 13, 1934, p. 13.

238. *"providential . . . forty-eight hours"*: "World Now Safe, Hanfstaengl Says," *New York Times*, July 2, 1934, p. 2.

238. *"restored to normal soon . . . friendships"*: "Hanfstaengl Gives Multi-Topic Talk," *New York Times*, June 18, 1934, p. 8.

240. *"McKean Twins"*: April 26, 1936, source unknown. MS scrapbook clipping.

240. *"Mrs. Quincy Adams Shaw McKean"*: Newspaper photo, July 24, 1936, source unknown. MS scrapbook clipping.

240. *"never be afflicted in this way"*: Quoted in MS letter to MTS, postmarked September 4, 1936.

240. *"I dread tomorrow"*: Ibid.

Chapter ix

245. *a young art historian:* Ingrid Schaffner.

251. *"being ditched by Margie"*: Benjamin Bradlee, author interview, Washington, D.C., December 2, 1988. All BB quotes from this interview.

252. *"Well, Mrs. McKean"*: Constance Bradlee Devens, author interview, Marlborough, Mass., November 1991.

253. *"One Christmas Eve":* Story from EB, among others.

255. *"Chick" Austin:* As soon as he was named director in 1927, Austin bumped the Atheneum's Connecticut Impressionists to the basement, opened a loan exhibition of old-master drawings from Paul Sachs's collection and then an exhibition of works by Braque, Cézanne, Gauguin, Laurencin, Matisse, Toulouse-Lautrec, and Van Gogh, all borrowed from galleries in New York and Paris. Armed with a recent two-million-dollar bequest to the museum, he bought not only Tintoretto, Fra Angelico, Daumier, and Goya but Hopper and Demuth. He soon raised money for a new building, to include galleries, and a theater for productions of the Friends and Enemies of Modern Music, a showcase for young composers like Thomson, Walter Piston, and George Antheil.

255. *"relaxed visage":* Virgil Thomson, *Virgil Thomson* (New York: Da Capo, 1967), p. 215.

256. *"the R months":* John Houseman, *Run-through* (New York: Simon & Schuster, 1972), p. 98.

256. *"extremely bisexual":* Bowden Broadwater, author interview, November 1992.

256. *"smiling and efficient":* Houseman, *Run-through,* p. 99.

256. *lead to collaboration:* It was at the Askews' one Sunday that Chick Austin met Virgil Thomson; there also that Kirk directed John Houseman to have the conversation with Thomson that resulted in Houseman's directing *Four Saints in Three Acts.*

257. *"Mrs. McKean was extraordinary":* Constance Bradlee letter to Frederick Bradlee, July 17, 1937. Courtesy FB.

257. *"like a schoolgirl":* Hope Williams, author interview, New York, April 1984. All HW quotes from this interview.

258. *"an experiment":* Virgil Thomson, p. 75.

258. *Father Thomas Feeney:* "Father Tom" was one of three brilliant Jesuit brothers. John had a parish in New Hampshire, and Leonard, the editor of the Jesuit weekly *America,* would come to national prominence in the 1940s at the center of what came to be called the Boston heresy case, which resulted in his being censured by the Pope. Leonard was a published poet and a humorist, whose *Fish on Friday* had been a best-seller in 1934; later, Teddy Chanler would collaborate with him on a sequence of songs for children. Dan and Louise Sargent became followers of Leonard Feeney, as did Teddy and Maria Chanler. Margarett was never drawn to his kind of demagoguery and conservatism. For an extremely biased account of the Feeney controversy, see the book by his associate, Catherine Goddard Clarke, *The Loyolas and the Cabots* (Boston: Ravengate Press, 1950).

259. *"A lot of fancy people":* Paul Moore, author interview, New York, October 1991.

259. *"Wouldn't it be nice"*: Account of Margarett's conversion from Teddy Chanler letter to DS, August 16, 1937.

262. *"Very smart"*: Jenny Reed Slote, telephone interview, May 1993.

263. *"saying all the right things"*: Lyn Austin, author interview, New York, March 9, 1993.

263. *"Mr. Cross"*: Jenny McKean, loose-leaf binder of Vassar writings, c.1939–1940; collection of the author.

265. *"A gallery isn't"*: Lee Hall, *Betty Parsons, Artist, Dealer, Collector* (New York: Harry N. Abrams, 1991), p. 77.

268. *"She was no longer"*: Jane Bowles, *My Sister's Hand in Mine: The Collected Works of Jane Bowles* (New York: Ecco Press, 1978), p. 49.

268. *"a major minor writer"*: Quoted in "Notes from the Director," program insert, *In the Summer House*, Vivian Beaumont Theater, Lincoln Center, New York, Summer 1993.

268. *"a fear of dogs"*: Millicent Dillon, *A Little Original Sin: The Life and Works of Jane Bowles* (New York: Holt, Rinehart & Winston, 1981), p. 26.

270. *"They had conversation"*: Oliver Smith, author interview, New York, February 18, 1987. All OS quotes from this interview.

270. *"My husband never loved me"*: The play was *In the Summer House*, in Bowles, *My Sister's Hand*, p. 263.

271. *"What type are you?"*: Robert Fizdale, conversation with author, June 1992.

272. *"the only mother"*: JMcK conversation with author, c.1966.

273. *"the watercolor . . . keep on"*: MS to SMcK, December 29, 1944.

Chapter x

277. *"The whole place"*: MS to SMcK, December 29, 1945.

278. *"a home-like"*: Four Winds promotional brochure, c.1944. Courtesy Billie Sorenson, director of public relations, Four Winds Hospital.

278. *more apt to return*: In "Convulsive Therapy and the Course of Bipolar Illness, 1940–1949," *Convulsive Therapy* IV, 2 (New York: Raven Press, 1988), pp. 126–32, George Winokur and Arnold Kadrmas reported they had come to this conclusion after scrutinizing the records of ninety-three Massachusetts patients given shock between 1940 and 1949. No clear reason for their findings emerged, but the authors did not rule out that shock itself altered the biological course of the condition.

278. *Later research*: This assertion has always been controversial; when, at the 1976 annual meeting of the American Psychiatric Association, Dr. John Friedberg gave a paper insisting "that, despite the importance of a negative finding, there has not been a single detailed report of a normal human brain after shock," he was vigorously rebutted, and his methods of data col-

lection were criticized. John Friedberg, M.D., "Shock Treatment, Brain Damage, and Memory Loss: A Neurological Perspective," *American Journal of Psychiatry* 134:9 (September 1977), pp. 1010–18.

278. *No one then theorized:* In "Bipolar Affective Disorder and Alcoholism," *American Journal of Psychiatry* 131:10 (October 1974), pp. 1130–33, James R. Morrison, M.D., theorized that alcoholism was a disease distinct from bipolar affective disorder and suggested that for effective recovery, both diseases had to be treated.

279. *"divinely menacing behavior":* Phyllis Chesler, *Women and Madness* (New York: Doubleday, 1972), p. xx.

279. *Kay Redmond Jamison: Touched with Fire: Manic Depressive Illness and the Artistic Temperament* (New York: The Free Press, 1993).

279. *"He buckled them":* Sylvia Plath, *The Bell Jar* (New York: Bantam, 1972), pp. 117–18.

282. *Writing to Betty Parsons:* MS wrote to BP consistently between April 1945 and March 1959, and with particular frequency during her second Four Winds stay (May–June 1946). MS's descriptions of hospital life, of Jenny's graduation, and of her family relationships during that period are drawn from these letters, as are her remarks to BP, unless otherwise noted. The letters were given to me after her death by BP's friend Gwyn Metz and her biographer Lee Hall.

283. *In long letters:* Letters from JB to MS have been lost, but MS refers to them in hers to BP.

290. *"odd restaurants . . . strong happiness":* MS to BP, April 23, 1947.

291. *"Mrs. McKean":* Dame, *Boston Sunday Herald,* c.1948.

292. *"get the wagon":* BW, author interview, Newport, R.I., March 20–21, 1982. All BW quotes from this interview, unless otherwise noted.

292. *When Robert Lowell arrived:* See Ian Hamilton, *Robert Lowell, A Biography* (New York: Random House, 1982), pp. 158–60.

293. *"Half dozen treatments":* MS to BP from Baldpate, March 11, 1948.

293. *"To all persons":* Copy of citation mailed to BW, May 9, 1949.

294. *"little we can do":* A. C. Malm to BW, March 1, 1949.

294. *"In accordance with":* Dr. George Schlomer to Mrs. Barclay Warburton III (Margie), June 8, 1949.

294. *"You could tell":* George Dix, author interview, New York, January 1994.

295. *"It is a delight . . . in ink":* MS sketchbook, Boca Grande, 1949.

296. *"nice and quiet":* Dr. Max Rinkel to BW, November 15, 1949.

296. *"I think it unlikely":* Dr. Robert Fleming to Alvin Hochberg, January 15, 1964.

296. *"Blow up 57th Street":* MS to BP from Vicksburg, Miss., April 28, 1950.

297. *"her knowledge of painting"*: Harry Martin, author interviews, Gloucester, Mass., July 1982, April 1984. All HM quotes from these interviews.

297. *"keener . . . uncomfortable"*: Jane Bowles, *Out in the World: Selected Letters of Jane Bowles, 1935–1970*, ed. Millicent Dillon (Santa Barbara: Black Sparrow Press, 1985), pp. 168–69.

299. *"central heating"*: Quoted by Harry Martin in author interview.

299. *"I'd give anything"*: Herbert "Whitey" Lutz to BP, August 3, 1950.

300. *"curious and interesting"*: Janet Flanner, *Paris Journal, 1944–1965* (New York and London: Harcourt Brace Jovanovich, Harvest edition, 1977), p. 197.

301. *"with my acrobatic finches"*: MS to BP, December 2, 1954.

301. *"no checking account"*: MS to BP, June 10, 1954.

301. *"her past happy time"*: Joseph Gelli to MV, October 12, 1957.

302. *"And don't you admire"*: MS to BP, June 10, 1954.

302. *"incredible magic"*: MS to BB from Florence, January 14, 1954. Margarett's letters are in the library at I Tatti and are quoted courtesy of Villa I Tatti, Harvard University Center for Italian Renaissance Studies, The Berenson Archive. BB's side of the correspondence, referred to in her letters, has vanished.

302. *"the one un*lighted *gallery"*: MS to BB, November 10, 1954.

303. *"a Jane Austen character"*: MS to BB, January 9, 1954.

303. *"a voluntary prisoner"*: MS to BB, April 8, 1954.

303. *"overlooking . . . in bloom"*: MS to BB, March 27, 1954.

304. *"true to your beliefs"*: MS to BP, June 10, 1954.

304. *"obstinately is not gray"*: Ibid.

305. *"very good shape"*: Quoted in Oliver Wolcott to Mrs. Barclay Warburton III (MV), June 18, 1953.

305. *"Why don't you do"*: MV, author interview.

305. *"rightly considered fortunate"*: MS to BP, October 26, 1954.

306. *"a little sadistic"*: Dr. Harold W. Lovell, M.D., to Margarett's lawyer, Walter Powers, April 4, 1962.

306. *"I feel reasonably certain"*: Dr. Robert Fleming to SMcK, Jr., December 17, 1962.

306. *"like ice"*: HMcK to SMcK, MV, JMcKM, DS, and Walter Powers, January 29, 1963.

307. *"this extraordinary person"*: Gloria Braggiotti Etting, author interview, Philadelphia, April 1987.

307. *"She is very ill"*: HPMcK to JMcKM, January 30, 1963.

307. *"present state"*: Quoted by HPMcK in a letter to SMcK, February 18, 1963.

308. *"reacted violently . . . uncommon"*: Memorandum of family conference, May 10, 1963, at office of Dr. Robert Fleming, Boston.

308. *"mentally ill person":* Commonwealth of Massachusetts, Probate Court, Docket #276047.

308. *"The change in my life":* MS to BP, June 10, 1954.

308. *"at Westwood":* AH to Joseph Gelli, May 27, 1964.

308. *"Am being mesmerized":* MS to BP, telegram, February 23, 1965.

309. *"all I know about art":* AH, author interview, Boston, June 1987.

310. *"Simplification":* MS sketchbook, Boca Grande, 1949.

310. *"None of them":* Dr. Raymond Adams, author interview, Boston, October 1987.

311. *"she had parties":* Aimée Lamb, author interview, Boston, October 1986.

311. *"such interesting people!":* Sylvia Cox, author interview, Boston, April 1984. All SC quotes from this interview.

311. *"For God's sake, Russell":* Russell Lyman, author interview, Needham, Mass., November 1986.

311. *"We talked about trees":* Stephen Vernon, author interview, Hamilton, Mass., April 1984. All SV quotes from this interview.

312. *"I've become a Democrat":* MW, author interviews.

313. *"We'd talk about flowers":* Richard Demenocal, author interview, Cambridge, December 1980.

313. *"Well, Mrs. McKean":* This story from AH.

314. *"Sargent on a city street":* Bangs material.

Index

Illustration Credits

Chapter-opening photographs:

Frontispiece, p. iv: Berenice Abbott/Commerce Graphics Ltd., Inc.; p. 1: Collection of the author; p. 37: Collection of the author; p. 71: Reproduced from the Collections of the Library of Congress; pp. 99, 127, 157: Collection of the author; p. 185: Photograph by Bachrach Studios, Boston; pp. 213, 243, 275: Collection of the author.

Black-and-white insert:

1–4. Collection of the author; 5. Private collection; 6. Collection of the author; 7. Courtesy Francis William Sargent; 8. Collection of the author; 9. Private collection; 10. Collection of the author; 11. Gift of Frederic C. Bartlett, 1928.707. Photograph c. 1994, the Art Institute of Chicago. All rights reserved; 12–20. Collection of the author; 21. Private collection. Photograph, Putnam Photographic Laboratory; 22. Private collection. Photograph, Monica Stevenson; 23. Private collection. Photograph, Putnam Photographic Laboratory; 24. Private collection. Photograph, Monica Stevenson; 25. Collection of the author; 26. Photograph by Honor Moore.

Color insert:

1. Private Collection. Photograph, Monica Stevenson; 2. Private Collection. Photograph, Greg Heins; 3. Private Collection. Photograph, Monica Stevenson; 4. Private Collection. Photograph, Robert Houser; 5. Private collection. Photograph, Monica Stevenson; 6. Private collection. Photograph, Robert Houser; 7. Private collection. Photograph, Monica Stevenson; 8. Private collection. Photograph, Monica Stevenson.

The Complete Poems and Plays

1909-1950

T. S. ELIOT

The Complete Poems and Plays

1909-1950

HARCOURT, BRACE & WORLD, INC.

NEW YORK

Contents

CONTENTS

Collected Poems

1909–1935

Prufrock
AND OTHER OBSERVATIONS
1917

For Jean Verdenal, 1889–1915
mort aux Dardanelles

Or puoi la quantitate
Comprender dell' amor ch'a te mi scalda,
Quando dismento nostra vanitate
Trattando l'ombre come cosa salda.

THE LOVE SONG
OF J. ALFRED PRUFROCK

S'io credesse che mia risposta fosse
A persona che mai tornasse al mondo,
Questa fiamma staria senza piu scosse.
Ma perciocche giammai di questo fondo
Non torno vivo alcun, s'i'odo il vero,
Senza tema d'infamia ti rispondo.

Let us go then, you and I,
When the evening is spread out against the sky
Like a patient etherised upon a table;
Let us go, through certain half-deserted streets,
The muttering retreats
Of restless nights in one-night cheap hotels
And sawdust restaurants with oyster-shells:
Streets that follow like a tedious argument
Of insidious intent
To lead you to an overwhelming question. . .
Oh, do not ask, "What is it?"
Let us go and make our visit.

[3]

 In the room the women come and go
Talking of Michelangelo.

 The yellow fog that rubs its back upon the window-panes,
The yellow smoke that rubs its muzzle on the window-panes
Licked its tongue into the corners of the evening,
Lingered upon the pools that stand in drains,
Let fall upon its back the soot that falls from chimneys,
Slipped by the terrace, made a sudden leap,
And seeing that it was a soft October night,
Curled once about the house, and fell asleep.

 And indeed there will be time
For the yellow smoke that slides along the street,
Rubbing its back upon the window-panes;
There will be time, there will be time
To prepare a face to meet the faces that you meet;
There will be time to murder and create,
And time for all the works and days of hands
That lift and drop a question on your plate;
Time for you and time for me,
And time yet for a hundred indecisions,
And for a hundred visions and revisions,
Before the taking of a toast and tea.

 In the room the women come and go
Talking of Michelangelo.

 And indeed there will be time
To wonder, "Do I dare?" and, "Do I dare?"
Time to turn back and descend the stair,
With a bald spot in the middle of my hair—
[They will say: "How his hair is growing thin!"]
My morning coat, my collar mounting firmly to the chin,
My necktie rich and modest, but asserted by a simple pin—
[They will say: "But how his arms and legs are thin!"]
Do I dare

Disturb the universe?
In a minute there is time
For decisions and revisions which a minute will reverse.

 For I have known them all already, known them all:—
Have known the evenings, mornings, afternoons,
I have measured out my life with coffee spoons;
I know the voices dying with a dying fall
Beneath the music from a farther room.
 So how should I presume?

 And I have known the eyes already, known them all—
The eyes that fix you in a formulated phrase,
And when I am formulated, sprawling on a pin,
When I am pinned and wriggling on the wall,
Then how should I begin
To spit out all the butt-ends of my days and ways?
 And how should I presume?

 And I have known the arms already, known them all—
Arms that are braceleted and white and bare
[But in the lamplight, downed with light brown hair!]
Is it perfume from a dress
That makes me so digress?
Arms that lie along a table, or wrap about a shawl.
 And should I then presume?
 And how should I begin?

.

Shall I say, I have gone at dusk through narrow streets
And watched the smoke that rises from the pipes
Of lonely men in shirt-sleeves, leaning out of windows? . . .

 I should have been a pair of ragged claws
Scuttling across the floors of silent seas.

.

And the afternoon, the evening, sleeps so peacefully!
Smoothed by long fingers,
Asleep . . . tired . . . or it malingers,

Stretched on the floor, here beside you and me.
Should I, after tea and cakes and ices,
Have the strength to force the moment to its crisis?
But though I have wept and fasted, wept and prayed,
Though I have seen my head [grown slightly bald] brought in upon
 a platter,
I am no prophet—and here's no great matter;
I have seen the moment of my greatness flicker,
And I have seen the eternal Footman hold my coat, and snicker,
And in short, I was afraid.

 And would it have been worth it, after all,
After the cups, the marmalade, the tea,
Among the porcelain, among some talk of you and me,
Would it have been worth while,
To have bitten off the matter with a smile,
To have squeezed the universe into a ball
To roll it toward some overwhelming question,
To say: "I am Lazarus, come from the dead,
Come back to tell you all, I shall tell you all"—
If one, settling a pillow by her head,
 Should say: "That is not what I meant at all.
 That is not it, at all."

 And would it have been worth it, after all,
Would it have been worth while,
After the sunsets and the dooryards and the sprinkled streets,
After the novels, after the teacups, after the skirts that trail along the
 floor—
And this, and so much more?—
It is impossible to say just what I mean!
But as if a magic lantern threw the nerves in patterns on a screen:
Would it have been worth while
If one, settling a pillow or throwing off a shawl,
And turning toward the window, should say:
 "That is not it at all,
 That is not what I meant, at all."

.

No! I am not Prince Hamlet, nor was meant to be;
Am an attendant lord, one that will do
To swell a progress, start a scene or two,
Advise the prince; no doubt, an easy tool,
Deferential, glad to be of use,
Politic, cautious, and meticulous;
Full of high sentence, but a bit obtuse;
At times, indeed, almost ridiculous—
Almost, at times, the Fool.

I grow old . . . I grow old . . .
I shall wear the bottoms of my trousers rolled.

Shall I part my hair behind? Do I dare to eat a peach?
I shall wear white flannel trousers, and walk upon the beach.
I have heard the mermaids singing, each to each.

I do not think that they will sing to me.

I have seen them riding seaward on the waves
Combing the white hair of the waves blown back
When the wind blows the water white and black.

We have lingered in the chambers of the sea
By sea-girls wreathed with seaweed red and brown
Till human voices wake us, and we drown.

PORTRAIT OF A LADY

Thou hast committed—
Fornication: but that was in another country,
And besides, the wench is dead.
 THE JEW OF MALTA.

I

Among the smoke and fog of a December afternoon
You have the scene arrange itself—as it will seem to do—
With "I have saved this afternoon for you";
And four wax candles in the darkened room,
Four rings of light upon the ceiling overhead,
An atmosphere of Juliet's tomb
Prepared for all the things to be said, or left unsaid.
We have been, let us say, to hear the latest Pole
Transmit the Preludes, through his hair and fingertips.
"So intimate, this Chopin, that I think his soul
Should be resurrected only among friends
Some two or three, who will not touch the bloom
That is rubbed and questioned in the concert room."
—And so the conversation slips
Among velleities and carefully caught regrets
Through attenuated tones of violins
Mingled with remote cornets
And begins.
"You do not know how much they mean to me, my friends,
And how, how rare and strange it is, to find
In a life composed so much, so much of odds and ends,
[For indeed I do not love it . . . you knew? you are not blind!
How keen you are!]
To find a friend who has these qualities,
Who has, and gives
Those qualities upon which friendship lives.
How much it means that I say this to you—
Without these friendships—life, what *cauchemar!*"

 Among the windings of the violins
And the ariettes
Of cracked cornets
Inside my brain a dull tom-tom begins
Absurdly hammering a prelude of its own,
Capricious monotone
That is at least one definite "false note."
—Let us take the air, in a tobacco trance,
Admire the monuments,
Discuss the late events,
Correct our watches by the public clocks.
Then sit for half an hour and drink our bocks.

<div align="center">II</div>

Now that lilacs are in bloom
She has a bowl of lilacs in her room
And twists one in her fingers while she talks.
"Ah, my friend, you do not know, you do not know
What life is, you who hold it in your hands";
(Slowly twisting the lilac stalks)
"You let it flow from you, you let it flow,
And youth is cruel, and has no remorse
And smiles at situations which it cannot see."
I smile, of course,
And go on drinking tea.
"Yet with these April sunsets, that somehow recall
My buried life, and Paris in the Spring,
I feel immeasurably at peace, and find the world
To be wonderful and youthful, after all."

 The voice returns like the insistent out-of-tune
Of a broken violin on an August afternoon:
"I am always sure that you understand
My feelings, always sure that you feel,
Sure that across the gulf you reach your hand.

You are invulnerable, you have no Achilles' heel.
You will go on, and when you have prevailed
You can say: at this point many a one has failed.
But what have I, but what have I, my friend,
To give you, what can you receive from me?
Only the friendship and the sympathy
Of one about to reach her journey's end.

I shall sit here, serving tea to friends. . . ."

I take my hat: how can I make a cowardly amends
For what she has said to me?
You will see me any morning in the park
Reading the comics and the sporting page.
Particularly I remark
An English countess goes upon the stage.
A Greek was murdered at a Polish dance,
Another bank defaulter has confessed.
I keep my countenance,
I remain self-possessed
Except when a street piano, mechanical and tired
Reiterates some worn-out common song
With the smell of hyacinths across the garden
Recalling things that other people have desired.
Are these ideas right or wrong?

III

The October night comes down; returning as before
Except for a slight sensation of being ill at ease
I mount the stairs and turn the handle of the door
And feel as if I had mounted on my hands and knees.
"And so you are going abroad; and when do you return?
But that's a useless question.
You hardly know when you are coming back,
You will find so much to learn."
My smile falls heavily among the bric-à-brac.

"Perhaps you can write to me."
My self-possession flares up for a second;
This is as I had reckoned.
"I have been wondering frequently of late
(But our beginnings never know our ends!)
Why we have not developed into friends."
I feel like one who smiles, and turning shall remark
Suddenly, his expression in a glass.
My self-possession gutters; we are really in the dark.

"For everybody said so, all our friends,
They all were sure our feelings would relate
So closely! I myself can hardly understand.
We must leave it now to fate.
You will write, at any rate.
Perhaps it is not too late.
I shall sit here, serving tea to friends."

And I must borrow every changing shape
To find expression . . . dance, dance
Like a dancing bear,
Cry like a parrot, chatter like an ape.
Let us take the air, in a tobacco trance—

Well! and what if she should die some afternoon,
Afternoon grey and smoky, evening yellow and rose;
Should die and leave me sitting pen in hand
With the smoke coming down above the housetops;
Doubtful, for a while
Not knowing what to feel or if I understand
Or whether wise or foolish, tardy or too soon . . .
Would she not have the advantage, after all?
This music is successful with a "dying fall"
Now that we talk of dying—
And should I have the right to smile?

PRELUDES

I

The winter evening settles down
With smell of steaks in passageways.
Six o'clock.
The burnt-out ends of smoky days.
And now a gusty shower wraps
The grimy scraps
Of withered leaves about your feet
And newspapers from vacant lots;
The showers beat
On broken blinds and chimney-pots,
And at the corner of the street
A lonely cab-horse steams and stamps.
And then the lighting of the lamps.

II

The morning comes to consciousness
Of faint stale smells of beer
From the sawdust-trampled street
With all its muddy feet that press
To early coffee-stands.
With the other masquerades
That time resumes,
One thinks of all the hands
That are raising dingy shades
In a thousand furnished rooms.

III

You tossed a blanket from the bed,
You lay upon your back, and waited;
You dozed, and watched the night revealing
The thousand sordid images
Of which your soul was constituted;

They flickered against the ceiling.
And when all the world came back
And the light crept up between the shutters
And you heard the sparrows in the gutters,
You had such a vision of the street
As the street hardly understands;
Sitting along the bed's edge, where
You curled the papers from your hair,
Or clasped the yellow soles of feet
In the palms of both soiled hands.

IV

His soul stretched tight across the skies
That fade behind a city block,
Or trampled by insistent feet
At four and five and six o'clock;
And short square fingers stuffing pipes,
And evening newspapers, and eyes
Assured of certain certainties,
The conscience of a blackened street
Impatient to assume the world.

I am moved by fancies that are curled
Around these images, and cling:
The notion of some infinitely gentle
Infinitely suffering thing.

Wipe your hand across your mouth, and laugh;
The worlds revolve like ancient women
Gathering fuel in vacant lots.

RHAPSODY ON A WINDY NIGHT

Twelve o'clock.
Along the reaches of the street
Held in a lunar synthesis,
Whispering lunar incantations
Dissolve the floors of memory
And all its clear relations
Its divisions and precisions,
Every street lamp that I pass
Beats like a fatalistic drum,
And through the spaces of the dark
Midnight shakes the memory
As a madman shakes a dead geranium.

Half-past one,
The street-lamp sputtered,
The street-lamp muttered,
The street-lamp said, "Regard that woman
Who hesitates toward you in the light of the door
Which opens on her like a grin.
You see the border of her dress
Is torn and stained with sand,
And you see the corner of her eye
Twists like a crooked pin."

The memory throws up high and dry
A crowd of twisted things,
A twisted branch upon the beach
Eaten smooth, and polished
As if the world gave up
The secret of its skeleton,
Stiff and white.
A broken spring in a factory yard,
Rust that clings to the form that the strength has left
Hard and curled and ready to snap.

 Half-past two,
The street-lamp said,
"Remark the cat which flattens itself in the gutter,
Slips out its tongue
And devours a morsel of rancid butter."
So the hand of the child, automatic,
Slipped out and pocketed a toy that was running along the quay.
I could see nothing behind that child's eye.
I have seen eyes in the street
Trying to peer through lighted shutters,
And a crab one afternoon in a pool,
An old crab with barnacles on his back,
Gripped the end of a stick which I held him.

 Half-past three,
The lamp sputtered,
The lamp muttered in the dark.
The lamp hummed:
"Regard the moon,
La lune ne garde aucune rancune,
She winks a feeble eye,
She smiles into corners.
She smooths the hair of the grass.
The moon has lost her memory.
A washed-out smallpox cracks her face,
Her hand twists a paper rose,
That smells of dust and eau de Cologne,
She is alone
With all the old nocturnal smells
That cross and cross across her brain."
The reminiscence comes
Of sunless dry geraniums
And dust in crevices,
Smells of chestnuts in the streets,
And female smells in shuttered rooms,
And cigarettes in corridors
And cocktail smells in bars.

The lamp said,
"Four o'clock,
Here is the number on the door.
Memory!
You have the key,
The little lamp spreads a ring on the stair.
Mount.
The bed is open; the tooth-brush hangs on the wall,
Put your shoes at the door, sleep, prepare for life."

The last twist of the knife.

MORNING AT THE WINDOW

They are rattling breakfast plates in basement kitchens,
And along the trampled edges of the street
I am aware of the damp souls of housemaids
Sprouting despondently at area gates.

The brown waves of fog toss up to me
Twisted faces from the bottom of the street,
And tear from a passer-by with muddy skirts
An aimless smile that hovers in the air
And vanishes along the level of the roofs.

THE *BOSTON EVENING TRANSCRIPT*

The readers of the *Boston Evening Transcript*
Sway in the wind like a field of ripe corn.

When evening quickens faintly in the street,
Wakening the appetites of life in some
And to others bringing the *Boston Evening Transcript*,
I mount the steps and ring the bell, turning

Wearily, as one would turn to nod good-bye to Rochefoucauld,
If the street were time and he at the end of the street,
And I say, "Cousin Harriet, here is the *Boston Evening Transcript*."

AUNT HELEN

Miss Helen Slingsby was my maiden aunt,
And lived in a small house near a fashionable square
Cared for by servants to the number of four.
Now when she died there was silence in heaven
And silence at her end of the street.
The shutters were drawn and the undertaker wiped his feet—
He was aware that this sort of thing had occurred before.
The dogs were handsomely provided for,
But shortly afterwards the parrot died too.
The Dresden clock continued ticking on the mantelpiece,
And the footman sat upon the dining-table
Holding the second housemaid on his knees—
Who had always been so careful while her mistress lived.

COUSIN NANCY

Miss Nancy Ellicott
Strode across the hills and broke them,
Rode across the hills and broke them—
The barren New England hills—
Riding to hounds
Over the cow-pasture.

Miss Nancy Ellicott smoked
And danced all the modern dances;
And her aunts were not quite sure how they felt about it,
But they knew that it was modern.

Upon the glazen shelves kept watch
Matthew and Waldo, guardians of the faith,
The army of unalterable law.

MR. APOLLINAX

Ω τῆς καινότητος. ῾Ηράκλεις, τῆς παραδοξολογίας.
 εὐμήχανος ἄνθρωπος.
 LUCIAN.

When Mr. Apollinax visited the United States
His laughter tinkled among the teacups.
I thought of Fragilion, that shy figure among the birch-trees,
And of Priapus in the shrubbery
Gaping at the lady in the swing.
In the palace of Mrs. Phlaccus, at Professor Channing-Cheetah's
He laughed like an irresponsible fœtus.
His laughter was submarine and profound
Like the old man of the sea's
Hidden under coral islands
Where worried bodies of drowned men drift down in the green silence,
Dropping from fingers of surf.
I looked for the head of Mr. Apollinax rolling under a chair.

 Or grinning over a screen
With seaweed in its hair.
I heard the beat of centaur's hoofs over the hard turf
As his dry and passionate talk devoured the afternoon.
"He is a charming man"—"But after all what did he mean?"—
"His pointed ears. . . . He must be unbalanced,"—
"There was something he said that I might have challenged."
Of dowager Mrs. Phlaccus, and Professor and Mrs. Cheetah
I remember a slice of lemon, and a bitten macaroon.

HYSTERIA

As she laughed I was aware of becoming involved in her laughter and being part of it, until her teeth were only accidental stars with a talent for squad-drill. I was drawn in by short gasps, inhaled at each momentary recovery, lost finally in the dark caverns of her throat, bruised by the ripple of unseen muscles. An elderly waiter with trembling hands was hurriedly spreading a pink and white checked cloth over the rusty green iron table, saying: "If the lady and gentleman wish to take their tea in the garden, if the lady and gentleman wish to take their tea in the garden . . ." I decided that if the shaking of her breasts could be stopped, some of the fragments of the afternoon might be collected, and I concentrated my attention with careful subtlety to this end.

CONVERSATION GALANTE

I observe: "Our sentimental friend the moon!
Or possibly (fantastic, I confess)
It may be Prester John's balloon
Or an old battered lantern hung aloft
To light poor travellers to their distress."
 She then: "How you digress!"

 And I then: "Someone frames upon the keys
That exquisite nocturne, with which we explain
The night and moonshine; music which we seize
To body forth our own vacuity."
 She then: "Does this refer to me?"
 "Oh no, it is I who am inane."

"You, madam, are the eternal humorist,
The eternal enemy of the absolute,
Giving our vagrant moods the slightest twist!

With your air indifferent and imperious
At a stroke our mad poetics to confute—"
 And—"Are we then so serious?"

LA FIGLIA CHE PIANGE

O quam te memorem virgo . . .

Stand on the highest pavement of the stair—
Lean on a garden urn—
Weave, weave the sunlight in your hair—
Clasp your flowers to you with a pained surprise—
Fling them to the ground and turn
With a fugitive resentment in your eyes:
But weave, weave the sunlight in your hair.

 So I would have had him leave,
So I would have had her stand and grieve,
So he would have left
As the soul leaves the body torn and bruised,
As the mind deserts the body it has used.
I should find
Some way incomparably light and deft,
Some way we both should understand,
Simple and faithless as a smile and shake of the hand.

 She turned away, but with the autumn weather
Compelled my imagination many days,
Many days and many hours:
Her hair over her arms and her arms full of flowers.
And I wonder how they should have been together!
I should have lost a gesture and a pose.
Sometimes these cogitations still amaze
The troubled midnight and the noon's repose.

Poems
1920

GERONTION

Thou hast nor youth nor age
But as it were an after dinner sleep
Dreaming of both.

Here I am, an old man in a dry month,
Being read to by a boy, waiting for rain.
I was neither at the hot gates
Nor fought in the warm rain
Nor knee deep in the salt marsh, heaving a cutlass,
Bitten by flies, fought.
My house is a decayed house,
And the jew squats on the window sill, the owner,
Spawned in some estaminet of Antwerp,
Blistered in Brussels, patched and peeled in London.
The goat coughs at night in the field overhead;
Rocks, moss, stonecrop, iron, merds.
The woman keeps the kitchen, makes tea,
Sneezes at evening, poking the peevish gutter.
 I an old man,
A dull head among windy spaces.

 Signs are taken for wonders. "We would see a sign!"
The word within a word, unable to speak a word,
Swaddled with darkness. In the juvescence of the year
Came Christ the tiger

 In depraved May, dogwood and chestnut, flowering judas,

[21]

To be eaten, to be divided, to be drunk
Among whispers; by Mr. Silvero
With caressing hands, at Limoges
Who walked all night in the next room;

 By Hakagawa, bowing among the Titians;
By Madame de Tornquist, in the dark room
Shifting the candles; Fräulein von Kulp
Who turned in the hall, one hand on the door.
 Vacant shuttles
Weave the wind. I have no ghosts,
An old man in a draughty house
Under a windy knob.

 After such knowledge, what forgiveness? Think now
History has many cunning passages, contrived corridors
And issues, deceives with whispering ambitions,
Guides us by vanities. Think now
She gives when our attention is distracted
And what she gives, gives with such supple confusions
That the giving famishes the craving. Gives too late
What's not believed in, or if still believed,
In memory only, reconsidered passion. Gives too soon
Into weak hands, what's thought can be dispensed with
Till the refusal propagates a fear. Think
Neither fear nor courage saves us. Unnatural vices
Are fathered by our heroism. Virtues
Are forced upon us by our impudent crimes.
These tears are shaken from the wrath-bearing tree.

 The tiger springs in the new year. Us he devours. Think at last
We have not reached conclusion, when I
Stiffen in a rented house. Think at last
I have not made this show purposelessly
And it is not by any concitation
Of the backward devils.
I would meet you upon this honestly.

I that was near your heart was removed therefrom
To lose beauty in terror, terror in inquisition.
I have lost my passion: why should I need to keep it
Since what is kept must be adulterated?
I have lost my sight, smell, hearing, taste and touch:
How should I use them for your closer contact?

These with a thousand small deliberations
Protract the profit of their chilled delirium,
Excite the membrane, when the sense has cooled,
With pungent sauces, multiply variety
In a wilderness of mirrors. What will the spider do,
Suspend its operations, will the weevil
Delay? De Bailhache, Fresca, Mrs. Cammel, whirled
Beyond the circuit of the shuddering Bear
In fractured atoms. Gull against the wind, in the windy straits
Of Belle Isle, or running on the Horn,
White feathers in the snow, the Gulf claims,
And an old man driven by the Trades
To a sleepy corner.

 Tenants of the house,
Thoughts of a dry brain in a dry season.

BURBANK WITH A BAEDEKER:
BLEISTEIN WITH A CIGAR

Tra-la-la-la-la-la-laire—nil nisi divinum stabile est; caetera fumus—the gondola stopped, the old palace was there, how charming its grey and pink—goats and monkeys, with such hair too!—so the countess passed on until she came through the little park, where Niobe presented her with a cabinet, and so departed.

 Burbank crossed a little bridge
 Descending at a small hotel;
 Princess Volupine arrived,
 They were together, and he fell.

Defunctive music under sea
 Passed seaward with the passing bell
Slowly: the God Hercules
 Had left him, that had loved him well.

The horses, under the axletree
 Beat up the dawn from Istria
With even feet. Her shuttered barge
 Burned on the water all the day.

But this or such was Bleistein's way:
 A saggy bending of the knees
And elbows, with the palms turned out,
 Chicago Semite Viennese.

A lustreless protrusive eye
 Stares from the protozoic slime
At a perspective of Canaletto.
 The smoky candle end of time

Declines. On the Rialto once.
 The rats are underneath the piles.
The jew is underneath the lot.
 Money in furs. The boatman smiles,

Princess Volupine extends
 A meagre, blue-nailed, phthisic hand
To climb the waterstair. Lights, lights,
 She entertains Sir Ferdinand

Klein. Who clipped the lion's wings
 And flea'd his rump and pared his claws?
Thought Burbank, meditating on
 Time's ruins, and the seven laws.

SWEENEY ERECT

And the trees about me,
Let them be dry and leafless; let the rocks
Groan with continual surges; and behind me
Make all a desolation. Look, look, wenches!

Paint me a cavernous waste shore
 Cast in the unstilled Cyclades,
Paint me the bold anfractuous rocks
 Faced by the snarled and yelping seas.

Display me Aeolus above
 Reviewing the insurgent gales
Which tangle Ariadne's hair
 And swell with haste the perjured sails.

Morning stirs the feet and hands
 (Nausicaa and Polypheme).
Gesture of orang-outang
 Rises from the sheets in steam.

This withered root of knots of hair
 Slitted below and gashed with eyes,
This oval O cropped out with teeth:
 The sickle motion from the thighs

Jackknifes upward at the knees
 Then straightens out from heel to hip
Pushing the framework of the bed
 And clawing at the pillow slip.

Sweeney addressed full length to shave
 Broadbottomed, pink from nape to base,
Knows the female temperament
 And wipes the suds around his face.

(The lengthened shadow of a man
 Is history, said Emerson
Who had not seen the silhouette
 Of Sweeney straddled in the sun.)

Tests the razor on his leg
 Waiting until the shriek subsides.
The epileptic on the bed
 Curves backward, clutching at her sides.

The ladies of the corridor
 Find themselves involved, disgraced,
Call witness to their principles
 And deprecate the lack of taste

Observing that hysteria
 Might easily be misunderstood;
Mrs. Turner intimates
 It does the house no sort of good.

But Doris, towelled from the bath,
 Enters padding on broad feet,
Bringing sal volatile
 And a glass of brandy neat.

A COOKING EGG

*En l'an trentiesme de mon aage
Que toutes mes hontes j'ay beues . . .*

Pipit sate upright in her chair
 Some distance from where I was sitting;
Views of the Oxford Colleges
 Lay on the table, with the knitting.

Daguerreotypes and silhouettes,
 Her grandfather and great great aunts,
Supported on the mantelpiece
 An *Invitation to the Dance.*

I shall not want Honour in Heaven
 For I shall meet Sir Philip Sidney
And have talk with Coriolanus
 And other heroes of that kidney.

I shall not want Capital in Heaven
 For I shall meet Sir Alfred Mond.
We two shall lie together, lapt
 In a five per cent. Exchequer Bond.

I shall not want Society in Heaven,
 Lucretia Borgia shall be my Bride;
Her anecdotes will be more amusing
 Than Pipit's experience could provide.

I shall not want Pipit in Heaven:
 Madame Blavatsky will instruct me
In the Seven Sacred Trances;
 Piccarda de Donati will conduct me.

But where is the penny world I bought
 To eat with Pipit behind the screen?
The red-eyed scavengers are creeping
 From Kentish Town and Golder's Green;

Where are the eagles and the trumpets?

 Buried beneath some snow-deep Alps.
Over buttered scones and crumpets
 Weeping, weeping multitudes
Droop in a hundred A.B.C.'s

LE DIRECTEUR

Malheur à la malheureuse Tamise
Qui coule si près du Spectateur.
Le directeur
Conservateur
Du Spectateur
Empeste la brise.
Les actionnaires
Réactionnaires
Du Spectateur
Conservateur
Bras dessus bras dessous
Font des tours
A pas de loup.
Dans un égout
Une petite fille
En guenilles
Camarde
Regarde
Le directeur
Du Spectateur
Conservateur
Et crève d'amour.

MÉLANGE ADULTÈRE DE TOUT

En Amérique, professeur;
En Angleterre, journaliste;
C'est à grands pas et en sueur
Que vous suivrez à peine ma piste.
En Yorkshire, conférencier;
A Londres, un peu banquier,
Vous me paierez bien la tête.

C'est à Paris que je me coiffe
Casque noir de jemenfoutiste.
En Allemagne, philosophe
Surexcité par Emporheben
Au grand air de Bergsteigleben;
J'erre toujours de-ci de-là
A divers coups de tra là là
De Damas jusqu'à Omaha.
Je célébrai mon jour de fête
Dans une oasis d'Afrique
Vetu d'une peau de girafe.

On montrera mon cénotaphe
Aux côtes brulantes de Mozambique.

LUNE DE MIEL

Ils ont vu les Pays-Bas, ils rentrent à Terre Haute;
Mais une nuit d'été, les voici à Ravenne,
A l'aise entre deux draps, chez deux centaines de punaises;
La sueur aestivale, et une forte odeur de chienne.
Ils restent sur le dos écartant les genoux
De quatre jambes molles tout gonflées de morsures.
On relève le drap pour mieux égratigner.
Moins d'une lieue d'ici est Saint Apollinaire
En Classe, basilique connue des amateurs
De chapitaux d'acanthe que tournoie le vent.

Ils vont prendre le train de huit heures
Prolonger leurs misères de Padoue à Milan
Où se trouvent la Cène, et un restaurant pas cher.
Lui pense aux pourboires, et rédige son bilan.
Ils auront vu la Suisse et traversé la France.
Et Saint Apollinaire, raide et ascétique,
Vieille usine désaffectée de Dieu, tient encore
Dans ses pierres écroulantes la forme précise de Byzance.

THE HIPPOPOTAMUS

Similiter et omnes revereantur Diaconos, ut mandatum Jesu Christi; et Episco-
pum, ut Jesum Christum, existentem filium Patris; Presbyteros autem, ut con-
cilium Dei et conjunctionem Apostolorum. Sine his Ecclesia non vocatur; de
quibus suadeo vos sic habeo. S. IGNATII AD TRALLIANOS.

And when this epistle is read among you, cause that it be read also in the
church of the Laodiceans.

The broad-backed hippopotamus
Rests on his belly in the mud;
Although he seems so firm to us
He is merely flesh and blood.

Flesh and blood is weak and frail,
Susceptible to nervous shock;
While the True Church can never fail
For it is based upon a rock.

The hippo's feeble steps may err
In compassing material ends,
While the True Church need never stir
To gather in its dividends.

The 'potamus can never reach
The mango on the mango-tree;
But fruits of pomegranate and peach
Refresh the Church from over sea.

At mating time the hippo's voice
Betrays inflexions hoarse and odd,
But every week we hear rejoice
The Church, at being one with God.

The hippopotamus's day
Is passed in sleep; at night he hunts;

God works in a mysterious way—
The Church can sleep and feed at once.

I saw the 'potamus take wing
Ascending from the damp savannas,
And quiring angels round him sing
The praise of God, in loud hosannas.

Blood of the Lamb shall wash him clean
And him shall heavenly arms enfold,
Among the saints he shall be seen
Performing on a harp of gold.

He shall be washed as white as snow,
By all the martyr'd virgins kist,
While the True Church remains below
Wrapt in the old miasmal mist.

DANS LE RESTAURANT

Le garçon délabré qui n'a rien à faire
Que de se gratter les doigts et se pencher sur mon épaule:
　"Dans mon pays il fera temps pluvieux,
　Du vent, du grand soleil, et de la pluie;
　C'est ce qu'on appelle le jour de lessive des gueux."
(Bavard, baveux, à la croupe arrondie,
Je te prie, au moins, ne bave pas dans la soupe.)
　"Les saules trempés, et des bourgeons sur les ronces—
　C'est là, dans une averse, qu'on s'abrite.
J'avais sept ans, elle était plus petite.
　Elle était toute mouillée, je lui ai donné des primevères."
Les taches de son gilet montent au chiffre de trente-huit.
　"Je la chatouillais, pour la faire rire.
　J'éprouvais un instant de puissance et de délire."

Mais alors, vieux lubrique, à cet âge . . .
"Monsieur, le fait est dur.
 Il est venu, nous peloter, un gros chien;
 Moi j'avais peur, je l'ai quittée à mi-chemin.
 C'est dommage."
 Mais alors, tu as ton vautour!

 Va t'en te décrotter les rides du visage;
Tiens, ma fourchette, décrasse-toi le crâne.
De quel droit payes-tu des expériences comme moi?
Tiens, voilà dix sous, pour la salle-de-bains.

 Phlébas, le Phénicien, pendant quinze jours noyé,
Oubliait les cris des mouettes et la houle de Cornouaille,
Et les profits et les pertes, et la cargaison d'étain:
Un courant de sous-mer l'emporta très loin,
Le repassant aux étapes de sa vie antérieure.
Figurez-vous donc, c'était un sort pénible;
Cependant, ce fut jadis un bel homme, de haute taille.

WHISPERS OF IMMORTALITY

Webster was much possessed by death
And saw the skull beneath the skin;
And breastless creatures under ground
Leaned backward with a lipless grin.

 Daffodil bulbs instead of balls
Stared from the sockets of the eyes!
He knew that thought clings round dead limbs
Tightening its lusts and luxuries.

 Donne, I suppose, was such another
Who found no substitute for sense,
To seize and clutch and penetrate;
Expert beyond experience,

He knew the anguish of the marrow
The ague of the skeleton;
No contact possible to flesh
Allayed the fever of the bone.

.

Grishkin is nice: her Russian eye
Is underlined for emphasis;
Uncorseted, her friendly bust
Gives promise of pneumatic bliss.

The couched Brazilian jaguar
Compels the scampering marmoset
With subtle effluence of cat;
Grishkin has a maisonette;

The sleek Brazilian jaguar
Does not in its arboreal gloom
Distil so rank a feline smell
As Grishkin in a drawing-room.

And even the Abstract Entities
Circumambulate her charm;
But our lot crawls between dry ribs
To keep our metaphysics warm.

MR. ELIOT'S SUNDAY MORNING SERVICE

Look, look, master, here comes two religious caterpillars.
THE JEW OF MALTA.

Polyphiloprogenitive
The sapient sutlers of the Lord
Drift across the window-panes.
In the beginning was the Word.

In the beginning was the Word.
Superfetation of τὸ ἕν,

And at the mensual turn of time
Produced enervate Origen.

A painter of the Umbrian school
Designed upon a gesso ground
The nimbus of the Baptized God.
The wilderness is cracked and browned

But through the water pale and thin
Still shine the unoffending feet
And there above the painter set
The Father and the Paraclete.

.

The sable presbyters approach
The avenue of penitence;
The young are red and pustular
Clutching piaculative pence.

Under the penitential gates
Sustained by staring Seraphim
Where the souls of the devout
Burn invisible and dim.

Along the garden-wall the bees
With hairy bellies pass between
The staminate and pistilate,
Blest office of the epicene.

Sweeney shifts from ham to ham
Stirring the water in his bath.
The masters of the subtle schools
Are controversial, polymath.

SWEENEY AMONG THE NIGHTINGALES

ὤμοι, πέπληγμαι καιρίαν πληγὴν ἔσω.

Apeneck Sweeney spreads his knees
Letting his arms hang down to laugh,
The zebra stripes along his jaw
Swelling to maculate giraffe.

The circles of the stormy moon
Slide westward toward the River Plate,
Death and the Raven drift above
And Sweeney guards the hornèd gate.

Gloomy Orion and the Dog
Are veiled; and hushed the shrunken seas;
The person in the Spanish cape
Tries to sit on Sweeney's knees

Slips and pulls the table cloth
Overturns a coffee-cup,
Reorganized upon the floor
She yawns and draws a stocking up;

The silent man in mocha brown
Sprawls at the window-sill and gapes;
The waiter brings in oranges
Bananas figs and hothouse grapes;

The silent vertebrate in brown
Contracts and concentrates, withdraws;
Rachel *née* Rabinovitch
Tears at the grapes with murderous paws;

She and the lady in the cape
Are suspect, thought to be in league;

Therefore the man with heavy eyes
Declines the gambit, shows fatigue,

Leaves the room and reappears
Outside the window, leaning in,
Branches of wistaria
Circumscribe a golden grin;

The host with someone indistinct
Converses at the door apart,
The nightingales are singing near
The Convent of the Sacred Heart,

And sang within the bloody wood
When Agamemnon cried aloud,
And let their liquid siftings fall
To stain the stiff dishonoured shroud.

The Waste Land
1922

"Nam Sibyllam quidem Cumis ego ipse oculis meis vidi
in ampulla pendere, et cum illi pueri dicerent: Σίβυλλα
τί θέλεις; respondebat illa: ἀποθανεῖν θέλω."

For Ezra Pound
il miglior fabbro.

I. THE BURIAL OF THE DEAD

April is the cruellest month, breeding
Lilacs out of the dead land, mixing
Memory and desire, stirring
Dull roots with spring rain.
Winter kept us warm, covering
Earth in forgetful snow, feeding
A little life with dried tubers.
Summer surprised us, coming over the Starnbergersee
With a shower of rain; we stopped in the colonnade,
And went on in sunlight, into the Hofgarten, 10
And drank coffee, and talked for an hour.
Bin gar keine Russin, stamm' aus Litauen, echt deutsch.
And when we were children, staying at the archduke's,
My cousin's, he took me out on a sled,
And I was frightened. He said, Marie,
Marie, hold on tight. And down we went.
In the mountains, there you feel free.
I read, much of the night, and go south in the winter.

What are the roots that clutch, what branches grow
Out of this stony rubbish? Son of man, 20
You cannot say, or guess, for you know only
A heap of broken images, where the sun beats,
And the dead tree gives no shelter, the cricket no relief,
And the dry stone no sound of water. Only
There is shadow under this red rock,
(Come in under the shadow of this red rock),
And I will show you something different from either
Your shadow at morning striding behind you
Or your shadow at evening rising to meet you;
I will show you fear in a handful of dust. 30

 Frisch weht der Wind
 Der Heimat zu
 Mein Irisch Kind,
 Wo weilest du?

"You gave me hyacinths first a year ago;
"They called me the hyacinth girl."
—Yet when we came back, late, from the Hyacinth garden,
Your arms full, and your hair wet, I could not
Speak, and my eyes failed, I was neither
Living nor dead, and I knew nothing, 40
Looking into the heart of light, the silence.
Oed' und leer das Meer.

 Madame Sosostris, famous clairvoyante,
Had a bad cold, nevertheless
Is known to be the wisest woman in Europe,
With a wicked pack of cards. Here, said she,
Is your card, the drowned Phoenician Sailor,
(Those are pearls that were his eyes. Look!)
Here is Belladonna, the Lady of the Rocks,
The lady of situations. 50
Here is the man with three staves, and here the Wheel,
And here is the one-eyed merchant, and this card,
Which is blank, is something he carries on his back,
Which I am forbidden to see. I do not find

The Hanged Man. Fear death by water.
I see crowds of people, walking round in a ring.
Thank you. If you see dear Mrs. Equitone,
Tell her I bring the horoscope myself:
One must be so careful these days.

 Unreal City, 60
Under the brown fog of a winter dawn,
A crowd flowed over London Bridge, so many,
I had not thought death had undone so many.
Sighs, short and infrequent, were exhaled,
And each man fixed his eyes before his feet.
Flowed up the hill and down King William Street,
To where Saint Mary Woolnoth kept the hours
With a dead sound on the final stroke of nine.
There I saw one I knew, and stopped him, crying: "Stetson!
"You who were with me in the ships at Mylae! 70
"That corpse you planted last year in your garden,
"Has it begun to sprout? Will it bloom this year?
"Or has the sudden frost disturbed its bed?
"Oh keep the Dog far hence, that's friend to men,
"Or with his nails he'll dig it up again!
"You! hypocrite lecteur!—mon semblable,—mon frère!"

II. A GAME OF CHESS

The Chair she sat in, like a burnished throne,
Glowed on the marble, where the glass
Held up by standards wrought with fruited vines
From which a golden Cupidon peeped out 80
(Another hid his eyes behind his wing)
Doubled the flames of sevenbranched candelabra
Reflecting light upon the table as
The glitter of her jewels rose to meet it,
From satin cases poured in rich profusion;

In vials of ivory and coloured glass
Unstoppered, lurked her strange synthetic perfumes,
Unguent, powdered, or liquid—troubled, confused
And drowned the sense in odours; stirred by the air
That freshened from the window, these ascended 90
In fattening the prolonged candle-flames,
Flung their smoke into the laquearia,
Stirring the pattern on the coffered ceiling.
Huge sea-wood fed with copper
Burned green and orange, framed by the coloured stone,
In which sad light a carvèd dolphin swam.
Above the antique mantel was displayed
As though a window gave upon the sylvan scene
The change of Philomel, by the barbarous king
So rudely forced; yet there the nightingale 100
Filled all the desert with inviolable voice
And still she cried, and still the world pursues,
"Jug Jug" to dirty ears.
And other withered stumps of time
Were told upon the walls; staring forms
Leaned out, leaning, hushing the room enclosed.
Footsteps shuffled on the stair.
Under the firelight, under the brush, her hair
Spread out in fiery points
Glowed into words, then would be savagely still. 110

 "My nerves are bad to-night. Yes, bad. Stay with me.
"Speak to me. Why do you never speak. Speak.
 "What are you thinking of? What thinking? What?
"I never know what you are thinking. Think."

 I think we are in rats' alley
Where the dead men lost their bones.

 "What is that noise?"
 The wind under the door.
"What is that noise now? What is the wind doing?"
 Nothing again nothing. 120

 "Do
"You know nothing? Do you see nothing? Do you remember
"Nothing?"

 I remember
Those are pearls that were his eyes.
"Are you alive, or not? Is there nothing in your head?"
 But

O O O O that Shakespeherian Rag—
It's so elegant
So intelligent 130
"What shall I do now? What shall I do?"
"I shall rush out as I am, and walk the street
"With my hair down, so. What shall we do to-morrow?
"What shall we ever do?"
 The hot water at ten.
And if it rains, a closed car at four.
And we shall play a game of chess,
Pressing lidless eyes and waiting for a knock upon the door.

 When Lil's husband got demobbed, I said—
I didn't mince my words, I said to her myself, 140
HURRY UP PLEASE ITS TIME
Now Albert's coming back, make yourself a bit smart.
He'll want to know what you done with that money he gave you
To get yourself some teeth. He did, I was there.
You have them all out, Lil, and get a nice set,
He said, I swear, I can't bear to look at you.
And no more can't I, I said, and think of poor Albert,
He's been in the army four years, he wants a good time,
And if you don't give it him, there's others will, I said.
Oh is there, she said. Something o' that, I said. 150
Then I'll know who to thank, she said, and give me a
 straight look.
HURRY UP PLEASE ITS TIME
If you don't like it you can get on with it, I said.
Others can pick and choose if you can't.

But if Albert makes off, it won't be for lack of telling.
You ought to be ashamed, I said, to look so antique.
(And her only thirty-one.)
I can't help it, she said, pulling a long face,
It's them pills I took, to bring it off, she said.
(She's had five already, and nearly died of young George.) 160
The chemist said it would be all right, but I've never been
 the same.
You are a proper fool, I said.
Well, if Albert won't leave you alone, there it is, I said,
What you get married for if you don't want children?
HURRY UP PLEASE ITS TIME
Well, that Sunday Albert was home, they had a hot gammon,
And they asked me in to dinner, to get the beauty of it hot—
HURRY UP PLEASE ITS TIME
HURRY UP PLEASE ITS TIME
Goonight Bill. Goonight Lou. Goonight May. Goonight. 170
Ta ta. Goonight. Goonight.
Good night, ladies, good night, sweet ladies, good night,
 good night.

III. THE FIRE SERMON

The river's tent is broken: the last fingers of leaf
Clutch and sink into the wet bank. The wind
Crosses the brown land, unheard. The nymphs are departed.
Sweet Thames, run softly, till I end my song.
The river bears no empty bottles, sandwich papers,
Silk handkerchiefs, cardboard boxes, cigarette ends
Or other testimony of summer nights. The nymphs are departed.
And their friends, the loitering heirs of city directors; 180
Departed, have left no addresses.
By the waters of Leman I sat down and wept . . .
Sweet Thames, run softly till I end my song,
Sweet Thames, run softly, for I speak not loud or long.
But at my back in a cold blast I hear

The rattle of the bones, and chuckle spread from ear to ear.
A rat crept softly through the vegetation
Dragging its slimy belly on the bank
While I was fishing in the dull canal
On a winter evening round behind the gashouse 190
Musing upon the king my brother's wreck
And on the king my father's death before him.
White bodies naked on the low damp ground
And bones cast in a little low dry garret,
Rattled by the rat's foot only, year to year.
But at my back from time to time I hear
The sound of horns and motors, which shall bring
Sweeney to Mrs. Porter in the spring.
O the moon shone bright on Mrs. Porter
And on her daughter 200
They wash their feet in soda water
Et O ces voix d'enfants, chantant dans la coupole!

 Twit twit twit
Jug jug jug jug jug jug
So rudely forc'd.
Tereu

 Unreal City
Under the brown fog of a winter noon
Mr. Eugenides, the Smyrna merchant
Unshaven, with a pocket full of currants 210
C.i.f. London: documents at sight,
Asked me in demotic French
To luncheon at the Cannon Street Hotel
Followed by a weekend at the Metropole.

 At the violet hour, when the eyes and back
Turn upward from the desk, when the human engine waits
Like a taxi throbbing waiting,
I Tiresias, though blind, throbbing between two lives,
Old man with wrinkled female breasts, can see
At the violet hour, the evening hour that strives 220

Homeward, and brings the sailor home from sea,
The typist home at teatime, clears her breakfast, lights
Her stove, and lays out food in tins.
Out of the window perilously spread
Her drying combinations touched by the sun's last rays,
On the divan are piled (at night her bed)
Stockings, slippers, camisoles, and stays.
I Tiresias, old man with wrinkled dugs
Perceived the scene, and foretold the rest—
I too awaited the expected guest. 230
He, the young man carbuncular, arrives,
A small house agent's clerk, with one bold stare,
One of the low on whom assurance sits
As a silk hat on a Bradford millionaire.
The time is now propitious, as he guesses,
The meal is ended, she is bored and tired,
Endeavours to engage her in caresses
Which still are unreproved, if undesired.
Flushed and decided, he assaults at once;
Exploring hands encounter no defence; 240
His vanity requires no response,
And makes a welcome of indifference.
(And I Tiresias have foresuffered all
Enacted on this same divan or bed;
I who have sat by Thebes below the wall
And walked among the lowest of the dead.)
Bestows one final patronising kiss,
And gropes his way, finding the stairs unlit . . .

　　She turns and looks a moment in the glass,
Hardly aware of her departed lover; 250
Her brain allows one half-formed thought to pass:
"Well now that's done: and I'm glad it's over."
When lovely woman stoops to folly and
Paces about her room again, alone,
She smoothes her hair with automatic hand,
And puts a record on the gramophone.

"This music crept by me upon the waters"
And along the Strand, up Queen Victoria Street.
O City city, I can sometimes hear
Beside a public bar in Lower Thames Street, 260
The pleasant whining of a mandoline
And a clatter and a chatter from within
Where fishmen lounge at noon: where the walls
Of Magnus Martyr hold
Inexplicable splendour of Ionian white and gold.

 The river sweats
 Oil and tar
 The barges drift
 With the turning tide
 Red sails 270
 Wide
 To leeward, swing on the heavy spar.
 The barges wash
 Drifting logs
 Down Greenwich reach
 Past the Isle of Dogs.
 Weialala leia
 Wallala leialala

 Elizabeth and Leicester
 Beating oars 280
 The stern was formed
 A gilded shell
 Red and gold
 The brisk swell
 Rippled both shores
 Southwest wind
 Carried down stream
 The peal of bells
 White towers
 Weialala leia 290
 Wallala leialala

"Trams and dusty trees.
Highbury bore me. Richmond and Kew
Undid me. By Richmond I raised my knees
Supine on the floor of a narrow canoe."

"My feet are at Moorgate, and my heart
Under my feet. After the event
He wept. He promised 'a new start.'
I made no comment. What should I resent?"

"On Margate Sands. 300
I can connect
Nothing with nothing.
The broken fingernails of dirty hands.
My people humble people who expect
Nothing."
 la la

To Carthage then I came

Burning burning burning burning
O Lord Thou pluckest me out
O Lord Thou pluckest 310

burning

———————————

IV. DEATH BY WATER

Phlebas the Phoenician, a fortnight dead,
Forgot the cry of gulls, and the deep sea swell
And the profit and loss.
 A current under sea
Picked his bones in whispers. As he rose and fell
He passed the stages of his age and youth
Entering the whirlpool.
 Gentile or Jew

O you who turn the wheel and look to windward, 320
Consider Phlebas, who was once handsome and tall as you.

V. WHAT THE THUNDER SAID

After the torchlight red on sweaty faces
After the frosty silence in the gardens
After the agony in stony places
The shouting and the crying
Prison and palace and reverberation
Of thunder of spring over distant mountains
He who was living is now dead
We who were living are now dying
With a little patience 330

 Here is no water but only rock
Rock and no water and the sandy road
The road winding above among the mountains
Which are mountains of rock without water
If there were water we should stop and drink
Amongst the rock one cannot stop or think
Sweat is dry and feet are in the sand
If there were only water amongst the rock
Dead mountain mouth of carious teeth that cannot spit
Here one can neither stand nor lie nor sit 340
There is not even silence in the mountains
But dry sterile thunder without rain
There is not even solitude in the mountains
But red sullen faces sneer and snarl
From doors of mudcracked houses
 If there were water
 And no rock
 If there were rock
 And also water
 And water 350
 A spring

A pool among the rock
If there were the sound of water only
Not the cicada
And dry grass singing
But sound of water over a rock
Where the hermit-thrush sings in the pine trees
Drip drop drip drop drop drop drop
But there is no water

Who is the third who walks always beside you? 360
When I count, there are only you and I together
But when I look ahead up the white road
There is always another one walking beside you
Gliding wrapt in a brown mantle, hooded
I do not know whether a man or a woman
—But who is that on the other side of you?

What is that sound high in the air
Murmur of maternal lamentation
Who are those hooded hordes swarming
Over endless plains, stumbling in cracked earth 370
Ringed by the flat horizon only
What is the city over the mountains
Cracks and reforms and bursts in the violet air
Falling towers
Jerusalem Athens Alexandria
Vienna London
Unreal

A woman drew her long black hair out tight
And fiddled whisper music on those strings
And bats with baby faces in the violet light 380
Whistled, and beat their wings
And crawled head downward down a blackened wall
And upside down in air were towers
Tolling reminiscent bells, that kept the hours
And voices singing out of empty cisterns and exhausted wells.

In this decayed hole among the mountains
In the faint moonlight, the grass is singing
Over the tumbled graves, about the chapel
There is the empty chapel, only the wind's home.
It has no windows, and the door swings, 390
Dry bones can harm no one.
Only a cock stood on the rooftree
Co co rico co co rico
In a flash of lightning. Then a damp gust
Bringing rain

Ganga was sunken, and the limp leaves
Waited for rain, while the black clouds
Gathered far distant, over Himavant.
The jungle crouched, humped in silence.
Then spoke the thunder 400
Da
Datta: what have we given?
My friend, blood shaking my heart
The awful daring of a moment's surrender
Which an age of prudence can never retract
By this, and this only, we have existed
Which is not to be found in our obituaries
Or in memories draped by the beneficent spider
Or under seals broken by the lean solicitor
In our empty rooms 410
Da
Dayadhvam: I have heard the key
Turn in the door once and turn once only
We think of the key, each in his prison
Thinking of the key, each confirms a prison
Only at nightfall, aethereal rumours
Revive for a moment a broken Coriolanus
Da
Damyata: The boat responded
Gaily, to the hand expert with sail and oar 420
The sea was calm, your heart would have responded

Gaily, when invited, beating obedient
To controlling hands

 I sat upon the shore
Fishing, with the arid plain behind me
Shall I at least set my lands in order?
London Bridge is falling down falling down falling down
Poi s'ascose nel foco che gli affina
Quando fiam uti chelidon—O swallow swallow
Le Prince d'Aquitaine à la tour abolie 430
These fragments I have shored against my ruins
Why then Ile fit you. Hieronymo's mad againe.
Datta. Dayadhvam. Damyata.
 Shantih shantih shantih

NOTES ON "THE WASTE LAND"

Not only the title, but the plan and a good deal of the incidental symbol-
ism of the poem were suggested by Miss Jessie L. Weston's book on the
Grail legend: *From Ritual to Romance* (Cambridge). Indeed, so deeply
am I indebted, Miss Weston's book will elucidate the difficulties of the
poem much better than my notes can do; and I recommend it (apart
from the great interest of the book itself) to any who think such elucida-
tion of the poem worth the trouble. To another work of anthropology I
am indebted in general, one which has influenced our generation pro-
foundly; I mean *The Golden Bough;* I have used especially the two
volumes *Adonis, Attis, Osiris.* Anyone who is acquainted with these
works will immediately recognise in the poem certain references to vege-
tation ceremonies.

I. THE BURIAL OF THE DEAD

Line 20. Cf. Ezekiel II, i.
23. Cf. Ecclesiastes XII, v.
31. V. Tristan und Isolde, I, verses 5–8.

42. Id. III, verse 24.

46. I am not familiar with the exact constitution of the Tarot pack of cards, from which I have obviously departed to suit my own convenience. The Hanged Man, a member of the traditional pack, fits my purpose in two ways: because he is associated in my mind with the Hanged God of Frazer, and because I associate him with the hooded figure in the passage of the disciples to Emmaus in Part V. The Phoenician Sailor and the Merchant appear later; also the "crowds of people," and Death by Water is executed in Part IV. The Man with Three Staves (an authentic member of the Tarot pack) I associate, quite arbitrarily, with the Fisher King himself.

60. Cf. Baudelaire:
"Fourmillante cité, cité pleine de rêves,
"Où le spectre en plein jour raccroche le passant."

63. Cf. Inferno III, 55–57:
"si lunga tratta
di gente, ch'io non avrei mai creduto
che morte tanta n'avesse disfatta."

64. Cf. Inferno IV, 25–27:
"Quivi, secondo che per ascoltare,
"non avea pianto, ma' che di sospiri,
"che l'aura eterna facevan tremare."

68. A phenomenon which I have often noticed.

74. Cf. the Dirge in Webster's *White Devil*.

76. V. Baudelaire, Preface to *Fleurs du Mal*.

II. A GAME OF CHESS

77. Cf. *Antony and Cleopatra*, II, ii, l. 190.

92. Laquearia. V. *Aeneid*, I, 726:
dependent lychni laquearibus aureis incensi, et noctem flammis funalia vincunt.

98. Sylvan scene. V. Milton, *Paradise Lost*, IV, 140.

99. V. Ovid, *Metamorphoses*, VI, Philomela.

100. Cf. Part III, l. 204.

115. Cf. Part III, l. 195.

118. Cf. Webster: "Is the wind in that door still?"

126. Cf. Part I, l. 37, 48.

138. Cf. the game of chess in Middleton's *Women beware Women*.

III. THE FIRE SERMON

176. V. Spenser, *Prothalamion.*

192. Cf. *The Tempest,* I, ii.

196. Cf. Marvell, *To His Coy Mistress.*

197. Cf. Day, *Parliament of Bees:*

"When of the sudden, listening, you shall hear,

"A noise of horns and hunting, which shall bring

"Actaeon to Diana in the spring,

"Where all shall see her naked skin . . ."

199. I do not know the origin of the ballad from which these lines are taken: it was reported to me from Sydney, Australia.

202. V. Verlaine, *Parsifal.*

210. The currants were quoted at a price "carriage and insurance free to London"; and the Bill of Lading etc. were to be handed to the buyer upon payment of the sight draft.

218. Tiresias, although a mere spectator and not indeed a "character," is yet the most important personage in the poem, uniting all the rest. Just as the one-eyed merchant, seller of currants, melts into the Phoenician Sailor, and the latter is not wholly distinct from Ferdinand Prince of Naples, so all the women are one woman, and the two sexes meet in Tiresias. What Tiresias *sees,* in fact, is the substance of the poem. The whole passage from Ovid is of great anthropological interest:

'. . . Cum Iunone iocos et maior vestra profecto est

Quam, quae contingit maribus,' dixisse, 'voluptas.'

Illa negat; placuit quae sit sententia docti

Quaerere Tiresiae: venus huic erat utraque nota.

Nam duo magnorum viridi coeuntia silva

Corpora serpentum baculi violaverat ictu

Deque viro factus, mirabile, femina septem

Egerat autumnos; octavo rursus eosdem

Vidit et 'est vestrae si tanta potentia plagae,'

Dixit 'ut auctoris sortem in contraria mutet,

Nunc quoque vos feriam!' percussis anguibus isdem

Forma prior rediit genetivaque venit imago.

Arbiter hic igitur sumptus de lite iocosa

Dicta Iovis firmat; gravius Saturnia iusto

Nec pro materia fertur doluisse suique

Iudicis aeterna damnavit lumina nocte,

At pater omnipotens (neque enim licet inrita cuiquam
Facta dei fecisse deo) pro lumine adempto
Scire futura dedit poenamque levavit honore.

221. This may not appear as exact as Sappho's lines, but I had in mind the "longshore" or "dory" fisherman, who returns at nightfall.

253. V Goldsmith, the song in *The Vicar of Wakefield*.

257. V. *The Tempest*, as above.

264. The interior of St. Magnus Martyr is to my mind one of the finest among Wren's interiors. See *The Proposed Demolition of Nineteen City Churches:* (P. S. King & Son, Ltd.).

266. The Song of the (three) Thames-daughters begins here. From line 292 to 306 inclusive they speak in turn. V. *Götterdämmerung*, III, i: the Rhine-daughters.

279. V. Froude, *Elizabeth*, Vol. I, ch. iv, letter of De Quadra to Philip of Spain:

"In the afternoon we were in a barge, watching the games on the river. (The queen) was alone with Lord Robert and myself on the poop, when they began to talk nonsense, and went so far that Lord Robert at last said, as I was on the spot there was no reason why they should not be married if the queen pleased."

293. Cf. *Purgatorio*, V, 133:

"Ricorditi di me, che son la Pia;
"Siena mi fe', disfecemi Maremma."

307. V. St. Augustine's *Confessions:* "to Carthage then I came, where a cauldron of unholy loves sang all about mine ears."

308. The complete text of the Buddha's Fire Sermon (which corresponds in importance to the Sermon on the Mount) from which these words are taken, will be found translated in the late Henry Clarke Warren's *Buddhism in Translation* (Harvard Oriental Series). Mr. Warren was one of the great pioneers of Buddhist studies in the Occident.

309. From St. Augustine's *Confessions* again. The collocation of these two representatives of eastern and western asceticism, as the culmination of this part of the poem, is not an accident.

V. WHAT THE THUNDER SAID

In the first part of Part V three themes are employed: the journey to Emmaus, the approach to the Chapel Perilous (see Miss Weston's book) and the present decay of eastern Europe.

357. This is *Turdus aonalaschkae pallasii,* the hermit-thrush which I have heard in Quebec Province. Chapman says (*Handbook of Birds of Eastern North America*) "it is most at home in secluded woodland and thickety retreats. . . . Its notes are not remarkable for variety or volume, but in purity and sweetness of tone and exquisite modulation they are unequalled." Its "water-dripping song" is justly celebrated.

360. The following lines were stimulated by the account of one of the Antarctic expeditions (I forget which, but I think one of Shackleton's): it was related that the party of explorers, at the extremity of their strength, had the constant delusion that there was *one more member* than could actually be counted.

367–77. Cf. Hermann Hesse, *Blick ins Chaos:* "Schon ist halb Europa, schon ist zumindest der halbe Osten Europas auf dem Wege zum Chaos, fährt betrunken im heiligem Wahn am Abgrund entlang und singt dazu, singt betrunken und hymnisch wie Dmitri Karamasoff sang. Ueber diese Lieder lacht der Bürger beleidigt, der Heilige und Seher hört sie mit Tränen."

402. "Datta, dayadhvam, damyata" (Give, sympathise, control). The fable of the meaning of the Thunder is found in the *Brihadaranyaka—Upanishad,* 5, 1. A translation is found in Deussen's *Sechzig Upanishads des Veda,* p. 489.

408. Cf. Webster, *The White Devil,* V, vi:

<div style="text-align:right">". . . they'll remarry</div>
Ere the worm pierce your winding-sheet, ere the spider
Make a thin curtain for your epitaphs."

412. Cf. *Inferno,* XXXIII, 46:
"ed io sentii chiavar l'uscio di sotto
all'orribile torre."
Also F. H. Bradley, *Appearance and Reality,* p. 346.
"My external sensations are no less private to myself than are my thoughts or my feelings. In either case my experience falls within my own circle, a circle closed on the outside; and, with all its elements alike, every sphere is opaque to the others which surround it. . . . In brief, regarded as an existence which appears in a soul, the whole world for each is peculiar and private to that soul."

425. V. Weston: *From Ritual to Romance;* chapter on the Fisher King.

428. V. *Purgatorio,* XXVI, 148.
" 'Ara vos prec per aquella valor
'que vos guida al som de l'escalina,

'sovegna vos a temps de ma dolor.'
Poi s'ascose nel foco che gli affina."

429. V. *Pervigilium Veneris*. Cf. Philomela in Parts II and III.

430. V. Gerard de Nerval, Sonnet *El Desdichado*.

432. V. Kyd's *Spanish Tragedy*.

434. Shantih. Repeated as here, a formal ending to an Upanishad. "The Peace which passeth understanding" is our equivalent to this word.

The Hollow Men
1925

Mistah Kurtz—he dead.

THE HOLLOW MEN

A penny for the Old Guy

I

We are the hollow men
We are the stuffed men
Leaning together
Headpiece filled with straw. Alas!
Our dried voices, when
We whisper together
Are quiet and meaningless
As wind in dry grass
Or rats' feet over broken glass
In our dry cellar

 Shape without form, shade without colour,
Paralysed force, gesture without motion;

 Those who have crossed
With direct eyes, to death's other Kingdom
Remember us—if at all—not as lost
Violent souls, but only
As the hollow men
The stuffed men.

II

Eyes I dare not meet in dreams
In death's dream kingdom
These do not appear:
There, the eyes are
Sunlight on a broken column
There, is a tree swinging
And voices are
In the wind's singing
More distant and more solemn
Than a fading star.

Let me be no nearer
In death's dream kingdom
Let me also wear
Such deliberate disguises
Rat's coat, crowskin, crossed staves
In a field
Behaving as the wind behaves
No nearer—

Not that final meeting
In the twilight kingdom

III

This is the dead land
This is cactus land
Here the stone images
Are raised, here they receive
The supplication of a dead man's hand
Under the twinkle of a fading star.

Is it like this
In death's other kingdom
Waking alone
At the hour when we are

Trembling with tenderness
Lips that would kiss
Form prayers to broken stone.

IV

The eyes are not here
There are no eyes here
In this valley of dying stars
In this hollow valley
This broken jaw of our lost kingdoms

In this last of meeting places
We grope together
And avoid speech
Gathered on this beach of the tumid river

Sightless, unless
The eyes reappear
As the perpetual star
Multifoliate rose
Of death's twilight kingdom
The hope only
Of empty men.

V

Here we go round the prickly pear
Prickly pear prickly pear
Here we go round the prickly pear
At five o'clock in the morning.

Between the idea
And the reality
Between the motion
And the act
Falls the Shadow
 For Thine is the Kingdom

 Between the conception
And the creation
Between the emotion
And the response
Falls the Shadow
 Life is very long

 Between the desire
And the spasm
Between the potency
And the existence
Between the essence
And the descent
Falls the Shadow
 For Thine is the Kingdom

 For Thine is
Life is
For Thine is the

 This is the way the world ends
This is the way the world ends
This is the way the world ends
Not with a bang but a whimper.

Ash-Wednesday
1930

I

Because I do not hope to turn again
Because I do not hope
Because I do not hope to turn
Desiring this man's gift and that man's scope
I no longer strive to strive towards such things
(Why should the agèd eagle stretch its wings?)
Why should I mourn
The vanished power of the usual reign?

Because I do not hope to know again
The infirm glory of the positive hour
Because I do not think
Because I know I shall not know
The one veritable transitory power
Because I cannot drink
There, where trees flower, and springs flow, for there is nothing again

Because I know that time is always time
And place is always and only place
And what is actual is actual only for one time
And only for one place
I rejoice that things are as they are and
I renounce the blessèd face
And renounce the voice
Because I cannot hope to turn again

Consequently I rejoice, having to construct something
Upon which to rejoice

And pray to God to have mercy upon us
And I pray that I may forget
These matters that with myself I too much discuss
Too much explain
Because I do not hope to turn again
Let these words answer
For what is done, not to be done again
May the judgement not be too heavy upon us

Because these wings are no longer wings to fly
But merely vans to beat the air
The air which is now thoroughly small and dry
Smaller and dryer than the will
Teach us to care and not to care
Teach us to sit still.

Pray for us sinners now and at the hour of our death
Pray for us now and at the hour of our death.

II

Lady, three white leopards sat under a juniper-tree
In the cool of the day, having fed to satiety
On my legs my heart my liver and that which had been contained
In the hollow round of my skull. And God said
Shall these bones live? shall these
Bones live? And that which had been contained
In the bones (which were already dry) said chirping:
Because of the goodness of this Lady
And because of her loveliness, and because
She honours the Virgin in meditation,
We shine with brightness. And I who am here dissembled
Proffer my deeds to oblivion, and my love
To the posterity of the desert and the fruit of the gourd.
It is this which recovers
My guts the strings of my eyes and the indigestible portions

Which the leopards reject. The Lady is withdrawn
In a white gown, to contemplation, in a white gown.
Let the whiteness of bones atone to forgetfulness.
There is no life in them. As I am forgotten
And would be forgotten, so I would forget
Thus devoted, concentrated in purpose. And God said
Prophesy to the wind, to the wind only for only
The wind will listen. And the bones sang chirping
With the burden of the grasshopper, saying

 Lady of silences
Calm and distressed
Torn and most whole
Rose of memory
Rose of forgetfulness
Exhausted and life-giving
Worried reposeful
The single Rose
Is now the Garden
Where all loves end
Terminate torment
Of love unsatisfied
The greater torment
Of love satisfied
End of the endless
Journey to no end
Conclusion of all that
Is inconclusible
Speech without word and
Word of no speech
Grace to the Mother
For the Garden
Where all love ends.

 Under a juniper-tree the bones sang, scattered and shining
We are glad to be scattered, we did little good to each other,
Under a tree in the cool of the day, with the blessing of sand,

Forgetting themselves and each other, united
In the quiet of the desert. This is the land which ye
Shall divide by lot. And neither division nor unity
Matters. This is the land. We have our inheritance.

III

At the first turning of the second stair
I turned and saw below
The same shape twisted on the banister
Under the vapour in the fetid air
Struggling with the devil of the stairs who wears
The deceitful face of hope and of despair.

 At the second turning of the second stair
I left them twisting, turning below;
There were no more faces and the stair was dark,
Damp, jaggèd, like an old man's mouth drivelling, beyond repair,
Or the toothed gullet of an agèd shark.

 At the first turning of the third stair
Was a slotted window bellied like the fig's fruit
And beyond the hawthorn blossom and a pasture scene
The broadbacked figure drest in blue and green
Enchanted the maytime with an antique flute.
Blown hair is sweet, brown hair over the mouth blown,
Lilac and brown hair;
Distraction, music of the flute, stops and steps of the mind over the
 third stair,
Fading, fading; strength beyond hope and despair
Climbing the third stair.

 Lord, I am not worthy
Lord, I am not worthy

 but speak the word only.

IV

Who walked between the violet and the violet
Who walked between
The various ranks of varied green
Going in white and blue, in Mary's colour,
Talking of trivial things
In ignorance and in knowledge of eternal dolour
Who moved among the others as they walked,
Who then made strong the fountains and made fresh the springs

Made cool the dry rock and made firm the sand
In blue of larkspur, blue of Mary's colour,
Sovegna vos

Here are the years that walk between, bearing
Away the fiddles and the flutes, restoring
One who moves in the time between sleep and waking, wearing

White light folded, sheathed about her, folded.
The new years walk, restoring
Through a bright cloud of tears, the years, restoring
With a new verse the ancient rhyme. Redeem
The time. Redeem
The unread vision in the higher dream
While jewelled unicorns draw by the gilded hearse.

The silent sister veiled in white and blue
Between the yews, behind the garden god,
Whose flute is breathless, bent her head and signed but spoke no word

But the fountain sprang up and the bird sang down
Redeem the time, redeem the dream
The token of the word unheard, unspoken

Till the wind shake a thousand whispers from the yew

And after this our exile

V

If the lost word is lost, if the spent word is spent
If the unheard, unspoken
Word is unspoken, unheard;
Still is the unspoken word, the Word unheard,
The Word without a word, the Word within
The world and for the world;
And the light shone in darkness and
Against the Word the unstilled world still whirled
About the centre of the silent Word.

O my people, what have I done unto thee.

Where shall the word be found, where will the word
Resound? Not here, there is not enough silence
Not on the sea or on the islands, not
On the mainland, in the desert or the rain land,
For those who walk in darkness
Both in the day time and in the night time
The right time and the right place are not here
No place of grace for those who avoid the face
No time to rejoice for those who walk among noise and deny the voice

Will the veiled sister pray for
Those who walk in darkness, who chose thee and oppose thee,
Those who are torn on the horn between season and season, time and
time, between
Hour and hour, word and word, power and power, those who wait
In darkness? Will the veiled sister pray
For children at the gate
Who will not go away and cannot pray:
Pray for those who chose and oppose

O my people, what have I done unto thee.

Will the veiled sister between the slender
Yew trees pray for those who offend her

And are terrified and cannot surrender
And affirm before the world and deny between the rocks
In the last desert between the last blue rocks
The desert in the garden the garden in the desert
Of drouth, spitting from the mouth the withered apple-seed.

O my people.

VI

Although I do not hope to turn again
Although I do not hope
Although I do not hope to turn

Wavering between the profit and the loss
In this brief transit where the dreams cross
The dreamcrossed twilight between birth and dying
(Bless me father) though I do not wish to wish these things
From the wide window towards the granite shore
The white sails still fly seaward, seaward flying
Unbroken wings

And the lost heart stiffens and rejoices
In the lost lilac and the lost sea voices
And the weak spirit quickens to rebel
For the bent golden-rod and the lost sea smell
Quickens to recover
The cry of quail and the whirling plover
And the blind eye creates
The empty forms between the ivory gates
And smell renews the salt savour of the sandy earth

This is the time of tension between dying and birth
The place of solitude where three dreams cross
Between blue rocks
But when the voices shaken from the yew-tree drift away
Let the other yew be shaken and reply.

Blessèd sister, holy mother, spirit of the fountain, spirit of the
 garden,
Suffer us not to mock ourselves with falsehood
Teach us to care and not to care
Teach us to sit still
Even among these rocks,
Our peace in His will
And even among these rocks
Sister, mother
And spirit of the river, spirit of the sea,
Suffer me not to be separated

And let my cry come unto Thee.

Ariel Poems

JOURNEY OF THE MAGI

'A cold coming we had of it,
Just the worst time of the year
For a journey, and such a long journey:
The ways deep and the weather sharp,
The very dead of winter.'
And the camels galled, sore-footed, refractory,
Lying down in the melting snow.
There were times we regretted
The summer palaces on slopes, the terraces,
And the silken girls bringing sherbet.
Then the camel men cursing and grumbling
And running away, and wanting their liquor and women,
And the night-fires going out, and the lack of shelters,
And the cities hostile and the towns unfriendly
And the villages dirty and charging high prices:
A hard time we had of it.
At the end we preferred to travel all night,
Sleeping in snatches,
With the voices singing in our ears, saying
That this was all folly.

Then at dawn we came down to a temperate valley,
Wet, below the snow line, smelling of vegetation;
With a running stream and a water-mill beating the darkness,
And three trees on the low sky,
And an old white horse galloped away in the meadow.

Then we came to a tavern with vine-leaves over the lintel,
Six hands at an open door dicing for pieces of silver,
And feet kicking the empty wine-skins.
But there was no information, and so we continued
And arrived at evening, not a moment too soon
Finding the place; it was (you may say) satisfactory.

 All this was a long time ago, I remember,
And I would do it again, but set down
This set down
This: were we led all that way for
Birth or Death? There was a Birth, certainly,
We had evidence and no doubt. I had seen birth and death,
But had thought they were different; this Birth was
Hard and bitter agony for us, like Death, our death.
We returned to our places, these Kingdoms,
But no longer at ease here, in the old dispensation,
With an alien people clutching their gods.
I should be glad of another death.

A SONG FOR SIMEON

Lord, the Roman hyacinths are blooming in bowls and
The winter sun creeps by the snow hills;
The stubborn season has made stand.
My life is light, waiting for the death wind,
Like a feather on the back of my hand.
Dust in sunlight and memory in corners
Wait for the wind that chills towards the dead land.

 Grant us thy peace.
I have walked many years in this city,
Kept faith and fast, provided for the poor,
Have given and taken honour and ease.
There went never any rejected from my door.

Who shall remember my house, where shall live my children's children
When the time of sorrow is come?
They will take to the goat's path, and the fox's home,
Fleeing from the foreign faces and the foreign swords.

Before the time of cords and scourges and lamentation
Grant us thy peace.
Before the stations of the mountain of desolation,
Before the certain hour of maternal sorrow,
Now at this birth season of decease,
Let the Infant, the still unspeaking and unspoken Word,
Grant Israel's consolation
To one who has eighty years and no to-morrow.

According to thy word.
They shall praise Thee and suffer in every generation
With glory and derision,
Light upon light, mounting the saints' stair.
Not for me the martyrdom, the ecstasy of thought and prayer,
Not for me the ultimate vision.
Grant me thy peace.
(And a sword shall pierce thy heart,
Thine also.)
I am tired with my own life and the lives of those after me,
I am dying in my own death and the deaths of those after me.
Let thy servant depart,
Having seen thy salvation.

ANIMULA

'Issues from the hand of God, the simple soul'
To a flat world of changing lights and noise,
To light, dark, dry or damp, chilly or warm;
Moving between the legs of tables and of chairs,
Rising or falling, grasping at kisses and toys,

Advancing boldly, sudden to take alarm,
Retreating to the corner of arm and knee,
Eager to be reassured, taking pleasure
In the fragrant brilliance of the Christmas tree,
Pleasure in the wind, the sunlight and the sea;
Studies the sunlit pattern on the floor
And running stags around a silver tray;
Confounds the actual and the fanciful,
Content with playing-cards and kings and queens,
What the fairies do and what the servants say.
The heavy burden of the growing soul
Perplexes and offends more, day by day;
Week by week, offends and perplexes more
With the imperatives of 'is and seems'
And may and may not, desire and control.
The pain of living and the drug of dreams
Curl up the small soul in the window seat
Behind the *Encyclopædia Britannica.*
Issues from the hand of time the simple soul
Irresolute and selfish, misshapen, lame,
Unable to fare forward or retreat,
Fearing the warm reality, the offered good,
Denying the importunity of the blood,
Shadow of its own shadows, spectre in its own gloom,
Leaving disordered papers in a dusty room;
Living first in the silence after the viaticum.

 Pray for Guiterriez, avid of speed and power,
For Boudin, blown to pieces,
For this one who made a great fortune,
And that one who went his own way.
Pray for Floret, by the boarhound slain between the yew trees,
Pray for us now and at the hour of our birth.

MARINA

Quis hic locus, quae regio, quae mundi plaga?

What seas what shores what grey rocks and what islands
What water lapping the bow
And scent of pine and the woodthrush singing through the fog
What images return
O my daughter.

 Those who sharpen the tooth of the dog, meaning
Death
Those who glitter with the glory of the humming-bird, meaning
Death
Those who sit in the stye of contentment, meaning
Death
Those who suffer the ecstasy of the animals, meaning
Death

 Are become unsubstantial, reduced by a wind,
A breath of pine, and the woodsong fog
By this grace dissolved in place

 What is this face, less clear and clearer
The pulse in the arm, less strong and stronger—
Given or lent? more distant than stars and nearer than the eye

 Whispers and small laughter between leaves and hurrying feet
Under sleep, where all the waters meet.

 Bowsprit cracked with ice and paint cracked with heat.
I made this, I have forgotten
And remember.
The rigging weak and the canvas rotten
Between one June and another September.
Made this unknowing, half conscious, unknown, my own.
The garboard strake leaks, the seams need caulking.

This form, this face, this life
Living to live in a world of time beyond me; let me
Resign my life for this life, my speech for that unspoken,
The awakened, lips parted, the hope, the new ships.

What seas what shores what granite islands towards my timbers
And woodthrush calling through the fog
My daughter.

Unfinished Poems

SWEENEY AGONISTES

FRAGMENTS OF AN ARISTOPHANIC MELODRAMA

ORESTES: You don't see them, you don't—but *I* see them: they are hunting me down, I must move on.—*Choephoroi.*

Hence the soul cannot be possessed of the divine union, until it has divested itself of the love of created beings.—*St. John of the Cross.*

FRAGMENT OF A PROLOGUE

DUSTY. DORIS.

DUSTY: How about Pereira?
DORIS: What about Pereira?
 I don't care.
DUSTY: You don't care!
 Who pays the rent?
DORIS: Yes he pays the rent
DUSTY: Well some men don't and some men do
 Some men don't and you know who
DORIS: You can have Pereira
DUSTY: What about Pereira?
DORIS: He's no gentleman, Pereira:
 You can't trust him!
DUSTY: Well that's true.
 He's no gentleman if you can't trust him
 And *if* you can't trust him—
 Then you never know what he's going to do.

[74]

DORIS: No it wouldn't do to be too nice to Pereira.
DUSTY: Now Sam's a gentleman through and through.
DORIS: I like Sam
DUSTY: *I* like Sam
 Yes and Sam's a nice boy too.
 He's a funny fellow
DORIS: He *is* a funny fellow
 He's like a fellow once I knew.
 He could make you laugh.
DUSTY: Sam can make you laugh:
 Sam's all right
DORIS: But Pereira won't do.
 We can't have Pereira
DUSTY: Well what you going to do?
TELEPHONE: Ting a ling ling
 Ting a ling ling
DUSTY: That's Pereira
DORIS: Yes that's Pereira
DUSTY: Well what you going to do?
TELEPHONE: Ting a ling ling
 Ting a ling ling
DUSTY: That's Pereira
DORIS: Well can't you stop that horrible noise?
 Pick up the receiver
DUSTY: What'll I say!
DORIS: Say what you like: say I'm ill,
 Say I broke my leg on the stairs
 Say we've had a fire
DUSTY: Hello Hello are you there?
 Yes this is Miss Dorrance's *flat*—
 Oh Mr. Pereira is that you? how do you do!
 Oh I'm *so* sorry. I *am* so sorry
 But Doris came home with a terrible chill
 No, just a chill
 Oh I *think* it's only a chill
 Yes indeed I hope so too—

Well I *hope* we shan't have to call a doctor
Doris just hates having a doctor
She says will you ring up on Monday
She hopes to be all right on Monday
I say do you mind if I ring off now
She's got her feet in mustard and water
I said I'm giving her mustard and water
All right, Monday you'll phone through.
Yes I'll tell her. Good bye. Goooood bye.
I'm sure, that's very kind of *you*.

<p style="text-align:center">Ah-h-h</p>

DORIS: Now I'm going to cut the cards for to-night.
 Oh guess what the first is
DUSTY: First is. What is?
DORIS: The King of Clubs
DUSTY: That's Pereira
DORIS: It might be Sweeney
DUSTY: It's Pereira
DORIS: It might *just* as well be Sweeney
DUSTY: Well anyway it's very queer.
DORIS: Here's the four of diamonds, what's that mean?
DUSTY [*reading*]: 'A small sum of money, or a present
 Of wearing apparel, or a party.'
 That's queer too.
DORIS: Here's the three. What's that mean?
DUSTY: 'News of an absent friend.'—Pereira!
DORIS: The Queen of Hearts!—Mrs. Porter!
DUSTY: Or it might be you
DORIS: Or it might be you
 We're all hearts. You can't be sure.
 It just depends on what comes next.
 You've got to *think* when you read the cards,
 It's not a thing that anyone can do.
DUSTY: Yes I know you've a touch with the cards
 What comes next?
DORIS: What comes next. It's the six.
DUSTY: 'A quarrel. An estrangement. Separation of friends.'
DORIS: Here's the two of spades.

DUSTY: The *two* of *spades!*
 THAT'S THE COFFIN!!
DORIS: THAT'S THE COFFIN?
 Oh good heavens what'll I do?
 Just before a party too!
DUSTY: Well it needn't be yours, it may mean a friend.
DORIS: No it's mine. I'm sure it's mine.
 I dreamt of weddings all last night.
 Yes it's mine. I know it's mine.
 Oh good heavens what'll I do.
 Well I'm not going to draw any more,
 You cut for luck. You cut for luck.
 It might break the spell. You cut for luck.
DUSTY: The Knave of Spades.
DORIS: That'll be Snow
DUSTY: Or it might be Swarts
DORIS: Or it might be Snow
DUSTY: It's a funny thing how I draw court cards
DORIS: There's a lot in the way you pick them up
DUSTY: There's an awful lot in the way you feel
DORIS: Sometimes they'll tell you nothing at all
DUSTY: You've got to know what you want to ask them
DORIS: You've got to know what you want to know
DUSTY: It's no use asking them too much
DORIS: It's no use asking more than once
DUSTY: Sometimes they're no use at all.
DORIS: I'd like to know about that coffin.
DUSTY: Well I never! What did I tell you?
 Wasn't I saying I always draw court cards?
 The Knave of Hearts!
 [*Whistle outside of the window.*]
 Well I *never*
 What a coincidence! Cards are queer!
 [*Whistle again.*]
DORIS: Is that Sam?
DUSTY: Of course it's Sam!
DORIS: Of course, the Knave of Hearts *is* Sam!
DUSTY [*leaning out of the window*]: Hello Sam!

WAUCHOPE: Hello dear
 How many's up there?
DUSTY: Nobody's up here
 How many's down there?
WAUCHOPE: Four of us here.
 Wait till I put the car round the corner
 We'll be right up
DUSTY: All right, come up.
DUSTY [*to* DORIS]: Cards are queer.
DORIS: I'd like to know about that coffin.
 KNOCK KNOCK KNOCK
 KNOCK KNOCK KNOCK
 KNOCK
 KNOCK
 KNOCK

DORIS. DUSTY. WAUCHOPE. HORSFALL. KLIPSTEIN. KRUMPACKER.

WAUCHOPE: Hello Doris! Hello Dusty! How do you do!
 How come? how come? will you permit me—
 I think you girls both know Captain Horsfall—
 We want you to meet two friends of ours,
 American gentlemen here on business.
 Meet Mr. Klipstein. Meet Mr. Krumpacker.
KLIPSTEIN: How do you do
KRUMPACKER: How do you do
KLIPSTEIN: I'm very pleased to make your acquaintance
KRUMPACKER: Extremely pleased to become acquainted
KLIPSTEIN: Sam—I should say Loot Sam Wauchope
KRUMPACKER: Of the Canadian Expeditionary Force—
KLIPSTEIN: The Loot has told us a lot about you.
KRUMPACKER: We were all in the war together
 Klip and me and the Cap and Sam.
KLIPSTEIN: Yes we did our bit, as you folks say,
 I'll tell the world we got the Hun on the run
KRUMPACKER: What about that poker game? eh what Sam?
 What about that poker game in Bordeaux?
 Yes Miss Dorrance you get Sam
 To tell about that poker game in Bordeaux.

DUSTY: Do you know London well, Mr. Krumpacker?

KLIPSTEIN: No we never been here before

KRUMPACKER: We hit this town last night for the first time

KLIPSTEIN: And I certainly hope it won't be the last time.

DORIS: You like London, Mr. Klipstein?

KRUMPACKER: Do we like London? do we like London!
 Do we like London!! Eh what Klip?

KLIPSTEIN: Say, Miss—er—uh—London's swell.
 We like London fine.

KRUMPACKER: Perfectly slick.

DUSTY: Why don't you come and live here then?

KLIPSTEIN: Well, no, Miss—er—you haven't quite got it
 (I'm afraid I didn't quite catch your name—
 But I'm very pleased to meet you all the same) —
 London's a little too gay for us
 Yes I'll say a little too gay.

KRUMPACKER: Yes London's a little too gay for us
 Don't think I mean anything *coarse*—
 But I'm afraid we couldn't stand the pace.
 What about it Klip?

KLIPSTEIN: You said it, Krum.
 London's a slick place, London's a swell place,
 London's a fine place to come on a visit—

KRUMPACKER: Specially when you got a real live Britisher
 A guy like Sam to show you around.
 Sam of course is at *home* in London,
 And he's promised to show us around.

FRAGMENT OF AN AGON

SWEENEY. WAUCHOPE. HORSFALL. KLIPSTEIN. KRUMPACKER.
SWARTS. SNOW. DORIS. DUSTY.

SWEENEY: I'll carry you off
 To a cannibal isle.

DORIS: You'll be the cannibal!

SWEENEY: You'll be the missionary!

You'll be my little seven stone missionary!
I'll gobble you up. I'll be the cannibal.
DORIS: You'll carry me off? To a cannibal isle?
SWEENEY: I'll be the cannibal.
DORIS: I'll be the missionary.
I'll convert you!
SWEENEY: I'll convert *you!*
Into a stew.
A nice little, white little, missionary stew.
DORIS: You wouldn't eat me!
SWEENEY: Yes I'd eat you!
In a nice little, white little, soft little, tender little,
Juicy little, right little, missionary stew.
You see this egg
You see this egg
Well that's life on a crocodile isle.
There's no telephones
There's no gramophones
There's no motor cars
No two-seaters, no six-seaters,
No Citroën, no Rolls-Royce.
Nothing to eat but the fruit as it grows.
Nothing to see but the palmtrees one way
And the sea the other way,
Nothing to hear but the sound of the surf.
Nothing at all but three things
DORIS: What things?
SWEENEY: Birth, and copulation, and death.
That's all, that's all, that's all, that's all,
Birth, and copulation, and death.
DORIS: I'd be bored.
SWEENEY: You'd be bored.
Birth, and copulation, and death.
DORIS: I'd be bored.
SWEENEY: You'd be bored.
Birth, and copulation, and death.
That's all the facts when you come to brass tacks:

Birth, and copulation, and death.
I've been born, and once is enough.
You dont remember, but I remember,
Once is enough.

SONG BY WAUCHOPE AND HORSFALL
SWARTS AS TAMBO. SNOW AS BONES

Under the bamboo
Bamboo bamboo
Under the bamboo tree
Two live as one
One live as two
Two live as three
Under the bam
Under the boo
Under the bamboo tree.

Where the breadfruit fall
And the penguin call
And the sound is the sound of the sea
Under the bam
Under the boo
Under the bamboo tree.

Where the Gauguin maids
In the banyan shades
Wear palmleaf drapery
Under the bam
Under the boo
Under the bamboo tree.

Tell me in what part of the wood
Do you want to flirt with me?
Under the breadfruit, banyan, palmleaf
Or under the bamboo tree?
Any old tree will do for me
Any old wood is just as good

Any old isle is just my style
Any fresh egg
Any fresh egg
And the sound of the coral sea.

DORIS: I dont like eggs; I never liked eggs;
 And I dont like life on your crocodile isle.

<div align="center">

SONG BY KLIPSTEIN AND KRUMPACKER
SNOW AND SWARTS AS BEFORE

</div>

My little island girl
My little island girl
I'm going to stay with you
And we wont worry what to do
We wont have to catch any trains
And we wont go home when it rains
We'll gather hibiscus flowers
For it wont be minutes but hours
For it wont be hours but years

diminuendo {
And the morning
And the evening
And noontime
And night
Morning
Evening
Noontime
Night

DORIS: That's not life, that's no life
 Why I'd just as soon be dead.
SWEENEY: That's what life is. Just is
DORIS: What is?
 What's that life is?
SWEENEY: Life is death.
 I knew a man once did a girl in—
DORIS: Oh Mr. Sweeney, please dont talk,
 I cut the cards before you came
 And I drew the coffin

SWARTS: *You* drew the coffin?
DORIS: I drew the COFFIN very last card.
 I dont care for such conversation
 A woman runs a terrible risk.
SNOW: Let Mr. Sweeney continue his story.
 I assure you, Sir, we are very inter*e*sted.
SWEENEY: I knew a man once did a girl in
 Any man might do a girl in
 Any man has to, needs to, wants to
 Once in a lifetime, do a girl in.
 Well he kept her there in a bath
 With a gallon of lysol in a bath
SWARTS: These fellows always get pinched in the end.
SNOW: Excuse me, they dont all get pinched in the end.
 What about them bones on Epsom Heath?
 I seen that in the papers
 You seen it in the papers
 They *dont* all get pinched in the end.
DORIS: A woman runs a terrible risk.
SNOW: Let Mr. Sweeney continue his story.
SWEENEY: This one didn't get pinched in the end
 But that's another story too.
 This went on for a couple of months
 Nobody came
 And nobody went
 But he took in the milk and he paid the rent.
SWARTS: What did he do?
 All that time, what did he do?
SWEENEY: What did he do! what did he do?
 That dont apply.
 Talk to live men about what they do.
 He used to come and see me sometimes
 I'd give him a drink and cheer him up.
DORIS: Cheer him up?
DUSTY: Cheer him up?
SWEENEY: Well here again that dont apply
 But I've gotta use words when I talk to you.
 But here's what I was going to say.

He didn't know if he was alive
 and the girl was dead
He didn't know if the girl was alive
 and he was dead
He didn't know if they both were alive
 or both were dead
If he was alive then the milkman wasn't
 and the rent-collector wasn't
And if they were alive then he was dead.
There wasn't any joint
There wasn't any joint
For when you're alone
When you're alone like he was alone
You're either or neither
I tell you again it dont apply
Death or life or life or death
Death is life and life is death
I gotta use words when I talk to you
But if you understand or if you dont
That's nothing to me and nothing to you
We all gotta do what we gotta do
We're gona sit here and drink this booze
We're gona sit here and have a tune
We're gona stay and we're gona go
And somebody's gotta pay the rent
DORIS: I know who
SWEENEY: But that's nothing to me and nothing to you.

FULL CHORUS: WAUCHOPE, HORSFALL, KLIPSTEIN, KRUMPACKER

When you're alone in the middle of the night and you wake
 in a sweat and a hell of a fright
When you're alone in the middle of the bed and you wake
 like someone hit you on the head
You've had a cream of a nightmare dream and you've got the
 hoo-ha's coming to you.
Hoo hoo hoo
You dreamt you waked up at seven o'clock and it's foggy and

it's damp and it's dawn and it's dark
And you wait for a knock and the turning of a lock for you
 know the hangman's waiting for you.
And perhaps you're alive
And perhaps you're dead
Hoo ha ha
Hoo ha ha
Hoo
Hoo
Hoo
Knock Knock Knock
Knock Knock Knock
Knock
Knock
Knock

CORIOLAN

I. TRIUMPHAL MARCH

Stone, bronze, stone, steel, stone, oakleaves, horses' heels
Over the paving.
And the flags. And the trumpets. And so many eagles.
How many? Count them. And such a press of people.
We hardly knew ourselves that day, or knew the City.
This is the way to the temple, and we so many crowding the way.
So many waiting, how many waiting? what did it matter, on such
 a day?
Are they coming? No, not yet. You can see some eagles. And hear
 the trumpets.
Here they come. Is he coming?
The natural wakeful life of our Ego is a perceiving.
We can wait with our stools and our sausages.
What comes first? Can you see? Tell us. It is

 5,800,000 rifles and carbines,
 102,000 machine guns,
 28,000 trench mortars,
 53,000 field and heavy guns,
I cannot tell how many projectiles, mines and fuses,
 13,000 aeroplanes,
 24,000 aeroplane engines,
 50,000 ammunition waggons,
 now 55,000 army waggons,
 11,000 field kitchens,
 1,150 field bakeries.

What a time that took. Will it be he now? No,
Those are the golf club Captains, these the Scouts,
And now the *société gymnastique de Poissy*
And now come the Mayor and the Liverymen. Look
There he is now, look:
There is no interrogation in his eyes
Or in the hands, quiet over the horse's neck,
And the eyes watchful, waiting, perceiving, indifferent.
O hidden under the dove's wing, hidden in the turtle's breast,
Under the palmtree at noon, under the running water
At the still point of the turning world. O hidden.

 Now they go up to the temple. Then the sacrifice.
Now come the virgins bearing urns, urns containing
Dust
Dust
Dust of dust, and now
Stone, bronze, stone, steel, stone, oakleaves, horses' heels
Over the paving.

 That is all we could see. But how many eagles! and how many
 trumpets!
(And Easter Day, we didn't get to the country,
So we took young Cyril to church. And they rang a bell

And he said right out loud, *crumpets.*)

<div align="right">Don't throw away that sausage,</div>

It'll come in handy. He's artful. Please, will you
Give us a light?
Light
Light
Et les soldats faisaient la haie? ILS LA FAISAIENT.

II. DIFFICULTIES OF A STATESMAN

Cry what shall I cry?
All flesh is grass: comprehending
The Companions of the Bath, the Knights of the British Empire,
 the Cavaliers,
O Cavaliers! of the Legion of Honour,
The Order of the Black Eagle (1st and 2nd class),
And the Order of the Rising Sun.
Cry cry what shall I cry?
The first thing to do is to form the committees:
The consultative councils, the standing committees, select commit-
 tees and sub-committees.
One secretary will do for several committees.
What shall I cry?
Arthur Edward Cyril Parker is appointed telephone operator
At a salary of one pound ten a week rising by annual increments
 of five shillings
To two pounds ten a week; with a bonus of thirty shillings at Christ-
 mas
And one week's leave a year.
A committee has been appointed to nominate a commission of en-
 gineers
To consider the Water Supply.
A commission is appointed
For Public Works, chiefly the question of rebuilding the fortifica-
 tions.

A commission is appointed
To confer with a Volscian commission
About perpetual peace: the fletchers and javelin-makers and smiths
Have appointed a joint committee to protest against the reduction
 of orders.
Meanwhile the guards shake dice on the marches
And the frogs (O Mantuan) croak in the marshes.
Fireflies flare against the faint sheet lightning
What shall I cry?
Mother mother
Here is the row of family portraits, dingy busts, all looking remark-
 ably Roman,
Remarkably like each other, lit up successively by the flare
Of a sweaty torchbearer, yawning.
O hidden under the . . . Hidden under the . . .
 Where the dove's foot rested and locked for a moment,
A still moment, repose of noon, set under the upper branches of
 noon's widest tree
Under the breast feather stirred by the small wind after noon
There the cyclamen spreads its wings, there the clematis droops over
 the lintel
O mother (not among these busts, all correctly inscribed)
I a tired head among these heads
Necks strong to bear them
Noses strong to break the wind
Mother
May we not be some time, almost now, together,
If the mactations, immolations, oblations, impetrations,
Are now observed
May we not be
O hidden
Hidden in the stillness of noon, in the silent croaking night.
Come with the sweep of the little bat's wing, with the small flare of
 the firefly or lightning bug,
"Rising and falling, crowned with dust," the small creatures,
The small creatures chirp thinly through the dust, through the night.

O mother
What shall I cry?
We demand a committee, a representative committee, a committee of
 investigation
 RESIGN RESIGN RESIGN

Minor Poems

EYES THAT LAST I SAW IN TEARS

Eyes that last I saw in tears
Through division
Here in death's dream kingdom
The golden vision reappears
I see the eyes but not the tears
This is my affliction

This is my affliction
Eyes I shall not see again
Eyes of decision
Eyes I shall not see unless
At the door of death's other kingdom
Where, as in this,
The eyes outlast a little while
A little while outlast the tears
And hold us in derision.

THE WIND SPRANG UP AT FOUR O'CLOCK

The wind sprang up at four o'clock
The wind sprang up and broke the bells
Swinging between life and death
Here, in death's dream kingdom
The waking echo of confusing strife
Is it a dream or something else
When the surface of the blackened river

Is a face that sweats with tears?
I saw across the blackened river
The camp fire shake with alien spears.
Here, across death's other river
The Tartar horsemen shake their spears.

———————

FIVE-FINGER EXERCISES

I. *Lines to a Persian Cat*

The songsters of the air repair
To the green fields of Russell Square.
Beneath the trees there is no ease
For the dull brain, the sharp desires
And the quick eyes of Woolly Bear.
There is no relief but in grief.
O when will the creaking heart cease?
When will the broken chair give ease?
Why will the summer day delay?
When will Time flow away?

II. *Lines to a Yorkshire Terrier*

In a brown field stood a tree
And the tree was crookt and dry.
In a black sky, from a green cloud
Natural forces shriek'd aloud,
Screamed, rattled, muttered endlessly.
Little dog was safe and warm
Under a cretonne eiderdown,
Yet the field was cracked and brown
And the tree was cramped and dry.
Pollicle dogs and cats all must
Jellicle cats and dogs all must
Like undertakers, come to dust.
Here a little dog I pause

Heaving up my prior paws,
Pause, and sleep endlessly.

III. *Lines to a Duck in the Park*

The long light shakes across the lake,
The forces of the morning quake,
The dawn is slant across the lawn,
Here is no eft or mortal snake
But only sluggish duck and drake.
I have seen the morning shine,
I have had the Bread and Wine,
Let the feathered mortals take
That which is their mortal due,
Pinching bread and finger too,
Easier had than squirming worm;
For I know, and so should you
That soon the enquiring worm shall try
Our well-preserved complacency.

IV. *Lines to Ralph Hodgson Esqre.*

How delightful to meet Mr. Hodgson!
 (Everyone wants to know *him*) —
With his musical sound
And his Baskerville Hound
Which, just at a word from his master
Will follow you faster and faster
And tear you limb from limb.
How delightful to meet Mr. Hodgson!
Who is worshipped by all waitresses
(They regard him as something apart)
While on his palate fine he presses
The juice of the gooseberry tart.
How delightful to meet Mr. Hodgson!
 (Everyone wants to know *him*).
He has 999 canaries
And round his head finches and fairies
In jubilant rapture skim.

How delightful to meet Mr. Hodgson!
 (Everyone wants to meet *him*) .

V. *Lines for Cuscuscaraway and Mirza Murad Ali Beg*

How unpleasant to meet Mr. Eliot!
With his features of clerical cut,
And his brow so grim
And his mouth so prim
And his conversation, so nicely
Restricted to What Precisely
And If and Perhaps and But.
How unpleasant to meet Mr. Eliot!
With a bobtail cur
In a coat of fur
And a porpentine cat
And a wopsical hat:
How unpleasant to meet Mr. Eliot!
 (Whether his mouth be open or shut) .

LANDSCAPES

I. *New Hampshire*

Children's voices in the orchard
Between the blossom- and the fruit-time:
Golden head, crimson head,
Between the green tip and the root.
Black wing, brown wing, hover over;
Twenty years and the spring is over;
To-day grieves, to-morrow grieves,
 Cover me over, light-in-leaves;
Golden head, black wing,
Cling, swing,
Spring, sing,
Swing up into the apple-tree.

II. *Virginia*

Red river, red river,
Slow flow heat is silence
No will is still as a river
Still. Will heat move
Only through the mocking-bird
Heard once? Still hills
Wait. Gates wait. Purple trees,
White trees, wait, wait,
Delay, decay. Living, living,
Never moving. Ever moving
Iron thoughts came with me
And go with me:
Red river, river, river.

III. *Usk*

Do not suddenly break the branch, or
Hope to find
The white hart behind the white well.
Glance aside, not for lance, do not spell
Old enchantments. Let them sleep.
"Gently dip, but not too deep,"
Lift your eyes
Where the roads dip and where the roads rise
Seek only there
Where the grey light meets the green air
The hermit's chapel, the pilgrim's prayer.

IV. *Rannoch, by Glencoe*

Here the crow starves, here the patient stag
Breeds for the rifle. Between the soft moor
And the soft sky, scarcely room
To leap or soar. Substance crumbles, in the thin air
Moon cold or moon hot. The road winds in
Listlessness of ancient war
Languor of broken steel,
Clamour of confused wrong, apt

In silence. Memory is strong
Beyond the bone. Pride snapped,
Shadow of pride is long, in the long pass
No concurrence of bone.

V. *Cape Ann*

O quick quick quick, quick hear the song-sparrow,
Swamp-sparrow, fox-sparrow, vesper-sparrow
At dawn and dusk. Follow the dance
Of the goldfinch at noon. Leave to chance
The Blackburnian warbler, the shy one. Hail
With shrill whistle the note of the quail, the bob-white
Dodging by bay-bush. Follow the feet
Of the walker, the water-thrush. Follow the flight
Of the dancing arrow, the purple martin. Greet
In silence the bullbat. All are delectable. Sweet sweet sweet
But resign this land at the end, resign it
To its true owner, the tough one, the sea-gull.
The palaver is finished.

LINES FOR AN OLD MAN

The tiger in the tiger-pit
Is not more irritable than I.
The whipping tail is not more still
Than when I smell the enemy
Writhing in the essential blood
Or dangling from the friendly tree.
When I lay bare the tooth of wit
The hissing over the archèd tongue
Is more affectionate than hate,
More bitter than the love of youth,
And inaccessible by the young.
Reflected from my golden eye
The dullard knows that he is mad.
Tell me if I am not glad!

Choruses from "The Rock"

I

The Eagle soars in the summit of Heaven,
The Hunter with his dogs pursues his circuit.
O perpetual revolution of configured stars,
O perpetual recurrence of determined seasons,
O world of spring and autumn, birth and dying!
The endless cycle of idea and action,
Endless invention, endless experiment,
Brings knowledge of motion, but not of stillness;
Knowledge of speech, but not of silence;
Knowledge of words, and ignorance of the Word.
All our knowledge brings us nearer to our ignorance,
All our ignorance brings us nearer to death,
But nearness to death no nearer to GOD.
Where is the Life we have lost in living?
Where is the wisdom we have lost in knowledge?
Where is the knowledge we have lost in information?
The cycles of Heaven in twenty centuries
Bring us farther from GOD and nearer to the Dust.

I journeyed to London, to the timekept City,
Where the River flows, with foreign flotations.
There I was told: we have too many churches,
And too few chop-houses. There I was told:
Let the vicars retire. Men do not need the Church
In the place where they work, but where they spend their
 Sundays.

In the City, we need no bells:
Let them waken the suburbs.
I journeyed to the suburbs, and there I was told:
We toil for six days, on the seventh we must motor
To Hindhead, or Maidenhead.
If the weather is foul we stay at home and read the papers.
In industrial districts, there I was told
Of economic laws.
In the pleasant countryside, there it seemed
That the country now is only fit for picnics.
And the Church does not seem to be wanted
In country or in suburbs; and in the town
Only for important weddings.

CHORUS LEADER: Silence! and preserve respectful distance.
For I perceive approaching
The Rock. Who will perhaps answer our doubtings.
The Rock. The Watcher. The Stranger.
He who has seen what has happened.
And who sees what is to happen.
The Witness. The Critic. The Stranger.
The God-shaken, in whom is the truth inborn.

Enter the ROCK, *led by a* BOY:

THE ROCK: The lot of man is ceaseless labour,
Or ceaseless idleness, which is still harder,
Or irregular labour, which is not pleasant.
I have trodden the winepress alone, and I know
That it is hard to be really useful, resigning
The things that men count for happiness, seeking
The good deeds that lead to obscurity, accepting
With equal face those that bring ignominy,
The applause of all or the love of none.
All men are ready to invest their money
But most expect dividends.
I say to you: *Make perfect your will.*
I say: take no thought of the harvest,
But only of proper sowing.

The world turns and the world changes,
But one thing does not change.
In all of my years, one thing does not change.
However you disguise it, this thing does not change:
The perpetual struggle of Good and Evil.
Forgetful, you neglect your shrines and churches;
The men you are in these times deride
What has been done of good, you find explanations
To satisfy the rational and enlightened mind.
Second, you neglect and belittle the desert.
The desert is not remote in southern tropics,
The desert is not only around the corner,
The desert is squeezed in the tube-train next to you,
The desert is in the heart of your brother.
The good man is the builder, if he build what is good.
I will show you the things that are now being done,
And some of the things that were long ago done,
That you may take heart. Make perfect your will.
Let me show you the work of the humble. Listen.

The lights fade; in the semi-darkness the voices of WORKMEN *are
heard chanting.*
 In the vacant places
 We will build with new bricks
 There are hands and machines
 And clay for new brick
 And lime for new mortar
 Where the bricks are fallen
 We will build with new stone
 Where the beams are rotten
 We will build with new timbers
 Where the word is unspoken
 We will build with new speech
 There is work together
 A Church for all
 And a job for each
 Every man to his work.

Now a group of WORKMEN *is silhouetted against the dim sky. From
farther away, they are answered by voices of the* UNEMPLOYED.

> No man has hired us
> With pocketed hands
> And lowered faces
> We stand about in open places
> And shiver in unlit rooms.
> Only the wind moves
> Over empty fields, untilled
> Where the plough rests, at an angle
> To the furrow. In this land
> There shall be one cigarette to two men,
> To two women one half pint of bitter
> Ale. In this land
> No man has hired us.
> Our life is unwelcome, our death
> Unmentioned in "The Times."

Chant of WORKMEN *again.*

> The river flows, the seasons turn,
> The sparrow and starling have no time to waste.
> If men do not build
> How shall they live?
> When the field is tilled
> And the wheat is bread
> They shall not die in a shortened bed
> And a narrow sheet. In this street
> There is no beginning, no movement, no peace and no end
> But noise without speech, food without taste.
> Without delay, without haste
> We would build the beginning and the end of this street.
> We build the meaning:
> A Church for all
> And a job for each
> Each man to his work.

II

Thus your fathers were made
Fellow citizens of the saints, of the household of GOD, being built
 upon the foundation
Of apostles and prophets, Christ Jesus Himself the chief corner-
 stone.
But you, have you built well, that you now sit helpless in a
 ruined house?
Where many are born to idleness, to frittered lives and squalid
 deaths, embittered scorn in honey-hives,
And those who would build and restore turn out the palms of
 their hands, or look in vain towards foreign lands for alms to
 be more or the urn to be filled.
Your building not fitly framed together, you sit ashamed and
 wonder whether and how you may be builded together for a
 habitation of GOD in the Spirit, the Spirit which moved on
 the face of the waters like a lantern set on the back of a
 tortoise.
And some say: "How can we love our neighbour? For love must
 be made real in act, as desire unites with desired; we have only
 our labour to give and our labour is not required.
We wait on corners, with nothing to bring but the songs we can
 sing which nobody wants to hear sung;
Waiting to be flung in the end, on a heap less useful than dung."

You, have you built well, have you forgotten the cornerstone?
Talking of right relations of men, but not of relations of men
 to GOD.
"Our citizenship is in Heaven"; yes, but that is the model and
 type for your citizenship upon earth.

When your fathers fixed the place of GOD,
And settled all the inconvenient saints,
Apostles, martyrs, in a kind of Whipsnade,
Then they could set about imperial expansion
Accompanied by industrial development.
Exporting iron, coal and cotton goods

And intellectual enlightenment
And everything, including capital
And several versions of the Word of GOD:
The British race assured of a mission
Performed it, but left much at home unsure.

 Of all that was done in the past, you eat the fruit, either rotten
 or ripe.
And the Church must be forever building, and always decaying,
 and always being restored.
For every ill deed in the past we suffer the consequence:
For sloth, for avarice, gluttony, neglect of the Word of GOD,
For pride, for lechery, treachery, for every act of sin.
And of all that was done that was good, you have the inheritance.
For good and ill deeds belong to a man alone, when he stands
 alone on the other side of death,
But here upon earth you have the reward of the good and ill that
 was done by those who have gone before you.
And all that is ill you may repair if you walk together in humble
 repentance, expiating the sins of your fathers;
And all that was good you must fight to keep with hearts as
 devoted as those of your fathers who fought to gain it.
The Church must be forever building, for it is forever decaying
 within and attacked from without;
For this is the law of life; and you must remember that while
 there is time of prosperity
The people will neglect the Temple, and in time of adversity
 they will decry it.

 What life have you if you have not life together?
There is no life that is not in community,
And no community not lived in praise of GOD.
Even the anchorite who meditates alone,
For whom the days and nights repeat the praise of GOD,
Prays for the Church, the Body of Christ incarnate.
And now you live dispersed on ribbon roads,
And no man knows or cares who is his neighbour

Unless his neighbour makes too much disturbance,
But all dash to and fro in motor cars,
Familiar with the roads and settled nowhere.
Nor does the family even move about together,
But every son would have his motor cycle,
And daughters ride away on casual pillions.

 Much to cast down, much to build, much to restore;
Let the work not delay, time and the arm not waste;
Let the clay be dug from the pit, let the saw cut the stone,
Let the fire not be quenched in the forge.

III

The Word of the LORD came unto me, saying:
O miserable cities of designing men,
O wretched generation of enlightened men,
Betrayed in the mazes of your ingenuities,
Sold by the proceeds of your proper inventions:
I have given you hands which you turn from worship,
I have given you speech, for endless palaver,
I have given you my Law, and you set up commissions,
I have given you lips, to express friendly sentiments,
I have given you hearts, for reciprocal distrust.
I have given you power of choice, and you only alternate
Between futile speculation and unconsidered action.
Many are engaged in writing books and printing them,
Many desire to see their names in print,
Many read nothing but the race reports.
Much is your reading, but not the Word of GOD,
Much is your building, but not the House of GOD.
Will you build me a house of plaster, with corrugated roofing,
To be filled with a litter of Sunday newspapers?
1ST MALE VOICE: A Cry from the East:
What shall be done to the shore of smoky ships?
Will you leave my people forgetful and forgotten
To idleness, labour, and delirious stupor?

There shall be left the broken chimney,
The peeled hull, a pile of rusty iron,
In a street of scattered brick where the goat climbs,
Where My Word is unspoken.

2ND MALE VOICE: A Cry from the North, from the West and from
 the South
Whence thousands travel daily to the timekept City;
Where My Word is unspoken,
In the land of lobelias and tennis flannels
The rabbit shall burrow and the thorn revisit,
The nettle shall flourish on the gravel court,
And the wind shall say: "Here were decent godless people:
Their only monument the asphalt road
And a thousand lost golf balls."

CHORUS: We build in vain unless the LORD build with us.
 Can you keep the City that the LORD keeps not with you?
A thousand policemen directing the traffic
Cannot tell you why you come or where you go.
A colony of cavies or a horde of active marmots
Build better than they that build without the LORD.
Shall we lift up our feet among perpetual ruins?
I have loved the beauty of Thy House, the peace of Thy
 sanctuary,
I have swept the floors and garnished the altars.
Where there is no temple there shall be no homes,
Though you have shelters and institutions,
Precarious lodgings while the rent is paid,
Subsiding basements where the rat breeds
Or sanitary dwellings with numbered doors
Or a house a little better than your neighbour's;
When the Stranger says: "What is the meaning of this city?
Do you huddle close together because you love each other?"
What will you answer? "We all dwell together
To make money from each other"? or "This is a community"?
And the Stranger will depart and return to the desert.
O my soul, be prepared for the coming of the Stranger,
Be prepared for him who knows how to ask questions.

O weariness of men who turn from GOD
To the grandeur of your mind and the glory of your action,
To arts and inventions and daring enterprises,
To schemes of human greatness thoroughly discredited,
Binding the earth and the water to your service,
Exploiting the seas and developing the mountains,
Dividing the stars into common and preferred,
Engaged in devising the perfect refrigerator,
Engaged in working out a rational morality,
Engaged in printing as many books as possible,
Plotting of happiness and flinging empty bottles,
Turning from your vacancy to fevered enthusiasm
For nation or race or what you call humanity;
Though you forget the way to the Temple,
There is one who remembers the way to your door:
Life you may evade, but Death you shall not.
You shall not deny the Stranger.

IV

There are those who would build the Temple,
And those who prefer that the Temples should not be built.
In the days of Nehemiah the Prophet
There was no exception to the general rule.
In Shushan the palace, in the month Nisan,
He served the wine to the King Artaxerxes,
And he grieved for the broken city, Jerusalem;
And the King gave him leave to depart
That he might rebuild the city.
So he went, with a few, to Jerusalem,
And there, by the dragon's well, by the dung gate,
By the fountain gate, by the king's pool,
Jerusalem lay waste, consumed with fire;
No place for a beast to pass.
There were enemies without to destroy him,
And spies and self-seekers within,
When he and his men laid their hands to rebuilding the wall.
So they built as men must build
With the sword in one hand and the trowel in the other.

V

O Lord, deliver me from the man of excellent intention and
impure heart: for the heart is deceitful above all things, and
desperately wicked.

Sanballat the Horonite and Tobiah the Ammonite and Geshem
the Arabian: were doubtless men of public spirit and zeal.

Preserve me from the enemy who has something to gain: and
from the friend who has something to lose.

Remembering the words of Nehemiah the Prophet: "The trowel
in hand, and the gun rather loose in the holster."

Those who sit in a house of which the use is forgotten: are like
snakes that lie on mouldering stairs, content in the sunlight.

And the others run about like dogs, full of enterprise, sniffing
and barking: they say, "This house is a nest of serpents, let us
destroy it,

And have done with these abominations, the turpitudes of the
Christians." And these are not justified, nor the others.

And they write innumerable books; being too vain and distracted
for silence: seeking every one after his own elevation, and
dodging his emptiness.

If humility and purity be not in the heart, they are not in the
home: and if they are not in the home, they are not in the City.

The man who has builded during the day would return to his
hearth at nightfall: to be blessed with the gift of silence, and
doze before he sleeps.

But we are encompassed with snakes and dogs: therefore some
must labour, and others must hold the spears.

VI

It is hard for those who have never known persecution,
And who have never known a Christian,
To believe these tales of Christian persecution.
It is hard for those who live near a Bank
To doubt the security of their money.
It is hard for those who live near a Police Station
To believe in the triumph of violence.
Do you think that the Faith has conquered the World

And that lions no longer need keepers?
Do you need to be told that whatever has been, can still be?
Do you need to be told that even such modest attainments
As you can boast in the way of polite society
Will hardly survive the Faith to which they owe their signifi-
 cance?
Men! polish your teeth on rising and retiring;
Women! polish your fingernails:
You polish the tooth of the dog and the talon of the cat.
Why should men love the Church? Why should they love her
 laws?
She tells them of Life and Death, and of all that they would
 forget.
She is tender where they would be hard, and hard where they
 like to be soft.
She tells them of Evil and Sin, and other unpleasant facts.
They constantly try to escape
From the darkness outside and within
By dreaming of systems so perfect that no one will need to be
 good.
But the man that is will shadow
The man that pretends to be.
And the Son of Man was not crucified once for all,
The blood of the martyrs not shed once for all,
The lives of the Saints not given once for all:
But the Son of Man is crucified always
And there shall be Martyrs and Saints.
And if blood of Martyrs is to flow on the steps
We must first build the steps;
And if the Temple is to be cast down
We must first build the Temple.

VII

In the beginning GOD created the world. Waste and void. Waste
 and void. And darkness was upon the face of the deep.
And when there were men, in their various ways, they struggled
 in torment towards GOD

Blindly and vainly, for man is a vain thing, and man without
GOD is a seed upon the wind: driven this way and that, and
finding no place of lodgement and germination.
They followed the light and the shadow, and the light led them
forward to light and the shadow led them to darkness,
Worshipping snakes or trees, worshipping devils rather than
nothing: crying for life beyond life, for ecstasy not of the flesh.
Waste and void. Waste and void. And darkness on the face of
the deep.

And the Spirit moved upon the face of the water.
And men who turned towards the light and were known of the
light
Invented the Higher Religions; and the Higher Religions were
good
And led men from light to light, to knowledge of Good and Evil.
But their light was ever surrounded and shot with darkness
As the air of temperate seas is pierced by the still dead breath of
the Arctic Current;
And they came to an end, a dead end stirred with a flicker of life,
And they came to the withered ancient look of a child that has
died of starvation.
Prayer wheels, worship of the dead, denial of this world, affirma-
tion of rites with forgotten meanings
In the restless wind-whipped sand, or the hills where the wind
will not let the snow rest.
Waste and void. Waste and void. And darkness on the face of
the deep.

Then came, at a predetermined moment, a moment in time
and of time,
A moment not out of time, but in time, in what we call history:
transecting, bisecting the world of time, a moment in time
but not like a moment of time,
A moment in time but time was made through that moment:
for without the meaning there is no time, and that moment
of time gave the meaning.

Then it seemed as if men must proceed from light to light, in the light of the Word,
Through the Passion and Sacrifice saved in spite of their negative being;
Bestial as always before, carnal, self-seeking as always before, selfish and purblind as ever before,
Yet always struggling, always reaffirming, always resuming their march on the way that was lit by the light;
Often halting, loitering, straying, delaying, returning, yet following no other way.

But it seems that something has happened that has never happened before: though we know not just when, or why, or how, or where.
Men have left GOD not for other gods, they say, but for no god; and this has never happened before
That men both deny gods and worship gods, professing first Reason,
And then Money, and Power, and what they call Life, or Race, or Dialectic.
The Church disowned, the tower overthrown, the bells upturned, what have we to do
But stand with empty hands and palms turned upwards
In an age which advances progressively backwards?

VOICE OF THE UNEMPLOYED [*afar off*]:
 In this land
There shall be one cigarette to two men,
To two women one half pint of bitter
Ale. . . .

CHORUS: What does the world say, does the whole world stray in high-powered cars on a by-pass way?

VOICE OF THE UNEMPLOYED [*more faintly*
 In this land
No man has hired us. . . .

CHORUS: Waste and void. Waste and void. And darkness on the face of the deep.
Has the Church failed mankind, or has mankind failed the Church?

When the Church is no longer regarded, not even opposed, and
 men have forgotten
All gods except Usury, Lust and Power.

VIII

O Father we welcome your words,
And we will take heart for the future,
Remembering the past.

The heathen are come into thine inheritance,
And thy temple have they defiled.

Who is this that cometh from Edom?

He has trodden the wine-press alone.

There came one who spoke of the shame of Jerusalem
And the holy places defiled;
Peter the Hermit, scourging with words.
And among his hearers were a few good men,
Many who were evil,
And most who were neither.
Like all men in all places,

Some went from love of glory,
Some went who were restless and curious,
Some were rapacious and lustful.
Many left their bodies to the kites of Syria
Or sea-strewn along the routes;
Many left their souls in Syria,
Living on, sunken in moral corruption;
Many came back well broken,
Diseased and beggared, finding
A stranger at the door in possession:
Came home cracked by the sun of the East
And the seven deadly sins in Syria.

But our King did well at Acre.
And in spite of all the dishonour,
The broken standards, the broken lives,
The broken faith in one place or another,
There was something left that was more than the tales
Of old men on winter evenings.
Only the faith could have done what was good of it,
Whole faith of a few,
Part faith of many.
Not avarice, lechery, treachery,
Envy, sloth, gluttony, jealousy, pride:
It was not these that made the Crusades,
But these that unmade them.

Remember the faith that took men from home
At the call of a wandering preacher.
Our age is an age of moderate virtue
And of moderate vice
When men will not lay down the Cross
Because they will never assume it.
Yet nothing is impossible, nothing,
To men of faith and conviction.
Let us therefore make perfect our will.
O GOD, help us.

IX

Son of Man, behold with thine eyes, and hear with thine ears
And set thine heart upon all that I show thee.
Who is this that has said: the House of GOD is a House of Sorrow;
We must walk in black and go sadly, with long-drawn faces,
We must go between empty walls, quavering lowly, whispering
 faintly,
Among a few flickering scattered lights?
They would put upon GOD their own sorrow, the grief they
 should feel
For their sins and faults as they go about their daily occasions.
Yet they walk in the street proudnecked, like thoroughbreds
 ready for races,

Adorning themselves, and busy in the market, the forum,
And all other secular meetings.
Thinking good of themselves, ready for any festivity,
Doing themselves very well.
Let us mourn in a private chamber, learning the way of penitence,
And then let us learn the joyful communion of saints.

The soul of Man must quicken to creation.
Out of the formless stone, when the artist united himself with stone,
Spring always new forms of life, from the soul of man that is joined to the soul of stone;
Out of the meaningless practical shapes of all that is living or lifeless
Joined with the artist's eye, new life, new form, new colour.
Out of the sea of sound the life of music,
Out of the slimy mud of words, out of the sleet and hail of verbal imprecisions,
Approximate thoughts and feelings, words that have taken the place of thoughts and feelings,
There spring the perfect order of speech, and the beauty of incantation.

LORD, shall we not bring these gifts to Your service?
Shall we not bring to Your service all our powers
For life, for dignity, grace and order,
And intellectual pleasures of the senses?
The LORD who created must wish us to create
And employ our creation again in His service
Which is already His service in creating.
For Man is joined spirit and body,
And therefore must serve as spirit and body.
Visible and invisible, two worlds meet in Man;
Visible and invisible must meet in His Temple;
You must not deny the body.

Now you shall see the Temple completed:
After much striving, after many obstacles;
For the work of creation is never without travail;
The formed stone, the visible crucifix,
The dressed altar, the lifting light,

Light

Light

The visible reminder of Invisible Light.

X

You have seen the house built, you have seen it adorned
By one who came in the night, it is now dedicated to GOD.
It is now a visible church, one more light set on a hill
In a world confused and dark and disturbed by portents of fear.
And what shall we say of the future? Is one church all we can
 build?
Or shall the Visible Church go on to conquer the World?

The great snake lies ever half awake, at the bottom of the pit
 of the world, curled
In folds of himself until he awakens in hunger and moving his
 head to right and to left prepares for his hour to devour.
But the Mystery of Iniquity is a pit too deep for mortal eyes to
 plumb. Come
Ye out from among those who prize the serpent's golden eyes,
The worshippers, self-given sacrifice of the snake. Take
Your way and be ye separate.
Be not too curious of Good and Evil;
Seek not to count the future waves of Time;
But be ye satisfied that you have light
Enough to take your step and find your foothold.

O Light Invisible, we praise Thee!
Too bright for mortal vision.

O Greater Light, we praise Thee for the less;
The eastern light our spires touch at morning,
The light that slants upon our western doors at evening,
The twilight over stagnant pools at batflight,
Moon light and star light, owl and moth light,
Glow-worm glowlight on a grassblade.
O Light Invisible, we worship Thee!

We thank Thee for the lights that we have kindled,
The light of altar and of sanctuary;
Small lights of those who meditate at midnight
And lights directed through the coloured panes of windows
And light reflected from the polished stone,
The gilded carven wood, the coloured fresco.
Our gaze is submarine, our eyes look upward
And see the light that fractures through unquiet water.
We see the light but see not whence it comes.
O Light Invisible, we glorify Thee!

In our rhythm of earthly life we tire of light. We are glad
 when the day ends, when the play ends; and ecstasy is too
 much pain.
We are children quickly tired: children who are up in the night
 and fall asleep as the rocket is fired; and the day is long for
 work or play.
We tire of distraction or concentration, we sleep and are glad
 to sleep,
Controlled by the rhythm of blood and the day and the night
 and the seasons.
And we must extinguish the candle, put out the light and
 relight it;
Forever must quench, forever relight the flame.
Therefore we thank Thee for our little light, that is dappled
 with shadow.
We thank Thee who hast moved us to building, to finding, to
 forming at the ends of our fingers and beams of our eyes.

And when we have built an altar to the Invisible Light, we may
 set thereon the little lights for which our bodily vision is made.
And we thank Thee that darkness reminds us of light.
O Light Invisible, we give Thee thanks for Thy great glory!

Four Quartets

Burnt Norton

τοῦ λόγου δ'ἐόντος ξυνοῦ ζώουσιν οἱ πολλοί
ὡς ἰδίαν ἔχοντες φρόνησιν.

I. p. 77. Fr. 2.

ὁδὸς ἄνω κάτω μία καὶ ὡυτή.

I. p. 89. Fr. 60.

Diels: *Die Fragmente der Vorsokratiker* (Herakleitos).

I

Time present and time past
Are both perhaps present in time future,
And time future contained in time past.
If all time is eternally present
All time is unredeemable.
What might have been is an abstraction
Remaining a perpetual possibility
Only in a world of speculation.
What might have been and what has been
Point to one end, which is always present.
Footfalls echo in the memory
Down the passage which we did not take
Towards the door we never opened
Into the rose-garden. My words echo
Thus, in your mind.
 But to what purpose
Disturbing the dust on a bowl of rose-leaves
I do not know.
 Other echoes
Inhabit the garden. Shall we follow?
Quick, said the bird, find them, find them,
Round the corner. Through the first gate,

Into our first world, shall we follow
The deception of the thrush? Into our first world.
There they were, dignified, invisible,
Moving without pressure, over the dead leaves,
In the autumn heat, through the vibrant air,
And the bird called, in response to
The unheard music hidden in the shrubbery,
And the unseen eyebeam crossed, for the roses
Had the look of flowers that are looked at.
There they were as our guests, accepted and accepting.
So we moved, and they, in a formal pattern,
Along the empty alley, into the box circle,
To look down into the drained pool.
Dry the pool, dry concrete, brown edged,
And the pool was filled with water out of sunlight,
And the lotos rose, quietly, quietly,
The surface glittered out of heart of light,
And they were behind us, reflected in the pool.
Then a cloud passed, and the pool was empty.
Go, said the bird, for the leaves were full of children,
Hidden excitedly, containing laughter.
Go, go, go, said the bird: human kind
Cannot bear very much reality.
Time past and time future
What might have been and what has been
Point to one end, which is always present.

II

Garlic and sapphires in the mud
Clot the bedded axle-tree.
The trilling wire in the blood
Sings below inveterate scars
And reconciles forgotten wars.
The dance along the artery
The circulation of the lymph
Are figured in the drift of stars

Ascend to summer in the tree
We move above the moving tree
In light upon the figured leaf
And hear upon the sodden floor
Below, the boarhound and the boar
Pursue their pattern as before
But reconciled among the stars.

 At the still point of the turning world. Neither flesh nor fleshless;
Neither from nor towards; at the still point, there the dance is,
But neither arrest nor movement. And do not call it fixity,
Where past and future are gathered. Neither movement from nor
 towards,
Neither ascent nor decline. Except for the point, the still point,
There would be no dance, and there is only the dance.
I can only say, *there* we have been: but I cannot say where.
And I cannot say, how long, for that is to place it in time.

 The inner freedom from the practical desire,
The release from action and suffering, release from the inner
And the outer compulsion, yet surrounded
By a grace of sense, a white light still and moving,
Erhebung without motion, concentration
Without elimination, both a new world
And the old made explicit, understood
In the completion of its partial ecstasy,
The resolution of its partial horror.
Yet the enchainment of past and future
Woven in the weakness of the changing body,
Protects mankind from heaven and damnation
Which flesh cannot endure.
 Time past and time future
Allow but a little consciousness.
To be conscious is not to be in time
But only in time can the moment in the rose-garden,
The moment in the arbour where the rain beat,

The moment in the draughty church at smokefall
Be remembered; involved with past and future.
Only through time time is conquered.

III

Here is a place of disaffection
Time before and time after
In a dim light: neither daylight
Investing form with lucid stillness
Turning shadow into transient beauty
With slow rotation suggesting permanence
Nor darkness to purify the soul
Emptying the sensual with deprivation
Cleansing affection from the temporal.
Neither plenitude nor vacancy. Only a flicker
Over the strained time-ridden faces
Distracted from distraction by distraction
Filled with fancies and empty of meaning
Tumid apathy with no concentration
Men and bits of paper, whirled by the cold wind
That blows before and after time,
Wind in and out of unwholesome lungs
Time before and time after.
Eructation of unhealthy souls
Into the faded air, the torpid
Driven on the wind that sweeps the gloomy hills of London,
Hampstead and Clerkenwell, Campden and Putney,
Highgate, Primrose and Ludgate. Not here
Not here the darkness, in this twittering world.

 Descend lower, descend only
Into the world of perpetual solitude,
World not world, but that which is not world,
Internal darkness, deprivation
And destitution of all property,
Desiccation of the world of sense,
Evacuation of the world of fancy,

Inoperancy of the world of spirit;
This is the one way, and the other
Is the same, not in movement
But abstention from movement; while the world moves
In appetency, on its metalled ways
Of time past and time future.

IV

Time and the bell have buried the day,
The black cloud carries the sun away.
Will the sunflower turn to us, will the clematis
Stray down, bend to us; tendril and spray
Clutch and cling?
Chill
Fingers of yew be curled
Down on us? After the kingfisher's wing
Has answered light to light, and is silent, the light is still
At the still point of the turning world.

V

Words move, music moves
Only in time; but that which is only living
Can only die. Words, after speech, reach
Into the silence. Only by the form, the pattern,
Can words or music reach
The stillness, as a Chinese jar still
Moves perpetually in its stillness.
Not the stillness of the violin, while the note lasts,
Not that only, but the co-existence,
Or say that the end precedes the beginning,
And the end and the beginning were always there
Before the beginning and after the end.
And all is always now. Words strain,
Crack and sometimes break, under the burden,
Under the tension, slip, slide, perish,
Decay with imprecision, will not stay in place,
Will not stay still. Shrieking voices

Scolding, mocking, or merely chattering,
Always assail them. The Word in the desert
Is most attacked by voices of temptation,
The crying shadow in the funeral dance,
The loud lament of the disconsolate chimera.

 The detail of the pattern is movement,
As in the figure of the ten stairs.
Desire itself is movement
Not in itself desirable;
Love is itself unmoving,
Only the cause and end of movement,
Timeless, and undesiring
Except in the aspect of time
Caught in the form of limitation
Between un-being and being.
Sudden in a shaft of sunlight
Even while the dust moves
There rises the hidden laughter
Of children in the foliage
Quick now, here, now, always—
Ridiculous the waste sad time
Stretching before and after.

East Coker

I

In my beginning is my end. In succession
Houses rise and fall, crumble, are extended,
Are removed, destroyed, restored, or in their place
Is an open field, or a factory, or a by-pass.
Old stone to new building, old timber to new fires,
Old fires to ashes, and ashes to the earth
Which is already flesh, fur and faeces,
Bone of man and beast, cornstalk and leaf.
Houses live and die: there is a time for building
And a time for living and for generation
And a time for the wind to break the loosened pane
And to shake the wainscot where the field-mouse trots
And to shake the tattered arras woven with a silent motto.

 In my beginning is my end. Now the light falls
Across the open field, leaving the deep lane
Shuttered with branches, dark in the afternoon,
Where you lean against a bank while a van passes,
And the deep lane insists on the direction
Into the village, in the electric heat
Hypnotised. In a warm haze the sultry light
Is absorbed, not refracted, by grey stone.
The dahlias sleep in the empty silence.
Wait for the early owl.
 In that open field
If you do not come too close, if you do not come too close,
On a Summer midnight, you can hear the music

Of the weak pipe and the little drum
And see them dancing around the bonfire
The association of man and woman
In daunsinge, signifying matrimonie—
A dignified and commodious sacrament.
Two and two, necessarye coniunction,
Holding eche other by the hand or the arm
Whiche betokeneth concorde. Round and round the fire
Leaping through the flames, or joined in circles,
Rustically solemn or in rustic laughter
Lifting heavy feet in clumsy shoes,
Earth feet, loam feet, lifted in country mirth
Mirth of those long since under earth
Nourishing the corn. Keeping time,
Keeping the rhythm in their dancing
As in their living in the living seasons
The time of the seasons and the constellations
The time of milking and the time of harvest
The time of the coupling of man and woman
And that of beasts. Feet rising and falling.
Eating and drinking. Dung and death.

 Dawn points, and another day
Prepares for heat and silence. Out at sea the dawn wind
Wrinkles and slides. I am here
Or there, or elsewhere. In my beginning.

II

What is the late November doing
With the disturbance of the spring
And creatures of the summer heat,
And snowdrops writhing under feet
And hollyhocks that aim too high
Red into grey and tumble down
Late roses filled with early snow?
Thunder rolled by the rolling stars
Simulates triumphal cars

Deployed in constellated wars
Scorpion fights against the Sun
Until the Sun and Moon go down
Comets weep and Leonids fly
Hunt the heavens and the plains
Whirled in a vortex that shall bring
The world to that destructive fire
Which burns before the ice-cap reigns.

 That was a way of putting it—not very satisfactory:
A periphrastic study in a worn-out poetical fashion,
Leaving one still with the intolerable wrestle
With words and meanings. The poetry does not matter.
It was not (to start again) what one had expected.
What was to be the value of the long looked forward to,
Long hoped for calm, the autumnal serenity
And the wisdom of age? Had they deceived us
Or deceived themselves, the quiet-voiced elders,
Bequeathing us merely a receipt for deceit?
The serenity only a deliberate hebetude,
The wisdom only the knowledge of dead secrets
Useless in the darkness into which they peered
Or from which they turned their eyes. There is, it seems to us,
At best, only a limited value
In the knowledge derived from experience.
The knowledge imposes a pattern, and falsifies,
For the pattern is new in every moment
And every moment is a new and shocking
Valuation of all we have been. We are only undeceived
Of that which, deceiving, could no longer harm.
In the middle, not only in the middle of the way
But all the way, in a dark wood, in a bramble,
On the edge of a grimpen, where is no secure foothold,
And menaced by monsters, fancy lights,
Risking enchantment. Do not let me hear
Of the wisdom of old men, but rather of their folly,
Their fear of fear and frenzy, their fear of possession,

Of belonging to another, or to others, or to God.
The only wisdom we can hope to acquire
Is the wisdom of humility: humility is endless.

 The houses are all gone under the sea.

 The dancers are all gone under the hill.

III

O dark dark dark. They all go into the dark,
The vacant interstellar spaces, the vacant into the vacant,
The captains, merchant bankers, eminent men of letters,
The generous patrons of art, the statesmen and the rulers,
Distinguished civil servants, chairmen of many committees,
Industrial lords and petty contractors, all go into the dark,
And dark the Sun and Moon, and the Almanach de Gotha
And the Stock Exchange Gazette, the Directory of Directors,
And cold the sense and lost the motive of action.
And we all go with them, into the silent funeral,
Nobody's funeral, for there is no one to bury.
I said to my soul, be still, and let the dark come upon you
Which shall be the darkness of God. As, in a theatre,
The lights are extinguished, for the scene to be changed
With a hollow rumble of wings, with a movement of darkness on
 darkness,
And we know that the hills and the trees, the distant panorama
And the bold imposing façade are all being rolled away—
Or as, when an underground train, in the tube, stops too long be-
 tween stations
And the conversation rises and slowly fades into silence
And you see behind every face the mental emptiness deepen
Leaving only the growing terror of nothing to think about;
Or when, under ether, the mind is conscious but conscious of
 nothing—
I said to my soul, be still, and wait without hope
For hope would be hope for the wrong thing; wait without love
For love would be love of the wrong thing; there is yet faith

But the faith and the love and the hope are all in the waiting.
Wait without thought, for you are not ready for thought:
So the darkness shall be the light, and the stillness the dancing.

 Whisper of running streams, and winter lightning.
The wild thyme unseen and the wild strawberry,
The laughter in the garden, echoed ecstasy
Not lost, but requiring, pointing to the agony
Of death and birth.
 You say I am repeating
Something I have said before. I shall say it again.
Shall I say it again? In order to arrive there,
To arrive where you are, to get from where you are not,
 You must go by a way wherein there is no ecstasy.
In order to arrive at what you do not know
 You must go by a way which is the way of ignorance.
In order to possess what you do not possess
 You must go by the way of dispossession.
In order to arrive at what you are not
 You must go through the way in which you are not.
And what you do not know is the only thing you know
And what you own is what you do not own
And where you are is where you are not.

IV

The wounded surgeon plies the steel
That questions the distempered part;
Beneath the bleeding hands we feel
The sharp compassion of the healer's art
Resolving the enigma of the fever chart.

 Our only health is the disease
If we obey the dying nurse
Whose constant care is not to please
But to remind of our, and Adam's curse,
And that, to be restored, our sickness must grow worse.

The whole earth is our hospital
Endowed by the ruined millionaire,
Wherein, if we do well, we shall
Die of the absolute paternal care
That will not leave us, but prevents us everywhere.

The chill ascends from feet to knees,
The fever sings in mental wires.
If to be warmed, then I must freeze
And quake in frigid purgatorial fires
Of which the flame is roses, and the smoke is briars.

The dripping blood our only drink,
The bloody flesh our only food:
In spite of which we like to think
That we are sound, substantial flesh and blood—
Again, in spite of that, we call this Friday good.

V

So here I am, in the middle way, having had twenty years—
Twenty years largely wasted, the years of *l'entre deux guerres*—
Trying to learn to use words, and every attempt
Is a wholly new start, and a different kind of failure
Because one has only learnt to get the better of words
For the thing one no longer has to say, or the way in which
One is no longer disposed to say it. And so each venture
Is a new beginning, a raid on the inarticulate
With shabby equipment always deteriorating
In the general mess of imprecision of feeling,
Undisciplined squads of emotion. And what there is to conquer
By strength and submission, has already been discovered
Once or twice, or several times, by men whom one cannot hope
To emulate—but there is no competition—
There is only the fight to recover what has been lost
And found and lost again and again: and now, under conditions
That seem unpropitious. But perhaps neither gain nor loss.
For us, there is only the trying. The rest is not our business.

Home is where one starts from. As we grow older
The world becomes stranger, the pattern more complicated
Of dead and living. Not the intense moment
Isolated, with no before and after,
But a lifetime burning in every moment
And not the lifetime of one man only
But of old stones that cannot be deciphered.
There is a time for the evening under starlight,
A time for the evening under lamplight
(The evening with the photograph album).
Love is most nearly itself
When here and now cease to matter.
Old men ought to be explorers
Here and there does not matter
We must be still and still moving
Into another intensity
For a further union, a deeper communion
Through the dark cold and the empty desolation,
The wave cry, the wind cry, the vast waters
Of the petrel and the porpoise. In my end is my beginning.

The Dry Salvages

(The Dry Salvages—presumably *les trois sauvages*—is a small group of rocks, with a beacon, off the N.E. coast of Cape Ann, Massachusetts. *Salvages* is pronounced to rhyme with *assuages*. *Groaner:* a whistling buoy.)

I

I do not know much about gods; but I think that the river
Is a strong brown god—sullen, untamed and intractable,
Patient to some degree, at first recognised as a frontier;
Useful, untrustworthy, as a conveyor of commerce;
Then only a problem confronting the builder of bridges.
The problem once solved, the brown god is almost forgotten
By the dwellers in cities—ever, however, implacable,
Keeping his seasons and rages, destroyer, reminder
Of what men choose to forget. Unhonoured, unpropitiated
By worshippers of the machine, but waiting, watching and waiting.
His rhythm was present in the nursery bedroom,
In the rank ailanthus of the April dooryard,
In the smell of grapes on the autumn table,
And the evening circle in the winter gaslight.

The river is within us, the sea is all about us;
The sea is the land's edge also, the granite
Into which it reaches, the beaches where it tosses
Its hints of earlier and other creation:
The starfish, the hermit crab, the whale's backbone;
The pools where it offers to our curiosity
The more delicate algae and the sea anemone.
It tosses up our losses, the torn seine,
The shattered lobsterpot, the broken oar
And the gear of foreign dead men. The sea has many voices,

[130]

Many gods and many voices.
 The salt is on the briar rose,
The fog is in the fir trees.
 The sea howl
And the sea yelp, are different voices
Often together heard; the whine in the rigging,
The menace and caress of wave that breaks on water,
The distant rote in the granite teeth,
And the wailing warning from the approaching headland
Are all sea voices, and the heaving groaner
Rounded homewards, and the seagull:
And under the oppression of the silent fog
The tolling bell
Measures time not our time, rung by the unhurried
Ground swell, a time
Older than the time of chronometers, older
Than time counted by anxious worried women
Lying awake, calculating the future,
Trying to unweave, unwind, unravel
And piece together the past and the future,
Between midnight and dawn, when the past is all deception,
The future futureless, before the morning watch
When time stops and time is never ending;
And the ground swell, that is and was from the beginning,
Clangs
The bell.

II

Where is there an end of it, the soundless wailing,
The silent withering of autumn flowers
Dropping their petals and remaining motionless;
Where is there an end to the drifting wreckage,
The prayer of the bone on the beach, the unprayable
Prayer at the calamitous annunciation?

 There is no end, but addition: the trailing
Consequence of further days and hours,
While emotion takes to itself the emotionless

Years of living among the breakage
Of what was believed in as the most reliable—
And therefore the fittest for renunciation.

 There is the final addition, the failing
Pride or resentment at failing powers,
The unattached devotion which might pass for devotionless,
In a drifting boat with a slow leakage,
The silent listening to the undeniable
Clamour of the bell of the last annunciation.

 Where is the end of them, the fishermen sailing
Into the wind's tail, where the fog cowers?
We cannot think of a time that is oceanless
Or of an ocean not littered with wastage
Or of a future that is not liable
Like the past, to have no destination.

 We have to think of them as forever bailing,
Setting and hauling, while the North East lowers
Over shallow banks unchanging and erosionless
Or drawing their money, drying sails at dockage;
Not as making a trip that will be unpayable
For a haul that will not bear examination.

 There is no end of it, the voiceless wailing,
No end to the withering of withered flowers,
To the movement of pain that is painless and motionless,
To the drift of the sea and the drifting wreckage,
The bone's prayer to Death its God. Only the hardly, barely prayable
Prayer of the one Annunciation.

 It seems, as one becomes older,
That the past has another pattern, and ceases to be a mere sequence—
Or even development: the latter a partial fallacy,
Encouraged by superficial notions of evolution,
Which becomes, in the popular mind, a means of disowning the past.
The moments of happiness—not the sense of well-being,

Fruition, fulfilment, security or affection,
Or even a very good dinner, but the sudden illumination—
We had the experience but missed the meaning,
And approach to the meaning restores the experience
In a different form, beyond any meaning
We can assign to happiness. I have said before
That the past experience revived in the meaning
Is not the experience of one life only
But of many generations—not forgetting
Something that is probably quite ineffable:
The backward look behind the assurance
Of recorded history, the backward half-look
Over the shoulder, towards the primitive terror.
Now, we come to discover that the moments of agony
(Whether, or not, due to misunderstanding,
Having hoped for the wrong things or dreaded the wrong things,
Is not in question) are likewise permanent
With such permanence as time has. We appreciate this better
In the agony of others, nearly experienced,
Involving ourselves, than in our own.
For our own past is covered by the currents of action,
But the torment of others remains an experience
Unqualified, unworn by subsequent attrition.
People change, and smile: but the agony abides.
Time the destroyer is time the preserver,
Like the river with its cargo of dead Negroes, cows and chicken coops,
The bitter apple and the bite in the apple.
And the ragged rock in the restless waters,
Waves wash over it, fogs conceal it;
On a halcyon day it is merely a monument,
In navigable weather it is always a seamark
To lay a course by: but in the sombre season
Or the sudden fury, is what it always was.

III

I sometimes wonder if that is what Krishna meant—
Among other things—or one way of putting the same thing:

That the future is a faded song, a Royal Rose or a lavender spray
Of wistful regret for those who are not yet here to regret,
Pressed between yellow leaves of a book that has never been opened.
And the way up is the way down, the way forward is the way back.
You cannot face it steadily, but this thing is sure,
That time is no healer: the patient is no longer here.
When the train starts, and the passengers are settled
To fruit, periodicals and business letters
(And those who saw them off have left the platform)
Their faces relax from grief into relief,
To the sleepy rhythm of a hundred hours.
Fare forward, travellers! not escaping from the past
Into different lives, or into any future;
You are not the same people who left that station
Or who will arrive at any terminus,
While the narrowing rails slide together behind you;
And on the deck of the drumming liner
Watching the furrow that widens behind you,
You shall not think "the past is finished"
Or "the future is before us."
At nightfall, in the rigging and the aerial,
Is a voice descanting (though not to the ear,
The murmuring shell of time, and not in any language)
"Fare forward, you who think that you are voyaging;
You are not those who saw the harbour
Receding, or those who will disembark.
Here between the hither and the farther shore
While time is withdrawn, consider the future
And the past with an equal mind.
At the moment which is not of action or inaction
You can receive this: 'on whatever sphere of being
The mind of a man may be intent
At the time of death'—that is the one action
(And the time of death is every moment)
Which shall fructify in the lives of others:
And do not think of the fruit of action.
Fare forward.

O voyagers, O seamen,
You who come to port, and you whose bodies
Will suffer the trial and judgement of the sea,
Or whatever event, this is your real destination."
So Krishna, as when he admonished Arjuna
On the field of battle.
 Not fare well,
But fare forward, voyagers.

IV

Lady, whose shrine stands on the promontory,
Pray for all those who are in ships, those
Whose business has to do with fish, and
Those concerned with every lawful traffic
And those who conduct them.

 Repeat a prayer also on behalf of
Women who have seen their sons or husbands
Setting forth, and not returning:
Figlia del tuo figlio,
Queen of Heaven.

 Also pray for those who were in ships, and
Ended their voyage on the sand, in the sea's lips
Or in the dark throat which will not reject them
Or wherever cannot reach them the sound of the sea bell's
Perpetual angelus.

V

To communicate with Mars, converse with spirits,
To report the behaviour of the sea monster,
Describe the horoscope, haruspicate or scry,
Observe disease in signatures, evoke
Biography from the wrinkles of the palm
And tragedy from fingers; release omens
By sortilege, or tea leaves, riddle the inevitable
With playing cards, fiddle with pentagrams

Or barbituric acids, or dissect
The recurrent image into pre-conscious terrors—
To explore the womb, or tomb, or dreams; all these are usual
Pastimes and drugs, and features of the press:
And always will be, some of them especially
When there is distress of nations and perplexity
Whether on the shores of Asia, or in the Edgware Road.
Men's curiosity searches past and future
And clings to that dimension. But to apprehend
The point of intersection of the timeless
With time, is an occupation for the saint—
No occupation either, but something given
And taken, in a lifetime's death in love,
Ardour and selflessness and self-surrender.
For most of us, there is only the unattended
Moment, the moment in and out of time,
The distraction fit, lost in a shaft of sunlight,
The wild thyme unseen, or the winter lightning
Or the waterfall, or music heard so deeply
That it is not heard at all, but you are the music
While the music lasts. These are only hints and guesses,
Hints followed by guesses; and the rest
Is prayer, observance, discipline, thought and action.
The hint half guessed, the gift half understood, is Incarnation.
Here the impossible union.
Of spheres of existence is actual,
Here the past and future
Are conquered, and reconciled,
Where action were otherwise movement
Of that which is only moved
And has in it no source of movement—
Driven by daemonic, chthonic
Powers. And right action is freedom
From past and future also.
For most of us, this is the aim
Never here to be realised;
Who are only undefeated

Because we have gone on trying;
We, content at the last
If our temporal reversion nourish
(Not too far from the yew-tree)
The life of significant soil.

Little Gidding

Midwinter spring is its own season
Sempiternal though sodden towards sundown,
Suspended in time, between pole and tropic.
When the short day is brightest, with frost and fire,
The brief sun flames the ice, on pond and ditches,
In windless cold that is the heart's heat,
Reflecting in a watery mirror
A glare that is blindness in the early afternoon.
And glow more intense than blaze of branch, or brazier,
Stirs the dumb spirit: no wind, but pentecostal fire
In the dark time of the year. Between melting and freezing
The soul's sap quivers. There is no earth smell
Or smell of living thing. This is the spring time
But not in time's covenant. Now the hedgerow
Is blanched for an hour with transitory blossom
Of snow, a bloom more sudden
Than that of summer, neither budding nor fading,
Not in the scheme of generation.
Where is the summer, the unimaginable
Zero summer?

 If you came this way,
Taking the route you would be likely to take
From the place you would be likely to come from,
If you came this way in may time, you would find the hedges
White again, in May, with voluptuary sweetness.
It would be the same at the end of the journey,
If you came at night like a broken king,
If you came by day not knowing what you came for,

It would be the same, when you leave the rough road
And turn behind the pig-sty to the dull façade
And the tombstone. And what you thought you came for
Is only a shell, a husk of meaning
From which the purpose breaks only when it is fulfilled
If at all. Either you had no purpose
Or the purpose is beyond the end you figured
And is altered in fulfilment. There are other places
Which also are the world's end, some at the sea jaws,
Or over a dark lake, in a desert or a city—
But this is the nearest, in place and time,
Now and in England.

 If you came this way,
Taking any route, starting from anywhere,
At any time or at any season,
It would always be the same: you would have to put off
Sense and notion. You are not here to verify,
Instruct yourself, or inform curiosity
Or carry report. You are here to kneel
Where prayer has been valid. And prayer is more
Than an order of words, the conscious occupation
Of the praying mind, or the sound of the voice praying.
And what the dead had no speech for, when living,
They can tell you, being dead: the communication
Of the dead is tongued with fire beyond the language of the living.
Here, the intersection of the timeless moment
Is England and nowhere. Never and always.

II

Ash on an old man's sleeve
Is all the ash the burnt roses leave.
Dust in the air suspended
Marks the place where a story ended.
Dust inbreathed was a house—
The wall, the wainscot and the mouse.
The death of hope and despair,
 This is the death of air.

There are flood and drouth
Over the eyes and in the mouth,
Dead water and dead sand
Contending for the upper hand.
The parched eviscerate soil
Gapes at the vanity of toil,
Laughs without mirth.
 This is the death of earth.

Water and fire succeed
The town, the pasture and the weed.
Water and fire deride
The sacrifice that we denied.
Water and fire shall rot
The marred foundations we forgot,
Of sanctuary and choir.
 This is the death of water and fire.

In the uncertain hour before the morning
 Near the ending of interminable night
 At the recurrent end of the unending
After the dark dove with the flickering tongue
 Had passed below the horizon of his homing
 While the dead leaves still rattled on like tin
Over the asphalt where no other sound was
 Between three districts whence the smoke arose
 I met one walking, loitering and hurried
As if blown towards me like the metal leaves
 Before the urban dawn wind unresisting.
 And as I fixed upon the down-turned face
That pointed scrutiny with which we challenge
 The first-met stranger in the waning dusk
 I caught the sudden look of some dead master
Whom I had known, forgotten, half recalled
 Both one and many; in the brown baked features
 The eyes of a familiar compound ghost
Both intimate and unidentifiable.

So I assumed a double part, and cried
And heard another's voice cry: 'What! are *you* here?'
Although we were not. I was still the same,
 Knowing myself yet being someone other—
 And he a face still forming; yet the words sufficed
To compel the recognition they preceded.
 And so, compliant to the common wind,
 Too strange to each other for misunderstanding,
In concord at this intersection time
 Of meeting nowhere, no before and after,
 We trod the pavement in a dead patrol.
I said: 'The wonder that I feel is easy,
 Yet ease is cause of wonder. Therefore speak:
 I may not comprehend, may not remember.'
And he: 'I am not eager to rehearse
 My thought and theory which you have forgotten.
 These things have served their purpose: let them be.
So with your own, and pray they be forgiven
 By others, as I pray you to forgive
 Both bad and good. Last season's fruit is eaten
And the fullfed beast shall kick the empty pail.
 For last year's words belong to last year's language
 And next year's words await another voice.
But, as the passage now presents no hindrance
 To the spirit unappeased and peregrine
 Between two worlds become much like each other,
So I find words I never thought to speak
 In streets I never thought I should revisit
 When I left my body on a distant shore.
Since our concern was speech, and speech impelled us
 To purify the dialect of the tribe
 And urge the mind to aftersight and foresight,
Let me disclose the gifts reserved for age
 To set a crown upon your lifetime's effort.
 First, the cold friction of expiring sense
Without enchantment, offering no promise
 But bitter tastelessness of shadow fruit

As body and soul begin to fall asunder.
Second, the conscious impotence of rage
 At human folly, and the laceration
 Of laughter at what ceases to amuse.
And last, the rending pain of re-enactment
 Of all that you have done, and been; the shame
 Of motives late revealed, and the awareness
Of things ill done and done to others' harm
 Which once you took for exercise of virtue.
 Then fools' approval stings, and honour stains.
From wrong to wrong the exasperated spirit
 Proceeds, unless restored by that refining fire
 Where you must move in measure, like a dancer.'
The day was breaking. In the disfigured street
 He left me, with a kind of valediction,
 And faded on the blowing of the horn.

III

There are three conditions which often look alike
Yet differ completely, flourish in the same hedgerow:
Attachment to self and to things and to persons, detachment
From self and from things and from persons; and, growing between
 them, indifference
Which resembles the others as death resembles life,
Being between two lives—unflowering, between
The live and the dead nettle. This is the use of memory:
For liberation—not less of love but expanding
Of love beyond desire, and so liberation
From the future as well as the past. Thus, love of a country
Begins as attachment to our own field of action
And comes to find that action of little importance
Though never indifferent. History may be servitude,
History may be freedom. See, now they vanish,
The faces and places, with the self which, as it could, loved them,
To become renewed, transfigured, in another pattern.

 Sin is Behovely, but
All shall be well, and

All manner of thing shall be well.
If I think, again, of this place,
And of people, not wholly commendable,
Of no immediate kin or kindness,
But some of peculiar genius,
All touched by a common genius,
United in the strife which divided them;
If I think of a king at nightfall,
Of three men, and more, on the scaffold
And a few who died forgotten
In other places, here and abroad,
And of one who died blind and quiet,
Why should we celebrate
These dead men more than the dying?
It is not to ring the bell backward
Nor is it an incantation
To summon the spectre of a Rose.
We cannot revive old factions
We cannot restore old policies
Or follow an antique drum.
These men, and those who opposed them
And those whom they opposed
Accept the constitution of silence
And are folded in a single party.
Whatever we inherit from the fortunate
We have taken from the defeated
What they had to leave us—a symbol:
A symbol perfected in death.
And all shall be well and
All manner of thing shall be well
By the purification of the motive
In the ground of our beseeching.

IV

The dove descending breaks the air
With flame of incandescent terror
Of which the tongues declare
The one discharge from sin and error.

The only hope, or else despair
 Lies in the choice of pyre or pyre—
 To be redeemed from fire by fire.

 Who then devised the torment? Love.
Love is the unfamiliar Name
Behind the hands that wove
The intolerable shirt of flame
Which human power cannot remove.
 We only live, only suspire
 Consumed by either fire or fire.

V

What we call the beginning is often the end
And to make an end is to make a beginning.
The end is where we start from. And every phrase
And sentence that is right (where every word is at home,
Taking its place to support the others,
The word neither diffident nor ostentatious,
An easy commerce of the old and the new,
The common word exact without vulgarity,
The formal word precise but not pedantic,
The complete consort dancing together)
Every phrase and every sentence is an end and a beginning,
Every poem an epitaph. And any action
Is a step to the block, to the fire, down the sea's throat
Or to an illegible stone: and that is where we start.
We die with the dying:
See, they depart, and we go with them.
We are born with the dead:
See, they return, and bring us with them.
The moment of the rose and the moment of the yew-tree
Are of equal duration. A people without history
Is not redeemed from time, for history is a pattern
Of timeless moments. So, while the light fails
On a winter's afternoon, in a secluded chapel

History is now and England.
With the drawing of this Love and the voice of this Calling

 We shall not cease from exploration
And the end of all our exploring
Will be to arrive where we started
And know the place for the first time.
Through the unknown, remembered gate
When the last of earth left to discover
Is that which was the beginning;
At the source of the longest river
The voice of the hidden waterfall
And the children in the apple-tree
Not known, because not looked for
But heard, half-heard, in the stillness
Between two waves of the sea.
Quick now, here, now, always—
A condition of complete simplicity
(Costing not less than everything)
And all shall be well and
All manner of thing shall be well
When the tongues of flame are in-folded
Into the crowned knot of fire
And the fire and the rose are one.

Old Possum's Book of
Practical Cats

This book is respectfully dedicated to those friends who have assisted its composition by their encouragement, criticism and suggestions: and in particular to Mr. T. E. Faber, Miss Alison Tandy, Miss Susan Wolcott, Miss Susanna Morley, and the Man in White Spats.

O. P.

THE NAMING OF CATS

The Naming of Cats is a difficult matter,
 It isn't just one of your holiday games;
You may think at first I'm as mad as a hatter
When I tell you, a cat must have THREE DIFFERENT NAMES.
First of all, there's the name that the family use daily,
 Such as Peter, Augustus, Alonzo or James,
Such as Victor or Jonathan, George or Bill Bailey—
 All of them sensible everyday names.
There are fancier names if you think they sound sweeter,
 Some for the gentlemen, some for the dames:
Such as Plato, Admetus, Electra, Demeter—
 But all of them sensible everyday names.
But I tell you, a cat needs a name that's particular,
 A name that's peculiar, and more dignified,
Else how can he keep up his tail perpendicular,
 Or spread out his whiskers, or cherish his pride?
Of names of this kind, I can give you a quorum,
 Such as Munkustrap, Quaxo, or Coricopat,
Such as Bombalurina, or else Jellylorum—
 Names that never belong to more than one cat.
But above and beyond there's still one name left over,
 And that is the name that you never will guess;
The name that no human research can discover—
 But THE CAT HIMSELF KNOWS, and will never confess.
When you notice a cat in profound meditation,
 The reason, I tell you, is always the same:
His mind is engaged in a rapt contemplation
 Of the thought, of the thought, of the thought of his name:
 His ineffable effable
 Effanineffable
Deep and inscrutable singular Name.

THE OLD GUMBIE CAT

I have a Gumbie Cat in mind, her name is Jennyanydots;
Her coat is of the tabby kind, with tiger stripes and leopard spots.
All day she sits upon the stair or on the steps or on the mat;
She sits and sits and sits and sits—and that's what makes a Gumbie
 Cat!

But when the day's hustle and bustle is done,
Then the Gumbie Cat's work is but hardly begun.
And when all the family's in bed and asleep,
She tucks up her skirts to the basement to creep.
She is deeply concerned with the ways of the mice—
Their behaviour's not good and their manners not nice;
So when she has got them lined up on the matting,
She teaches them music, crocheting and tatting.

I have a Gumbie Cat in mind, her name is Jennyanydots;
Her equal would be hard to find, she likes the warm and sunny spots.
All day she sits beside the hearth or on the bed or on my hat:
She sits and sits and sits and sits—and that's what makes a Gumbie
 Cat!

But when the day's hustle and bustle is done,
Then the Gumbie Cat's work is but hardly begun.
As she finds that the mice will not ever keep quiet,
She is sure it is due to irregular diet;
And believing that nothing is done without trying,
She sets right to work with her baking and frying.
She makes them a mouse-cake of bread and dried peas,
And a *beautiful* fry of lean bacon and cheese.

I have a Gumbie Cat in mind, her name is Jennyanydots;
The curtain-cord she likes to wind, and tie it into sailor-knots.

She sits upon the window-sill, or anything that's smooth and flat:
She sits and sits and sits and sits—and that's what makes a Gumbie
 Cat!

But when the day's hustle and bustle is done,
Then the Gumbie Cat's work is but hardly begun.
She thinks that the cockroaches just need employment
To prevent them from idle and wanton destroyment.
So she's formed, from that lot of disorderly louts,
A troop of well-disciplined helpful boy-scouts,
With a purpose in life and a good deed to do—
And she's even created a Beetles' Tattoo.

So for Old Gumbie Cats let us now give three cheers—
On whom well-ordered households depend, it appears.

GROWLTIGER'S LAST STAND

GROWLTIGER was a Bravo Cat, who lived upon a barge:
In fact he was the roughest cat that ever roamed at large.
From Gravesend up to Oxford he pursued his evil aims,
Rejoicing in his title of "The Terror of the Thames."

His manners and appearance did not calculate to please;
His coat was torn and seedy, he was baggy at the knees;
One ear was somewhat missing, no need to tell you why,
And he scowled upon a hostile world from one forbidding eye.

The cottagers of Rotherhithe knew something of his fame,
At Hammersmith and Putney people shuddered at his name.
They would fortify the hen-house, lock up the silly goose,
When the rumour ran along the shore: GROWLTIGER'S ON THE LOOSE!

Woe to the weak canary, that fluttered from its cage;
Woe to the pampered Pekinese, that faced Growltiger's rage.

Woe to the bristly Bandicoot, that lurks on foreign ships,
And woe to any Cat with whom Growltiger came to grips!

But most to Cats of foreign race his hatred had been vowed;
To Cats of foreign name and race no quarter was allowed.
The Persian and the Siamese regarded him with fear—
Because it was a Siamese had mauled his missing ear.

Now on a peaceful summer night, all nature seemed at play,
The tender moon was shining bright, the barge at Molesey lay.
All in the balmy moonlight it lay rocking on the tide—
And Growltiger was disposed to show his sentimental side.

His bucko mate, GRUMBUSKIN, long since had disappeared,
For to the Bell at Hampton he had gone to wet his beard;
And his bosun, TUMBLEBRUTUS, he too had stol'n away—
In the yard behind the Lion he was prowling for his prey.

In the forepeak of the vessel Growltiger sate alone,
Concentrating his attention on the Lady GRIDDLEBONE.
And his raffish crew were sleeping in their barrels and their bunks—
As the Siamese came creeping in their sampans and their junks.

Growltiger had no eye or ear for aught but Griddlebone,
And the Lady seemed enraptured by his manly baritone,
Disposed to relaxation, and awaiting no surprise—
But the moonlight shone reflected from a thousand bright blue eyes.

And closer still and closer the sampans circled round,
And yet from all the enemy there was not heard a sound.
The lovers sang their last duet, in danger of their lives—
For the foe was armed with toasting forks and cruel carving knives.

Then GILBERT gave the signal to his fierce Mongolian horde;
With a frightful burst of fireworks the Chinks they swarmed aboard.
Abandoning their sampans, and their pullaways and junks,
They battened down the hatches on the crew within their bunks.

Then Griddlebone she gave a screech, for she was badly skeered;
I am sorry to admit it, but she quickly disappeared.
She probably escaped with ease, I'm sure she was not drowned—
But a serried ring of flashing steel Growltiger did surround.

The ruthless foe pressed forward, in stubborn rank on rank;
Growltiger to his vast surprise was forced to walk the plank.
He who a hundred victims had driven to that drop,
At the end of all his crimes was forced to go ker-flip, ker-flop.

Oh there was joy in Wapping when the news flew through the
 land;
At Maidenhead and Henley there was dancing on the strand.
Rats were roasted whole at Brentford, and at Victoria Dock,
And a day of celebration was commanded in Bangkok.

THE RUM TUM TUGGER

The Rum Tum Tugger is a Curious Cat:
If you offer him pheasant he would rather have grouse.
If you put him in a house he would much prefer a flat,
If you put him in a flat then he'd rather have a house.
If you set him on a mouse then he only wants a rat,
If you set him on a rat then he'd rather chase a mouse.
Yes the Rum Tum Tugger is a Curious Cat—
 And there isn't any call for me to shout it:
 For he will do
 As he do do
 And there's no doing anything about it!

The Rum Tum Tugger is a terrible bore:
When you let him in, then he wants to be out;
He's always on the wrong side of every door,
And as soon as he's at home, then he'd like to get about.

He likes to lie in the bureau drawer,
But he makes such a fuss if he can't get out.
Yes the Rum Tum Tugger is a Curious Cat—
 And it isn't any use for you to doubt it:
 For he will do
 As he do do
 And there's no doing anything about it!

 The Rum Tum Tugger is a curious beast:
His disobliging ways are a matter of habit.
If you offer him fish then he always wants a feast;
When there isn't any fish then he won't eat rabbit.
If you offer him cream then he sniffs and sneers,
For he only likes what he finds for himself;
So you'll catch him in it right up to the ears,
If you put it away on the larder shelf.
The Rum Tum Tugger is artful and knowing,
The Rum Tum Tugger doesn't care for a cuddle;
But he'll leap on your lap in the middle of your sewing,
For there's nothing he enjoys like a horrible muddle.
Yes the Rum Tum Tugger is a Curious Cat—
 And there isn't any need for me to spout it:
 For he will do
 As he do do
 And there's no doing anything about it!

THE SONG OF THE JELLICLES

 Jellicle Cats come out tonight,
 Jellicle Cats come one come all:
 The Jellicle Moon is shining bright—
 Jellicles come to the Jellicle Ball.

Jellicle Cats are black and white,
Jellicle Cats are rather small;

Jellicle Cats are merry and bright,
And pleasant to hear when they caterwaul.
Jellicle Cats have cheerful faces,
Jellicle Cats have bright black eyes;
They like to practise their airs and graces
And wait for the Jellicle Moon to rise.

Jellicle Cats develop slowly,
Jellicle Cats are not too big;
Jellicle Cats are roly-poly,
They know how to dance a gavotte and a jig.
Until the Jellicle Moon appears
They make their toilette and take their repose:
Jellicles wash behind their ears,
Jellicles dry between their toes.

Jellicle Cats are white and black,
Jellicle Cats are of moderate size;
Jellicles jump like a jumping-jack,
Jellicle Cats have moonlit eyes.
They're quiet enough in the morning hours,
They're quiet enough in the afternoon,
Reserving their terpsichorean powers
To dance by the light of the Jellicle Moon.

Jellicle Cats are black and white,
Jellicle Cats (as I said) are small;
If it happens to be a stormy night
They will practise a caper or two in the hall.
If it happens the sun is shining bright
You would say they had nothing to do at all:
They are resting and saving themselves to be right
For the Jellicle Moon and the Jellicle Ball.

MUNGOJERRIE AND RUMPELTEAZER

Mungojerrie and Rumpelteazer were a very notorious couple of cats.
As knockabout clowns, quick-change comedians, tight-rope walkers
 and acrobats
They had an extensive reputation. They made their home in Vic-
 toria Grove—
That was merely their centre of operation, for they were incurably
 given to rove.
They were very well known in Cornwall Gardens, in Launceston
 Place and in Kensington Square—
They had really a little more reputation than a couple of cats can
 very well bear.

 If the area window was found ajar
 And the basement looked like a field of war,
 If a tile or two came loose on the roof,
 Which presently ceased to be waterproof,
 If the drawers were pulled out from the bedroom chests,
 And you couldn't find one of your winter vests,
 Or after supper one of the girls
 Suddenly missed her Woolworth pearls:
Then the family would say: "It's that horrible cat!
It was Mungojerrie—or Rumpelteazer!"—And most of the time they
 left it at that.

 Mungojerrie and Rumpelteazer had a very unusual gift of the gab.
They were highly efficient cat-burglars as well, and remarkably smart
 at a smash-and-grab.
They made their home in Victoria Grove. They had no regular oc-
 cupation.
They were plausible fellows, and liked to engage a friendly police-
 man in conversation.

 When the family assembled for Sunday dinner,
 With their minds made up that they wouldn't get thinner

On Argentine joint, potatoes and greens,
And the cook would appear from behind the scenes
And say in a voice that was broken with sorrow:
"I'm afraid you must wait and have dinner *tomorrow!*
For the joint has gone from the oven—like that!"
Then the family would say: "It's that horrible cat!
It was Mungojerrie—or Rumpelteazer!"—And most of the time they
 left it at that.

Mungojerrie and Rumpelteazer had a wonderful way of working
 together.
And some of the time you would say it was luck, and some of the
 time you would say it was weather.
They would go through the house like a hurricane, and no sober
 person could take his oath
Was it Mungojerrie—or Rumpelteazer? or could you have sworn that
 it mightn't be both?

And when you heard a dining-room smash
Or up from the pantry there came a loud crash
Or down from the library came a loud *ping*
From a vase which was commonly said to be Ming—
Then the family would say: "Now which was which cat?
It was Mungojerrie! AND Rumpelteazer!"—And there's nothing at all
 to be done about that!

OLD DEUTERONOMY

Old Deuteronomy's lived a long time;
 He's a Cat who has lived many lives in succession.
He was famous in proverb and famous in rhyme
 A long while before Queen Victoria's accession.
Old Deuteronomy's buried nine wives
 And more—I am tempted to say, ninety-nine;
And his numerous progeny prospers and thrives

And the village is proud of him in his decline.
At the sight of that placid and bland physiognomy,
 When he sits in the sun on the vicarage wall,
The Oldest Inhabitant croaks: "Well, of all . . .
 Things . . . Can it be . . . really! . . . No! . . . Yes! . . .
 Ho! hi!
 Oh, my eye!
My mind may be wandering, but I confess
I *believe* it is Old Deuteronomy!"

 Old Deuteronomy sits in the street,
 He sits in the High Street on market day;
The bullocks may bellow, the sheep they may bleat,
 But the dogs and the herdsmen will turn them away.
The cars and the lorries run over the kerb,
 And the villagers put up a notice: ROAD CLOSED—
So that nothing untoward may chance to disturb
 Deuteronomy's rest when he feels so disposed
Or when he's engaged in domestic economy:
 And the Oldest Inhabitant croaks: "Well, of all . . .
 Things . . . Can it be . . . really! . . . No! . . . Yes! . . .
 Ho! hi!
 Oh, my eye!
My sight's unreliable, but I can guess
That the cause of the trouble is Old Deuteronomy!"

 Old Deuteronomy lies on the floor
 Of the Fox and French Horn for his afternoon sleep;
And when the men say: "There's just time for one more,"
 Then the landlady from her back parlour will peep
And say: "Now then, out you go, by the back door,
 For Old Deuteronomy mustn't be woken—
I'll have the police if there's any uproar"—
 And out they all shuffle, without a word spoken.
The digestive repose of that feline's gastronomy
 Must never be broken, whatever befall:
And the Oldest Inhabitant croaks: "Well, of all . . .

Things . . . Can it be . . . really! . . . Yes! . . . No! . . .
 Ho! hi!
 Oh, my eye!
My legs may be tottery, I must go slow
And be careful of Old Deuteronomy!"

OF THE AWEFULL BATTLE OF THE PEKES AND THE POLLICLES: TOGETHER WITH SOME ACCOUNT OF THE PARTICIPATION OF THE PUGS AND THE POMS, AND THE INTERVENTION OF THE GREAT RUMPUSCAT

The Pekes and the Pollicles, everyone knows,
Are proud and implacable passionate foes;
It is always the same, wherever one goes.
And the Pugs and the Poms, although most people say
That they do not like fighting, yet once in a way,
They will now and again join in to the fray
And they
 Bark bark bark bark
 Bark bark BARK BARK
 Until you can hear them all over the Park.

Now on the occasion of which I shall speak
Almost nothing had happened for nearly a week
(And that's a long time for a Pol or a Peke).
The big Police Dog was away from his beat—
I don't know the reason, but most people think
He'd slipped into the Wellington Arms for a drink—
And no one at all was about on the street
When a Peke and a Pollicle happened to meet.
They did not advance, or exactly retreat,
But they glared at each other, and scraped their hind feet,
And started to
 Bark bark bark bark

<div style="text-align: center;">

Bark bark BARK BARK
</div>

Until you could hear them all over the Park.

 Now the Peke, although people may say what they please,
Is no British Dog, but a Heathen Chinese.
And so all the Pekes, when they heard the uproar,
Some came to the window, some came to the door;
There were surely a dozen, more likely a score.
And together they started to grumble and wheeze
In their huffery-snuffery Heathen Chinese.
But a terrible din is what Pollicles like,
For your Pollicle Dog is a dour Yorkshire tyke,
And his braw Scottish cousins are snappers and biters,
And every dog-jack of them notable fighters;
And so they stepped out, with their pipers in order,
Playing *When the Blue Bonnets Came Over the Border.*
Then the Pugs and the Poms held no longer aloof,
But some from the balcony, some from the roof,
Joined in
To the din
With a

<div style="text-align: center;">

Bark bark bark bark
Bark bark BARK BARK
</div>

Until you could hear them all over the Park.

 Now when these bold heroes together assembled,
The traffic all stopped, and the Underground trembled,
And some of the neighbours were so much afraid
That they started to ring up the Fire Brigade.
When suddenly, up from a small basement flat,
Why who should stalk out but the GREAT RUMPUSCAT.
His eyes were like fireballs fearfully blazing,
He gave a great yawn, and his jaws were amazing;
And when he looked out through the bars of the area,
You never saw anything fiercer or hairier.
And what with the glare of his eyes and his yawning,
The Pekes and the Pollicles quickly took warning.

He looked at the sky and he gave a great leap—
And they every last one of them scattered like sheep.

And when the Police Dog returned to his beat,
There wasn't a single one left in the street.

MR. MISTOFFELEES

You ought to know Mr. Mistoffelees!
The Original Conjuring Cat—
(There can be no doubt about that).
Please listen to me and don't scoff. All his
Inventions are off his own bat.
There's no such Cat in the metropolis;
He holds all the patent monopolies
For performing surprising illusions
And creating eccentric confusions.
　At prestidigitation
　　And at legerdemain
　He'll defy examination
　　And deceive you again.
The greatest magicians have something to learn
From Mr. Mistoffelees' Conjuring Turn.
Presto!
　Away we go!
　　And we all say: OH!
　　　Well I never!
　　　Was there ever
　　　A Cat so clever
　　　　As Magical Mr. Mistoffelees!

　He is quiet and small, he is black
From his ears to the tip of his tail;
He can creep through the tiniest crack,
He can walk on the narrowest rail.

He can pick any card from a pack,
He is equally cunning with dice;
He is always deceiving you into believing
That he's only hunting for mice.
　　He can play any trick with a cork
　　　Or a spoon and a bit of fish-paste;
　　If you look for a knife or a fork
　　　And you think it is merely misplaced—
You have seen it one moment, and then it is *gawn!*
But you'll find it next week lying out on the lawn.
　　And we all say: OH!
　　　Well I never!
　　　Was there ever
　　　A Cat so clever
　　　　As Magical Mr. Mistoffelees!

　　His manner is vague and aloof,
You would think there was nobody shyer—
But his voice has been heard on the roof
When he was curled up by the fire.
And he's sometimes been heard by the fire
When he was about on the roof—
(At least we all *heard* that somebody purred)
Which is incontestable proof
　　Of his singular magical powers:
　　　And I have known the family to call
　　Him in from the garden for hours,
　　　While he was asleep in the hall.
And not long ago this phenomenal Cat
Produced *seven kittens* right out of a hat!
　　And we all said: OH!
　　　Well I never!
　　　Did you ever
　　　Know a Cat so clever
　　　　As Magical Mr. Mistoffelees!

MACAVITY: THE MYSTERY CAT

Macavity's a Mystery Cat: he's called the Hidden Paw—
For he's the master criminal who can defy the Law.
He's the bafflement of Scotland Yard, the Flying Squad's despair:
For when they reach the scene of crime—*Macavity's not there!*

Macavity, Macavity, there's no one like Macavity,
He's broken every human law, he breaks the law of gravity.
His powers of levitation would make a fakir stare,
And when you reach the scene of crime—*Macavity's not there!*
You may seek him in the basement, you may look up in the air—
But I tell you once and once again, *Macavity's not there!*

Macavity's a ginger cat, he's very tall and thin;
You would know him if you saw him, for his eyes are sunken in.
His brow is deeply lined with thought, his head is highly domed;
His coat is dusty from neglect, his whiskers are uncombed.
He sways his head from side to side, with movements like a snake;
And when you think he's half asleep, he's always wide awake.

Macavity, Macavity, there's no one like Macavity,
For he's a fiend in feline shape, a monster of depravity.
You may meet him in a by-street, you may see him in the square—
But when a crime's discovered, then *Macavity's not there!*

He's outwardly respectable. (They say he cheats at cards.)
And his footprints are not found in any file of Scotland Yard's.
And when the larder's looted, or the jewel-case is rifled,
Or when the milk is missing, or another Peke's been stifled,
Or the greenhouse glass is broken, and the trellis past repair—
Ay, there's the wonder of the thing! *Macavity's not there!*

And when the Foreign Office find a Treaty's gone astray,
Or the Admiralty lose some plans and drawings by the way,
There may be a scrap of paper in the hall or on the stair—

But it's useless to investigate—*Macavity's not there!*
And when the loss has been disclosed, the Secret Service say:
"It *must* have been Macavity!"—but he's a mile away.
You'll be sure to find him resting, or a-licking of his thumbs,
Or engaged in doing complicated long division sums.

 Macavity, Macavity, there's no one like Macavity,
There never was a Cat of such deceitfulness and suavity.
He always has an alibi, and one or two to spare:
At whatever time the deed took place—MACAVITY WASN'T THERE!
And they say that all the Cats whose wicked deeds are widely known
(I might mention Mungojerrie, I might mention Griddlebone)
Are nothing more than agents for the Cat who all the time
Just controls their operations: the Napoleon of Crime!

GUS: THE THEATRE CAT

Gus is the Cat at the Theatre Door.
His name, as I ought to have told you before,
Is really Asparagus. That's such a fuss
To pronounce, that we usually call him just Gus.
His coat's very shabby, he's thin as a rake,
And he suffers from palsy that makes his paw shake.
Yet he was, in his youth, quite the smartest of Cats—
But no longer a terror to mice and to rats.
For he isn't the Cat that he was in his prime;
Though his name was quite famous, he says, in its time.
And whenever he joins his friends at their club
 (Which takes place at the back of the neighbouring pub)
He loves to regale them, if someone else pays,
With anecdotes drawn from his palmiest days.
For he once was a Star of the highest degree—
He has acted with Irving, he's acted with Tree.
And he likes to relate his success on the Halls,
Where the Gallery once gave him seven cat-calls.

But his grandest creation, as he loves to tell,
Was Firefrorefiddle, the Fiend of the Fell.

"I have played," so he says, "every possible part,
And I used to know seventy speeches by heart.
I'd extemporize back-chat, I knew how to gag,
And I knew how to let the cat out of the bag.
I knew how to act with my back and my tail;
With an hour of rehearsal, I never could fail.
I'd a voice that would soften the hardest of hearts,
Whether I took the lead, or in character parts.
I have sat by the bedside of poor Little Nell;
When the Curfew was rung, then I swung on the bell.
In the Pantomime season I never fell flat,
And I once understudied Dick Whittington's Cat.
But my grandest creation, as history will tell,
Was Firefrorefiddle, the Fiend of the Fell."

Then, if someone will give him a toothful of gin,
He will tell how he once played a part in *East Lynne*.
At a Shakespeare performance he once walked on pat,
When some actor suggested the need for a cat.
He once played a Tiger—could do it again—
Which an Indian Colonel pursued down a drain.
And he thinks that he still can, much better than most,
Produce blood-curdling noises to bring on the Ghost.
And he once crossed the stage on a telegraph wire,
To rescue a child when a house was on fire.
And he says: "Now, these kittens, they do not get trained
As we did in the days when Victoria reigned.
They never get drilled in a regular troupe,
And they think they are smart, just to jump through a hoop."
And he'll say, as he scratches himself with his claws,
"Well, the Theatre's certainly not what it was.
These modern productions are all very well,
But there's nothing to equal, from what I hear tell,

> That moment of mystery
> When I made history
> As Firefrorefiddle, the Fiend of the Fell."

BUSTOPHER JONES: THE CAT ABOUT TOWN

Bustopher Jones is *not* skin and bones—
In fact, he's remarkably fat.
He doesn't haunt pubs—he has eight or nine clubs,
For he's the St. James's Street Cat!
He's the Cat we all greet as he walks down the street
In his coat of fastidious black:
No commonplace mousers have such well-cut trousers
Or such an impeccable back.
In the whole of St. James's the smartest of names is
The name of this Brummell of Cats;
And we're all of us proud to be nodded or bowed to
By Bustopher Jones in white spats!

His visits are occasional to the *Senior Educational*
And it is against the rules
For any one Cat to belong both to that
And the *Joint Superior Schools*.
For a similar reason, when game is in season
He is found, not at *Fox's,* but *Blimp's;*
He is frequently seen at the gay *Stage and Screen*
Which is famous for winkles and shrimps.
In the season of venison he gives his ben'son
To the *Pothunter's* succulent bones;
And just before noon's not a moment too soon
To drop in for a drink at the *Drones*.
When he's seen in a hurry there's probably curry
At the *Siamese*—or at the *Glutton;*
If he looks full of gloom then he's lunched at the *Tomb*
On cabbage, rice pudding and mutton.

So, much in this way, passes Bustopher's day—
At one club or another he's found.
It can be no surprise that under our eyes
He has grown unmistakably round.
He's a twenty-five pounder, or I am a bounder,
And he's putting on weight every day:
But he's so well preserved because he's observed
All his life a routine, so he'll say.
Or, to put it in rhyme: "I shall last out my time"
Is the word of this stoutest of Cats.
It must and it shall be Spring in Pall Mall
While Bustopher Jones wears white spats!

SKIMBLESHANKS: THE RAILWAY CAT

There's a whisper down the line at 11.39
When the Night Mail's ready to depart,
Saying "Skimble where is Skimble has he gone to hunt the thimble?
We must find him or the train can't start."
All the guards and all the porters and the stationmaster's daughters
They are searching high and low,
Saying "Skimble where is Skimble for unless he's very nimble
Then the Night Mail just can't go."
At 11.42 then the signal's nearly due
And the passengers are frantic to a man—
Then Skimble will appear and he'll saunter to the rear:
He's been busy in the luggage van!
He gives one flash of his glass-green eyes
And the signal goes "All Clear!"
And we're off at last for the northern part
Of the Northern Hemisphere!

You may say that by and large it is Skimble who's in charge
Of the Sleeping Car Express.
From the driver and the guards to the bagmen playing cards

He will supervise them all, more or less.
Down the corridor he paces and examines all the faces
Of the travellers in the First and in the Third;
He establishes control by a regular patrol
And he'd know at once if anything occurred.
He will watch you without winking and he sees what you are
 thinking
And it's certain that he doesn't approve
Of hilarity and riot, so the folk are very quiet
When Skimble is about and on the move.
 You can play no pranks with Skimbleshanks!
 He's a Cat that cannot be ignored;
 So nothing goes wrong on the Northern Mail
 When Skimbleshanks is aboard.

Oh it's very pleasant when you have found your little den
With your name written up on the door.
And the berth is very neat with a newly folded sheet
And there's not a speck of dust on the floor.
There is every sort of light—you can make it dark or bright;
There's a handle that you turn to make a breeze.
There's a funny little basin you're supposed to wash your face in
And a crank to shut the window if you sneeze.
Then the guard looks in politely and will ask you very brightly
"Do you like your morning tea weak or strong?"
But Skimble's just behind him and was ready to remind him,
For Skimble won't let anything go wrong.
 And when you creep into your cosy berth
 And pull up the counterpane,
 You ought to reflect that it's very nice
 To know that you won't be bothered by mice—
 You can leave all that to the Railway Cat,
 The Cat of the Railway Train!

In the watches of the night he is always fresh and bright;
Every now and then he has a cup of tea
With perhaps a drop of Scotch while he's keeping on the watch,

Only stopping here and there to catch a flea.
You were fast asleep at Crewe and so you never knew
That he was walking up and down the station;
You were sleeping all the while he was busy at Carlisle,
Where he greets the stationmaster with elation.
But you saw him at Dumfries, where he speaks to the police
If there's anything they ought to know about:
When you get to Gallowgate there you do not have to wait—
For Skimbleshanks will help you to get out!
 He gives you a wave of his long brown tail
 Which says: "I'll see you again!
 You'll meet without fail on the Midnight Mail
 The Cat of the Railway Train."

THE AD-DRESSING OF CATS

You've read of several kinds of Cat,
And my opinion now is that
You should need no interpreter
To understand their character.
You now have learned enough to see
That Cats are much like you and me
And other people whom we find
Possessed of various types of mind.
For some are sane and some are mad
And some are good and some are bad
And some are better, some are worse—
But all may be described in verse.
You've seen them both at work and games,
And learnt about their proper names,
Their habits and their habitat:
But
 How would you ad-dress a Cat?

So first, your memory I'll jog,
And say: A CAT IS NOT A DOG.

Now dogs pretend they like to fight;
They often bark, more seldom bite;
But yet a Dog is, on the whole,
What you would call a simple soul.
Of course I'm not including Pekes,
And such fantastic canine freaks.
The usual Dog about the Town
Is much inclined to play the clown,
And far from showing too much pride
Is frequently undignified.
He's very easily taken in—
Just chuck him underneath the chin
Or slap his back or shake his paw,
And he will gambol and guffaw.
He's such an easy-going lout,
He'll answer any hail or shout.

Again I must remind you that
A Dog's a Dog—A CAT'S A CAT.

With Cats, some say, one rule is true:
Don't speak till you are spoken to.
Myself, I do not hold with that—
I say, you should ad-dress a Cat.
But always keep in mind that he
Resents familiarity.
I bow, and taking off my hat,
Ad-dress him in this form: O CAT!
But if he is the Cat next door,
Whom I have often met before
(He comes to see me in my flat)
I greet him with an OOPSA CAT!
I think I've heard them call him James—
But we've not got so far as names.
Before a Cat will condescend
To treat you as a trusted friend,
Some little token of esteem

Is needed, like a dish of cream;
And you might now and then supply
Some caviare, or Strassburg Pie,
Some potted grouse, or salmon paste—
He's sure to have his personal taste.
(I know a Cat, who makes a habit
Of eating nothing else but rabbit,
And when he's finished, licks his paws
So's not to waste the onion sauce.)
A Cat's entitled to expect
These evidences of respect.
And so in time you reach your aim,
And finally call him by his NAME.

So this is this, and that is that:
And there's how you AD-DRESS A CAT.

Murder in the Cathedral

Part I

CHARACTERS

A Chorus of Women of Canterbury
Three Priests of the Cathedral
A Herald
Archbishop Thomas Becket
Four Tempters
Attendants

The Scene is the Archbishop's Hall, on December 2nd, 1170

Chorus: Here let us stand, close by the cathedral. Here let us wait.
 Are we drawn by danger? Is it the knowledge of safety, that draws
 our feet
 Towards the cathedral? What danger can be
 For us, the poor, the poor women of Canterbury? what tribu-
 lation
 With which we are not already familiar? There is no danger
 For us, and there is no safety in the cathedral. Some presage of
 an act
 Which our eyes are compelled to witness, has forced our feet
 Towards the cathedral. We are forced to bear witness.

 Since golden October declined into sombre November
 And the apples were gathered and stored, and the land became
 brown sharp points of death in a waste of water and mud,
 The New Year waits, breathes, waits, whispers in darkness
 While the labourer kicks off a muddy boot and stretches his hand
 to the fire,
 The New Year waits, destiny waits for the coming.
 Who has stretched out his hand to the fire and remembered the
 Saints at All Hallows,

[175]

Remembered the martyrs and saints who wait? and who shall
Stretch out his hand to the fire, and deny his master? who shall
 be warm
By the fire, and deny his master?

 Seven years and the summer is over
Seven years since the Archbishop left us,
He who was always kind to his people.
But it would not be well if he should return.
King rules or barons rule;
We have suffered various oppression,
But mostly we are left to our own devices,
And we are content if we are left alone.
We try to keep our households in order;
The merchant, shy and cautious, tries to compile a little fortune,
And the labourer bends to his piece of earth, earth-colour, his
 own colour,
Preferring to pass unobserved.
Now I fear disturbance of the quiet seasons:
Winter shall come bringing death from the sea,
Ruinous spring shall beat at our doors,
Root and shoot shall eat our eyes and our ears,
Disastrous summer burn up the beds of our streams
And the poor shall wait for another decaying October.
Why should the summer bring consolation
For autumn fires and winter fogs?
What shall we do in the heat of summer
But wait in barren orchards for another October?
Some malady is coming upon us. We wait, we wait,
And the saints and martyrs wait, for those who shall be martyrs
 and saints.
Destiny waits in the hand of God, shaping the still unshapen:
I have seen these things in a shaft of sunlight.
Destiny waits in the hand of God, not in the hands of statesmen
Who do, some well, some ill, planning and guessing,
Having their aims which turn in their hands in the pattern of
 time.

Come, happy December, who shall observe you, who shall pre-
serve you?
Shall the Son of Man be born again in the litter of scorn?
For us, the poor, there is no action,
But only to wait and to witness.
[*Enter* PRIESTS.]

FIRST PRIEST: Seven years and the summer is over.
Seven years since the Archbishop left us.

SECOND PRIEST: What does the Archbishop do, and our Sovereign
Lord the Pope
With the stubborn King and the French King
In ceaseless intrigue, combinations,
In conference, meetings accepted, meetings refused,
Meetings unended or endless
At one place or another in France?

THIRD PRIEST: I see nothing quite conclusive in the art of temporal
government,
But violence, duplicity and frequent malversation.
King rules or barons rule:
The strong man strongly and the weak man by caprice.
They have but one law, to seize the power and keep it,
And the steadfast can manipulate the greed and lust of others,
The feeble is devoured by his own.

FIRST PRIEST: Shall these things not end
Until the poor at the gate
Have forgotten their friend, their Father in God, have forgotten
That they had a friend?
[*Enter* HERALD.]

HERALD: Servants of God, and watchers of the temple,
I am here to inform you, without circumlocution:
The Archbishop is in England, and is close outside the city.
I was sent before in haste
To give you notice of his coming, as much as was possible,
That you may prepare to meet him.

FIRST PRIEST: What, is the exile ended, is our Lord Archbishop
Reunited with the King? what reconciliation
Of two proud men? what peace can be found

To grow between the hammer and the anvil? Tell us,
Are the old disputes at an end, is the wall of pride cast down
That divided them? Is it peace or war? Does he come
In full assurance, or only secure
In the power of Rome, the spiritual rule,
The assurance of right, and the love of the people,
Contemning the hatred and envy of barons?

HERALD: You are right to express a certain incredulity.
He comes in pride and sorrow, affirming all his claims,
Assured, beyond doubt, of the devotion of the people,
Who receive him with scenes of frenzied enthusiasm,
Lining the road and throwing down their capes,
Strewing the way with leaves and late flowers of the season.
The streets of the city will be packed to suffocation,
And I think that his horse will be deprived of its tail,
A single hair of which becomes a precious relic.
He is at one with the Pope, and with the King of France,
Who indeed would have liked to detain him in his kingdom:
But as for our King, that is another matter.

FIRST PRIEST: But again, is it war or peace?

HERALD: Peace, but not the kiss of peace.
A patched up affair, if you ask my opinion.
And if you ask me, I think the Lord Archbishop
Is not the man to cherish any illusions,
Or yet to diminish the least of his pretensions.
If you ask my opinion, I think that this peace
Is nothing like an end, or like a beginning.
It is common knowledge that when the Archbishop
Parted from the King, he said to the King,
My Lord, he said, I leave you as a man
Whom in this life I shall not see again.
I have this, I assure you, on the highest authority;
There are several opinions as to what he meant
But no one considers it a happy prognostic. [Exit.]

FIRST PRIEST: I fear for the Archbishop, I fear for the Church,
I know that the pride bred of sudden prosperity
Was but confirmed by bitter adversity.

I saw him as Chancellor, flattered by the King,
Liked or feared by courtiers, in their overbearing fashion,
Despised and despising, always isolated,
Never one among them, always insecure;
His pride always feeding upon his own virtues,
Pride drawing sustenance from impartiality,
Pride drawing sustenance from generosity,
Loathing power given by temporal devolution,
Wishing subjection to God alone.
Had the King been greater, or had he been weaker
Things had perhaps been different for Thomas.

SECOND PRIEST: Yet our lord is returned. Our lord has come back
 to his own again.
 We have had enough of waiting, from December to dismal December.
 The Archbishop shall be at our head, dispelling dismay and
 doubt.
 He will tell us what we are to do, he will give us our orders,
 instruct us.
 Our Lord is at one with the Pope, and also the King of France.
 We can lean on a rock, we can feel a firm foothold
 Against the perpetual wash of tides of balance of forces of barons
 and landholders.
 The rock of God is beneath our feet. Let us meet the Archbishop with cordial thanksgiving:
 Our lord, our Archbishop returns. And when the Archbishop
 returns
 Our doubts are dispelled. Let us therefore rejoice,
 I say rejoice, and show a glad face for his welcome.
 I am the Archbishop's man. Let us give the Archbishop welcome!

THIRD PRIEST: For good or ill, let the wheel turn.
 The wheel has been still, these seven years, and no good.
 For ill or good, let the wheel turn.
 For who knows the end of good or evil?
 Until the grinders cease
 And the door shall be shut in the street,
 And all the daughters of music shall be brought low.

CHORUS: Here is no continuing city, here is no abiding stay.
 Ill the wind, ill the time, uncertain the profit, certain the danger.
 O late late late, late is the time, late too late, and rotten the year;
 Evil the wind, and bitter the sea, and grey the sky, grey grey grey.
 O Thomas, return, Archbishop; return, return to France.
 Return. Quickly. Quietly. Leave us to perish in quiet.
 You come with applause, you come with rejoicing, but you come
 bringing death into Canterbury:
 A doom on the house, a doom on yourself, a doom on the world.

 We do not wish anything to happen.
 Seven years we have lived quietly,
 Succeeded in avoiding notice,
 Living and partly living.
 There have been oppression and luxury,
 There have been poverty and licence,
 There has been minor injustice.
 Yet we have gone on living,
 Living and partly living.
 Sometimes the corn has failed us,
 Sometimes the harvest is good,
 One year is a year of rain,
 Another a year of dryness,
 One year the apples are abundant,
 Another year the plums are lacking.
 Yet we have gone on living,
 Living and partly living.
 We have kept the feasts, heard the masses,
 We have brewed beer and cyder,
 Gathered wood against the winter,
 Talked at the corner of the fire,
 Talked at the corners of streets,
 Talked not always in whispers,
 Living and partly living.
 We have seen births, deaths and marriages,
 We have had various scandals,
 We have been afflicted with taxes,
 We have had laughter and gossip,

Several girls have disappeared
Unaccountably, and some not able to.
We have all had our private terrors,
Our particular shadows, our secret fears.

But now a great fear is upon us, a fear not of one but of many,
A fear like birth and death, when we see birth and death alone
In a void apart. We
Are afraid in a fear which we cannot know, which we cannot
face, which none understands,
And our hearts are torn from us, our brains unskinned like the
layers of an onion, our selves are lost lost
In a final fear which none understands. O Thomas Archbishop,
O Thomas our Lord, leave us and leave us be, in our humble
and tarnished frame of existence, leave us; do not ask us
To stand to the doom on the house, the doom on the Arch-
bishop, the doom on the world.
Archbishop, secure and assured of your fate, unaffrayed among
the shades, do you realise what you ask, do you realise what
it means
To the small folk drawn into the pattern of fate, the small folk
who live among small things,
The strain on the brain of the small folk who stand to the doom
of the house, the doom of their lord, the doom of the world?
O Thomas, Archbishop, leave us, leave us, leave sullen Dover,
and set sail for France. Thomas our Archbishop still our Arch-
bishop even in France. Thomas Archbishop, set the white sail
between the grey sky and the bitter sea, leave us, leave us for
France.

SECOND PRIEST: What a way to talk at such a juncture!
You are foolish, immodest and babbling women.
Do you not know that the good Archbishop
Is likely to arrive at any moment?
The crowds in the streets will be cheering and cheering,
You go on croaking like frogs in the treetops:
But frogs at least can be cooked and eaten.
Whatever you are afraid of, in your craven apprehension,

Let me ask you at the least to put on pleasant faces,
And give a hearty welcome to our good Archbishop.
[*Enter* THOMAS.]

THOMAS: Peace. And let them be, in their exaltation.
They speak better than they know, and beyond your under-
standing.
They know and do not know, what it is to act or suffer.
They know and do not know, that acting is suffering
And suffering is action. Neither does the actor suffer
Nor the patient act. But both are fixed
In an eternal action, an eternal patience
To which all must consent that it may be willed
And which all must suffer that they may will it,
That the pattern may subsist, for the pattern is the action
And the suffering, that the wheel may turn and still
Be forever still.

SECOND PRIEST: O my Lord, forgive me, I did not see you coming,
Engrossed by the chatter of these foolish women.
Forgive us, my Lord, you would have had a better welcome
If we had been sooner prepared for the event.
But your Lordship knows that seven years of waiting,
Seven years of prayer, seven years of emptiness,
Have better prepared our hearts for your coming,
Than seven days could make ready Canterbury.
However, I will have fires laid in all your rooms
To take the chill off our English December,
Your Lordship now being used to a better climate.
Your Lordship will find your rooms in order as you left them.

THOMAS: And will try to leave them in order as I find them.
I am more than grateful for all your kind attentions.
These are small matters. Little rest in Canterbury
With eager enemies restless about us.
Rebellious bishops, York, London, Salisbury,
Would have intercepted our letters,
Filled the coast with spies and sent to meet me
Some who hold me in bitterest hate.
By God's grace aware of their prevision
I sent my letters on another day,

Had fair crossing, found at Sandwich
Broc, Warenne, and the Sheriff of Kent,
Those who had sworn to have my head from me.
Only John, the Dean of Salisbury,
Fearing for the King's name, warning against treason,
Made them hold their hands. So for the time
We are unmolested.

FIRST PRIEST: But do they follow after?

THOMAS: For a little time the hungry hawk
Will only soar and hover, circling lower,
Waiting excuse, pretence, opportunity.
End will be simple, sudden, God-given.
Meanwhile the substance of our first act
Will be shadows, and the strife with shadows.
Heavier the interval than the consummation.
All things prepare the event. Watch.

[*Enter* FIRST TEMPTER.]

FIRST TEMPTER: You see, my Lord, I do not wait upon ceremony:
Here I have come, forgetting all acrimony,
Hoping that your present gravity
Will find excuse for my humble levity
Remembering all the good time past.
Your Lordship won't despise an old friend out of favour?
Old Tom, gay Tom, Becket of London,
Your Lordship won't forget that evening on the river
When the King, and you and I were all friends together?
Friendship should be more than biting Time can sever.
What, my Lord, now that you recover
Favour with the King, shall we say that summer's over
Or that the good time cannot last?
Fluting in the meadows, viols in the hall,
Laughter and apple-blossom floating on the water,
Singing at nightfall, whispering in chambers,
Fires devouring the winter season,
Eating up the darkness, with wit and wine and wisdom!
Now that the King and you are in amity,
Clergy and laity may return to gaiety,
Mirth and sportfulness need not walk warily.

THOMAS: You talk of seasons that are past. I remember
 Not worth forgetting.
TEMPTER: And of the new season.
 Spring has come in winter. Snow in the branches
 Shall float as sweet as blossoms. Ice along the ditches
 Mirror the sunlight. Love in the orchard
 Send the sap shooting. Mirth matches melancholy.
THOMAS: We do not know very much of the future
 Except that from generation to generation
 The same things happen again and again.
 Men learn little from others' experience.
 But in the life of one man, never
 The same time returns. Sever
 The cord, shed the scale. Only
 The fool, fixed in his folly, may think
 He can turn the wheel on which he turns.
TEMPTER: My Lord, a nod is as good as a wink.
 A man will often love what he spurns.
 For the good times past, that are come again
 I am your man.
THOMAS: Not in this train.
 Look to your behaviour. You were safer
 Think of penitence and follow your master.
TEMPTER: Not at this gait!
 If you go so fast, others may go faster.
 Your Lordship is too proud!
 The safest beast is not the one that roars most loud.
 This was not the way of the King our master!
 You were not used to be so hard upon sinners
 When they were your friends. Be easy, man!
 The easy man lives to eat the best dinners.
 Take a friend's advice. Leave well alone,
 Or your goose may be cooked and eaten to the bone.
THOMAS: You come twenty years too late.
TEMPTER: Then I leave you to your fate.
 I leave you to the pleasures of your higher vices,
 Which will have to be paid for at higher prices.
 Farewell, my Lord, I do not wait upon ceremony,

I leave as I came, forgetting all acrimony,
Hoping that your present gravity
Will find excuse for my humble levity.
If you will remember me, my Lord, at your prayers,
I'll remember you at kissing-time below the stairs.

THOMAS: Leave-well-alone, the springtime fancy,
So one thought goes whistling down the wind.
The impossible is still temptation.
The impossible, the undesirable,
Voices under sleep, waking a dead world,
So that the mind may not be whole in the present.
[*Enter* SECOND TEMPTER.]

SECOND TEMPTER. Your Lordship has forgotten me, perhaps. I will
remind you.
We met at Clarendon, at Northampton,
And last at Montmirail, in Maine. Now that I have recalled
them,
Let us but set these not too pleasant memories
In balance against other, earlier
And weightier ones: those of the Chancellorship.
See how the late ones rise! The master of policy
Whom all acknowledged, should guide the state again.

THOMAS: Your meaning?

TEMPTER: The Chancellorship that you resigned
When you were made Archbishop—that was a mistake
On your part—still may be regained. Think, my Lord,
Power obtained grows to glory,
Life lasting, a permanent possession,
A templed tomb, monument of marble.
Rule over men reckon no madness.

THOMAS: To the man of God what gladness?

TEMPTER: Sadness
Only to those giving love to God alone.
Fare forward, shun two files of shadows:
Mirth merrymaking, melting strength in sweetness,
Fiddling to feebleness, doomed to disdain;
And godlovers' longings, lost in God.
Shall he who held the solid substance

Wander waking with deceitful shadows?
Power is present. Holiness hereafter.
THOMAS: Who then?
TEMPTER: The Chancellor. King and Chancellor.
King commands. Chancellor richly rules.
This is a sentence not taught in the schools.
To set down the great, protect the poor,
Beneath the throne of God can man do more?
Disarm the ruffian, strengthen the laws,
Rule for the good of the better cause,
Dispensing justice make all even,
Is thrive on earth, and perhaps in heaven.
THOMAS: What means?
TEMPTER: Real Power
Is purchased at price of a certain submission.
Your spiritual power is earthly perdition.
Power is present, for him who will wield.
THOMAS: Whose was it?
TEMPTER: His who is gone.
THOMAS: Who shall have it?
TEMPTER: He who will come.
THOMAS: What shall be the month?
TEMPTER: The last from the first.
THOMAS: What shall we give for it?
TEMPTER: Pretence of priestly power.
THOMAS: Why should we give it?
TEMPTER: For the power and the glory.
THOMAS: No!
TEMPTER: Yes! Or bravery will be broken,
 Cabined in Canterbury, realmless ruler,
 Self-bound servant of a powerless Pope,
 The old stag, circled with hounds.
THOMAS: No!
TEMPTER: Yes! men must manoeuvre. Monarchs also,
 Waging war abroad, need fast friends at home.
 Private policy is public profit;
 Dignity still shall be dressed with decorum.

THOMAS: You forget the bishops
 Whom I have laid under excommunication.
TEMPTER: Hungry hatred
 Will not strive against intelligent self-interest.
THOMAS: You forget the barons. Who will not forget
 Constant curbing of pretty privilege.
TEMPTER: Against the barons
 Is King's cause, churl's cause, Chancellor's cause.
THOMAS: No! shall I, who keep the keys
 Of heaven and hell, supreme alone in England,
 Who bind and loose, with power from the Pope,
 Descend to desire a punier power?
 Delegate to deal the doom of damnation,
 To condemn kings, not serve among their servants,
 Is my open office. No! Go.
TEMPTER: Then I leave you to your fate.
 Your sin soars sunward, covering kings' falcons.
THOMAS: Temporal power, to build a good world,
 To keep order, as the world knows order.
 Those who put their faith in worldly order
 Not controlled by the order of God,
 In confident ignorance, but arrest disorder,
 Make it fast, breed fatal disease,
 Degrade what they exalt. Power with the King—
 I *was* the King, his arm, his better reason.
 But what was once exaltation
 Would now be only mean descent.
 [*Enter* THIRD TEMPTER.]
THIRD TEMPTER: I am an unexpected visitor.
THOMAS: I expected you.
TEMPTER: But not in this guise, or for my present purpose.
THOMAS: No purpose brings surprise.
TEMPTER: Well, my Lord,
 I am no trifler, and no politician.
 To idle or intrigue at court
 I have no skill. I am no courtier.
 I know a horse, a dog, a wench;

I know how to hold my estates in order,
A country-keeping lord who minds his own business.
It is we country lords who know the country
And we who know what the country needs.
It is our country. We care for the country.
We are the backbone of the nation.
We, not the plotting parasites
About the King. Excuse my bluntness:
I am a rough straightforward Englishman.

THOMAS: Proceed straight forward.

TEMPTER: Purpose is plain.
Endurance of friendship does not depend
Upon ourselves, but upon circumstance.
But circumstance is not undetermined.
Unreal friendship may turn to real
But real friendship, once ended, cannot be mended.
Sooner shall enmity turn to alliance.
The enmity that never knew friendship
Can sooner know accord.

THOMAS: For a countryman
You wrap your meaning in as dark generality
As any courtier.

TEMPTER: This is the simple fact!
You have no hope of reconciliation
With Henry the King. You look only
To blind assertion in isolation.
That is a mistake.

THOMAS: O Henry, O my King!

TEMPTER: Other friends
May be found in the present situation.
King in England is not all-powerful;
King is in France, squabbling in Anjou;
Round him waiting hungry sons.
We are for England. We are in England.
You and I, my Lord, are Normans.
England is a land for Norman
Sovereignty. Let the Angevin
Destroy himself, fighting in Anjou.

He does not understand us, the English barons.
 We are the people.
THOMAS: To what does this lead?
TEMPTER: To a happy coalition
 Of intelligent interests.
THOMAS: But what have you—
 If you do speak for barons—
TEMPTER: For a powerful party
 Which has turned its eyes in your direction—
 To gain from you, your Lordship asks.
 For us, Church favour would be an advantage,
 Blessing of Pope powerful protection
 In the fight for liberty. You, my Lord,
 In being with us, would fight a good stroke
 At once, for England and for Rome,
 Ending the tyrannous jurisdiction
 Of king's court over bishop's court,
 Of king's court over baron's court.
THOMAS: Which I helped to found.
TEMPTER: Which you helped to found.
 But time past is time forgotten.
 We expect the rise of a new constellation.
THOMAS: And if the Archbishop cannot trust the King,
 How can he trust those who work for King's undoing?
TEMPTER: Kings will allow no power but their own;
 Church and people have good cause against the throne.
THOMAS: If the Archbishop cannot trust the Throne,
 He has good cause to trust none but God alone.
 It is not better to be thrown
 To a thousand hungry appetites than to one.
 At a future time this may be shown.
 I ruled once as Chancellor
 And men like you were glad to wait at my door.
 Not only in the court, but in the field
 And in the tilt-yard I made many yield.
 Shall I who ruled like an eagle over doves
 Now take the shape of a wolf among wolves?
 Pursue your treacheries as you have done before:

No one shall say that I betrayed a king.
TEMPTER: Then, my Lord, I shall not wait at your door;
 And I well hope, before another spring
 The King will show his regard for your loyalty.
THOMAS: To make, then break, this thought has come before,
 The desperate exercise of failing power.
 Samson in Gaza did no more.
 But if I break, I must break myself alone.
 [*Enter* FOURTH TEMPTER.]
FOURTH TEMPTER: Well done, Thomas, your will is hard to bend.
 And with me beside you, you shall not lack a friend.
THOMAS: Who are you? I expected
 Three visitors, not four.
TEMPTER: Do not be surprised to receive one more.
 Had I been expected, I had been here before.
 I always precede expectation.
THOMAS: Who are you?
TEMPTER: As you do not know me, I do not need a name,
 And, as you know me, that is why I come.
 You know me, but have never seen my face.
 To meet before was never time or place.
THOMAS: Say what you come to say.
TEMPTER: It shall be said at last.
 Hooks have been baited with morsels of the past.
 Wantonness is weakness. As for the King,
 His hardened hatred shall have no end.
 You know truly, the King will never trust
 Twice, the man who has been his friend.
 Borrow use cautiously, employ
 Your services as long as you have to lend.
 You would wait for trap to snap
 Having served your turn, broken and crushed.
 As for barons, envy of lesser men
 Is still more stubborn than king's anger.
 Kings have public policy, barons private profit,
 Jealousy raging possession of the fiend.
 Barons are employable against each other;
 Greater enemies must kings destroy.

THOMAS: What is your counsel?
TEMPTER: Fare forward to the end.
 All other ways are closed to you
 Except the way already chosen.
 But what is pleasure, kingly rule,
 Or rule of men beneath a king,
 With craft in corners, stealthy stratagem,
 To general grasp of spiritual power?
 Man oppressed by sin, since Adam fell—
 You hold the keys of heaven and hell.
 Power to bind and loose: bind, Thomas, bind,
 King and bishop under your heel.
 King, emperor, bishop, baron, king:
 Uncertain mastery of melting armies,
 War, plague, and revolution,
 New conspiracies, broken pacts;
 To be master or servant within an hour,
 This is the course of temporal power.
 The Old King shall know it, when at last breath,
 No sons, no empire, he bites broken teeth.
 You hold the skein: wind, Thomas, wind
 The thread of eternal life and death.
 You hold this power, hold it.
THOMAS: Supreme, in this land?
TEMPTER: Supreme, but for one.
THOMAS: That I do not understand.
TEMPTER: It is not for me to tell you how this may be so;
 I am only here, Thomas, to tell you what you know.
THOMAS: How long shall this be?
TEMPTER: Save what you know already, ask nothing of me.
 But think, Thomas, think of glory after death.
 When king is dead, there's another king,
 And one more king is another reign.
 King is forgotten, when another shall come:
 Saint and Martyr rule from the tomb.
 Think, Thomas, think of enemies dismayed,
 Creeping in penance, frightened of a shade;
 Think of pilgrims, standing in line

Before the glittering jewelled shrine,
From generation to generation
Bending the knee in supplication.
Think of the miracles, by God's grace,
And think of your enemies, in another place.

THOMAS: I have thought of these things.

TEMPTER: That is why I tell you.
Your thoughts have more power than kings to compel you.
You have also thought, sometimes at your prayers,
Sometimes hesitating at the angles of stairs,
And between sleep and waking, early in the morning,
When the bird cries, have thought of further scorning.
That nothing lasts, but the wheel turns,
The nest is rifled, and the bird mourns;
That the shrine shall be pillaged, and the gold spent,
The jewels gone for light ladies' ornament,
The sanctuary broken, and its stores
Swept into the laps of parasites and whores.
When miracles cease, and the faithful desert you,
And men shall only do their best to forget you.
And later is worse, when men will not hate you
Enough to defame or to execrate you,
But pondering the qualities that you lacked
Will only try to find the historical fact.
When men shall declare that there was no mystery
About this man who played a certain part in history.

THOMAS: But what is there to do? what is left to be done?
Is there no enduring crown to be won?

TEMPTER: Yes, Thomas, yes; you have thought of that too.
What can compare with glory of Saints
Dwelling forever in presence of God?
What earthly glory, of king or emperor,
What earthly pride, that is not poverty
Compared with richness of heavenly grandeur?
Seek the way of martyrdom, make yourself the lowest
On earth, to be high in heaven.

And see far off below you, where the gulf is fixed,
Your persecutors, in timeless torment,
Parched passion, beyond expiation.

THOMAS: No!
Who are you, tempting with my own desires?
Others have come, temporal tempters,
With pleasure and power at palpable price.
What do you offer? what do you ask?

TEMPTER: I offer what you desire. I ask
What you have to give. Is it too much
For such a vision of eternal grandeur?

THOMAS: Others offered real goods, worthless
But real. You only offer
Dreams to damnation.

TEMPTER: You have often dreamt them.

THOMAS: Is there no way, in my soul's sickness,
Does not lead to damnation in pride?
I well know that these temptations
Mean present vanity and future torment.
Can sinful pride be driven out
Only by more sinful? Can I neither act nor suffer
Without perdition?

TEMPTER: You know and do not know, what it is to act or suffer.
You know and do not know, that acting is suffering,
And suffering action. Neither does the actor suffer
Nor the patient act. But both are fixed
In an eternal action, an eternal patience
To which all must consent that it may be willed
And which all must suffer that they may will it,
That the pattern may subsist, that the wheel may turn and still
Be forever still.

CHORUS: There is no rest in the house. There is no rest in the street.
I hear restless movement of feet. And the air is heavy and thick.
Thick and heavy the sky. And the earth presses up beneath my
 feet.
What is the sickly smell, the vapour? the dark green light from

a cloud on a withered tree? The earth is heaving to parturi-
tion of issue of hell. What is the sticky dew that forms on the
back of my hand?

THE FOUR TEMPTERS: Man's life is a cheat and a disappointment;
All things are unreal,
Unreal or disappointing:
The Catherine wheel, the pantomime cat,
The prizes given at the children's party,
The prize awarded for the English Essay,
The scholar's degree, the statesman's decoration.
All things become less real, man passes
From unreality to unreality.
This man is obstinate, blind, intent
On self-destruction,
Passing from deception to deception,
From grandeur to grandeur to final illusion,
Lost in the wonder of his own greatness,
The enemy of society, enemy of himself.

THE THREE PRIESTS: O Thomas my Lord do not fight the intractable
tide,
Do not sail the irresistible wind; in the storm,
Should we not wait for the sea to subside, in the night
Abide the coming of day, when the traveller may find his way,
The sailor lay course by the sun?

CHORUS, PRIESTS *and* TEMPTERS *alternately:*
C. Is it the owl that calls, or a signal between the trees?
P. Is the window-bar made fast, is the door under lock and bolt?
T. Is it rain that taps at the window, is it wind that pokes at the
door?
C. Does the torch flame in the hall, the candle in the room?
P. Does the watchman walk by the wall?
T. Does the mastiff prowl by the gate?
C. Death has a hundred hands and walks by a thousand ways.
P. He may come in the sight of all, he may pass unseen unheard.
T. Come whispering through the ear, or a sudden shock on the
skull.

C. A man may walk with a lamp at night, and yet be drowned in
 a ditch.

P. A man may climb the stair in the day, and slip on a broken
 step.

T. A man may sit at meat, and feel the cold in his groin.

CHORUS: We have not been happy, my Lord, we have not been too
 happy.

We are not ignorant women, we know what we must expect and
 not expect.

We know of oppression and torture,

We know of extortion and violence,

Destitution, disease,

The old without fire in winter,

The child without milk in summer,

Our labour taken away from us,

Our sins made heavier upon us.

We have seen the young man mutilated,

The torn girl trembling by the mill-stream.

And meanwhile we have gone on living,

Living and partly living,

Picking together the pieces,

Gathering faggots at nightfall,

Building a partial shelter,

For sleeping, and eating and drinking and laughter.

God gave us always some reason, some hope; but now a new
 terror has soiled us, which none can avert, none can avoid,
 flowing under our feet and over the sky;

Under doors and down chimneys, flowing in at the ear and the
 mouth and the eye.

God is leaving us, God is leaving us, more pang, more pain, than
 birth or death.

Sweet and cloying through the dark air

Falls the stifling scent of despair;

The forms take shape in the dark air:

Puss-purr of leopard, footfall of padding bear,

Palm-pat of nodding ape, square hyaena waiting
For laughter, laughter, laughter. The Lords of Hell are here.
They curl round you, lie at your feet, swing and wing through
 the dark air.
O Thomas Archbishop, save us, save us, save yourself that we
 may be saved;
Destroy yourself and we are destroyed.

THOMAS: Now is my way clear, now is the meaning plain:
Temptation shall not come in this kind again.
The last temptation is the greatest treason:
To do the right deed for the wrong reason.
The natural vigour in the venial sin
Is the way in which our lives begin.
Thirty years ago, I searched all the ways
That lead to pleasure, advancement and praise.
Delight in sense, in learning and in thought,
Music and philosophy, curiosity,
The purple bullfinch in the lilac tree,
The tiltyard skill, the strategy of chess,
Love in the garden, singing to the instrument,
Were all things equally desirable.
Ambition comes when early force is spent
And when we find no longer all things possible.
Ambition comes behind and unobservable.
Sin grows with doing good. When I imposed the King's law
In England, and waged war with him against Toulouse,
I beat the barons at their own game. I
Could then despise the men who thought me most contemptible,
The raw nobility, whose manners matched their fingernails.
While I ate out of the King's dish
To become servant of God was never my wish.
Servant of God has chance of greater sin
And sorrow, than the man who serves a king.
For those who serve the greater cause may make the cause serve
 them,
Still doing right: and striving with political men
May make that cause political, not by what they do
But by what they are. I know

What yet remains to show you of my history
Will seem to most of you at best futility,
Senseless self-slaughter of a lunatic,
Arrogant passion of a fanatic.
I know that history at all times draws
The strangest consequence from remotest cause.
But for every evil, every sacrilege,
Crime, wrong, oppression and the axe's edge,
Indifference, exploitation, you, and you,
And you, must all be punished. So must you.
I shall no longer act or suffer, to the sword's end.
Now my good Angel, whom God appoints
To be my guardian, hover over the swords' points.

Interlude

THE ARCHBISHOP *preaches in the Cathedral on Christmas Morning, 1170*

'Glory to God in the highest, and on earth peace, good will toward men.' *The fourteenth verse of the second chapter of the Gospel according to Saint Luke.* In the Name of the Father, and of the Son, and of the Holy Ghost. Amen.

Dear children of God, my sermon this morning will be a very short one. I wish only that you should ponder and meditate the deep meaning and mystery of our masses of Christmas Day. For whenever Mass is said, we re-enact the Passion and Death of Our Lord; and on this Christmas Day we do this in celebration of His Birth. So that at the same moment we rejoice in His coming for the salvation of men, and offer again to God His Body and Blood in sacrifice, oblation and satisfaction for the sins of the whole world. It was in this same night that has just passed, that a multitude of the heavenly host appeared before the shepherds at Bethlehem, saying, 'Glory to God in the highest, and on earth peace, good will toward men'; at this same time of all the year that we celebrate at once the Birth of Our Lord and His Passion and Death upon the Cross. Beloved, as the World sees, this is to behave in a strange fashion. For who in the World will both mourn and rejoice at once and for the same reason? For either joy will be overborne by mourning, or mourning will be cast out by joy; so it is only in these our Christian mysteries that we can rejoice and mourn at once for the same reason. But think for a while on the meaning of this word 'peace.' Does it seem strange to you that the angels should have announced Peace, when ceaselessly the world has been stricken with War and the fear of War? Does it seem to you that the angelic voices were mistaken, and that the promise was a disappointment and a cheat?

Reflect now, how Our Lord Himself spoke of Peace. He said to His disciples 'My peace I leave with you, my peace I give unto you.' Did

[198]

He mean peace as we think of it: the kingdom of England at peace
with its neighbours, the barons at peace with the King, the house-
holder counting over his peaceful gains, the swept hearth, his best
wine for a friend at the table, his wife singing to the children? Those
men His disciples knew no such things: they went forth to journey
afar, to suffer by land and sea, to know torture, imprisonment, dis-
appointment, to suffer death by martyrdom. What then did He
mean? If you ask that, remember then that He said also, 'Not as the
world gives, give I unto you.' So then, He gave to His disciples peace,
but not peace as the world gives.

Consider also one thing of which you have probably never thought.
Not only do we at the feast of Christmas celebrate at once Our Lord's
Birth and His Death: but on the next day we celebrate the martyr-
dom of His first martyr, the blessed Stephen. Is it an accident, do you
think, that the day of the first martyr follows immediately the day of
the Birth of Christ? By no means. Just as we rejoice and mourn at
once, in the Birth and in the Passion of Our Lord; so also, in a
smaller figure, we both rejoice and mourn in the death of martyrs.
We mourn, for the sins of the world that has martyred them; we re-
joice, that another soul is numbered among the Saints in Heaven, for
the glory of God and for the salvation of men.

Beloved, we do not think of a martyr simply as a good Christian
who has been killed because he is a Christian: for that would be
solely to mourn. We do not think of him simply as a good Christian
who has been elevated to the company of the Saints: for that would
be simply to rejoice: and neither our mourning nor our rejoicing is
as the world's is. A Christian martyrdom is no accident. Saints are not
made by accident. Still less is a Christian martyrdom the effect of a
man's will to become a Saint, as a man by willing and contriving may
become a ruler of men. Ambition fortifies the will of man to become
ruler over other men: it operates with deception, cajolery, and vio-
lence, it is the action of impurity upon impurity. Not so in Heaven.
A martyr, a saint, is always made by the design of God, for His love
of men, to warn them and to lead them, to bring them back to His
ways. A martyrdom is never the design of man; for the true martyr
is he who has become the instrument of God, who has lost his will in
the will of God, not lost it but found it, for he has found freedom in
submission to God. The martyr no longer desires anything for him-

self, not even the glory of martyrdom. So thus as on earth the Church mourns and rejoices at once, in a fashion that the world cannot understand; so in Heaven the Saints are most high, having made themselves most low, seeing themselves not as we see them, but in the light of the Godhead from which they draw their being.

I have spoken to you today, dear children of God, of the martyrs of the past, asking you to remember especially our martyr of Canterbury, the blessed Archbishop Elphege; because it is fitting, on Christ's birth day, to remember what is that Peace which He brought; and because, dear children, I do not think I shall ever preach to you again; and because it is possible that in a short time you may have yet another martyr, and that one perhaps not the last. I would have you keep in your hearts these words that I say, and think of them at another time. In the Name of the Father, and of the Son, and of the Holy Ghost. Amen.

Part II

CHARACTERS

THREE PRIESTS
FOUR KNIGHTS
ARCHBISHOP THOMAS BECKET
CHORUS OF WOMEN OF CANTERBURY
ATTENDANTS

*The first scene is in the Archbishop's Hall, the second scene
is in the Cathedral, on December 29th, 1170*

CHORUS: Does the bird sing in the South?
 Only the sea-bird cries, driven inland by the storm.
 What sign of the spring of the year?
 Only the death of the old: not a stir, not a shoot, not a breath.
 Do the days begin to lengthen?
 Longer and darker the day, shorter and colder the night.
 Still and stifling the air: but a wind is stored up in the East.
 The starved crow sits in the field, attentive; and in the wood
 The owl rehearses the hollow note of death.
 What signs of a bitter spring?
 The wind stored up in the East.
 What, at the time of the birth of Our Lord, at Christmastide,
 Is there not peace upon earth, goodwill among men?
 The peace of this world is always uncertain, unless men keep the
 peace of God.
 And war among men defiles this world, but death in the Lord
 renews it,
 And the world must be cleaned in the winter, or we shall have
 only
 A sour spring, a parched summer, an empty harvest.
 Between Christmas and Easter what work shall be done?

The ploughman shall go out in March and turn the same earth
He has turned before, the bird shall sing the same song.
When the leaf is out on the tree, when the elder and may
Burst over the stream, and the air is clear and high,
And voices trill at windows, and children tumble in front of the
 door,
What work shall have been done, what wrong
Shall the bird's song cover, the green tree cover, what wrong
Shall the fresh earth cover? We wait, and the time is short
But waiting is long.
[*Enter the* FOUR KNIGHTS.]

FIRST KNIGHT: Servants of the king.
FIRST PRIEST: And known to us.
 You are welcome. Have you ridden far?
FIRST KNIGHT: Not far today, but matters urgent
 Have brought us from France. We rode hard,
 Took ship yesterday, landed last night,
 Having business with the Archbishop.
SECOND KNIGHT: Urgent business.
THIRD KNIGHT: From the King.
FOURTH KNIGHT: By the King's order.
FIRST KNIGHT: Our men are outside.
FIRST PRIEST: You know the Archbishop's hospitality.
 We are about to go to dinner.
 The good Archbishop would be vexed
 If we did not offer you entertainment
 Before your business. Please dine with us.
 Your men shall be looked after also.
 Dinner before business. Do you like roast pork?
FIRST KNIGHT: Business before dinner. We will roast your pork
 First, and dine upon it after.
SECOND KNIGHT: We must see the Archbishop.
THIRD KNIGHT: Go, tell the Archbishop
 We have no need of his hospitality.
 We will find our own dinner.
FIRST PRIEST [*to attendant*]: Go, tell His Lordship.
FOURTH KNIGHT: How much longer will you keep us waiting?

[*Enter* THOMAS.]

THOMAS [*to* PRIESTS]: However certain our expectation
 The moment foreseen may be unexpected
 When it arrives. It comes when we are
 Engrossed with matters of other urgency.
 On my table you will find
 The papers in order, and the documents signed.
 [*To* KNIGHTS.]
 You are welcome, whatever your business may be.
 You say, from the King?

FIRST KNIGHT: Most surely from the King.
 We must speak with you alone.

THOMAS [*to* PRIESTS]: Leave us then alone.
 Now what is the matter?

FIRST KNIGHT: This is the matter.

THE FOUR KNIGHTS: You are the Archbishop in revolt against the
 King; in rebellion to the King and the law of the land;
 You are the Archbishop who was made by the King; whom he
 set in your place to carry out his command.
 You are his servant, his tool, and his jack,
 You wore his favours on your back,
 You had your honours all from his hand; from him you had the
 power, the seal and the ring.
 This is the man who was the tradesman's son: the backstairs brat
 who was born in Cheapside;
 This is the creature that crawled upon the King; swollen with
 blood and swollen with pride.
 Creeping out of the London dirt,
 Crawling up like a louse on your shirt,
 The man who cheated, swindled, lied; broke his oath and be-
 trayed his King.

THOMAS: This is not true.
 Both before and after I received the ring
 I have been a loyal vassal to the King.
 Saving my order, I am at his command,
 As his most faithful vassal in the land.

FIRST KNIGHT: Saving your order! let your order save you—

As I do not think it is like to do.
Saving your ambition is what you mean,
Saving your pride, envy and spleen.
SECOND KNIGHT: Saving your insolence and greed.
Won't you ask us to pray to God for you, in your need?
THIRD KNIGHT: Yes, we'll pray for you!
FOURTH KNIGHT: Yes, we'll pray for you!
THE FOUR KNIGHTS: Yes, we'll pray that God may help you!
THOMAS: But, gentlemen, your business
Which you said so urgent, is it only
Scolding and blaspheming?
FIRST KNIGHT: That was only
Our indignation, as loyal subjects.
THOMAS: Loyal? to whom?
FIRST KNIGHT: To the King!
SECOND KNIGHT: The King!
THIRD KNIGHT: The King!
FOURTH KNIGHT: God bless him!
THOMAS: Then let your new coat of loyalty be worn
Carefully, so it get not soiled or torn.
Have you something to say?
FIRST KNIGHT: By the King's command.
Shall we say it now?
SECOND KNIGHT: Without delay,
Before the old fox is off and away.
THOMAS: What you have to say
By the King's command—if it be the King's command—
Should be said in public. If you make charges,
Then in public I will refute them.
FIRST KNIGHT: No! here and now!
[*They make to attack him, but the priests and attendants return
and quietly interpose themselves.*]
THOMAS: Now and here!
FIRST KNIGHT: Of your earlier misdeeds I shall make no mention.
They are too well known. But after dissension
Had ended, in France, and you were endued
With your former privilege, how did you show your gratitude?
You had fled from England, not exiled

Or threatened, mind you; but in the hope
Of stirring up trouble in the French dominions.
You sowed strife abroad, you reviled
The King to the King of France, to the Pope,
Raising up against him false opinions.
SECOND KNIGHT: Yet the King, out of his charity,
And urged by your friends, offered clemency,
Made a pact of peace, and all dispute ended
Sent you back to your See as you demanded.
THIRD KNIGHT: And burying the memory of your transgressions
Restored your honours and your possessions.
All was granted for which you sued:
Yet how, I repeat, did you show your gratitude?
FOURTH KNIGHT: Suspending those who had crowned the young
 prince,
Denying the legality of his coronation;
Binding with the chains of anathema,
Using every means in your power to evince
The King's faithful servants, everyone who transacts
His business in his absence, the business of the nation.
FIRST KNIGHT: These are the facts.
Say therefore if you will be content
To answer in the King's presence. Therefore were we sent.
THOMAS: Never was it my wish
To uncrown the King's son, or to diminish
His honour and power. Why should he wish
To deprive my people of me and keep me from my own
And bid me sit in Canterbury, alone?
I would wish him three crowns rather than one,
And as for the bishops, it is not my yoke
That is laid upon them, or mine to revoke.
Let them go to the Pope. It was he who condemned them.
FIRST KNIGHT: Through you they were suspended.
SECOND KNIGHT: By you be this amended.
THIRD KNIGHT: Absolve them.
FOURTH KNIGHT: Absolve them.
THOMAS: I do not deny
That this was done through me. But it is not I

> Who can loose whom the Pope has bound.
> Let them go to him, upon whom redounds
> Their contempt towards me, their contempt towards the Church
> shown.

FIRST KNIGHT: Be that as it may, here is the King's command:
> That you and your servants depart from this land.

THOMAS: If that *is* the King's command, I will be bold
> To say: seven years were my people without
> My presence; seven years of misery and pain.
> Seven years a mendicant on foreign charity
> I lingered abroad: seven years is no brevity.
> I shall not get those seven years back again.
> Never again, you must make no doubt,
> Shall the sea run between the shepherd and his fold.

FIRST KNIGHT: The King's justice, the King's majesty,
> You insult with gross indignity;
> Insolent madman, whom nothing deters
> From attaining his servants and ministers.

THOMAS: It is not I who insult the King,
> And there is higher than I or the King.
> It is not I, Becket from Cheapside,
> It is not against me, Becket, that you strive.
> It is not Becket who pronounces doom,
> But the Law of Christ's Church, the judgement of Rome.
> Go then to Rome, or let Rome come
> Here, to you, in the person of her most unworthy son.
> Petty politicians in your endless adventure!
> Rome alone can absolve those who break Christ's indenture.

FIRST KNIGHT: Priest, you have spoken in peril of your life.

SECOND KNIGHT: Priest, you have spoken in danger of the knife.

THIRD KNIGHT: Priest, you have spoken treachery and treason.

FOURTH KNIGHT: Priest! traitor confirmed in malfeasance.

THOMAS: I submit my cause to the judgement of Rome.
> But if you kill me, I shall rise from my tomb
> To submit my cause before God's throne.

KNIGHTS: Priest! monk! and servant! take, hold, detain,
> Restrain this man, in the King's name;

Or answer with your bodies, if he escape before we come,
We come for the King's justice, we come again. [*Exeunt.*]

THOMAS: Pursue those who flee, track down those who evade;
Come for arrest, come with the sword,
Here, here, you shall find me ready, in the battle of the Lord.
At whatsoever time you are ready to come,
You will find me still more ready for martyrdom.

CHORUS: I have smelt them, the death-bringers, senses are quickened
By subtile forebodings; I have heard
Fluting in the nighttime, fluting and owls, have seen at noon
Scaly wings slanting over, huge and ridiculous. I have tasted
The savour of putrid flesh in the spoon. I have felt
The heaving of earth at nightfall, restless, absurd. I have heard
Laughter in the noises of beasts that make strange noises: jackal,
 jackass, jackdaw; the scurrying noise of mouse and jerboa; the
 laugh of the loon, the lunatic bird. I have seen
Grey necks twisting, rat tails twining, in the thick light of dawn.
 I have eaten
Smooth creatures still living, with the strong salt taste of living
 things under sea; I have tasted
The living lobster, the crab, the oyster, the whelk and the
 prawn; and they live and spawn in my bowels, and my bowels
 dissolve in the light of dawn. I have smelt
Death in the rose, death in the hollyhock, sweet pea, hyacinth,
 primrose and cowslip. I have seen
Trunk and horn, tusk and hoof, in odd places;
I have lain on the floor of the sea and breathed with the breath-
 ing of the sea-anemone, swallowed with ingurgitation of the
 sponge. I have lain in the soil and criticised the worm. In the
 air
Flirted with the passage of the kite, I have plunged with the kite
 and cowered with the wren. I have felt
The horn of the beetle, the scale of the viper, the mobile hard
 insensitive skin of the elephant, the evasive flank of the fish.
 I have smelt
Corruption in the dish, incense in the latrine, the sewer in the
 incense, the smell of sweet soap in the woodpath, a hellish

sweet scent in the woodpath, while the ground heaved. I have
 seen
Rings of light coiling downwards, leading
To the horror of the ape. Have I not known, not known
What was coming to be? It was here, in the kitchen, in the
 passage,
In the mews in the barn in the byre in the market place
In our veins our bowels our skulls as well
As well as in the plottings of potentates
As well as in the consultations of powers.
What is woven on the loom of fate
What is woven in the councils of princes
Is woven also in our veins, our brains,
Is woven like a pattern of living worms
In the guts of the women of Canterbury.

 I have smelt them, the death-bringers; now is too late
For action, too soon for contrition.
Nothing is possible but the shamed swoon
Of those consenting to the last humiliation.
I have consented, Lord Archbishop, have consented.
Am torn away, subdued, violated,
United to the spiritual flesh of nature,
Mastered by the animal powers of spirit,
Dominated by the lust of self-demolition,
By the final utter uttermost death of spirit,
By the final ectasy of waste and shame,
O Lord Archbishop, O Thomas Archbishop, forgive us, forgive
 us, pray for us that we may pray for you, out of our shame.
THOMAS: Peace, and be at peace with your thoughts and visions.
These things had to come to you and you to accept them.
This is your share of the eternal burden,
The perpetual glory. This is one moment,
But know that another
Shall pierce you with a sudden painful joy
When the figure of God's purpose is made complete.
You shall forget these things, toiling in the household,
You shall remember them, droning by the fire,

When age and forgetfulness sweeten memory
Only like a dream that has often been told
And often been changed in the telling. They will seem unreal.
Human kind cannot bear very much reality.

PRIESTS [*severally*]: My Lord, you must not stop here. To the min-
ster. Through the cloister. No time to waste. They are coming
back, armed. To the altar, to the altar. They are here already. To
the sanctuary. They are breaking in. We can barricade the min-
ster doors. You cannot stay here. Force him to come. Seize him.

THOMAS: All my life they have been coming, these feet. All my life
I have waited. Death will come only when I am worthy,
And if I am worthy, there is no danger.
I have therefore only to make perfect my will.

PRIESTS: My Lord, they are coming. They will break through
presently.
You will be killed. Come to the altar.

THOMAS: Peace! be quiet! remember where you are, and what is
happening;
No life here is sought for but mine,
And I am not in danger: only near to death.

PRIESTS: Make haste, my Lord. Don't stop here talking. It is not right.
What shall become of us, my Lord, if you are killed; what shall
become of us?

THOMAS: That again is another theme
To be developed and resolved in the pattern of time.
It is not for me to run from city to city;
To meet death gladly is only
The only way in which I can defend
The Law of God, the holy canons.

PRIESTS: My Lord, to vespers! You must not be absent from vespers.
You must not be absent from the divine office. To vespers.
Into the cathedral!

THOMAS: Go to vespers, remember me at your prayers.
They shall find the shepherd here; the flock shall be spared.
I have had a tremor of bliss, a wink of heaven, a whisper,
And I would no longer be denied; all things
Proceed to a joyful consummation.

PRIESTS: Seize him! force him! drag him!

THOMAS: Keep your hands off!

PRIESTS: To vespers! Take his feet! Up with him! Hurry.

> [*They drag him off. While the* CHORUS *speak, the scene is changed to the cathedral.*]

CHORUS [*while a* Dies Irae *is sung in Latin by a choir in the distance*]:
> Numb the hand and dry the eyelid,
> Still the horror, but more horror
> Than when tearing in the belly.

> Still the horror, but more horror
> Than when twisting in the fingers,
> Than when splitting in the skull.

> More than footfall in the passage,
> More than shadow in the doorway,
> More than fury in the hall.

> The agents of hell disappear, the human, they shrink and
> dissolve
> Into dust on the wind, forgotten, unmemorable; only is here
> The white flat face of Death, God's silent servant,
> And behind the face of Death the Judgement
> And behind the Judgement the Void, more horrid than active
> shapes of hell;
> Emptiness, absence, separation from God;
> The horror of the effortless journey, to the empty land
> Which is no land, only emptiness, absence, the Void,
> Where those who were men can no longer turn the mind
> To distraction, delusion, escape into dream, pretence,
> Where the soul is no longer deceived, for there are no objects,
> no tones,
> No colours, no forms to distract, to divert the soul
> From seeing itself, foully united forever, nothing with nothing,
> Not what we call death, but what beyond death is not death,
> We fear, we fear. Who shall then plead for me,
> Who intercede for me, in my most need?

Dead upon the tree, my Saviour,
Let not be in vain Thy labour;
Help me, Lord, in my last fear.

Dust I am, to dust am bending,
From the final doom impending
Help me, Lord, for death is near.

In the cathedral. THOMAS *and* PRIESTS
PRIESTS: Bar the door. Bar the door.
 The door is barred.
 We are safe. We are safe.
 The enemy may rage outside, he will tire
 In vain. They cannot break in.
 They dare not break in.
 They cannot break in. They have not the force.
 We are safe. We are safe.
THOMAS: Unbar the doors! throw open the doors!
 I will not have the house of prayer, the church of Christ,
 The sanctuary, turned into a fortress.
 The church shall protect her own, in her own way, not
 As oak and stone; stone and oak decay,
 Give no stay, but the Church shall endure.
 The church shall be open, even to our enemies. Open the door!
PRIEST: My Lord! these are not men, these come not as men come,
 but
 Like maddened beasts. They come not like men, who
 Respect the sanctuary, who kneel to the Body of Christ,
 But like beasts. You would bar the door
 Against the lion, the leopard, the wolf or the boar,
 Why not more
 Against beasts with the souls of damned men, against men
 Who would damn themselves to beasts. My Lord! My Lord!
THOMAS: Unbar the door!
 You think me reckless, desperate and mad.
 You argue by results, as this world does,
 To settle if an act be good or bad.

You defer to the fact. For every life and every act
Consequence of good and evil can be shown.
And as in time results of many deeds are blended
So good and evil in the end become confounded.
It is not in time that my death shall be known;
It is out of time that my decision is taken
If you call that decision
To which my whole being gives entire consent.
I give my life
To the Law of God above the Law of Man.
Those who do not the same
How should they know what I do?
How should you know what I do? Yet how much more
Should you know than these madmen beating on the door.
Unbar the door! unbar the door!
We are not here to triumph by fighting, by stratagem, or by
 resistance,
Not to fight with beasts as men. We have fought the beast
And have conquered. We have only to conquer
Now, by suffering. This is the easier victory.
Now is the triumph of the Cross, now
Open the door! I command it. OPEN THE DOOR!
[*The door is opened. The* KNIGHTS *enter, slightly tipsy.*]
PRIESTS: This way, my Lord! Quick. Up the stair. To the roof.
 To the crypt. Quick. Come. Force him.
KNIGHTS [*one line each*]: Where is Becket, the traitor to the King?
 Where is Becket, the meddling priest?
Come down Daniel to the lions' den,
 Come down Daniel for the mark of the beast.

Are you washed in the blood of the Lamb?
 Are you marked with the mark of the beast?
Come down Daniel to the lions' den,
 Come down Daniel and join in the feast.

Where is Becket the Cheapside brat?
 Where is Becket the faithless priest?

> Come down Daniel to the lions' den,
>> Come down Daniel and join in the feast.

THOMAS: It is the just man who
> Like a bold lion, should be without fear.
> I am here.
> No traitor to the King. I am a priest,
> A Christian, saved by the blood of Christ,
> Ready to suffer with my blood.
> This is the sign of the Church always,
> The sign of blood. Blood for blood.
> His blood given to buy my life,
> My blood given to pay for His death,
> My death for His death.

KNIGHTS: Absolve all those you have excommunicated.
> Resign the powers you have arrogated.
> Restore to the King the money you appropriated.
> Renew the obedience you have violated.

THOMAS: For my Lord I am now ready to die,
> That **His Church** may have peace and liberty.
> Do with me as you will, to your hurt and shame;
> But none of my people, in God's name,
> Whether layman or clerk, shall you touch.
> This I forbid.

KNIGHTS: Traitor! traitor! traitor! traitor!

THOMAS: You, Reginald, three times traitor you:
> Traitor to me as my temporal vassal,
> Traitor to me as your spiritual lord,
> Traitor to God in desecrating His Church.

FIRST KNIGHT: No faith do I owe to a renegade,
> And what I owe shall now be paid.

THOMAS: Now to Almighty God, to the Blessed Mary ever Virgin, to the blessed John the Baptist, the holy apostles Peter and Paul, to the blessed martyr Denys, and to all the Saints, I commend my cause and that of the Church.
> *While the* KNIGHTS *kill him, we hear the*

CHORUS: Clear the air! clean the sky! wash the wind! take stone from
> stone and wash them.

The land is foul, the water is foul, our beasts and ourselves
 defiled with blood.
A rain of blood has blinded my eyes. Where is England? where
 is Kent? where is Canterbury?
O far far far far in the past; and I wander in a land of barren
 boughs: if I break them, they bleed; I wander in a land of
 dry stones: if I touch them they bleed.
How how can I ever return, to the soft quiet seasons?
Night stay with us, stop sun, hold season, let the day not come,
 let the spring not come.
Can I look again at the day and its common things, and see
 them all smeared with blood, through a curtain of falling
 blood?
We did not wish anything to happen.
We understood the private catastrophe,
The personal loss, the general misery,
Living and partly living;
The terror by night that ends in daily action,
The terror by day that ends in sleep;
But the talk in the market-place, the hand on the broom,
The nighttime heaping of the ashes,
The fuel laid on the fire at daybreak,
These acts marked a limit to our suffering.
Every horror had its definition,
Every sorrow had a kind of end:
In life there is not time to grieve long.
But this, this is out of life, this is out of time,
An instant eternity of evil and wrong.
We are soiled by a filth that we cannot clean, united to super-
 natural vermin,
It is not we alone, it is not the house, it is not the city that is
 defiled,
But the world that is wholly foul.
Clear the air! clean the sky! wash the wind! take the stone from
 the stone, take the skin from the arm, take the muscle from
 the bone, and wash them. Wash the stone, wash the bone,
 wash the brain, wash the soul, wash them wash them!

[*The* KNIGHTS, *having completed the murder, advance to the front of the stage and address the audience.*]

FIRST KNIGHT: We beg you to give us your attention for a few moments. We know that you may be disposed to judge unfavourably of our action. You are Englishmen, and therefore you believe in fair play: and when you see one man being set upon by four, then your sympathies are all with the under dog. I respect such feelings, I share them. Nevertheless, I appeal to your sense of honour. You are Englishmen, and therefore will not judge anybody without hearing both sides of the case. That is in accordance with our long established principle of Trial by Jury. I am not myself qualified to put our case to you. I am a man of action and not of words. For that reason I shall do no more than introduce the other speakers, who, with their various abilities, and different points of view, will be able to lay before you the merits of this extremely complex problem. I shall call upon our youngest member to speak first. William de Traci.

SECOND KNIGHT: I am afraid I am not anything like such an experienced speaker as Reginald Fitz Urse would lead you to believe. But there is one thing I should like to say, and I might as well say it at once. It is this: in what we have done, and whatever you may think of it, we have been perfectly disinterested. [*The other* KNIGHTS: 'Hear! hear!'.] *We* are not getting anything out of this. We have much more to lose than to gain. We are four plain Englishmen who put our country first. I dare say that we didn't make a very good impression when we came in. The fact is that we knew we had taken on a pretty stiff job; I'll only speak for myself, but I had drunk a good deal—I am not a drinking man ordinarily—to brace myself up for it. When you come to the point, it does go against the grain to kill an Archbishop, especially when you have been brought up in good Church traditions. So if we seemed a bit rowdy, you will understand why it was; and for my part I am awfully sorry about it. We realised that this was our duty, but all the same we had to work ourselves up to it. And, as I said, *we* are not getting a penny out of this. We know perfectly well how things will turn out. King Henry—God bless him—will have to say, for reasons of state,

that he never meant this to happen; and there is going to be an awful row; and at the best we shall have to spend the rest of our lives abroad. And even when reasonable people come to see that the Archbishop *had* to be put out of the way—and personally I had a tremendous admiration for him—you must have noticed what a good show he put up at the end—they won't give *us* any glory. No, we have done for ourselves, there's no mistake about that. So, as I said at the beginning, please give us at least the credit for being completely disinterested in this business. I think that is about all I have to say.

FIRST KNIGHT: I think we will all agree that William de Traci has spoken well and has made a very important point. The gist of his argument is this: that we have been completely disinterested. But our act itself needs more justification than that; and you must hear our other speakers. I shall next call upon Hugh de Morville.

THIRD KNIGHT: I should like first to recur to a point that was very well put by our leader, Reginald Fitz Urse: that you are Englishmen, and therefore your sympathies are always with the under dog. It is the English spirit of fair play. Now the worthy Archbishop, whose good qualities I very much admired, has throughout been presented as the under dog. But is this really the case? I am going to appeal not to your emotions but to your reason. You are hard-headed sensible people, as I can see, and not to be taken in by emotional clap-trap. I therefore ask you to consider soberly: what were the Archbishop's aims? and what are King Henry's aims? In the answer to these questions lies the key to the problem.

The King's aim has been perfectly consistent. During the reign of the late Queen Matilda and the irruption of the unhappy usurper Stephen, the kingdom was very much divided. Our King saw that the one thing needful was to restore order: to curb the excessive powers of local government, which were usually exercised for selfish and often for seditious ends, and to systematise the judiciary. There was utter chaos: there were three kinds of justice and three kinds of court: that of the King, that of the Bishops, and that of the baronage. I must repeat one

point that the last speaker has made. While the late Archbishop was Chancellor, he wholeheartedly supported the King's designs: this is an important point, which, if necessary, I can substantiate. Now the King intended that Becket, who had proved himself an extremely able administrator—no one denies that—should unite the offices of Chancellor and Archbishop. No one would have grudged him that; no one than he was better qualified to fill at once these two most important posts. Had Becket concurred with the King's wishes, we should have had an almost ideal State: a union of spiritual and temporal administration, under the central government. I knew Becket well, in various official relations; and I may say that I have never known a man so well qualified for the highest rank of the Civil Service. And what happened? The moment that Becket, at the King's instance, had been made Archbishop, he resigned the office of Chancellor, he became more priestly than the priests, he ostentatiously and offensively adopted an ascetic manner of life, he openly abandoned every policy that he had heretofore supported; he affirmed immediately that there was a higher order than that which our King, and he as the King's servant, had for so many years striven to establish; and that—God knows why—the two orders were incompatible.

You will agree with me that such interference by an Archbishop offends the instincts of a people like ours. So far, I know that I have your approval: I read it in your faces. It is only with the measures we have had to adopt, in order to set matters to rights, that you take issue. No one regrets the necessity for violence more than we do. Unhappily, there are times when violence is the only way in which social justice can be secured. At another time, you would condemn an Archbishop by vote of Parliament and execute him formally as a traitor, and no one would have to bear the burden of being called murderer. And at a later time still, even such temperate measures as these would become unnecessary. But, if you have now arrived at a just subordination of the pretensions of the Church to the welfare of the State, remember that it is we who took the first step. We have been instrumental in bringing about the state of affairs

that you approve. We have served your interests; we merit your applause; and if there is any guilt whatever in the matter, you must share it with us.

FIRST KNIGHT: Morville has given us a great deal to think about. It seems to me that he has said almost the last word, for those who have been able to follow his very subtle reasoning. We have, however, one more speaker, who has I think another point of view to express. If there are any who are still unconvinced, I think that Richard Brito will be able to convince them. Richard Brito.

FOURTH KNIGHT: The speakers who have preceded me, to say nothing of our leader, Reginald Fitz Urse, have all spoken very much to the point. I have nothing to add along their particular lines of argument. What I have to say may be put in the form of a question: *Who killed the Archbishop?* As you have been eye-witnesses of this lamentable scene, you may feel some surprise at my putting it in this way. But consider the course of events. I am obliged, very briefly, to go over the ground traversed by the last speaker. While the late Archbishop was Chancellor, no one, under the King, did more to weld the country together, to give it the unity, the stability, order, tranquillity, and justice that it so badly needed. From the moment he became Arch-bishop, he completely reversed his policy; he showed himself to be utterly indifferent to the fate of the country, to be, in fact, a monster of egotism, a menace to society. This egotism grew upon him, until it became at last an undoubted mania. Every means that had been tried to conciliate him, to restore him to reason, had failed. Now I have unimpeachable evidence to the effect that before he left France he clearly prophesied, in the presence of numerous witnesses, that he had not long to live, and that he would be killed in England. He used every means of provo-cation; from his conduct, step by step, there can be no inference except that he had determined upon a death by martyrdom. This man, formerly a great public servant, had become a wrecker. Even at the last, he could have given us reason: you have seen how he evaded our questions. And when he had de-liberately exasperated us beyond human endurance, he could still have easily escaped; he could have kept himself from us

long enough to allow our righteous anger to cool. That was just
what he did not wish to happen; he insisted, while we were still
inflamed with wrath, that the doors should be opened. Need I
say more? I think, with these facts before you, you will un-
hesitatingly render a verdict of Suicide while of Unsound Mind.
It is the only charitable verdict you can give, upon one who was,
after all, a great man.

FIRST KNIGHT: Thank you, Brito. I think that there is no more to
be said; and I suggest that you now disperse quietly to your
homes. Please be careful not to loiter in groups at street corners,
and do nothing that might provoke any public outbreak.

[*Exeunt* KNIGHTS.]

FIRST PRIEST: O father, father, gone from us, lost to us,
How shall we find you, from what far place
Do you look down on us? You now in Heaven,
Who shall now guide us, protect us, direct us?
After what journey through what further dread
Shall we recover your presence? when inherit
Your strength? The Church lies bereft,
Alone, desecrated, desolated, and the heathen shall build on
the ruins,
Their world without God. I see it. I see it.

THIRD PRIEST: No. For the Church is stronger for this action,
Triumphant in adversity. It is fortified
By persecution: supreme, so long as men will die for it.
Go, weak sad men, lost erring souls, homeless in earth or heaven.
Go where the sunset reddens the last grey rock
Of Brittany, or the Gates of Hercules.
Go venture shipwreck on the sullen coasts
Where blackamoors make captive Christian men;
Go to the northern seas confined with ice
Where the dead breath makes numb the hand, makes dull the
brain;
Find an oasis in the desert sun,
Go seek alliance with the heathen Saracen,
To share his filthy rites, and try to snatch
Forgetfulness in his libidinous courts,
Oblivion in the fountain by the date-tree;

Or sit and bite your nails in Aquitaine.
In the small circle of pain within the skull
You still shall tramp and tread one endless round
Of thought, to justify your action to yourselves,
Weaving a fiction which unravels as you weave,
Pacing forever in the hell of make-believe
Which never is belief: this is your fate on earth
And we must think no further of you. O my lord
The glory of whose new state is hidden from us,
Pray for us of your charity; now in the sight of God
Conjoined with all the saints and martyrs gone before you,
Remember us. Let our thanks ascend
To God, who has given us another Saint in Canterbury.

CHORUS [*while a* Te Deum *is sung in Latin by a choir in the distance*]:

We praise Thee, O God, for Thy glory displayed in all the creatures of the earth,
In the snow, in the rain, in the wind, in the storm; in all of Thy creatures, both the hunters and the hunted.
For all things exist only as seen by Thee, only as known by Thee, all things exist
Only in Thy light, and Thy glory is declared even in that which denies Thee; the darkness declares the glory of light.
Those who deny Thee could not deny, if Thou didst not exist; and their denial is never complete, for if it were so, they would not exist.
They affirm Thee in living; all things affirm Thee in living; the bird in the air, both the hawk and the finch; the beast on the earth, both the wolf and the lamb; the worm in the soil and the worm in the belly.
Therefore man, whom Thou hast made to be conscious of Thee, must consciously praise Thee, in thought and in word and in deed.
Even with the hand to the broom, the back bent in laying the fire, the knee bent in cleaning the hearth, we, the scrubbers and sweepers of Canterbury,
The back bent under toil, the knee bent under sin, the hands to the face under fear, the head bent under grief,

Even in us the voices of seasons, the snuffle of winter, the song
of spring, the drone of summer, the voices of beasts and of
birds, praise Thee.
We thank Thee for Thy mercies of blood, for Thy redemption
by blood. For the blood of Thy martyrs and saints
Shall enrich the earth, shall create the holy places.
For wherever a saint has dwelt, wherever a martyr has given his
blood for the blood of Christ,
There is holy ground, and the sanctity shall not depart from it
Though armies trample over it, though sightseers come with
guide-books looking over it;
From where the western seas gnaw at the coast of Iona,
To the death in the desert, the prayer in forgotten places by
the broken imperial column,
From such ground springs that which forever renews the earth
Though it is forever denied. Therefore, O God, we thank Thee
Who hast given such blessing to Canterbury.

Forgive us, O Lord, we acknowledge ourselves as type of the
common man,
Of the men and women who shut the door and sit by the fire;
Who fear the blessing of God, the loneliness of the night of
God, the surrender required, the deprivation inflicted;
Who fear the injustice of men less than the justice of God;
Who fear the hand at the window, the fire in the thatch, the
fist in the tavern, the push into the canal,
Less than we fear the love of God.
We acknowledge our trespass, our weakness, our fault; we
acknowledge
That the sin of the world is upon our heads; that the blood of
the martyrs and the agony of the saints
Is upon our heads.
Lord, have mercy upon us.
Christ, have mercy upon us.
Lord, have mercy upon us.
Blessed Thomas, pray for us.

The Family Reunion

PERSONS

AMY, DOWAGER LADY MONCHENSEY
IVY, VIOLET, *and* AGATHA, *her younger sisters*
COL. THE HON. GERALD PIPER, *and* THE HON. CHARLES PIPER,
brothers of her deceased husband
MARY, *daughter of a deceased cousin of Lady Monchensey*
DENMAN, *a parlourmaid*
HARRY, LORD MONCHENSEY, *Amy's eldest son*
DOWNING, *his servant and chauffeur*
DR. WARBURTON
SERGEANT WINCHELL
THE EUMENIDES

The scene is laid in a country house in the North of England

Part I

The Drawing Room, After Tea.
An Afternoon in Late March

SCENE I

A̲m̲y̲, I̲v̲y̲, V̲i̲o̲l̲e̲t̲, A̲g̲a̲t̲h̲a̲, G̲e̲r̲a̲l̲d̲, C̲h̲a̲r̲l̲e̲s̲, M̲a̲r̲y̲
D̲e̲n̲m̲a̲n̲ *enters to draw the curtains*

A̲m̲y̲: Not yet! I will ring for you. It is still quite light.
 I have nothing to do but watch the days draw out,
 Now that I sit in the house from October to June,
 And the swallow comes too soon and the spring will be over
 And the cuckoo will be gone before I am out again.
 O Sun, that was once so warm, O Light that was taken for granted
 When I was young and strong, and sun and light unsought for
 And the night unfeared and the day expected
 And clocks could be trusted, tomorrow assured
 And time would not stop in the dark!
 Put on the lights. But leave the curtains undrawn.
 Make up the fire. Will the spring never come? I am cold.
A̲g̲a̲t̲h̲a̲: Wishwood was always a cold place, Amy.
I̲v̲y̲: I have always told Amy she should go south in the winter.
 Were I in Amy's position, I would go south in the winter.
 I would follow the sun, not wait for the sun to come here.
 I would go south in the winter, if I could afford it,
 Not freeze, as I do, in Bayswater, by a gas-fire counting shillings.
V̲i̲o̲l̲e̲t̲: Go south! to the English circulating libraries,
 To the military widows and the English chaplains,
 To the chilly deck-chair and the strong cold tea—
 The strong cold stewed bad Indian tea.

[225]

CHARLES: That's not Amy's style at all. We are country-bred people.
 Amy has been too long used to our ways
 Living with horses and dogs and guns
 Ever to want to leave England in the winter.
 But a single man like me is better off in London:
 A man can be very cosy at his club
 Even in an English winter.
GERALD: Well, as for me,
 I'd just as soon be a subaltern again
 To be back in the East. An incomparable climate
 For a man who can exercise a little common prudence;
 And your servants look after you very much better.
AMY: My servants are perfectly competent, Gerald.
 I can still see to that.
VIOLET: Well, as for me,
 I would never go south, no, definitely never,
 Even could I do it as well as Amy:
 England's bad enough, I would never go south,
 Simply to see the vulgarest people—
 You can keep out of their way at home;
 People with money from heaven knows where—
GERALD: Dividends from aeroplane shares.
VIOLET: They bathe all day and they dance all night
 In the absolute *minimum* of clothes.
CHARLES: It's the cocktail-drinking does the harm:
 There's nothing on earth so bad for the young.
 All that a civilised person needs
 Is a glass of dry sherry or two before dinner.
 The modern young people don't know what they're drinking,
 Modern young people don't care what they're eating;
 They've lost their sense of taste and smell
 Because of their cocktails and cigarettes.
 [*Enter* DENMAN *with sherry and whisky.* CHARLES *takes sherry
 and* GERALD *whisky.*]
 That's what it comes to.
 [*Lights a cigarette.*]
IVY: The younger generation
 Are undoubtedly decadent.

CHARLES: The younger generation
 Are not what we were. Haven't the stamina,
 Haven't the sense of responsibility.
GERALD: You're being very hard on the younger generation.
 I don't come across them very much now, myself;
 But I must say I've met some very decent specimens
 And some first-class shots—better than you were,
 Charles, as I remember. Besides, you've got to make allowances:
 We haven't left them such an easy world to live in.
 Let the younger generation speak for itself:
 It's Mary's generation. What does she think about it?
MARY: Really, Cousin Gerald, if you want information
 About the younger generation, you must ask someone else.
 I'm afraid that I don't deserve the compliment:
 I don't belong to any generation. [*Exit.*]
VIOLET: Really, Gerald, I must say you're very tactless,
 And I think that Charles might have been more considerate.
GERALD: I'm very sorry: but why was she upset?
 I only meant to draw her into the conversation.
CHARLES: She's a nice girl; but it's a difficult age for her.
 I suppose she must be getting on for thirty?
 She ought to be married, that's what it is.
AMY: So she should have been, if things had gone as I intended.
 Harry's return does not make things easy for her
 At the moment: but life may still go right.
 Meanwhile, let us drop the subject. The less said the better.
GERALD: That reminds me, Amy,
 When are the boys all due to arrive?
AMY: I do not want the clock to stop in the dark.
 If you want to know why I never leave Wishwood
 That is the reason. I keep Wishwood alive
 To keep the family alive, to keep them together,
 To keep me alive, and I live to keep them.
 You none of you understand how old you are
 And death will come to you as a mild surprise,
 A momentary shudder in a vacant room.
 Only Agatha seems to discover some meaning in death
 Which I cannot find.

 —I am only certain of Arthur and John,
 Arthur in London, John in Leicestershire:
 They should both be here in good time for dinner.
 Harry telephoned to me from Marseilles,
 He would come by air to Paris, and so to London,
 And hoped to arrive in the course of the evening.
VIOLET: Harry was always the most likely to be late.
AMY: This time, it will not be his fault.
 We are very lucky to have Harry at all.
IVY: And when will you have your birthday cake, Amy,
 And open your presents?
AMY: After dinner:
 That is the best time.
IVY: It is the first time
 You have not had your cake and your presents at tea.
AMY: This is a very particular occasion
 As you ought to know. It will be the first time
 For eight years that we have all been together.
AGATHA: It is going to be rather painful for Harry
 After eight years and all that has happened
 To come back to Wishwood.
GERALD: Why, painful?
VIOLET: Gerald! you know what Agatha means.
AGATHA: I mean painful, because everything is irrevocable,
 Because the past is irremediable,
 Because the future can only be built
 Upon the real past. Wandering in the tropics
 Or against the painted scene of the Mediterranean,
 Harry must often have remembered Wishwood—
 The nursery tea, the school holiday,
 The daring feats on the old pony,
 And thought to creep back through the little door.
 He will find a new Wishwood. Adaptation is hard.
AMY: Nothing is changed, Agatha, at Wishwood.
 Everything is kept as it was when he left it,
 Except the old pony, and the mongrel setter
 Which I had to have destroyed.
 Nothing has been changed. I have seen to that.

AGATHA: Yes. I mean that at Wishwood he will find another Harry.
 The man who returns will have to meet
 The boy who left. Round by the stables,
 In the coach-house, in the orchard,
 In the plantation, down the corridor
 That led to the nursery, round the corner
 Of the new wing, he will have to face him—
 And it will not be a very *jolly* corner.
 When the loop in time comes—and it does not come for every-
 body—
 The hidden is revealed, and the spectres show themselves.
GERALD: I don't in the least know what you're talking about.
 You seem to be wanting to give us all the hump.
 I must say, this isn't cheerful for Amy's birthday
 Or for Harry's homecoming. Make him feel at home, I say!
 Make him feel that what has happened doesn't matter.
 He's taken his medicine, I've no doubt.
 Let him marry again and carry on at Wishwood.
AMY: Thank you, Gerald. Though Agatha means
 As a rule, a good deal more than she cares to betray,
 I am bound to say that I agree with you.
CHARLES: I never wrote to him when he lost his wife—
 That was just about a year ago, wasn't it?
 Do you think that I ought to mention it now?
 It seems to me too late.
AMY: Much too late.
 If he wants to talk about it, that's another matter;
 But I don't believe he will. He will wish to forget it.
 I do not mince matters in front of the family:
 You can call it nothing but a blessed relief.
VIOLET: *I* call it providential.
IVY: Yet it must have been shocking,
 Especially to lose anybody in *that* way—
 Swept off the deck in the middle of a storm,
 And never even to recover the body.
CHARLES: "Well-known Peeress Vanishes from Liner."
GERALD: Yes, it's odd to think of her as permanently *missing*.
VIOLET: Had she been drinking?

AMY: I would never ask him.
IVY: These things are much better not enquired into.
 She may have done it in a fit of temper.
GERALD: I never met her.
AMY: I am very glad you did not.
 I am very glad that none of you ever met her.
 It will make the situation very much easier
 And is why I was so anxious you should all be here.
 She never would have been one of the family,
 She never wished to be one of the family,
 She only wanted to keep him to herself
 To satisfy her vanity. That's why she dragged him
 All over Europe and half round the world
 To expensive hotels and undesirable society
 Which she could choose herself. She never wanted
 Harry's relations or Harry's old friends;
 She never wanted to fit herself to Harry,
 But only to bring Harry down to her own level.
 A restless shivering painted shadow
 In life, she is less than a shadow in death.
 You might as well all of you know the truth
 For the sake of the future. There can be no grief
 And no regret and no remorse.
 I would have prevented it if I could. For the sake of the future:
 Harry is to take command at Wishwood
 And I hope we can contrive his future happiness.
 Do not discuss his absence. Please behave only
 As if nothing had happened in the last eight years.
GERALD: That will be a little difficult.
VIOLET: Nonsense, Gerald!
 You must see for yourself it's the only thing to do.
AGATHA: Thus with most careful devotion
 Thus with precise attention
 To detail, interfering preparation
 Of that which is already prepared
 Men tighten the knot of confusion
 Into perfect misunderstanding,

Reflecting a pocket-torch of observation
Upon each other's opacity
Neglecting all the admonitions
From the world around the corner
The wind's talk in the dry holly-tree
The inclination of the moon
The attraction of the dark passage
The paw under the door.

CHORUS [IVY, VIOLET, GERALD *and* CHARLES]: Why do we feel embarrassed, impatient, fretful, ill at ease,

Assembled like amateur actors who have not been assigned their parts?

Like amateur actors in a dream when the curtain rises, to find themselves dressed for a different play, or having rehearsed the wrong parts,

Waiting for the rustling in the stalls, the titter in the dress circle, the laughter and catcalls in the gallery?

CHARLES: I might have been in St. James's Street, in a comfortable chair rather nearer the fire.

IVY: I might have been visiting Cousin Lily at Sidmouth, if I had not had to come to this party.

GERALD: I might have been staying with Compton-Smith, down at his place in Dorset.

VIOLET: I should have been helping Lady Bumpus, at the Vicar's American Tea.

CHORUS: Yet we are here at Amy's command, to play an unread part in some monstrous farce, ridiculous in some nightmare pantomime.

AMY: What's that? I thought I saw someone pass the window.
What time is it?

CHARLES: Nearly twenty to seven.

AMY: John should be here now, he has the shortest way to come.
John at least, if not Arthur. Hark, there is someone coming:
Yes, it must be John.
[*Enter* HARRY.]
Harry!
[HARRY *stops suddenly at the door and stares at the window.*]

IVY: Welcome, Harry!

GERALD: Well done!

VIOLET: Welcome home to Wishwood!

CHARLES: Why, what's the matter?

AMY: Harry, if you want the curtains drawn you should let me ring
 for Denman.

HARRY: How can you sit in this blaze of light for all the world to
 look at?

 If you knew how you looked, when I saw you through the win-
 dow!

 Do you like to be stared at by eyes through a window?

AMY: You forget, Harry, that you are at Wishwood,

 Not in town, where you have to close the blinds.

 There is no one to see you but our servants who belong here,

 And who all want to see you back, Harry.

HARRY: Look there, look there: do you see them?

GERALD: No, I don't see anyone about.

HARRY: No, no, not there. Look there!

 Can't you see them? *You* don't see them, but I see them,

 And they see me. This is the first time that I have seen them.

 In the Java Straits, in the Sunda Sea,

 In the sweet sickly tropical night, I knew they were coming.

 In Italy, from behind the nightingale's thicket,

 The eyes stared at me, and corrupted that song.

 Behind the palm trees in the Grand Hotel

 They were always there. But I did not *see* them.

 Why should they wait until I came back to Wishwood?

 There were a thousand places where I might have met them!

 Why here? why here?

 Many happy returns of the day, mother.

 Aunt Ivy, Aunt Violet, Uncle Gerald, Uncle Charles, Agatha.

AMY: We are very glad to have you back, Harry.

 Now we shall all be together for dinner.

 The servants have been looking forward to your coming:

 Would you like to have them in after dinner

 Or wait till tomorrow? I am sure you must be tired.

 You will find everybody here, and everything the same.

Mr. Bevan—you remember—wants to call tomorrow
On some legal business, a question about taxes—
But I think you would rather wait till you are rested.
Your room is all ready for you. Nothing has been changed.

HARRY: Changed? nothing changed? how can you say that nothing
 is changed?
You all look so withered and young.

GERALD: We must have a ride tomorrow.
You'll find you know the country as well as ever.
There wasn't an inch of it you didn't know.
But you'll have to see about a couple of new hunters.

CHARLES: And I've a new wine merchant to recommend you;
Your cellar could do with a little attention.

IVY: And you'll really have to find a successor to old Hawkins.
It's really high time the old man was pensioned.
He's let the rock garden go to rack and ruin,
And he's nearly half blind. I've spoken to your mother
Time and time again: she's done nothing about it
Because she preferred to wait for your coming.

VIOLET: And time and time again I have spoken to your mother
About the waste that goes on in the kitchen.
Mrs. Packell is too old to know what she is doing.
It really needs a man in charge of things at Wishwood.

AMY: You see your aunts and uncles are very helpful, Harry.
I have always found them forthcoming with advice
Which I have never taken. Now it is your business.
I have only struggled to keep Wishwood going
And to make no changes before your return.
Now it's for you to manage. I am an old woman.
They can give me no further advice when I'm dead.

IVY: Oh, dear Amy!
No one wants you to die, I'm sure!
Now that Harry's back, is the time to think of living.

HARRY: Time and time and time, and change, no change!
You all of you try to talk as if nothing had happened,
And yet you are talking of nothing else. Why not get to the point
Or if you want to pretend that I am another person—

A person that you have conspired to invent, please do so
In my absence. I shall be less embarrassing to you. Agatha?
AGATHA: I think, Harry, that having got so far—
If you want no pretences, let us have no pretences:
And you must try at once to make us understand,
And we must try to understand you.
HARRY: But how can I explain, how can I explain to *you?*
You will understand less after I have explained it.
All that I could hope to make you understand
Is only events: not what has happened.
And people to whom nothing has ever happened
Cannot understand the unimportance of events.
GERALD: Well, you can't say that nothing has happened to *me.*
I started as a youngster on the North West Frontier—
Been in tight corners most of my life
And some pretty nasty messes.
CHARLES: And there isn't much would surprise me, Harry;
Or shock me, either.
HARRY: You are all people
To whom nothing has happened, at most a continual impact
Of external events. You have gone through life in sleep,
Never woken to the nightmare. I tell you, life would be un-
 endurable
If you were wide awake. You do not know
The noxious smell untraceable in the drains,
Inaccessible to the plumbers, that has its hour of the night; you
 do not know
The unspoken voice of sorrow in the ancient bedroom
At three o'clock in the morning. I am not speaking
Of my own experience, but trying to give you
Comparisons in a more familiar medium. I am the old house
With the noxious smell and the sorrow before morning,
In which all past is present, all degradation
Is unredeemable. As for what happens—
Of the past you can only see what is past,
Not what is always present. That is what matters.
AGATHA: Nevertheless, Harry, best tell us as you can:

 Talk in your own language, without stopping to debate
 Whether it may be too far beyond our understanding.
HARRY: The sudden solitude in a crowded desert
 In a thick smoke, many creatures moving
 Without direction, for no direction
 Leads anywhere but round and round in that vapour—
 Without purpose, and without principle of conduct
 In flickering intervals of light and darkness;
 The partial anaesthesia of suffering without feeling
 And partial observation of one's own automatism
 While the slow stain sinks deeper through the skin
 Tainting the flesh and discolouring the bone—
 This is what matters, but it is unspeakable,
 Untranslatable: I talk in general terms
 Because the particular has no language. One thinks to escape
 By violence, but one is still alone
 In an over-crowded desert, jostled by ghosts.
 It was only reversing the senseless direction
 For a momentary rest on the burning wheel
 That cloudless night in the mid-Atlantic
 When I pushed her over.
VIOLET: Pushed her?
HARRY: You would never imagine anyone could sink so quickly.
 I had always supposed, wherever I went
 That she would be with me; whatever I did
 That she was unkillable. It was not like that.
 Everything is true in a different sense.
 I expected to find her when I went back to the cabin.
 Later, I became excited, I think I made enquiries;
 The purser and the steward were extremely sympathetic
 And the doctor very attentive.
 That night I slept heavily, alone.
AMY: Harry!
CHARLES: You mustn't indulge such dangerous fancies.
 It's only doing harm to your mother and yourself.
 Of course we know what really happened, we read it in the
 papers—

No need to revert to it. Remember, my boy,
I understand, your life together made it seem more horrible.
There's a lot in my own past life that presses on my chest
When I wake, as I do now, early before morning.
I understand these feelings better than you know—
But *you* have no reason to reproach yourself.
Your conscience can be clear.

HARRY: It goes a good deal deepei
That what people call their conscience; it is just the cancer
That eats away the self. I knew how you would take it.
First of all, you isolate the single event
As something so dreadful that it couldn't have happened,
Because you could not bear it. So you must believe
That I suffer from delusions. It is not my conscience,
Not my mind, that is diseased, but the world I have to live in.
—I lay two days in contented drowsiness·
Then I recovered. I am afraid of sleep:
A condition in which one can be caught for the last time.
And also waking. She is nearer than ever.
The contamination has reached the marrow
And *they* are always near. Here, nearer than ever.
They are very close here. I had not expected that.

AMY: Harry, Harry, you are very tired
And overwrought. Coming so far
And making such haste, the change is too sudden for you.
You are unused to our foggy climate
And the northern country. When you see Wishwood
Again by day, all will be the same again.
I beg you to go now and rest before dinner.
Get Downing to draw you a hot bath,
And you will feel better.

AGATHA: There are certain points I do not yet understand:
They will be clear later. I am also convinced
That you only hold a fragment of the explanation.
It is only because of what you do not understand
That you feel the need to declare what you do.
There is more to understand: hold fast to that
As the way to freedom.

HARRY: I think I see what you mean,
 Dimly—as you once explained the sobbing in the chimney
 The evil in the dark closet, which they said was not there,
 Which they explained away, but you explained them
 Or at least, made me cease to be afraid of them.
 I will go and have my bath. [*Exit.*]
GERALD: God preserve us!
 I never thought it would be as bad as this.
VIOLET: There is only one thing to be done:
 Harry must see a doctor.
IVY: But I understand—
 I have heard of such cases before—that people in his condition
 Often betray the most immoderate resentment
 At such a suggestion. They can be very cunning—
 Their malady makes them so. They do not want to be cured
 And they know what you are thinking.
CHARLES: He has probably let this notion grow in his mind,
 Living among strangers, with no one to talk to.
 I suspect it is simply that the wish to get rid of her
 Makes him believe he did. He cannot trust his good fortune.
 I believe that all he needs is someone to talk to,
 To get it off his mind. I'll have a talk to him tomorrow.
AMY: Most certainly not, Charles, you are not the right person.
 I prefer to believe that a few days at Wishwood
 Among his own family, is all that he needs.
GERALD: Nevertheless, Amy, there's something in Violet's suggestion.
 Why not ring up Warburton, and ask him to join us?
 He's an old friend of the family, it's perfectly natural
 That he should be asked. He looked after all the boys
 When they were children. I'll have a word with him.
 He can talk to Harry, and Harry need have no suspicion.
 I'd trust Warburton's opinion.
AMY: If anyone speaks to Dr. Warburton
 It should be myself. What does Agatha think?
AGATHA: It seems a necessary move
 In an unnecessary action,
 Not for the good that it will do
 But that nothing may be left undone

On the margin of the impossible.
AMY: Very well.
 I will ring up the doctor myself. [*Exit.*]
CHARLES: Meanwhile, I have an idea. Why not question Downing?
 He's been with Harry ten years, he's absolutely discreet.
 He was with them on the boat. He might be of use.
IVY: Charles! you don't really suppose
 That he might have pushed her over?
CHARLES: In any case, I shouldn't blame Harry.
 I might have done the same thing once, myself.
 Nobody knows what he's likely to do
 Until there's somebody he wants to get rid of.
GERALD: Even so, we don't want Downing to know
 Any more than he knows already.
 And even if he knew, it's very much better
 That he shouldn't know that we knew it also.
 Why not let sleeping dogs lie?
CHARLES: All the same, there's a question or two
 [*Rings the bell.*]
 That I'd like to ask Downing.
 He shan't know why I'm asking.
[*Enter* DENMAN.]
 Denman, where is Downing? Is he up with his Lordship?
DENMAN: He's out in the garage, Sir, with his Lordship's car.
CHARLES: Tell him I'd like to have a word with him, please.
 [*Exit* DENMAN.]
VIOLET: Charles, if you are determined upon this investigation,
 Which I am convinced is going to lead us nowhere,
 And which I am sure Amy would disapprove of—
 I only wish to express my emphatic protest
 Both against your purpose and the means you are employing.
CHARLES: My purpose is, to find out what's wrong with Harry:
 Until we know that, we can do nothing for him.
 And as for my means, we can't afford to be squeamish
 In taking hold of anything that comes to hand.
 If you are interested in helping Harry
 You can hardly object to the means.

VIOLET: I do object.

IVY: And I wish to associate myself with my sister
 In her objections—

AGATHA: I have no objection,
 Any more than I object to asking Dr. Warburton:
 I only see that this is all quite irrelevant;
 We had better leave Charles to talk to Downing
 And pursue his own methods. *[Rises.]*

VIOLET: I do not agree.
 I think there should be witnesses. I intend to remain.
 And I wish to be present to hear what Downing says.
 I want to know at once, not to be told about it later.

IVY: And I shall stay with Violet.

AGATHA: I shall return
 When Downing has left you. *[Exit.]*

CHARLES: Well, I'm very sorry
 You all see it like this: but there simply are times
 When there's nothing to do but take the bull by the horns,
 And this is one.

 [Knock: and enter DOWNING.]

CHARLES: Good evening, Downing.
 It's good to see you again, after all these years.
 You're well, I hope?

DOWNING: Thank you, very well indeed, Sir.

CHARLES: I'm sorry to send for you so abruptly,
 But I've a question I'd like to put to you,
 I'm sure you won't mind, it's about his Lordship.
 You've looked after his Lordship for over ten years . . .

DOWNING: Eleven years, Sir, next Lady Day.

CHARLES: Eleven years, and you know him pretty well.
 And I'm sure that you've been a good friend to him, too.
 We haven't seen him for nearly eight years;
 And to tell the truth, now that we've seen him,
 We're a little worried about his health.
 He doesn't seem to be . . . quite himself.

DOWNING: Quite natural, if I may say so, Sir,
 After what happened.

CHARLES: Quite so, quite.
 Downing, you were with them on the voyage from New York—
 We didn't learn very much about the circumstances;
 We only knew what we read in the papers—
 Of course, there was a great deal too much in the papers.
 Downing, do you think that it might have been suicide,
 And that his Lordship knew it?
DOWNING: Unlikely, Sir, if I may say so.
 Much more likely to have been an accident.
 I mean, knowing her Ladyship,
 I don't think she had the courage.
CHARLES: Did she ever talk of suicide?
DOWNING: Oh, yes, she did, every now and again.
 But in my opinion, it is those that talk
 That are the least likely. To my way of thinking
 She only did it to frighten people.
 If you take my meaning—just for the effect.
CHARLES: I understand, Downing. Was she in good spirits?
DOWNING: Well, always about the same, Sir.
 What I mean is, always up and down.
 Down in the morning, and up in the evening,
 And *then* she used to get rather excited,
 And, in a way, irresponsible, Sir.
 If I may make so bold, Sir,
 I always thought that a very few cocktails
 Went a long way with her Ladyship.
 She wasn't one of those that are *designed* for drinking:
 It's natural for some and unnatural for others.
CHARLES: And how was his Lordship, during the voyage?
DOWNING: Well, you might say depressed, Sir.
 But you know his Lordship was always very quiet:
 Very uncommon that I saw him in high spirits.
 For what my judgment's worth, I always said his Lordship
 Suffered from what they call a kind of repression.
 But what struck me . . . more nervous than usual;
 I mean to say, you could see that he was nervous.
 He behaved as if he thought something might happen.
CHARLES: What sort of thing?

DOWNING: Well, I don't know, Sir.
 But he seemed very anxious about my Lady.
 Tried to keep her in when the weather was rough,
 Didn't like to see her lean over the rail.
 He was in a rare fright, once or twice.
 But you know, it is just my opinion, Sir,
 That his Lordship is rather psychic, as they say.
CHARLES: Were they always together?
DOWNING: Always, Sir.
 That was just my complaint against my Lady.
 It's my opinion that man and wife
 Shouldn't see too much of each other, Sir.
 Quite the contrary of the usual opinion,
 I dare say. She wouldn't leave him alone.
 And there's my complaint against these ocean liners
 With all their swimming baths and gymnasiums
 There's not even a place where a man can go
 For a quiet smoke, where the women can't follow him.
 She wouldn't leave him out of her sight.
CHARLES: During that evening, did you see him?
DOWNING: Oh, yes, Sir, I'm sure I saw him.
 I don't mean to say that he had any orders—
 His Lordship is always most considerate
 About keeping me up. But when I say I saw him,
 I mean that I saw him accidental.
 You see, Sir, I was down in the Tourist,
 And I took a bit of air before I went to bed,
 And you could see the corner of the upper deck.
 And I remember, there I saw his Lordship
 Leaning over the rail, looking at the water—
 There wasn't a moon, but I was sure it was him.
 While I took my turn about, for near half an hour
 He stayed there alone, looking over the rail.
 Her Ladyship must have been all right then,
 Mustn't she, Sir? or else he'd have known it.
CHARLES: Oh, yes . . . quite so. Thank you, Downing,
 I don't think we need you any more.
GERALD: Oh, Downing,

Is there anything wrong with his Lordship's car?
DOWNING: Oh, no, Sir, she's in good running order:
 I see to that.
GERALD: I only wondered
Why you've been busy about it tonight.
DOWNING: Nothing wrong, Sir:
 Only I like to have her always ready.
 Would there be anything more, Sir?
GERALD: Thank you, Downing;
 Nothing more. [*Exit* DOWNING.]
VIOLET: Well, Charles, I must say, with your investigations,
 You seem to have left matters much as they were—
 Except for having brought Downing into it:
 Of which I disapprove.
CHARLES: Of which you disapprove.
 But I believe that an unconscious accomplice is desirable.
CHORUS: Why should we stand here like guilty conspirators, waiting
 for some revelation
 When the hidden shall be exposed, and the newsboy shall shout
 in the street?
 When the private shall be made public, the common photog-
 rapher
 Flashlight for the picture papers: why do we huddle together
 In a horrid amity of misfortune? why should we be implicated,
 brought in and brought together?
IVY: I do not trust Charles with his confident vulgarity, acquired
 from worldly associates.
GERALD: Ivy is only concerned for herself, and her credit among her
 shabby genteel acquaintance.
VIOLET: Gerald is certain to make some blunder, he is useless out of
 the army.
CHARLES: Violet is afraid that her status as Amy's sister will be
 diminished.
CHORUS: We all of us make the pretension
 To be the uncommon exception
 To the universal bondage.
 We like to appear in the newspapers
 So long as we are in the right column.

We know about the railway accident
We know about the sudden thrombosis
And the slowly hardening artery.
We like to be thought well of by others
So that we may think well of ourselves.
And any explanation will satisfy:
We only ask to be reassured
About the noises in the cellar
And the window that should not have been open.

Why do we all behave as if the door might suddenly open, the
 curtains be drawn,
The cellar make some dreadful disclosure, the roof disappear,
And we should cease to be sure of what is real or unreal?
Hold tight, hold tight, we must insist that the world is what we
 have always taken it to be.
AMY'S VOICE: Ivy! Violet! has Arthur or John come yet?
IVY: There is no news of Arthur or John.
 [*Enter* AMY *and* AGATHA.]
AMY: It is very annoying. They both promised to be here
In good time for dinner. It is very annoying.
Now they can hardly arrive in time to dress.
I do not understand what could have gone wrong
With both of them, coming from different directions.
Well, we must go and dress, I suppose. I hope Harry will feel
 better
After his rest upstairs. [*Exeunt, except* AGATHA.]

SCENE II

AGATHA

[*Enter* MARY *with flowers.*]

MARY: The spring is very late in this northern country,
 Late and uncertain, clings to the south wall.
 The gardener had no garden-flowers to give me for this evening.
AGATHA: I always forget how late the spring is, here.
MARY: I had rather wait for our windblown blossoms,
 Such as they are, than have these greenhouse flowers
 Which do not belong here, which do not know
 The wind and rain, as I know them.
AGATHA: I wonder how many we shall be for dinner.
MARY: Seven . . . nine . . . ten surely.
 I hear that Harry has arrived already
 And he was the only one that was uncertain.
 Arthur or John may be late, of course.
 We may have to keep the dinner back . . .
AGATHA: And also Dr. Warburton. At least, Amy has invited him.
MARY: Dr. Warburton? I think she might have told me;
 It is very difficult, having to plan
 For uncertain numbers. Why did she ask him?
AGATHA: She only thought of asking him, a little while ago.
MARY: Well, there's something to be said for having an outsider;
 For what is more formal than a family dinner?
 An official occasion of uncomfortable people
 Who meet very seldom, making conversation.
 I am very glad if Dr. Warburton is coming.
 I shall have to sit between Arthur and John.
 Which is worse, thinking of what to say to John,
 Or having to listen to Arthur's chatter
 When he thinks he is behaving like a man of the world?
 Cousin Agatha, I want your advice.
AGATHA: I should have thought
 You had more than you wanted of that, when at college.

MARY: I might have known you'd throw that up against me.
 I know I wasn't one of your favourite students:
 I only saw you as the principal
 Who knew the way of dominating timid girls.
 I don't see you any differently now;
 But I really wish that I'd taken your advice
 And tried for a fellowship, seven years ago.
 Now I want your advice, because there's no one else to ask,
 And because you are strong, and because you don't belong here
 Any more than I do. I want to get away.
AGATHA: After seven years?
MARY: Oh, you don't understand!
 But you do understand. You only want to know
 Whether I understand. You know perfectly well,
 What Cousin Amy wants, she usually gets.
 Why do *you* so seldom come here? *You*'re not afraid of her,
 But I think you must have wanted to avoid collision.
 I suppose I could have gone, if I'd had the moral courage,
 Even against a will like hers. I know very well
 Why she wanted to keep me. She didn't need me:
 She would have done just as well with a hired servant
 Or with none. She only wanted me for Harry—
 Not such a compliment: she only wanted
 To have a tame daughter-in-law with very little money,
 A housekeeper-companion for her and Harry.
 Even when he married, she still held on to me
 Because she couldn't bear to let any project go;
 And even when *she* died: I believed that Cousin Amy—
 I almost believed it—had killed her by willing.
 Doesn't that sound awful? I know that it does.
 Did you ever meet her? What was she like?
AGATHA: I am the only one who ever met her,
 The only one Harry asked to his wedding:
 Amy did not know that. I was sorry for her;
 I could see that she distrusted me—she was frightened of the
 family,
 She wanted to fight them—with the weapons of the weak,

Which are too violent. And it could not have been easy,
Living with Harry. It's not what she did to Harry,
That's important, I think, but what he did to himself.

MARY: But it wasn't till I knew that Harry had returned
That I felt the strength to go. I know I must go.
But where? I want a job: and you can help me.

AGATHA: I am very sorry, Mary, I am very sorry for you;
Though you may not think me capable of such a feeling.
I would like to help you: but you must not run away.
Any time before now, it would have shown courage
And would have been right. Now, the courage is only the
 moment
And the moment is only fear and pride. I see more than this,
More than I can tell you, more than there are words for.
At this moment, there is no decision to be made;
The decision will be made by powers beyond us
Which now and then emerge. You and I, Mary,
Are only watchers and waiters: not the easiest rôle.
I must go and change for dinner. [*Exit.*]

MARY: So you will not help me!
Waiting, waiting, always waiting.
I think this house *means* to keep us waiting.
[*Enter* HARRY.]

HARRY: Waiting? For what?

MARY: How do you do, Harry.
You are down very early. I thought you had just arrived.
Did you have a comfortable journey?

HARRY: Not very.
But, at least, it did not last long. How are you, Mary?

MARY: Oh, very well. What are you looking for?

HARRY: I had only just noticed that this room is quite unchanged:
The same hangings . . . the same pictures . . . even the table,
The chairs, the sofa . . . all in the same positions.
I was looking to see if anything was changed,
But if so, I can't find it.

MARY: Your mother insisted
On everything being kept the same as when you left it.

HARRY: I wish she had not done that. It's very unnatural,
 This arresting of the normal change of things:
 But it's very like her. What I might have expected.
 It only makes the changing of people
 All the more manifest.
MARY: Yes, nothing changes here,
 And we just go on . . . drying up, I suppose,
 Not noticing the change. But to you, I am sure,
 We must seem very altered.
HARRY: You have hardly changed at all—
 And I haven't seen you since you came down from Oxford.
MARY: Well, I must go and change for dinner.
 We do change—to that extent.
HARRY: No, don't go just yet.
MARY: Are you glad to be at home?
HARRY: There was something
 I wanted to ask you. I don't know yet.
 All these years I'd been longing to get back
 Because I thought I never should. I thought it was a place
 Where life was substantial and simplified—
 But the simplification took place in my memory,
 I think. It seems I shall get rid of nothing,
 Of none of the shadows that I wanted to escape;
 And at the same time, other memories,
 Earlier, forgotten, begin to return
 Out of my childhood. I can't explain.
 But I thought I might escape from one life to another,
 And it may be all one life, with no escape. Tell me,
 Were you ever happy here, as a child at Wishwood?
MARY: Happy? not really, though I never knew why:
 It always seemed that it must be my own fault,
 And never to be happy was always to be naughty.
 But there were reasons: I was only a cousin
 Kept here because there was nothing else to do with me.
 I didn't belong here. It was different for you.
 And you seemed so much older. We were rather in awe of you—
 At least, I was.

HARRY: Why were we not happy?
MARY: Well, it all seemed to be imposed upon us;
 Even the nice things were laid out ready,
 And the treats were always so carefully prepared;
 There was never any time to invent our own enjoyments.
 But perhaps it was all designed for you, not for us.
HARRY: No, it didn't seem like that. I was part of the design
 As well as you. But what was the design?
 It never came off. But do you remember
MARY: The hollow tree in what we called the wilderness
HARRY: Down near the river. That was the block house
 From which we fought the Indians. Arthur and John.
MARY: It was the cave where we met by moonlight
 To raise the evil spirits.
HARRY: Arthur and John.
 Of course we were punished for being out at night
 After being put to bed. But at least they never knew
 Where we had been.
MARY: They never found the secret.
HARRY: Not then. But later, coming back from school
 For the holidays, after the formal reception
 And the family festivities, I made my escape
 As soon as I could, and slipped down to the river
 To find the old hiding place. The wilderness was gone,
 The tree had been felled, and a neat summer-house
 Had been erected, 'to please the children.'
 It's absurd that one's only memory of freedom
 Should be a hollow tree in a wood by the river.
MARY: But when I was a child I took everything for granted,
 Including the stupidity of older people—
 They lived in another world, which did not touch me.
 Just now, I find them very difficult to bear.
 They are always assured that you ought to be happy
 At the very moment when you are wholly conscious
 Of being a misfit, of being superfluous.
 But why should I talk about my commonplace troubles?
 They must seem very trivial indeed to you.

It's just ordinary hopelessness.

HARRY: One thing you cannot know:
The sudden extinction of every alternative,
The unexpected crash of the iron cataract.
You do not know what hope is, until you have lost it.
You only know what it is not to hope:
You do not know what it is to have hope taken from you,
Or to fling it away, to join the legion of the hopeless
Unrecognised by other men, though sometimes by each other.

MARY: I know what you mean. That is an experience
I have not had. Nevertheless, however real,
However cruel, it may be a deception.

HARRY: What I see
May be one dream or another; if there is nothing else
The most real is what I fear. The bright colour fades
Together with the unrecapturable emotion,
The glow upon the world, that never found its object;
And the eye adjusts itself to a twilight
Where the dead stone is seen to be batrachian,
The aphyllous branch ophidian.

MARY: You bring your own landscape
No more real than the other. And in a way you contradict
 yourself:
That sudden comprehension of the death of hope
Of which you speak, I know you have experienced it,
And I can well imagine how awful it must be.
But in this world another hope keeps springing
In an unexpected place, while we are unconscious of it.
You hoped for something, in coming back to Wishwood,
Or you would not have come.

HARRY: Whatever I hoped for
Now that I am here I know I shall not find it.
The instinct to return to the point of departure
And start again as if nothing had happened,
Isn't that all folly? It's like the hollow tree,
Not there.

MARY: But surely, what you say

Only proves that you expected Wishwood
To be your real self, to do something for you
That you can only do for yourself.
What you need to alter is something inside you
Which you can change anywhere—here, as well as elsewhere.

HARRY: Something inside me, you think, that can be altered!
And here, indeed! where I have felt them near me,
Here and here and here—wherever I am not looking,
Always flickering at the corner of my eye,
Almost whispering just out of earshot—
And inside too, in the nightly panic
Of dreaming dissolution. You do not know,
You cannot know, you cannot understand.

MARY: I think I could understand, but you would have to be patient
With me, and with people who have not had your experience.

HARRY: If I tried to explain, you could never understand:
Explaining would only make a worse misunderstanding;
Explaining would only set me farther away from you.
There is only one way for you to understand
And that is by seeing. They are much too clever
To admit you into *our* world. Yours is no better.
They have seen to that: it is part of the torment.

MARY: If you think I am incapable of understanding you—
But in any case, I must get ready for dinner.

HARRY: No, no, don't go! Please don't leave me
Just at this moment. I feel it is important.
Something should have come of this conversation.

MARY: I am not a wise person,
And in the ordinary sense I don't know you very well,
Although I remember you better than you think,
And what is the real you. I haven't much experience,
But I see something now which doesn't come from tutors
Or from books, or from thinking, or from observation:
Something which I did not know I knew.
Even if, as you say, Wishwood is a cheat,
Your family a delusion—then it's *all* a delusion,
Everything you feel—I don't mean what you think,
But what you feel. You attach yourself to loathing

As others do to loving: an infatuation
That's wrong, a good that's misdirected. You deceive yourself
Like the man convinced that he is paralysed
Or like the man who believes that he is blind
While he still sees the sunlight. I know that this is true.

HARRY: I have spent many years in useless travel;
You have staid in England, yet you seem
Like someone who comes from a very long distance,
Or the distant waterfall in the forest,
Inaccessible, half-heard.
And I hear your voice as in the silence
Between two storms, one hears the moderate usual noises
In the grass and leaves, of life persisting,
Which ordinarily pass unnoticed.
Perhaps you are right, though I do not know
How you should know it. Is the cold spring
Is the spring not an evil time, that excites us with lying voices?

MARY: The cold spring now is the time
For the ache in the moving root
The agony in the dark
The slow flow throbbing the trunk
The pain of the breaking bud.
These are the ones that suffer least:
The aconite under the snow
And the snowdrop crying for a moment in the wood.

HARRY: Spring is an issue of blood
A season of sacrifice
And the wail of the new full tide
Returning the ghosts of the dead
Those whom the winter drowned
Do not the ghosts of the drowned
Return to land in the spring?
Do the dead want to return?

MARY: Pain is the opposite of joy
But joy is a kind of pain
I believe the moment of birth
Is when we have knowledge of death
I believe the season of birth

Is the season of sacrifice
For the tree and the beast, and the fish
Thrashing itself upstream:
And what of the terrified spirit
Compelled to be reborn
To rise toward the violent sun
Wet wings into the rain cloud
Harefoot over the moon?

HARRY: What have we been saying? I think I was saying
That it seemed as if I had been always here
And you were someone who had come from a long distance.
Whether I know what I am saying, or why I say it,
That does not matter. You bring me news
Of a door that opens at the end of a corridor,
Sunlight and singing; when I had felt sure
That every corridor only led to another,
Or to a blank wall; that I kept moving
Only so as not to stay still. Singing and light.
Stop!
What is that? do you feel it?

MARY: What, Harry?

HARRY: That apprehension deeper than all sense,
Deeper than the sense of smell, but like a smell
In that it is indescribable, a sweet and bitter smell
From another world. I know it, I know it!
More potent than ever before, a vapour dissolving
All other worlds, and me into it. O Mary!
Don't look at me like that! Stop! Try to stop it!
I am going. Oh, why, now? Come out!
Come out! Where are you? Let me see you,
Since I know you are there, I know you are spying on me.
Why do you play with me, why do you let me go,
Only to surround me?—When I remember them
They leave me alone: when I forget them
Only for an instant of inattention
They are roused again, the sleepless hunters

That will not let me sleep. At the moment before sleep
I always see their claws distended
Quietly, as if they had never stirred.
It was only a moment, it was only one moment
That I stood in sunlight, and thought I might stay there.

MARY: Look at me. You can depend on me.
Harry! Harry! It's all *right,* I tell you.
If you will depend on me, it will be all right.

HARRY: Come out!

[*The curtains part, revealing the Eumenides in the window
 embrasure.*]

Why do you show yourselves now for the first time?
When I knew her, I was not the same person.
I was not any person. Nothing that I did
Has to do with me. The accident of a dreaming moment,
Of a dreaming age, when I was someone else
Thinking of something else, puts me among you.
I tell you, it is not me you are looking at,
Not me you are grinning at, not me your confidential looks
Incriminate, but that other person, if person,
You thought I was: let your necrophily
Feed upon that carcase. They will not go.

MARY: Harry! There is no one here.

[*She goes to the window and pulls the curtains across.*]

HARRY: They were here, I tell you. They are here.
Are you so imperceptive, have you such dull senses
That you could not see them? If I had realised
That you were so obtuse, I would not have listened
To your nonsense. Can't you help me?
You're of no use to me. I must face them.
I must fight them. But they are stupid.
How can one fight with stupidity?
Yet I must speak to them.

[*He rushes forward and tears apart the curtains: but the embra-
 sure is empty.*]

MARY: Oh, Harry!

SCENE III

Harry, Mary, Ivy, Violet, Gerald, Charles

VIOLET: Good evening, Mary: aren't you dressed yet?
 How do you think that Harry is looking?
 Why, who could have pulled those curtains apart?
 [*Pulls them together.*]
 Very well, I think, after such a long journey;
 You know what a rush he had to be here in time
 For his mother's birthday.

IVY: Mary, my dear,
 Did you arrange these flowers? Just let me change them.
 You don't mind, do you? I know so much about flowers;
 Flowers have always been my passion.
 You know I had my own garden once, in Cornwall,
 When I could afford a garden; and I took several prizes
 With my delphiniums. In fact, I was rather an authority.

GERALD: Good evening, Mary. You've seen Harry, I see.
 It's good to have him back again, isn't it?
 We must make him feel at home. And most auspicious
 That he could be here for his mother's birthday.

MARY: I must go and change. I came in very late. [*Exit.*]

CHARLES: Now we only want Arthur and John.
 I am glad that you'll all be together, Harry;
 They need the influence of their elder brother.
 Arthur's a bit irresponsible, you know;
 You should have a sobering effect upon him.
 After all, you're the head of the family.

AMY'S VOICE: Violet! Has Arthur or John come yet?

VIOLET: Neither of them is here yet, Amy.

 [*Enter* AMY *with* DR. WARBURTON.]

AMY: It is most vexing. What can have happened?
 I suppose it's the fog that is holding them up,
 So it's no use to telephone anywhere. Harry!
 Haven't you seen Dr. Warburton?
 You know he's the oldest friend of the family,

And he's known you longer than anybody, Harry.
When he heard that you were going to be here for dinner
He broke an important engagement to come.

WARBURTON: I dare say we've both changed a good deal, Harry.
A country practitioner doesn't get younger.
It takes me back longer than you can remember
To see you again. But you can't have forgotten
The day when you came back from school with measles
And we had such a time to keep you in bed.
You didn't like being ill in the holidays.

IVY: It *was* unpleasant, coming home to have an illness.

VIOLET: It was always the same with your minor ailments
And children's epidemics: you would never stay in bed
Because you were convinced that you would never get well.

HARRY: Not, I think, without some justification:
For what you call restoration to health
Is only incubation of another malady.

WARBURTON: You mustn't take such a pessimistic view
Which is hardly complimentary to my profession.
But I remember, when I was a student at Cambridge,
I used to dream of making some great discovery
To do away with one disease or another.
Now I've had forty years' experience
I've left off thinking in terms of the laboratory.
We're all of us ill in one way or another:
We call it health when we find no symptom
Of illness. Health is a relative term.

IVY: You must have had a very rich experience, Doctor,
In forty years.

WARBURTON: Indeed, yes.
Even in a country practice. My first patient, now—
You wouldn't believe it, ladies—was a murderer,
Who suffered from an incurable cancer.
How he fought against it! I never saw a man
More anxious to live.

HARRY: Not at all extraordinary.
It is really harder to believe in murder
Than to believe in cancer. Cancer is here:

The lump, the dull pain, the occasional sickness:
Murder a reversal of sleep and waking.
Murder was there. Your ordinary murderer
Regards himself as an innocent victim.
To himself he is still what he used to be
Or what he would be. He cannot realise
That everything is irrevocable,
The past unredeemable. But cancer, now,
That is something real.

WARBURTON: Well, let's not talk of such matters.
How did we get onto the subject of cancer?
I really don't know.—But now you're all grown up
I haven't a patient left at Wishwood.
Wishwood was always a cold place, but healthy.
It's only when I get an invitation to dinner
That I ever see your mother.

VIOLET: Yes, look at your mother!
Except that she can't get about now in winter
You wouldn't think that she was a day older
Than on her birthday ten years ago.

GERALD: Is there any use in waiting for Arthur and John?

AMY: We might as well go in to dinner.
They may come before we finish. Will you take me in, Doctor?
I think we are very much the oldest present—
In fact we are the oldest inhabitants.
As we came first, we will go first, in to dinner.

WARBURTON: With pleasure, Lady Monchensey,
And I hope that next year will bring me the same honour.
 [*Exeunt* AMY, DR. WARBURTON, HARRY.]

CHORUS: I am afraid of all that has happened, and of all that is to
 come;
 Of the things to come that sit at the door, as if they had been
 there always.
 And the past is about to happen, and the future was long since
 settled.
 And the wings of the future darken the past, the beak and claws
 have desecrated
 History. Shamed

> The first cry in the bedroom, the noise in the nursery, mutilated
> The family album, rendered ludicrous
> The tenants' dinner, the family pic-nic on the moors. Have torn
> The roof from the house, or perhaps it was never there.
> And the bird sits on the broken chimney. I am afraid.

Ivy: This is a most undignified terror, and I must struggle against it.

GERALD: I am used to tangible danger, but only to what I can understand.

VIOLET: It is the obtuseness of Gerald and Charles and that doctor,
 that gets on my nerves.

CHARLES: If the matter were left in my hands, I think I could manage the situation. [*Exeunt.*]

[*Enter* MARY, *and passes through to dinner. Enter* AGATHA.]

AGATHA: The eye is on this house
> The eye covers it
> There are three together
> May the three be separated
> May the knot that was tied
> Become unknotted
> May the crossed bones
> In the filled-up well
> Be at last straightened
> May the weasel and the otter
> Be about their proper business
> The eye of the day time
> And the eye of the night time
> Be diverted from this house
> Till the knot is unknotted
> The crossed is uncrossed
> And the crooked is made straight.

 [*Exit to dinner.*]

Part II

The Library, After Dinner

SCENE I

HARRY, WARBURTON

WARBURTON: I'm glad of a few minutes alone with you, Harry.
 In fact, I had another reason for coming this evening
 Than simply in honour of your mother's birthday.
 I wanted a private conversation with you
 On a confidential matter.

HARRY: I can imagine—
 Though I think it is probably going to be useless,
 Or if anything, make matters rather more difficult.
 But talk about it, if you like.

WARBURTON: You don't understand me.
 I'm sure you cannot know what is on my mind;
 And as for making matters more difficult—
 It is much more difficult not to be prepared
 For something that is very likely to happen.

HARRY: O God, man, the things that are going to happen
 Have already happened.

WARBURTON: That is in a sense true,
 But without your knowing it, and what you know
 Or do not know, at any moment
 May make an endless difference to the future.
 It's about your mother . . .

HARRY: What about my mother?
 Everything has always been referred back to mother.
 When we were children, before we went to school,
 The rule of conduct was simply pleasing mother;

[258]

Misconduct was simply being unkind to mother;
What was wrong was whatever made her suffer,
And whatever made her happy was what was virtuous—
Though never very happy, I remember. That was why
We all felt like failures, before we had begun.
When we came back, for the school holidays,
They were not holidays, but simply a time
In which we were supposed to make up to mother
For all the weeks during which she had not seen us
Except at half-term, and seeing us then
Only seemed to make her more unhappy, and made us
Feel more guilty, and so we misbehaved
Next day at school, in order to be punished,
For punishment made us feel less guilty. Mother
Never punished us, but made us feel guilty.
I think that the things that are taken for granted
At home, make a deeper impression upon children
Than what they are told.

WARBURTON: Stop, Harry, you're mistaken.
I mean, you don't know what I want to tell you.
You may be quite right, but what we are concerned with
Now, is your mother's happiness in the future,
For the time she has to live: not with the past.

HARRY: Oh, is there any difference!
How can we be concerned with the past
And not with the future? or with the future
And not with the past? What I'm telling you
Is very important. Very important.
You must let me explain, and then you can talk.
I don't know why, but just this evening
I feel an overwhelming need for explanation—
But perhaps I only dream that I am talking
And shall wake to find that I have been silent
Or talked to the stone deaf: and the others
Seem to hear something else than what I am saying.
But if you want to talk, at least you can tell me
Something useful. Do you remember my father?

WARBURTON: Why, yes, of course, Harry, but I really don't see
 What that has to do with the present occasion
 Or with what I have to tell you.
HARRY: What you have to tell me
 Is either something that I know already
 Or unimportant, or else untrue.
 But I want to know more about my father.
 I hardly remember him, and I know very well
 That I was kept apart from him, till he went away.
 We never heard him mentioned, but in some way or another
 We felt that he was always here.
 But when we would have grasped for him, there was only a
 vacuum
 Surrounded by whispering aunts: Ivy and Violet—
 Agatha never came then. Where was my father?
WARBURTON: Harry, there's no good probing for misery.
 There was enough once: but what festered
 Then, has only left a cautery.
 Leave it alone. You know that your mother
 And your father were never very happy together:
 They separated by mutual consent
 And he went to live abroad. You were only a boy
 When he died. You would not remember.
HARRY: But now I do remember. Not Arthur or John,
 They were too young. But now I remember
 A summer day of unusual heat,
 The day I lost my butterfly net;
 I remember the silence, and the hushed excitement
 And the low conversation of triumphant aunts.
 It is the conversations not overheard,
 Not intended to be heard, with the sidewise looks,
 That bring death into the heart of a child.
 That was the day he died. Of course.
 I mean, I suppose, the day on which the news arrived.
WARBURTON: You overinterpret.
 I am sure that your mother always loved him;
 There was never the slightest suspicion of scandal.

HARRY: Scandal? who said scandal? I did not.
 Yes, I see now. That night, when she kissed me,
 I felt the trap close. If you won't tell me,
 I must ask Agatha. I never dared before.
WARBURTON: I advise you strongly, not to ask your aunt—
 I mean, there is nothing she could tell you. But, Harry,
 We can't sit here all the evening, you know;
 You will have to have the birthday celebration,
 And your brothers will be here. Won't you let me tell you
 What I had to say?
HARRY: Very well, tell me.
WARBURTON: It's about your mother's health that I wanted to talk
 to you.
 I must tell you, Harry, that although your mother
 Is still so alert, so vigorous of mind,
 Although she seems as vital as ever—
 It is only the force of her personality,
 Her indomitable will, that keeps her alive.
 I needn't go into technicalities
 At the present moment. The whole machine is weak
 And running down. Her heart's very feeble.
 With care, and avoiding all excitement
 She may live several years. A sudden shock
 Might send her off at any moment.
 If she had been another woman
 She would not have lived until now.
 Her determination has kept her going:
 She has only lived for your return to Wishwood,
 For you to take command at Wishwood,
 And for that reason, it is most essential
 That nothing should disturb or excite her.
HARRY: Well!
WARBURTON: I'm very sorry for you, Harry.
 I should have liked to spare you this,
 Just now. But there were two reasons
 Why you had to know. One is your mother,
 To make her happy for the time she has to live.

The other is yourself: the future of Wishwood
Depends on you. I don't like to say this;
But you know that I am a very old friend,
And have always been a party to the family secrets—
You know as well as I do that Arthur and John
Have been a great disappointment to your mother.
John's very steady—but he's not exactly brilliant;
And Arthur has always been rather irresponsible.
Your mother's hopes are all centred on you.

HARRY: Hopes? . . . Tell me
Did you know my father at about my present age?

WARBURTON: Why, yes, Harry, of course I did.

HARRY: What did he look like then? Did he look at all like me?

WARBURTON: Very much like you. Of course there are differences:
But, allowing for the changes in fashion
And your being clean-shaven, very much like you.
And now, Harry, let's talk about yourself.

HARRY: I never saw a photograph. There is no portrait.

WARBURTON: What I want to know is, whether you've been sleeping . . .
[*Enter* DENMAN.]

DENMAN: It's Sergeant Winchell is here, my Lord,
And wants to see your Lordship very urgent,
And Dr. Warburton. He says it's very urgent
Or he wouldn't have troubled you.

HARRY: I'll see him.
[*Exit* DENMAN.]

WARBURTON: I wonder what he wants. I hope nothing has happened
To either of your brothers.

HARRY: Nothing can have happened
To either of my brothers. Nothing can happen—
If Sergeant Winchell is real. But Denman saw him.
But what if Denman saw him, and yet he was not real?
That would be worse than anything that has happened.
What if *you* saw him, and . . .

WARBURTON: Harry! Pull yourself together.
Something may have happened to one of your brothers.
[*Enter* WINCHELL.]

WINCHELL: Good evening, my Lord. Good evening, Doctor.
 Many happy . . . Oh, I'm sorry, my Lord,
 I was thinking it was your birthday, not her Ladyship's.
HARRY: Her Ladyship's!
 [*He darts at* WINCHELL *and seizes him by the shoulders.*]
 He *is* real, Doctor.
 So let us resume the conversation. You and I
 And Winchell. Sit down, Winchell,
 And have a glass of port. We were talking of my father.
WINCHELL: Always at your jokes, I see. You don't look a year older
 Than when I saw you last, my Lord. But a country sergeant
 Doesn't get younger. Thank you, no, my Lord;
 I don't find port agrees with the rheumatism.
WARBURTON: For God's sake, Winchell, tell us your business.
 His Lordship isn't very well this evening.
WINCHELL: I understand, Sir.
 It'd be the same if it was my birthday—
 I beg pardon, I'm forgetting.
 If it was my mother's. God rest her soul,
 She's been dead these ten years. How is her Ladyship,
 If I may ask, my Lord?
HARRY: Why do you keep asking
 About her Ladyship? Do you know or don't you?
 I'm not afraid of you.
WINCHELL: I should hope not, my Lord.
 I didn't mean to put myself forward.
 But you see, my Lord, I had good reason for asking . . .
HARRY: Well, do you want me to produce her for you?
WINCHELL: Oh, no, indeed, my Lord, I'd much rather not . . .
HARRY: You mean you think I can't. But I might surprise you;
 I think I might be able to give you a shock.
WINCHELL: There's been shock enough for one evening, my Lord:
 That's what I've come about.
WARBURTON: For Heaven's sake, Winchell,
 Tell us your business.
WINCHELL: It's about Mr John.
HARRY: John!

WINCHELL: Yes, my Lord, I'm sorry.
 I thought I'd better have a word with you quiet,
 Rather than phone and perhaps disturb her Ladyship.
 So I slipped along on my bike. Mostly walking,
 What with the fog so thick, or I'd have been here sooner.
 I'd telephoned to Dr. Warburton's,
 And they told me he was here, and that you'd arrived.
 Mr. John's had a bit of an accident
 On the West Road, in the fog, coming along
 At a pretty smart pace, I fancy, ran into a lorry
 Drawn up round the bend. We'll have the driver up for this:
 Says he doesn't know this part of the country
 And stopped to take his bearings. We've got him at the Arms—
 Mr. John, I mean. By a bit of luck
 Dr. Owen was there, and looked him over;
 Says there's nothing wrong but some nasty cuts
 And a bad concussion; says he'll come round
 In the morning, most likely, but he mustn't be moved.
 But Dr. Owen was anxious that you should have a look at him.
WARBURTON: Quite right, quite right. I'll go and have a look at him.
 We must explain to your mother . . .
AMY'S VOICE: Harry! Harry!
 Who's there with you? Is it Arthur or John?
 [*Enter* AMY, *followed severally by* VIOLET, IVY, GERALD, AGATHA,
 and CHARLES]
 Winchell! what are you here for?
WINCHELL: I'm sorry, my Lady, but I've just told the doctor,
 It's really nothing but a minor accident.
WARBURTON: It's John has had the accident, Lady Monchensey;
 And Winchell tells me Dr. Owen has seen him
 And says it's nothing but a slight concussion,
 But he mustn't be moved tonight. I'd trust Owen
 On a matter like this. You can trust Owen.
 We'll bring him up tomorrow; and a few days' rest,
 I've no doubt, will be all that he needs.
AMY: Accident? What sort of an accident?
WINCHELL: Coming along in the fog, my Lady,
 And he must have been in rather a hurry.

There was a lorry drawn up where it shouldn't be,
Outside of the village, on the West Road.
AMY: Where is he?
WINCHELL: At the Arms, my Lady;
Of course, he hasn't come round yet.
Dr. Owen was there, by a bit of luck.
GERALD: I'll go down and see him, Amy, and come back and report
 to you.
AMY: I must see for myself. Order the car at once.
WARBURTON: I forbid it, Lady Monchensey.
 As your doctor, I forbid you to leave the house tonight.
 There is nothing you could do, and out in this weather
 At this time of night, I would not answer for the consequences.
 I am going myself. I will come back and report to you.
AMY: I must see for myself. I do not believe you.
CHARLES: Much better leave it to Warburton, Amy.
 Extremely fortunate for us that he's here.
 We must put ourselves under Warburton's orders.
WARBURTON: I repeat, Lady Monchensey, that you must not go out.
 If you do, I must decline to continue to treat you.
 You are only delaying me. I shall return at once.
AMY: Well, I suppose you are right. But can I trust you?
WARBURTON: You have trusted me a good many years, Lady Mon-
 chensey;
 This is not the time to begin to doubt me.
 Come, Winchell. We can put your bicycle
 On the back of my car.
 [*Exeunt* WARBURTON *and* WINCHELL.]
VIOLET: Well, Harry,
 I think that you might have had something to say.
 Aren't you sorry for your brother? Aren't you aware
 Of what is going on? and what it means to your mother?
HARRY: Oh, of course I'm sorry. But from what Winchell says
 I don't think the matter can be very serious.
 A minor trouble like a concussion
 Cannot make very much difference to John.
 A brief vacation from the kind of consciousness
 That John enjoys, can't make very much difference

To him or to anyone else. If he was ever really conscious,
I should be glad for him to have a breathing spell:
But John's ordinary day isn't much more than breathing.
IVY: Really, Harry! how can you be so callous?
I always thought you were so fond of John.
VIOLET: And if you don't care what happens to John,
You might show some consideration to your mother.
AMY: I do not know very much:
And as I get older, I am coming to think
How little I have ever known.
But I think your remarks are much more inappropriate
Than Harry's.
HARRY: It's only when they see nothing
That people can always show the suitable emotions—
And so far as they feel at all, their emotions are suitable.
They don't understand what it is to be awake,
To be living on several planes at once
Though one cannot speak with several voices at once.
I have all of the rightminded feeling about John
That you consider appropriate. Only, that's not the language
That I choose to be talking. I will not talk yours.
AMY: You looked like your father
When you said that.
HARRY: I think, mother,
I shall make you lie down. You must be very tired.
 [*Exeunt* HARRY *and* AMY.]
VIOLET: I really do not understand Harry's behaviour.
AGATHA: I think it is as well to leave Harry to establish
If he can, some communication with his mother.
VIOLET: I do not seem to be very popular tonight.
CHARLES: Well, there's no sort of use in any of us going—
On a night like this—it's a good three miles;
There's nothing we could do that Warburton can't.
If he's worse than Winchell said, then he'll let us know at once.
GERALD: I am really more afraid of the shock for Amy;
But I think that Warburton understands *that*.
IVY: You are quite right, Gerald, the one thing that matters

Is not to let her see that anyone is worried.
We must carry on as if nothing had happened,
And have the cake and presents.
GERALD: But *I'm* worried about Arthur:
He's much more apt than John to get into trouble.
CHARLES: Oh, but Arthur's a brilliant driver.
After all the experience he's had at Brooklands,
He's not likely to get into trouble.
GERALD: A brilliant driver, but more reckless.
IVY: Yet I remember, when they were boys,
Arthur was always the more adventurous
But John was the one that had the accidents,
Somehow, just because he *was* the slow one.
He was always the one to fall off the pony,
Or out of a tree—and always on his head.
VIOLET: But a year ago, Arthur took me out in his car,
And I told him I would never go out with him again.
Not that I wanted to go with him at all—
Though of course he meant well—but I think an open car
Is so undignified: you're blown about so,
And you feel so conspicuous, lolling back
And so near the street, and everyone staring;
And the pace he went at was simply terrifying.
I said I would rather walk: and I did.
GERALD: Walk? where to?
VIOLET: He started out to take me to Cheltenham;
But I stopped him somewhere in Chiswick, I think.
Anyway, the district was unfamiliar
And I had the greatest trouble in getting home.
I am sure he meant well. But I do think he is reckless.
GERALD: I wonder how much Amy knows about Arthur?
CHARLES: More than she cares to mention, I imagine.
[*Enter* HARRY.]
HARRY: Mother is asleep, I think: it's strange how the old
Can drop off to sleep in the middle of calamity
Like children, or like hardened campaigners. She looked
Very much as she must have looked when she was a child.

You've been holding a meeting—the usual family inquest
On the characters of all the junior members?
Or engaged in predicting the minor event,
Engaged in foreseeing the minor disaster?
You go on trying to think of each thing separately,
Making small things important, so that everything
May be unimportant, a slight deviation
From some imaginary course that life ought to take,
That you call normal. What you call the normal
Is merely the unreal and the unimportant.
I was like that in a way, so long as I could think
Even of my own life as an isolated ruin,
A casual bit of waste in an orderly universe.
But it begins to seem just part of some huge disaster,
Some monstrous mistake and aberration
Of all men, of the world, which I cannot put in order.
If you only knew the years that I have had to live
Since I came home, a few hours ago, to Wishwood.

VIOLET: I will make no observation on what you say, Harry;
My comments are not always welcome in this family.
[*Enter* DENMAN.]

DENMAN: Excuse me, Miss Ivy. There's a trunk call for you.

IVY: A trunk call? for me? why, who can want me?

DENMAN: He wouldn't give his name, Miss; but it's Mr. Arthur.

IVY: Arthur! Oh, dear, I'm afraid *he's* had an accident.
 [*Exeunt* IVY *and* DENMAN.]

VIOLET: When it's Ivy that he's asking for, I expect the worst.

AGATHA: Whatever you have learned, Harry, you must remember
That there is always more: we cannot rest in being
The impatient spectators of malice or stupidity.
We must try to penetrate the other private worlds
Of make-believe and fear. To rest in our own suffering
Is evasion of suffering. We must learn to suffer more.

VIOLET: Agatha's remarks are invariably pointed.

HARRY: Do you think that I believe what I said just now?
That was only what I should like to believe.
I was talking in abstractions: and you answered in abstractions.

I have a private puzzle. Were they simply outside,
I might escape somewhere, perhaps. Were they simply inside
I could cheat them perhaps with the aid of Dr. Warburton—
Or any other doctor, who would be another Warburton,
If you decided to set another doctor on me.
But this is too real for your words to alter.
Oh, there *must* be another way of talking
That would get us somewhere. You don't understand me.
You can't understand me. It's not being alone
That is the horror, to be alone with the horror.
What matters is the filthiness. I can clean my skin,
Purify my life, void my mind,
But always the filthiness, that lies a little deeper . . .
[*Enter* IVY.]
IVY: Where is there an evening paper?
GERALD: Why, what's the matter?
IVY: Somebody, look for Arthur in the evening paper.
That was Arthur, ringing up from London:
The connection was so bad, I could hardly hear him,
And his voice was very queer. It seems that Arthur too
Has had an accident. I don't think he's hurt,
But he says that he hasn't got the use of his car,
And he missed the last train, so he's coming up tomorrow;
And he said there was something about it in the paper,
But it's all a mistake. And not to tell his mother.
VIOLET: What's the use of asking for an evening paper?
You know as well as I do, at this distance from London
Nobody's likely to have this evening's paper.
CHARLES: Stop, I think I bought a lunch edition
Before I left St. Pancras. If I did, it's in my overcoat.
I'll see if it's there. There might be something in that. [*Exit.*]
GERALD: Well, I said that Arthur was every bit as likely
To have an accident as John. And it wasn't John's fault,
I don't believe. John is unlucky,
But Arthur is definitely reckless.
VIOLET: I think these racing cars ought to be prohibited.
[*Re-enter* CHARLES, *with a newspaper.*]

CHARLES: Yes, there is a paragraph . . . I'm glad to say
 It's not very conspicuous . . .
GERALD: There'll have been more in the later editions.
 You'd better read it to us.
CHARLES [*reads*]:
 'Peer's Brother in Motor Smash'
 'The Hon. Arthur Gerald Charles Piper, younger brother of
 Lord Monchensey, who ran into and demolished a rounds-
 man's cart in Ebury Street early on the morning of January
 1st, was fined £50 and costs today, and forbidden to drive a
 car for the next twelve months.
 While trying to extricate his car from the collision, Mr. Piper
 reversed into a shop-window. When challenged, Mr. Piper
 said: "I thought it was all open country about here"—'
GERALD: Where?
CHARLES: In Ebury Street. 'The police stated that at the time of the
 accident Mr. Piper was being pursued by a patrol, and was
 travelling at the rate of 66 miles an hour. When asked why
 he did not stop when signalled by the police car, he said: "I
 thought you were having a game with me." '
GERALD: This is what the Communists make capital out of.
CHARLES: There's a little more. 'The Piper family . . .' no, we needn't
 read that.
VIOLET: This is just what I expected. But if Agatha
 Is going to moralise about it, I shall scream.
GERALD: It's going to be awkward, explaining this to Amy.
IVY: Poor Arthur! I'm sure that you're being much too hard on him.
CHARLES: In my time, these affairs were kept out of the papers;
 But nowadays, there's no such thing as privacy.
CHORUS: In an old house there is always listening, and more is heard
 than is spoken.
 And what is spoken remains in the room, waiting for the future
 to hear it.
 And whatever happens began in the past, and presses hard on
 the future.
 The agony in the curtained bedroom, whether of birth or of
 dying,

Gathers in to itself all the voices of the past, and projects them
 into the future.
The treble voices on the lawn
The mowing of hay in summer
The dogs and the old pony
The stumble and the wail of little pain
The chopping of wood in autumn
And the singing in the kitchen
And the steps at night in the corridor
The moment of sudden loathing
And the season of stifled sorrow
The whisper, the transparent deception
The keeping up of appearances
The making the best of a bad job
All twined and tangled together, all are recorded.
There is no avoiding these things
And we know nothing of exorcism
And whether in Argos or England
There are certain inflexible laws
Unalterable, in the nature of music.
There is nothing at all to be done about it,
There is nothing to do about anything,
And now it is nearly time for the news
We must listen to the weather report
And the international catastrophes. [*Exeunt* CHORUS.]

SCENE II

HARRY, AGATHA

HARRY: John will recover, be what he always was;
 Arthur again be sober, though not for very long;
 And everything will go on as before. These mild surprises
 Should be in the routine of normal life at Wishwood.

John is the only one of us I can conceive
As settling down to make himself at home at Wishwood,
Make a dull marriage, marry some woman stupider—
Stupider than himself. He can resist the influence
Of Wishwood, being unconscious, living in gentle motion
Of horses, and right visits to the right neighbours
At the right times; and be an excellent landlord.

AGATHA: What is in your mind, Harry?
I can guess about the past and what you mean about the future;
But a present is missing, needed to connect them.
You may be afraid that I would not understand you,
You may also be afraid of being understood,
Try not to regard it as an explanation.

HARRY: I still have to learn exactly what their meaning is.
At the beginning, eight years ago,
I felt, at first, that sense of separation,
Of isolation unredeemable, irrevocable—
It's eternal, or gives a knowledge of eternity,
Because it feels eternal while it lasts. That is one hell.
Then the numbness came to cover it—that is another—
That was the second hell of not being there,
The degradation of being parted from my self,
From the self which persisted only as an eye, seeing.
All this last year, I could not fit myself together:
When I was inside the old dream, I felt all the same emotion
Or lack of emotion, as before: the same loathing
Diffused, I not a person, in a world not of persons
But only of contaminating presences.
And then I had no horror of my action,
I only felt the repetition of it
Over and over. When I was outside,
I could associate nothing of it with myself,
Though nothing else was real. I thought foolishly
That when I got back to Wishwood, as I had left it,
Everything would fall into place. But *they* prevent it.
I still have to find out what their meaning is.
Here I have been finding
A misery long forgotten, and a new torture,

The shadow of something behind our meagre childhood,
Some origin of wretchedness. Is that what they would show me?
And now I want you to tell me about my father.
AGATHA: What do you want to know about your father?
HARRY: If I knew, then I should not have to ask.
You know what I want to know, and that is enough:
Warburton told me that, though he did not mean to.
What I want to know is something I need to know,
And only you can tell me. I know that much.
AGATHA: I had to fight for many years to win my dispossession,
And many years to keep it. What people know me as,
The efficient principal of a women's college—
That is the surface. There is a deeper
Organisation, which your question disturbs.
HARRY: When I know, I know that in some way I shall find
That I have always known it. And that will be better.
AGATHA: I will try to tell you. I hope I have the strength.
HARRY: I have thought of you as the completely strong,
The liberated from the human wheel.
So I looked to you for strength. Now I think it is
A common pursuit of liberation.
AGATHA: Your father might have lived—or so I see him—
An exceptionally cultivated country squire,
Reading, sketching, playing on the flute,
Something of an oddity to his county neighbours,
But not neglecting public duties.
He hid his strength beneath unusual weakness,
The diffidence of a solitary man:
Where he was weak he recognised your mother's power,
And yielded to it.
HARRY: There was no ecstasy.
Tell me now, who were my parents?
AGATHA: Your father and your mother.
HARRY: You tell me nothing.
AGATHA: The dead man whom you have assumed to be your father,
And my sister whom you acknowledge as your mother:
There is no mystery here.
HARRY: What then?

AGATHA: You see your mother as identified with this house—
 It was not always so. There were many years
 Before she succeeded in making terms with Wishwood,
 Until she took your father's place, and reached the point where
 Wishwood supported her, and she supported Wishwood.
 At first it was a vacancy. A man and a woman
 Married, alone in a lonely country house together,
 For three years childless, learning the meaning
 Of loneliness. Your mother wanted a sister here
 Always. I was the youngest: I was then
 An undergraduate at Oxford. I came
 Once for a long vacation. I remember
 A summer day of unusual heat
 For this cold country.
HARRY: And then?
AGATHA: There are hours when there seems to be no past or future,
 Only a present moment of pointed light
 When you want to burn. When you stretch out your hand
 To the flames. They only come once,
 Thank God, that kind. Perhaps there is another kind,
 I believe, across a whole Thibet of broken stones
 That lie, fang up, a lifetime's march. I have believed this.
HARRY: I have known neither.
AGATHA: The autumn came too soon, not soon enough.
 The rain and wind had not shaken your father
 Awake yet. I found him thinking
 How to get rid of your mother. What simple plots!
 He was not suited to the rôle of murderer.
HARRY: In what way did he wish to murder her?
AGATHA: Oh, a dozen foolish ways, each one abandoned
 For something more ingenious. You were due in three months
 time;
 You would not have been born in that event: I stopped him.
 I can take no credit for a little common sense,
 He would have bungled it.
 I did not want to kill *you!*
 You to be killed! What were you then? only a thing called 'life'—
 Something that should have been *mine,* as I felt then.

Most people would not have felt that compunction
If they felt no other. But I wanted you!
If that had happened, I knew I should have carried
Death in life, death through lifetime, death in my womb.
I felt that you were in some way mine!
And that in any case I should have no other child.

HARRY: And have me. That is the way things happen.
Everything is true in a different sense,
A sense that would have seemed meaningless before.
Everything tends towards reconciliation
As the stone falls, as the tree falls. And in the end
That is the completion which at the beginning
Would have seemed the ruin.
Perhaps my life has only been a dream
Dreamt through me by the minds of others. Perhaps
I only dreamt I pushed her.

AGATHA: So I had supposed. What of it?
What we have written is not a story of detection,
Of crime and punishment, but of sin and expiation.
It is possible that you have not known what sin
You shall expiate, or whose, or why. It is certain
That the knowledge of it must precede the expiation.
It is possible that sin may strain and struggle
In its dark instinctive birth, to come to consciousness
And so find expurgation. It is possible
You are the consciousness of your unhappy family,
Its bird sent flying through the purgatorial flame.
Indeed it is possible. You may learn hereafter,
Moving alone through flames of ice, chosen
To resolve the enchantment under which we suffer.

HARRY: Look, I do not know why,
I feel happy for a moment, as if I had come home.
It is quite irrational, but now
I feel quite happy, as if happiness
Did not consist in getting what one wanted
Or in getting rid of what can't be got rid of
But in a different vision. This is like an end.

AGATHA: And a beginning. Harry, my dear,

I feel very tired, as only the old feel.
The young feel tired at the end of an action,—
The old, at the beginning. It is as if
I had been living all these years upon my capital,
Instead of earning my spiritual income daily:
And I am old, to start again to make my living.

HARRY: But you are not unhappy, just now?

AGATHA: What does the word mean?
There's relief from a burden that I carried,
And exhaustion at the moment of relief.
The burden's yours now, yours
The burden of all the family. And I am a little frightened.

HARRY: You, frightened! I can hardly imagine it.
I wish I had known—but that was impossible.
I only now begin to have some understanding
Of you, and of all of us. Family affection
Was a kind of formal obligation, a duty
Only noticed by its neglect. One had that part to play.
After such training, I could endure, these ten years,
Playing a part that had been imposed upon me;
And I returned to find another one made ready—
The book laid out, lines underscored, and the costume
Ready to be put on. But it is very odd:
When other people seemed so strong, their apparent strength
Stifled my decision. Now I see
I might even become fonder of my mother—
More compassionate at least—by understanding.
But she would not like that. Now I see
I have been wounded in a war of phantoms.
Not by human beings—they have no more power than I.
The things I thought were real are shadows, and the real
Are what I thought were private shadows. O that awful privacy
Of the insane mind! Now I can live in public.
Liberty is a different kind of pain from prison.

AGATHA: I only looked through the little door
When the sun was shining on the rose-garden:
And heard in the distance tiny voices
And then a black raven flew over.

And then I was only my own feet walking
Away, down a concrete corridor
In a dead air. Only feet walking
And sharp heels scraping. Over and under
Echo and noise of feet.
I was only the feet, and the eye
Seeing the feet: the unwinking eye
Fixing the movement. Over and under.

HARRY: In and out, in an endless drift
Of shrieking forms in a circular desert
Weaving with contagion of putrescent embraces
On dissolving bone. In and out, the movement
Until the chain broke, and I was left
Under the single eye above the desert.

AGATHA: Up and down, through the stone passages
Of an immense and empty hospital
Pervaded by a smell of disinfectant,
Looking straight ahead, passing barred windows
Up and down. Until the chain breaks.

HARRY: To and fro, dragging my feet
Among inner shadows in the smoky wilderness,
Trying to avoid the clasping branches
And the giant lizard. To and fro.
Until the chain breaks.
 The chain breaks,
The wheel stops, and the noise of machinery,
And the desert is cleared, under the judicial sun
Of the final eye, and the awful evacuation
Cleanses.
I was not there, you were not there, only our phantasms
And what did not happen is as true as what did happen,
O my dear, and you walked through the little door
And I ran to meet you in the rose-garden.

AGATHA: This is the next moment. This is the beginning.
We do not pass twice through the same door
Or return to the door through which we did not pass.
I have seen the first stage: relief from what happened
Is also relief from that unfulfilled craving

Flattered in sleep, and deceived in waking.

 You have a long journey.

HARRY: Not yet! not yet! this is the first time that I have been free
From the ring of ghosts with joined hands, from the pursuers,
And come into a quiet place.

 Why is it so quiet?
Do you feel a kind of stirring underneath the air?
Do you? don't you? a communication, a scent
Direct to the brain . . . but not just as before,
Not quite like, not the same . . .
[*The* EUMENIDES *appear.*]

 and this time
You cannot think that I am surprised to see you.
And you shall not think that I am afraid to see you.
This time, you are real, this time, you are outside me,
And just endurable. I know that you are ready,
Ready to leave Wishwood, and I am going with you.
You followed me here, where I thought I should escape you—
No! you were already here before I arrived.
Now I see at last that I am following you,
And I know that there can be only one itinerary
And one destination. Let us lose no time. I will follow.
[*The curtains close.* AGATHA *goes to the window, in a somnam-
 bular fashion, and opens the curtains, disclosing the empty
 embrasure. She steps into the place which the* EUMENIDES *had
 occupied.*]

AGATHA: A curse comes to being
 As a child is formed.
 In both, the incredible
 Becomes the actual
 Without our intention
 Knowing what is intended.
 A curse is like a child, formed
 In a moment of unconsciousness
 In an accidental bed
 Or under an elder tree
 According to the phase

Of the determined moon.
A curse is like a child, formed
To grow to maturity:
Accident is design
And design is accident
In a cloud of unknowing.
O my child, my curse,
You shall be fulfilled:
The knot shall be unknotted
And the crooked made straight.
> [*She moves back into the room.*]
What have I been saying? I think I was saying
That you have a long journey. You have nothing to stay for.
Think of it as like a children's treasure hunt:
Here you have found a clue, hidden in the obvious place.
Delay, and it is lost. Love compels cruelty
To those who do not understand love.
What you have wished to know, what you have learned
Mean the end of a relation, make it impossible.
You did not intend this, I did not intend it,
No one intended, but . . . You must go.

HARRY: Shall we ever meet again?

AGATHA: Shall we ever meet again?
 And who will meet again? Meeting is for strangers.
 Meeting is for those who do not know each other.

HARRY: I know that I have made a decision
 In a moment of clarity, and now I feel dull again.
 I only know that I made a decision
 Which your words echo. I am still befouled,
 But I know there is only one way out of defilement—
 Which leads in the end to reconciliation.
 And I know that I must go.

AGATHA: You must go.
 [*Enter* AMY.]

AMY: What are you saying to Harry? He has only arrived,
 And you tell him to go?

AGATHA: He shall go.

AMY: He shall go? and who are you to say he shall go?
 I think I know well enough why you wish him to go.
AGATHA: I wish nothing. I only say what I know must happen.
AMY: You only say what you intended to happen.
HARRY: Oh, mother,
 This is not to do with Agatha, any more than with the rest of
 you.
 My advice has come from quite a different quarter,
 But I cannot explain that to you now. Only be sure
 That I know what I am doing, and what I must do,
 And that it is the best thing for everybody.
 But at present, I cannot explain it to anyone:
 I do not know the words in which to explain it—
 That is what makes it harder. You must just believe me,
 Until I come again.
AMY: But why are you going?
HARRY: I can only speak
 And you cannot hear me. I can only speak
 So you may not think I conceal an explanation,
 And to tell you that I would have liked to explain.
AMY: Why should Agatha know, and I not be allowed to?
HARRY: I do not know whether Agatha knows
 Or how much she knows. Any knowledge she may have—
 It was not I who told her . . . All this year,
 This last year, I have been in flight
 But always in ignorance of invisible pursuers.
 Now I know that all my life has been a flight
 And phantoms fed upon me while I fled. Now I know
 That the last apparent refuge, the safe shelter,
 That is where one meets them. That is the way of spectres . . .
AMY: There is no one here.
 No one, but your family!
HARRY: And now I know
 That my business is not to run away, but to pursue,
 Not to avoid being found, but to seek.
 I would not have chosen this way, had there been any other!
 It is at once the hardest thing, and the only thing possible.

Now they will lead me. I shall be safe with them;
I am not safe here.
AMY: So you *will* run away.
AGATHA: In a world of fugitives
The person taking the opposite direction
Will appear to run away.
AMY: I was speaking to Harry.
HARRY: It is very hard, when one has just recovered sanity,
And not yet assured in possession, that is when
One begins to seem the maddest to other people.
It is hard for you too, mother, it is indeed harder,
Not to understand.
AMY: Where are you going?
HARRY: I shall have to learn. That is still unsettled.
I have not yet had the precise directions.
Where does one go from a world of insanity?
Somewhere on the other side of despair.
To the worship in the desert, the thirst and deprivation,
A stony sanctuary and a primitive altar,
The heat of the sun and the icy vigil,
A care over lives of humble people,
The lesson of ignorance, of incurable diseases.
Such things are possible. It is love and terror
Of what waits and wants me, and will not let me fall.
Let the cricket chirp. John shall be the master.
All I have is his. No harm can come to him.
What would destroy me will be life for John,
I am responsible for him. Why I have this election
I do not understand. It must have been preparing always,
And I see it was what I always wanted. Strength demanded
That seems too much, is just strength enough given.
I must follow the bright angels. [*Exit.*]

SCENE III

AMY, AGATHA

AMY: I was a fool, to ask you again to Wishwood;
 But I thought, thirty-five years is long, and death is an end,
 And I thought that time might have made a change in Agatha-
 It has made enough in *me*. Thirty-five years ago
 You took my husband from me. Now you take my son.
AGATHA: What did I take? nothing that you ever had.
 What did I get? thirty years of solitude,
 Alone, among women, in a women's college,
 Trying not to dislike women. Thirty years in which to think.
 Do you suppose that I wanted to return to Wishwood?
AMY: The more rapacious, to take what I never had;
 The more unpardonable, to taunt me with not having it.
 Had you taken what I had, you would have left me at least a
 memory
 Of something to live upon. You knew that you took everything
 Except the walls, the furniture, the acres;
 Leaving nothing—but what I could breed for myself,
 What I could plant here. Seven years I kept him,
 For the sake of the future, a discontented ghost,
 In his own house. What of the humiliation,
 Of the chilly pretences in the silent bedroom,
 Forcing sons upon an unwilling father?
 Dare you think what that does to one? Try to think of it.
 I *would* have sons, if I could not have a husband:
 Then I let him go. I abased myself.
 Did I show any weakness, any self-pity?
 I forced myself to the purposes of Wishwood;
 I even asked you back, for visits, after he was gone,
 So that there might be no ugly rumours.
 You thought I did not know!
 You may be close, but I always saw through *him*.
 And now it is my son.

AGATHA: I know one thing, Amy:
 That you have never changed. And perhaps I have not.
 I thought that I had, until this evening.
 But at least I wanted to. Now I must begin.
 There is nothing more difficult. But you are just the same:
 Just as voracious for what you cannot have
 Because you repel it.
AMY: I prepared the situation
 For us to be reconciled, because of Harry,
 Because of his mistakes, because of his unhappiness,
 Because of the misery that he has left behind him,
 Because of the waste. I wanted to obliterate
 His past life, and have nothing except to remind him
 Of the years when he had been a happy boy at Wishwood;
 For his future success.
AGATHA: Success is relative:
 It is what we can make of the mess we have made of things,
 It is what he can make, not what you would make for him.
AMY: Success is one thing, what you would make for him
 Is another. I call it failure. Your fury for possession
 Is only the stronger for all these years of abstinence.
 Thirty-five years ago you took my husband from me
 And now you take my son.
AGATHA: Why should we quarrel for what neither can have?
 If neither has ever had a husband or a son
 We have no ground for argument.
AMY: Who set you up to judge? what, if you please,
 Gives *you* the power to know what is best for Harry?
 What gave you this influence to persuade him
 To abandon his duty, his family and his happiness?
 Who has planned his good? is it you or I?
 Thirty-five years designing his life,
 Eight years watching, without him, at Wishwood,
 Years of bitterness and disappointment.
 What share had you in this? what have you given?
 And now at the moment of success against failure,
 When I felt assured of his settlement and happiness,

You who took my husband, now you take my son.
You take him from Wishwood, you take him from me,
You take him . . .
[*Enter* MARY.]

MARY: Excuse me, Cousin Amy. I have just seen Denman.
She came to tell me that Harry is leaving:
Downing told her. He has got the car out.
What is the matter?

AMY: That woman there,
She has persuaded him: I do not know how.
I have been always trying to make myself believe
That he was not such a weakling as his father
In the hands of any unscrupulous woman.
I have no influence over him; *you* can try,
But you will not succeed: she has some spell
That works from generation to generation.

MARY: Is Harry really going?

AGATHA: He is going.
But that is not my spell, it is none of my doing:
I have only watched and waited. In this world
It is inexplicable, the resolution is in another.

MARY: Oh, but it is the danger comes from another!
Can you not stop him? Cousin Agatha, stop him!
You do not know what I have seen and what I know!
He is in great danger, I know that, don't ask me,
You would not believe me, but I tell you I know.
You must keep him here, you must not let him leave.
I do not know what must be done, what can be done,
Even here, but elsewhere, everywhere, he is in danger.
I will stay or I will go, whichever is better;
I do not care what happens to me,
But Harry must not go. Cousin Agatha!

AGATHA: Here the danger, here the death, here, not elsewhere;
Elsewhere no doubt is agony, renunciation,
But birth and life. Harry has crossed the frontier
Beyond which safety and danger have a different meaning.
And he cannot return. That is his privilege.

For those who live in this world, this world only,
Do you think that I would take the responsibility
Of tempting them over the border? No one could, no one who
 knows.
No one who has the least suspicion of what is to be found there.
But Harry has been led across the frontier: he must follow;
For him the death is now only on this side,
For him, danger and safety have another meaning.
They have made this clear. And I who have seen them must be-
 lieve them.
MARY: Oh! . . . so . . . *you* have seen them too!
AGATHA: We must all go, each in his own direction,
 You, and I, and Harry. You and I,
 My dear, may very likely meet again
 In our wanderings in the neutral territory
 Between two worlds.
MARY: Then you *will* help me!
 You remember what I said to you this evening?
 I knew that I was right: you made me wait for this—
 Only for this. I suppose I did not really mean it
 Then, but I mean it now. Of course it was much too late
 Then, for anything to come for me: I should have known it;
 It was all over, I believe, before it began;
 But I deceived myself. It takes so many years
 To learn that one is dead! So you must help me.
 I will go. But I suppose it is much too late
 Now, to try to get a fellowship?
AMY: So you will all leave me!
 An old woman alone in a damned house.
 I will let the walls crumble. Why should I worry
 To keep the tiles on the roof, combat the endless weather,
 Resist the wind? fight with increasing taxes
 And unpaid rents and tithes? nourish investments
 With wakeful nights and patient calculations
 With the solicitor, the broker, agent? Why should I?
 It is no concern of the body in the tomb
 To bother about the upkeep. Let the wind and rain do that.

[*While* AMY *has been speaking,* HARRY *has entered, dressed
 for departure.*]

HARRY: But, mother, you will always have Arthur and John
 To worry about: not that John is any worry—
 The destined and the perfect master of Wishwood,
 The satisfactory son. And as for me,
 I am the last you need to worry about;
 I have my course to pursue, and I am safe from normal dangers
 If I pursue it. I cannot account for this
 But it is so, mother. Until I come again.

AMY: If you go now, I shall never see you again.

 [*Meanwhile* VIOLET, GERALD *and* CHARLES *have entered.*]

CHARLES: Where is Harry going? What is the matter?

AMY: Ask Agatha.

GERALD: Why, what's the matter? Where is he going?

AMY: Ask Agatha.

VIOLET: I cannot understand at all. Why is he leaving?

AMY: Ask Agatha.

VIOLET: Really, it sometimes seems to me
 That I am the only sane person in this house.
 Your behaviour all seems to me quite unaccountable.
 What *has* happened, Amy?

AMY: Harry is going away—to become a missionary.

HARRY: But . . . !

CHARLES: A missionary! that's never happened in our family!
 And why in such a hurry? Before you make up your mind . . .

VIOLET: You can't really think of *living* in a tropical climate!

GERALD: There's nothing wrong with a tropical climate—
 But you have to go in for some sort of training;
 The medical knowledge is the first thing.
 I've met with missionaries, often enough—
 Some of them very decent fellows. A maligned profession.
 They're sometimes very useful, knowing the natives,
 Though occasionally troublesome. But you'll have to learn the
 language
 And several dialects. It means a lot of preparation.

VIOLET: And you need some religious qualification!
 I think you should consult the vicar . . .

GERALD: And don't forget
 That you'll need various inoculations—
 That depends on where you're going.
CHARLES: Such a thing
 Has never happened in our family.
VIOLET: I cannot understand it.
HARRY: I never said that I was going to be a missionary.
 I would explain, but you would none of you believe it;
 If you believed it, still you would not understand.
 You can't know why I'm going. You have not seen
 What I have seen. Oh, why should you make it so ridiculous
 Just now? I only want, please,
 As little fuss as possible. You must get used to it;
 Meanwhile, I apologise for my bad manners.
 But if you *could* understand you would be quite happy about it,
 So I shall say good-bye, until we meet again.
GERALD: Well, if you are determined, Harry, we must accept it;
 But it's a bad night, and you will have to be careful.
 You're taking Downing with you?
HARRY: Oh, yes, I'm taking Downing.
 You need not fear that I am in any danger
 Of such accidents as happen to Arthur and John:
 Take care of *them*. My address, mother,
 Will be care of the bank in London until you hear from me.
 Good-bye, mother.
AMY: Good-bye, Harry.
HARRY: Good-byc.
AGATHA: Good-bye.
HARRY: Good-bye, Mary.
MARY: Good-bye, Harry. Take care of yourself. [*Exit* HARRY.]
AMY: At my age, I only just begin to apprehend the truth
 About things too late to mend: and that is to be old.
 Nevertheless, I am glad if I can come to know them.
 I always wanted too much for my children,
 More than life can give. And now I am punished for it.
 Gerald! you are the stupidest person in this room,
 Violet, you are the most malicious in a harmless way;
 I prefer your company to that of any of the others

Just to help me to the next room. Where I can lie down.
Then you can leave me.
GERALD: Oh, certainly, Amy.
VIOLET: I do not understand
A single thing that's happened. [*Exeunt* AMY, VIOLET, GERALD.]
CHARLES: It's very odd,
But I am beginning to feel, just beginning to feel
That there is something I *could* understand, if I were told it.
But I'm not sure that I want to know. I suppose I'm getting old:
Old age came softly up to now. I felt safe enough;
And now I don't feel safe. As if the earth should open
Right to the centre, as I was about to cross Pall Mall.
I thought that life could bring no further surprises;
But I remember now, that I am always surprised
By the bull-dog in the Burlington Arcade.
What if every moment were like that, if one were awake?
You both seem to know more about this than I do.
[*Enter* DOWNING, *hurriedly, in chauffeur's costume.*]
DOWNING: Oh, excuse me, Miss, excuse me, Mr. Charles:
His Lordship sent me back because he remembered
He thinks he left his cigarette-case on the table.
Oh, there it is. Thank you. Good night, Miss; good night,
Miss Mary; good night, Sir.
MARY: Downing, will you promise never to leave his Lordship
While you are away?
DOWNING: Oh, certainly, Miss;
I'll never leave him so long as he requires me.
MARY: But he will need you. You must never leave him.
DOWNING: You may think it laughable, what I'm going to say—
But it's not really strange, Miss, when you come to look at it:
After all these years that I've been with him
I think I understand his Lordship better than anybody;
And I have a kind of feeling that his Lordship won't need me
Very long now. I can't give you any reasons.
But to show you what I mean, though you'd hardly credit it,
I've always said, whatever happened to his Lordship
Was just a kind of preparation for something else.

I've no gift of language, but I'm sure of what I mean:
We most of us seem to live according to circumstance,
But with people like him, there's something inside them
That accounts for what happens to them. You get a feeling of it.
So I seem to know beforehand, when something's going to
 happen,
And it seems quite natural, being his Lordship.
And that's why I say now, I have a feeling
That he won't want me long, and he won't want anybody.

AGATHA: And, Downing, if his behaviour seems unaccountable
At times, you mustn't worry about that.
He is every bit as sane as you or I,
He sees the world as clearly as you or I see it,
It is only that he has seen a great deal more than that,
And we have seen them too—Miss Mary and I.

DOWNING: I understand you, Miss. And if I may say so,
Now that you've raised the subject, I'm most relieved—
If you understand my meaning. I thought that was the reason
We was off tonight. In fact, I half expected it,
So I had the car all ready. You mean them ghosts, Miss!
I wondered when his Lordship would get round to seeing them—
And so you've seen them too! They must have given you a turn!
They did me, at first. You soon get used to them.
Of course, I knew they was to do with his Lordship,
And not with me, so I could see them cheerful-like,
In a manner of speaking. There's no harm in *them,*
I'll take my oath. Will that be all, Miss?

AGATHA: That will be all, thank you, Downing. We mustn't keep
 you;
His Lordship will be wondering why you've been so long.

 [*Exit* DOWNING. *Enter* IVY.]

IVY: Where is Downing going? where is Harry?
Look. Here's a telegram come from Arthur;
[*Enter* GERALD *and* VIOLET.]
I wonder why he sent it, after telephoning.
Shall I read it to you? I was wondering
Whether to show it to Amy or not.

[*Reads.*]
'Regret delayed business in town many happy returns see you
 tomorrow many happy returns hurrah love Arthur.'
I mean, after what we know of what did happen,
Do you think Amy ought to see it?

VIOLET: No, certainly not.
 You do not know what has been going on, Ivy.
 And if you did, you would not understand it.
 I do not understand, so how could you? Amy is not well;
 And she is resting.

IVY: Oh, I'm sorry. But can't you explain?
 Why do you all look so peculiar? I think I might be allowed
 To know what has happened.

AMY'S VOICE: Agatha! Mary! come!
 The clock has stopped in the dark!

 [*Exeunt* AGATHA *and* MARY. *Pause.*
 Enter WARBURTON.]

WARBURTON: Well! it's a filthy night to be out in.
 That's why I've been so long, going and coming.
 But I'm glad to say that John is getting on nicely;
 It wasn't so serious as Winchell made out,
 And we'll have him up here in the morning.
 I hope Lady Monchensey hasn't been worrying?
 I'm anxious to relieve her mind. Why, what's the trouble?
 [*Enter* MARY.]

MARY: Dr. Warburton!

WARBURTON: Excuse me. [*Exeunt* MARY *and* WARBURTON.]

CHORUS: We do not like to look out of the same window, and see
 quite a different landscape.
 We do not like to climb a stair, and find that it takes us down.
 We do not like to walk out of a door, and find ourselves back in
 the same room.
 We do not like the maze in the garden, because it too closely
 resembles the maze in the brain.
 We do not like what happens when we are awake, because it too
 closely resembles what happens when we are asleep.
 We understand the ordinary business of living,
 We know how to work the machine,

We can usually avoid accidents,
We are insured against fire,
Against larceny and illness,
Against defective plumbing,
But not against the act of God.
We know various spells and enchantments,
And minor forms of sorcery,
Divination and chiromancy,
Specifics against insomnia,
Lumbago, and the loss of money.
But the circle of our understanding
Is a very restricted area.
Except for a limited number
Of strictly practical purposes
We do not know what we are doing;
And even, when you think of it,
We do not know much about thinking.
What is happening outside of the circle?
And what is the meaning of happening?
What ambush lies beyond the heather
And behind the Standing Stones?
Beyond the Heaviside Layer
And behind the smiling moon?
And what is being done to us?
And what are we, and what are we doing?
To each and all of these questions
There is no conceivable answer.
We have suffered far more than a personal loss—
We have lost our way in the dark.

IVY: I shall have to stay till after the funeral: will my ticket to London
 still be valid?

GERALD: I do not look forward with pleasure to dealing with Arthur
 and John in the morning.

VIOLET: We must wait for the will to be read. I shall send a wire in
 the morning.

CHARLES: I fear that my mind is not what it was—or was it?—and yet
 I think that I might understand.

ALL: But we must adjust ourselves to the moment: we must do the
 right thing. [*Exeunt.*]

[*Enter, from one door,* AGATHA *and* MARY, *and set a small portable
 table. From another door, enter* DENMAN *carrying a birthday
 cake with lighted candles, which she sets on the table. Exit*
 DENMAN. AGATHA *and* MARY *walk slowly in single file round
 and round the table, clockwise. At each revolution they blow
 out a few candles, so that their last words are spoken in the
 dark.*]

AGATHA: A curse is slow in coming
 To complete fruition
 It cannot be hurried
 And it cannot be delayed

MARY: It cannot be diverted
 An attempt to divert it
 Only implicates others
 At the day of consummation

AGATHA: A curse is a power
 Not subject to reason
 Each curse has its course
 Its own way of expiation
 Follow follow

MARY: Not in the day time
 And in the hither world
 Where we know what we are doing
 There is not its operation
 Follow follow

AGATHA: But in the night time
 And in the nether world
 Where the meshes we have woven
 Bind us to each other
 Follow follow

MARY: A curse is written
 On the under side of things
 Behind the smiling mirror
 And behind the smiling moon
 Follow follow

AGATHA: This way the pilgrimage
 Of expiation
 Round and round the circle
 Completing the charm
 So the knot be unknotted
 The cross be uncrossed
 The crooked be made straight
 And the curse be ended
 By intercession
 By pilgrimage
 By those who depart
 In several directions
 For their own redemption
 And that of the departed—
 May they rest in peace.

The Cocktail Party

A COMEDY

PERSONS

EDWARD CHAMBERLAYNE
JULIA (MRS. SHUTTLETHWAITE)
CELIA COPLESTONE
ALEXANDER MacCOLGIE GIBBS
PETER QUILPE
AN UNIDENTIFIED GUEST, *later identified as*
SIR HENRY HARCOURT-REILLY
LAVINIA CHAMBERLAYNE
A NURSE-SECRETARY
CATERER'S MAN

The scene is laid in London

Act I

SCENE 1

The drawing room of the Chamberlaynes' London flat. Early evening. Edward Chamberlayne, Julia Shuttlethwaite, Celia Coplestone, Peter Quilpe, Alexander MacColgie Gibbs, *and an* Unidentified Guest.

ALEX: You've missed the point completely, Julia:
There *were* no tigers. *That* was the point.
JULIA: Then what were you doing, up in a tree:
You and the Maharaja?
ALEX: My dear Julia!
It's perfectly hopeless. You haven't been listening.
PETER: You'll have to tell us all over again, Alex.
ALEX: I never tell the same story twice.
JULIA: But I'm still waiting to know what happened.
I know it started as a story about tigers.
ALEX: I said there were no tigers.
CELIA: Oh do stop wrangling,
Both of you. It's your turn, Julia.
Do tell us that story you told the other day, about Lady Klootz
and the wedding cake.
PETER: And how the butler found her in the pantry, rinsing her
mouth out with champagne.
I like that story.
CELIA: I love that story.
ALEX: *I'm* never tired of hearing that story.
JULIA: Well, you all seem to know it.
CELIA: Do we all know it?
But we're never tired of hearing *you* tell it.
I don't believe everyone here knows it.

[297]

[*To the* UNIDENTIFIED GUEST]
 You don't know it, do you?
UNIDENTIFIED GUEST: No, I've never heard it.
CELIA: Here's one new listener for you, Julia;
 And I don't believe that Edward knows it.
EDWARD: I may have heard it, but I don't remember it.
CELIA: And Julia's the only person to tell it.
 She's such a good mimic.
JULIA: Am I a good mimic?
PETER: You *are* a good mimic. You never miss anything.
ALEX: She never misses anything unless she wants to.
CELIA: Especially the Lithuanian accent.
JULIA: Lithuanian? Lady Klootz?
PETER: I thought she was Belgian.
PETER: I thought she was Belgian.
ALEX: Her father belonged to a Baltic family—
 One of the *oldest* Baltic families
 With a branch in Sweden and one in Denmark.
 There were several very lovely daughters:
 I wonder what's become of them now.
JULIA: Lady Klootz was very lovely, once upon a time.
 What a life she led! I used to say to her: 'Greta!
 You have too much vitality.' But she enjoyed herself.
 [*To the* UNIDENTIFIED GUEST]
 Did *you* know Lady Klootz?
UNIDENTIFIED GUEST: No, I never met her.
CELIA: Go on with the story about the wedding cake.
JULIA: Well, but it really isn't my story.
 I heard it first from Delia Verinder
 Who was there when it happened.
 [*To the* UNIDENTIFIED GUEST]
 Do *you* know Delia Verinder?
UNIDENTIFIED GUEST: No, I don't know her.
JULIA: Well, one can't be too careful
 Before one tells a story.
ALEX: Delia Verinder?
 Was she the one who had three brothers?
JULIA: How many brothers? Two, I think.

ALEX: No, there were three, but you wouldn't know the third one:
　　They kept him rather quiet.
JULIA: 　　　　　　　　　Oh, you mean *that* one.
ALEX: He was feeble-minded.
JULIA: 　　　　　　　　　Oh, not feeble-minded:
　　He was only harmless.
ALEX: 　　　　　　　　Well then, harmless.
JULIA: He was very clever at repairing clocks;
　　And he had a remarkable sense of hearing—
　　The only man I ever met who could hear the cry of bats.
PETER: Hear the cry of bats?
JULIA: 　　　　　　　　He could hear the cry of bats.
CELIA: But how do you know he could hear the cry of bats?
JULIA: Because he said so. And I believed him.
CELIA: But if he was so . . . harmless, how could you believe him?
　　He might have imagined it.
JULIA: 　　　　　　　　My darling Celia,
　　You needn't be so sceptical. I stayed there once
　　At their castle in the North. How he suffered!
　　They had to find an island for him
　　Where there were no bats.
ALEX: 　　　　　　　　And is he still there?
　　Julia is really a mine of information.
CELIA: There isn't much that Julia doesn't know.
PETER: Go on with the story about the wedding cake.
　　　　　　　　　　　[EDWARD *leaves the room.*]
JULIA: No, we'll wait until Edward comes back into the room.
　　Now I want to relax. Are there any more cocktails?
PETER: But do go on. Edward wasn't listening anyway.
JULIA: No, he wasn't listening, but he's such a strain—
　　Edward without Lavinia! He's quite impossible!
　　Leaving it to me to keep things going.
　　What a host! And nothing fit to eat!
　　The only reason for a cocktail party
　　For a gluttonous old woman like me
　　Is a really nice tit-bit. I can drink at home.
　　　　　　　　　[EDWARD *returns with a tray.*]
　　Edward, give me another of those delicious olives.

What's that? Potato crisps? No, I can't endure them.

Well, I started to tell you about Lady Klootz.

It was at the Vincewell wedding. Oh, so many years ago!

[*To the* Unidentified Guest]

Did *you* know the Vincewells?

Unidentified Guest: No, I don't know the Vincewells.

Julia: Oh, they're both dead now. But I wanted to know.

If they'd been friends of yours, I couldn't tell the story.

Peter: Were they the parents of Tony Vincewell?

Julia: Yes. Tony was the product, but not the solution.

He only made the situation more difficult.

You know Tony Vincewell? You knew him at Oxford?

Peter: No, I never knew him at Oxford:

I came across him last year in California.

Julia: I've always wanted to go to California.

Do tell us what you were doing in California.

Celia: Making a film.

Peter: Trying to make a film.

Julia: Oh, what film was it? I wonder if I've seen it.

Peter: No, you wouldn't have seen it. As a matter of fact

It was never produced. They did a film

But they used a different scenario.

Julia: Not the one you wrote?

Peter: Not the one I wrote:

But I had a very enjoyable time.

Celia: Go on with the story about the wedding cake.

Julia: Edward, do sit down for a moment:

I know you're always the perfect host,

But just try to pretend you're another guest

At Lavinia's party. There are so many questions

I want to ask you. It's a golden opportunity

Now Lavinia's away. I've always said:

'If I could only get Edward alone

And have a really *serious* conversation!'

I said so to Lavinia. She agreed with me.

She said: 'I wish you'd try.' And this is the first time

I've ever seen you without Lavinia

Except for the time she got locked in the lavatory

And couldn't get out. I know what you're thinking!
I know you think I'm a silly old woman
But I'm really very serious. Lavinia takes me seriously.
I believe that's the reason why she went way—
So that I could make you talk. Perhaps she's in the pantry
Listening to all we say!

EDWARD: No, she's not in the pantry.

CELIA: Will she be away for some time, Edward?

EDWARD: I really don't know until I hear from her.
If her aunt is very ill, she may be gone some time.

CELIA: And how will you manage while she is away?

EDWARD: I really don't know. I may go away myself.

CELIA: Go away yourself!

JULIA: Have you an aunt too?

EDWARD: No, I haven't any aunt. But I might go away.

CELIA: But, Edward . . . what was I going to say?
It's dreadful for old ladies alone in the country,
And almost impossible to get a nurse.

JULIA: Is that her Aunt Laura?

EDWARD: No; another aunt
Whom you wouldn't know. Her mother's sister
And rather a recluse.

JULIA: Her favourite aunt?

EDWARD: Her aunt's favourite niece. And she's rather difficult.
When she's ill, she insists on having Lavinia.

JULIA: I never heard of her being ill before.

EDWARD: No, she's always very strong. That's why when she's ill
She gets into a panic.

JULIA: And sends for Lavinia.
I quite understand. Are there any prospects?

EDWARD: No, I think she put it all into an annuity.

JULIA: So it's very unselfish of Lavinia
Yet very like her. But really, Edward,
Lavinia may be away for weeks,
Or she may come back and be called away again.
I understand these tough old women—
I'm one myself: I feel as if I knew
All about that aunt in Hampshire.

EDWARD: Hampshire?
JULIA: Didn't you say Hampshire?
EDWARD: No, I didn't say Hampshire.
JULIA: Did you say Hampstead?
EDWARD: No, I didn't say Hampstead.
JULIA: But she must live somewhere.
EDWARD: She lives in Essex.
JULIA: Anywhere near Colchester? Lavinia loves oysters.
EDWARD: No. In the *depths* of Essex.
JULIA: Well, we won't probe into it.
 You have the address, and the telephone number?
 I might run down and see Lavinia
 On my way to Cornwall. But let's be sensible:
 Now you must let me be *your* maiden aunt—
 Living on an annuity, of course.
 I am going to make you dine alone with me
 On Friday, and talk to me about everything.
EDWARD: Everything?
JULIA: Oh, you know what I mean.
 The next election. And the secrets of your cases.
EDWARD: Most of my secrets are quite uninteresting.
JULIA: Well, you shan't escape. You dine with me on Friday.
 I've already chosen the people you're to meet.
EDWARD: But you asked me to dine with you alone.
JULIA: Yes, alone!
 Without Lavinia! You'll like the other people—
 But you're to talk to me. So that's all settled.
 And now I must be going.
EDWARD: Must you be going?
PETER: But won't you tell the story about Lady Klootz?
JULIA: What Lady Klootz?
CELIA: And the wedding cake.
JULIA: Wedding cake? I wasn't at her wedding.
 Edward, it's been a delightful evening:
 The potato crisps were really excellent.
 Now let me see. Have I got everything?
 It's such a nice party, I hate to leave it.
 It's such a nice party, I'd like to repeat it.

Why don't you *all* come to dinner on Friday?
No, I'm afraid my good Mrs. Batten
Would give me notice. And now I must be going.
ALEX: I'm afraid *I* ought to be going.
PETER: Celia—
May I walk along with you?
CELIA: No, I'm sorry, Peter;
I've got to take a taxi.
JULIA: You come with me, Peter:
You can get *me* a taxi, and then I can drop you.
I expect you on Friday, Edward. And Celia—
I must see you very soon. Now don't all go
Just because I'm going. Good-bye, Edward.
EDWARD: Good-bye, Julia. [*Exeunt* JULIA *and* PETER.]
CELIA: Good-bye, Edward.
Shall I see you soon?
EDWARD: Perhaps. I don't know.
CELIA: Perhaps you don't know? Very well, good-bye.
EDWARD: Good-bye, Celia.
ALEX: Good-bye, Edward. I do hope
You'll have better news of Lavinia's aunt.
EDWARD: Oh . . . yes . . . thank you. Good-bye, Alex,
It was nice of you to come. [*Exeunt* ALEX *and* CELIA.]
[*To the* UNIDENTIFIED GUEST]
Don't go yet.
Don't go yet. We'll finish the cocktails.
Or would you rather have whisky?
UNIDENTIFIED GUEST: Gin.
EDWARD: Anything in it?
UNIDENTIFIED GUEST: A drop of water.
EDWARD: I want to apologise for this evening.
The fact is, I tried to put off this party:
These were only the people I couldn't put off
Because I couldn't get at them in time;
And I didn't know that *you* were coming.
I thought that Lavinia had told me the names
Of all the people she said she'd invited.
But it's only that dreadful old woman who mattered—

I shouldn't have minded anyone else,
 [*The bell rings.* EDWARD *goes to the door, saying:*]
But she always turns up when she's least wanted.
 [*Opens the door*]
Julia!
[*Enter* JULIA.]

JULIA: Edward! How lucky that it's raining!
It made me remember my umbrella,
And there it is! Now what are you two plotting?
How very lucky it was my umbrella,
And not Alexander's—*he's* so inquisitive!
But *I* never poke into other people's business.
Well, good-bye again. I'm off at last. [*Exit.*]

EDWARD: I'm sorry. I'm afraid I don't know your name.

UNIDENTIFIED GUEST: I ought to be going.

EDWARD: Don't go yet.
I very much want to talk to somebody;
And it's easier to talk to a person you don't know.
The fact is, that Lavinia has left me.

UNIDENTIFIED GUEST: Your wife has left you?

EDWARD: Without warning, of course;
Just when she'd arranged a cocktail party.
She'd gone when I came in, this afternoon.
She left a note to say that she was leaving me;
But I don't know where she's gone.

UNIDENTIFIED GUEST: This is an occasion.
May I take another drink?

EDWARD: Whisky?

UNIDENTIFIED GUEST: Gin.

EDWARD: Anything in it?

UNIDENTIFIED GUEST: Nothing but water.
And I recommend you the same prescription . . .
Let me prepare it for you, if I may . . .
Strong . . . but sip it slowly . . . and drink it sitting down.
Breathe deeply, and adopt a relaxed position.
There we are. Now for a few questions.
How long married?

EDWARD: Five years.

UNIDENTIFIED GUEST: Children?

EDWARD: No.

UNIDENTIFIED GUEST: Then look at the brighter side.
 You say you don't know where she's gone?

EDWARD: No, I do not.

UNIDENTIFIED GUEST: Do you know who the man is?

EDWARD: There was no other man—
 None that I know of.

UNIDENTIFIED GUEST: Or another woman
 Of whom she thought she had cause to be jealous?

EDWARD: She had nothing to complain of in my behaviour.

UNIDENTIFIED GUEST: Then no doubt it's all for the best.
 With another man, she might have made a mistake
 And want to come back to you. If another woman,
 She might decide to be forgiving
 And gain an advantage. If there's no other woman
 And no other man, then the reason may be deeper
 And you've ground for hope that she won't come back at all.
 If another man, then you'd want to re-marry
 To prove to the world that somebody wanted you;
 If another woman, you might have to marry her—
 You might even imagine that you wanted to marry her.

EDWARD: But I want my wife back.

UNIDENTIFIED GUEST: That's the natural reaction.
 It's embarrassing, and inconvenient.
 It was inconvenient, having to lie about it
 Because you can't tell the truth on the telephone.
 It will all take time that you can't well spare;
 But I put it to you . . .

EDWARD: Don't put it to me.

UNIDENTIFIED GUEST: Then I suggest . . .

EDWARD: And please don't suggest.
 I have often used these terms in examining witnesses,
 So I don't like them. May I put it to *you?*
 I know that I invited this conversation:
 But I don't know who you are. This is not what I expected.
 I only wanted to relieve my mind

By telling someone what I'd been concealing.
I don't think I want to know who you are;
But, at the same time, unless you know my wife
A good deal better than I thought, or unless you know
A good deal more about us than appears—
I think your speculations rather offensive.

UNIDENTIFIED GUEST: I know you as well as I know your wife;
And I knew that all you wanted was the luxury
Of an intimate disclosure to a stranger.
Let me, therefore, remain the stranger.
But let me tell you, that to approach the stranger
Is to invite the unexpected, release a new force,
Or let the genie out of the bottle.
It is to start a train of events
Beyond your control. So let me continue.
I will say then, you experience some relief
Of which you're not aware. It will come to you slowly:
When you wake in the morning, when you go to bed at night,
That you are beginning to enjoy your independence;
Finding your life becoming cosier and cosier
Without the consistent critic, the patient misunderstander
Arranging life a little better than you like it,
Preferring not quite the same friends as yourself,
Or making your friends like her better than you;
And, turning the past over and over,
You'll wonder only that you endured it for so long.
And perhaps at times you will feel a little jealous
That she saw it first, and had the courage to break it—
Thus giving herself a permanent advantage.

EDWARD: It might turn out so, yet . . .

UNIDENTIFIED GUEST: Are you going to say, you love her?

EDWARD: Why, I thought we took each other for granted.
I never thought I should be any happier
With another person. Why speak of love?
We were used to each other. So her going away
At a moment's notice, without explanation,
Only a note to say that she had gone
And was not coming back—well, I can't understand it.

 Nobody likes to be left with a mystery:
 It's so . . . unfinished.
UNIDENTIFIED GUEST: Yes, it's unfinished;
 And nobody likes to be left with a mystery.
 But there's more to it than that. There's a loss of personality;
 Or rather, you've lost touch with the person
 You thought you were. You no longer feel quite human.
 You're suddenly reduced to the status of an object—
 A living object, but no longer a person.
 It's always happening, because one is an object
 As well as a person. But we forget about it
 As quickly as we can. When you've dressed for a party
 And are going downstairs, with everything about you
 Arranged to support you in the role you have chosen,
 Then sometimes, when you come to the bottom step
 There is one step more than your feet expected
 And you come down with a jolt. Just for a moment
 You have the experience of being an object
 At the mercy of a malevolent staircase.
 Or, take a surgical operation.
 In consultation with the doctor and the surgeon,
 In going to bed in the nursing home,
 In talking to the matron, you are still the subject,
 The centre of reality. But, stretched on the table,
 You are a piece of furniture in a repair shop
 For those who surround you, the masked actors;
 All there is of you is your body
 And the 'you' is withdrawn. May I replenish?
EDWARD: Oh, I'm sorry. What were you drinking?
 Whisky?
UNIDENTIFIED GUEST: Gin.
EDWARD: Anything with it?
UNIDENTIFIED GUEST: Water.
EDWARD: To what does this lead?
UNIDENTIFIED GUEST: To finding out
 What you really are. What you really feel.
 What you really are among other people.
 Most of the time we take ourselves for granted,

As we have to, and live on a little knowledge
About ourselves as we were. Who are you now?
You don't know any more than I do,
But rather less. You are nothing but a set
Of obsolete responses. The one thing to do
Is to do nothing. Wait.

EDWARD: Wait!
But waiting is the one thing impossible.
Besides, don't you see that it makes me ridiculous?

UNIDENTIFIED GUEST: It will do you no harm to find yourself ridicu-
 lous.
Resign yourself to be the fool you are.
That's the best advice that *I* can give you.

EDWARD: But how can I wait, not knowing what I'm waiting for?
Shall I say to my friends, 'My wife has gone away'?
And they answer 'Where?' and I say 'I don't know';
And they say 'But when will she be back?'
And I reply 'I don't know that she *is* coming back.'
And they ask 'But what are you going to do?'
And I answer 'Nothing.' They will think me mad
Or simply contemptible.

UNIDENTIFIED GUEST: All to the good.
You will find that you survive humiliation.
And that's an experience of incalculable value.

EDWARD: Stop! I agree that much of what you've said
Is true enough. But that is not all.
Since I saw her this morning when we had breakfast
I no longer remember what my wife is like.
I am not quite sure that I could describe her
If I had to ask the police to search for her.
I'm sure I don't know what she was wearing
When I saw her last. And yet I want her back.
And I *must* get her back, to find out what has happened
During the five years that we've been married.
I must find out who she is, to find out who I am.
And what is the use of all your analysis
If I am to remain always lost in the dark?

UNIDENTIFIED GUEST: There is certainly no purpose in remaining in
 the dark
 Except long enough to clear from the mind
 The illusion of having ever been in the light.
 The fact that you can't give a reason for wanting her
 Is the best reason for believing that you want her.
EDWARD: I want to see her again—here.
UNIDENTIFIED GUEST: You shall see her again—here.
EDWARD: Do you mean to say that you know where she is?
UNIDENTIFIED GUEST: That question is not worth the trouble of an
 answer.
 But if I bring her back it must be on one condition:
 That you promise to ask her no questions
 Of where she has been.
EDWARD: I will not ask them.
 And yet—it seems to me—when we began to talk
 I was not sure I wanted her; and now I want her.
 Do I want her? Or is it merely your suggestion?
UNIDENTIFIED GUEST: We do not know yet. In twenty-four hours
 She will come to you here. You will be here to meet her.
 [*The doorbell rings.*]
EDWARD: I must answer the door.
 [EDWARD *goes to the door.*]
 So it's you again, Julia!
[*Enter* JULIA *and* PETER.]
JULIA: Edward, I'm so glad to find you.
 Do you know, I must have left my glasses here,
 And I simply can't see a thing without them.
 I've been dragging Peter all over town
 Looking for them everywhere I've been.
 Has anybody found them? You can tell if they're mine—
 Some kind of a plastic sort of frame—
 I'm afraid I don't remember the colour,
 But I'd know them, because one lens is missing.
UNIDENTIFIED GUEST [*Sings*]:
 As I was drinkin' gin and water,
 And me bein' the One Eyed Riley,

Who came in but the landlord's daughter
And she took my heart entirely.

You will keep our appointment?

EDWARD: I shall keep it.

UNIDENTIFIED GUEST [*Sings*]:

Tooryooly toory-iley
What's the matter with One Eyed Riley?

[*Exit.*]

JULIA: Edward, who *is* that dreadful man?
I've never been so insulted in my life.
It's very lucky that I left my spectacles:
This is what I call an adventure!
Tell me about him. You've been *drinking* together!
So this is the kind of friend you have
When Lavinia is out of the way! Who is he?

EDWARD: *I* don't know.

JULIA: *You* don't know?

EDWARD: I never saw him before in my life.

JULIA: But how did he come here?

EDWARD: *I* don't know.

JULIA: *You* don't know! And what's his name?
Did I hear him say his name was Riley?

EDWARD: I don't know his name.

JULIA: You don't know his *name?*

EDWARD: I tell you I've no idea who he is
Or how he got here.

JULIA: But what did you talk about?
Or were you singing songs all the time?
There's altogether too much mystery
About this place today.

EDWARD: I'm very sorry.

JULIA: No, I love it. But that reminds me
About my glasses. That's the greatest mystery.
Peter! why aren't you looking for them?
Look on the mantelpiece. Where was I sitting?
Just turn out the bottom of that sofa—
No, this chair. Look under the cushion.

EDWARD: Are you quite sure they're not in your bag?

JULIA: Why no, of course not: that's where I keep them.
 Oh, here they are! Thank you, Edward;
 That really was very clever of you;
 I'd never have found them but for you.
 The next time I lose *anything*, Edward,
 I'll come straight to you, instead of to St. Anthony.
 And now I must fly. I've kept the taxi waiting.
 Come along, Peter.
PETER: I hope you won't mind
 If I don't come with you, Julia? On the way back
 I remembered something I had to say to Edward . . .
JULIA: Oh, about Lavinia?
PETER: No, not about Lavinia.
 It's something I want to consult him about,
 And I could do it now.
JULIA: Of course I don't mind.
PETER: Well, at least you must let me take you down in the lift.
JULIA: No, you stop and talk to Edward. I'm not helpless yet.
 And besides, I like to manage the machine myself—
 In a lift I can meditate. Good-bye then.
 And thank you—both of you—very much. *[Exit.]*
PETER: I hope I'm not disturbing you, Edward.
EDWARD: I seem to have been disturbed already;
 And I did rather want to be alone.
 But what's it all about?
PETER: I want your help.
 I was going to telephone and try to see you later;
 But this seemed an opportunity.
EDWARD: And what's your trouble?
PETER: This evening I felt I could bear it no longer.
 That awful party! I'm sorry, Edward;
 Of course it was really a very nice party
 For everyone but me. And that wasn't your fault.
 I don't suppose you noticed the situation.
EDWARD: I did think I noticed one or two things;
 But I don't pretend I was aware of everything.
PETER: Oh, I'm very glad that you didn't notice:
 I must have behaved rather better than I thought.

If you didn't notice, I don't suppose the others did,
Though I'm rather afraid of Julia Shuttlethwaite.
EDWARD: Julia is certainly observant,
But I think she had some other matter on her mind.
PETER: It's about Celia. Myself and Celia.
EDWARD: Why, what could there be about yourself and Celia?
Have you anything in common, do you think?
PETER: It seemed to me we had a great deal in common.
We're both of us artists.
EDWARD: I never thought of that.
What arts do you practise?
PETER: You won't have seen my novel
Though it had some very good reviews.
But it's more the cinema that interests both of us.
EDWARD: A common interest in the moving pictures
Frequently brings young people together.
PETER: Now you're only being sarcastic:
Celia was interested in the art of the film.
EDWARD: As a possible profession?
PETER: She might make it a profession;
Though she had her poetry.
EDWARD: Yes, I've seen her poetry—
Interesting if one is interested in Celia.
Apart, of course, from its literary merit
Which I don't pretend to judge.
PETER: Well, I can judge it,
And I think it's very good. But that's not the point.
The point is, I thought we had a great deal in common
And I think she thought so too.
EDWARD: How did you come to know her?
[Enter ALEX.]
ALEX: Ah, there you are, Edward! Do you know why I've looked in?
EDWARD: I'd like to know first how you got in, Alex.
ALEX: Why, I came and found that the door was open
And so I thought I'd slip in and see if anyone was with you.
PETER: Julia must have left it open.
EDWARD: Never mind;
So long as you both shut it when you go out.

ALEX: Ah, but you're coming with me, Edward.
 I thought, Edward may be all alone this evening,
 And I know that he hates to spend an evening alone,
 So you're going to come out and have dinner with me.
EDWARD: That's very thoughtful of you, Alex, I'm sure;
 But I rather *want* to be alone, this evening.
ALEX: But you've got to have some dinner. Are you going out?
 Is there anyone here to get dinner for you?
EDWARD: No, I shan't want much, and I'll get it myself.
ALEX: Ah, in that case I know what I'll do.
 I'm going to give you a little surprise:
 You know, I'm rather a famous cook.
 I'm going straight to your kitchen now
 And I shall prepare you a nice little dinner
 Which you can have alone. And then we'll leave you.
 Meanwhile, you and Peter can go on talking
 And I shan't disturb you.
EDWARD: My dear Alex,
 There'll be nothing in the larder worthy of your cooking.
 I couldn't think of it.
ALEX: Ah, but that's my special gift—
 Concocting a toothsome meal out of nothing.
 Any scraps you have will do. I learned that in the East.
 With a handful of rice and a little dried fish
 I can make half a dozen dishes. Don't say a word.
 I shall begin at once. [*Exit to kitchen.*]
EDWARD: Well, where did you leave off?
PETER: You asked me how I came to know Celia.
 I met her here, about a year ago.
EDWARD: At one of Lavinia's amateur Thursdays?
PETER: A Thursday. Why do you say amateur?
EDWARD: Lavinia's attempts at starting a salon.
 Where I entertained the minor guests
 And dealt with the misfits, Lavinia's mistakes.
 But you were one of the minor successes
 For a time at least.
PETER: I wouldn't say that.
 But Lavinia was awfully kind to me

And I owe her a great deal. And then I met Celia.
She was different from any girl I'd ever known
And not easy to talk to, on that occasion.
EDWARD: Did you see her often?
ALEX'S VOICE: Edward, have you a double boiler?
EDWARD: I suppose there must be a double boiler:
Isn't there one in every kitchen?
ALEX'S VOICE: I can't find it.
There goes *that* surprise. I must think of another.
PETER: Not very often.
And when I did, I got no chance to talk to her.
EDWARD: You and Celia were asked for different purposes.
Your role was to be one of Lavinia's discoveries;
Celia's, to provide society and fashion.
Lavinia always had the ambition
To establish herself in two worlds at once—
But she herself had to be the link between them.
That is why, I think, her Thursdays were a failure.
PETER: You speak as if everything was finished.
EDWARD: Oh no, no, everything is left unfinished.
But you haven't told me how you came to know Celia.
PETER: I saw her again a few days later
Alone at a concert. And I was alone.
I've always gone to concerts alone—
At first, because I knew no one to go with,
And later, I found I preferred to go alone.
But a girl like Celia, it seemed very strange,
Because I had thought of her merely as a name
In a society column, to find her there alone.
Anyway, we got into conversation
And I found that she went to concerts alone
And to look at pictures. So we often met
In the same way, and sometimes went together.
And to be with Celia, that was something different
From company or solitude. And we sometimes had tea
And once or twice dined together.
EDWARD: And after that

Did she ever introduce you to her family
Or to any of her friends?
PETER: No, but once or twice she spoke of them
And about their lack of intellectual interests.
EDWARD: And what happened after that?
PETER: Oh, nothing happened.
But I thought that she really cared about me.
And I was so happy when we were together—
So . . . contented, so . . . at peace: I can't express it;
I had never imagined such quiet happiness.
I had only experienced excitement, delirium,
Desire for possession. It was not like that at all.
It was something very strange. There was such . . .
 tranquillity . . .
EDWARD: And what interrupted this interesting affair?
[*Enter* ALEX *in shirtsleeves and an apron.*]
ALEX: Edward, I can't find any curry powder.
EDWARD: There isn't any curry powder. Lavinia hates curry.
ALEX: There goes another surprise, then. I must think.
I didn't expect to find any mangoes,
But I *did* count upon curry powder. [*Exit.*]
PETER: That is exactly what I want to know.
She has simply faded—into some other picture—
Like a film effect. She doesn't want to see me;
Makes excuses, not very plausible,
And when I do see her, she seems preoccupied
With some secret excitement which I cannot share.
EDWARD: Do you think she has simply lost interest in you?
PETER: You put it just wrong. I think of it differently.
It is not her interest in *me* that I miss—
But those moments in which we seemed to share some percep-
 tion,
Some feeling, some indefinable experience
In which we were both unaware of ourselves.
In your terms, perhaps, she's lost interest in me.
EDWARD: That is all very normal. If you could only know
How lucky you are. In a little while

This might have become an ordinary affair
Like any other. As the fever cooled
You would have found that she was another woman
And that you were another man. I congratulate you
On a timely escape.

PETER: I should prefer to be spared
Your congratulations. I had to talk to someone.
And I have been telling you of something real—
My first experience of reality
And perhaps it is the last. And you don't understand.

EDWARD: My dear Peter, I have only been telling you
What would have happened to you with Celia
In another six months' time. There it is.
You can take it or leave it.

PETER: But what am I to do?

EDWARD: Nothing. Wait. Go back to California.

PETER: But I must see Celia.

EDWARD: Will it be the same Celia?
Better be content with the Celia you remember.
Remember! I say it's already a memory.

PETER: But I must see Celia at least to make her tell me
What has happened, in her terms. Until I know that
I shan't know the truth about even the memory.
Did we really share these interests? Did we really feel the same
When we heard certain music? Or looked at certain pictures?
There was something real. But what is the reality . . .
 [*The telephone rings.*]

EDWARD: Excuse me a moment.
[*Into telephone*] Hello! . . . I can't talk now . . .
Yes, there is . . . Well then, I'll ring you
As soon as I can.
 I'm sorry. You were saying?

PETER: I was saying, what is the reality
Of experience between two unreal people?
If I can only hold to the memory
I can bear any future. But I must find out
The truth about the past, for the sake of the memory.

EDWARD: There's no memory you can wrap in camphor

But the moths will get in. So you want to see Celia.
I don't know why I should be taking all this trouble
To protect you from the fool you are.
What do you want me to do?

PETER: See Celia for me.
You know her in a different way from me
And you are so much older.

EDWARD: So much older?

PETER: Yes, I'm sure that she would listen to you
As someone disinterested.

EDWARD: Well, I will see Celia.

PETER: Thank you, Edward. It's very good of you.
[*Enter* ALEX, *with his jacket on.*]

ALEX: Oh, Edward! I've prepared you such a treat!
I really think that of all my triumphs
This is the greatest. To make something out of nothing!
Never, even when travelling in Albania,
Have I made such a supper out of so few materials
As I found in your refrigerator. But of course
I was lucky to find half-a-dozen eggs.

EDWARD: What! You used all those eggs! Lavinia's aunt
Has just sent them from the country.

ALEX: Ah, so the aunt
Really exists. A substantial proof.

EDWARD: No, no . . . I mean, this is another aunt.

ALEX: I understand. The real aunt. But you'll be grateful.
There are very few peasants in Montenegro
Who can have the dish that you'll be eating, nowadays.

EDWARD: But what about my breakfast?

ALEX: Don't worry about breakfast.
All you should want is a cup of black coffee
And a little dry toast. I've left it simmering.
Don't leave it longer than another ten minutes.
Now I'll be going, and I'll take Peter with me.

PETER: Edward, I've taken too much of your time,
And you want to be alone. Give my love to Lavinia
When she comes back . . . but, if you don't mind,
I'd rather you didn't tell *her* what I've told you.

EDWARD: I shall not say anything about it to Lavinia.
PETER: Thank you, Edward. Good night.
EDWARD: Good night, Peter,
 And good night, Alex. Oh, and if you don't mind,
 Please *shut the door after you,* so it latches.
ALEX: Remember, Edward, not more than ten minutes,
 Twenty minutes, and my work will be ruined.

> [*Exeunt* ALEX *and* PETER.]

> [EDWARD *picks up the telephone, and dials a number.*]

EDWARD: Is Miss Celia Coplestone in? . . . How long ago? . . .
 No, it doesn't matter.

<div align="center">

CURTAIN

</div>

<div align="center">

SCENE 2

</div>

The same room a quarter of an hour later. EDWARD *is alone,
 playing Patience. The doorbell rings, and he answers it.*

CELIA'S VOICE: Are you alone?

> [EDWARD *returns with* CELIA.]

EDWARD: Celia! Why have you come back?
 I said I would telephone as soon as I could:
 And I tried to get you a short while ago.
CELIA: If there had happened to be anyone with you
 I was going to say I'd come back for my umbrella. . . .
 I must say you don't seem very pleased to see me.
 Edward, I understand what has happened
 But I could not understand your manner on the telephone.
 It did not seem like you. So I felt I must see you.
 Tell me it's all right, and then I'll go.
EDWARD: But how can you say you understand what has happened?
 I don't know what has happened, or what is going to happen;
 And to try to understand it, I want to be alone.
CELIA: I should have thought it was perfectly simple.
 Lavinia has left you.
EDWARD: Yes, that *was* the situation.
 I suppose it was pretty obvious to everyone.

CELIA: It was obvious that the aunt was a pure invention
 On the spur of the moment, and not a very good one.
 You should have been prepared with something better, for Julia;
 But it doesn't really matter. They will know soon enough.
 Doesn't that settle all our difficulties?
EDWARD: It has only brought to light the real difficulties.
CELIA: But surely, these are only temporary.
 You know I accepted the situation
 Because a divorce would ruin your career;
 And we thought that Lavinia would never want to leave you.
 Surely you don't hold to that silly convention
 That the husband must always be the one to be divorced?
 And if she chooses to give *you* the grounds . . .
EDWARD: I see. But it is not like that at all.
 Lavinia is coming back.
CELIA: Lavinia coming back!
 Do you mean to say that she's laid a trap for us?
EDWARD: No. If there is a trap, we are all in the trap,
 We have set it for ourselves. But I do not know
 What kind of a trap it is.
CELIA: Then what has happened?
 [The telephone rings.]
EDWARD: Damn the telephone. I suppose I must answer it.
 Hello . . . oh, hello! . . . No. I mean yes, Alex;
 Yes, of course . . . it was marvellous.
 I've never tasted anything like it . . .
 Yes, that's very interesting. But I just wondered
 Whether it mightn't be rather indigestible? . . .
 Oh, no, Alex, don't bring me any cheese;
 I've got some cheese . . . No, not Norwegian;
 But I don't really want cheese . . . Slipper what? . . .
 Oh, from Jugoslavia . . . prunes and alcohol?
 No, really, Alex, I don't want anything.
 I'm very tired. Thanks awfully, Alex.
 Good night.
CELIA: What on earth was that about?
EDWARD: That was Alex.
CELIA: I know it was Alex.

But what was he talking of?

EDWARD: I had quite forgotten.
He made his way in, a little while ago,
And insisted on cooking me something for supper;
And he said I must eat it within ten minutes.
I suppose it's still cooking.

CELIA: You suppose it's still cooking!
I thought I noticed a peculiar smell:
Of course it's still cooking—or doing *something*.
I must go and investigate.

> [*Starts to leave the room*]

EDWARD: For heaven's sake, don't bother!

> [*Exit* CELIA.]

Suppose someone came and found you in the kitchen?

> [EDWARD *goes over to the table and inspects his game of Patience.*
> *He moves a card. The doorbell rings repeatedly. Re-enter*
> CELIA, *in an apron.*]

CELIA: You'd better answer the door, Edward.
It's the best thing to do. Don't lose your head.
You see, I really did leave my umbrella;
And I'll say I found you here starving and helpless
And had to do something. Anyway, I'm *staying*
And I'm not going to hide.

> [*Returns to kitchen. The bell rings again.*]

EDWARD [*Goes to front door, and is heard to say:*] Julia!
What have you come back for?

> [*Enter* JULIA.]

JULIA: I've had an inspiration!

> [*Enter* CELIA *with saucepan.*]

CELIA: Edward, it's ruined!

EDWARD: What a good thing.

CELIA: But it's ruined the saucepan too.

EDWARD: *And* half a dozen eggs.
I wanted one for breakfast. A boiled egg.
It's the only thing I know how to cook.

JULIA: Celia! I see you've had the same inspiration
That I had. Edward must be fed.
He's under such a strain. We must keep his strength up.

Edward! Don't you realize how lucky you are
 To have *two* Good Samaritans? I never heard of that before.
EDWARD: The man who fell among thieves was luckier than I:
 He was left at an inn.
JULIA: Edward, how ungrateful!
 What's in that saucepan?
CELIA: Nobody knows.
EDWARD: It's something that Alex came and prepared for me.
 He *would* do it. Three Good Samaritans.
 I forgot all about it.
JULIA: But you mustn't touch it.
EDWARD: Of course I shan't touch it.
JULIA: My dear, I should have warned you:
 Anything that Alex makes is absolutely deadly.
 I could tell such tales of his poisoning people.
 Now, my dear, you give me that apron
 And we'll see what I can do. You stay and talk to Edward.
 [*Exit* JULIA.]
CELIA: But what has happened, Edward? What has happened?
EDWARD: Lavinia is coming back, I think.
CELIA: You think! don't you know?
EDWARD: No, but I believe it. That man who was here—
CELIA: Yes, who was that man? I was rather afraid of him;
 He has some sort of power.
EDWARD: I don't know who he is.
 But I had some talk with him, when the rest of you had left,
 And he said he would bring Lavinia back, tomorrow.
CELIA: But why should that man want to bring her back—
 Unless he is the Devil! I could believe he was.
EDWARD: Because I asked him to.
CELIA: Because you asked him to!
 Then he *must* be the Devil! He must have bewitched you.
 How did he persuade you to want her back?
 [*A popping noise is heard from the kitchen*]
EDWARD: What the devil's that?
 [*Re-enter* JULIA, *in apron, with a tray and three glasses.*]
JULIA: I've had an inspiration!
 There's nothing in the place fit to eat:

I've looked high and low. But I found some champagne—
Only a half bottle, to be sure,
And of course it isn't chilled. But it's so refreshing;
And I thought, we are all in need of a stimulant
After this disaster. Now I'll propose a health.
Can you guess whose health I'm going to propose?

EDWARD: No, I can't. But I won't drink to Alex's.

JULIA: Oh, it isn't Alex's. Come, I give you
Lavinia's aunt! You might have guessed it.

EDWARD AND CELIA: Lavinia's aunt.

JULIA: Now, the next question
Is, what's to be done. That's very simple.
It's too late, or too early, to go to a restaurant.
You must both come home with me.

EDWARD: No, I'm sorry, Julia.
I'm too tired to go out, and I'm not at all hungry.
I shall have a few biscuits.

JULIA: But you, Celia?
You must come and have a light supper with me—
Something very light.

CELIA: Thank you, Julia.
I think I will, if I may follow you
In about ten minutes? Before I go, there's something
I want to say to Edward.

JULIA: About Lavinia?
Well, come on quickly. And take a taxi.
You know, you're looking absolutely famished.
Good night, Edward. [*Exit* JULIA.]

CELIA: Well, how did he persuade you?

EDWARD: How did he persuade me? Did he persuade me?
I have a very clear impression
That he tried to persuade me it was all for the best
That Lavinia had gone; that I ought to be thankful.
And yet, the effect of all his argument
Was to make me see that I wanted her back.

CELIA: That's the Devil's method! So you want Lavinia back!
Lavinia! So the one thing you care about
Is to avoid a break—anything unpleasant!

No, it can't be that. I won't think it's that.
I think it is just a moment of surrender
To fatigue. And panic. You can't face the trouble.

EDWARD: No, it is not that. It is not only that.

CELIA: It cannot be simply a question of vanity:
That you think the world will laugh at you
Because your wife has left you for another man?
I shall soon put that right, Edward,
When you are free.

EDWARD: No, it is not that.
And all these reasons were suggested to me
By the man I call Riley—though his name is not Riley;
It was just a name in a song he sang . . .

CELIA: He sang you a song about a man named Riley!
Really, Edward, I think you are mad—
I mean, you're on the edge of a nervous breakdown.
Edward, if I go away now
Will you promise me to see a very great doctor
Whom I have heard of—and his name *is* Reilly!

EDWARD: It would need someone greater than the greatest doctor
To cure *this* illness.

CELIA: Edward, if I go now,
Will you assure me that everything is right,
That you do not mean to have Lavinia back
And that you do mean to gain your freedom,
And that everything is all right between us?
That's all that matters. Truly, Edward,
If that is right, everything else will be,
I promise you.

EDWARD: No, Celia.
It has been very wonderful, and I'm very grateful,
And I think you are a very rare person.
But it was too late. And I should have known
That it wasn't fair to you.

CELIA: It wasn't fair to *me!*
You can stand there and talk about being fair to *me!*

EDWARD: But for Lavinia leaving, this would never have arisen.
What future had you ever thought there could be?

CELIA: What had I thought that the future could be?
 I abandoned the future before we began,
 And after that I lived in a present
 Where time was meaningless, a private world of *ours*,
 Where the word 'happiness' had a different meaning
 Or so it seemed.
EDWARD: I have heard of that experience.
CELIA: A dream. I was happy in it till today,
 And then, when Julia asked about Lavinia
 And it came to me that Lavinia had left you
 And that you would be free—then I suddenly discovered
 That the dream was not enough; that I wanted something more
 And I waited, and wanted to run to tell you.
 Perhaps the dream was better. It seemed the real reality,
 And if this is reality, it is very like a dream.
 Perhaps it was I who betrayed my own dream
 All the while; and to find I wanted
 This world as well as that . . . well, it's humiliating.
EDWARD: There is no reason why you should feel humiliated . . .
CELIA: Oh, don't think that *you* can humiliate me!
 Humiliation—it's something I've done to myself.
 I am not sure even that you seem real enough
 To humiliate me. I suppose that most women
 Would feel degraded to find that a man
 With whom they thought they had shared something wonderful
 Had taken them only as a passing diversion.
 Oh, I dare say that you deceived yourself;
 But that's what it was, no doubt.
EDWARD: I *didn't* take you as a passing diversion!
 If you want to speak of passing diversions
 How did you take Peter?
CELIA: Peter? Peter who?
EDWARD: Peter Quilpe, who was here this evening. *He* was in a dream
 And now he is simply unhappy and bewildered.
CELIA: I simply don't know what you are talking about.
 Edward, this is really too crude a subterfuge
 To justify yourself. There was never anything
 Between me and Peter.

EDWARD: Wasn't there? *He* thought so.
 He came back this evening to talk to me about it.
CELIA: But this is ridiculous! I never gave Peter
 Any reason to suppose I cared for him.
 I thought he had talent; I saw that he was lonely;
 I thought that I could help him. I took him to concerts.
 But then, as he came to make more acquaintances,
 I found him less interesting, and rather conceited.
 But why should we talk about Peter? All that matters
 Is, that you think you want Lavinia.
 And if that is the sort of person you are—
 Well, you had better have her.
EDWARD: It's not like that.
 It is not that I am in love with Lavinia.
 I don't think I was ever really in love with her.
 If I have ever been in love—and I think that I have—
 I have never been in love with anyone but you,
 And perhaps I still am. But this can't go on.
 It never could have been . . . a permanent thing:
 You should have a man . . . nearer your own age.
CELIA: I don't think I care for advice from you, Edward.
 You are not entitled to take any interest
 Now, in *my* future. I only hope you're competent
 To manage your own. But if you are not in love
 And never have been in love with Lavinia,
 What is it that you want?
EDWARD: I am not sure.
 The one thing of which I am relatively certain
 Is, that only since this morning
 I have met myself as a middle-aged man
 Beginning to know what it is to feel old.
 That is the worst moment, when you feel that you have lost
 The desire for all that was most desirable,
 And before you are contented with what you can desire;
 Before you know what is left to be desired;
 And you go on wishing that you could desire
 What desire has left behind. But you cannot understand.
 How could *you* understand what it is to feel old?

CELIA: But I want to understand you. I could understand.
 And, Edward, please believe that whatever happens
 I shall not loathe you. I shall only feel sorry for you.
 It's only myself I am in danger of hating.
 But what will your life be? I cannot bear to think of it.
 Oh, Edward! Can you be happy with Lavinia?
EDWARD: No—not happy: or, if there is any happiness,
 Only the happiness of knowing
 That the misery does not feed on the ruin of loveliness,
 That the tedium is not the residue of ecstasy.
 I see that my life was determined long ago
 And that the struggle to escape from it
 Is only a make-believe, a pretence
 That what is, is not, or could be changed.
 The self that can say 'I want this—or want that'—
 The self that wills—he is a feeble creature;
 He has to come to terms in the end
 With the obstinate, the tougher self; who does not speak,
 Who never talks, who cannot argue;
 And who in some men may be the *guardian*—
 But in men like me, the dull, the implacable,
 The indomitable spirit of mediocrity.
 The willing self can contrive the disaster
 Of this unwilling partnership—but can only flourish
 In submission to the rule of the stronger partner.
CELIA: I am not sure, Edward, that I understand you;
 And yet I understand as I never did before.
 I think—I believe—you are being yourself
 As you never were before, with me.
 Twice you have changed since I have been looking at you.
 I looked at your face: and I thought that I knew
 And loved every contour; and as I looked
 It withered, as if I had unwrapped a mummy.
 I listened to your voice, that had always thrilled me,
 And it became another voice—no, not a voice:
 What I heard was only the noise of an insect,
 Dry, endless, meaningless, inhuman—
 You might have made it by scraping your legs together—

Or however grasshoppers do it. I looked,
And listened for your heart, your blood;
And saw only a beetle the size of a man
With nothing more inside it than what comes out
When you tread on a beetle.

EDWARD: Perhaps that is what I am.
Tread on me, if you like.

CELIA: No, I won't tread on you.
That is not what you are. It is only what was left
Of what I had thought you were. I see another person,
I see you as a person whom I never saw before.
The man I saw before, he was only a projection—
I see that now—of something that I wanted—
No, not *wanted*—something I aspired to—
Something that I desperately wanted to exist.
It must happen somewhere—but what, and where is it?
And I ask you to forgive me.

EDWARD: You . . . ask me to forgive *you!*

CELIA: Yes, for two things. First . . .

 [*The telephone rings.*]

EDWARD: Damn the telephone.
I suppose I had better answer it.

CELIA: Yes, better answer it.

EDWARD: Hello! . . . Oh, Julia: what is it now?
Your spectacles again . . . where did you leave them?
Or have we . . . have I got to hunt all over?
Have you looked in your bag? . . . Well, don't snap my head
 off . . .
You're sure, in the kitchen? Beside the champagne bottle?
You're quite sure? . . . Very well, hold on if you like;
We . . . I'll look for them.

CELIA: Yes, you look for them.
I shall never go into your kitchen again.

 [*Exit* EDWARD. *He returns with the spectacles and a bottle.*]

EDWARD: She was right for once.

CELIA: She is always right.
But why bring an empty champagne bottle?

EDWARD: It isn't empty. It may be a little flat—

But why did she say that it was a half bottle?
It's one of my best: and I have no half bottles.
Well, I hoped that you would drink a final glass with me.
CELIA: What should we drink to?
EDWARD: Whom shall we drink to?
CELIA: To the Guardians.
EDWARD: To the Guardians?
CELIA: To the Guardians. It was you who spoke of guardians.
 [*They drink.*]
It may be that even Julia is a guardian.
Perhaps she is *my* guardian. Give me the spectacles.
Good night, Edward.
EDWARD: Good night . . . Celia.
 [*Exit* CELIA.] Oh!
 [*He snatches up the receiver.*]
Hello, Julia! are you there? . . .
Well, I'm awfully sorry to have kept you waiting;
But we . . . I had to hunt for them . . . No, I found them.
. . . Yes, she's bringing them now . . . Good night.
 CURTAIN

SCENE 3

The same room: late afternoon of the next day. EDWARD *alone.*
He goes to the door.

EDWARD: Oh . . . good evening.
 [*Enter the* UNIDENTIFIED GUEST.]
UNIDENTIFIED GUEST: Good evening, Mr. Chamberlayne.
EDWARD: Well. May I offer you some gin and water?
UNIDENTIFIED GUEST: No, thank you. This is a different occasion.
EDWARD: I take it that as you have come alone
 You have been unsuccessful.
UNIDENTIFIED GUEST: Not at all.
 I have come to remind you—you have made a decision.
EDWARD: Are you thinking that I may have changed my mind?
UNIDENTIFIED GUEST: No. You will not be ready to change your mind

Until you recover from having made a decision.
No. I have come to tell you that you will change your mind,
But that it will not matter. It will be too late.

EDWARD: I have half a mind to change my mind now
To show you that I am free to change it.

UNIDENTIFIED GUEST: You will change your mind, but you are not free.
Your moment of freedom was yesterday.
You made a decision. You set in motion
Forces in your life and in the lives of others
Which cannot be reversed. That is one consideration.
And another is this: it is a serious matter
To bring someone back from the dead.

EDWARD: From the dead?
That figure of speech is somewhat . . . dramatic,
As it was only yesterday that my wife left me.

UNIDENTIFIED GUEST: Ah, but we die to each other daily.
What we know of other people
Is only our memory of the moments
During which we knew them. And they have changed since then.
To pretend that they and we are the same
Is a useful and convenient social convention
Which must sometimes be broken. We must also remember
That at every meeting we are meeting a stranger.

EDWARD: So you want me to greet my wife as a stranger?
That will not be easy.

UNIDENTIFIED GUEST: It is very difficult.
But it is perhaps still more difficult
To keep up the pretence that you are not strangers.
The affectionate ghosts: the grandmother,
The lively bachelor uncle at the Christmas party,
The beloved nursemaid—those who enfolded
Your childhood years in comfort, mirth, security—
If they returned, would it not be embarrassing?
What would you say to them, or they to you
After the first ten minutes? You would find it difficult
To treat them as strangers, but still more difficult
To pretend that you were not strange to each other.

EDWARD: You can hardly expect me to obliterate
 The last five years.
UNIDENTIFIED GUEST: I ask you to forget nothing.
 To try to forget is to try to conceal.
EDWARD: There are certainly things I should like to forget.
UNIDENTIFIED GUEST: And persons also. But you must not forget
 them.
 You must face them all, but meet them as strangers.
EDWARD: Then I myself must also be a stranger.
UNIDENTIFIED GUEST: And to yourself as well. But remember,
 When you see your wife, you must ask no questions
 And give no explanations. I have said the same to her.
 Don't strangle each other with knotted memories.
 Now I shall go.
EDWARD: Stop! Will you come back with her?
UNIDENTIFIED GUEST: No, I shall not come with her.
EDWARD: I don't know why,
 But I think I should like you to bring her yourself.
UNIDENTIFIED GUEST: Yes, I know you would. And for definite rea-
 sons
 Which I am not prepared to explain to you
 I must ask you not to speak of me to her;
 And she will not mention me to you.
EDWARD: I promise.
UNIDENTIFIED GUEST: And now you must await your visitors.
EDWARD: Visitors? What visitors?
UNIDENTIFIED GUEST: Whoever comes. The strangers.
 As for myself, I shall take the precaution
 Of leaving by the service staircase.
EDWARD: May I ask one question?
UNIDENTIFIED GUEST: You may ask it.
EDWARD: Who are you?
UNIDENTIFIED GUEST: I also am a stranger.
 [*Exit. A pause.* EDWARD *moves about restlessly. The bell rings,*
 and he goes to the front door.]
EDWARD: Celia!
CELIA: Has Lavinia arrived?
EDWARD: Celia! Why have you come?

I expect Lavinia at any moment.
You must not be here. Why have you come here?

CELIA: Because Lavinia asked me.

EDWARD: Because Lavinia asked you!

CELIA: Well, not directly. Julia had a telegram
Asking her to come, and to bring me with her.
Julia was delayed, and sent me on ahead.

EDWARD: It seems very odd. And not like Lavinia.
I suppose there is nothing to do but wait.
Won't you sit down?

CELIA: Thank you.

[Pause]

EDWARD: Oh, my God, what shall we talk about?
We can't sit here in silence.

CELIA: Oh, I could.
Just looking at you. Edward, forgive my laughing.
You look like a little boy who's been sent for
To the headmaster's study; and is not quite sure
What he's been found out in. I never saw you so before.
This is really a ludicrous situation.

EDWARD: I'm afraid I can't see the humorous side of it.

CELIA: I'm not really laughing at *you,* Edward.
I couldn't have laughed at anything, yesterday;
But I've learnt a lot in twenty-four hours.
It wasn't a very pleasant experience.
Oh, I'm glad I came!
I can see you at last as a human being.
Can't you see me that way too, and laugh about it?

EDWARD: I wish I could. I wish I understood anything.
I'm completely in the dark.

CELIA: But it's all so simple.
Can't you see that . . .

[The doorbell rings.]

EDWARD: There's Lavinia.

[Goes to front door.]

Peter!

[Enter PETER.]

PETER: Where's Lavinia?

EDWARD: Don't tell me that Lavinia
 Sent you a telegram . . .
PETER: No, not to me,
 But to Alex. She told him to come here
 And to bring me with him. He'll be here in a minute.
 Celia! Have you heard from Lavinia too?
 Or am I interrupting?
CELIA: I've just explained to Edward—
 I only got here this moment myself—
 That she telegraphed to Julia to come and bring me with her.
EDWARD: I wonder whom else Lavinia has invited.
PETER: Why, I got the impression that Lavinia intended
 To have yesterday's cocktail party today.
 So I don't suppose her aunt can have died.
EDWARD: What aunt?
PETER: The aunt you told us about.
 But Edward—you remember our conversation yesterday?
EDWARD: Of course.
PETER: I hope you've done nothing about it.
EDWARD: No, I've done nothing.
PETER: I'm so glad.
 Because I've changed my mind. I mean, I've decided
 That it's all no use. I'm going to California.
CELIA: You're going to California!
PETER: Yes, I have a new job.
EDWARD: And how did that happen, overnight?
PETER: Why, it's a man Alex put me in touch with
 And we settled everything this morning.
 Alex is a wonderful person to know,
 Because, you see, he knows everybody, everywhere.
 So what I've really come for is to say good-bye.
CELIA: Well, Peter, I'm awfully glad, for your sake,
 Though of course we . . . I shall miss you;
 You know how I depended on you for concerts,
 And picture exhibitions—more than you realised.
 It *was* fun, wasn't it! But now you'll have a chance,
 I hope, to realise your ambitions.
 I shall miss you.

PETER: It's nice of you to say so;
 But you'll find someone better, to go about with.
CELIA: I don't think that I shall be going to concerts.
 I am going away too.
 [LAVINIA *lets herself in with a latch-key*.]
PETER: You're going abroad?
CELIA: I don't know. Perhaps.
EDWARD: You're both going away!
 [*Enter* LAVINIA.]
LAVINIA: Who's going away? Well, Celia. Well, Peter.
 I didn't expect to find either of you here.
PETER *and* CELIA: But the telegram!
LAVINIA: What telegram?
CELIA: The one you sent to Julia.
PETER: And the one you sent to Alex.
LAVINIA: I don't know what you mean.
 Edward, have you been sending telegrams?
EDWARD: Of course I haven't sent any telegrams.
LAVINIA: This is some of Julia's mischief.
 And is *she* coming?
PETER: Yes, and Alex.
LAVINIA: Then I shall ask *them* for an explanation.
 Meanwhile, I suppose we might as well sit down.
 What shall we talk about?
EDWARD: Peter's going to America.
PETER: Yes, and I would have rung you up tomorrow
 And come in to say good-bye before I left.
LAVINIA: And Celia's going too? Was that what I heard?
 I congratulate you both. To Hollywood, of course?
 How exciting for you, Celia! Now you'll have a chance
 At last, to realise your ambitions.
 You're going together?
PETER: We're not going together.
 Celia told us she was going away,
 But I don't know where.
LAVINIA: You don't know where?
 And do you know where you are going, yourself?
PETER: Yes, of course, I'm going to California.

LAVINIA: Well, Celia, why don't *you* go to California?
 Everyone says it's a wonderful climate:
 The people who go there never want to leave it.
CELIA: Lavinia, I think I understand about Peter . . .
LAVINIA: I have no doubt you do.
CELIA: And why he is going . . .
LAVINIA: I don't doubt that either.
CELIA: And I believe he is right to go.
LAVINIA: Oh, so you advised him?
PETER: She knew nothing about it.
CELIA: But now that I may be going away—somewhere—
 I should like to say good-bye—as friends.
LAVINIA: Why, Celia, but haven't we always been friends?
 I thought you were one of my dearest friends—
 At least, in so far as a girl *can* be a friend
 Of a woman so much older than herself.
CELIA: Lavinia,
 Don't put me off. I may not see you again.
 What I want to say is this: I should like you to remember me
 As someone who wants you and Edward to be happy.
LAVINIA: You are very kind, but very mysterious.
 I'm sure that we shall manage somehow, thank you,
 As we have in the past.
CELIA: Oh, not as in the past!
 [*The doorbell rings, and* EDWARD *goes to answer it.*]
 Oh, I'm afraid that all this sounds rather silly!
 But . . .
 [EDWARD *re-enters with* JULIA.]
JULIA: There you are, Lavinia! I'm sorry to be late,
 But your telegram was a bit unexpected.
 I dropped everything to come. And how is the dear aunt?
LAVINIA: So far as I know, she is very well, thank you.
JULIA: She must have made a marvellous recovery.
 I said so to myself, when I got your telegram.
LAVINIA: But where, may I ask, was this telegram sent from?
JULIA: Why, from Essex, of course.
LAVINIA: And why from Essex?
JULIA: Because you've been in Essex.

LAVINIA: Because I've been in Essex!
JULIA: Lavinia! Don't say you've had a lapse of memory!
 Then that accounts for the aunt—and the telegram.
LAVINIA: Well, perhaps I was in Essex. I really don't know.
JULIA: You don't know where you were? Lavinia!
 Don't tell me you were abducted! Tell us;
 I'm thrilled . . .
 [*The doorbell rings.* EDWARD *goes to answer it. Enter* ALEX.]
ALEX: Has Lavinia arrived?
EDWARD: Yes.
ALEX: Welcome back, Lavinia!
 When I got your telegram . . .
LAVINIA: Where from?
ALEX: Dedham.
LAVINIA: Dedham is in Essex. So it was from Dedham.
 Edward, have *you* any friends in Dedham?
EDWARD: No, *I* have no connections in Dedham.
JULIA: Well, it's all delightfully mysterious.
ALEX: But what is the mystery?
JULIA: Alex, *don't* be inquisitive.
 Lavinia has had a lapse of memory,
 And so, of course, she sent us telegrams:
 And now I don't believe she really wants us.
 I can see that she is quite worn out
 After her anxiety about her aunt—
 Who you'll be glad to hear, has quite recovered, Alex—
 And after that long journey on the old Great Eastern,
 Waiting at junctions. And I suppose she's famished.
ALEX: Ah, in that case I know what I'll do . . .
JULIA: No, Alex.
 We must leave them alone, and let Lavinia rest.
 Now we'll all go back to *my* house. Peter, call a taxi.
 [*Exit* PETER.]
 We'll have a cocktail party at *my* house today.
CELIA: Well, I'll go now. Good-bye, Lavinia.
 Good-bye, Edward.
EDWARD: Good-bye, Celia.
CELIA: Good-bye, Lavinia.

LAVINIA: Good-bye, Celia. [*Exit* CELIA.]
JULIA: And now, Alex, you and I should be going.
EDWARD: Are you sure you haven't left anything, Julia?
JULIA: Left anything? Oh, you mean my spectacles.
 No, they're here. Besides, they're no use to me.
 I'm not coming back again *this* evening.
LAVINIA: Stop! I want you to explain the telegram.
JULIA: Explain the telegram? What do you think, Alex?
ALEX: No, Julia, *we* can't explain the telegram.
LAVINIA: I am sure that you could explain the telegram.
 I don't know why. But it seems to me that yesterday
 I started some machine, that goes on working,
 And I cannot stop it; no, it's not like a machine—
 Or if it's a machine, someone else is running it.
 But who? Somebody is always interfering . . .
 I don't feel free . . . and yet I started it . . .
JULIA: Alex, do you think we could explain *anything?*
ALEX: I think not, Julia. She must find out for herself:
 That's the only way.
JULIA: How right you are!
 Well, my dears, I shall see you very soon.
EDWARD: *When* shall we see you?
JULIA: Did I say you'd see me?
 Good-bye. I believe . . . I haven't left anything.
 [*Enter* PETER.]
PETER: I've got a taxi, Julia.
JULIA: Splendid! Good-bye!
 [*Exeunt* JULIA, ALEX *and* PETER.]
LAVINIA: I must say, you don't seem very pleased to see me.
EDWARD: I can't say that I've had much opportunity
 To seem anything. But of course I'm glad to see you.
LAVINIA: Yes, that was a silly thing to say.
 Like a schoolgirl. Like Celia. I don't know why I said it.
 Well, here I am.
EDWARD: I am to ask no questions.
LAVINIA: And I know I am to give no explanations.
EDWARD: And I am to give no explanations.
LAVINIA: And I am to ask no questions. And yet . . . why not?

EDWARD: I don't know why not. So what are we to talk about?
LAVINIA: There is one thing I ought to know, because of other
 people
 And what to do about them. It's about that party.
 I suppose you won't believe I forgot all about it!
 I let you down badly. What did you do about it?
 I only remembered after I had left.
EDWARD: I telephoned to everyone I knew was coming
 But I couldn't get everyone. And so a few came.
LAVINIA: Who came?
EDWARD: Just those who were here this evening . . .
LAVINIA: That's odd.
EDWARD: . . . and one other. I don't know who he was,
 But *you* ought to know.
LAVINIA: Yes, I think I know.
 But I'm puzzled by Julia. That woman is the devil.
 She knows by instinct when something's going to happen.
 Trust her not to miss any awkward situation!
 And what did you tell them!
EDWARD: I invented an aunt
 Who was ill in the country, and had sent for you.
LAVINIA: Really, Edward! You had better have told the truth:
 Nothing less than the truth could deceive Julia.
 But how did the aunt come to live in Essex?
EDWARD: Julia compelled me to make her live somewhere.
LAVINIA: I see. So Julia made her live in Essex;
 And made the telegrams come from Essex.
 Well, I shall have to tell Julia the truth.
 I shall always tell the truth now.
 We have wasted such a lot of time in lying.
EDWARD: I don't quite know what you mean.
LAVINIA: Oh, Edward!
 The point is, that since I've been away
 I see that I've taken you much too seriously.
 And now I can see how absurd you are.
EDWARD: That is a very serious conclusion
 To have arrived at in . . . how many? . . . thirty-two hours.
LAVINIA: Yes, a very important discovery,

Finding that you've spent five years of your life
With a man who has no sense of humour;
And that the effect upon me was
That I lost all sense of humour myself.
That's what came of always giving in to *you*.

EDWARD: I was unaware that you'd always given in to me.
It struck me very differently. As we're on the subject,
I thought that it was I who had given in to *you*.

LAVINIA: I know what you mean by giving in to *me:*
You mean, leaving all the practical decisions
That you should have made yourself. I remember—
Oh, I ought to have realised what was coming—
When we were planning our honeymoon,
I couldn't make you say where you wanted to go . . .

EDWARD: But I wanted *you* to make that decision.

LAVINIA: But how could I tell where I wanted to go
Unless you suggested some other place first?
And I remember that finally in desperation
I said: 'I suppose you'd as soon go to Peacehaven'—
And you said 'I don't mind.'

EDWARD: Of course I didn't mind.
I meant it as a compliment.

LAVINIA: You meant it as a compliment!

EDWARD: It's just that way of taking things that makes you so exas-
perating.

LAVINIA: You were so considerate, people said;
And you thought you were unselfish. It was only passivity;
You only wanted to be bolstered, encouraged . . .

EDWARD: Encouraged? To what?

LAVINIA: To think well of yourself.
You know it was I who made you work at the Bar . . .

EDWARD: You nagged me because I didn't get enough work
And said that I ought to meet more people:
But when the briefs began to come in—
And they didn't come through any of *your* friends—
You suddenly found it inconvenient
That I should be always too busy or too tired
To be of use to you socially . . .

LAVINIA: I *never* complained.
EDWARD: No; and it was perfectly infuriating,
 The way you *didn't* complain . . .
LAVINIA: It was you who complained
 Of seeing nobody but solicitors and clients . . .
EDWARD: And you were never very sympathetic.
LAVINIA: Well, but I tried to do something about it.
 That was why I took so much trouble
 To have those Thursdays, to give you the chance
 Of talking to intellectual people . . .
EDWARD: You would have given me about as much opportunity
 If you had hired me as your butler:
 Some of your guests may have thought I *was* the butler.
LAVINIA: And on several occasions, when somebody was coming
 Whom I particularly wanted you to meet,
 You didn't arrive until just as they were leaving.
EDWARD: Well, at least, *they* can't have thought I was the butler.
LAVINIA: Everything I tried only made matters worse,
 And the moment you were offered something that you wanted
 You wanted something else. I shall treat you very differently
 In future.
EDWARD: Thank you for the warning. But tell me,
 Since this is how you see me, why did you come back?
LAVINIA: Frankly, I don't know. I was warned of the danger,
 Yet something, or somebody, compelled me to come.
 And why did you want me?
EDWARD: I don't know either.
 You say you were trying to 'encourage' me:
 Then why did you always make me feel insignificant?
 I may not have known what life I wanted,
 But it wasn't the life you chose for me.
 You wanted your husband to be successful,
 You wanted me to supply a public background
 For your kind of public life. You wished to be a hostess
 For whom my career would be a support.
 Well, I tried to be accommodating. But in future,
 I shall behave, I assure you, very differently.
LAVINIA: Bravo! This is surprising.

Now who could have taught you to answer back like that?
EDWARD: I have had quite enough humiliation
 Lately, to bring me to the point
 At which humiliation ceases to humiliate.
 You get to the point at which you cease to feel
 And then you speak your mind.
LAVINIA: That will be a novelty
 To find that you have a mind to speak.
 Anyway, I'm prepared to take you as you are.
EDWARD: You mean, you are prepared to take me
 As I was, or as you think I am.
 But what do you think I am?
LAVINIA: Oh, what you always were.
 As for me, I'm rather a different person
 Whom you must get to know.
EDWARD: This is very interesting:
 But you seem to assume that you've done all the changing—
 Though I haven't yet found it a change for the better.
 But doesn't it occur to you that possibly
 I may have changed too?
LAVINIA: Oh, Edward, when you were a little boy,
 I'm sure you were always getting yourself measured
 To prove how you had grown since the last holidays.
 You were always intensely concerned with yourself;
 And if other people grow, well, you want to grow too.
 In what way have you changed?
EDWARD: The change that comes
 From seeing oneself through the eyes of other people.
LAVINIA: That must have been very shattering for you.
 But never mind, you'll soon get over it
 And find yourself another little part to play,
 With another face, to take people in.
EDWARD: One of the most infuriating things about you
 Has always been your perfect assurance
 That you understood me better than I understood myself.
LAVINIA: And the most infuriating thing about you
 Has always been your placid assumption
 That I wasn't worth the trouble of understanding.

EDWARD: So here we are again. Back in the trap,
　　With only one difference, perhaps—we can fight each other,
　　Instead of each taking his corner of the cage.
　　Well, it's a better way of passing the evening
　　Than listening to the gramophone.
LAVINIA: 　　　　　　　　　　We have very good records;
　　But I always suspected that you really hated music
　　And that the gramophone was only your escape
　　From talking to me when we had to be alone.
EDWARD: I've often wondered why you married me.
LAVINIA: Well, you really were rather attractive, you know;
　　And you kept on *saying* that you were in love with me—
　　I believe you were trying to persuade yourself you were.
　　I seemed always on the verge of some wonderful experience
　　And then it never happened. I wonder now
　　How you could have thought you were in love with me.
EDWARD: Everybody told me that I was;
　　And they told me how well suited we were.
LAVINIA: It's a pity you had no opinion of your own.
　　Oh, Edward, I should like to be good to you—
　　Or if that's impossible, at least be horrid to you—
　　Anything but nothing, which is all you seem to want of me.
　　But I'm sorry for you . . .
EDWARD: 　　　　　　　　Don't say you are sorry for me!
　　I have had enough of people being sorry for me.
LAVINIA: Yes, because they can never be so sorry for you
　　As you are for yourself. And that's hard to bear.
　　I thought that there might be some way out for you
　　If I went away. I thought that if I died
　　To you, I who had been only a ghost to you,
　　You might be able to find the road back
　　To a time when you were real—for you must have been real
　　At some time or other, before you ever knew me.
　　Perhaps only when you were a child.
EDWARD: I don't want you to make yourself responsible for me:
　　It's only another kind of contempt.
　　And I do not want you to explain me to myself.
　　You're still trying to invent a personality for me

Which will only keep me away from myself.

LAVINIA: You're complicating what is in fact very simple.
But there is one point which I see clearly:
We are not to relapse into the kind of life we led
Until yesterday morning.

EDWARD: There was a door
And I could not open it. I could not touch the handle.
Why could I not walk out of my prison?
What is hell? Hell is oneself,
Hell is alone, the other figures in it
Merely projections. There is nothing to escape from
And nothing to escape to. One is always alone.

LAVINIA: Edward, what *are* you talking about?
Talking to yourself. Could you bear, for a moment,
To think about *me?*

EDWARD: It was only yesterday
That damnation took place. And now I must live with it
Day by day, hour by hour, forever and ever.

LAVINIA: I think you're on the edge of a nervous breakdown!

EDWARD: Don't say that!

LAVINIA: I must say it.
I know . . . of a doctor who I think could help you.

EDWARD: If I go to a doctor, I shall make my own choice;
Not take one whom you choose. How do I know
That you wouldn't see him first, and tell him all about me
From *your* point of view? But I don't need a doctor.
I am simply in hell. Where there are no doctors—
At least, not in a professional capacity.

LAVINIA: One can be practical, even in hell:
And you know I am much more practical than you are.

EDWARD: I ought to know by now what you consider practical.
Practical! I remember, on our honeymoon,
You were always wrapping things up in tissue paper
And then had to unwrap everything again
To find what you wanted. And I never could teach you
How to put the cap on a tube of tooth-paste.

LAVINIA: Very well then, I shall not try to press you.
You're much too divided to know what you want.

But, being divided, you will tend to compromise,
And your sort of compromise will be the old one.
EDWARD: You don't understand me. Have I not made it clear
That in future you will find me a different person?
LAVINIA: Indeed. And has the difference nothing to do
With Celia going off to California?
EDWARD: Celia? Going to California?
LAVINIA: Yes, with Peter.
Really, Edward, if you were human
You would burst out laughing. But you won't.
EDWARD: O God, O God, if I could return to yesterday
Before I thought that I had made a decision.
What devil left the door on the latch
For these doubts to enter? And then you came back, you
The angel of destruction—just as I felt sure.
In a moment, at your touch, there is nothing but ruin.
O God, what have I done? The python. The octopus.
Must I become after all what you would make me?
LAVINIA: Well, Edward, as I am unable to make you laugh,
And as I can't persuade you to see a doctor,
There's nothing else at present that I can do about it.
I ought to go and have a look in the kitchen.
I know there are some eggs. But we must go out for dinner.
Meanwhile, my luggage is in the hall downstairs:
Will you get the porter to fetch it up for me?
 CURTAIN

Act Two

SIR HENRY HARCOURT-REILLY'S *consulting room in London.*
Morning: several weeks later. SIR HENRY *alone at his desk.*
He presses an electric button. The NURSE-SECRETARY *enters,*
with Appointment Book.

REILLY: About those three appointments this morning, Miss Barra-
 way:
 I should like to run over my instructions again.
 You understand, of course, that it is important
 To avoid any meeting?
NURSE-SECRETARY: You made that clear, Sir Henry:
 The first appointment at eleven o'clock.
 He is to be shown into the small waiting room;
 And you will see him almost at once.
REILLY: I shall see him at once. And the second?
NURSE-SECRETARY: The second to be shown into the other room
 Just as usual. She arrives at a quarter past;
 But you may keep her waiting.
REILLY: Or she may keep me waiting;
 But I think she will be punctual.
NURSE-SECRETARY: I telephone through
 The moment she arrives. I leave her there
 Until you ring three times.
REILLY: And the third patient?
NURSE-SECRETARY: The third one to be shown into the small room;
 And I need not let you know that she has arrived.
 Then, when you ring, I show the others out;
 And only after they have left the house . . .
REILLY: Quite right, Miss Barraway. That's all for the moment.

[344]

NURSE-SECRETARY: Mr. Gibbs is here, Sir Henry.
REILLY: Ask him to come straight in.
 [*Exit* NURSE-SECRETARY.]

 [ALEX *enters almost immediately.*]
ALEX: When is Chamberlayne's appointment?
REILLY: At eleven o'clock,
 The conventional hour. We have not much time.
 Tell me now, did you have any difficulty
 In convincing him I was the man for his case?
ALEX: Difficulty? No! He was only impatient
 At having to wait four days for the appointment.
REILLY: It was necessary to delay his appointment
 To lower his resistance. But what I mean is,
 Does he trust your judgment?
ALEX: Yes, implicitly.
 It's not that he regards me as very intelligent,
 But he thinks I'm well informed: the sort of person
 Who would know the right doctor, as well as the right shops.
 Besides, he was ready to consult any doctor
 Recommended by anyone except his wife.
REILLY: I had already impressed upon her
 That she was not to mention my name to him.
ALEX: With your usual foresight. Now, he's quite triumphant
 Because he thinks he's stolen a march on her.
 And when you've sent him to a sanatorium
 Where she can't get at him—then, he believes,
 She will be very penitent. He's enjoying his illness.
REILLY: Illness offers him a double advantage:
 To escape from himself—and get the better of his wife.
ALEX: Not to escape from her?
REILLY: He doesn't want to escape from her.
ALEX: He is staying at his club.
REILLY: Yes, that is where he wrote from.
 [*The house-telephone rings.*]
 Hello! yes, show him up.
ALEX: You will have a busy morning!
 I will go out by the service staircase

And come back when they've gone.

REILLY: Yes, when they've gone.

[*Exit* ALEX *by side door.*]

[EDWARD *is shown in by* NURSE-SECRETARY.]

EDWARD: Sir Harcourt-Reilly—

[*Stops and stares at* REILLY]

REILLY: [*Without looking up from his papers.*] Good morning, Mr.
 Chamberlayne.

 Please sit down. I won't keep you a moment.

 —Now, Mr. Chamberlayne?

EDWARD: It came into my mind

 Before I entered the door, that you might be the same person:

 And I dismissed that as just another symptom.

 Well, I should have known better than to come here

 On the recommendation of a man who did not know you.

 But Alex is so plausible. And his recommendations

 Of shops have always been satisfactory.

 I beg your pardon. But he *is* a blunderer.

 I should like to know . . . but what is the use!

 I suppose I might as well go away at once.

REILLY: No. If you please, sit down, Mr. Chamberlayne.

 You are not going away, so you might as well sit down.

 You were going to ask a question.

EDWARD: When you came to my flat

 Had you been invited by my wife as a guest

 As I supposed? . . . Or did she *send* you?

REILLY: I cannot say that I had been invited,

 And Mrs. Chamberlayne did not know that I was coming.

 But I knew you would be there, and whom I should find with
 you.

EDWARD: But you had seen my wife?

REILLY: Oh yes, I had seen her.

EDWARD: So this *is* a trap!

REILLY: Let's not call it a trap.

 But if it is a trap, then you cannot escape from it:

 And so . . . you might as well sit down.

 I think you will find that chair comfortable.

EDWARD: You knew,

Before I began to tell you, what had happened?

REILLY: That is so, that is so. But all in good time.
Let us dismiss that question for the moment.
Tell me first, about the difficulties
On which you want my professional opinion.

EDWARD: It's not for me to blame you for bringing my wife back,
I suppose. You seemed to be trying to persuade me
That I was better off without her. But didn't you realise
That I was in no state to make a decision?

REILLY: If I had not brought your wife back, Mr. Chamberlayne,
Do you suppose that things would be any better—now?

EDWARD: I don't know, I'm sure. They could hardly be worse.

REILLY: They might be much worse. You might have ruined three
lives
By your indecision. Now there are only two—
Which you still have the chance of redeeming from ruin.

EDWARD: You talk as if I was capable of action:
If I were, I should not need to consult you
Or anyone else. I came here as a patient.
If you take no interest in my case, I can go elsewhere.

REILLY: You have reason to believe that you are very ill?

EDWARD: I should have thought a doctor could see that for himself.
Or at least that he would enquire about the symptoms.
Two people advised me recently,
Almost in the same words, that I ought to see a doctor.
They said—again, in almost the same words—
That I was on the edge of a nervous breakdown.
I didn't know it then myself—but if they saw it
I should have thought that a doctor could see it.

REILLY: 'Nervous breakdown' is a term I never use:
It can mean almost anything.

EDWARD: And since then, I have realised
That mine is a very unusual case.

REILLY: All cases are unique, and very similar to others.

EDWARD: Is there a sanatorium to which you send such patients
As myself, under your personal observation?

REILLY: You are very impetuous, Mr. Chamberlayne.
There are several kinds of sanatoria

For several kinds of patient. And there are also patients
For whom a sanatorium is the worst place possible.
We must first find out what is wrong with you
Before we decide what to do with you.

EDWARD: I doubt if you have ever had a case like mine:
I have ceased to believe in my own personality.

REILLY: Oh, dear yes; this is serious. A very common malady.
Very prevalent indeed.

EDWARD: I remember, in my childhood . . .

REILLY: I always begin from the immediate situation
And then go back as far as I find necessary.
You see, your memories of childhood—
I mean, in your present state of mind—
Would be largely fictitious; and as for your dreams,
You would produce amazing dreams, to oblige me.
I could make you dream any kind of dream I suggested,
And it would only go to flatter your vanity
With the temporary stimulus of feeling interesting.

EDWARD: But I am obsessed by the thought of my own insignificance.

REILLY: Precisely. And I could make you feel important,
And you would imagine it a marvellous cure;
And you would go on, doing such amount of mischief
As lay within your power—until you came to grief.
Half of the harm that is done in this world
Is due to people who want to feel important.
They don't mean to do harm—but the harm does not interest
 them.
Or they do not see it, or they justify it
Because they are absorbed in the endless struggle
To think well of themselves.

EDWARD: If I am like that
I must have done a great deal of harm.

REILLY: Oh, not so much as you would like to think.
Only, shall we say, within your modest capacity.
Try to explain what has happened since I left you.

EDWARD: I see now why I wanted my wife to come back.
It was because of what she had made me into.
We had not been alone again for fifteen minutes

Before I felt, and still more acutely—
Indeed, acutely, perhaps, for the first time,
The whole oppression, the unreality
Of the role she had always imposed upon me
With the obstinate, unconscious, sub-human strength
That some women have. Without her, it was vacancy.
When I thought she had left me, I began to dissolve,
To cease to exist. That was what she had done to me!
I cannot live with her—that is now intolerable;
I cannot live without her, for she has made me incapable
Of having any existence of my own.
That is what she has done to me in five years together!
She has made the world a place I cannot live in
Except on her terms. I must be alone,
But not in the same world. So I want you to put me
Into your sanatorium. I could be alone there?

[*House-telephone rings.*]

REILLY: [*Into telephone*] Yes.

 [*To* EDWARD] Yes, you could be alone there.

EDWARD: I wonder
 If you have understood a word of what I have been saying.

REILLY: You must have patience with me, Mr. Chamberlayne:
 I learn a good deal by merely observing you,
 And letting you talk as long as you please,
 And taking note of what you do not say.

EDWARD: I once experienced the extreme of physical pain,
 And now I know there is suffering worse than that.
 It is surprising, if one had time to be surprised:
 I am not afraid of the death of the body,
 But this death is terrifying. The death of the spirit—
 Can you understand what I suffer?

REILLY: I understand what you mean.

EDWARD: I can no longer act for myself.
 Coming to see you—that's the last decision
 I was capable of making. I am in your hands.
 I cannot take any further responsibility.

REILLY: Many patients come in that belief.

EDWARD: And now will you send me to the sanatorium?

REILLY: You have nothing else to tell me?

EDWARD: What else can I tell you?
 You don't want to hear about my early history.

REILLY: No, I did not want to hear about your *early* history.

EDWARD: And so will you send me to the sanatorium?
 I can't go home again. And at my club
 They won't let you keep a room for more than seven days;
 I haven't the courage to go to a hotel,
 And besides, I need more shirts—you can get my wife
 To have my things sent on: whatever I shall need.
 But of course you mustn't tell her where I am.
 Is it far to go?

REILLY: You might say, a long journey.
 But before I treat a patient like yourself
 I need to know a great deal more about him,
 Than the patient himself can always tell me.
 Indeed, it is often the case that my patients
 Are only pieces of a total situation
 Which I have to explore. The single patient
 Who is ill by himself, is rather the exception.
 I have recently had another patient
 Whose situation is much the same as your own.
 [*Presses the bell on his desk three times*]
 You must accept a rather unusual procedure:
 I propose to introduce you to the other patient.

EDWARD: What do you mean? Who is this other patient?
 I consider this very unprofessional conduct—
 I will not discuss my case before another patient.

REILLY: On the contrary. That is the only way
 In which it can be discussed. You have told me nothing.
 You have had the opportunity, and you have said enough
 To convince me that you have been making up your case
 So to speak, as you went along. A barrister
 Ought to know his brief before he enters the court.

EDWARD: I am at least free to leave. And I propose to do so.
 My mind is made up. I shall go to a hotel.

REILLY: It is just because you are not free, Mr. Chamberlayne,
 That you have come to me. It is for me to give you that—

Your freedom. That is my affair.
 [LAVINIA *is shown in by the* NURSE-SECRETARY.]
But here is the other patient.
EDWARD: Lavinia!
LAVINIA: Well, Sir Henry!
 I said I would come to talk about my husband:
 I didn't say I was prepared to meet him.
EDWARD: And I did not expect to meet *you*, Lavinia.
 I call this a very dishonourable trick.
REILLY: Honesty before honour, Mr. Chamberlayne.
 Sit down, please, both of you. Mrs. Chamberlayne,
 Your husband wishes to enter a sanatorium,
 And that is a question which naturally concerns you.
EDWARD: I am not going to any sanatorium.
 I am going to a hotel. And I shall ask you, Lavinia,
 To be so good as to send me on some clothes.
LAVINIA: Oh, to what hotel?
EDWARD: I don't know—I mean to say,
 That doesn't concern you.
LAVINIA: In that case, Edward,
 I don't think your clothes concern me either.
 [*To* REILLY]
 I presume you will send him to the same sanatorium
 To which you sent me? Well, he needs it more than I did.
REILLY: I am glad that you have come to see it in that light—
 At least, for the moment. But, Mrs. Chamberlayne,
 You have never visited my sanatorium.
LAVINIA: What do you mean? I asked to be sent
 And you took me there. If that was not a sanatorium
 What was it?
REILLY: A kind of hotel. A retreat
 For people who imagine that they need a respite
 From everyday life. They return refreshed;
 And if they believe it to be a sanatorium
 That is good reason for not sending them to one.
 The people who need my sort of sanatorium
 Are not easily deceived.
LAVINIA: Are you a devil

Or merely a lunatic practical joker?

EDWARD: I incline to the second explanation
Without the qualification 'lunatic.'
Why should *you* go to a sanatorium?
I have never known anyone in my life
With fewer mental complications than you;
You're stronger than a . . . battleship. That's what drove me mad.
I am the one who needs a sanatorium—
But I'm not going there.

REILLY: You are right, Mr. Chamberlayne.
You are no case for my sanatorium:
You are much too ill.

EDWARD: Much too ill?
Then I'll go and be ill in a suburban boarding-house.

LAVINIA: That would never suit you, Edward. Now I know of a hotel
In the New Forest . . .

EDWARD: How like you, Lavinia.
You always know of something better.

LAVINIA: It's only that I have a more practical mind
Than you have, Edward. You do know that.

EDWARD: Only because you've told me so often.
I'd like to see *you* filling up an income-tax form.

LAVINIA: Don't be silly, Edward. When I say practical,
I mean practical in the things that really matter.

REILLY: May I interrupt this interesting discussion?
I say you are both too ill. There are several symptoms
Which must occur together, and to a marked degree,
To qualify a patient for *my* sanatorium:
And one of them is an honest mind.
That is one of the causes of their suffering.

LAVINIA: No one can say my husband has an honest mind.

EDWARD: And I could not honestly say that of *you,* Lavinia.

REILLY: I congratulate you both on your perspicacity.
Your sympathetic understanding of each other
Will prepare you to appreciate what I have to say to you.
I do not trouble myself with the common cheat,
Or with the insuperably, innocently dull:

My patients such as you are the self-deceivers
Taking infinite pains, exhausting their energy,
Yet never quite successful. You have both of you pretended
To be consulting me; both, tried to impose upon me
Your own diagnosis, and prescribe your own cure.
But when you put yourselves into hands like mine
You surrender a great deal more than you meant to.
This is the consequence of trying to lie to me.
LAVINIA: I did not come here to be insulted.
REILLY: You have come where the word 'insult' has no meaning;
And you must put up with that. All that you have told me—
Both of you—was true enough: you described your feelings—
Or some of them—omitting the important facts.
Let me take your husband first.

[*To* EDWARD]

You were lying to me
By concealing your relations with Miss Coplestone.
EDWARD: This is monstrous! My wife knew nothing about it.
LAVINIA: Really, Edward! Even if I'd been blind
There were plenty of people to let me know about it.
I wonder if there was anyone who didn't know.
REILLY: There was one, in fact. But you, Mrs. Chamberlayne,
Tried to make me believe that it was this discovery
Precipitated what you called your nervous breakdown.
LAVINIA: But it's true! I was completely prostrated;
Even if I have made a partial recovery.
REILLY: Certainly, you were completely prostrated,
And certainly, you have somewhat recovered.
But you failed to mention that the cause of your distress
Was the defection of your lover—who suddenly
For the first time in his life, fell in love with someone,
And with someone of whom you had reason to be jealous.
EDWARD: Really, Lavinia! This is very interesting.
You seem to have been much more successful at concealment
Than I was. Now I wonder who it could have been.
LAVINIA: Well, tell him if you like.
REILLY: A young man named Peter.
EDWARD: Peter? Peter who?

REILLY: Mr. Peter Quilpe
 Was a frequent guest.
EDWARD: Peter Quilpe!
 Peter Quilpe! Really Lavinia!
 I congratulate you. You could not have chosen
 Anyone I was less likely to suspect.
 And then he came to *me* to confide about Celia!
 I have never heard anything so utterly ludicrous:
 This is the best joke that ever happened.
LAVINIA: I never knew you had such a sense of humour.
REILLY: It is the first more hopeful symptom.
LAVINIA: How did you know all this?
REILLY: That I cannot disclose.
 I have my own method of collecting information
 About my patients. You must not ask me to reveal it—
 That is a matter of professional etiquette.
LAVINIA: I have not noticed much professional etiquette
 About your behaviour today.
REILLY: A point well taken.
 But permit me to remark that my revelations
 About each of you, to one another,
 Have not been of anything that you confided to me.
 The information I have exchanged between you
 Was all obtained from outside sources.
 Mrs. Chamberlayne, when you came to me two months ago
 I was dissatisfied with your explanation
 Of your obvious symptoms of emotional strain
 And so I made enquiries.
EDWARD: It was two months ago
 That your breakdown began! And I never noticed it.
LAVINIA: You wouldn't notice anything. You never noticed *me*.
REILLY: Now, I want to point out to both of you
 How much you have in common. Indeed, I consider
 That you are exceptionally well-suited to each other.
 Mr. Chamberlayne, when you thought your wife had left you,
 You discovered, to your surprise and consternation,
 That you were not really in love with Miss Coplestone . . .
LAVINIA: My husband has never been in love with anybody.

REILLY: And were not prepared to make the least sacrifice
 On her account. This injured your vanity.
 You liked to think of yourself as a passionate lover.
 Then you realised, what your wife has justly remarked,
 That you had never been in love with anybody;
 Which made you suspect that you were incapable
 Of loving. To men of a certain type
 The suspicion that they are incapable of loving
 Is as disturbing to their self-esteem
 As, in cruder men, the fear of impotence.
LAVINIA: You *are* cold-hearted, Edward.
REILLY: So you say, Mrs. Chamberlayne.
 And now, let us turn to your side of the problem.
 When you discovered that your young friend
 (Though you knew, in your heart, that he was not in love with
 you,
 And were always humiliated by the awareness
 That you had forced him into this position) —
 When, I say, you discovered that your young friend
 Had actually fallen in love with Miss Coplestone,
 It took you some time, I have no doubt,
 Before you would admit it. Though perhaps you knew it
 Before he did. You pretended to yourself,
 I suspect, and for as long as you could,
 That he was aiming at a higher social distinction
 Than the honour conferred by being *your* lover.
 When you had to face the fact that his feelings towards her
 Were different from any you had aroused in him—
 It was a shock. You had wanted to be loved;
 You had come to see that no one had ever loved you.
 Then you began to fear that no one *could* love you.
EDWARD: I'm beginning to feel very sorry for you, Lavinia.
 You know, you really are exceptionally unlovable,
 And I never quite knew why. I thought it was *my* fault.
REILLY: And now you begin to see, I hope,
 How much you have in common. The same isolation.
 A man who finds himself incapable of loving
 And a woman who finds that no man can love her.

LAVINIA: It seems to me that what we have in common
 Might be just enough to make us loathe one another.
REILLY: See it rather as the bond which holds you together.
 While still in a state of unenlightenment,
 You could always say: 'He could not love any woman';
 You could always say: 'No man could love her.'
 You could accuse each other of your own faults,
 And so could avoid understanding each other.
 Now, you have only to reverse the propositions
 And put them together.
LAVINIA: Is that possible?
REILLY: If I had sent either of you to the sanatorium
 In the state in which you came to me—I tell you this:
 It would have been a horror beyond your imagining,
 For you would have been left with what you brought with you:
 The shadow of desires of desires. A prey
 To the devils who arrive at their plenitude of power
 When they have you to themselves.
LAVINIA: Then what can we do
 When we can go neither back nor forward? Edward!
 What can we do?
REILLY: You have answered your own question,
 Though you do not know the meaning of what you have said.
EDWARD: Lavinia, we must make the best of a bad job.
 That is what he means.
REILLY: When you find, Mr. Chamberlayne,
 The best of a bad job is all any of us make of it—
 Except of course, the saints—such as those who go
 To the sanatorium—you will forget this phrase,
 And in forgetting it will alter the condition.
LAVINIA: Edward, there *is* that hotel in the New Forest
 If you want to go there. The proprietor
 Who has just taken over, is a friend of Alex's.
 I could go down with you, and then leave you there
 If you want to be alone . . .
EDWARD: But I can't go away!
 I have a case coming on next Monday.
LAVINIA: Then will you stop at your club?

EDWARD: No, they won't let me.
I must leave tomorrow—but how did you know
I was staying at the club?
LAVINIA: Really, Edward!
I have *some* sense of responsibility.
I was going to leave some shirts there for you.
EDWARD: It seems to me that I might as well go home.
LAVINIA: Then we can share a taxi, and be economical.
Edward, have you anything else to ask him
Before we go?
EDWARD: Yes, I have.
But it's difficult to say.
LAVINIA: But I wish you would say it.
At least, there is something I would like you to ask.
EDWARD: It's about the future of . . . the others.
I don't want to build on other people's ruins.
LAVINIA: Exactly. And I have a question too.
Sir Henry, was it you who sent those telegrams?
REILLY: I think I will dispose of your husband's problem.
[*To* EDWARD]
Your business is not to clear your conscience
But to learn how to bear the burdens on your conscience.
With the future of the others you are not concerned.
LAVINIA: I think you have answered my question too.
They had to tell us, themselves, that they had made their de-
cision.
EDWARD: Have you anything else to say to us, Sir Henry?
REILLY: No. Not in this capacity.
[EDWARD *takes out his cheque-book.* REILLY *raises his hand.*]
My secretary will send you my account.
Go in peace. And work out your salvation with diligence.
[*Exeunt* EDWARD *and* LAVINIA.]
[REILLY *goes to the couch and lies down. The house-telephone*
rings. He gets up and answers it.]
REILLY: Yes? . . . Yes. Come in.
[*Enter* JULIA *by side door.*]
 She's waiting downstairs.
JULIA: I know that, Henry. I brought her here myself.

REILLY: Oh? You didn't let her know you were seeing me first?
JULIA: Of course not. I dropped her at the door
 And went on in the taxi, round the corner;
 Waited a moment, and slipped in by the back way.
 I only came to tell you, I am sure she is ready
 To make a decision.
REILLY: Was she reluctant?
 Was that why you brought her?
JULIA: Oh no, not reluctant:
 Only diffident. She cannot believe
 That you will take her seriously.
REILLY: That is not uncommon.
JULIA: Or that she deserves to be taken seriously.
REILLY: That is most uncommon.
JULIA: Henry, get up. You can't be as tired as that. I shall wait in the
 next room,
 And come back when she's gone.
REILLY: Yes, when she's gone.
JULIA: Will Alex be here?
REILLY: Yes, he'll be here.

 [*Exit* JULIA *by side door.*]
 [REILLY *presses button.*
 NURSE-SECRETARY *shows in* CELIA.]
REILLY: Miss Celia Coplestone? . . . Won't you sit down?
 I believe you are a friend of Mrs. Shuttlethwaite.
CELIA: Yes, it was Julia . . . Mrs. Shuttlethwaite
 Who advised me to come to you.—But I've met you before,
 Haven't I, somewhere? . . . Oh, of course.
 But I didn't know . . .
REILLY: There is nothing you need to know.
 I was there at the instance of Mrs. Shuttlethwaite.
CELIA: That makes it even more perplexing. However,
 I don't want to waste your time. And I'm awfully afraid
 That you'll think that I am wasting it anyway.
 I suppose most people, when they come to see you,
 Are obviously ill, or can give good reasons
 For wanting to see you. Well, I can't.
 I just came in desperation. And I shan't be offended

If you simply tell me to go away again.

REILLY: Most of my patients begin, Miss Coplestone,
By telling me exactly what is the matter with them,
And what I am to do about it. They are quite sure
They have had a nervous breakdown—that is what they call it—
And usually they think that someone else is to blame.

CELIA: I at least have no one to blame but myself.

REILLY: And after that, the prologue to my treatment
Is to try to show them that they are mistaken
About the nature of their illness, and lead them to see
That it's not so interesting as they had imagined.
When I get as far as that, there is something to be done.

CELIA: Well, I can't pretend that my trouble is interesting;
But I shan't begin that way. I feel perfectly well.
I could lead an active life—if there's anything to work for;
I don't imagine that I am being persecuted;
I don't hear any voices, I have no delusions—
Except that the world I live in seems all a delusion!
But oughtn't I first to tell you the circumstances?
I'd forgotten that you know nothing about me;
And with what I've been going through, these last weeks,
I somehow took it for granted that I needn't explain myself.

REILLY: I know quite enough about you for the moment:
Try first to describe your present state of mind.

CELIA: Well, there are two things I can't understand,
Which you might consider symptoms. But first I must tell you
That I should really *like* to think there's something wrong with
me—
Because, if there isn't, then there's something wrong,
Or at least, very different from what it seemed to be,
With the world itself—and that's much more frightening!
That would be terrible. So I'd rather believe
There is something wrong with me, that could be put right.
I'd do anything you told me, to get back to normality.

REILLY: We must find out about you, before we decide
What *is* normality. You say there are two things:
What is the first?

CELIA: An awareness of solitude.

But that sounds so flat. I don't mean simply
That there's been a crash: though indeed there has been
It isn't simply the end of an illusion
In the ordinary way, or being ditched.
Of course that's something that's always happening
To all sorts of people, and they get over it
More or less, or at least they carry on.
No. I mean that what has happened has made me aware
That I've always been alone. That one always is alone.
Not simply the ending of one relationship,
Not even simply finding that it never existed—
But a revelation about my relationship
With *everybody*. Do you know—
It no longer seems worth while to *speak* to anyone!

REILLY: And what about your parents?
CELIA: Oh, they live in the country,
Now they can't afford to have a place in town.
It's all they can do to keep the country house going:
But it's been in the family so long, they won't leave it.

REILLY: And you live in London?
CELIA: I share a flat
With a cousin: but she's abroad at the moment,
And my family want me to come down and stay with them.
But I just can't face it.

REILLY: So you want to see no one?
CELIA: No . . . it isn't that I *want* to be alone,
But that everyone's alone—or so it seems to me.
They make noises, and think they are talking to each other;
They make faces, and think they understand each other.
And I'm sure that they don't. Is that a delusion?

REILLY: A delusion is something we must return from.
There are other states of mind, which we take to be delusion,
But which we have to accept and go on from.
And the second symptom?

CELIA: That's stranger still.
It sounds ridiculous—but the only word for it
That I can find, is a sense of sin.

REILLY: You suffer from a sense of sin, Miss Coplestone?
 This is most unusual.

CELIA: It seemed to *me* abnormal.

REILLY: We have yet to find what would be normal
 For *you,* before we use the term 'abnormal.'
 Tell me what you mean by a sense of sin.

CELIA: It's much easier to tell you what I don't mean:
 I don't mean sin in the ordinary sense.

REILLY: And what, in your opinion, is the ordinary sense?

CELIA: Well . . . I suppose it's being immoral—
 And I don't feel as if I was immoral:
 In fact, aren't the people one thinks of as immoral
 Just the people who we say have no moral sense?
 I've never noticed that immorality
 Was accompanied by a sense of sin:
 At least, I have never come across it.
 I suppose it is wicked to hurt other people
 If you know that you're hurting them. I haven't hurt *her.*
 I wasn't taking anything away from her—
 Anything she wanted. I may have been a fool:
 But I don't mind at all having been a fool.

REILLY: And what is the point of view of your family?

CELIA: Well, my bringing up was pretty conventional—
 I had always been taught to disbelieve in sin.
 Oh, I don't mean that it was ever mentioned!
 But anything wrong, from our point of view,
 Was either bad form, or was psychological.
 And bad form always led to disaster
 Because the people one knew disapproved of it.
 I don't worry much about form, myself—
 But when everything's bad form, or mental kinks,
 You either become bad form, and cease to care,
 Or else, if you care, you must be kinky.

REILLY: And so you suppose you have what you call a 'kink'?

CELIA: But everything seemed so right, at the time!
 I've been thinking about it, over and over;
 I can see now, it was all a mistake:

But I don't see why mistakes should make one feel sinful!
And yet I can't find any other word for it.
It must be some kind of hallucination;
Yet, at the same time, I'm frightened by the fear
That it is more real than anything I believed in.

REILLY: What is more real than anything you believed in?

CELIA: It's not the feeling of anything I've ever *done*,
 Which I might get away from, or of anything in me
 I could get rid of—but of emptiness, of failure
 Towards someone, or something, outside of myself;
 And I feel I must . . . *atone*—is that the word?
 Can you treat a patient for such a state of mind?

REILLY: What had you believed were your relations with this man?

CELIA: Oh, you'd guessed that, had you? That's clever of you.
 No, perhaps I made it obvious. You don't need to know
 About him, do you?

REILLY: No.

CELIA: Perhaps I'm only typical.

REILLY: There are different types. Some are rarer than others.

CELIA: Oh, I thought that I was giving him so much!
 And he to me—and the giving and the taking
 Seemed so right: not in terms of calculation
 Of what was good for the persons we had been
 But for the new person, *us*. If I could feel
 As I did then, even now it would seem right.
 And then I found we were only strangers
 And that there had been neither giving nor taking
 But that we had merely made use of each other
 Each for his purpose. That's horrible. Can we only love
 Something created by our own imagination?
 Are we all in fact unloving and unlovable?
 Then one *is* alone, and if one is alone
 Then lover and belovèd are equally unreal
 And the dreamer is no more real than his dreams.

REILLY: And this man. What does he now seem like, to you?

CELIA: Like a child who has wandered into a forest
 Playing with an imaginary playmate

And suddenly discovers he is only a child
Lost in a forest, wanting to go home.
REILLY: Compassion may be already a clue
Towards finding your own way out of the forest.
CELIA: But even if I find my way out of the forest
I shall be left with the inconsolable memory
Of the treasure I went into the forest to find
And never found, and which was not there
And perhaps is not anywhere? But if not anywhere,
Why do I feel guilty at not having found it?
REILLY: Disillusion can become itself an illusion
If we rest in it.
CELIA: I cannot argue.
It's not that I'm afraid of being hurt again:
Nothing again can either hurt or heal.
I have thought at moments that the ecstasy is real
Although those who experience it may have no reality.
For what happened is remembered like a dream
In which one is exalted by intensity of loving
In the spirit, a vibration of delight
Without desire, for desire is fulfilled
In the delight of loving. A state one does not know
When awake. But what, or whom I loved,
Or what in me was loving, I do not know.
And if that is all meaningless, I want to be cured
Of a craving for something I cannot find
And of the shame of never finding it.
Can you cure me?
REILLY: The condition is curable.
But the form of treatment must be your own choice:
I cannot choose for you. If that is what you wish,
I can reconcile you to the human condition,
The condition to which some who have gone as far as you
Have succeeded in returning. They may remember
The vision they have had, but they cease to regret it,
Maintain themselves by the common routine,
Learn to avoid excessive expectation,

Become tolerant of themselves and others,
Giving and taking, in the usual actions
What there is to give and take. They do not repine;
Are contented with the morning that separates
And with the evening that brings together
For casual talk before the fire
Two people who know they do not understand each other,
Breeding children whom they do not understand
And who will never understand them.

CELIA: Is that the best life?

REILLY: It is a good life. Though you will not know how good
Till you come to the end. But you will want nothing else,
And the other life will be only like a book
You have read once, and lost. In a world of lunacy,
Violence, stupidity, greed . . . it is a good life.

CELIA: I know I ought to be able to accept that
If I might still have it. Yet it leaves me cold.
Perhaps that's just a part of my illness,
But I feel it would be a kind of surrender—
No, not a surrender—more like a betrayal.
You see, I think I really had a vision of something
Though I don't know what it is. I don't want to forget it.
I want to live with it. I could do without everything,
Put up with anything, if I might cherish it.
In fact, I think it would really be dishonest
For me, now, to try to make a life with *any*body!
I couldn't give anyone the kind of love—
I wish I could—which belongs to that life.
Oh, I'm afraid this sounds like raving!
Or just cantankerousness . . . still,
If there's no other way . . . then I feel just hopeless.

REILLY: There *is* another way, if you have the courage.
The first I could describe in familiar terms
Because you have seen it, as we all have seen it,
Illustrated, more or less, in lives of those about us.
The second is unknown, and so requires faith—
The kind of faith that issues from despair.
The destination cannot be described;

You will know very little until you get there;
You will journey blind. But the way leads towards possession
Of what you have sought for in the wrong place.

CELIA: That sounds like what I want. But what is my duty?

REILLY: Whichever way you choose will prescribe its own duty.

CELIA: Which way is better?

REILLY: Neither way is better.
Both ways are necessary. It is also necessary
To make a choice between them.

CELIA: Then I choose the second.

REILLY: It is a terrifying journey.

CELIA: I am not frightened
But glad. I suppose it is a lonely way?

REILLY: No lonelier than the other. But those who take the other
Can forget their loneliness. You will not forget yours.
Each way means loneliness—and communion.
Both ways avoid the final desolation
Of solitude in the phantasmal world
Of imagination, shuffling memories and desires.

CELIA: That is the hell I have been in.

REILLY: It isn't hell
Till you become incapable of anything else.
Now—do you feel quite sure?

CELIA: I want your second way.
So what am I to do?

REILLY: You will go to the sanatorium.

CELIA: Oh, what an anti-climax! I have known people
Who have been to your sanatorium, and come back again—
I don't mean to say they weren't much better for it—
That's why I came to you. But they returned . . .
Well . . . I mean . . . to everyday life.

REILLY: True. But the friends you have in mind
Cannot have been to this sanatorium.
I am very careful whom I send there:
Those who go do not come back as these did.

CELIA: It sounds like a prison. But they can't *all* stay there!
I mean, it would make the place so over-crowded.

REILLY: Not very many go. But I said they did not come back

In the sense in which your friends came back.
I did not say they stayed there.

CELIA: What becomes of them?

REILLY: They choose, Miss Coplestone. Nothing is forced on them.
Some of them return, in a physical sense;
No one disappears. They lead very active lives
Very often, in the world.

CELIA: How soon will you send me there?

REILLY: How soon will you be ready?

CELIA: Tonight, by nine o'clock.

REILLY: Go home then, and make your preparations.
Here is the address for you to give your friends;

 [*Writes on a slip of paper.*]

You had better let your family know at once.
I will send a car for you at nine o'clock.

CELIA: What do I need to take with me?

REILLY: Nothing.
Everything you need will be provided for you.
And you will have no expenses at the sanatorium.

CELIA: I don't in the least know what I am doing
Or why I am doing it. There is nothing else to do:
That is the only reason.

REILLY: It is the best reason.

CELIA: But I know it is I who have made the decision:
I must tell you that. Oh, I almost forgot—
May I ask what your fee is?

REILLY: I have told my secretary
That there is no fee.

CELIA: But ...

REILLY: For a case like yours
There is no fee.

 [*Presses button.*]

CELIA: You have been very kind.

REILLY: Go in peace, my daughter.
Work out your salvation with diligence.

 [NURSE-SECRETARY *appears at door. Exit* CELIA.
 REILLY *dials on house-telephone.*]

REILLY [*Into telephone*]: It is finished. You can come in now.

[*Enter* JULIA *by side door.*]
 She will go far, that one.
JULIA: Very far, I think.
 You do not need to tell me. I knew from the beginning.
REILLY: It's the other ones I am worried about.
JULIA: Nonsense, Henry. *I* shall keep an eye on them.
REILLY: To send them back: what have they to go back to?
 To the stale food mouldering in the larder,
 The stale thoughts mouldering in their minds.
 Each unable to disguise his own meanness
 From himself, because it is known to the other.
 It's not the knowledge of the mutual treachery
 But the knowledge that the other understands the motive—
 Mirror to mirror, reflecting vanity.
 I have taken a great risk.
JULIA: We must always take risks.
 That is our destiny. Since you question the decision
 What possible alternative can you imagine?
REILLY: None.
JULIA: Very well then. We must take the risk.
 All we could do was to give them the chance.
 And now, when they are stripped naked to their souls
 And can choose, whether to put on proper costumes
 Or huddle quickly into new disguises,
 They have, for the first time, somewhere to start from.
 Oh, of course, they might just murder each other!
 But I don't think they will do that. We shall see.
 It's the thought of Celia that weighs upon my mind.
REILLY: Of Celia?
JULIA: Of Celia.
REILLY: But when I said just now
 That she would go far, you agreed with me.
JULIA: Oh yes, she will go far. And we know where she is going.
 But what do we know of the terrors of the journey?
 You and I don't know the process by which the human is
 Transhumanised: what do we know
 Of the kind of suffering they must undergo
 On the way of illumination?

REILLY: Will she be frightened
 By the first appearance of projected spirits?
JULIA: Henry, you simply do not understand innocence.
 She will be afraid of nothing; she will not even know
 That there is anything there to be afraid of.
 She is too humble. She will pass between the scolding hills,
 Through the valley of derision, like a child sent on an errand
 In eagerness and patience. Yet she must suffer.
REILLY: When I express confidence in anything
 You always raise doubts; when I am apprehensive
 Then you see no reason for anything but confidence.
JULIA: That's one way in which I am so useful to you.
 You ought to be grateful.
REILLY: And when I say to one like her,
 'Work out your salvation with diligence,' I do not understand
 What I myself am saying.
JULIA: You must accept your limitations.
 —But how much longer will Alex keep us waiting?
REILLY: He should be here by now. I'll speak to Miss Barraway.
 [*Takes up house-telephone.*]
 Miss Barraway, when Mr. Gibbs arrives . . .
 Oh, very good.
 [*To* JULIA]
 He's on his way up.
 [*Into telephone*]
 You may bring the tray in now, Miss Barraway.
 [*Enter* ALEX.]
ALEX: Well! Well! and how have we got on?
JULIA: Everything is in order.
ALEX: The Chamberlaynes have chosen?
REILLY: They accept their destiny.
ALEX: And *she* has made the choice?
REILLY: She will be fetched this evening.
 [NURSE-SECRETARY *enters with a tray, a decanter and three*
 glasses, and exits. REILLY *pours drinks.*]
 And now we are ready to proceed to the libation.
ALEX: The words for the building of the hearth.
 [*They raise their glasses.*]

REILLY: Let them build the hearth
　　Under the protection of the stars.
ALEX: Let them place a chair each side of it.
JULIA: May the holy ones watch over the roof,
　　May the Moon herself influence the bed.
　　　　　　　　　[They drink.]
ALEX: The words for those who go upon a journey.
REILLY: Protector of travellers
　　Bless the road.
ALEX: Watch over her in the desert
　　Watch over her in the mountain
　　Watch over her in the labyrinth
　　Watch over her by the quicksand.
JULIA: Protect her from the Voices
　　Protect her from the Visions
　　Protect her in the tumult
　　Protect her in the silence.
　　　　　　　　　[They drink.]
REILLY: There is one for whom the words cannot be spoken.
ALEX: They cannot be spoken yet.
JULIA:　　　　　　　　You mean Peter Quilpe.
REILLY: He has not yet come to where the words are valid.
JULIA: Shall we ever speak them?
ALEX:　　　　　　　　Others, perhaps, will speak them.
　　You know, I have connections—even in California.

CURTAIN

Act Three

The drawing room of the Chamberlaynes' London flat. Two years later. A late afternoon in July. A CATERER'S MAN *is arranging a buffet table.* LAVINIA *enters from side door.*

CATERER'S MAN: Have you any further orders for us, Madam?
LAVINIA: You could bring in the trolley with the glasses
 And leave them ready.
CATERER'S MAN: Very good, Madam.
 [*Exit.* LAVINIA *looks about the room critically and moves a bowl of flowers.*]
 [*Re-enter* CATERER'S MAN *with trolley.*]
LAVINIA: There, in that corner. That's the most convenient;
 You can get in and out. Is there anything you need
 That you can't find in the kitchen?
CATERER'S MAN: Nothing, Madam.
 Will there be anything more you require?
LAVINIA: Nothing more, I think, till half past six.
 [*Exit* CATERER'S MAN.]
 [EDWARD *lets himself in at the front door.*]
EDWARD: I'm in good time, I think. I hope you've not been worrying.
LAVINIA: Oh no. I did in fact ring up your chambers,
 And your clerk told me you had already left.
 But all I rang up for was to reassure you . . .
EDWARD [*Smiling*]: That you hadn't run away?
LAVINIA: Now Edward, that's unfair!
 You know that we've given *several* parties
 In the last two years. And I've attended *all* of them.
 I hope you're not too tired?
EDWARD: Oh no, a quiet day.
 Two consultations with solicitors

[370]

On quite straightforward cases. It's you who should be tired.

LAVINIA: I'm not tired yet. But I know that I'll be glad
When it's all over.

EDWARD: I like the dress you're wearing:
I'm glad you put on that one.

LAVINIA: Well, Edward!
Do you know it's the first time you've paid me a compliment
Before a party? And that's when one needs them.

EDWARD: Well, you deserve it.—We asked too many people.

LAVINIA: It's true, a great many more accepted
Than we thought would want to come. But what can you do?
There's usually a lot who don't want to come
But all the same would be bitterly offended
To hear we'd given a party without asking them.

EDWARD: Perhaps we ought to have arranged to have two parties
Instead of one.

LAVINIA: That's never satisfactory.
Everyone who's asked to either party
Suspects that the other one was more important.

EDWARD: That's true. You have a very practical mind.

LAVINIA: But you know, I don't think that you need worry:
They won't all come, out of those who accepted.
You know we said, 'We can ask twenty more
Because they will be going to the Gunnings instead.'

EDWARD: I know, that's what we said at the time;
But I'd forgotten what the Gunnings' parties were like.
Their guests will get just enough to make them thirsty;
They'll come on to us later, roaring for drink.
Well, let's hope that those who come to us early
Will be going on to the Gunnings afterwards,
To make room for those who come from the Gunnings.

LAVINIA: And if it's very crowded, they can't get at the cocktails,
And the man won't be able to take the tray about,
So they'll go away again. Anyway, at that stage
There's nothing whatever you can do about it:
And everyone likes to be seen at a party
Where everybody else is, to show they've been invited.
That's what makes it a success. Is that picture straight?

EDWARD: Yes, it is.

LAVINIA: No, it isn't. Do please straighten it.

EDWARD: Is it straight now?

LAVINIA: Too much to the left.

EDWARD: How's that now?

LAVINIA: No, I meant the right.
 That will do. I'm too tired to bother.

EDWARD: After they're all gone, we will have some champagne,
 Just ourselves. You lie down now, Lavinia.
 No one will be coming for at least half an hour;
 So just stretch out.

LAVINIA: You must sit beside me,
 Then I can relax.

EDWARD: This is the best moment
 Of the whole party.

LAVINIA: Oh no, Edward.
 The best moment is the moment it's over;
 And then to remember, it's the end of the season
 And no more parties.

EDWARD: And no more committees.

LAVINIA: Can we get away soon?

EDWARD: By the end of next week
 I shall be quite free.

LAVINIA: And we can be alone.
 I love that house being so remote.

EDWARD: That's why we took it. And I'm really thankful
 To have that excuse for not seeing people;
 And you do need to rest now.

 [*The doorbell rings.*]

LAVINIA: Oh, bother!
 Now who would come so early? I simply *can't* get up.

CATERER'S MAN: Mrs. Shuttlethwaite!

LAVINIA: Oh, it's Julia!

 [*Enter* JULIA.]

JULIA: Well, my dears, and here I am!
 I seem *literally* to have caught you napping!
 I know I'm much too early; but the fact is, my dears,

That I have to go on to the Gunnings' party—
And you know what *they* offer in the way of food and drink!
And I've had to miss my tea, and I'm simply ravenous
And dying of thirst. What can Parkinson's do for me?
Oh yes, I know this is a Parkinson party;
I recognised one of their men at the door—
An old friend of mine, in fact. But I'm forgetting!
I've got a surprise: I've brought Alex with me!
He only got back this morning from somewhere—
One of his mysterious expeditions,
And we're going to get him to tell us all about it.
But what's become of him?
[*Enter* ALEX.]

EDWARD: Well, Alex!
Where on earth do you turn up from?

ALEX: Where on earth? From the East. From Kinkanja—
An island that you won't have heard of
Yet. Got back this morning. I heard about your party
And, as I thought you might be leaving for the country,
I said, I must not miss the opportunity
To see Edward and Lavinia.

LAVINIA: How are you, Alex?

ALEX: I did try to get you on the telephone
After lunch, but my secretary couldn't get through to you.
Never mind, I said—to myself, not to her—
Never mind: the unexpected guest
Is the one to whom they give the warmest welcome.
I know them well enough for that.

JULIA: But tell us, Alex.
What were you doing in this strange place—
What's it called?

ALEX: Kinkanja.

JULIA: What were you doing
In Kinkanja? Visiting some Sultan?
You were shooting tigers?

ALEX: There are no tigers, Julia,
In Kinkanja. And there are no sultans.

I have been staying with the Governor.
Three of us have been out on a tour of inspection
Of local conditions.
JULIA: What about? Monkey nuts?
ALEX: That was a nearer guess than you think.
No, not monkey nuts. But it had to do with monkeys—
Though whether the monkeys are the core of the problem
Or merely a symptom, I am not so sure.
At least, the monkeys have become the pretext
For general unrest amongst the natives.
EDWARD: But how do the monkeys create unrest?
ALEX: To begin with, the monkeys are very destructive . . .
JULIA: You don't need to tell me that monkeys are destructive.
I shall never forget Mary Mallington's monkey,
The horrid little beast—stole my ticket to Mentone
And I had to travel in a very slow train
And in a *couchette*. She was very angry
When I told her the creature ought to be destroyed.
LAVINIA: But can't they exterminate these monkeys
If they are a pest?
ALEX: Unfortunately,
The majority of the natives are heathen:
They hold these monkeys in peculiar veneration
And do not want them killed. So they blame the Government
For the damage that the monkeys do.
EDWARD: That seems unreasonable.
ALEX: It is unreasonable,
But characteristic. And that's not the worst of it.
Some of the tribes are Christian converts,
And, naturally, take a different view.
They trap the monkeys. And they eat them.
The young monkeys are extremely palatable:
I've cooked them myself . . .
EDWARD: And did anybody eat them
When you cooked them?
ALEX: Oh yes, indeed.
I invented for the natives several new recipes.
But you see, what with eating the monkeys

And what with protecting their crops from the monkeys
The Christian natives prosper exceedingly:
And that creates friction between them and the others.
And that's the real problem. I hope I'm not boring you?

EDWARD: No indeed: we are anxious to learn the solution.

ALEX: I'm not sure that there *is* any solution.
But even this does not bring us to the heart of the matter.
There are also foreign agitators,
Stirring up trouble . . .

LAVINIA: Why don't you expel them?

ALEX: They are citizens of a friendly neighbouring state
Which we have just recognized. You see, Lavinia,
There are very deep waters.

EDWARD: And the agitators;
How do they agitate?

ALEX: By convincing the heathen
That the slaughter of monkeys has put a curse on them
Which can only be removed by slaughtering the Christians.
They have even been persuading some of the converts—
Who, after all, prefer not to be slaughtered—
To relapse into heathendom. So, instead of eating monkeys
They are eating Christians.

JULIA: Who have eaten monkeys.

ALEX: The native is not, I fear, very logical.

JULIA: I wondered where you were taking us, with your monkeys.
I thought I was going to dine out on those monkeys:
But one can't dine out on eating Christians—
Even among pagans!

ALEX: Not on the *whole* story.

EDWARD: And have any of the English residents been murdered?

ALEX: Yes, but they are not usually eaten.
When these people have done with a European
He is, as a rule, no longer fit to eat.

EDWARD: And what has your commission accomplished?

ALEX: We have just drawn up an interim report.

EDWARD: Will it be made public?

ALEX: It cannot be, at present:
There are too many international complications.

Eventually, there may be an official publication.

EDWARD: But when?

ALEX: In a year or two.

EDWARD: And meanwhile?

ALEX: Meanwhile the monkeys multiply.

LAVINIA: And the Christians?

ALEX: Ah, the Christians! Now, I think I ought to tell you
About someone you know—or knew . . .

JULIA: Edward!
Somebody must have walked over my grave:
I'm feeling so chilly. Give me some gin.
Not a cocktail. I'm freezing—in July!

CATERER'S MAN: Mr. Quilpe!

EDWARD: Now who . . .
 [*Enter* PETER.]

 Why, it's Peter!

LAVINIA: Peter!

PETER: Hullo, everybody!

LAVINIA: When did you arrive?

PETER: I flew over from New York last night—
I left Los Angeles three days ago.
I saw Sheila Paisley at lunch today
And she told me you were giving a party—
She's coming on later, after the Gunnings—
So I said, I really must crash in:
It's my only chance to see Edward and Lavinia.
I'm only over for a week, you see,
And I'm driving down to the country this evening,
So I knew you wouldn't mind my looking in so early.
It does seem ages since I last saw any of you!
And how are you, Alex? And dear old Julia!

LAVINIA: So you've just come from New York.

PETER: Yeah, from New York.
The Bologolomskys saw me off.
You remember Princess Bologolomsky
In the old days? We dined the other night
At the Saffron Monkey. That's the place to go now.

ALEX: How very odd. *My* monkeys are saffron.

PETER: Your monkeys, Alex? I always said
 That Alex knew everybody. But I didn't know
 That he knew any monkeys.
JULIA: But give us your news;
 Give us your news of the world, Peter.
 We lead such a quiet life, here in London.
PETER: You always did enjoy a leg-pull, Julia:
 But you all know I'm working for Pan-Am-Eagle?
EDWARD: No. Tell us, what is Pan-Am-Eagle?
PETER: You must have been living a quiet life!
 Don't you go to the movies?
LAVINIA: Occasionally.
PETER: Alex knows.
 Did you see my last picture, Alex?
ALEX: I knew about it, but I didn't see it.
 There is no cinema in Kinkanja.
PETER: Kinkanja? Where's that? They don't have pictures?
 Pan-Am-Eagle must look into this.
 Perhaps it would be a good place to make one.
 —Alex knows all about Pan-Am-Eagle:
 It was he who introduced me to the great Bela.
JULIA: And who is the great Bela?
PETER: Why, Bela Szogody—
 He's my boss. I thought everyone knew *his* name.
JULIA: Is he your connection in California, Alex?
ALEX: Yes, we have sometimes obliged each other.
PETER: Well, it was Bela sent me over
 Just for a week. And I have my hands full.
 I'm going down tonight, to Boltwell.
JULIA: To stay with the Duke?
PETER: And do him a good turn.
 We're making a film of English life
 And we want to use Boltwell.
JULIA: But I understood that Boltwell
 Is in a very decayed condition.
PETER: Exactly. It is. And that's why we're interested.
 The most decayed noble mansion in England!
 At least, of any that are still inhabited.

We've got a team of experts over
To study the decay, so as to reproduce it.
Then we build another Boltwell in California.

JULIA: But what is your position, Peter?
Have you become an expert on decaying houses?

PETER: Oh dear no! I've written the script of this film,
And Bela is very pleased with it.
He thought I should see the original Boltwell;
And besides, he thought that as I'm English
I ought to know the best way to handle a duke.
Besides that, we've got the casting director:
He's looking for some typical English faces—
Of course, only for minor parts—
And I'll help him decide what faces are typical.

JULIA: Peter, I've thought of a wonderful idea!
I've always wanted to go to California:
Couldn't you persuade your casting director
To take us all over? We're all very typical.

PETER: No, I'm afraid . . .

CATERER'S MAN: Sir Henry Harcourt-Reilly!

JULIA: Oh, I forgot! I'd another surprise for you.
 [*Enter* REILLY.]
I want you to meet Sir Henry Harcourt-Reilly—

EDWARD: We're delighted to see him. But we *have* met before.

JULIA: Then if you know him already, you won't be afraid of him.
You know, I was afraid of him at first:
He looks so forbidding . . .

REILLY: My dear Julia,
You are giving me a very bad introduction—
Supposing that an introduction was necessary.

JULIA: My dear Henry, you are interrupting me.

LAVINIA: If you can interrupt Julia, Sir Henry,
You are the perfect guest we've been waiting for.

REILLY: I should not dream of trying to interrupt Julia . . .

JULIA: But you're both interrupting!

REILLY: Who is interrupting now?

JULIA: Now my head's fairly spinning. I must have a cocktail.

EDWARD [*To* REILLY]: And will you have a cocktail?
REILLY: Might I have a glass of water?
EDWARD: Anything with it?
REILLY: Nothing, thank you.
LAVINIA: May I introduce Mr. Peter Quilpe?
 Sir Henry Harcourt-Reilly. Peter's an old friend
 Of my husband and myself. Oh, I forgot—
 [*Turning to* ALEX]
 I rather assumed that you knew each other—
 I don't know why I should. Mr. MacColgie Gibbs.
ALEX: Indeed, yes, we have met.
REILLY: On several commissions.
JULIA: We've been having such an interesting conversation.
 Peter's just over from California
 Where he's something very important in films.
 He's making a film of English life
 And he's going to find parts for all of us. Think of it!
PETER: But, Julia, I was just about to explain—
 I'm afraid I can't find parts for anybody
 In *this* film—it's not my business;
 And that's not the way we do it.
JULIA: But, Peter;
 If you're taking Boltwell to California
 Why can't you take me?
PETER: We're not taking Boltwell.
 We reconstruct a Boltwell.
JULIA: Very well, then:
 Why not reconstruct *me?* It's very much cheaper.
 Oh dear, I can see you're determined not to have me.
PETER: You know you'd never come if we invited you.
 But there's someone I wanted to ask about,
 Who did really want to get into films,
 And I always thought she could make a success of it
 If she only got the chance. It's Celia Coplestone.
 She always wanted to. And now I could help her.
 I've already spoken to Bela about her,
 And I want to introduce her to our casting director.

I've got an idea for another film.
Can you tell me where she is? I couldn't find her
In the telephone directory.

JULIA: Not in the directory,
Or in any directory. You can tell them now, Alex.·

LAVINIA: What does Julia mean?

ALEX: I was about to speak of her
When you came in, Peter. I'm afraid you can't have Celia.

PETER: Oh . . . Is she married?

ALEX: Not married, but dead.

LAVINIA: Celia?

ALEX: Dead.

PETER: Dead. That knocks the bottom out of it.

EDWARD: Celia dead.

JULIA: You had better tell them, Alex,
The news that you bring back from Kinkanja.

LAVINIA: Kinkanja? What was Celia doing in Kinkanja?
We heard that she had joined some nursing order . . .

ALEX: She had joined an order. A very austere one.
And as she already had experience of nursing . . .

LAVINIA: Yes, she had been a V.A.D. I remember.

ALEX: She was directed to Kinkanja,
Where there are various endemic diseases
Besides, of course, those brought by Europeans,
And where the conditions are favourable to plague.

EDWARD: Go on.

ALEX: It seems that there were three of them—
Three sisters at this station, in a Christian village;
And half the natives were dying of pestilence.
They must have been overworked for weeks.

EDWARD: And then?

ALEX: And then, the insurrection broke out
Among the heathen, of which I was telling you.
They knew of it, but would not leave the dying natives.
Eventually, two of them escaped:
One died in the jungle, and the other
Will never be fit for normal life again.
But Celia Coplestone, she was taken.

When our people got there, they questioned the villagers—
Those who survived. And then they found her body,
Or at least, they found the traces of it.
EDWARD: But before that . . .
ALEX: It was difficult to tell.
But from what we know of local practices
It would seem that she must have been crucified
Very near an ant-hill.
LAVINIA: But Celia! . . . of all people . . .
EDWARD: And just for a handful of plague-stricken natives
Who would have died anyway.
ALEX: Yes, the patients died anyway;
Being tainted with the plague, they were not eaten.
LAVINIA: Oh, Edward, I'm so sorry—what a feeble thing to say!
But you know what I mean.
EDWARD: And you know what I'm thinking
PETER: I don't understand at all. But then I've been away
For two years and don't know what happened
To Celia, during those two years.
Two years! Thinking about Celia.
EDWARD: It's the waste that I resent.
PETER: You know more than I do:
For *me*, it's everything else that's a waste.
Two years! And it was all a mistake.
Julia! Why don't *you* say anything?
JULIA: You gave her those two years, as best you could.
PETER: When did she . . . take up this career?
JULIA: Two years ago.
PETER: Two years ago! I tried to forget about her,
Until I began to think myself a success
And got a little more self-confidence;
And then I thought about her again. More and more
At first I did not want to know about Celia
And so I never asked. Then I wanted to know
And did not dare to ask. It took all my courage
To ask you about her just now; but I never thought
Of anything like this. I suppose I didn't know her,
I didn't understand her. I understand nothing.

REILLY: You understand your *métier*, Mr. Quilpe—
 Which is the most that any of us can ask for.
PETER: And what a *métier!* I've tried to believe in it
 So that I might believe in myself.
 I thought I had ideas to make a revolution
 In the cinema, that no one could ignore—
 But here I am, making a second-rate film!
 But I thought it was going to lead to something better,
 And that seemed possible, while Celia was alive.
 I wanted it, believed in it, for Celia.
 And, of course, I wanted to do something for Celia—
 But what mattered was, that Celia was alive.
 And now it's all worthless. Celia's not alive.
LAVINIA: No, it's not all worthless, Peter. You've only just begun.
 I mean, this only brings you to the point
 At which you *must* begin. You were saying just now
 That you never knew Celia. We none of us did.
 What you've been living on is an image of Celia
 Which you made for yourself, to meet your own needs.
 Peter, please don't think I'm being unkind . . .
PETER: No, I don't think you're being unkind, Lavinia;
 And I know that you're right.
LAVINIA: And perhaps what I've been saying
 Will seem less unkind if I can make you understand
 That in fact I've been talking about myself.
EDWARD: Lavinia is right. This is where you start from.
 If you find out now, Peter, things about yourself
 That you don't like to face: well, just remember
 That some men have to learn much worse things
 About themselves, and learn them later
 When it's harder to recover, and make a new beginning.
 It's not so hard for you. You're naturally good.
PETER: I'm sorry. I don't believe I've taken in
 All that you've been saying. But I'm grateful all the same.
 You know, all the time that you've been talking,
 One thought has been going round and round in my head—
 That I've only been interested in myself:
 And that isn't good enough for Celia.

JULIA: You must have learned how to look at people, Peter,
 When you looked at them with an eye for the films:
 That is, when you're not concerned with yourself
 But just being an eye. You will come to think of Celia
 Like that, one day. And then you'll understand her
 And be reconciled, and be happy in the thought of her.

LAVINIA: Sir Henry, there is something I want to say to you.
 While Alex was telling us what happened to Celia
 I was looking at your face. And it seemed from your expression
 That the way in which she died did not disturb you
 Or the fact that she died because she would not leave
 A few dying natives.

REILLY: Who knows, Mrs. Chamberlayne,
 The difference that made to the natives who were dying
 Or the state of mind in which they died?

LAVINIA: I'm willing to grant that. What struck me, though,
 Was that your face showed no surprise or horror
 At the way in which she died. I don't know if you knew her.
 I suspect you did. In any case you knew *about* her;
 Yet I thought your expression was one of . . . satisfaction!

REILLY: Mrs. Chamberlayne, I must be very transparent
 Or else you are very perceptive.

JULIA: Oh, Henry!
 Lavinia is much more observant than you think.
 I believe that she has forced you to a show-down.

REILLY: You state the position correctly, Julia.
 Do you mind if I quote poetry, Mrs. Chamberlayne?

LAVINIA: Oh no, I should love to hear you speaking poetry . . .

JULIA: She has made a point, Henry.

LAVINIA: . . . if it answers my question.

REILLY: *Ere Babylon was dust*
 The magus Zoroaster, my dead child,
 Met his own image walking in the garden.
 That apparition, sole of men, he saw.
 For know there are two worlds of life and death:
 One that which thou beholdest; but the other
 Is underneath the grave, where do inhabit
 The shadows of all forms that think and live

Till death unite them and they part no more.
—When I first met Miss Coplestone, in this room,
I saw the image, standing behind her chair,
Of a Celia Coplestone whose face showed the astonishment
Of the first five minutes after a violent death.
If this strains your credulity, Mrs. Chamberlayne,
I ask you only to entertain the suggestion
That a sudden intuition, in certain minds,
May tend to express itself at once in a picture.
That happens to me, sometimes. So it was obvious
That here was a woman under sentence of death.
That was her destiny. The only question
Then was, what sort of death? *I* could not know;
Because it was for her to choose the way of life
To lead to death, and, without knowing the end
Yet choose the form of death. We know the death she chose.
I did not know that she would die in this way,
She did not know. So all that I could do
Was to direct her in the way of preparation.
That way, which she accepted, led to this death.
And if that is not a happy death, what death is happy?

EDWARD: Do you mean that having chosen this form of death
She did not suffer as ordinary people suffer?

REILLY: Not at all what I mean. Rather the contrary.
I'd say that she suffered all that we should suffer
In fear and pain and loathing—all these together—
And reluctance of the body to become a *thing*.
I'd say she suffered more, because more conscious
Than the rest of us. She paid the highest price
In suffering. That is part of the design.

LAVINIA: Perhaps she had been through greater agony beforehand.
I mean—I know nothing of her last two years.

REILLY: That shows some insight on your part, Mrs. Chamberlayne;
But such experience can only be hinted at
In myths and images. To speak about it
We talk of darkness, labyrinths, Minotaur terrors.
But that world does not take the place of this one.
Do you imagine that the Saint in the desert

With spiritual evil always at his shoulder
Suffered any less from hunger, damp, exposure,
Bowel trouble, and the fear of lions,
Cold of the night and heat of the day, than we should?

EDWARD: But if this was right—if this was right for Celia—
There must be something else that is terribly wrong,
And the rest of us are somehow involved in the wrong.
I should only speak for myself. I'm sure that *I* am.

REILLY: Let me free your mind from one impediment:
You must try to detach yourself from what you still feel
As your responsibility.

EDWARD: I cannot help the feeling
That, in some way, my responsibility
Is greater than that of a band of half-crazed savages.

LAVINIA: Oh, Edward, I knew! I knew what you were thinking!
Doesn't it help you, that I feel guilty too?

REILLY: If we all were judged according to the consequences
Of all our words and deeds, beyond the intention
And beyond our limited understanding
Of ourselves and others, we should all be condemned.
Mrs. Chamberlayne, I often have to make a decision
Which may mean restoration or ruin to a patient—
And sometimes I have made the wrong decision.
As for Miss Coplestone, because you think her death was waste
You blame yourselves, and because you blame yourselves
You think her life was wasted. It was triumphant.
But I am no more responsible for the triumph—
And just as responsible for her death as you are.

LAVINIA: Yet I know I shall go on blaming myself
For being so unkind to her . . . so spiteful.
I shall go on seeing her at the moment
When she said good-bye to us, two years ago.

EDWARD: Your responsibility is nothing to mine, Lavinia.

LAVINIA: I'm not sure about that. If I had understood you
Then I might not have misunderstood Celia.

REILLY: You will have to live with these memories and make them
Into something new. Only by acceptance
Of the past will you alter its meaning.

JULIA: Henry, I think it is time that *I* said something.
 Everyone makes a choice, of one kind or another,
 And then must take the consequences. Celia chose
 A way of which the consequence was Kinkanja.
 Peter chose a way that leads him to Boltwell:
 And he's got to go there.
PETER: I see what you mean.
 I wish I didn't have to. But the car will be waiting,
 And the experts—I'd almost forgotten them.
 I realize that I can't get out of it—
 What else can I do?
ALEX: It is your film.
 And I know that Bela expects great things of it.
PETER: So now I'll be going.
EDWARD: Shall we see you again, Peter,
 Before you leave England?
LAVINIA: Do try to come to see us.
 You know, I think it would do us all good—
 You and me and Edward . . . to talk about Celia.
PETER: Thanks very much. But not this time—
 I simply shan't be able to.
EDWARD: But on your next visit?
PETER: The next time I come to England, I promise you.
 I really do want to see you both, very much.
 Good-bye, Julia. Good-bye, Alex. Good-bye, Sir Henry. [*Exit.*]
JULIA: And now the consequence of the Chamberlaynes' choice
 Is a cocktail party. They must be ready for it.
 Their guests may be arriving at any moment.
REILLY: Julia, you are right. It is also right
 That the Chamberlaynes should now be giving a party.
LAVINIA: And I have been thinking, for these last five minutes,
 How I could face my guests. I wish it was over.
 I mean . . . I am glad you came . . . I am glad Alex told us . . .
 And Peter had to know . . .
EDWARD: Now I think I understand . . .
LAVINIA: Then I hope you will explain it to me!
EDWARD: Oh, it isn't much
 That I understand yet! But Sir Henry has been saying,

I think, that every moment is a fresh beginning;
And Julia, that life is only keeping on;
And somehow, the two ideas seem to fit together.
LAVINIA: But all the same . . . I don't want to see these people.
REILLY: It is your appointed burden. And as for the party,
I am sure it will be a success.
JULIA: And I think, Henry,
That we should leave before the party begins.
They will get on better without us. You too, Alex.
LAVINIA: We don't *want* you to go!
ALEX: We have another engagement.
REILLY: And on this occasion I shall not be unexpected.
JULIA: Now, Henry. Now, Alex. We're going to the Gunnings'.
 [*Exeunt* JULIA, REILLY *and* ALEX.]
LAVINIA: Edward, how am I looking?
EDWARD: Very well.
I might almost say, your best. But you always look your best.
LAVINIA: Oh, Edward, that spoils it. No woman can believe
That she always looks her best. You're rather transparent,
You know, when you're trying to cheer me up.
To say I always look my best can only mean the worst.
EDWARD: I never shall learn how to pay a compliment.
LAVINIA: What you should have done was to admire my dress.
EDWARD: But I've already told you how much I like it.
LAVINIA: But so much has happened since then. And besides,
One sometimes likes to hear the same compliment twice.
EDWARD: And now for the party.
LAVINIA: Now for the party.
EDWARD: It will soon be over.
LAVINIA: I wish it would begin.
EDWARD: There's the doorbell.
LAVINIA: Oh, I'm glad. It's begun.
 CURTAIN

ONE-EYED RILEY

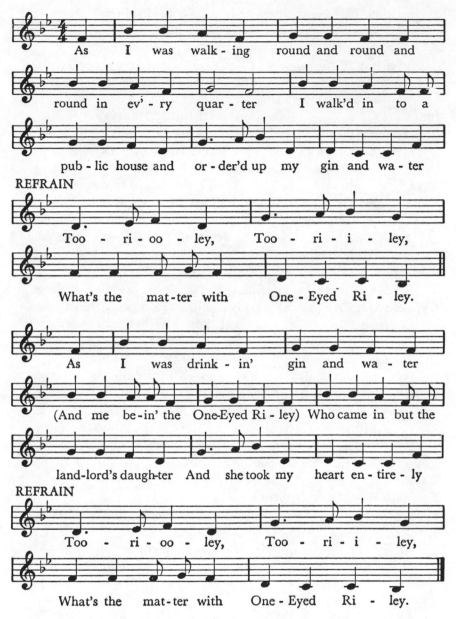

[The tune of *One-Eyed Riley* as scored from the author's dictation by Miss Mary Trevelyan.]

Index

INDEX OF FIRST LINES